THE PLEASURES
OF THE IMAGINATION

David Garrick by Thomas Gainsborough, 1770

THE
PLEASURES
OF THE
IMAGINATION

ENGLISH CULTURE IN THE
EIGHTEENTH CENTURY

JOHN BREWER

THE UNIVERSITY OF CHICAGO PRESS

The University of Chicago Press, Chicago 60637

Published by arrangement with Farrar, Straus and Giroux
Originally published in 1997 by HarperCollins*Publishers,* United Kingdom,
and by Farrar, Straus and Giroux in the United States.
University of Chicago Press edition 2000
Printed in the United States of America
05 04 03 02 01 00 6 5 4 3 2

Library of Congress Cataloging-in-Publication Data
Brewer, John, 1947–
The pleasures of the imagination : English culture in the eighteenth century / John Brewer.
p. cm.
Originally published: New York : Farrar, Straus and Giroux, 1997.
Includes bibliographical references and index.
ISBN 0-226-07419-6 (pbk. : alk. paper)
1. England—Civilization—18th century. 2. England—Social life and customs—
18th century. 3. England—Intellectual life—18th century. I. Title.
DA485.B74 2000
942.07—dc21
 99-057059

CONTENTS

PLATES

Between pages 82 and 83

Between pages 274 and 275

Between pages 466 and 467

PREFACE

I WAS BROUGHT UP in a house full of eighteenth-century antiques, ferried by my father from Liverpool to museums and galleries in Birkenhead, Preston, Port Sunlight and Manchester and to country houses in the North of England and Wales; I was taught at university by Bernard Bailyn, Derek Beales, Herbert Butterfield and Jack Plumb who, from their many different points of view, all loved the eighteenth century. I have studied, lectured and researched in universities and libraries on both sides of the Atlantic with unsurpassed collections of eighteenth-century documents and images, and worked not only with historians but literary critics and art historians, museum curators and librarians. *The Pleasures of the Imagination* is the culmination of many years' work. Though it was written in the last six years, it draws on research that I first began in the 1960s and 1970s. At Cambridge University; at Yale, where I was able to use the extraordinary collections in the Yale Center for British Art and Wilmarth Lewis's shrine to Horace Walpole in Farmington, Connecticut; at Harvard, where the Theatre Collection and the Houghton Library are just two of the University's archival treasures; and at the Clark and Huntington Libraries whose books, pamphlets, prints and paintings enjoy, as I did, the balmy climate of southern California, I have transcribed diaries, discovered songs and handbills, and pored over prints and drawings. I hope that *The Pleasures of the Imagination* goes some way to paying the enormous debt I owe to these institutions and to the teachers, colleagues, librarians and archivists who have helped my researches.

My aim in writing this book has been to build a bridge between the general reader and academic scholarship, to write an accessible account of the fine arts and literature in eighteenth-century England that would draw on the scholarly research and speculation of historians, art historians and literary critics that have made the field so exciting in the last twenty years. *The Pleasures of the Imagination* is the story of how English

eighteenth-century men and women came to see themselves and their
society in a new way, one that distinguished the realm of 'fine arts and
literature', or what we might call 'High Culture' from other forms of
human endeavour. Looking back from the twentieth century, it is easy
for us to think of eighteenth-century culture as a collection of objects
and artefacts such as paintings, country houses and their gardens, famous
literary works, and musical compositions like the oratorios of Handel.
These individual works of the imagination are vital to our understanding
of eighteenth-century culture, but they are only part of a larger transfor-
mation that occurred not just in works of art, but in ways of thinking
about literature, viewing pictures and listening to music, in people's
sense of themselves as creative, tasteful or polite, in the development of
new institutions such as pleasure gardens and coffee houses, and in the
presence of new figures on the cultural scene such as the commercial
impresario and the professional author. A history of such a culture is
therefore about ideas and attitudes, markets and institutions, as well as
about individual works of art and their creators.

Scholarly writing on these subjects is often technical and detailed,
much written in abstract rather than luminous prose. To make this work
more transparent to the general reader, I have linked the main themes
of this book to a series of biographical sketches, which feature familiar
figures like James Boswell and Sir Joshua Reynolds, but also include
such obscure men and women as John Marsh, a provincial composer and
musical performer of prodigious energy and Anna Larpent, a London
lady of refinement who devoted much of her life to literature, the theatre
and art. Following the example of my eighteenth-century predecessors,
I have used their journals, letters and memoirs not just to retell a life,
but to use their stories to explain the character of the age.

The Pleasures of the Imagination does not aspire to be a comprehensive
survey of eighteenth-century English culture, and there will doubtless
be enthusiasts for sculpture, dance, and the minor arts such as watercolour
painting who will feel that I could have written more on their favourite
subject. But my aim is to convey a larger sense of what the culture was
like, what values it embraced, how it worked socially as well as aesthetic-
ally. As I wrote the chapters of the book I realized that I could easily
have written a separate work on each one, and that some of my general
themes were begging for four or five chapters apiece. But this would
have been to inflict on the reader the sort of book that one sixteenth-

century critic of great tomes called 'a portable work if your horse be not too weak'. Seven hundred pages are enough.

During its long gestation *The Pleasures of the Imagination* has seen changes in the nature of publishing not altogether unlike those I describe for eighteenth-century London. Small imprints have been swallowed by multinational communications companies; the pressures of Mammon, personified by the soberly dressed accountant, have made the bottom line the *ne plus ultra* of publishing. The British net book agreement, seen by some as a block of trade and by others as the last bastion protecting literary quality, the small press and the independent bookshop, is, as I write, being defended – almost certainly without effect – in the English courts. *The Pleasures of the Imagination* has been caught in the undertow of this sea-change. Commissioned by two editors who subsequently left their publishing houses, temporarily plunged into a limbo, it has finally seen the light of day thanks to the on-going commitment of Elisabeth Sifton in New York, the timely involvement of Stuart Proffitt at Harper-Collins and the indefatigable efforts of my agent, Gill Coleridge, without whose support this book would never have happened. Elisabeth has, as always, insisted on the virtues of lucid prose, savaging my dangling modifiers and attacking redundant adverbs. Stuart has fought a Burkean rearguard action against my alien abstractions, repeatedly forced me to tighten up the argument, and showered me with suggestions and requests for more examples. Thanks to both of them (though I had not realized how time-consuming the task of editing has become), the final version of the book is better than I could have hoped. I cannot thank Gill Coleridge enough. She has looked after my interests with consummate skill, dealt with my quiddities and constantly kept up my spirits. I like to wonder how she would have coped with a client like Samuel Johnson ('I respect Ms Coleridge, sir, she has raised the price of literature') or with some of the more extravagant eighteenth-century Grub Street hacks.

I began to write this book in Los Angeles; most of it was composed in the British Library and the East End of London; and I finished it in Florence. Thanks to the support of J. Paul Getty and Guggenheim fellowships, I enjoyed two years of writing. Los Angeles is an appropriate place to write a book about art and money, culture and society. It often reminded me of eighteenth-century London – a brash, modern, commercial city, eager to cover its naked consumerism in the respectable garb of cultural refinement. Los Angeles has a reputation as hedonistic and

philistine – a sort of home of the lowest common denominator – which not only vexes the great and the good of the city but obscures its remarkable cultural treasures – museums and galleries like the Norton Simon Museum and the Getty, and libraries like the Huntington – not to mention what in my view is the best history department in the United States. At the University of California in Los Angeles, I directed a three year research project on culture and consumption in the seventeenth and eighteenth centuries, and learned a great deal from all its contributors. I'm especially grateful to Roy Porter (who also read the manuscript), Susan Staves and Ann Bermingham who helped coordinate the programme. Max Novak taught an interdisciplinary seminar on eighteenth-century culture with me, and resolutely made the case for the critic as historian. Bill Weber helped me on music and kindly pointed me to the Larpent Diary at the Huntington. Peter Reill and Lori Stein were always supportive, through thick and thin, and Perry Anderson, who read an earlier, incomplete version of the book, offered kind words of support at a time when they were most needed. Larry Klein, from whom I've learnt so much about politeness, showed me unpublished work and helped me think out much of the argument of Chapter 2.

In London and Florence a number of friends read the manuscript or offered aid, criticism and advice: Juliet Gardiner, Claire L'Enfant and Jenny Uglow were all kind enough to do a little moonlighting on my behalf. David Godwin was a strong supporter of the project but, thanks to the vagaries of Grub Street, was not able to see it through. David Alexander (who also provided me with prints from his collection), Malcolm Baker, David Bindman, Tim Clayton, Richard Godfrey, Andrew Edmunds, Mark Hallett, Marcia Pointon, and David Solkin gave me the benefit of their collective wisdom on painting and the graphic arts. Bob Batchelor, Michele Cohen, Iain Cornelius, Ulrike Ittershagen, Roger Lonsdale, Ronald Paulson, Julie Peters, Krzysztof Pomian, Roberta Sassatelli, Charles Saumarez-Smith, Simon Schaffer, John Styles, Amanda Vickery and Kathleen Wilson all offered help, references or encouragement or comments on the text (not all of which were heeded).

I would also like to thank Nicholas Savage and his staff at the Royal Academy Library and Archives; the staff of the Huntington Library, especially Mary Robertson, who helped me with the Marsh diary; the Archivist and staff of the Newcastle-upon-Tyne Central Library who preserve the spirit and works of Thomas Bewick; the staff at the West

Sussex Record Office, especially Dr Tim McCann; the staff at the Lewis Walpole Library, especially Joan Sussler; Richard Wendorf and his colleagues at the Houghton Library which presides over the Harvard Theatre Collection and the staff of the print room of the Guildhall Library.

Several research assistants worked with me on this project: Hal Gladfelder and Dorothy Auyong at UCLA; Tim Wales who, like me, was captivated by the Marsh Diary; Don Carleton, who traced pictures in US collections with such energy and skill; Sarah Monks, who is the first art historian I have met who was also a computer wizard; and Giannis Giannakitsas and Claire Walsh who gave timely aid in Florence.

I have always wanted to ensure that *The Pleasures of the Imagination* would be a beautiful object, as visually appealing as John Bell's illustrated texts of English literature whose success I discuss in Chapter 11. The staff at HarperCollins – Arabella Quin in editorial and Philip Lewis (who designed the book) – have fulfilled my desire.

I owe a special debt to Brian Allen, the Director of the Paul Mellon Centre for Studies in British Art, now housed in splendid new premises in Bedford Square. He not only read the manuscript but answered countless queries and questions, deftly pointing out errors and guiding me to materials that I might otherwise have overlooked. He and his staff have been a constant source of help and good cheer, providing me with books and chasing up materials in their photo archive, so that I could complete almost all my picture research there.

Over the last few years I have counted on the support and encouragement of a number of friends. Peter Mandler (who also read the manuscript) and Ruth Ehrlich provided shelter, sustenance and good cheer when, in my usual peripatetic way, I was without a roof in London. Andrew Wheatcroft urged me to boldness when my spirits flagged, and Eckhart Hellmuth took me to Munich and the Handelian opera to test my ideas. Simon, Ginny, Gabriel and Chloe of Hardscrabble Road remained true to their flighty friend. At the European University Institute, where I have enjoyed the company of a remarkable group of students, my colleagues and collaborators, Andrea Cariino and Laurence Fontaine, have offered new perspectives on British history, while Olwen Hufton has been an inspiration and a wonderful family friend.

My greatest debt is to Stella Tillyard. We have shared together the pleasures of researching, writing and debating the eighteenth century, a

family life lived at what at times has seemed more than full stretch, and the arrival of Lori while both of us were half way through manuscripts. But this book is for Grace, who has remained funny and feisty (in Italian and English) despite having to bear with the obsessions of her parents and their repeated trips to archives, conferences and book signings; whose companionship meant so much during the trips to Cavini and Le Campagne for *gelati* and *risotti al mare* and for liquid refreshment and the occasional dance at the Bar Fiasco in the spring of 1996; and who constantly reminds me that there is more to life than writing history books.

INTRODUCTION

ONE DAY TOWARDS the end of the eighteenth century, Archibald Alison, an indolent, good-natured cleric given to contemplating the works of man with as much attention as the works of God, dragged himself from his bed, where he habitually lay until two in the afternoon, and sat down in his home in Kenley, Shropshire, to write the opening lines of his first book, *Essays on the Nature and Principles of Taste*. Alison hoped that his remarks, eventually published in Edinburgh in 1790, would impress men and women of refinement and cultivation and especially his patron, Sir William Pulteney. In it he explained:

> The fine arts are considered as the arts which are addressed to the imagination, and the pleasures they afford, are described, by way of distinction, as the Pleasures of the Imagination . . . the[ir] object is to produce the emotions of taste.

His definitions were comfortable, accessible and – it has to be admitted – decidedly clichéd. They repeated a view endorsed by all the finest British writers on taste and the arts, including Joseph Addison, Edmund Burke and David Hume. Alison and his illustrious forebears wanted to distinguish the 'emotions of taste' from other feelings such as sexual desire and acquisitiveness, and to separate those things that were tasteful from the ordinary and useful objects of everyday life.

Alison was a Scot, a retiring cleric in the Church of England with two ecclesiastical sinecures and a prebend at Salisbury, which enabled him to indulge his dilettante taste for writing elegant fragments and well-turned sermons and for pursuing his desultory interest in natural history. He led a pleasant rural life in Shropshire and Hampshire before moving, for the benefit of his sons' education, to Edinburgh in 1800. Yet, like many minor figures of the period, he was part of a much larger movement, for these issues of taste and the imagination exercised many of the leading figures of the European Enlightenment. The French critic,

the abbé Batteux, for example, offered the first coherent account of the fine arts in his *Les beaux arts reduits à un même principe* (1746), which isolated music, poetry, painting, sculpture and dance as the fine arts, distinguishing them from mechanical skills. Montesquieu synthesized prevailing views of taste in his entry 'Gout' in Diderot's *Encyclopédie*, emphasizing their importance in producing the sensation of pleasure, while the second edition of the *Encyclopédie* had a separate entry on the fine arts and aesthetics. In Germany a number of philosophers, including Alexander Baumgarten (who invented the term aesthetics in the 1750s), Moses Mendelssohn, who expanded Baumgarten's theories to apply to the visual arts and music as well as poetry and literature, and Immanuel Kant whose *Kritik der Urteilskraft* (1790) placed a theory of beauty and the arts on a par with the theory of truth and of goodness, developed the Enlightenment's most elaborate analysis of the arts, establishing them as a separate area of philosophical inquiry.

Though these writings on taste were not exclusively concerned with manmade things – they nearly all discussed the way in which natural scenery provoked feelings akin to those evoked by a work of art – they succeeded in creating a new category of what Edmund Burke called 'works of the imagination and the elegant arts'. Of course magnificent works of art, writings about the nature of poetry or painting, and ideas about beauty and sublimity all existed long before the eighteenth century; as the European *philosophes* would have been the first to acknowledge they dated back at least to classical antiquity. But until the eighteenth century they had not been treated as a whole, with theatre, music, literature, and painting given a special collective identity. Our modern idea of 'high culture' is an eighteenth-century invention.

Why did this happen? Part of the explanation lies in the general rethinking of knowledge and human understanding provoked by the seventeenth-century scientific discoveries of Galileo and Newton and by the philosophical and psychological speculations of Descartes, Hobbes and Locke. Neither the medieval system of knowledge based on Aristotle nor the Renaissance *studia humanitas* survived the upheavals of this scientific revolution, which distinguished the arts from the sciences, posed in sharp relief the question whether the modern world was the equal or better of the ancients, and divided the European republic of letters between those who supported the Ancients and those who admired the Moderns.

Yet equally important were changes in the arts themselves, which ceased in the eighteenth century to be the preserve of kings, courtiers, aristocrats and clerics and became the property of a larger public. This more commercial and less courtly culture was to be found in coffee houses in Venice, Amsterdam, London, Paris and Vienna, clubs and reading societies in Germany, academies in provincial France, literary and philosophical societies in provincial Britain, commercial theatres of London, Paris and Lisbon, art dealers' shops and auction houses in Naples, Rome and Amsterdam and at professional concerts performed in London, Paris, Frankfurt, Berlin and Vienna. It was sustained, above all, by printers and publishers, engravers and printsellers, who linked together different regions and nations by disseminating images, books and pamphlets through networks of middlemen, *colporteurs* and shopkeepers throughout Europe. By the middle of the eighteenth century Roman print dealers were distributing images of the Virgin Mary or the Pantheon to Dublin, St Petersburg and Brussels; art dealers in Florence and Naples were shipping precious oil paintings to the drawing rooms of Paris and the English shires; clandestine publishers in Switzerland and the United Provinces were smuggling scurrilous radical books and pornographic pamphlets – so-called *livres philosophiques* – across the border into France and into the libraries of merchants and aristocrats.

These developments were not entirely novel. The earliest picture dealers appear in Italy in the late fourteenth century; by the fifteenth century the Pand, an art fair with some seventy to ninety stalls, was being held twice a year in the cathedral cloisters at Antwerp. The book and print trades also had a long commercial history. The first print catalogue circulated by a dealer was published in Rome in 1572, the first printed book catalogue appeared twenty years later in Leiden. At the great European fairs at Leiden, Frankfurt, Leipzig and Krakow merchants from all over Europe traded books, pictures and prints. The roots of eighteenth-century culture stretched back to the Renaissance and to the advent of printing and the first production of engravings on metal.

Nor had the arts freed themselves from the influence of royal and princely courts. This was especially true with theatre and music. The international stars of eighteenth-century opera like the castrato Francesco Bernardi, known as Senesino, were professional performers paid fabulous salaries to sing all over Europe (he performed in Venice, Bologna, Florence, Genoa, Rome, Naples, Dresden, London and Paris) but, like many

theatre troupes, the singers who accompanied him were usually court employees. In small states, like that of the Bishop Prince-Elector of Mainz, a princely court continued to dominate cultural life.

But the arts became more commercial and less courtly because they became more urban. Taste in the arts was considered a sign of refinement, cultivation and politeness, qualities it was believed were best nurtured in towns and cities. As the novelist Oliver Goldsmith concluded in his *Enquiry into the Present State of Polite Learning in Europe* (1759), culture flourished best in convivial, urban surroundings:

> Learning is most advanced in populous cities, where chance often conspired with industry to promote it; where the members of this large university, if I may so call it, catch manners as they rise, study life not logic, and have the world as correspondents.

The arts came together in the great cities of Europe – London, Paris, Naples, Amsterdam, Rome, Madrid, Lisbon and Vienna – which had theatres and concert halls, booksellers and art dealers and enough prosperous people to create a sizeable public. But they were not confined to the biggest towns. Cities like Edinburgh, Dublin, Stockholm, Copenhagen, Dresden, Bordeaux, Barcelona, Cadiz and Seville, though they each had fewer than 100,000 inhabitants at mid-century, enjoyed a flourishing cultural life, and by the end of the century even quite small towns, as we shall see, had their theatres and reading clubs, bookshops and artists.

Taste became one of the attributes of a new sort of person – the 'sociable man' of Addison and Steele's *Spectator*, the *hônnete homme* of Voltaire's *Le Mondain*, and the 'Cosmopolitan' described by Weiland in *Der Deutsche Merkur* – who was literate, could talk about art, literature and music and showed off his refinement through agreeable conversation in company. It is difficult to define what social groups are referred to here – the language is deliberately vague and speaks of personal qualities rather than rank – but it is clear that they do not include the urban poor or rural peasants, most of whom lacked the wealth, leisure and literacy to enjoy such pleasures. Women of appropriate rank and virtue were included in the community of taste but kept out of some of its most important institutions, notably clubs and associations; their habitat was the drawing room and salon rather than the tavern or coffee house. The community was emphatically not confined to the aristocracy: all over Europe artisans and merchants, shopkeepers and farmers, lawyers,

doctors and minor clergy bought books, collected prints to display in their parlours and dining rooms and, when they could, attended dances, plays and concerts.

The fine arts, whatever the composition of their public, were viewed as one of the defining features of modern commercial society. As one of the first guides to the arts in London put it,

> The cultivation of the polite arts is justly deemed an object of the highest importance in every well-regulated state; for it is universally allowed, that in proportion as these are encouraged or discountenanced, the manners of the people are civilized and improved, or degenerate into brutal ferocity, and savage moroseness.

The Scottish philosophers and political economists saw this more clearly than anyone else. David Hume, John Millar and Adam Smith explained how society had moved from rude barbarism to modern civilization, from primitivism to sophisticated commerce. The many forms of co-operation and interdependence created by trade and economic exchange, they argued, encouraged a refinement of manners as well as propagating better taste. The marketplace as much as the court created polite, refined and cultured people. The frictions of commerce polished modern man and just as a person's taste revealed their degree of refinement, so the state of the arts showed how civilized a nation had become. As Hume put it in his essay 'Of Refinement in the Arts':

> Industry and refinement in the mechanical arts generally produce some refinements in the liberal; nor can one be carried to perfection, without being accompanied, in some degree, with the other. The same age, which produces great philosophers and politicians, renowned generals and poets, usually abounds with skilful weavers, and ship-carpenters . . . The spirit of the age affects all the arts; and the minds of men, being once roused from their lethargy and put into fermentation, turn themselves on all sides, and carry improvements into every art and science.

So the rise of the fine arts and of social refinement were not isolated phenomena; they were intimately tied, as Hume argued and as Diderot explained in the *vade mecum* of modernity, the *Encyclopédie*, to the practical and technical improvements and commercial practices of the modern world.

It followed that modern commercial societies were not like either the ancient civilizations or the tribal communities of the Americas or the South Seas. Hume, for example, was at pains to point out that, for all their achievements, the Ancients lacked politeness and the arts of conversation; he might have said the same about the tribes in North America. This historical and sociological analysis meant that it was possible to look at any past or present society – Highland Scotland or Tahiti, for example – and assign it to a stage in the process of human and social development. All societies were different but they all followed a common path and should be judged by the same criteria.

Several conclusions followed from this. First, the burden of the Ancients was lifted. Not everyone wished to throw off the classical heritage, and some critics continued to maintain the superiority of Greece and Rome, especially in the arts. But those who wanted to escape the influence of antiquity could now argue that it was pointless to follow ancient ways in a modern world. As Thomas Sheridan, defending the 'manifest superiority' of the English language, explained:

> the true way of imitating the wisdom of our forefathers is, not to tread exactly in their steps, and to do the same things in the same manner; but to act in such a way as we might with reason suppose they would, did they live in these days, and things were so situated as they are at present.

The key to progress was emulation not imitation.

Secondly, it became clear that what Hume called 'the Rise and Progress of the Arts and Sciences' had their costs. They enabled a literate, polite and urbane class to enjoy an unprecedented number of theatrical and musical performances, books and paintings, but they also marginalized forms of popular expression such as ballads and folktales, woodcuts and seasonal festivals. The process was twofold. On the one hand peasant songs and stories were viewed as primitive – as belonging to an earlier stage of social development – when compared with polite music and literature, which meant that as society advanced they would gradually vanish. The international values of refinement would erase local language and custom; the growth of commerce would change the manners of the most barbarous people. On the other, the belief that such popular forms of expression were insufficiently refined led men of taste to neglect or

condemn them as vulgar or crude, just as they no longer believed in fairies or witches and viewed bull- and cockbaiting as cruel.

Of course the line between a refined commercial culture and popular forms of expression was never sharp. The Remondini family of engravers in the Italian Veneto sold fine engravings depicting classical allegories as well as crude cuts of the saints; the English chapbooks, French *bibliothèque bleue* and the *pliegos de cordel* of Spain were small unbound and cheaply printed popular tales for a humble audience, but their titles included polite novels and classical stories. Indeed by the later eighteenth century and early nineteenth century leading artists and intellectuals had become convinced that many forms of folk and popular expression needed to be rescued or preserved. As a collector of folktales from the Harz mountains complained, 'they are falling fast into oblivion'. J. G. Herder collected folksongs in Riga, Goethe in Alsace, the Italian priest Alberto Fortis in Dalmatia and Walter Scott in the Highlands of Scotland. Novelists, critics and poets discovered their alter ego: a rich and complex world of popular cultures – folk, regional and national customs – that contrasted with the fine arts because they were local and particular, rather than conforming to a general taste. They distinguished what Herder called *Kultur des Volkes* from *Kultur der Gelehrten*, popular from learned culture.

The enthusiasm for the recovery and preservation of primitive and less refined forms of expression – passionately pursued by some of the most refined folk of Europe – reflected a profound and growing ambivalence towards the sophistication of civilized life that became especially strong in the last quarter of the century. For although the story of how societies changed was broadly accepted, not everyone viewed it as an unmitigated good or a simple story of improvement. A nostalgic primitivism, found in the works of Rousseau and his numerous followers, vaunted the bravery, virtue and spontaneity of the 'noble savage' and the martial ardour and uninhibited vision of the tribes of old in order to attack the artifice and hypocrisy of modern over-refinement. Luxury, these critics claimed, was the plague of the age. For if wealth and commerce nurtured the fine arts, they were also the seed of their corruption, creating a world of appearances and false desires. As one minor English poet put it, 'In polish'd arts unnumber'd virtues lie,/ But ah! unnumber'd vices they supply.' Montesquieu echoed the sentiment: 'Wealth is the result of commerce, luxury the consequence of wealth, and the perfection of the arts is that of luxury.'

Refinement was not the same as virtue. The former was found in playhouses and at the opera, in assemblies and at dances, public gatherings and exhibitions, all of which were occasions for display, fashion and intrigue; the latter was more often seen in the spontaneous and unaffected conduct of innocent children, simple rural folk and the less civilized nations of the world. Over-refinement made nations degenerate and their people selfish. John Brown, an Anglican clergyman and the author of the best-selling jeremiad *Estimate of the Manners and Principles of the Times* (1757–8), who was hired by Catherine the Great to improve the morals of the Russian court but killed himself before he reached St Petersburg, put the view as forcefully as anyone: manners had become '*vain luxurious*, and *selfish* . . . SHOW and PLEASURE are the main objects of Pursuit . . . the general Habit of *refined Indulgence* is *strong*, and the Habit of *induring* is *lost* . . . the general Spirit of *Religion, Honour*, and *public Love*, are weakened or vanished'.

This attack on modern refinement was less a critique of those excluded from it than an attempt to redefine its terms. The subject for the 1769 poetry prize given by the *Académie française*, hardly a marginal body, was *Les Inconvénients du luxe* or 'the drawbacks of Luxury'. The competition prompted many entries which complained of how the luxuries of the town had drained the virtuous countryside of wealth and people and which condemned the *nouveaux riches*. Ironically, primitive nostalgia and the attacks on urban sophistication took the form of fashionable poems, plays and novels, of which Goldsmith's *Vicar of Wakefield* and Rousseau's *La Nouvelle Eloise* are two of the most famous examples, and of skilfully executed engravings and paintings by such artists as Greuze or Gainsborough, which celebrated natural feeling and the simplicities of rural life but which were exhibited and sold in towns. It was necessary to be civilized in order to appreciate the virtues of the primitive life.

But this critique touched a raw nerve because it identified one of the greatest anxieties about the fine arts. For though in theory the pleasures of the imagination provoked by the arts were supposed to be different from the pleasures derived from sexual desire, economic acquisition or social distinction, in practice it was extremely difficult to dissociate them from cupidity, greed and vanity, the giddy pleasures associated with fashionable life in every European city. The immorality of reading novels and romances (which in some French engravings was associated with

female masturbation), the moral laxity associated with theatres and their players (d'Alembert's regret that Geneva banned the theatre, expressed in an article on the city in the *Encyclopédie*, provoked vitriolic condemnation, not least from Rousseau), the extravagance of the opera (a topic in every city which had a major company), the role of middlemen and entrepreneurs in shaping false taste (Alexander Pope for example denounced booksellers as indiscriminate money grubbers who would do anything, including diving into sewers and taking part in pissing contests, for a profit), the commercialism of a publishing world that produced hack writers, condemned by authors from Swift to Schiller, and the growth of a fashionable but ignorant audience for the arts – all of these put the arts' claim to their special status at risk.

At the same time technical and commercial developments diluted the purity of the arts and blurred the boundary between them and other forms of expression. Goethe much admired the designs of the British sculptor John Flaxman, but he was horrified by the idea that the neoclassical pottery and porcelain made after Flaxman's designs by the entrepreneur Josiah Wedgwood would be viewed as art. 'The burgeoning taste of the public', he wrote, 'has been perverted and destroyed . . . the English, with their modern "antique" pottery and wares made of paste, their gaudy black and red art, gather piles of money from all over the globe: but if one is truthful one gets no more out of [this] antiquity than from a porcelain bowl, pretty wallpaper or a pair of shoe-buckles.' Others were less fastidious, borrowing from commercial design, as in the case of Hogarth, or using popular song, like Haydn in his arrangement of Scottish folk songs. The dynamic energy of artists and entrepreneurs, the avidity of the public for taste and entertainment constantly challenged a stable and fixed notion of the place of the arts and, as a result, one of the most important subjects of artistic endeavour in the eighteenth century became the arts themselves. The controversies about the status of 'high culture' and the nature of the arts, about commercialism and sensationalism and about the role of the media are not late twentieth-century developments but as old as the notion of the fine arts themselves.

Though the growth of the arts and their public institutions occurred throughout eighteenth-century Europe, they appeared to many contemporaries to be especially prominent across the Channel. In part this was

because of the rapidity of change in England. In 1660, when Charles II was restored to the throne, there were few professional authors, musicians or painters, no public concert series, galleries, newspaper critics and reviews; by the dawn of the nineteenth century these were all part of the cultural life of Britain. In the seventeenth century the arts in England had seemed poorly developed when compared with France, the United Provinces, Italy or Spain. The English court was a much weaker patron of the arts than the great monarchies of France and Spain or the principalities of Italy and central Europe; there were no large cities apart from London; and the skilled craft traditions that underpinned the arts in the Netherlands, Germany and the Italian city-states were only in their infancy. But during the next hundred years London became the largest city in Europe and while there was little urban growth on much of the continent, English cities grew apace, accounting for nearly three quarters of European urban population growth between 1750 and 1800; native craft traditions flourished, helped by the influx of skilled French Protestants after Louis XIV ended religious toleration in 1685; eventually native practitioners of the graphic and applied arts came to compete with the best in Europe.

As many foreign commentators and visitors to England recognized, the rise of the arts in England was the triumph of a commercial and urban society, not the achievement of a royal court. It was the political as well as economic condition of England – its weak monarchy, free constitution and rule of law – which helped to create literature and performing arts that aimed for a public and were organized commercially rather than being confined to a few.

When his former mistress, Adrienne Lecouvreur, died in 1730 and was refused a Christian burial in Paris because she was an actress, Voltaire launched a bitter attack on the French by contrasting their bigoted and reprehensible values with the enlightened virtues of England. In England, he maintained, Lecouvreur, like other actresses, would have been buried in Westminster Abbey; in London 'whoever has talents is a great man'. Voltaire went on to compare London to the great classical cities and to describe it as the modern seat of civilization. Grief and anger go some way to explain the force of his contrast, but others shared his view. Foreign visitors to England, like the German Baron Pollnitz, as well as English patriots, were apt to describe London as the new Rome, and foreign artists flocked to the city to revel in its freedoms. England became

an enlightenment ideal-type, representing what the *philosophes* wanted to achieve.

London, the fastest growing city in Europe, became rather like late nineteenth-century New York or late twentieth-century Los Angeles: it stood out as the metropolis of the moment, a city of riches, conscious of its rising status and eager to clothe its naked wealth in the elegant and respectable garments of good taste. London acted as a cultural magnet, drawing to it an astonishing number of artists and musicians. Here was a new and largely undeveloped centre for the arts where flagging reputations could be revived, fortunes repaired (this seems to have been Canaletto's reason for visiting London), and new careers launched unencumbered by the opposition of well established rivals. Between 1675 and 1750 eighty-three Italian composers were resident in London; there were painters and decorators from France, Italy, Poland, a whole school of Swedish artists, Germans, Dutchmen and Belgians, not to mention the Scots and Irish and the occasional Hungarian.

Josef Haydn, who first visited London in 1791, was intoxicated with the British capital. Released from the shackles of the Esterhazy court, he revelled in London's commercial concert life and plunged himself into a frenzy of activity. 'How sweet is some degree of liberty!' wrote the composer. 'The consciousness of being no longer a bond servant sweetens all my toil.' (Haydn wrote 768 pages of music during his two visits.) Money also helped: Haydn's concert series and private commissions earned him unprecedented fees – an army officer even paid him fifty guineas for two regimental marches. After netting £800 from his benefit concert in 1794, he commented, 'This one can only make in England.'

Travellers tend to see what they expect, and foreign visitors saw what the German pastor and philosopher Karl Moritz, who came to England in 1782, called 'prosperity and opulence', the commerce and liberty which Voltaire had commented on fifty years before and which Haydn was to enjoy a decade later. England as viewed by the enlightened tourist was considered a country of great freedom, and the itinerary most visitors followed bore out this view. Trips to pleasure gardens like Vauxhall and to the main shopping streets convinced visitors of the liberties granted the populace, who mingled with gentlemen and aristocrats in the pleasure gardens and who openly abused overdressed fops and courtiers on the streets. Foreigners went to the theatre not just to see the great players like David Garrick and Sarah Siddons but to observe

what the Irish cleric Dr. Thomas Campbell called the boisterous 'Angloism' of the audience. And they tipped the door-keeper of the gallery of the House of Commons so they could listen to liberty in action and ogle the politicians. Moritz, who attended both the House of Commons and a parliamentary election at Westminster, was much taken by the idea of English liberty:

> when you see ... how high and low, rich and poor, all concur in declaring their feelings and their convictions, that a carter, a common tar, or a scavenger, is still a man, nay, an Englishman; and as such has his rights and privileges defined and known as exactly and as well as his king, or as his king's minister – take my word for it, you will feel yourself very differently affected from what you are, when staring at our soldiers in their exercises at Berlin.

Many visitors came to the conclusion that, thanks to its political system, Britain was a place with less poverty and less inequality of wealth than most of Europe. Moritz wrote,

> in the thickest crowds [are] ... persons, from the highest to the lowest ranks, almost all well-looking people and cleanly and neatly dressed. I rarely see even a fellow with a wheelbarrow, who has not a shirt on; and that too such an one, as shews it has been washed; nor even a beggar, without both a shirt, and shoes and stockings.

Liberty and prosperity went hand in hand.

Tourist visions are always parodies even if, like many parodies, they contain a kernel of truth. Moritz, like other foreign visitors, must have averted his gaze from the terrible poverty that we know existed in London. (English visitors, like the Newcastle engraver Thomas Bewick, were far more likely to comment on the vicissitudes of the poor.) Nevertheless Moritz's view of England as a country with less inequality than its neighbours (a perception supported, incidentally, by British visitors to the continent, like the novelist Tobias Smollett and the agriculturalist Arthur Young, who were shocked by European poverty) is borne out by modern scholarship. The middle ranks of society, which ranged from minor gentlemen to well-off artisans, whose family income was between £50 and £200 a year, comprised nearly 25 per cent of the population by the 1780s and made up much of the new audience for the arts. The disparity of wealth between a duke and a chimney-sweep was staggering, but

between these extremes a large class of moderately prosperous property-holders was able to enjoy what Adam Smith called the 'decencies' of life, to buy books and prints and to attend musical evenings and the theatre.

Visitors like Voltaire and Moritz, neither of whom was especially gullible, took such an optimistic view of England because it accorded with their preconception that freedom and the flourishing of the arts were inextricably linked. As David Hume put it, *'it is impossible for the arts and sciences to arise, at first, among any people unless that people enjoy the blessing of a free government'*. Liberty and the rule of law, which protected property, were the handmaidens of commerce which, in turn, helped the liberal and fine arts flourish. When Voltaire or the Scottish political economists imagined a nation that epitomized a modern commercial society they thought of England because of both its economy and its unusual political system.

Again, recent historical research bears them out. Though the British economy was not growing faster than some of its continental rivals, it was different in kind: more economic activity was for the market and less for subsistence and a larger proportion of the workforce was not employed on the land. By 1750 more people worked in industry, trade, commerce and services than in agriculture. England had already become a nation of shopkeepers. In a survey of England and Wales of 1759, tax officials counted 141,700 retail outlets, of which 21,603 were in London. Almost every tourist commented on the Strand, London's main shopping street, with its milliners and haberdashers, booksellers and printshops, large windows and elaborate displays. Moritz proclaimed:

> here it is contrived as much as possible, to place in view for the public inspection, every production of art, and every effort of industry. Paintings, mechanisms, curiosities of all kinds, are here exhibited in the large and light shop windows, in the most advantageous manner; nor are spectators wanting, who here and there, in the middle of the street, stand still to observe any curious performance. Such a street seemed to me to resemble a well regulated cabinet of curiosities.

The Strand, of course, was unique, but with its bustle and display, trade in art, literature and luxury goods, it proved what the tourist already knew – that England was the embodiment of modern commerce and refinement.

Foreign visitors and commentators emphasized England's liberty and modernity. Its vigorous political culture, epitomized by the most fully developed European newspaper press, the absence of prior censorship (the Licensing Act had lapsed in 1695), the existence of religious toleration and of freedom to worship, the concern for subjects' rights and the openness of society all impressed foreigners because they were conspicuous by their absence elsewhere. Before the Revolution France lacked a vigorous political daily press but had more than 120 official censors. Even states known for their liberality – Venice and most of the provinces of the Low Countries – had some sort of prior censorship. And all over Europe laws discriminated against those who did not follow the official religion, and arbitrary procedures were used against which subjects had little redress.

Of course in idealizing England and emphasizing its modernity, *philosophes* tended to downplay its more traditional aspects and to see political and religious conflict as a sign of liberty rather than of a divided nation. The struggles of the seventeenth century, in which the nation had been plunged into civil war, regicide and irresoluble religious differences, were viewed in the light of what Voltaire and others believed to be their felicitous consequence: the triumph of English liberty.

Foreign visitors therefore tended to underestimate the depth of divisions that continued to affect every aspect of life from government policy about trade to church music and the patronage of painters. In part because of their own very different political experiences, they failed to understand the ferocious quarrels between Whigs and Tories, parties first formed during the attempt to exclude Charles II's Catholic brother from the throne during the Exclusion Crisis of 1679–81. The Whigs' commitment to religious toleration (at least for Protestants) and to a limited monarchy, which most *philosophes* also embraced, was always strongly opposed by the Tory belief in a strong alliance between a Protestant national church and an hereditary monarchy. Religious differences followed political divisions: the Protestant sects (the so-called Dissenters or Nonconformists, made up of Presbyterians, Independents, Baptists and Quakers) which rejected the national Church of England usually supported the Whigs, while Anglicans were usually Tory. Catholics, excluded from political office, remained a small minority (about 80,000 in 1770) whose sympathies were usually Tory, though they were sometimes Jacobite or Whig. The two parties fought over the monarchical succession, the role of the Church

of England and the nature of the English constitution; in the first half of the eighteenth century a succession of plots and rebellions (notably the Jacobite Risings of 1715 and 1745) tried to overthrow the Hanoverian dynasty and return the Stuarts, who had been deposed during the Glorious Revolution of 1688, to the throne. The English nation was therefore far more divided than it often appeared to outside observers, and though Whigs and Tories shared a vision of a flourishing commercial society, their views on the political and religious character of the regime differed radically. Not until the French Revolution irrevocably ended the mutual admiration of many European *philosophes* and the English nation did Europeans begin to understand that English society was not quite what they thought it to be – that it was conservative, hierarchical and traditional as well as dynamic and progressive. They had missed this because they usually saw Britain through the eyes of its more radical and liberal subjects.

When Scottish philosophers and political economists like David Hume and John Millar wrote about the arts, they did not discuss the merits of individual works but asked how the new system of the arts, with its new institutions and conceptions of taste, had come into being. This is the approach I follow in *The Pleasures of the Imagination*. My aim is not to explain how and why certain novels, paintings, plays or oratorios moved and affected their readers, viewers and listeners or to celebrate the merits of authors like Fielding, painters like Hogarth or composers such as Purcell but to understand a larger historical process. This does not mean that I do not have strong critical preferences for certain works and artists, just as Hume had his predilections and dislikes, but in this book these preferences are beside the point. I am examining writing, bookselling, publishing and reading rather than the genius of Johnson; exhibiting societies, academies, art dealers and collecting rather than the brilliance of Reynolds; and censorship, subsidies, theatres, audiences and actors rather than the talents of Garrick. Johnson, Reynolds and Garrick, together with a host of other artists, feature prominently in the following pages but as figures who helped to shape the institutions of literature, painting and the theatre and not as isolated geniuses. I am concerned less with the critical reputation conferred on them by posterity than with their part in creating the culture of their day.

The ways in which the arts worked in eighteenth-century England are often best understood not only through its major figures but through

the experiences of those we have now largely forgotten: unsuccessful hack writers and minor painters, failed playwrights and actors, figures whose reputation and fame did not long survive their own lifetime, impresarios and entrepreneurs who peddled the arts even if they did not create them and the many men and women who made up the audience for literature and the fine arts. Johnson, Reynolds and Garrick have leading roles, but they have to share the stage with a large cast of less familiar but often equally engaging characters.

When Hume wrote his essay 'Of Refinement in the Arts' he ranged from the Tartars to modern Poland, though he ended with a discussion of Great Britain and England, which he seems at times to treat as one and the same place. My approach is rather different and looks at literature and the arts from three perspectives – those of London, English provincial cities and the British nation. Each viewpoint has its importance at different times: London first developed the new institutions of the arts, they flourished in the provinces especially after 1760, and they helped forge a British elite by the end of the century. There was a similar development in what was fashionable to depict in books, pictures and plays. Pope, Samuel Richardson and William Hogarth made London a central subject of their art; Gainsborough and a succession of poets portrayed provincial life; and the wilds of the Scottish Highlands and north Wales were popular subjects for poets and painters in the last two decades of the century. This approach has the disadvantage that it does not treat developments in Scotland and Ireland – in Edinburgh and Glasgow, Dublin and the grand Irish country houses – as distinctive but rather as part of a larger whole. On the other hand it enables us to see that British culture was never a monolith but was viewed differently by groups from different perspectives. Though there might be shared agreement about the existence of a distinctive British culture, its content and boundaries were, as we shall see, a persistent source of dispute. London intellectuals and provincial artists, amateur painters and professional actors, libertines and clergymen, impresarios and art dealers, hack writers and foreign musicians and critics of every stripe not only produced, sold and enjoyed works of art but, through their words and deeds, shaped English culture. The fugitive spirit of English culture dwells as much in their strident disagreements and frequent controversies as in the works of art themselves.

I

CONTEXTS

CHAPTER ONE

Changing Places:
The Court and the City

HIGH CULTURE IS LESS a set of discrete works of art than a phenomenon
shaped by circles of conversation and criticism formed by its creators,
distributors and consumers. In the sixteenth and seventeenth centuries
in England such communities were largely confined to the royal court
or, if found outside the ruler's palace, looked to the monarch and his
entourage as leaders of taste. The court was the centre of high culture,
its superiority expressed in its magnificent buildings, ornate tapestries,
lavish decoration and exquisite collections of paintings, all of which
created a glittering stage on which the drama of monarchy was enacted.

But in the late seventeenth century high culture moved out of the
narrow confines of the court and into diverse spaces in London. It slipped
out of palaces and into coffee houses, reading societies, debating clubs, as-
sembly rooms, galleries and concert halls; ceasing to be the handmaiden of
royal politics, it became the partner of commerce. Between the restoration
of Charles II in 1660 and the accession of George III one hundred years
later art, literature, music and the theatre were transformed into thriving
commercial enterprises. These looked not to the court but to coffee houses,
key places in creating new cultural communities, and to the clubs and
associations which were among London's leading cultural patrons.

People at the time were much struck by this remarkable change.
Whether they greeted it with enthusiasm or complained at the loss of a
better age, the cultural life of London and its new institutions gripped
them. Just as artists had once devoted themselves to depicting the court
and its values, so London was now repeatedly represented on the stage,
in prose and verse, in painting and engraved image. The city had become
not only the centre of culture but one of its key subjects.

How did this change come about? To answer this question we have

to look back to the court culture of the Tudors and early Stuarts and to
the political circumstances that fatally undermined the credibility of the
monarch and his entourage.

The English court of the sixteenth and seventeenth centuries, especi-
ally during the reigns of Henry VIII (1509–47), Elizabeth I (1558–
1603) and Charles I (1625–49), followed the pattern of many monarchies
throughout Europe. Royal courts were centres of national power, arenas
where the struggles and alliances between monarchs and nobility were
played out. Increasingly, as kings tried to reduce the military might of
their most powerful subjects and as nobles came to accept humanist ideas
that valued learning and taste as much as martial prowess, courts became
centres of culture and refinement. Modelling themselves on the Italian
courts at Florence, Urbino and Ferrara, the English monarchs and their
courtiers created communities in which good conversation, taste and
learning were cherished.

These values were embodied in the courtier, in his manners and
elegant comportment – the gesture of a hand, the subtlety of a bow, a
witty remark – but also in the objects with which he surrounded himself.
From the Thames to the Danube princes urged their courtiers on a
headlong pursuit of tasteful magnificence, the collection and display of
everything rare, beautiful and wonderful. The Italian humanist Giovanni
Pontano described these objects as 'statues, pictures, tapestries, divans,
chairs of ivory, cloth interwoven with gems, many-coloured boxes and
coffers in the Arabian style, crystal vases and other things of this kind
. . . [whose] sight . . . is pleasing and brings prestige to the owner of the
house'. They all spoke to the wealth, taste and *virtu* of their owner.
Rulers were in the forefront of this fashion, wrapping themselves in
visual splendour and using their palaces, pictures, libraries and collections
of curiosities to display both their exquisite taste and their divinely
ordained authority.

For the monarch's courtiers cultural pursuits were a means to an
end. Dancing, drawing, literary composition and the playing of musical
instruments – those skills that the Italian Renaissance courts and their
chief propagandist, Baldassare Castiglione, had made the essence of the
noble courtier – were used as weapons in wars of personal intrigue and
seduction designed to enhance the status of their possessor and win the
monarch's favour. The monarch, at the apex of court power and centre
of its ritual, and the greatest patron of the arts, was the cynosure of this

culture, standing (or, more usually, sitting) at the centre of a system of artistic practice intended to represent his or her sacred omnipotence and monopoly of power.

At first sight the English court was not a prepossessing place in which to display such royal magnificence, for it consisted of a hotchpotch of asymmetric late-medieval buildings. It was intimate, local and particular, the personal territory of the ruler. In the chief palace, at Whitehall, the king's private servants and officials lived crammed together in close proximity to the monarch. Quite unlike the grand palaces of other European monarchs, it was a warren of ill-proportioned rooms and temporary structures erected for special occasions. Canvas banqueting halls put up to entertain foreign dignitaries were jumbled up with gardens, bowling alleys, a theatre and tennis court, as well as the monarch's private chambers and public receiving rooms. Repairs and alterations were constantly under way.

Yet, for all its architectural incoherence and its importance as a place of intrigue, the monarch and his followers thought of the court as a microcosm of how the kingdom ought to be, the harmonious expression of a social order centred on the monarch. Though its members were quarrelsome and contentious, in its literature, ceremony and theatre it represented itself as orderly, coherent and hierarchical. Within its narrow confines the court and its elaborate patterns of distinction were believed to reproduce the patterns of the knowable world. It was not necessary to represent anything else, because all things could be represented through the court.

Charles I's court represented the English apotheosis of this Renaissance ideal of kingship. The patron of Peter Paul Rubens, Van Dyck and Inigo Jones, Charles owned some of the finest pictures in Europe, including works by Leonardo, Correggio, Caravaggio, Mantegna, Raphael, Bronzino, Titian, Rembrandt and Dürer. 'When it comes to fine pictures,' said Rubens on his visit to London in 1629–30, 'I have never seen such a large number in one place as in the royal palace.'

Ritual and ceremony complemented art, reaching their apogee in the court masque, a mixture of theatre, music, tableau and ritual, shaped by classical myths and Renaissance iconography, and performed by courtiers – sometimes including the king and queen themselves – before an audience of courtiers. The object of the masque was, in the words of the poet Ben Jonson, 'the studie of magnificence'; it praised the mysteries of

kingship, the organic unity of an obedient polity and the virtues of the monarch. The masque's extravagant costume and complex machinery were elaborately coordinated into a harmonious whole representing both court and nation. They revealed a natural order centred on the king: as Sir John Davenant put it in the masque *Britannia Triumphans*, performed in 1638, 'Move then in such a noble order here/As if you each his governed planet were,/And he moved first, to move you in each sphere.' Inigo Jones's scenery and the extravagant lyrics of the masque, like Charles's exquisite collection of paintings, were intended to create a world of beauty and harmony, a royal realm of moral and political virtue.

Yet, as Charles I was to discover to his cost, the illusion of a unitary, hierarchical, moral and orderly court – and with it a unitary polity – was exceptionally difficult to sustain. While *Britannia Triumphans* opened with a scene in which rebellious citizens of past reigns are dispelled by Heroic Virtue, faction, disorder and rebellion were much harder to deal with in British society. Within a decade of Davenant's eulogy to the king, its plot was reversed: Charles I had lost two civil wars and was the prisoner of his rebellious subjects. On 30 January 1649 he was led by his captors through the Banqueting Hall in Whitehall, where frequent court masques had celebrated divine kingship and whose ceiling, painted at his behest by Rubens, depicted the apotheosis of his father, James I (fig. 1). On a scaffold outside he was summarily decapitated. The culture of the courtly prince in England was killed by the same stroke. No British monarch was ever to match Charles I either as a patron of the arts or as the fabricator of such an astonishingly rich and complex representation of royal power.

Between 1649 and 1653 Charles I's magnificent collection of paintings was sold, and in the ensuing years the King's Musick, employing eighty-eight musicians, was radically reduced. Beyond the confines of the court the Puritans removed organs from places of worship (so that in 1660 there were more in taverns than in churches) and closed the playhouses. More than 100 years later Horace Walpole, the aristocratic author of *Anecdotes of Painting in England* (who, like a good eighteenth-century Whig, slept with a copy of Charles I's death warrant above his bed), commented that 'the arts were, in a manner, expelled with the royal family from Britain'.

The Puritan regimes of Oliver Cromwell and his followers (1649–60), which replaced the house of Stuart, were those of the written and

1. *The Apotheosis of James I* by
Peter Paul Rubens, *c.* 1635

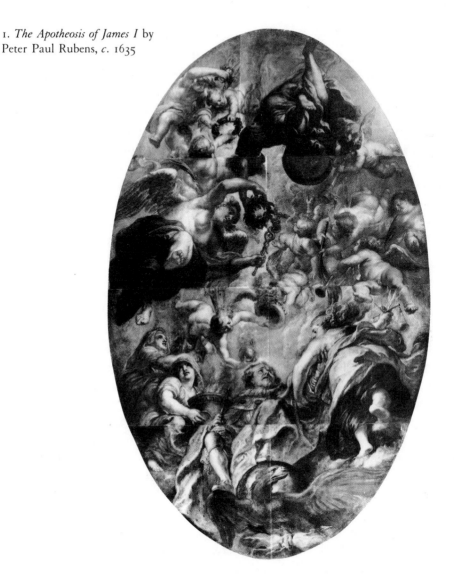

spoken word. They loved Scripture, enjoyed sermons, and produced a torrent of polemical print, but they despised and feared ritual and images as the symbols of worldliness, popery and arbitrary power. (Unsurprisingly, though the Puritans planned to transform the royal collection of books into a public library, they never contemplated housing Charles's pictures in a public museum.) Nevertheless there was some respite towards the end of the Protectorate in what was otherwise a bleak era

for the arts. Oliver Cromwell, though not a prince, acquired a court, albeit a rather sober one. A great lover of music as long as it was not in church, he permitted private performances and secular court festivities; a few paintings and tapestries appeared at his residence at Hampton Court – Mantegna's enormous cartoons of *The Triumph of Caesar* were hung in the Long Gallery; Cromwell's bedroom was decorated with paintings of Vulcan, Mars and (less probably) Venus; antique marbles of nude men and women were displayed in the Privy Garden, much to the horror of the stricter supporters of the regime. Officially sanctioned theatre returned in the guise of opera, with the performance of William D'Avenant's *The Cruelty of the Spaniards in Peru*, held at the Cockpit in Drury Lane in 1658. But Cromwell's court was never a significant social or cultural centre, nor did artists make any serious attempt at an icono-graphical representation of the Puritan regime. Only in the field of literature, in the works of John Milton and Andrew Marvell, did the Cromwellian regime make any contribution to English culture.

After the restoration of the crown in 1660, first Charles II (1660–85) and then his brother James II (1685–88) aspired to recreate the monarchy of their father and even to emulate the lavish embodiment of royal authority epitomized by Louis XIV's Versailles. But this was no easy task. If the restored monarchy was to be more than a pale imitation of its predecessors and a weak copy of the extravagant absolutist regime across the Channel, it needed to build a palace that was a worthy home, symbol and stage for a powerful monarch, to have a fit setting for the artistic expression and performance of ideals of kingship.

Shortly before the outbreak of civil war Charles I had been working with Inigo Jones on a plan to erect a huge new palace at Whitehall. The king was still examining schemes for the building shortly before his execution. Charles II began where his father had left off, starting to construct two new palaces, one at Greenwich, the other at Winchester. Neither was ever completed. The palace at Winchester was to have been Charles's Versailles (fig. 2). Designed by Christopher Wren on land purported to be the meeting place of King Arthur's knights of the Round Table, it was to have been linked to the cathedral by a street of fine town houses to accommodate court servants and nobility. Like Versailles, it would have drawn the aristocracy away from the capital and into the monarch's exclusive orbit. Work began in 1683, at a time when the restored monarchy, having recently vanquished its Whig foes, was at the

height of its power and prosperity. But Charles died two years later, and his successor James neglected the building, letting it fall into disrepair. Only an outer shell, the thinnest façade of monarchy, was ever completed. So the palace remained until it was burned down at the end of the nineteenth century. Its magnificent marble pillars, a gift to Charles from the Duke of Tuscany, were given away by the Hanoverians to the Duke of Bolton; the remnant of Wren's vision served as an enduring reminder of the unfulfilled aspirations of the 'merry monarch' and, more prosaically, as a prisoner-of-war camp and a local gaol.

No new palace was completed for the British monarchy until the nineteenth century. Its greatest achievements after the Restoration were, in the tradition of the modern middle classes, a succession of remodellings. Charles II spent lavishly on Windsor Castle, creating a splendid series of state apartments, notably St George's Hall. Here the full panoply of baroque symbolism and allegory, notably in Antonio Verrio's ceilings, celebrated monarchical power and virtue. James II made comparable improvements in the great rambling medieval palace at Whitehall.

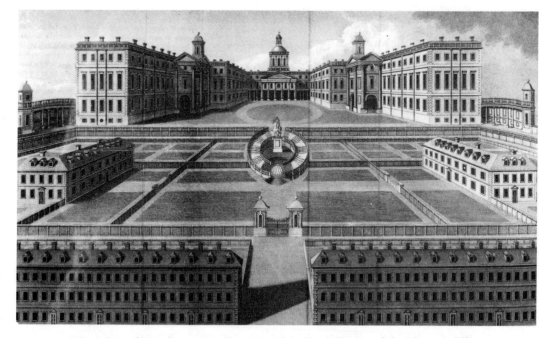

2. The Palace of Winchester: *The East View of the King's House and the Adjoining Offices as Intended to have been Finished by Sir Christopher Wren* by J. Cave, engraved by J. Pass, 1798

Apartments were designed by Wren, decorated by Grinling Gibbons and Verrio, hung with the last important set of tapestries to be ordered by a British monarch, and filled with paintings by such artists as Godfrey Kneller. Charles and James may have wanted to emulate the Sun King but they lacked the money to do so. Charles was too indolent – he never applied himself to the business of kingship as Louis XIV did – and James's rule was too brief. In consequence their works were incomplete miniatures of Versailles; they lacked the monumentality that was the essence of grand monarchy.

William III and Mary II, though they neglected Whitehall, continued their predecessors' policy of piecemeal improvement. A series of new apartments, again designed by Wren, was added to Cardinal Wolsey's sixteenth-century palace at Hampton Court, which also acquired an elaborate new garden, whose design was personally supervised by William. The joint monarchs also acquired Kensington Palace from the Finch family in 1689, transforming it into what John Evelyn described as 'a very sweete Villa . . . very noble, tho not very great . . . the Garden about it very delicious'. This converted aristocratic residence had a council chamber, audience chamber, library and chapel; it also displayed William's fine collection of art. Evelyn was especially impressed by 'the Gallerys furnished with all the best pictures of all the Houses, of Titian, Raphel, Corregio, Holben, Julio Romano, Bassan, V:Dyke: Tintoret, & others, with a world of Porcelain'.

William and Mary, though they were not averse to putting their good taste on public display, did not care to live in the grand manner. They closed down Charles's recently decorated state apartments at Windsor, which thereafter received only intermittent royal use. When Mrs Philip Lybbe Powys, a member of the Oxfordshire gentry whose greatest passion was peering into stately homes and country seats, visited Windsor in 1766 she commented in her journal, 'there is but little worthy of one's observation; the furniture is old and dirty, most of the best pictures removed, . . . and the whole place so very un-neat that it hurts one to see almost the only place in England worthy to be styled our King's Palace so totally neglected.' The castle awaited rescue and renewal at the hands of George III, who began to use it regularly in the 1780s.

While Windsor was shut up after the Glorious Revolution of 1688, the palace at Whitehall went up in flames on a bitterly cold and windy day in January 1698, sparing only Inigo Jones's Banqueting Hall and

Whitehall Gate. Here was a great opportunity to build a modern palace in the heart of the city. But William pointedly ignored Wren's plans for an extravagant new palace. As Daniel Defoe remarked of Whitehall in his *Tour Through the Whole Island of Great Britain*, first published in 1724, 'I have nothing more to say of it, but that it was, and is not, but may revive.' But Defoe's hope that 'a time will come, when that Phoenix shall revive, and when a building shall be erected there, suiting the majesty and magnificence of the British princes, and the riches of the British nation' was overly optimistic. Subsequent rebuilding schemes had lukewarm support and came to naught.

When Whitehall burnt down William could hardly have been more disgruntled with the nation that had made him king. Hounded by his parliamentary critics and hankering to return to Holland, pressed for money and angry at the ingratitude of the people he believed he had saved, he was in no mood to exalt the English crown. In 1700, two years before his death, as if preparing for a move home, he had his favourite cultural treasures at Kensington packed up and shipped off to his beloved Dutch palace at Het Loo.

None of William's successors was a great palace builder. Queen Anne and the first two Georges, like their predecessors, were improvers rather than innovators. Three new state rooms – the King's Drawing Room, the Cupola or Cube Room and the Privy Chamber – and new courtyards to serve George I's extended German family were added at Kensington, and a new stable block erected at St James's. It remained for George III to acquire the first new royal residence in more than half a century, an early eighteenth-century red-brick ducal mansion close to St James's Park and at the end of the Mall. George paid £28,000 for Buckingham House in 1762, quickly doubling his expenditure by adding new apartments, including the Library where he was one day to entertain Dr Johnson, the Saloon Room in which Queen Charlotte held her drawing rooms, and a music room for private concerts. But only in the nineteenth century, with complete rebuilding after 1825, did this large house become the substantial palace that we see today. Indeed, during the eighteenth century it was known as the Queen's House, for it was less a palace for royal business and monarchical functions – which took place across the park at St James's – than a private royal residence where Queen Charlotte brought up her numerous and unruly children (fig. 3).

Despite the growing importance of Britain as an international power,

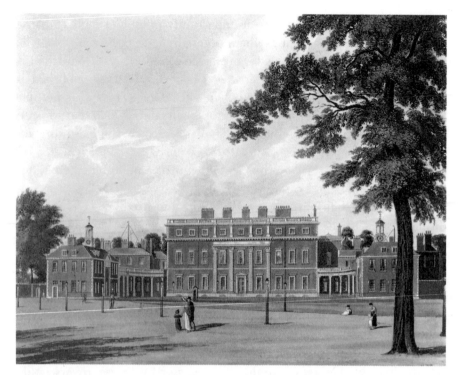

3. *Buckingham House* by W. Westall, engraved by T. Sutherland, 1819

then, no ruler constructed an extravagant stage on which to display the court's refinement or the monarch's taste in music and the decorative arts. This is all the more extraordinary when compared with the building achievements of the great baroque princes of Europe. Princely palaces of inordinate size and richness were springing up in Stockholm, Berlin, St Petersburg and Dresden, at Schönbrunn outside Vienna and Caserta outside Naples. Even pip-squeak princelings like the Prince Bishop of Würzburg lived in palaces that put the British monarch's residences to shame. It was a constant source of puzzlement and wonder to foreign visitors to England that the monarch of such a powerful nation should live in such low circumstances. As a print of St James's Palace in the series *Nouveau Théâtre de la Grande Bretagne* put it, 'c'est dans ce médiocre Edifice, que réside aujourd'hui LE PLUS PUISSANT, LE PLUS HEUREUX: ET LE PLUS SAGE ROI DU MONDE (MDCCXXIV)' (In this mediocre edifice today lives the strongest, happiest and the wisest king in the world). The only palaces in England were erected by English

aristocrats. The Duke of Marlborough built Blenheim at public expense, while successive monarchs lived in ramshackle firetraps, dreaming of unbuilt magnificence. Britain's rulers lacked the personal wealth to build a vast palace and never turned to parliament for funds to house them in monarchical grandeur. They lacked the political will and personal inclination to build a *grand palais*.

Without a proper stage it was difficult to perform the rituals of power effectively. The court could serve as a cultural centre for the arts and literature only as long as it was large, visible and fashionable – filled with courtiers, hangers-on and admirers, full of social excitement, glittering ritual and solemn ceremony. After the Civil War Charles II's court, though without a modern palace, aspired to be such a place. Until an assassination plot against him in 1683 led him to be more cautious, the king made it exceptionally open and accessible. The vast, rambling palace at Whitehall, with its chapel, theatre and 1,400 rooms, was full of court servants, wits, rakes, ambassadors, musicians, minor functionaries, whores and hangers-on. Charles, who actively disliked court formality, was accessible to all, receiving petitions and requests not only during audiences but at all hours of the day. It was easy for the inebriated, rakish John Wilmot, Earl of Rochester, lurching in the palace corridors, to mistake the king for a fellow courtier and to thrust his scurrilous lampoon on king and nation into the monarch's outstretched hand: 'Poor prince! thy prick, like thy buffoons at Court,/ Will govern thee because it makes thee sport.' Whitehall was a place of little ceremony and less etiquette, the centre of a giddy social round of dances, merriment, balls and plays.

Charles himself enjoyed the parody of solemnity and Rochester's ribald encomia. His official response to the earl's verse was to banish Rochester from the court, but his true wishes were granted in the quick return of his boon companion. Charles preferred such witty verses to work of more serious intent. He offered scant reward to Abraham Cowley, the most loyal of loyalist poets and most discreet of diplomats, and Samuel Butler, the author of *Hudibras*, a brilliant attack on Puritan hypocrisy, died in penury. The court was full of aristocratic wits and amateur literati like the Duke of Buckingham, the Earl of Dorset and Sir Charles Sedley, who wrote their own plays and verse and who generously patronized less affluent writers like John Dryden. In between bouts of drinking, gambling and womanizing, Charles himself showed great

interest in music and painting. He patronized the musicians Henry
Purcell, John Blow, Pelham Humfrey and John Banister (sending the
last two to study in France), the decorator Antonio Verrio, the carver
Grinling Gibbons, and the painters Kneller and Lely. He also managed
to recover some of his father's pictures and to add substantial Dutch
holdings to the royal collection. But the merry monarch's greatest contri-
bution was as a leader of fashion: an innovator in the use of violins for
sacred music in the Chapel Royal (condemned by the sanctimonious John
Evelyn as fitter for a tavern than a church); an ardent advocate of French
music, dancing, furnishings and costume – tastes he had acquired in
exile; and the proponent of rhymed heroic drama and the comedy of
manners in the theatre.

But the court suffered from two overwhelming difficulties – public
penury and private misconduct. The palaces remained incomplete and
the royal musicians unpaid because of the parlous state of royal finances.
As early as 1666 Samuel Pepys learned that 'many of the [King's] musique
are ready to starve, they being five years behind-hand for their wages';
in 1677 Louis Grabu, the French Master of the King's Musick, was owed
more than £600. Charles's extravagance and financial mismanagement,
his lavish gifts to his royal favourites, mistresses and bastards, were a
poor foundation for the sustained munificence necessary to maintain
royal appearances.

Charles's court exuded a congenial hedonism. It was exuberant and
intemperate, given to both languor and excess. This made it difficult to
represent it as a salubrious seat of heroic power, though this was not for
want of trying. In his *Absalom and Achitophel*, first published in 1681,
John Dryden produced a brilliant and sustained apologia for the restored
regime. But such works, much admired by the king and the court, were
undercut by the irony and satire of the likes of the Earl of Rochester,
Dryden's rakish literary opponent, who died, worn out by a life of
debauchery, at the age of thirty-three.

It was not possible to recreate Charles I's theatrical expression of his
royal authority because it no longer commanded uncritical assent even
from those who should have believed in it. Courtiers might participate
in the ritual and show of kingship, but their view of the symbols of
authority was ironic, satiric and sometimes openly parodic. One evening
in 1663, only three years after the Restoration, three courtiers – Sir
Charles Sedley, Lord Buckhurst, the future Earl of Dorset, and Sir

Thomas Ogle – left the palace of Whitehall and walked north to the flesh-pots and taverns of Covent Garden. Sedley's literary reputation at the court of Charles II was second to none. Playwright, poet and translator, he was told by his monarch that 'Nature had given him a patent to be Apollo's viceroy' and that 'his style, either in writing or discourse, would be the standard of the English tongue'. Buckhurst was the great Maecenas of Charles's court, the patron of Dryden, Butler and Wycherley, and the author of one of the Restoration's most famous songs, 'To All You Ladies'. Both appeared, as Lisideius and Eugenius, in Dryden's *Essay on Dramatick Poesie* (1668), which was dedicated to Buckhurst. The impression they made that evening was rather different. From the balcony of Oxford Kate's Tavern they shocked and delighted a crowd of onlookers with their blasphemous and obscene antics. According to Samuel Pepys, Sedley 'showed his nakedness – acting all the postures of lust and buggery that could be imagined, and abusing of scripture . . . preaching a Mountebank sermon from that pulpit . . . that being done, he took a glass of wine and washed his prick in it and then drank it off; and then took another and drank the King's health'. Finally, according to the waspish gossip, Anthony à Wood, all three men turned their backs on the citizenry, 'Putting down their breeches they excrementiz'd in the street.'

This story of members of the Restoration court, including two of its greatest literary luminaries, dumping on the London citizenry is more than yet another incident in the long catalogue of libertinage and debauchery for which Charles II's entourage was famous. It reveals how far the ideal of the Renaissance court and courtier had fallen in England, and how the rituals and ceremonies of power – preaching the Christian word, dipping the host in the wine, loyally toasting the monarch's health – could be mocked and parodied even by men close to the king. The trouble was that Charles shared this ironic, parodic view. He protected his friends when they fell foul of the law and laughed at their libertine ways. He was not himself averse to blasphemous parody: he had his mistress and illegitimate son painted like a Raphael madonna and child (fig. 4). As Charles's companion the Earl of Mulgrave explained, the king had a 'natural aversion' to ceremony: 'He could not on pre-meditation act the part of a King for a moment, which carried him to the other extreme . . . of letting all distinction and ceremony fall to the ground as useless and foppish.'

4. *Barbara Villiers, Duchess of Cleveland with her Son, First Duke of Grafton* after Lely

The scepticism, irony and satire with which the king and his courtiers viewed the rituals and symbols of authority gave them some distance from values they held dear in their more sober moments. Memories of the republic, of the bloodshed of the Civil Wars and of the execution of the king were too close, uncritical commitment to the full panoply of court culture almost too much of a risk. Better a ribald verse circulated among friends than the public acclamation of princely authority in a royal masque. As Rochester put it, 'Our Sphere of Action is Life's Happiness/And he who thinks beyond, thinks like an Ass.' Courtiers and monarchs had not recovered the confidence needed to claim the court as not only a seat of pleasure but a morally exemplary institution. Not until the reign of George III, when his life of domestic felicity was taken as a model of propriety, did the culture of the royal family make such a moral appeal, and by then the royal court had shrunk into a *bürgerlich* household. The court would survive, of course, but only as one of several centres of literary and artistic endeavour.

Sexual licence and a heroic view of kingship need not be mutually exclusive. Louis XIV's Versailles managed both. But to do so it had to distinguish between its private and public face, to conceal its licence behind a heroic façade. This Charles and his followers did not do. Cynical and sceptical, their conspicuous profligacy undercut a credible representation of sacred kinship. They shared with many others a desire to forget the republican experiment, but in their defiantly libertine ways they were not at one with the nation. Many of the sober citizens and stalwart Protestants who supported the Restoration were horrified by the antics of the court. 'Rude, rough whoremongers . . . vain, empty, carelesse' was Anthony à Wood's view of Charles's courtiers. Samuel Pepys, a libertine himself in some respects, was shocked when courtiers openly laughed at the Bishop of Winchester preaching against the vices of the court in the Chapel Royal. There could be no more ardent royalist and Tory than the diarist John Evelyn, but his last memory of King Charles filled him with horror and disgust:

> I am never to forget the unexpressable luxury & prophanesse, gaming, & all dissolution, and as it were total forgetfullnesse of God (it being Sunday evening) . . . I was witnesse of; the King, sitting & toying with his Concubines Portsmouth, Cleaveland, & Mazarine . . . A french boy singing love songs . . . whilst about 20 of the greate Courtiers & other dissolute persons were at Basset round a large table, a bank of at least 2000 in Gold before them . . . it being a sceane of uttmost vanity.

For many of the monarchy's ardent supporters, Charles was a bitter disappointment. He was too languid and lubricious, too indolent and informal, to create a lofty notion of kingship or a heroic court. He compromised the part of king by also playing court jester.

Subsequent monarchs and their courts were more in tune with the piety that Evelyn and many others beyond Whitehall shared, but none succeeded in using the arts to project a distinct view of royalty. During his brief reign James II restored etiquette and formality but cut the size of the royal household, the heart of the court, by half. William and Mary, besieged for places and favours by those who had levered them on to the throne, expanded the court to the more than 1,000 places it had offered under Charles II. But neither William, the dour Dutch soldier, nor Mary, James's daughter, who had hated the English court

in her youth, wished to play a prominent courtly role. Both were, by temperament, reluctant to face importuning petitioners and aristocratic hangers-on. They favoured domesticity and respectability. Swearing was banned from court, daily morning chapel required of the household, and fasts held once a month. There were few major entertainments, even fewer after Mary's death in 1694. William may have been a discerning connoisseur of painting, with a fine collection of Italian and north European pictures, and Mary a strong supporter of royal music, but neither was an arbiter of taste or a leader of fashion.

The same was true of Queen Anne. Only in music did the last Stuart monarch help to shape taste. She was a strong supporter of Blow, Croft, Clarke and Handel, on whom she conferred a pension of £200 a year, and of the revival of sacred music in Britain as a whole. She also loved secular music, arranging for the performance of operas on her birthday and for private concerts in her bed-chamber or closet. But she seemed totally indifferent to other arts. She did not possess a single copy of her own state portrait and she showed no literary interests beyond a penchant for sermons.

Anne's constant confinements and, after 1708, her persistent illness kept her out of the public eye. When she did appear in public, she tried to cast herself as a maternal and domestic figure. She chose as her coronation text a passage from Isaiah, 'Kings shall be thy nursing Fathers, and Queens thy nursing Mothers,' and her most frequent public appearances were as a healer, when she 'touched' as many as 400 victims of scrofula a week (including the young Samuel Johnson) in order to encourage the healing of the 'royal disease'. As these actions indicate, Anne was worthy, pious and conscientious in her royal duties, but she was also a sad figure in her declining years. 'She appeared to me', wrote the Scottish landowner Sir John Clerk, who was one of the negotiators of the legislative union with Scotland of 1707, 'the most despicable mortal I have seen in any station. The poor Lady . . . was . . . under a very severe fit of the Gout, ill dressed, blotted in her countenance, and surrounded with plaisters, cataplasims, and dirty-like rags' – a sickly woman who presided over what people thought of as a dull court.

After 1714 neither the Whig supporters of the new Hanoverian dynasty nor its Tory and Jacobite opponents wanted a cult of monarchy focused on its court. Anne's Hanoverian successors have often been dismissed as philistine and uncultured. It was both a lament and a common

criticism of the early Hanoverians that they failed miserably as patrons
of the arts. Critics of many different persuasions – including Alexander
Pope in *The Dunciad*, William Hogarth in his attacks on the un-English
idea of a royal academy of art, and Horace Walpole in his waspish
letters on the uncouth conduct of George II – condemned the court's
philistinism and its failure to shape a national culture that expressed
Britain's place as a major European power. When the court and the
monarch were represented in literature or the graphic arts they were
almost invariably satirized, scorned and lampooned – and not, as in the
seventeenth century, by those at court, but by those in the town.

People with such views were not necessarily anti-monarchical. Tories
like Pope and Tobias Smollett looked back sentimentally to an earlier
age, berating the Georges for failing to follow what they claimed had
been the policy of their predecessors in rewarding the aesthetically skilled
and morally virtuous. As the opposition paper *Fog's Journal* put it in
1730, 'Poets and Philosophers are the fit Ornaments . . . of a polite and
sensible Court, such as was that of *Augustus*, but Fidlers, Singers, Buf-
foons, and Stockjobbers, would best suit the Court of a *Tiberius* or a
Nero, where Stupidity, Lewdness, and Rapine sat in Council, and exerted
all their Strength, in Opposition to every Thing that was sensible.' The
implications of this remark were clear to its readers: the eighteenth
century may have been an Augustan age but this did not make the
British monarch a modern Augustus.

Of all the Hanoverian kings George II was the least interested in
literature and the arts. Indeed, he revelled in his unlettered state. As
Lord Hervey, a famously malicious and sharp-eyed court gossip, relayed
in his *Memoirs*, 'The King used often to brag of the contempt he had
for books and letters', calling his well-read wife, Caroline, 'a pedant' and
urging her to avoid what he called 'lettered nonsense' more suitable for
'a school-mistress than a queen'. George, who thought of kings as soldiers
rather than scholars, despised reading because he 'felt as if he was doing
something mean and below him'.

George's penchant for what Pope called 'Gun, Drum, Trumpet,
Blunderbuss and Thunder' was understandable in the last British mon-
arch to lead his troops in battle. But George's pleasure in his triumph
over the French at Dettingen (1743) was no excuse for his philistinism.
Renaissance princes and enlightened absolutist monarchs like Federico
da Montefeltro and Frederick the Great were just as happy in the study

as on the battlefield. George lacked the temperament (and probably the intelligence) of a reading man.

His taste in painting was little better. When he returned from Hanover in 1735 he was horrified to discover that the queen, on Hervey's advice, had taken away his favourite pictures in Kensington Palace and replaced them with some of the finest canvases from the royal collection. He insisted on the removal of all the new pictures, including the Van Dycks, and when asked by Hervey if he really wanted 'the gigantic fat Venus restored', brusquely responded, 'I like my fat Venus much better than anything you have given me instead.'

George's remark may have been less naive than Hervey supposed. This was the age, after all, in which most gentlemen's cabinets contained erotica such as the engravings, after Guilio Romano, illustrating the sonnets of the sixteenth-century Italian poet Pietro Aretino, usually referred to as 'Aretino's Postures'. George was only publicly asserting a taste that was usually kept private. But his blunt comment was of a piece with his self-presentation as a bluff and unaffected soldier whose sole cultural passions were an enthusiasm for opera and martial music and an abiding interest in the theatre.

Both George I and George III had greater pretensions. George I doubled Handel's pension and patronized the Royal Academy of Music, which had been established to encourage opera in London, and supported a number of artists, most notably James Thornhill, whom he knighted in 1720. George III purchased the important collection of Italian paintings assembled by Consul Smith of Venice, founded the Royal Academy of Art, patronized Allan Ramsay as a portraitist and Benjamin West as a history painter, accumulated the nation's finest collection of books (it became the core of the future British Library), pensioned Dr Johnson and played the flute, harpsichord and piano.

But these personal tastes and enthusiasms were neither part of a grand cultural project nor focused on the court. Between 1688 and the accession of George III the court shrank steadily in size. More importantly, it became ever more domestic and enclosed, the monarch less and less of a public figure. George I and George II were frequently absent, away at their beloved 'country estate' of Hanover. All three Georges, though they believed strongly in the punctilio and stiff etiquette of the court, were passionately attached to their privacy, to living on an intimate scale. George III and Queen Charlotte, if the novelist and reluctant

courtier Frances Burney is to be believed, positively discouraged visitors to court except on formal and official occasions. George III was also the first monarch to distinguish his private residence from his public office. As befitted a prince who was raised in an isolated and prim household – 'no boys', said his younger brother, 'were ever brought up with a greater ignorance of evil ... We retained all our native innocence' – George was also the first male monarch since Charles I not to take a mistress. The Hanoverian court, especially under George III, was domestic, dull and prim. The royal couple retired early, the queen forbade her daughters to read romances, the king offered his equerries barley water as refreshment and condemned his aristocratic subjects for their lack of piety and their lax morals. Charles II and his court had been satirized for their lewd and light-hearted ways; George III and his court were lampooned for penny-pinching sententiousness. Charles II had been a royal rake who lived a life in which public and private were barely differentiated; George III lived in the snug bosom of his family, the first 'middle-class' monarch. It is perhaps significant that the two most open and culturally powerful English courts of the eighteenth century were those of two libertines who saw themselves as connoisseurs and patrons, namely Frederick, Prince of Wales, the son of George II who died prematurely in 1751, and George III's eldest son, the Prince Regent.

George III, like his two predecessors, patronized musicians, painters, the theatre, opera and, less frequently, men of letters, but the crown was only one of many sources of patronage and certainly did not offer artists the most lucrative rewards available. At the end of the eighteenth century Joseph Haydn could earn more than three times as much at a single public benefit in London (£350) as at an entire series of private royal concerts. The greatest value of royal patronage lay in its social cachet which could be parlayed into rich commissions. In short, the British monarch acted as a private patron, rarely as a national one.

Nowhere was this more the case than in royal portraiture. It was comparatively rare to portray the British monarch as a heroic prince; William III was the last monarch of which this was the general rule (fig. 5). Mary and Anne had the disadvantage of their sex; German court artists painted the Hanoverians in heroic guise, but this was much less common in British portraits. Even their coronation and official portraits lacked the heroic, grand manner that was to be revived under George III. The symbols of the royal office appear as tools of the trade, not

5. *William III on Horseback with Allegorical Figures* by
Godfrey Kneller, 1701

appurtenances of regal authority. The domestication of the British royal
family is evinced by their depiction in those exemplars of publicly rep-
resented private life, the small painted canvases that were known as
'conversation pieces'. Zoffany, in particular, painted a number of intimate
scenes of the royal family (fig. 6).

Of course, there were occasions, particularly those of adversity or
triumph, when the monarch was represented as the embodiment of the
nation and the regime was celebrated with extravagant praise. Wootton's
equestrian portrait of George II, painted in the flush of victory over the
French at Dettingen (fig. 7), and Handel's music, notably the *Te Deum*
of 1743, are cases in point. But they do not amount to a sustained attempt
to use the arts as an adjunct of kingship, nor do they prove the cultural
dominance of the court.

Under George III and in the aftermath of Britain's remarkable

victories during the Seven Years War there was a revival of regal encour-
agement of the arts as appropriate to a great nation. The apartments
that George III had renovated at Windsor, decorated with a series of
religious and historical paintings by Benjamin West, celebrated the
country's martial prowess and religious piety. In reaction to the French
Revolution, the ruler and the institution of monarchy came to symbolize
the nation to a degree that had not been true since the reign of Queen
Elizabeth. Though the royal family was not free from criticism, the
leaders of the political nation, even the leaders of fashion, were unusually
united in its support.

But the aims of George III and the way in which his rule was
publicly represented were very different from those of Charles I. The
object of royal patronage, as the Scottish judge and philosopher Lord
Kames made clear in the dedication in 1762 of his *Elements of Criticism*

6. *Queen Charlotte and Members of her Family* by Johann Zoffany, 1773

to George III, was not the apotheosis of kingship. Rather, the monarch should help to temper the excesses of a rich commercial society by encouraging its members to promote the morally edifying fine arts instead of frittering away their wealth on tawdry pleasures and sensual gratification:

> The Fine Arts have ever been encouraged by wise Princes, not simply for private amusement, but for their beneficial influence in society. By uniting the different ranks in the same elegant pleasures, they promote benevolence: by cherishing love of order, they enforce submission to government, and by inspiring a delicacy of feeling, they make regular government a double blessing ... To promote the Fine Arts in Britain, has become of greater importance than is generally imagined. A flourishing commerce begets opulence; and opulence, inflaming our appetite for pleasure, is commonly vented on luxury, and on every sensual gratification: selfishness rears its head; becomes fashionable; and infecting all ranks, extinguishes the

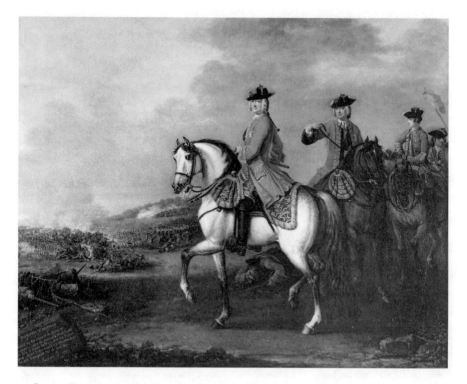

7. *George II at the Battle of Dettingen* by John Wootton *c.* 1743

amor patriae, and every spark of public spirit. To prevent or retard such fatal corruption, the genius of an Alfred cannot devise any means more efficacious, than the venting opulence upon the Fine Arts; riches employed, instead of encouraging vice, will excite both public and private virtues. Of this happy effect Ancient Greece furnishes one shining instance; and why should we despair of another in Britain?

For Kames, culture was important as a means of controlling and legitimating commercial society. A cynic might say that he saw the pursuit of art as a means to justify the accumulation of wealth. But the important point is that even when he addresses his monarch, Kames defines the fine arts in relation to the world of commerce, not the realm of kingship.

The British monarchy's inability or unwillingness to use the arts effectively to create a special sense of kingship was no more fully revealed than in one of the most extravagant regal spectacles of the eighteenth century, the commemoration of the Peace of Aix-la-Chapelle in 1749. George II's Master of Ordnance, the Duke of Montagu; his favourite composer, the royal pensioner George Frederick Handel; Charles Frederick, Controller of His Majesty's Fireworks; and Jean-Nicholas Servandoni, who orchestrated celebrations for the French court, agreed to stage the spectacle. For several weeks the tranquillity of Green Park was interrupted by the noise of workmen sawing and hammering as they erected a 100-foot-tall wooden structure, 'a magnificent *Doric* Temple, from which extended two wings terminated by pavillions ... adorned with Frets, Guilding, Lustres, Artificial Flowers, Inscriptions, Statues, Allegorical Pictures etc.' Adorned with the arms of the Duke of Montagu (who paid for much of its construction), it contained a musician's gallery, the figure of Peace attended by Neptune and Mars, and a bas-relief of George II handing Peace to Britannia. Perched on the top of the edifice was a long pole mounted with the Apollonian symbol of baroque kingship, a great Sun (fig. 8).

Handel agreed to compose an appropriate overture – the *Music for the Royal Fireworks* – and, after much pressure from the king's courtiers, wrote a piece that accorded with the martial bombast George loved. Handel's wish for violins was overruled; complying with the king's desires he increased the brass section to create a big, lopsided orchestra

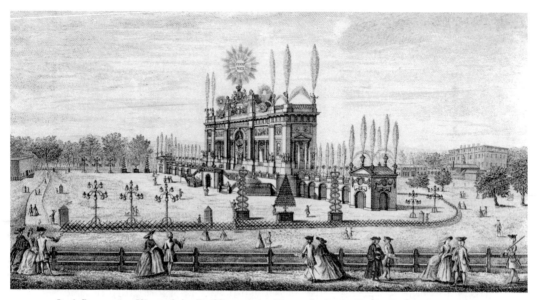

8. *A Perspective View of the Building of the Fireworks in the Green Park, taken from the Reservoir* by P. Brookes, engraved by P. Angier, 1749

of twenty-four trumpets, twenty French horns, sixteen hautboys, sixteen bassoons, eight pairs of kettledrums, twelve side-drums, and flutes and fifes.

The projected commemoration did not meet with universal approval. In the weeks prior to the performance many articles in the opposition press (including a letter by Samuel Johnson) attacked its cost and extravagance and argued that money would be better spent helping the returning soldiers and sailors who, having served their country, now faced unemployment because of a glutted labour market. Party politics intruded into the royal ceremony.

The celebration itself was planned for 27 April, but the first performance of Handel's music was preempted by an entrepreneur, Jonathan Tyers, the proprietor of London's largest and most popular pleasure garden at Vauxhall, on the south side of the Thames. Tyers staged a public rehearsal of Handel's piece before an audience of 12,000 a few days before the official commemoration. This event, which Handel had originally opposed, occurred because the crown lacked the experience and resources to stage the Green Park spectacle on its own. Montagu had jumped at the chance of borrowing more than £700 worth of equipment and using the skills of the Vauxhall Garden staff when Tyers

agreed to provide the crown with the technical expertise, illuminations and 'transparencies' – large, see-through images illuminated with back light – which were deemed necessary for such a grand affair but which the king's household did not own. Tyers was used to entertaining large crowds in his twelve acres of gardens; he, like the other owners of pleasure gardens in the London suburbs, had plenty of experience in staging outdoor concerts, including those accompanied by firework displays; and he was an expert in lighting, *trompe-l'oeil* effects and illuminations. Like a good businessman, Tyers exacted a price for his aid – the right to hold a rehearsal in his garden. Usually the Vauxhall entrance fee was one shilling, but on this special occasion he charged 2/6*d*. If the estimates of the attendance at Vauxhall on 21 April are correct, Tyers did well. His gross receipts for the night were £1,500. The event was a great success. Though there was much complaint in the press about the jostling crowds and among aristocrats about the proximity of so many of the hoi polloi, the performance met with widespread approval.

This patriotic, commercial spectacle which people from many ranks of society scrambled to attend was supposed to be a foretaste of the royal extravaganza planned for the following week. The Vauxhall performance had consisted exclusively of Handel's music; the command performance in Green Park was to be accompanied by a spectacular firework show and by the firing of 101 brass cannon.

On the hot, humid and drizzling night of 27 April 1749 vast crowds assembled in Green Park. They did not mingle indiscriminately as they had at Vauxhall; special areas were cordoned off for courtiers and gentlefolk. The performance of Handel's music went well, but the rest of the evening slid inexorably into disaster. At first many of the fireworks, damped by the weather, fizzled and refused to light; there were longueurs during which the crowd grew restless; Servandoni and the Duke of Montagu began a public fight, and when the Italian drew his sword he was arrested. As the men whose task it was to light the fireworks grew impatient, they became careless and set one of the pavilions alight. Smoke and smouldering embers soon were replaced by flames: there was a large conflagration as the pavilion was burnt to the ground. Satirists and opponents of the government were quick to seize on the crown's misfortune. A few days later an engraving of the wooden building in Green Park appeared in the London printshops with the title *The Grand Whim for Posterity to Laugh At*, while another print, *The Contrast 1749. No Money,*

with Fireworks. Money, with Commerce (fig. 9), showed an impoverished Englishman before the firework display and a prosperous Dutchman before some ships, a pointed reference to the benefits the Low Countries had enjoyed through their neutrality during the war. Entrepreneurs were turning a profit at the royal expense. The fireworks that failed were sold off to the Duke of Richmond, who mounted his own far more successful firework display on the Thames some three weeks later.

This mid-century fiasco perfectly expresses the longstanding inability of the monarch and his court to represent themselves effectively on a public stage. This frailty can be seen not only in the political criticism that the crown's celebration drew, but in the court's enforced dependence on Jonathan Tyers, a man who viewed culture as a commodity to be sold rather than as a means to praise monarchs. Of course, Tyers's staging of the *Fireworks Music* was a patriotic act intended to celebrate the peace as well as a business coup. But a commercial performance before an undifferentiated body of paying customers in a public pleasure garden was a very different event from a celebration in which the hierarchies and ranks of society assembled in a royal park for a performance that only a king could pull off. On each occasion the same piece of music was performed, but in each it assumed a different significance.

Handel may have intended the *Music for the Royal Fireworks* to celebrate George II's heroic and martial view of kingship – the piece had, after all, been commissioned through court patronage. But when it was hijacked by Tyers, performed without the king and without fireworks, it ceased to be a work of royal triumphalism, and became a general *public* celebration of the benefits of peace, another item in the longstanding commercial repertoire of popular music performed at one of London's favourite resorts.

The power that London held over the eighteenth-century English imagination is not difficult to understand. One in ten English people lived there; one in six Britons spent part of their working life in the metropolis. Ten times larger than any other English city, it dwarfed the other British capitals of Edinburgh (57,000) and Dublin (90,000) and, with nearly 750,000 inhabitants at mid-century, was the largest city in western Europe. Only Paris approached it in size, and it was more than twice as big as Naples, the third city of the continent. Not only more

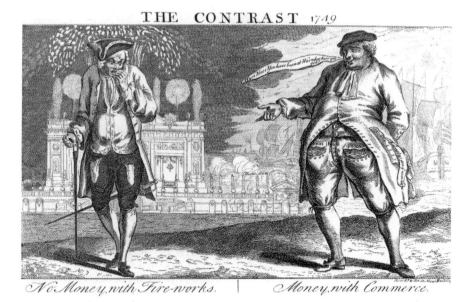

THE CONTRAST 1749

No Money, with Fire-works. | *Money, with Commerce.*

9. *The Contrast 1749.* Artist unknown

populous, London offered a different quality of life. Nowhere else in Britain was so urban; no other city quite so exciting and shocking.

Variety, energy, noise – these were the first impressions of visitors to London. They were astonished by its constant flow of humanity, which some of them found impossible to imagine as the routine of urban life and attributed to some special event. They marvelled at the riches displayed in aristocratic town houses and on shop counters. 'Every article that is elegant and fashionable may be seen, arranged with the utmost taste and symmetry,' exclaimed the German visitor von Archenholz in 1785. 'Nothing can be more superb than the silversmiths' shops. In looking at the prodigious quantity of plate piled up and exposed there, one can only form a proper idea of the riches of the nation. The greatest shops in St. Honoré at Paris, appear contemptible when compared to those of London.' But visitors were also shocked by the abject poverty they saw in the alleys and rookeries that stood cheek by jowl with the homes of the wealthy. The prudent Newcastle wood-engraver, Thomas Bewick, rejected the excesses of London: 'I did not like London – it appeared to me to be a World of itself where every thing in the extreme, might at once be seen – extreme riches – extreme poverty – extreme Grandeur & extreme wretchedness.'

Yet for others it was the very variety of the city that held its appeal.
As a correspondent in the paper *Old England* put it in 1748, 'what a
Medley of Neighbourhood do we see? Here lives a Personage of high
Distinction; next Door a Butcher with his stinking Shambles! A Tallow-
Chandler shall front my Lord's nice *Venetian* window; and two or three
brawny naked Curriers in their Pits shall face a fine lady in her back
Closet, and disturb her spiritual Thoughts.' The city included theatres
and churches, brothels and hospitals, exchanges and markets, a river
teeming with ship-laden commerce and parks filled with promenaders.
It was a place of parade, somewhere to watch and be watched, and a
realm of the senses offering convivial, culinary and sexual pleasures in
its taverns, chop houses and bagnios. Above all it was a place where
fortunes could be made and fame acquired. It offered opportunity, even
if its promise was not always fulfilled.

No one captured the city and the moods it evoked better than the
minor versifier John Bancks:

> Houses, churches mixed together,
> Streets unpleasant in all weather;
> Prisons, palaces continuous,
> Gates, a bridge, the Thames irriguous.
> Gaudy things enough to tempt ye,
> Showy outsides, insides empty;
> Bubbles, trades, mechanic arts,
> Coaches, wheelbarrows and carts.
> Warrants, bailiffs, bills unpaid,
> Lords of laundresses afraid;
> Rogues that nightly rob and shoot men,
> Hangmen, aldermen, and footmen.
> Lawyers, poets, priests, physicians,
> Noble, simple, all conditions:
> Worth beneath a threadbare cover,
> Villainy bedaubed all over.
> Women black, red, fair and grey,
> Prudes and such as never pray,
> Handsome, ugly, noisy, still,
> Some that will not, some that will.
> Many a beau without a shilling,
> Many a widow not unwilling;

Many a bargain, if you like it:
This is London! How d'ye like it.

The uniqueness of London helps to explain why it became one of the most important characters in eighteenth-century English literature, appearing repeatedly in prose and verse, the novel and the periodical. It was more than a place of streets and houses, rackety districts and aristocratic quarters; it was also a fantastic, imaginary space – Defoe's 'prodigious Thing', Pope's 'seat of Dulness', Swift's scabrous city of 'Filth of all hues and odours', Smollett's place of oriental splendour, wealthier and grander than 'Bagdad, Diarbekir, Damascus, Ispahan and Samarkand' as portrayed 'in the Arabian Nights' Entertainment, and the Persian Tales'. For London, both as a real place and as an imagined locale in art and literature, was the focus of aspiration and the seat of the imagination for many eighteenth-century Britons. It drew Scottish authors and publishers like Tobias Smollett, David Hume and William Strahan; Irish essayists, orators and actors like Dean Swift, Oliver Goldsmith, Edmund Burke and the Sheridans, father and son; Welsh poets and painters like Evan Lloyd and Richard Wilson; and English provincials, none more distinguished than Johnson and Garrick, who walked from Lichfield together in 1737.

One such figure, a twenty-two-year-old Scottish gentleman who arrived in London in pursuit of a commission in the Guards in 1762, left in his *London Journal* a remarkable record of his impressions of the city (fig. 10). Like many of those who came to seek their fortune in the metropolis, James Boswell was overwhelmed and exhilarated. 'When we came to Highgate hill and had a view of London, I was all life and joy . . . my soul bounded forth to a certain prospect of happy futurity. I sung all manner of songs, and began to make one about an amorous meeting with a pretty girl . . . I gave three huzzas, and we went briskly on.' He roamed the city's streets, ate and drank in its taverns and coffee houses, attended its clubs and assemblies, patronized the theatres and seduced their actresses, and marvelled at the mixed multitudes on the London streets.

Bundled in the city's cloak of anonymity Boswell shrugged off the confines of his Edinburgh upbringing, dressed himself anew and set off to play a repertoire of parts on the urban stage. 'I have discovered', he wrote, 'that we may be in some degree whatever character we choose.' He spent a night on the town disguised as a rough blackguard. He took

the part of a rake, whoring in St James's Park, in a manner that Rochester or Sedley would have approved. (After the 'luscious fatigues' of one night 'I . . . seemed to myself as one of the wits in King Charles the Second's time.') Suppressing his Scottish accent, he adopted the guise of a selfish, beef-eating and cruel Englishman.

> In this view I resolved today to be a true-born Old Englishman. I went into the City to Dolly's Steak-house in Paternoster Row and swallowed my dinner by myself to fulfil the charge of selfishness; I had a large fat beef-steak to fulfil the charge of beef-eating; and I went at five o'clock to the Royal Cockpit in St. James's Park and saw cock-fighting for about seven hours to fulfil the charge of cruelty.

In the Shakespeare's Head on Russell Street in Covent Garden with 'two very pretty girls' he switched roles, casting himself as the highwayman Macheath from John Gay's *The Beggar's Opera*: 'I surveyed my seraglio and found them both good subjects for amorous play. I toyed with them and drank about and sung *Youth's the Season* [one of the highwayman's tavern songs] and thought myself Captain Macheath.' Publishing some minor literary work and polemicizing in the newspapers, he applauded himself as a minor literary figure.

But the part Boswell felt most obliged to play (we do not know if he enjoyed it as much as his libertine roles) was that of the polite and imaginative gentleman portrayed in Addison and Steele's *Spectator*. Reflecting in his journal on life in London, Boswell remarked,

> In reality, a person of small fortune who has only the common views of life and would just be as well as anybody else, cannot like London. But a person of imagination and feeling, such as the Spectator finely describes, can have the most lively enjoyment from the sight of external objects without regard to property at all . . . Here a young man of curiosity and observation may have a sufficient fund of present entertainment, and may lay up ideas to employ the mind in old age.

Later he confessed to 'strong dispositions to be a Mr. Addison. Indeed I had accustomed myself so much to laugh at everything that it required time to render my imagination solid and give me just notions of real life and of religion. But I hoped by degrees to attain some degree of

10. *James Boswell Esqr. of Auchinleck,*
after Sir Joshua Reynolds, 1787

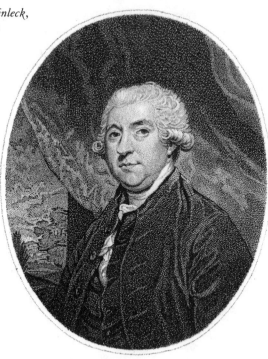

propriety.' He wanted to combine Addison's 'character in sentiment' with the 'gaiety' of Sir Richard Steele.

Throughout Boswell's time in London the spectres of Addison and Steele were at his shoulder. On one visit to Drury Lane Theatre Boswell imagined 'that it was the age of Sir Richard Steele, and that I was like him sitting in judgment on a new comedy'; during another, he and his companion, William Johnson Temple, 'endeavoured to work our minds into the frame of the Spectator, but we could not. We were both too dissipated.' Listening to a service in Westminster Abbey, Boswell recalled 'the ideas of ... this magnificent and venerable temple ... which I had from *The Spectator*', while on a jaunt to Oxford he imagined himself 'the Spectator taking one of his rural excursions'. Every week on Saturday he visited Child's Coffee House in St Paul's Churchyard because of its association with Addison and Steele: 'The Spectator mentions his being seen at Child's, which makes me have an affection for it. I think myself like him, and am serenely happy there.' Discreetly watching the shoppers, Irish sedan-chair men and whores on the Strand, Boswell envisaged

himself as a member of what Joseph Addison in the tenth number of
the *Spectator* had called 'the Fraternity of Spectators'. The city enabled
Boswell to create shifting personae and to revel in the ambiguities of
being both actor and audience, but the *Spectator* enabled him to create
order out of this variety.

Taverns and coffee houses like Child's served many purposes in
eighteenth-century London. They were places of pleasure and business,
catering to customers from all walks of life, centres of rumour, news
and information. In these snug centres of conversation and conviviality,
groups of men (and, less usually, women) gathered to drink, gossip, trade,
debate and intrigue.

 Taverns were not new; in England they date from at least the twelfth
century, when they were first recorded selling wine, but coffee houses
were a seventeenth-century innovation, when they appeared in many of
the great trading cities and capitals of Europe. The first opened in

11. *La Croix's, the corner of Warwick Street, near Swallow Street, St. James's*

St Mark's Square in Venice in 1647; others quickly followed in Marseilles, Paris (where the Café Procope began business in 1660), Vienna and Frankfurt. The first English coffee house opened in Oxford in the 1650s, and by 1700 they were to be found throughout London. A survey of 1739 records 551 coffee houses, 207 inns and 447 taverns there (fig. 11).

Coffee houses offered their customers chocolate, wine, brandy and punch as well as coffee, all served from a small bar in a corner of the main room. They had benches and tables where anyone could sit, and some had booths or snugs rather like a modern English public house (fig. 12). But their chief attraction was that they became centres of conversation and 'intelligence', commercial premises and places of private exchange where deals were cut and money, goods and information traded. As the numbers of coffee houses grew, they became more specialized. The modern stockmarket originated at Jonathan's Coffee House in Exchange Alley which, as the *Annual Register* of 1762 put it, 'had been a market, time out of mind, for buying and selling Government securities'. Similarly, shipping and insurance services were centred on Lloyd's Coffee House in Lombard Street, which issued its first news sheet in the 1690s, its first shipping list in 1734, and opened its first register in 1760. Lawyers met at Alice's and Hell Coffee House, both close to Westminster Hall, while politicians – the Tories at the Cocoa Tree, the Whigs at Arthur's – had their own coffee houses in the West End. Booksellers met at the Chapter Coffee House in Paternoster Row, where they commissioned Johnson's *Lives of the English Poets* at a meeting in 1777. Artists, including the painters Hogarth, Hayman, Lambert and Jonathan Richardson and the sculptor Roubiliac, gathered at Old Slaughter's Coffee House in St Martin's Lane; literati patronized Will's and the Bedford Coffee House, both in Covent Garden; actors gathered at Wright's nearby, and opera singers and dancing masters met at the Orange in the Haymarket. The coffee house was the precursor of the modern office, but once you were there you were as likely to talk about matters of general interest – the latest play, sexual scandal or political quarrel – as carry on business.

Besides being meeting places, coffee houses were *postes restantes*, libraries, places of exhibition and sometimes even theatres. One of the West End houses that Boswell frequented, Mount's in Grosvenor Street, was used by the sentimental novelist Laurence Sterne to send importunate letters to his beloved Eliza Draper. Coffee houses also provided a wide

range of newspapers and pamphlets, whose contents often provoked coffee-house debate. When Boswell wanted to consult back copies of the *Public Advertiser* he was directed to the Chapter Coffee House in St Paul's Churchyard, the favoured hostelry of many booksellers, which kept entire runs of London and provincial newspapers. It also contained a library of recent publications kept up by the booksellers to advertise their wares. Lectures on science, medicine and oratory were delivered in coffee rooms. The Great Piazza Coffee House in Covent Garden, where Boswell liked to dine, was owned by the retired actor Charles Macklin, who fitted it out with a small theatre for oratory, while the most famous of the city's public debating societies, at which Boswell spoke in July 1763, met at the Robin Hood Tavern in Butchers' Row. Books, prints, pictures, medals and curios were often exhibited at Garraway's in Exchange Alley and the Rainbow in St Martin's Lane before being auctioned by specialist art dealers like Christopher Cock and Abraham Langford.

For a visitor to London like Boswell, clubs and coffee houses shaped social and cultural life. He met his friends Dempster and Erskine at the Bedford Coffee House and planned to 'damn' a play at Covent Garden Theatre. Another time he went to see Thomas Arne's popular opera *Artaxerxes* before adjourning to the Piazza. He met his printer and book-seller at the Queen's Head Coffee House in High Holborn to plan his publications and, as we have seen, he took a weekly jaunt to Child's to listen to the conversation. Books, concerts, plays and pictures were spirited through the air, sucked into the coffee house, and drawn into snug booths and corners by the animated warmth of conversation and the occasional fire of controversy.

Despite their popularity, in their early years coffee houses were con-troversial, looked upon with suspicion by Tory stalwarts, royalists (who remembered the radical gatherings and societies of the Interregnum) and those who feared political and religious polemics. 'Controversy', wrote one peer to Charles II, 'is a Civill warr with the Pen, which Pulls out the sorde soone afterwards.' For the socially conservative Roger North, coffee houses were also 'Places of Promiscuous resort', unregulated gatherings at which gentlemen, citizens and underlings mingled. Open to all who could pay, they displayed a disconcertingly egalitarian ethos: 'Pre-eminence of place none here should mind,/ But take the next fit seat that he can find;/ Nor need any, if Finer persons come,/ Rise up to assigne to them his room.' As Samuel Butler sniffily remarked, the

12. *The Coffee House* by Thomas Rowlandson, *c.* 1790

coffee-house proprietor 'admits of no distinction of persons'. Yet for others this was precisely the coffee house's virtue: it created an open form of sociability. The antiquarian and biographer John Aubrey, for instance, praised 'the modern advantage of coffee-howses in this great Citie, before which men knew not how to be acquainted, but with their owne relations, or societies'.

Open to all ranks, the coffee houses were places of free expression, which did not endear them to the crown. Charles II and James II saw them as uncontrolled centres of 'the most seditious, indecent and scandalous discourses', and made repeated efforts to close them down or curb their activities. Their motives were doubly political. Coffee houses (like taverns) were centres of political opposition to the crown. They also undermined the hierarchical values of monarchical absolutism centred on the court: they encouraged a polyphony of public conversations which challenged the voice of the crown, trying to assert its monopoly over opinion and taste, and they usurped the prerogative of the prince by debating politics, religion and literature. The coffee house acted as one of many points of exchange in a network of institutions. It thrived as a

transmitter, spreading news abroad and, as a receiver, depending on the intelligence of its customers and newsprint. It breathed the oxygen of publicity, and this was precisely why the royal authorities disliked it.

In 1675 an exasperated Charles II issued a proclamation closing down all London's coffee houses. The edict was an abject failure. A general public outcry forced the king to withdraw it a few days later, his defeat concealed by a face-saving formula in which coffee-house proprietors agreed 'to be wonderful good for the future, and to take care to prevent treasonable talk in their houses'. Charles had underestimated the extent to which the town had already absorbed the culture of the court. His boon companions and political followers had their favourite taverns and clubs – fashionable houses like the Sun in Threadneedle Street and Will's in Covent Garden, the home of the Restoration court wits. From their point of view it was better to have loyalist and Tory coffee houses than to have no coffee houses at all. Despite royal hostility the coffee houses flourished.

After the Glorious Revolution of 1688 the coffee house was praised as well as criticized. Its defenders described it as an orderly and sober place which contrasted with the drunkenness and ribaldry of the ale house. Coffee, 'this wakeful and civil drink', encouraged business acumen, cool deliberation and rational conversation. It made men sober, not merry. By Queen Anne's reign Richard Steele and Joseph Addison were idealizing the coffee house in the pages of the *Spectator*, the *Tatler* and the *Guardian* as a centre of 'Polite Conversation' in which the improving effects of decorous sociability formed men of morality and taste: 'When men are thus knit together, by a Love of Society, and not by a Spirit of Faction,' remarked Addison in the ninth number of the *Spectator*, 'and don't meet to censure or annoy those that are absent, but to enjoy one another; When they are thus combined for their own Improvement, or for the Good of others, or at least to relax themselves from the Business of the Day, by an innocent and chearful Conversation, there may be something very useful in these little Institutions and Establishments.' The coffee house was claimed as a new sort of urban territory, one which was accessible and orderly, a permeable, public institution where familiars and strangers could meet for polite conversation. It turned its back on the libertinism of the court and the uncouth drunkenness of the ale house. No matter that coffee houses like the Rose, Hummum's and the Shakespeare's Head in Russell Street in Covent Garden were bagnios,

brothels or houses frequented by ladies of the town; no matter that, like others after him, the actor Hildebrand Horden was murdered in 1696 'in a frivolous and accidental brawl' in a coffee house; no matter that many establishments were notorious for their drunkenness and lax morals. Addison and Steele shaped an exemplary institution, fabricating an ideal of polite conduct and good taste developed in a convivial environment. They made the coffee house the representative institution of urban life.

So when Boswell settled into a booth in Child's and eavesdropped on his neighbours' conversation, he was acknowledging how profoundly his view of London and of polite urban conduct had been influenced by Addison and Steele. His response was not unusual. Letters, memoirs, essays and works of fiction throughout the century frequently cite the *Spectator* as the key to understanding modern city life.

Of course, some of the groups that met regularly wanted a less indiscriminate environment, and tavern proprietors and coffee-house owners were glad to oblige. While their ordinary customers mingled in a common room, they offered smaller chambers to clubs and private associations. Like the less formal and exclusive groups that met in coffee rooms, clubs were places or gatherings of people for conversation. Boswell's description of a meeting at St Paul's Coffee House is typical:

> I went to a club to which I belong. It meets every other Thursday at St. Paul's Church Yard. It consists of clergymen, physicians, and several other professions. There are of it: Dr. Franklin, Rose of Chiswick, Burgh of Newington Green, Mr. Price who writes on morals, Dr. Jeffries, a keen Supporter of the Bill of Rights, and a good many more. We have wine and punch upon the table. Some of us smoke a pipe, conversation goes on pretty formally, sometimes sensibly and sometimes furiously. At nine there is a sideboard with Welsh rabbits and apple puffs, porter and beer. Our reckoning is about 18d a head.

Such societies retreated from the openness of the coffee room and the tavern parlour. Clubs were self-perpetuating, electing new members by either open vote or secret ballot. Their deliberations were private, though rarely secret. For though societies often confined themselves to the pleasures of conviviality and good conversation, many had larger purposes, patronizing artists and writers or sponsoring publications or plays.

When Boswell and Dr Johnson spent their evenings at the Mitre
Tavern off Fleet Street discussing the literary luminaries and artists of
the previous century, they spoke of writers, playwrights and poets, nearly
all of whom had belonged to convivial literary societies. In the late
seventeenth century Dryden and his cronies had gathered to read poetry
and trade epithets at Will's Coffee House in Bow Street. During Anne's
reign the Scriblerians, including Lord Oxford, John Gay, Jonathan Swift
and Alexander Pope, met at the Smyrna in Pall Mall; Addison and Steele
held court at Button's in Covent Garden. By mid-century the Bedford
Coffee House on the Piazza, close to the entrance of the Covent Garden
Theatre, had become the most important literary meeting place. When
Bonnell Thornton published the first number of the *Connoisseur* in 1754
he boasted of his literary credentials by describing his evenings there:
'This coffee house is every night crowded out with men of parts. Almost
every one you meet is a polite scholar and a wit ... every branch of
literature is critically examined, and the merit of every production of the
press or performance of the theatre, weighed and determined.' The
Bedford was especially popular with playwrights and poets. For several
years David Garrick, a figure whom every aspiring author wished to
meet, used it as his postal address.

But the most powerful club of the early eighteenth century was the
Kit-Cat, which took its name from Christopher Cat, a mutton-piemaker
and proprietor of the Cat and Fiddle in Gray's Inn Lane, where the
society first met. Like all clubs, the Kit-Cat, which flourished between
1696 and 1720, was a talking shop, a place for drinking and conversation.
But it was also a society with a purpose – to shape the arts by creating
an elaborate web of influence and patronage and by creating a sympath-
etic climate of opinion for writers it favoured. The Kit-Cats helped
publishers like Tonson by setting up subscriptions to buy books. They
sponsored plays and operas, paying playwrights for their dedications and
attending performances en masse. Many of the subscribers for the build-
ing of the Queen's Theatre in the Haymarket, newly erected in 1704
and managed by two Kit-Cats, William Congreve and Sir John Van-
brugh, were club members. The wealthiest and most influential Kit-Cats
supported poorer literary colleagues by giving them money and places
in the government bureaucracy. They even paid for the funeral of John
Dryden, though they did not concur with his Tory sympathies.

The Kit-Cat's aims were political as well as cultural: to promote the

views and taste of the Whig party. Its fifty-five members included a few men who were indifferent to politics, but none were Tories and most were ardent proponents of the Whig cause. The club was aristocratic. It included most of the powerful Whig grandees of taste and no fewer than ten of its members were dukes. Though many were courtiers, they chose to gather in the town, joined by a bevy of literary men, including Addison, Steele, Congreve, Vanbrugh and Maynwaring. The club's artist, Sir Godfrey Kneller, who was Principal Painter to the monarch, memorialized its members in his series of Kit-Cat portraits. Jacob Tonson, the original convener of the club, was its one man of commerce, a leading London publisher and bookseller.

The Kit-Cats gathered regularly to eat, drink and toast their favourite beauties. The libertine, bibulous values of the Restoration courtier lived on in the pornographic verses read at their meetings – 'With that he seiz'd her panting in his Arms/ Greedy of tasting her forbidden Charms/ Swift thro the curling breaks his Pintle drove/ To seek amongst dark shade the Springs of Love' – and in the toasting and drinking bouts that accompanied them. The club's most important patron was none other than the Earl of Dorset, the former Lord Buckhurst, one of the young Restoration bucks who thirty years earlier had shat on the London citizenry from the balcony of Oxford Kate's Tavern (fig. 13). But Dorset, the patron of Dryden, Shadwell and a host of poets, now shared his leisure hours with Addison and Steele (figs. 14 and 15), writers bent on tempering aristocratic vice with polite probity. In private the Kit-Cats continued the extravagant traditions of the courtier and rake, but their public patronage furthered an urban ideal of cultured conversation and Whig politeness. The former had its literary form in the unpublished manuscript of a ribald poem or song, the latter in the widely disseminated printed prose of the periodical essay.

The Kit-Cat Club exemplifies the shift that took place in the early eighteenth century from court to city, from raffish courtier to polite man-about-town. Kneller's series of Kit-Cat portraits epitomize the change. Based on models of courtly portraiture introduced into England in the early seventeenth century by Van Dyck, they subtly alter the genre. Like Van Dyck's pictures, Kneller's portraits were life-size, but the canvas was smaller, so that the upper half of the body, on which the picture focused, seems much closer to the viewer. This sense of intimacy is reinforced by the way in which the individual Kit-Cats look out of the

13. *Charles Sackville, Earl of Dorset* by Godfrey Kneller, engraved by John Faber, 1734

14. *Joseph Addison Esq.* by Godfrey Kneller, engraved by John Faber, 1733

15. *Sir Richard Steele* by Godfrey Kneller, engraved by John Faber, 1733

picture and at the viewer. They seem conscious of being observed by a spectator and reciprocate by looking back. There is none of the grand self-absorption of the court portrait; these are men engaged with society. Kneller's paintings were much admired and were widely circulated as engravings (fig. 16).

The Kit-Cats' portraits were hung in a room in Jacob Tonson's house, where the club gravitated after its first meetings in Gray's Inn Lane. All, with one later exception, were of equal size, portraying men in the same pose and with few special signs of rank or station. They were a collective portrait of a society of equals, engaged in civilized conversation. This was, of course, an idealization. Dorset and Tonson were not of the same class; Steele had neither the wealth nor the influence of his ducal companions. But, like most clubs, the Kit-Cat adopted a pose of fraternal equality. Within its confines, at least, its members were supposed to ignore the inequalities that existed in society at large.

The Kit-Cats looked not just to one another, but to the cultivated public rather than the court. Here Jacob Tonson was a key figure (fig. 17). The 'Chief Merchant of the Muses', he was the most powerful

bookseller of the day, specializing in prestigious literary collections. He published Milton, Congreve, Dryden (to whom he paid the princely sum of 250 guineas for the copyright of his *Fables* of 1698–9) and the first printed works of Alexander Pope. He and the members of his family who inherited his business had a hand in six major editions of Shakespeare's *Works*, including those of Pope (1725) and Dr Johnson (1765). Tonson was also one of the chief supporters of the Copyright Act of 1709–10, which provided the first statutory protection of literary property. He was, as his soubriquet makes clear, a man of the marketplace. Membership of the Kit-Cats enabled Tonson to develop a patronage network, but he sought aristocratic help not to reach inside the court but to reach out to a larger audience. The public was his end in view.

The traditions of the Kit-Cat lived on throughout the eighteenth century. They were to be found in such clubs as the Dilettante Society, which combined an interest in classical antiquities with an enthusiasm for erotica, in the fashionable Whig circles around the Prince of Wales in the 1780s, and in the libertine and epicene followers of William Beckford and Lord Byron. But no such group was ever able to influence

16. Subscription ticket to set of prints of the Kit-Cat Club
engraved by G. Van der Gucht

taste in quite the manner of the Kit-Cats, though the Prince of Wales's circle came close. For the libertine sensibility was a growing liability, and the old sense that works of art and literature existed for private pleasure, just as sociability existed for private gratification, began to come under sustained attack. Samuel Richardson's portrayal of the rake Lovelace in *Clarissa* and Hogarth's engraved series of *The Rake's Progress* are the most famous instances of the repeated criticism of those who pursued pleasure without responsibility. As members of the Dilettante Society were to discover, their claim to be arbiters of taste was undermined by public criticism of their sensual – and erotic – appreciation of works of art. Pleasure might flourish in the privacy of the gentleman's club, but, as Addison and Steele understood, the public required an instructive aesthetic.

The most influential club of the second half of the eighteenth century was Dr Johnson's Literary Club, which met at the Turk's Head in Gerrard Street in Soho and to which Boswell was elected in 1773. During its thirty years (it outlived Johnson by several years), it boasted a remarkable membership. Set up in 1764 at the suggestion of Sir Joshua Reynolds, it originally consisted of nine members: Johnson himself (fig. 18); Reynolds; Edmund Burke; Burke's father-in-law, the physician Dr Christopher

Nugent; two of Johnson's gentlemen friends from Oxford, Topham Beau-clerk and Bennet Langton; Oliver Goldsmith; the Huguenot stockbroker, Mr Anthony Chamier; and Sir John Hawkins. What began as a small circle of friends became a much larger and more formal society which had thirty-five members by 1791, when Boswell published his *Life of Johnson*. Sir Joseph Banks, the botanist; Charles Burney, the historian of music; the actors and managers David Garrick, Richard Brinsley Sheridan and George Colman; the historian Edward Gibbon; the orientalist Sir William Jones; Adam Smith, the political economist, and the politician Charles James Fox were some of the luminaries who were elected to it.

While the Kit-Cat Club had been dominated by aristocrats – only Tonson and Vanbrugh, the son of a Chester merchant and sugar-baker, were not wealthy, landed or titled – the Literary Club took its tenor from members of the literary and artistic professions. It had wealthy and aristocratic members, especially after the club decided to expand, but they were chosen for their talent. The Kit-Cat's political colouring was flamboyantly Whig, but the Literary Club remained neutral. It included

17. *Jacob Tonson* by Godfrey
Kneller, engraved by John
Faber, 1733

political mavericks like Johnson himself, committed Whigs like Fox and
Reynolds, and known conservatives such as Goldsmith. The nature of
the club changed in the mid-1770s, when it grew rapidly and its meetings
became less frequent. Johnson himself began to attend less often, writing
to Boswell in March 1777, 'It is proposed to augment our club from
twenty to thirty, of which I am glad; for as we have several in it whom
I do not much like to consort with, I am for reducing it to a mere
miscellaneous collection of conspicuous men, without any determinate
character.' Though membership was still largely decided by friendships
with Johnson, Burke and Reynolds, it became more of a public body,
rewarding conspicuous talent. Colman and Sheridan were elected very
shortly after they became the theatre managers at Covent Garden and
Drury Lane; Sir William Jones joined in the year after his acclaimed
volume of Persian verses; George Steevens was elected after his edition
of Shakespeare, Thomas Warton shortly after the publication of the last
volume of his *History of English Poetry*. Sir Joseph Banks joined the club
in the year he became president of the Royal Society, Adam Smith when
he arrived in London with the manuscript of *The Wealth of Nations*.
What had begun as a circle of intimates had become a larger group of
men of influence. What united them was not a common conviviality but
their shared sense that membership of the club confirmed their status as
'conspicuous men'.

While the Kit-Cats had focused their attentions on verse, the theatre,
periodical essays and political polemics, the members of Johnson's club
produced a far more diverse literature. In addition to the genres embraced
by the Kit-Cats, they produced works on aesthetics and art (Burke and
Reynolds), biography (Johnson, Boswell, Malone, Hawkins), literary criti-
cism (Johnson, Malone, Steevens), medicine and science (Drs Fordyce
and Nugent), oriental languages and literature (Jones, Percy), political
economy (Smith), botany and travel (Banks), theology (from the three
episcopal members), history (Gibbon, Charles James Fox) and the history
of music (Hawkins, Burney).

Much of this work codified and ordered the sprawling, diverse and
heterogeneous creative activity of previous generations. Johnson's *Lives
of the Poets* (1779–81), Thomas Warton's *History of English Poetry* (1774–
81), Burney's and Hawkins's histories of music, Sir Joshua Reynolds's
Discourses on art, and the critical editions of the 'classics' edited by
Johnson, Steevens, Percy and Malone combined history with criticism,

18. *Samuel Johnson, LL.D*
by Joshua Reynolds,
engraved by John Hall,
1787

placed the art of their contemporaries in the context of their predecessors, and shaped a series of traditions which were collectively identified as a valuable cultural heritage. The effect of these works was not to narrow this inheritance into a single strand but to establish their authors as sympathetic custodians and interpreters of many rich and diverse traditions.

Though members of the club did not share a single political or artistic vision, they were assiduous in helping one another: subscribing to each other's publications, offering introductions to booksellers, writing prologues and verses, praising and promoting each other's books, plays and poems, and talking one another up as major figures. Reynolds's design for the west window of New College Chapel in Oxford gained much of its fame from Thomas Warton's laudatory 'Verses on Reynolds's Window'.

Johnson wrote the dedication of Burney's *History of Music* to the queen (1776) and of Reynolds's first seven discourses to the king (1778), while Boswell dedicated his *Life of Johnson* to Reynolds, as someone whose 'excellence not only in the Art over which you have long presided with unrivalled fame but also in Philosophy and elegant Literature, is well known to the present, and will continue to be the admiration of future ages'. The inner circle within the club showered one another with praise. According to Johnson, Burke was 'one of the first men of this country', Goldsmith 'one of the first men we have as an author', and of Burney he said, 'I much question if there is in the world such another man, for mind, intelligence and manners.' Goldsmith viewed Johnson as the great 'Cham' of literature, while for Boswell he was 'the first author in England'. Garrick introduced Burney as 'a First Rate Man'. Even the critical and humorous epitaphs that members wrote about each other could not resist the extravagant compliment. Reynolds's contribution to such praise took the form of portraiture. He painted more than twenty of the club's members, depicting its most famous figures – Burke, Garrick, Johnson and himself – more than once. Engravings were made of nearly all these paintings which sold to a wide public.

The club's contemporaries, both friend and foe, were conscious of the collective identity and critical power of the Johnson circle. In his *Poetical Review of the Literary and Moral Character of Dr. Johnson*, John Courtenay, an MP and admirer of the club, lauded Johnson's leadership: 'By nature's gifts ordain'd mankind to rule,/ He, like a Titian, form'd his brilliant school.' Aided by 'our boasted GOLDSMITH', Reynolds, 'our Raphael', 'melodious BURNEY' and a group of other critics, Johnson's *influence wide improv'd our letter'd isle*'. Others were less enthusiastic about the group's power, though equally convinced of its influence. The *Critical Review* commented on Burney and Reynolds's mutual enthusiasm for 'regulating and correcting the public taste', while Johnson's foes attacked him as 'Dr Pomposo'. Johnson's response to these criticisms, notably to James Gillray's print, *Apollo and the Muses Inflicting Penance on Dr Pomposo Round Parnassus* (1783) (fig. 19), shows how important he and his followers thought it was to be noticed as luminaries, even if it meant exposure to criticism. When Reynolds told him about the print he replied, 'Sir, I am very glad to hear this. I hope the day will never come when I shall neither be the subject of calumny or ridicule, for then I shall be neglected and forgotten.'

For Johnson and his circle were acutely conscious, in a way that the Kit-Cats were not, about contemporary fame and future reputation. Because they wished to shape, protect and conserve traditions, whether in literature, music or painting, they were conscious not only of history but of posterity. The group was fortunate in its memorialists: their critical and artistic work survived, and their lives were preserved for posterity in a number of biographies, of which Boswell's *Life of Johnson* was merely the most famous.

Members of Johnson's club were connected to other cultural circles. The actor-managers, notably David Garrick, held court at their own clubs. Burke, Fox and Sheridan belonged to a Whig political coterie. Many club members frequented the meetings hosted by Mrs Montagu and by Mrs Vesey, whose husband was a club member, of the London Bluestockings, a circle of learned women and writers whose gatherings

19. *Apollo and the Muses Inflicting Penance on Doctor Pomposo Round Parnassus*, engraved by James Gillray, 1783. This shows Samuel Johnson (Pomposo) scourged for his criticisms of English poets in *Lives of the Poets*

were similar to the salons run by aristocratic ladies in Paris. Johnson himself had other circles of conversation and acquaintance, notably around Mrs Thrale and the Burney family, and also with a group of old and impecunious literary friends.

All these clubs, societies and less formal circles fashioned themselves as communities of taste and knowledge, helping to form opinion. This was just as true of a small book club made up of obscure citizens as of Dr Johnson's luminaries. Coffee-house clubs and tavern associations were involved in all the processes by which culture was shaped: the creation of works of art and the imagination, their communication, reception and consumption. Groups of writers, artists and performers debated their ideas and projects, criticized their friends and rivals, and penned their polemics in coffee-house booths. The newspapers, pamphlets and periodicals offered by proprietors kept them abreast of news, scandal and criticism. Theatrical impresarios, publishers and printshop owners met together to commission plays, criticism and prints. And those who admired antiquities examined the different states of an engraving, and others thumbed through the latest novel or history, argued with their fellows and then returned home to their journals, in which they recorded their opinions on the matters of the day.

As London appeared as a character in novels, plays and essays, and as its topography became familiar through scenic engravings and satirical prints, so it became defined not merely as the capital and the hub of the nation's economy but as a centre of culture. Early London guidebooks, which first appeared in the late seventeenth century, confined themselves to describing palaces, churches, the town houses of the aristocracy and the major civic buildings. They invited visitors to see London as the political centre of the nation. But within several decades theatres, pleasure gardens, exhibition and concert rooms featured more and more prominently. One of the largest entries in the frequently reprinted portable guidebook *London in Miniature* is devoted to a detailed description of the pleasure garden at Vauxhall. The *London Guide* of 1782 opens not with royal palaces but with a detailed account of city theatres. The visitor's journey continued to include, as it still does, the Tower of London, St Paul's Cathedral and the royal palaces, but the image and map of the city was now dominated by its cultural landscape.

In speaking of 'the city' we give London an integrity and coherence that it actually lacked. As Boswell remarked, the *Spectator* 'observes, one

end of London is like a different country from the other in look and in manners'. Metropolitan life was, as we have seen, about variety and difference, something that had to be confronted, whether by Boswellian enthusiasm, moral disapprobation or the ambiguity of Daniel Defoe. Arts and literature were discussed not in the abstract but as activities associated with special places – Grub Street, the home of the impoverished writer; Covent Garden, with its theatre and whores; the Haymarket, where there was opera; Smithfield, the centre of summer theatricals; Drury Lane, like its Covent Garden rival, a place of low life and theatre; Vauxhall Gardens, a site of summer pleasures; and St Paul's Churchyard, centre of London publishing.

Guidebooks, verses, novels, periodical essays, plays, topographical surveys, engravings and many forms of popular literature offered much more than an anatomy of London. They breathed life into the metropolis, animating its parts. Different districts and streets, even individual alleys and buildings were associated with high or low life, writing or butchering, printselling or coachmaking, prostitution or preaching. If London thus became a character, it was a creature of shifting moods and sympathies, dark and louring in Bunhill Fields and Bedlam, facetious and witty in St James's Park or in Pall Mall.

There was remarkable agreement that the city signified variety, instability and change, that it embodied the protean character of the commercial world. But responses to this differed. Boswell loved London with 'as violent an affection as the most romantic lover ever had for his mistress'. Compulsively sociable, inveterately curious, often lewd, made giddy, as his friends complained, by the rich variety of urban life, Boswell had the sensibility and the social position to enjoy the wonders of the town. His journals, his letters and his *Life of Johnson*, in which London features almost as heroically as the Great Cham of Literature himself, offer us a compelling picture of a bustling, crowded, energetic, sociable city, teeming with novelty. Boswell's London was the city celebrated in Johnson's famous remark – 'When a man is tired of London he is tired of life; for there is in London all that life can afford.'

For Boswell London's pleasures were also its virtues. London's busy commercial life taught men manners and politeness; its cultural institutions encouraged good taste in the arts and literature; and its gregarious sociability bred urbanity, good conversation and refinement. Only in London could he acquire the manners of Mr Spectator. Boswell's view

was of a piece with those who saw it as the symbol of modern civilization. As the editor of the *London Guide* boldly exclaimed, 'This city ... is now what ancient Rome once was; the seat of Liberty; the encourager of arts, and the admiration of the whole world.'

But many of Boswell's contemporaries took a much bleaker view of London and considered it an unnatural, grotesque being compounded of luxury, greed, dirt, chaos and squalor. Their view is exemplified by the rustic Squire Bramble's repugnance at urban life in Smollett's novel, *Humphry Clinker*. He was appalled at how

> the different departments of life are jumbled together. The hod-carrier, the low mechanic, the tapster, the publican, the shopkeeper, the pettifogger, the citizen, the courtier, *all tread upon the kibes of one another*: actuated by the demons of profligacy and licentious-ness, they are seen every where, rambling, riding, rolling, rushing, justling, mixing, bouncing, cracking and crashing, in one vile ferment of stupidity and corruption.

Where Boswell saw elegant aristocrats, accomplished gentlemen, worthy merchants and industrious authors, they saw vicious rakes, once-respectable folk ruined by artifice and fashion, grasping and duplicitous traders and scandalmongering hacks. Where Boswell saw elegant assembly rooms, snug taverns and comfortable coffee houses, they saw dark alleys, rookeries filled with ragged lodgers, stinking basements and foul streets. Where he saw an ordered variety, they saw chaos. Where he heard conversation, they heard only a Babel of voices.

Like Hogarth in his engraving of *The Enraged Musician*, the author of *Hell upon Earth: or the Town in an Uproar*, an earlier satire, depicts London as a place of cacophonous discord and unmeaning sound. It is in an 'uproar', filled with 'smutty jests' and 'loud laughter', 'Chit-Chat' and 'tittle-tattle', so that 'All the common people's *Jaws* in and round this great metropolis [are] in full Employment'. In Covent Garden the 'Cursing, Rending and Roaring' of a brothel madam drowns 'the Cries and Groans of *departing* Maidenheads'; in the West End the fop 'affects unintelligible Terms of Speech'; in the city coffee house the orator 'gives his jaws a *Breaking*'; everywhere sensible conversation is drowned out by curses, the oaths of 'snarling curs', and the asinine 'braying Booby'. *Hell upon Earth*, like many other satires, painted a witty but sometimes

frightening picture of London as chaotic and unharmonious, filled with the bruited murmurings of the mob.

The satirists had a point. Crime, prostitution, drunkenness, theft, embezzlement and brutal and duplicitous exploitation were conspicuous features of urban life. Luxury and abject poverty lived cheek by jowl; the streets were definitely disorderly and sometimes dangerous. Urban life was giddy and unstable, full of temptations and opportunities for vice. As the American Samuel Curwen fastidiously complained in 1775, 'You will not wonder at luxury, dissipation and profligacy of manners said to reign in this enormous capital when you consider that the temptations to indulgence and self-forgetfulness from the lowest haunts to the most elegant and expensive rendervouzs [sic] of the noble and polite world are almost beyond the powers of numbers to make up.'

But just as Boswell's imagined city came from the pages of the *Spectator*, so the city of luxury and waste, corruption and profligacy was a literary artifact with a long pedigree. Juvenal's Roman satires, contrasting a degenerate capital with virtuous rusticity, and the classical attacks by Cicero, Seneca, Sallust, Apuleius and Atticus on urban luxury were the models for such works as Pope's *The Dunciad*, Swift's *Description of a City Shower*, John Gay's *Trivia*, Fielding's *Amelia* and Smollett's *Humphry Clinker*.

More recent genres were added to these older traditions. Since Elizabethan times 'coney-catching' tracts and stories had exposed the cheats and swindles of the town. Ostensibly written to warn of the city's vices, they offered a prurient and titillating picture of London low life. These guides to the disreputable underworld had a new lease on life in the eighteenth century. Ned Ward, tavern keeper and hack writer, produced the first of them in his part-book publication *The London Spy: the Vanities and Vices of the Town Exposed to View* (1698–1703). Moving from theatre to bagnio and from tavern to the opera, Ward regaled his readers with a vivid account of the pleasures of the town. Ward's peregrinations through London spawned many imitators, notably Tom Brown's *Amusements Serious and Comical, Celebrated from the Meridian of London* (1700) and *The New London Spy, or a Twenty-four hours Ramble through the Bills of Mortality ... Modern, High and Low Life ... Covent Garden, Theatres, Jelly-Houses, Gaming-Houses, Night-Houses, Public Gardens, Motherly Matrons, and their Obliging Daughters, Mock-Milliners, Pimps, Panders, Parasites, Decrepit Watchmen etc.* This view of London as a place

20. *Tom Getting the Best of a Charley* by George Cruikshank, 1820

in which one journeyed on a voyage of exploration, uncovering the hidden city and its low life, persisted into the nineteenth century, when it reached its apogee in Pierce Egan's *Life in London; or the Day and Night Scenes of Jerry Hawthorn and his elegant friend Corinthian Tom* (1820–21), illustrated by George Cruikshank. Here, in a manner reminiscent of the Restoration rakes Sedley, Buckhurst and Ogle, three young bucks launch themselves on the town, taunting watchmen and tippling in gin-shops and low ale houses (fig. 20).

Whether celebrated as the seat of commerce and the cultivated product of modern civilization, derogated as corrupt, luxurious and disordered, or simply viewed with astonishment, London continued to inspire writers and artists. It had become a city of words and images. In the eighteenth century – as today – works of art frequently reflected on the circumstances of their creation: the environment they inhabited, the nature of their representation and the connections between art and society. As London grew in importance as a centre for the arts, so it and the activities within it became matters of moral deliberation and aesthetic representation. Much of what we know about London's culture – its

print- and bookshops, its pleasure gardens and theatres, its concerts and operas, its literary coteries and clubs of actors – derives from literary and visual sources. Few of these representations, whether critical or adulatory, were dispassionate. Artistic disputes focused on London's cultural life, because its cultural institutions now had the power to shape culture in Britain as a whole. As the end of the century approached, the dynamics of British culture began to move again, towards provincial towns and cities, to be attentive to regions and less to London. But until then, London predominated because, as we shall see in the chapters which follow, the worlds of print, paint and performance were centred there. Each became commercialized, and acquired substantial publics, impresarios, critics and many professionals. As they become more complex, circles of cultural conversation greatly expanded, and a struggle ensued over who was to decide how culture was to be interpreted.

CHAPTER TWO

The Pleasures of the Imagination

ON 9 APRIL 1792 Anna Margaretta Larpent rose at 7.30, a little earlier than her usual hour, 'spent some time', as she described it, 'in self-examination', and then read two chapters of that blistering critique of the British constitution, Thomas Paine's *Rights of Man*, before sitting down to breakfast. During the morning she tutored her two teenage sons, John and George, who were on holiday from their school in Cheam. In a ritual that was to be repeated throughout the holidays, she and John read passages from an instructive and improving work, Sarah Trimmer's *Sacred History*, a didactic anthology from the Scriptures written by a best-selling evangelical and advocate of Sunday schools. She taught George to spell, read and learn Latin.

After their morning exercises all three left their house in Newman Street, in the West End of London, to see the kangaroo on exhibit from Botany Bay. It was, wrote Larpent, 'like a Hare, with hind legs of immense length[,] the front feet more like paws. It vaults six or eight feet high and gowes awkwardly in a Slower motion on the joint of the hind legs. It feeds on hay, is of a horse colour, its lower tooth broad, & with the power of opening or rather cleavering it in two. The meat of some shot by convicts like lean beef.' After admiring this curiosity, the family proceeded to the Polygraphic Exhibition in Schomberg House on Pall Mall. Here they saw a display of a number of mechanical reproductions of oil paintings manufactured by the portrait painter and theatrical manager Joseph Booth. Anna Larpent and her husband sat down to dinner at about three o'clock. Then they both went to the Covent Garden Theatre to see Thomas Holcroft's sentimental comedy *The Road to Ruin*, together with an afterpiece, *Oscar and Malvina*, which Larpent dismissed as an inconsequential but entertaining mess: 'A Pantomimicall Jumble of Barbarous Customs, modern Nonsense the Music Scottish. Very pretty. the Pipes and Horn very pleasing & characteristic.'

This particular day, devoted to reading, instruction, natural history, art and the theatre, was typical of Anna Larpent's life in London. In the month of April 1792 in addition to Paine's *Rights of Man* Larpent read Richardson's *Clarissa* for the second time – 'the stile is prolix, the manners obsolete, & I felt and fidgetted at the repetitions not being 15, yet surely it is wonderfully wrought'; the conservative monthly digest of new books, the *Critical Review*; a Goldoni play, probably in the original Italian, a language she knew well; Smellie's *Philosophy of Nature*, which she considered poorly organized but of sufficient value to transcribe extracts for her children; a novel by Thomas Holcroft, *Anna St Ives*, dismissed as 'sad stuff I cannot read on'; her father's manuscript memoirs; and a new opera, *Just in Time*. She also visited an exhibition of Ozias Humphry's 'crayon pictures', took in an opera, saw Sarah Siddons as Lady Randolph in Home's tragedy *Douglas* – 'I never was more painfully delighted. Douglas is a charming Poem in itself – such admirable simplicity yet such classical taste – such beautiful description – & so well acted' – attended a concert at Mrs Beaver's, and listened while her husband and stepson read aloud to her from the newspapers and Sutherland's *Tour to Constantinople*.

Anna Larpent personified a cultured lady of late eighteenth-century London. She was not an aristocrat but neither was she poor. Though she was busy with household duties and the education of her children, like many other moderately prosperous women (the family income was more than £400 a year) she had enough time and leisure to enjoy many of the metropolis's cultural activities. But she did not view her recreations frivolously. She aspired to what she called 'a refinement which can only be felt in the pure pleasure of intellectual pursuits'. The proof of this quest, the evidence that her frequent play- and concert-going, together with her assiduous reading, were edifying rather than amusing, is to be found in her journal (fig. 21). The seventeen volumes that survive, covering the years 1773–1828, contain not only a detailed chronicle of her activities but also a carefully and repeatedly drawn representation of herself as a cultured person. Though she certainly saw herself in other ways – as a Christian, a friend, a mother and a wife – her overriding concern in the diary was with her fashioning of a refined persona. Her version of the good life is one devoted to self-improvement through literature, the arts and learning.

Anna Larpent had an unusual background. She had been born in

1758 in Turkey. Her mother was a foreign diplomat's daughter, fluent in several languages, while her father, Sir James Porter, was a self-made man of no formal education who nevertheless learned mathematics, Latin, French and Italian, wrote a much-praised *History of Turkey*, became a fellow of the Royal Society, and passed on to his daughter a passion for self-improvement. After the family's return to England and the death of her two parents, Anna Porter married in 1782 a much older man, a widower named John Larpent, the son of a chief clerk in the Foreign Office, who held the post of Chief Inspector of Plays in the Office of the Lord Chamberlain. His task was to read and, where necessary, to censor the manuscript texts of all theatrical dramas before they were performed on the London stage. He was the last surviving censor in a country that otherwise enjoyed freedom of the press. He was aided in his duties by his wife, who had strong views on theatrical propriety. She was therefore able, in her own way, to shape dramas offered to the public. We know, for example, that Schiller's *Die Räuber*, translated into English as *The Robbers* in 1792, was first banned and then radically rewritten in order to conform to the Larpents' ideas of 'safe' drama.

Anna Larpent's social acquaintance was primarily with middle- to high-ranking public servants and diplomats. Her father's best friend, George Lewis Scott, who became her guardian after James Porter's death, was a diplomat's son, a brilliant amateur mathematician who had tutored George III before his accession to the throne. She was close to Joseph Planta, the Swiss diplomat who became keeper of manuscripts in the British Museum. Other friends included David Solander, a Swedish protégé of Linnaeus, who was also a keeper at the British Museum and who, like Reinhold and George Forster, had accompanied James Cook to the South Seas; Pasquale Paoli, the Corsican leader who was in exile in London; and the Vannecks, a rich London merchant family of Dutch descent. She had some acquaintance with aristocrats, particularly with the Bathurst family and the patrons of John Gay, the Duke and Duchess of Queensberry. (In 1777 she went to see Gay's sequel to *The Beggar's Opera*, *Polly*, with the aged duchess, reporting that 'She heard it with delight. She sang all the airs after the Actors – she told me a story about every song – how Gay wrote it such a night after supper at Amesbury, how he wanted a Rime, how she helped him out &c &c.') But most of her friends were merely genteel. Yet what really mattered to her was intelligence. As she said about her friend the painter

Allan Ramsay, she 'liked the society generally of very clever people'.

As Anna Larpent's journal makes clear, attending a concert or visiting an exhibition had ceased to be a special, isolated event, but was part of a cultural repertoire that shaped everyday life. With the gradual profusion of Georgian assembly rooms, plays, picture galleries, libraries, museums and pleasure gardens a full range of cultural resources was now available for those who wished to be refined. This growing public provision of culture was paralleled by a concern, explicitly reiterated in Anna Larpent's diary, for private cultivation: the acquisition of such accomplishments as writing, drawing, playing music and the development of good taste. These were the two contexts – one public, the other private, yet intertwined – for the emergence of a new identity as a public person of taste and refinement.

As a young woman, Anna Larpent attended public assemblies, masquerades and balls at Almack's Assembly Rooms and at the Pantheon,

21. Page of Anna Larpent's diary, 1792

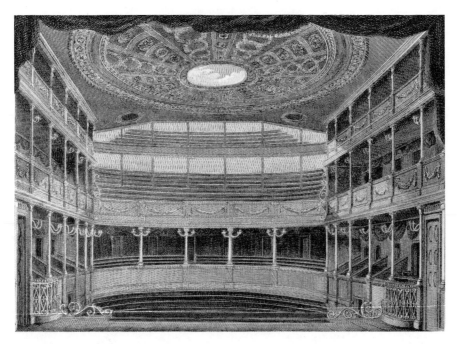

22. *Informal View of the Old Theatre Royal Drury Lane as it appeared in 1792* by Capon, engraved by Howlett

the vast auditorium opened on Oxford Street in 1771. She was a frequent visitor to Ranelagh Pleasure Gardens near the Chelsea Hospital, spending six summer evenings taking tea, promenading and listening to the orchestra there in 1778, for example. Throughout her life she regularly attended the two main London theatres at Covent Garden and Drury Lane, visited the opera at the King's Theatre in the Haymarket or at the Pantheon, and subscribed to subscription concerts, supporting three different series in the 1790s. She almost never missed the annual Royal Academy painting exhibitions in Pall Mall and Somerset House, and usually returned to them several times. She was a habituée of the Shakespeare Gallery in Pall Mall, where John Boydell displayed paintings by British artists on subjects from Shakespeare's plays, and a frequent visitor to the Poets' Gallery in Fleet Street, which contained paintings based on the most famous lines of British verse.

If Anna Larpent had sought such pleasures 100 years earlier, her choice would have been much more limited. Though the number of theatres did not increase during the century – except for a brief period

in the 1730s when government control of them was challenged – the number of seats grew. In the late seventeenth century there were two royal patent theatres, Drury Lane and Dorset Garden, but only one of them was active between 1682 and 1695; both were intimate places with a capacity of about 400, designed to accommodate an audience of courtiers and their friends. By the 1730s the largest theatres – the King's in the Haymarket, devoted to opera, and the Covent Garden Theatre, which John Rich had built on the proceeds of the success of *The Beggar's Opera* – could each hold 1,400. But these auditoria were dwarfed by the theatres newly built at the end of the century. New Covent Garden, described by Larpent as 'much improved. commodious. light. Elegant. Chearful. The Boxes and Galleries so contrived that there are no pillars to obstruct the view – it forms an amphitheatre in tiers', had a capacity of 2,500. The new Drury Lane was even bigger, holding 3,600 (figs. 22 and 23).

Similarly, the music rooms visited by Larpent were much larger than earlier in the century. Musical life in 1700 was dominated by two concert halls – Hickford's Rooms in Panton Street and York Buildings off the

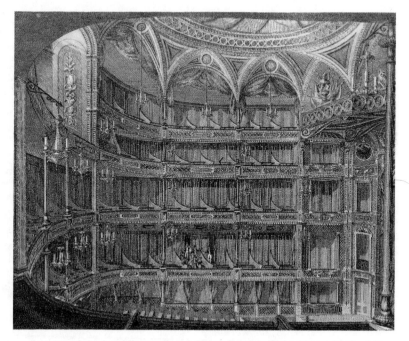

23. *Interior of the late Theatre Royal Drury Lane built by Henry Holland Esq. R.A.*, engraved by Dale, 1820

Strand – and by three subscription concert series. In the 1720s and 1730s
the enlargement of Hickford's Rooms, the foundation of the Academy
of Ancient Music devoted to the performance of Byrd, Palestrina, Tallis
and Purcell as well as some contemporary composers, and the establish-
ment of outdoor orchestras in London pleasure gardens were signs of
musical vigour, but it was not until George III's reign that large houses
were opened. The first performances at the Pantheon on Oxford Street
– described by the musical historian Charles Burney as 'the most elegant
structure in Europe, if not on the globe' (he was not a disinterested party,
being one of the Pantheon's investors) – were held in 1771 (fig. 24). Four
years later the Hanover Square Rooms, which were able to seat more
than 900 listeners, began its illustrious career as the most important
London music hall. From the 1760s, when the German composers Johann
Christian Bach and Carl Abel began them, a succession of professional
concert series drew to London well-known musicians from all over
Europe, including Haydn and Mozart. By the end of the century the
city offered opera, choral and instrumental concerts of both professionals

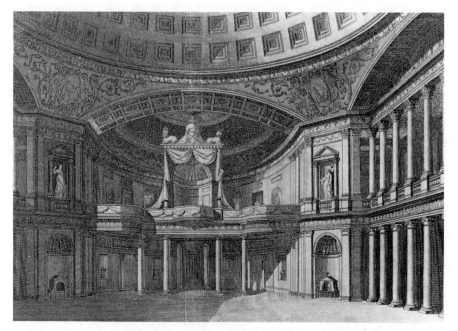

24. *An Inside View of the Pantheon exhibiting Their Majesties Box fitted up under the direction
of Mr James Wyatt for the commemoration of Handel* by Dixon, engraved by Angus, 1784

25. *View of the Magnificent Box erected for their Majesties in Westminster Abbey under the direction of Mr James Wyatt at the commemoration of Handel* by Dixon, engraved by William Walker, 1784

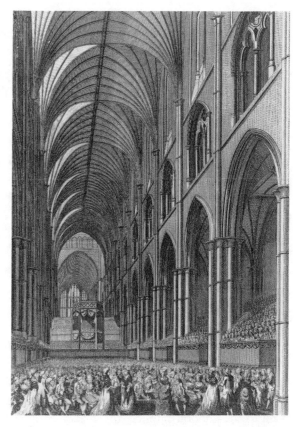

and amateurs, as well as music performed as part of the programme of London theatres. It was possible to attend a major musical event every night of the week. The *Public Advertiser* for 7 January 1791 informed its readers of opera performances on Tuesday and Saturday, a professional concert at Hanover Square on Monday, the Concert of Antient Music in Tottenham Street on Wednesday, and further performances at the Pantheon on Thursday and by Haydn on Friday. It was even possible to hear music on Sundays, when public entertainments were banned, by attending a nobleman's private subscription concert. The Handel festivals, begun in London in 1784 on what was believed to be the 100th anniversary of his birth, and later copied in the provinces, created a new sort of musical spectacle which brought together amateurs and professionals, provincials and Londoners, huge orchestras, large choirs and big audiences, making music not only fashionable but stirringly patriotic (fig. 25).

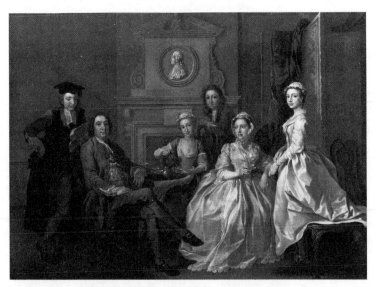

26. *Jonathan Tyers and his Family* by Francis Hayman, 1740

A similar transformation occurred in the visual arts. In 1700 paintings were displayed in auction rooms and coffee houses before they were sold, a few artists' studios contained pictures designed to show off their owners' taste, and it was possible to visit one or two private aristocratic collections, if one could secure an introduction. But there were no exhibits of art open to the general public. Apart from the pictures in Vauxhall Pleasure Gardens and the grander paintings that Hogarth and his fellow artists donated for public display at the London Foundling Hospital, there was little public art before the establishment of exhibiting societies and the Royal Academy in the 1760s. The success of these public shows, especially after the opening of the Royal Academy's rooms in Somerset House, prompted a spate of commercial projects, including Boydell's Shakespeare Gallery, Macklin's Poets' Gallery and Henry Fuseli's Milton Gallery, all of which displayed paintings and sold prints illustrating the greatest works of English literature. In these same years picture-going became fashionable, the newspapers carried extensive reviews of the exhibits, and individual artists organized their own exhibitions. In 1780, the year that Somerset House opened to the public, Anna Larpent visited the Royal Academy exhibition twice in its opening few weeks, as well as attending three other art exhibits, including one devoted to her favourite painter, Angelika Kauffmann.

Like many of her contemporaries, Larpent also made occasional visits to London's pleasure gardens. She preferred the sober and respectable venue of Ranelagh to the livelier but more popular atmosphere at Vauxhall, which she described as 'a most disagreeable place' after her first visit there in 1780. But she would not have visited such gardens at all earlier in the century. Before the 1730s pleasure gardens were regarded as dangerous, disreputable and therefore unfashionable. Loitering and lurching young bucks, boisterous after a hard night's drinking, young ladies of the town seeking customers in the garden's shades, alleys and arbours: those who frequented pleasure gardens were neither polite nor respectable. Yet over the decades this changed. A succession of entrepreneurs, of whom the most famous was the proprietor of Vauxhall, Jonathan Tyers, began to offer genteel entertainments and to purge the gardens of undesirable elements (fig. 26). They built orchestras and organs, hired musicians, opened places to eat and to sit, and commissioned sculptors and artists to shape a pleasant but edifying environment (figs. 27 & 28). Tyers's success spawned imitators. New gardens opened at

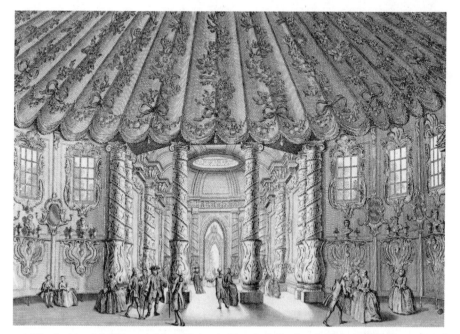

27. *The Inside of the Elegant Music Room in Vauxhall Gardens* by Samuel Wale, engraved by H. Roberts, 1752

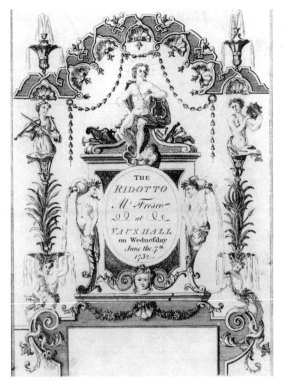

28. Ticket. *The Ridotto Al'Fresco at Vauxhall, 7th June 1732* by John Laguerre, 1732

Marylebone in 1737–8 (fig. 29), and in 1742 the epitome of the fashionable garden opened in Chelsea at Ranelagh. These were the most famous of the many pleasure gardens that ringed London's suburbs. In Spa Fields, Sadler's and Bagnigge Wells, Bermondsey, Chelsea and Lambeth, at Cuper's Gardens and even in low-life Wapping, proprietors offered orchestras and vocalists, picture galleries, illuminated transparencies and fireworks, sculpture and jugglers, dancing and equestrian performances (fig. 30). Ranelagh was the most expensive – admission was 2/6d., more than double Vauxhall's fee – and claimed to be more exclusive. Its garden was dominated by a vast rotunda whose interior was ringed with fifty-two boxes (fig. 31). An orchestra and organist played music while fashionable men and women promenaded round the floor. Regular concerts were held in the summer – Mozart performed there on the harpsichord and organ on 24 June 1764 – and in the 1790s it was the site of several fashionable masquerades. The pleasure garden, though its proprietors did not always succeed in ensuring the respectability that they so ardently

wanted, remained an essential part of London's fashionable year until well into the nineteenth century.

The theatres and concert halls of the West End, the artists' studios in Covent Garden, the picture galleries on Pall Mall, the exhibitions at Somerset House and the pleasure gardens of London's suburbs became part of an established itinerary of cultural pleasures, creating the expectation that a person of refinement and fashion would be acquainted with them all. When the Southampton bookseller Thomas Baker produced a gentleman's appointment book, *A Royal Engagement Pocket Atlas*, in the 1780s, its frontispiece of engagements referred to Almack's and Vauxhall Gardens, while its endpiece had a *putto*, female figure and satyr together holding a scroll marked 'Masquerade Pantheon Ranelagh Ridotto Coterie Opera Festina Bootles Fete Champet [sic] Play' (fig. 32a,b). Such places and activities, the diary implied, were an essential part of the social calendar.

As we have seen, the authors of guidebooks and the engravers of pictures helped to shape the notion that cultural life in London consisted of a series of connected activities – theatre-going and exhibition-visiting, listening to concerts and reading literature – that comprised fashionable

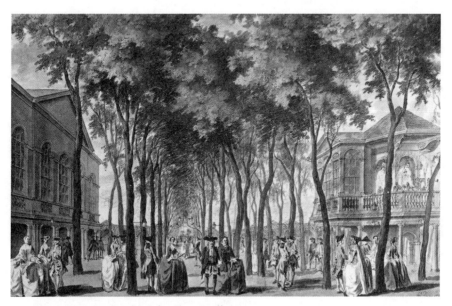

29. *Marylebone Gardens* by John Donowell, *c.* 1750

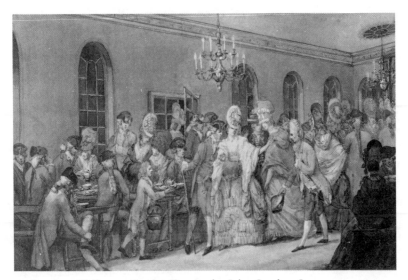

30. *Bagnigge Wells on a Sunday Evening* by John Sanders Jnr, 1772

life. But this sentiment was also repeatedly expressed in private diaries and journals. In the diaries of London residents such as the novelist Frances Burney and Johnson's friend Hester Thrale, the journals of provincial gentlemen like the Chichester composer John Marsh, the ebullient record of the Scot James Boswell, the daily jottings of foreigners like the American merchant Samuel Curwen, exiled in London between 1775 and 1784, and the young German novelist Sophie von la Roche, who visited England in the 1780s, and even in the ungrammatical and poorly written account of a farmer like John Yeoman we find the same itinerary repeated: Covent Garden and Drury Lane theatres, a trip to Ranelagh or Vauxhall during the summer, attendance at the Royal Academy and other picture shows, visits to coffee houses, a tour of the British Museum, the occasional concert and forays to circulating libraries and booksellers.

Naturally, the private journals reflect the predilections of their authors. Larpent had a professional interest in the theatre, Marsh preferred concerts, Curwen liked to attend lectures on science and aesthetics, Sophie von la Roche loved pictures and shopping, while John Yeoman sought out catch and glee clubs where he could join in the singing. Yet they all shared a sense that they had embarked on a voyage of discovery which was plotted by the same landmarks of metropolitan culture.

Neither the diaries nor the guides and prints treated cultural activities in isolation. On the one hand they were part of a larger itinerary which included London's great sites – its palaces, private houses and public buildings; on the other, they were part of the London season, the occasion on which the fashionable world was on public display. At the theatre, in the pleasure garden, the exhibition room, the assembly room, even the lecture hall and the rooms of certain learned societies audiences made publicly visible their wealth, status, social and sexual charms. (This was one of their sources of attraction for the tourist.) The ostensible reason for a person's presence – seeing the play, attending an auction, visiting an artist's studio, listening to a concert – was often subordinate to a more powerful set of social imperatives. The audiences were not passive but incorporated culture as part of their own social performance. As the *Theatrical Monitor* of 1768 complained, 'During the time of the representation of a play, the quality in the boxes are totally employed in finding out, and beckoning to their acquaintances, male and female; they criticize on fashions, whisper cross the benches, make significant nods, and give hints of this and that, and t'other body.'

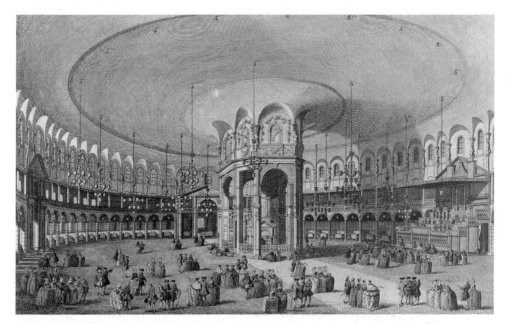

31. *An Inside View of the Rotunda in Ranelagh* by Antonio Canaletto, engraved by N. Parr, 1751

32. *A Royal Engagement Pocket Atlas*, 1780s; left *Frontispiece*; right *Endpiece*

Cultural performances were deeply implicated in the flamboyantly hedonistic life of fashionable society. Linked in a social calendar that included balls and masquerades, gambling for high stakes and the tittle-tattle of polite conversation, they were the occasion for courtship, seduction and the pleasures of the flesh (fig. 33). As Anna Larpent wrote in her journal after an evening at the Pantheon in the spring of 1774, 'There is an emptiness, a lightness in all public places which I dislike, & which too, I dread liking since methinks it must warp the soul take it from nobler pursuits, from the contemplation of my God, my Duty.'

Larpent's diary is full of such sentiments. Even as she followed the social round, she complained about its 'hurry, dissipation, nonsense'. 'I wonder', she wrote, 'at the mad multitude who hunt London dissipation . . . How horrid is the life of (too many) people of fashion, one might imagine they forgot they had souls.' Yet this did not prevent her from pursuing these pleasures: 'I was at two balls in a week concerts & dissipation in proportion a surfeit.' On a summer visit to the country she

reflected on the contrast between rural tranquillity and the fevered activ-
ity of London: 'In town I find a hurry affecting my spirits, an assemblage
of frequently disgusting, vain circumstances that may lead to vanity to
error fatigue interruption.'

These criticisms were the clichés of the day, echoed in the journals
of other young women launched on the tide of the London season. They
belong to the long litany of complaint about theatre- and concert-going,
assemblies and masquerades, pleasure gardens and public exhibitions.
These pursuits could be justified (some more easily than others), but it
was by no means obvious that they were virtuous and uplifting. They
needed to be defended, to be legitimized not only in the eyes of outsiders
but, as Anna Larpent's journal shows, by their audiences. Though some
were deeply pious Christians who shunned public entertainments, and
some libertines who dreamed only of pleasure, most of polite society
fell somewhere in between. They were like Larpent, attending both
masquerades and sermons.

33. *Masquerade Ticket, Ranelagh
Gardens* by Giovanni Battista
Cipriani, engraved by Francesco
Bartolozzi, 1776

The criticism of refined pleasures and the anxiety of play- and concert-goers like Anna Larpent shaped the debate about English culture throughout the century. Commercialized culture had repeatedly to be defended against several accusations, not least that polite amusements provided a fig leaf of respectability to cover the naked pursuit of what the critic Bernard Mandeville called 'Lust and Vanity', and that such dissipation produced an effeminate people 'ensoftened by Pleasure, Vice and Prodigality'. Culture was too luxurious, too effeminate and too foreign. We need to examine these accusations in more detail, not least because only then can we appreciate how cultural pursuits were praised and defended.

In 1761 Thomas Cole, a preacher at St Paul's, Covent Garden, a church within a stone's throw of two theatres and many more brothels, published a series of sermons against 'Luxury, Infidelity and Enthusiasm'. He began with a tirade against fashionable London life:

> An ostentatious extravagance is continually displaying itself in every part of this voluptuous city, and amongst all ranks and conditions of men. An emulous endeavour to outvie each other in the elegant accommodations of life, seems to be, not only the ruling ambition of a few, but the main ambition of a vast majority; the character-istick, and almost universal passion of the age. There is scarce any one, but seems to be ashamed, as it were, of living within the compass of his own proper sphere, be it either great or small.

Cole's jeremiad was aimed at more than the arts and fashionable rec-reations, of course; it was a general indictment of modern luxury, the prodigality of false desires excited by the pleasures and conspicuous consumption of the city. But, like many other critics, Cole singled out a passion for the arts as the acme of acquisitiveness and fashion: '*the virtuoso arts* are giving their instruction how to gratify the *lust of the eyes*, and to display the *pride of life* . . . There is always something in the delights they afford, which renders them rather dangerous with respect to their moral influence.' The arts were seductive, threatening to distract people from their godly, public duty.

Much of this criticism was based on a pious hostility to worldliness. Religious critics were fond of citing the words of St Paul: 'all that is in the world, the lust of the flesh, the lust of the eyes, and the pride of life, is not of the Father, but is of the world'; they wanted a spiritual outlook

36. *A City Rout* by Richard St George Mansergh, engraved by I. W., 1772

that rejected what the churchman William Law called the *'bubble, vapours, dreams and shadows'* of the material world in favour of a pious life of Christian devotion. And they were especially concerned, as Law made clear in his widely read *A Serious Call to a Devout and Holy Life* (1729), about polite folk who professed to be Christians and regularly attended church but still enjoyed 'visiting, conversation, reading and hearing Plays and Romances ... Operas, Assemblies, Balls and Diversions'. For such critics, godliness was not expressed in the superficial habits of occasional church attendance but required the true Christian to live a completely pious life that rejected worldliness. The pursuit of worldly pleasures and true godliness were incompatible (plates 2 and 3).

The anxieties of pious Christians, including Anna Larpent, about the potentially pernicious effects of cultural pleasure were well founded. Theatres and pleasure gardens were filled with what Samuel Curwen described as the 'pitiable votaries to Venus'; sexual intrigue and gossip were the business transacted in exhibition halls and assemblies. In this culture of display, vanity, pride and greed as well as the finest clothing were on show

(fig. 36). No wonder it seemed to critics like Henry Fielding, writing in the 1750s, that England was swamped by a 'vast torrent of luxury' and that, as one pamphleteer complained, 'the gratification of their Appetites . . . is the Duty – the only indispensable Duty required from rational creatures'.

Lust of the flesh and eyes seemed to be matched by sloth and pride. Critics attacked fashionable recreations because they distracted people from their work, civic duties and public responsibilities. The leisure time required to attend the theatre or to appreciate painting was condemned as 'idleness'. Greedy impresarios were attacked for seducing the vulgar and the ignorant into believing that they could be leisured men and women of taste. It was claimed that merchants neglected the counting house for the opera, artisans their trade for a book club, aldermen their civic calling for a country house, and mothers their children and husbands for the latest play. Prints and satires poured scorn on the parvenu, ignorant and ill-informed, but wealthy and desperate to be refined and modish. In *A Common Council Man of Candlestick Ward and his Wife on a Visit to Mr Deputy at his Modern Built Villa near Clapham* (1771), the 'cit' arrives in his coach outside the house of his friend (plate 4). The villa is an astonishing mishmash of taste, a mixture of Georgian, gothic and Venetian features, crowned by a chinese dragon. The common council-man and his wife have fallen from their carriage, his fashionable wig decorating his horse. Imitating the tastes of one's social superiors has an inevitable fate: pride leads to a fall. From this point of view, cultural refinement was a social solvent: fashion created a cult of 'the new' that emphasized what Bernard Mandeville called 'Objects of Mutability'; audiences, especially in the theatre and the pleasure garden, dissolved society's class distinctions, and cultural entrepreneurs, pandering to people's pride and vanity, encouraged the apprentice to ape the gentleman. In Pope's eyes the supporters of a commercialized culture were 'This Mess, toss'd up from Hockley-Hole and White's', a mixture of 'Dukes and Butchers' from aristocratic gambling clubs and one of the poorest and most squalid parts of London. Garrick took a similar view of the theatre audience:

> Above 'twas like Bedlam, all roaring and rattling!
> Below, the fine folk were all curts'ying and prattling:
> Strange jumble together – Turks, Christians, and Jews!
> At the Temple of Folly, all crowd to the pews.

Culture put the social order out of joint.

Much of this criticism made women the special object of its wrath. William Law's *A Serious Call* contrasts Flavia, the fashionable collector of poetry, with Miranda, a pious and unworldly Christian. The Scottish schoolmaster James Burgh, in *Britain's Remembrancer*, an admonitory tract published in 1746, singled out refined and fashionable women for special rebuke:

> Can you say you ever come away from the tumultuous scenes of Pleasure, which ingross the bulk of your Time, without having your Minds disturbed and thrown into a ferment of irregular and exorbitant desires, which, if you loved a life of sobriety, peace and retirement, would never have stirred in your breasts? Can you pretend that the sight of gorgeous dresses, of gawdy paintings, and all the various magnificence, which exquisite art supported by unbounded extravagance can put together; that the hearing of the most melting strains of music, and of the most rapturous and passionate flights of poetry; can you pretend, I say, that these have any other effects upon you than to fill your fancies with a thousand

37. *A Common Council Man of Candlestick Ward and his Wife on a Visit to Mr Deputy at his Modern Built Villa near Clapham*, 1771

romantic wishes and desires altogether inconsistent with your station
and above your rank in life, and to make your homes dull and
tiresome to you?

The author of *The Devil on Crutches* (1755) complained that women in
the theatre, 'though they resent the least loose Discourse in private
company, . . . are fond of the most fulsome Obscenity upon the Stage,
and will not suffer a Blush to take Possession of their Cheeks, while
they are attending to scenes that would disgrace the Stews', while another
commentator bemoaned the 'indecent attitudes, obscene labels, and simi-
lar decorations of the figures' in printshops, claiming that 'girls often go
in parties to visit the windows of printshops, that they may amuse them-
selves with the view of prints which impart the most impure ideas' (figs.
38 & 39).

At first sight, this concern suggests that the importance of women
in the arts was growing. And indeed many women besides Anna Lar-
pent were noted for their enthusiasm for literature, painting and the

38. *Spectators at a Print-Shop
in St Paul's Churchyard,
c.* 1760

39. *The Return from a Masquerade – A Morning Scene* by Robert Dighton, 1784

performing arts. As the *Athenian Mercury*, a periodical that catered predominantly to women, put it early in the century, women are 'a Strong Party in the World'. They were the readers of periodicals and novels; the devotees of the circulating library; most of the audience at the theatre, opera and pleasure garden; enthusiastic participants in the masquerade; the collectors of prints and the purchasers of paintings; the organizers of amateur dramatics and theatricals; and the family member most likely to preside over most forms of decoration and furnishing. As John Potter remarked, with some pardonable exaggeration, in his *Observations on the Present State of Music and Musicians* (1762): 'In *Great-Britain* the ladies are as free as the gentlemen; and we have no diversions, or public amusements, in which the one may not appear, without any offence, as frankly as the other.'

The power of women was seen in almost every cultural form. There were women's periodicals like the *Athenian Mercury*, the *Ladies Mercury*, the *Visitor*, and the *Town and Country Magazine*; conversation pieces and domestic portraits in painting, 'she tragedies' (whose central figures were

women in distress) and sentimental comedies; even the funereal sculpture of Roubiliac was seen as especially catering to female taste.

There were also many female writers, painters, actors and musicians. Aphra Behn, the Tory poet, playwright and novelist and the first professional woman writer to be buried in Westminster Abbey, was the first of many successful women playwrights and novelists. Between 1750 and 1770 six of the twenty most popular novelists in England were women. More than thirty editions of Eliza Haywood's novels were published; Sarah Fielding, though not as popular as her brother Henry, outsold Voltaire, Cleland, Marmontel, Goldsmith and Cervantes. In the same period 185 editions of novels were published whose authors we know to be women. Many novels whose anonymous authors have not been identified would also have been written by women, who were less likely than men to put their names on title pages.

Critics recognized this increasing contribution of women to English culture. A biographical dictionary of women distinguished for 'their Magnanimity, Learning, Genius, Virtue, Piety and other excellent endowments' appeared in 1766, and several articles and poems published in the 1770s, including an essay in the *Westminster Magazine* which suggested that learned women be given honorary degrees at Oxford, praised groups of celebrated literary ladies. In 1777 the painter Richard Samuel engraved a group portrait of *The Nine Living Muses of Great Britain*, which was distributed in *Johnson's Ladies New and Polite Pocket Memorandum for 1778*. He exhibited a finished painting on the same subject in the Royal Academy exhibition of 1779, depicting a pantheon of modern figures portrayed in classical garb (plate 1): Elizabeth Carter, bluestocking and translator of the Stoic Epictetus; Angelika Kauffmann, one of the two women members of the original Royal Academy, and a famously fashionable artist all over Europe; Anna Letitia Barbauld, educationalist, poet and essayist; Elizabeth Linley, the singer and wife of the playwright politician Richard Brinsley Sheridan; Catharine Sawbridge Macaulay, historian and feminist; Elizabeth Montagu, author of a famous essay on Shakespeare, leader of the London Bluestockings and a wealthy literary patron: Elizabeth Griffith, the Irish actress, playwright and novelist; Hannah More, playwright, poet, novelist and conservative polemicist; and the novelist Charlotte Lennox.

It is not clear why Samuel chose these particular women. They were not a coherent group, though many were in Elizabeth Montagu's circle

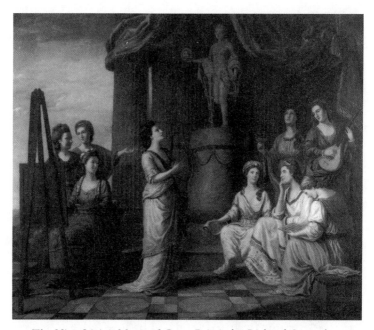

40. *The Nine Living Muses of Great Britain* by Richard Samuel, 1779

and several had contacts with Johnson and his club, but we can gauge their public importance by their influence on the young Anna Larpent. She read several novels by Elizabeth Griffith and Charlotte Lennox and studied Elizabeth Carter's translation of Epictetus. She liked Hannah More's play *Percy* so much that she saw it several times and bought the printed text. And in her diary she showered Angelika Kauffmann's submissions to the annual Royal Academy shows with compliments.

This female participation in the arts provoked responses that ranged from ambivalence to outright hostility. Both men and women roundly condemned women who they thought sought fame and fortune, as opposed to those who were amateurs, gentlefolk, or who worked for self-improvement, so that they would prove better companions to their husbands and wiser teachers of their children. As Hannah More explained, a woman's 'talents are only a means to a still higher attainment, ... she is not to rest in them as an end; ... merely to exercise them as an instrument for the acquisition of fame and the promoting of pleasure, is subversive of her delicacy as a woman'. A 'watchful mother', she added, 'must have the talents of her daughter cultivated, not exhibited'.

Thus Anna Larpent, despite her admiration of women writers, painters and actresses, looked askance at the professional female artist. Though she admired Sarah Siddons, she was also sure that 'Acting revolts in women against female delicacy'; her admiration of Angelika Kauffmann did not prevent her asserting that 'being an Artist [is] incompatible with the Duties of a good Wife & Mother'; and though she read and praised many women novelists, she reprobated 'those pecuniary wants' that led them to publish.

While Larpent struggled to reconcile the lives of women actors, painters and authors with their Christian duties as wives and mothers, many critics had larger concerns. For them, the presence of women in the arts implied not simply a culture aimed at and devoured by women but, more insidiously, the feminization of a culture they believed should embody masculine values. Complaints about this were commonplace. Jonathan Swift's remark to his lover, Stella, that he'd 'not meddle with the Spectator – let him fair-sex it to the world's end', expressed his contempt for the periodical's appeal to women readers. Joseph Warton dismissed a tragic theatre dominated by love 'which, by totally engrossing the theatre, hath contributed to degrade that noble school of virtue into an academy of effeminacy', while 'the ruling principle' of the Anglican clergyman John Brown's best-selling *Estimate of the Manners and Principles of the Times* (1757–8) was its blanket condemnation of 'unmanly dissipation', and its attack on '*vain*, *luxurious*, and *selfish* EFFEMINACY' (fig. 41).

These criticisms contained a strong element of anxiety about the conduct of men. Brown makes the point explicit, complaining that 'the one sex [have] ... advanced in boldness, as the other have sunk into effeminacy'. He and other critics used the term 'effeminacy' in several different ways. First and foremost they saw it as the surrender to private desire and passion, whether this took the form of vanity, concupiscence, cupidity or avarice. Human feeling and desire, they believed, should either be controlled or be shaped so as to act for the public good; a failure to do so was 'effeminate'. A libertine like Richardson's Lovelace in *Clarissa* was effeminate, though he embodied what we now would consider aggressive male heterosexuality. The gentleman collector, obsessed with accumulating objects of art and neglectful of his public responsibilities, was similarly effeminate, as was the 'fop' who took appearances and manners as the sum total of virtuous conduct. As one essayist of the

1730s commented: 'I would fain know, whether any thing that is Noble or Brave can be expected from such Creatures, who, if they are not Women, are at least Hermaphrodites, in their very Souls ... Do such nice Gentlemen, who dress and play with their Bodies, as with Puppets, promise their native Country either refined and active Statesmen, or hardy and intrepid Soldiers?' Effeminacy, then, was about unbridled passion, display, vanity and private interests rather than public duty. It drew on a longstanding set of associations, particularly in Christian literature but also in classical writing, between women and these qualities. And it was often embodied in a female figure: the woman who vainly sought admiration for her accomplishments in the eyes of male admirers, or the novel-reader led into false passions by the delusive ideas propagated by authors. But for all this, the issue of effeminacy was very much an issue for men.

'Estimate' Brown saw effeminacy as the consequence of an advanced commercial society, with its 'Superfluity ... and present Exorbitant

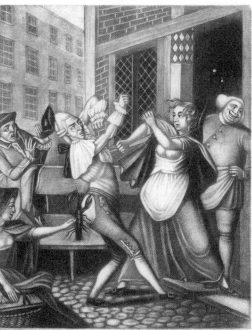

41. The Billingsgate fishwife outboxes the effete Frenchman in *Sal Dab giving Monsieur a receipt in full*, published by R. Sayer and J. Bennett, 1766

Sal Dab givin Monsieur a Receipt in full.
London, Printed for R. Sayer, Printseller N.º 53 Fleet Street, as the Act directs 21 Sept.ʳ 1766. 410

Degree of Trade and Wealth'. Like some twentieth-century historians, he attributed the development of a new kind of culture in the eighteenth century to Britain's economic success. And he and others believed that this culture had brought about a new sort of refinement, a greater sophistication, a development in which women had played an important role. Their company and conversation were widely held to make men less rude and brutal, more refined and polite. An important purpose of the assembly, the theatre, concert hall and picture gallery was to be a place where the sexes could mingle, and one of the values of the performance was that it gave men and women a topic of refined conversation. But such an arrangement brought its dangers: men would be led away from their civic responsibilities, seduced by women into a life of pleasure rather than duty; they would behave effeminately, wallowing in the luxury that modern life afforded. And the effect would be disastrous. Britain, 'once the boast and confidence of her friends, the envy and dread of her enemies, the nurse of heroes, the glory and admiration of mankind, is now, alas! a reproach among the nations, the school of licentiousness and unmanly luxury, lost to public spirit, and to every great and generous principle.'

The fear that luxury and refinement were weakening the moral fibre of the nation persisted throughout the eighteenth century, but at times of national crisis – during wars, rebellions and revolutions – the rumble of worry rose to a roar. During the Jacobite Rebellion of 1745, at the loss of the American colonies, and with the outbreak of the French Revolution, as well as on every occasion when Britain went to war against France, critics agonized over the state of the nation. Was a bold, masculine, martial nation becoming effete and effeminate? This issue was often defined as a struggle between older, indigenous British values and continental foreign ideas of refinement, invading the nation by unmilitary means. Thus Samuel Foote, in one of his popular anti-French plays of the 1750s: 'The importation of these puppies [French valets, dancing masters and hairdressers] makes a part of the politics of your old friends, the French; unable to resist you, whilst you retain your ancient roughness, they have recourse to these minions, who would first, by unmanly means, sap and soften all your native spirit, and then deliver you an easy prey to their employers.' Refinement, culture and civilization, it would seem from such comments, were not of native stock (even though they were alive and well in Britain) but subversive foreign imports. Brown

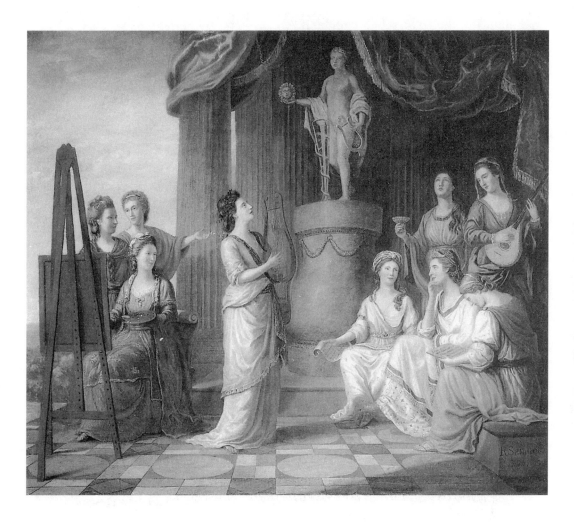

The Nine Living Muses of Great Britain: Portraits in the Characters of the Muses in the Temple of Apollo by Richard Samuel, 1779

PLATE I

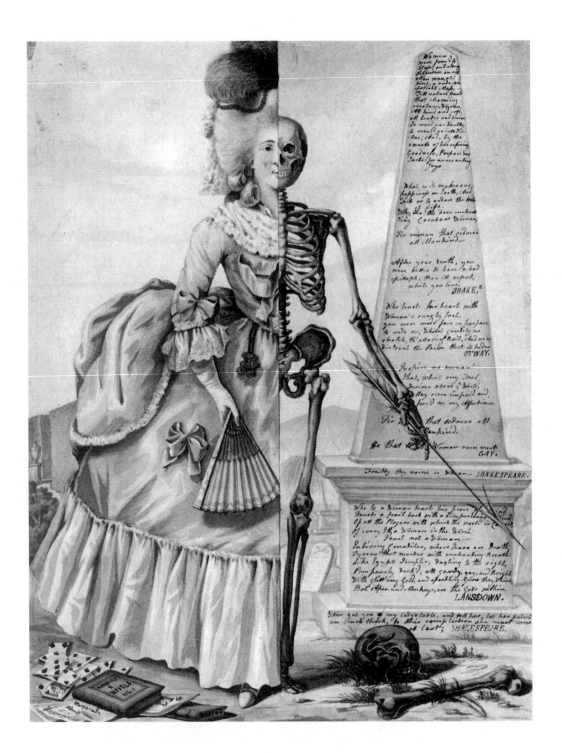

Female and male versions of the transitory vanities of society which conceal human mortality. *Life and Death Contrasted, or an Essay on Woman* by Robert Dighton, 1784

PLATE 2

Death and Life Contrasted, or an Essay on Man by Robert Dighton, 1784

PLATE 3

*A Common Council Man of Candlestick Ward and his Wife on a Visit to
Mr Deputy – at his Modern Built Villa near Clapham*, by an unknown artist, 1771

PLATE 4

was clear on this point. French manners, he wrote, were 'as *vain* and *effeminate* as our own, and the very Archetype from which ours are drawn'. Foreigners in general, and the French in particular, had an interest in spreading effeminacy because it sapped the patriotism and public-spiritedness that protected the rights of Englishmen at home and kept such despotic powers as France at bay. Englishmen faced internal and external threats.

Much of this criticism dwelt on the aristocratic penchant for all things French and on fashionable society's enthusiasm for affected and florid manners, behaviour which its opponents associated with the duplicitous and sycophantic conduct found in the enervated climate of a despotic society. The issues were power and sex. Under an arbitrary government, especially in its royal courts, emollience and charm were necessary to

42. *My Lord Tip-Toe. Just arrived from Monkey Land,* published by M. Darly, 1771

manipulate the monarch whose word was law. French court society for example, was characterized by indiscriminate mingling of the sexes, excessive male solicitousness to women, and constant sexual intrigue. It was difficult to divest notions of refinement or politeness of associations that were worryingly alien, courtly and aristocratic, when fashionable society continued to consider Paris its cynosure, and a continental visit essential to good breeding (fig. 42).

This was more than a matter of fashion, for British culture drew extensively on the intellectual riches of France. French treatises on the *beaux arts*, painting and literature shaped British criticism and aesthetics, and French writers enjoyed extraordinary success, both in their own language and in translation. A survey of more than 200 eighteenth-century British libraries has shown that eight out of ten contained works by Voltaire; in the last quarter of the century Rousseau was one of the most popular and controversial authors in Britain; for most of the century people of rank and education could read and speak French, the common tongue of European gentlefolk, and were expected to acquire a knowledge of French literature.

Anna Larpent read almost as much French as English fiction: the novels and stories of Marivaux, Lesage, whose *Gil Blas* was a major source of picturesque fiction, Marmontel, whose witty, beautifully crafted moral tales she read repeatedly and, of course, Voltaire and Rousseau. Her reading of Shakespeare was matched by her study of the tragedies of Racine and Corneille and the comedies of Molière and Marivaux. Alongside Hume and Gibbon she read the histories of Voltaire, Raynal and Rollin. Like every polished letter-writer, she knew the correspondence of Madame de Sévigné, and when she studied taste, she turned to two of the most influential French critics, Boileau and the Abbé Dubos. She had a more cosmopolitan upbringing than most young English women, but there is ample evidence that at least until the French Revolution, the British man or woman of letters relied heavily on literature and criticism in French. This influence was often suppressed or denied, but the frequent attempts to assert Britain's cultural independence from France demonstrate how powerful was the bond that some wished to be broken.

English cultural anxiety about the achievements of other European nations was reinforced by an influx of foreign artists and skilled craftsmen from the continent. London was wealthy, but English artisans and artists,

except in literature, were feeble in comparison to those in the rest of
Europe. The opportunity was too good to miss. Between 1675 and 1750
eighty-three Italian composers were resident in London; there were
painters and decorators from France, Italy, Poland, a whole school of
Swedish artists, Germans, Dutchmen and Belgians, not to mention the
occasional Hungarian. In the early part of the century the visual arts
were dominated by Dutch, German and French artists and decorators,
by Dutch and French engravers, and music was virtually controlled
by Italian and German performers and composers. The English also
imported enormous numbers of foreign paintings and engravings. The
London theatre staged Molière and Racine, and the opera was almost
exclusively Italian, performed by imported artists and sung in its original
tongue. No wonder that Garrick complained in one of his prologues, 'Virtu
to such a height is grown,/ All Artists are encourg'd – but our own.'

This influx of artists was both a cause and effect of the cosmopolitan
nature of culture in eighteenth-century Europe. A successful musician
or painter expected to be peripatetic. Handel, born in Halle, worked and
studied in Florence, Rome, Naples and Venice, in Hanover, Düsseldorf
and Dresden as well as London and Dublin. Antonio Joli, a painter of
topographical views and theatrical scenery from Modena, who worked
in London between 1742 and 1748, had previously been employed in
Germany, Rome and Venice. In 1749 he went to Madrid, and between
1754 and 1762 he commuted between Venice and Naples. Artists followed
commissions and wealth. But from the British point of view, which was
suffused with anxiety about the weakness of native artistic traditions,
this cosmopolitanism felt like foreign invasion, and the patronage of
foreign artists and art by rich and fashionable Englishmen seemed like
a form of cultural treason. In 1755 the anonymous author of *The Devil
on Crutches*, a satire ironically based on a French original, Alain-René
Lesage's picaresque *Le Diable Boiteux* (1707), looked down on a group
of modern aristocrats:

> How these *honest* souls rejoice to think, they shall once again hear
> harmonious Nonsense, warbled from a Eunuch's throat, in a
> Language they do not understand. They prefer the Scraping of a
> foreign Fiddle, to all the Beauties of Poetry in their own Tongue,
> aided by Music that would not disgrace the greatest ancient Masters
> of that Art. The *L'Allegro* and *Penseroso* of your own *Milton*, are

proofs of what I assert. There was a Time, when the Patrons of
their Country, were the Patrons of Merit, when the homely Compo-
sitions of *Shakespeare*, *Jonson* and *Fletcher*, were the delight of all
Degrees of People. But those Days are past, and Reason must give
Place to Sound.

Two years later a satirical polemic, *The Tryal of the Lady Allurea Luxury,*
before the Lord Chief-Justice Upright, on an Information for a Conspiracy,
presented a one-sided indictment of modern refinement. Luxury was
represented as female, foreign and seductive, a courtier who enters Eng-
land as the mistress of Charles II, and writes obscene, libertine and
blasphemous tracts and verses. Her defence is that she has shaped modern
taste and encouraged a traffic in culture that has made many men rich.
As one of her defenders, 'Cappodocia', points out:

> We knew not what Elegance and true taste were, till she came
> amongst us – Tis to her we are obliged for the highest Satisfactions
> of Life – Painting, Sculpture, Poetry, and Music, were scarce known
> to us, till she gave them Encouragement – I have myself imported
> many Thousands of curious Pictures and Statues from *Rome, Flor-*
> *ence*, and other Cities of *Italy* – and hope, from that great Repository
> *Herculaneum*, to be able soon, under the Protection of that Lady,
> to enrich the Collections of all the Nobility and Gentry of this
> Kingdom, who have a Taste for Vertu.

But under cross-examination by the patriotic magistrate she is forced to
agree that 'a few good Pictures in a public School, always ready for the
perusal, study, and imitation of the Youth of the Nation, would ...
contribute more to the Increase of good Painters amongst us, than ten
thousand private Collections, even of the best paintings to be found in
Europe'. Her defence, that the international trade in *virtu* is good for
business, is rejected out of hand. Lord Chief Justice Upright's verdict is
clear: 'She hath opened the Sluices of Corruption – and a Torrent of
Wickedness hath broke in upon, and overflowed the Banks of Justice,
Temperance, Religion, and Morality.'

This tract, published at the outbreak of the Seven Years War with
France, made clear that a credible defence of the arts would have to show
that they were not empty amusements or crude pleasures but could be
patriotic, Christian, useful and manly. Throughout the century repeated
though quite different efforts were made to give British culture a respect-

able pedigree. Yet none was entirely successful, as we shall see, for every apology for the arts contained within itself the seeds of its own destruction.

One way in which critics distinguished the arts from fashionable recreations was by claiming that they were uniquely objects of 'taste'. They argued that a special sort of relationship existed between art and those who enjoyed it, which involved feeling and the emotions but not the gross passions of greed and desire. 'Works of imagination and the elegant arts', as Edmund Burke called them – plays, poems, operas and concertos, paintings and sculptures – were different from other products of human endeavour because they were objects of taste, whose purpose, in the famous phrase of Joseph Addison, was to stimulate 'the pleasures of the imagination'. The pleasures associated with taste were not the same as 'the gratification of appetite', which critics of these refined pleasures saw as precisely their greatest vice.

In seeking to define the new cultural category of 'the fine arts', sometimes called 'elegant arts' or 'arts of taste', critics like Burke and Addison were not merely trying to distinguish the refined sensations produced by art from the social and sexual pleasures which excited the passions. They also distinguished the fine arts, whose end was pleasure, from the 'necessary', 'mechanical' or 'useful arts' – the crafts of the artisan – and from those intellectual matters – science, history and philosophy – whose appreciation was achieved not through taste but through *understanding*. They were defining a field of human endeavour which was neither utilitarian nor rational but pleasing because it affected people's feelings. The danger, of course, was that pleasure and sentiment could be seen as idleness and passion. Where was the morality or value in art?

Critics and philosophers disagreed about which activities fell into the category of 'works of the imagination and the elegant arts'. Poetry, painting and music – what the Scottish critic Archibald Alison in his *Essays on Taste* (1790) specified as 'the landscapes of Claude Lorraine, the music of Handel and the poetry of Milton' – were invariably included. Architecture, dance, gardening, sculpture and, with declining frequency, oratory and eloquence were also identified as 'fine or elegant arts'. By the mid-eighteenth century it was commonly asserted that the defining characteristic of 'polite' culture, whatever its precise content, was that it

was the object of taste. Culture was defined in terms of the response it
evoked in its audience. As Burke put it, 'I mean by the word Taste no
more than that faculty, or those faculties of mind which are affected
with, or which form a judgment of the works of the imagination and
the elegant arts.'

But what was 'taste'? Who had it and how could it be acquired? As
James Miller commented in *The Man of Taste*, taste had become a byword:
'fine ladies and gentlemen dress with taste ... the painters paint with
taste, and in short, fiddlers, players, singers, dancers and mechanics them-
selves are all the sons and daughters of taste. Yet in this amazing super-
abundance of taste few can say what it really is, or what the word
signifies.' Like so many of her contemporaries, Anna Larpent thought
the definition of taste a question of great moment, for the integrity of
culture and the nature of individual refinement depended on how it was
determined. After her father's death, when she was given the task of
educating her younger sister Clara, she devised a course of reading and
together the two young women debated the question of whether taste
could be treated like scientific knowledge or regarded as a matter of
sense and feeling. They read Addison's famous essays on the imagination
from the *Spectator*, Mark Akenside's poem, *The Pleasures of the Imagina-
tion*, which popularized Addison's ideas, Pope's *An Essay on Criticism*,
Sir Joshua Reynolds's *Discourses* on art, and the *Dialogue of Taste*, written
by their friend, Allan Ramsay. Larpent does not record what conclusion
she and her sister may have drawn, but other remarks in her diary make
it clear that she adhered to the prevailing view that taste was a matter
of feeling. This was not a very satisfactory answer, however. What was
the nature of this feeling, and who was able to possess it?

If taste was a matter of feeling was it not something potentially
available to everyone? Most critics argued that appreciation of the arts
and imaginative literature was not limited by a person's powers of under-
standing because it was a matter of sense rather than reason. The prin-
ciples of taste, wrote one commentator, 'are common to our whole species,
and arise from that internal sense of beauty which every man, in some
degree at least, evidently possesses'. Everyone had the potential for good
taste. The Scottish philosopher Francis Hutcheson went further in his
influential *Inquiry into the Original of our Ideas of Beauty and Virtue* (1725),
insisting that the appreciation of beauty did not depend upon specialized
knowledge: 'The Pleasure does not arise from any Knowledge of Prin-

ciples, Proportions, Causes, or of the Usefulness of the Object; but strikes us at first with the Idea of Beauty: nor does the most accurate Knowledge increase this Pleasure of Beauty, however it may super-add a distinct, rational Pleasure from prospects of Advantage, or from Increase of Knowledge.'

This view of culture as something that appealed to the senses posed problems. If it was so sensuous and seductive, how were the feelings it provoked to be distinguished from the grosser senses? How could works of imagination and the fine arts avoid contamination by lust and mammon? As we have seen, they were part of the fashionable London season, the occasion for sexual intrigue, and managed by those who treated culture as a commodity to be bought and sold. Everyone's natural potential for good taste, the clergyman Alexander Gerard pointed out in his popular work *An Essay on Taste* (1759), could easily be distorted by what he called 'gratification of appetite' and 'pursuit of gain'; similarly Edmund Burke warned that good taste must be distinguished 'from desire or lust; which is an energy of mind, that hurries us on to the possession of certain objects'.

Such views were popularized in the periodical press. An essay by Bishop Berkeley in the *Guardian* No. 49 drew a distinction between natural and what he called 'Fantastical Pleasures':

Under Natural Pleasures I comprehended those which are universally suited, as well to the rational as to the sensual part of our nature. And of the pleasures which affect our senses, those only are to be esteemed natural that are contained within the rules of reason, which is allowed to be as necessary an ingredient of human nature as sense. And, indeed, excesses of any kind are hardly to be esteemed pleasures, much less natural pleasures ... It is evident that a desire terminated in money is fantastical; so is the desire for outward distinctions, which bring no delight of sense, nor recommend us as useful to mankind; and the desire of things merely because they are new or foreign. Men who are indisposed to a due exertion of their higher parts, are driven to such pursuits as these from a restlessness of the mind, and the sensitive appetites being easily satisfied.

Burke and Gerard maintained that the way to avoid such pitfalls was to learn to look upon art and literature from a disinterested point of view, to permit it to excite feeling but to experience it dispassionately.

Viewers must set aside their worldly interests. The relationship between the person of taste and the work of art had to be direct and unencumbered, not distorted by lower sorts of desire. As David Hume put it, cultural appreciation depended on 'A perfect serenity of mind, a recollection of thought, a due attention to the object; if any of these circumstances are wanting, our experiment will be fallacious, and we shall be unable to judge of the catholic and universal beauty.'

The pleasures of the imagination excited by works of art were therefore opposed to the 'sensual' and 'voluptuous' pleasures of the body. Both Hutcheson and Gerard distinguished 'external' and 'internal' senses: the first were carnal and active, the second tasteful and passive. Gerard's comments on the opening page of his *An Essay on Taste* epitomize this widely held view:

> A fine Taste is neither wholly the gift of *nature*, nor wholly the effect of *art*. It derives its origin from certain powers natural to the mind; but these powers cannot attain their full perfection, unless they are assisted by proper culture [i.e. cultivation]. Taste consists chiefly in the improvement of these principles, which are commonly called the *powers of the imagination*, and are considered by modern philosophers as *internal* or *reflex senses*, supplying us with finer and more delicate perceptions, than any which can be properly referred to our external organs.

Gerard's distinction shows how critics reconciled the seemingly democratic view that taste was natural and innate with a strong sense that it was also something 'finer' and 'more delicate' which could only reach its peak through 'culture'. Such cultivation meant not so much the acquisition of knowledge as the development of a particular frame of mind or way of looking. The key question was, how could such a disinterested perspective be obtained?

The answer was unclear. On the one hand, it was argued that refinement was most easily attained by gentlemen who had the means and leisure time to adopt a broader view. Not required to work for a living, not economically dependent on others, they were considered to have unbiased and impartial views. As Addison explained in one of the *Spectator* papers:

> A Man of Polite Imagination is let into a great many Pleasures that the Vulgar are not capable of receiving. He can converse with a

picture, and find an agreeable companion in a Statue. He meets
with a secret Refreshment in a Description, and often feels a greater
Satisfaction in the Prospect of Fields and Meadows, than another
does in the Possession. It gives him, indeed, a kind of Property in
every thing he sees, and makes the most rude uncultivated parts of
nature administer to his Pleasures: So that he looks upon the World,
as it were, in another Light, and discovers in it a Multitude of
Charms, that conceal themselves from the generality of Mankind.

So good taste was a badge of distinction. Taste was something everyone
had, but some people had more than others. The prosperous were more
likely to enjoy its pleasures than the poor.

But the issue was not so straightforward. For although there was
general agreement that financial independence made good taste possible,
it was not itself a guarantee of taste. After all, it was not difficult to
imagine a tasteless person of independent means. This, in turn, raised
the question of whether he was a gentleman. If gentility and taste had
to be cultivated and did not simply occur because of rank, it became
much more difficult to define them, to establish the boundary between
gentility and vulgarity, between good and bad taste.

Making such distinctions was inhibited not only by the ambiguities
in notions of taste but also in the status of gentlemen. For Guy Miège,
a Swiss immigrant to England in the late seventeenth century, a gentle-
man was anyone with 'a liberal, or genteel Education, that looks
Gentleman-like (whether he be so, or not) and has wherewithall to live
freely and handsomely'. Richard Steele also took the view that gentle-
men were made rather than born. 'The Appellation of a Gentleman',
he wrote in the *Tatler* No. 207, 'is never to be affixed to a Man's
Circumstances.' Even a shopkeeper, he argued, could be genteel. And,
just as many publications were designed to explain the nature of
taste, so there were many manuals so that 'Youth may be thereby
Embued with Learning and Gentleman-like Qualities for their
Advancement or Conversation'. Social and cultural boundaries con-
stantly shifted, not least because of the opportunities to cross them.
The realm of good taste, which was supposed to mark the extent of
legitimate culture, was in fact extremely fluid and difficult to determine,
as the culture itself acquired new forms and audiences. As a result
taste was always in the forefront of any discussion about how to define
the arts and literature. The stakes were high and the terms of the debate

explosive, involving sex and money, politics and social standing.

Even in their most abstract and philosophical forms, discussions of taste concerned the position of the *amateur*, the lover of the arts, rather than the artistic creator. Treatises on taste were studies in how culture was appreciated rather than how it was made; they examined the feelings and response of those who looked, watched and listened. They assumed that arbiters of taste were observers rather than creators – collectors of pictures rather than painters, the audience for music or drama rather than its performers, and readers rather than writers. The appreciative amateur, who did not profit from culture, was given pride of place over the professional artist, whose status was compromised by his using art to make a living, by sullying good taste with foul mammon. Taste was not a question for the artist but for the public, the collective body of those who had taste.

What was this body? Throughout the eighteenth century this remained a vexed question. On the one hand commercial pressures largely favoured cultural expansion. On the other, there was a contrary desire to define the tasteful public not as those who were *present* as listeners, viewers or readers, but as those few among them who could *appreciate*, who could respond tastefully to what they saw, heard or read. As the economic barriers that restricted access to the arts were lowered in the eighteenth century and the numbers who enjoyed them certainly increased, cultural provision grew richer and more varied. As a result of this transformation culture became a commodity, an item or event that could be bought and sold. One could buy landscapes by the yard, shares in book copyrights, a percentage of a play, or a box at the opera. Money rather than privilege became the chief currency of culture. Some arts and cultural goods were, of course, extremely expensive. To com- mission a full-length portrait by Reynolds or rent a box at the opera was beyond the means of all but the very rich. But much was available for less. Admission to concerts and spectacles in London's pleasure gardens (except for the socially exclusive Ranelagh) was a shilling or less. The cheapest seats in the theatre (filled on the basis of first come, first served) were the same price, and one could get in at half the cost after the second act. At mid-century half-price admission cost the equivalent of two quarts of ale. The newspapers, journals and pamphlets kept in coffee houses could be read for the price of a drink. Secondhand books and cheap prints, bought at street stalls or in shops, cost a shilling or less. These

possibilities were not beyond the means of an artisan earning between £40 and £60 a year.

Given such prices, culture was well within the purchasing power of the 'middling sort' who had enough money and leisure time to acquire a small but solid library and prints or paintings to decorate their houses, and to enjoy periodic visits to the theatre, art exhibits and concerts. Music was the most expensive recreation – the cost of buying instruments or subscribing to a concert series was high; opera, as today, was the dearest of all – but even a sizeable oil-painting could be bought at auction for between five shillings and a pound.

As we can tell from the inventories of possessions made for probate of wills, the houses of prosperous merchants, shopkeepers, farmers and traders were ever more densely populated by books, prints and pictures. When the London haberdasher Robert Fotherby died in 1709, he had no fewer than forty-four pictures hanging in his dining-room. A mercer who died four years earlier left his heirs almost 1,000 books. These spectacular individual examples were part of a broader trend. Between the 1670s and 1720s pictures recorded in inventories increased threefold, appearing in about two thirds of the surviving documents, while book ownership grew at almost the same rate. Women of the same social standing as men were much more likely to own both books and pictures.

But the optimistic picture conveyed by these figures, which suggest that many people took the opportunity to acquire works of art and literature, just as they eagerly flocked to the theatre and the exhibition hall, needs to be qualified, for other barriers besides wealth restricted access to culture. More than anything else, taste depended upon the written and printed word, on the descriptions, criticisms and discussions of cultural activity which created communities of interest. Music and the theatre could be enjoyed by illiterate people, and their access to literature was also helped by the practice among all classes of reading aloud. But it was very difficult, unless you were a fluent reader, to talk knowingly and with authority about the cultural fashions of the day. In circles such as Anna Larpent's, developing critical opinions was every bit as important as watching a play or hearing a concert, and one of the chief sources of critical comment was newspapers and periodicals. Anna Larpent's observations in her journal on pictures at the Royal Academy may not have been consciously taken from or modelled on reports in the press, but their resemblance to newspaper comment shows that her

private comments closely concurred with public discussion. Those who
could not read lacked a crucial link in the chain of communication that
connected public exhibition and performance to the printed column and
the written manuscript, and both to the spoken realm of drawing-room
conversation.

Admission to a theatre or exhibition hall often depended upon the
appearance of respectability. Theatre managers, proprietors of pleasure
gardens, organizers of public assemblies and members of exhibiting
societies took measures (admittedly not always successful) to exclude
people they found undesirable. Shabbily genteel people did not wish to
risk the humiliation of being turned away at the door. Poor hacks like
the young Samuel Johnson and Oliver Goldsmith would wait to go out
on what Johnson called 'clean shirt days'; a satire of the 1720s depicted
hacks and poets 'cogging their Stockings and darning their Shirt Collars
in order . . . to borrow half a Crown and beg a Dinner'. The ill-dressed,
ragged and poor, or servants wearing their masters' livery, even if they
were able to pay the price of admission, were often excluded from places
where their presence might offend more respectable folk. The persistent
barrage of complaint about disreputable customers was a sign of impre-
sarios' hostility to members of the public whose presence they believed
did not reflect well on their establishments.

Clubs and societies could, of course, more easily restrict access to
the cultural activities they promoted. Reading societies, concert series
and public assemblies were self-perpetuating bodies of subscribers, and
admitted only those who were like-minded and 'acceptable', a term that
was supposed to speak to someone's taste but more often referred to
their social standing. Sometimes this was simple snobbery of the sort
that the gentleman composer John Marsh encountered when trying to
get his friends who were tradesmen into a local assembly, but it was also
a matter of maintaining a particular milieu which might, as in the case
of artisans' and tradesmen's clubs, exclude gentlemen. Whatever the kind
of association, it valued its exclusivity. An introduction, the recommen-
dation of a member or subscriber, was necessary. Culture was not only
a commodity but also the currency of patronage and the means by which
social distinctions were made.

Yet even those with an elitist view of culture did not reject the idea
that its proper audience should be *the public*. Many English commen-
tators, especially Whigs, argued that the distinctive feature of Britain,

and the circumstance that enabled it to be a new centre of civilization, was its public, separate from court, church and state. This was partly a political argument based on the view that the free British constitution fostered what the Scottish philosopher George Turnbull called the 'aptitude to promote public spirit, virtue and the arts, beyond any other in the world'. This view became such a cliché that it was parodied and lampooned, most notably by Alexander Pope. But the idea that 'the Ease of our Government and the liberty of professing Opinions' was a stimulus to debate and the source of effective criticism did not die easily. It fitted too well with the notion of national singularity, the belief that the peculiarities of the English lay in a political and social order of unique liberality.

The beneficial consequences of open government, a free press and active debate were obvious. Artists who had to present their work before the tribunal of the public would be encouraged, it was argued, to produce better work; open debate about culture would raise standards. As the highly influential Whig critic and moralist Anthony Ashley Cooper, third Earl of Shaftesbury, put it,

> without a public voice, knowingly guided and directed, there is nothing which can raise a true ambition in the artist; nothing which can exalt the genius of the workman, or make him emulous of fame, and of the approbation of his country, and of posterity ... When the free spirit of a nation turns itself this way, judgments are formed; critics arise; the public eye and ear improve; a right taste prevails, and in a manner forces its way.

It was therefore possible to represent the growing cultural public not as a sign of luxury and degeneracy, but as a symptom of a healthy political order, uniquely modern and British. The boldest and most optimistic commentators, notably such poets as James Thomson and social commentators like James Millar, traced a cultural history which began in Greece, gravitated to Rome, and moved progressively westward until it reached 'the sceptred isle'. Debating societies and literary and philosophical clubs saw themselves as superior to the ancients and to their continental rivals because they enjoyed the advantages of a free constitution and a commercial economy, both of which ensured an unprecedented circulation of ideas.

This enthusiasm tended to beg an important question, namely, who

were the public and how were they defined? Twentieth-century defi-
nitions tend to emphasize the public's associations with openness and
visibility, as when we use the expression 'public performance'. This was
also an eighteenth-century usage. In his *Dictionary* Dr Johnson defined
the adjective 'public' as 'open, notorious, generally known', 'general, done
by many', 'open for general entertainment', and the noun as 'the people'
and as 'open view; general notice'. But he also went on to speak of public
as 'regarding the good of the community'. In this instance 'public' is a
moral value, which Johnson contrasted with private and particular
interests. In the first case the definition of the public is exceptionally
broad – it is a question of bums on seats – but the second opens up the
possibility that the public does not consist of 'people' but of particular
people who know what is good.

A commercialized culture had its audiences: rowdy servants in a
theatre's upper galleries, drunken bucks in the pleasure garden, fashion-
able belles and beaux wanting to be seen in picture galleries and private
assemblies. But were they the body which decided what was in good
taste? Or did the public consist solely of those who were discerning and
had good taste? Artists were at once dependent on paying audiences
and resentful of their power. Reynolds warned his fellow artists about
the 'mischievous tendency' of Royal Academy exhibits which seduced
'the Painter into an ambition of pleasing indiscriminately the mixed
multitude of people who resort to them'. And the critic and failed painter
Anthony Pasquin launched a furious attack on the fashionable art public:
'the mightiest evil to be regretted is, that the VULGAR, who have no
knowledge of propriety, should, from their numbers, their riches, and
consequently their power, have the national patronage within their
dominion; and yet these bipedal reptiles must be uniformly soothed and
solicited, under such a forcible designation, as THE PUBLIC.' The tension
between these different senses of 'the public' had the paradoxical effect
of reinforcing a consensus about the importance of the public as an
arbiter of taste while exacerbating disagreement about its membership.
The problem was similar to that posed by 'taste'. The impulse to imagine
an inclusive, open public was countered by a concern for exclusiveness.

The size and scope of the British public, its opportunities for freedom
of expression, whether hooting down a play at Covent Garden or dam-
ning a picture in the correspondence columns of the *Morning Post*, were
considered symptomatic of the virtues of British political life, but also as

disturbingly disorderly and unregulated, not only by moral critics of modern depravity but by the artists and performers who desperately needed the approval of their audiences. Audiences and the public, their good and ill conduct, their approval and their disorderliness, were constant subjects of artistic and literary comment. Novels, poems, paintings and plays repeatedly reflected on the relations between artists and their public, on the tensions and paradoxes that surrounded culture and mammon. Pope's *The Dunciad* and Swift's *The Battle of the Books* excoriated the venal world of bookselling, the novelist Charlotte Lennox satirized both the deluded romantic reader and the cynically fashionable public in her *The Female Quixote* (1752), while artists like Thomas Rowlandson painted images of people looking at pictures or being painted, of people going to the theatre, listening and playing music, reading and writing; playwrights were preoccupied with the nature of performance (plays within plays, from Buckingham's *The Rehearsal* (1672) to Sheridan's *The Critic* [1779], were common), and numerous prologues discussed the unruly nature of the audience. This attention was part of the artists' desire to establish the idea of a respectable public, a body whose support would secure their own status. As Garrick remarked, 'There are no hopes of seeing a perfect stage, till the public as well as the managers get rid of their errors and prejudices: the reformation must begin with the first. When the taste of the public is right the managers and actors must follow it or starve.'

Given the efforts of cultural middlemen and impresarios, it was not difficult to buy a picture or attend a theatre or concert, but it took time, effort and money to become, like Anna Larpent, a person of taste. Why did she and others choose these activities rather than engage in other forms of pleasure or recreation? Why literature and not cards, serious conversation not tittle-tattle, the exhibition room and gallery rather than the public promenade, the concert hall rather than the tavern? Of course, in practice many people of taste enjoyed both – it was not always a question of one rather than the other – but journals and diaries reveal that their authors saw a contrast between virtuous culture and frivolous society. In their eyes taste and morality were compatible, even if some aspects of refined pleasure were to be condemned.

The extraordinary expansion in cultural provision enabled many aristocrats, gentlefolk, merchants and artisans to pursue their cultural interests, but it does not explain why they should want to belong to a

community of taste. The conventional modern answer to such questions is usually derived from *The Theory of the Leisure Class* (1899), the classic work of the nineteenth-century sociologist Thorstein Veblen, who believed that the pursuit of good taste and the growth of refinement were prompted by a desire to emulate and imitate one's social superiors. Owning exquisite pictures and patronizing the opera were signs of social distinction, and people who aspired to high status therefore did both. In Anna Larpent's case, the assiduous pursuit of refinement was therefore less a matter of keeping up with her middle-class friends than of imitating and emulating her aristocratic acquaintances – the Duke and Duchess of Queensberry and Earl Bathurst. Veblen's interpretation would not have surprised most eighteenth-century critics, who had long anticipated his views, seeing emulation as either the spur to improvement or, with less approval, as a source of luxury and moral corruption. (It would, however, have seemed less credible to Larpent herself, whose journal offers not an iota of evidence that social emulation mattered to her.) But neither Veblen nor his Georgian predecessors explain why taste rather than some other individual quality was seen as so important in deciding a person's status.

To understand why people considered an interest in the arts and imaginative literature as a way to lead a better, more virtuous life, we have to see how cultural pursuits fitted into a larger scheme of social and moral values. We need to return to the origins of public culture, to the circumstances of its inception, for they profoundly affected how it was understood.

The last years of the seventeenth century and the first of the eighteenth were not only years of transition, when the focus of English culture moved from the court to the city, but also an age of political, religious and moral crisis. Political passions, religious enthusiasm and social antagonism divided Britain. The wounds of the civil wars refused to heal; sectarianism was rife. Thriving commerce and powerful new financial interests made the nation richer, but they appeared to undermine the landed social order, to perpetuate flux and change, to fragment society and destroy its unity. And recent new philosophy and scientific discoveries and new ways of thinking, though they could be reconciled with more traditional beliefs, nevertheless encouraged doubt, dispute and heterodoxy. The

propertied classes, attached to beliefs that valued a stable political order based on land and frightened by the possible return of the upheavals of the civil wars, hankered after a harmonious, unchanging polity. In the *Spectator* No. 125 Joseph Addison graphically depicted the ills of national disharmony:

> There cannot a greater judgment befall a country than such a dreadful spirit of division that rends a government into two distinct people, and makes them greater strangers to one another, than if they were actually two different nations ... A furious party-spirit, when it rages in its full violence, exerts it self in civil war and bloodshed; and when it is under its greatest restraints naturally breaks out in falsehood, detraction, calumny, and a partial administration of justice. In a word, it fills a nation with spleen and rancour, and extinguishes all the seeds of good-nature, compassion and humanity ...
>
> If this party-spirit has so ill an effect on our morals, it has likewise a great one upon our judgments ... Knowledge and Learning suffer in a particular manner from this strange prejudice, which at present prevails amongst all Ranks of the British Nation. As Men formerly became eminent in learned Societies by their Parts and Acquisitions, they now distinguish themselves by the Warmth and Violence with which they espouse their respective Parties. Books are valued upon the like Considerations: an Abusive Scurrilous Style passes for Satyr, and a dull Scheme of Party-Notions is called fine Writing.

Whigs and Tories alike concurred in regretting such a state of affairs, but their disagreements over how unanimity should be achieved perpetuated the divisiveness they so desperately wished to overcome.

For moralists and social commentators the problem was to tame the diverse issues of religion and politics, to create coherence and unity in a society characterized by change and variety, and to harness the insights of the new philosophy. Many different solutions were offered, but the important one for our purposes, both because it placed special emphasis on works of the imagination and the fine arts and because of its subsequent popularity, was the notion of politeness.

Today the term politeness conjures up ideas of etiquette, of conventions that help to smooth social relations, even if they are not essential

to them. In the eighteenth century it meant much more, for politeness embodied an idea of what the true gentleman and gentlewoman should be; conversation was the means for its achievement and politeness the means by which social improvement and refinement could be realized. In opposition to political divisiveness and religious bigotry, politeness proposed a more harmonious ideal. And, though it would be wrong to claim that it succeeded in curing the ills it sought to relieve, it did provide a new way of understanding and responding to the anxieties of the age. It placed culture at the centre of its analysis.

The ideal of politeness became well established during the course of the eighteenth century, and its language and values permeated every aspect of cultural life. Authors offered their readers 'polite literature' or 'polite learning', painters, engravers and architects toiled to produce the 'polite arts', composers in the theatre and the pleasure garden penned 'polite songs', and members of the public visited 'places of public and polite amusement' and patronized 'polite assemblies' with 'polite companions'.

Ideas about politeness were disseminated after the turn of the century in the newly founded periodical press, particularly in Richard Steele's *Tatler* and Joseph Addison and Steele's *Spectator*. The *Tatler*, which appeared thrice weekly from 1709 until 1711, was in turn superseded by the daily *Spectator*, which came to be seen as the very embodiment of politeness. Addison and Steele were not alone. Many advocates of politeness used other periodicals, didactic manuals and works of imaginative literature to address an audience of men and women, gentlefolk and citizens. But the *Spectator* was by far the most successful. Appearing in 635 numbers between October 1711 and 1714 and cheaply priced at one penny, its essays, letters and occasional poems commented on manners, morals and literature. It was an immediate success. In the tenth issue Addison boasted that 3,000 copies were distributed daily, claiming as many as twenty readers per copy, and his claims are broadly borne out by the surviving evidence. Clubs in Lincolnshire and groups of Highland lairds gathered to discuss the paper's contents. It was read as far afield as New England and the East India Company's fort in Sumatra. The *Spectator* taught Benjamin Franklin good prose and was used by Voltaire to improve his English. When Addison and Steele sold their copyright to the collected edition in 1712 it was worth £1,150, a prodigious sum (fig. 43).

The *Spectator*'s extensive circulation throughout the eighteenth century is almost impossible to estimate, for individual essays were often

43. *The Edwards Family* by William Hogarth, 1733–34. Mary Edwards, one of Hogarth's richest patrons, holds open the *Spectator* at essay 580, where Addison writes of how God is everywhere, and gestures to her son, Gerard Anne, as a sign of divine presence

reprinted in schoolbooks, conduct manuals and collections of prose and *belles-lettres*. Vicesimus Knox, a cleric and literary compiler, wrote in 1779: 'There is scarcely an individual, not only of those who profess learning, but of those who devote any of their time to reading, who has not digested the Spectators.' By the end of the century it was regarded as 'a classic' or, as one Scot put it, 'one of those standard books which have done the greatest honour to the English nation'. Anna Larpent, it need hardly be added, records reading the *Spectator* in every year but one between her sixteenth and twenty-second birthdays. Together with the Bible and certain volumes of sermons, it was her constant literary companion.

What did the *Spectator* and its supporters mean by politeness? It was at once a philosophy, a way of life to which one committed oneself, and the means to understand oneself and one's place in the world. Embracing every aspect of manners and morals, it was a complete system of conduct.

'Politeness', explained one manual, 'is a system of behaviour polished by good breeding, and disposes us on all occasions to render ourselves agreeable. It does not constitute merit, it shews it to advantage, as it equally regulates that manner of speaking, and acting, which convey[s] grace and command[s] respect.' The aim of politeness was to reach an accommodation with the complexities of modern life and to replace political zeal and religious bigotry with mutual tolerance and understanding. The means of achieving this was a manner of conversing and dealing with people which, by teaching one to regulate one's passions and to cultivate good taste, would enable a person to realize what was in the public interest and for the general good. It involved both learning a technique of self-discipline and adopting the values of a refined, moderate sociability.

The intellectual roots of politeness extended back to the etiquette of the Italian courts of the sixteenth century, though proponents of politeness tended to think of it as a modern feature of eighteenth-century British society. Such works as Castiglione's manual written for the court of Urbino, *The Book of the Courtier* (1528), had been refined, rewritten and sometimes significantly altered as they were transmitted, usually via France, into English. Thus Giovanni della Casa's *Galateo*, first published in 1559, was reworked in French as *Bienséance de la Conversation entre les Hommes*, printed in Paris in 1617, then translated into English as *Youth's Behaviour* (which went through eleven editions between 1640 and 1692), whose main text was then reprinted as 'Rules of Civility and Behaviour' in William Winstanley's *New Help to Discourse*, published in nine editions between 1669 and 1733.

As conduct manuals and works of politeness moved north and westward through Italy and France, before finally crossing the Channel to England, their audience changed. Castiglione and his imitators had addressed courtiers; French seventeenth-century works of *politesse* were intended for aristocrats who were trying to escape the rigid formality of the royal court; in England polite literature's much larger public may have embraced almost everyone who was literate. Politeness was never confined to the advice book, its most obvious vehicle of expression, nor to the gentleman, its most conspicuous embodiment.

Politeness, it was said, could not flourish in isolation. It would wither into self-regard or mutate into intolerance unless it was cultivated in society. It thrived on being watched and seen. The persistent, gentle frictions of social life, the repeated need to 'please in company', produced

the smooth emollience of the polite person. The home of politeness was in company, and the place of company was in the institutions that lay at the heart of urban culture. As Joseph Addison exclaimed in the *Spectator*, 'I shall be ambitious to have it said of me, that I have brought philosophy out of closets and libraries, schools and colleges, to dwell in clubs and assemblies, at tea-tables, and in coffee-houses.' Politeness had its own special place. It avoided the enclosed polemical worlds of the church and the academy, and rejected the court in favour of the city, preferring settings which, if neither wholly private nor completely public, were unquestionably convivial.

The proponents of politeness set out to create an ecumenical, urbane community of those who shared a vision of the world, to form what Addison called 'the Fraternity of Spectators' consisting of 'every one that considers the World as a Theatre, and desires to form a right Judgment of those who are the Actors on it'. The *Spectator* was careful not to speak for a sectional interest, like such polemical party papers as the Whig *Freeholder* or Jonathan Swift's Tory *Examiner*. It spoke for the generality of mankind – 'the blanks of society' – seeking not to impose uniformity on society but to understand and celebrate its variety. Steele, asking his readers to send their contributions for inclusion in the *Spectator*, called on

> all manner of Persons, whether Scholars, Citizens, Courtiers, Gentlemen, of the Town or of Country, and all Beaux, Rakes, Smarts, Prudes, Coquets, Housewives, and all sorts of Wits, whether Male or Female, and however distinguished . . . and of what Manners or Dispositions soever, whether the Ambitious or Humble-minded, the Proud or Pitiful, Ingenious or Base-minded, Good or Ill-natur'd. Publick-spirited or Selfish; and under what Fortune or Circumstance soever, whether the Contented or Miserable, Happy or Unfortunate, High or Low, Rich or Poor . . . Healthy or Sick, Married or Single . . . and of what Trade, Occupation, Profession, Station, Country, Faction, Party, Perswasion, Quality, Age or Condition soever, who have ever made Thinking a Part of their Business or Diversion, and have anything worthy to impart on these Subjects to the World.

Steele's tone is ironic, witty and bantering; he pokes fun at his readers as one would tease a friend, and he mocks the absurd variety of humankind. But he also makes clear that his call for a variety of letters has a larger purpose:

This sort of Intelligence will give a lively Image of the Chain of mutual Dependance of Humane Society, take off impertinent Prejudices, enlarge the Minds of those, whose Views are confined to their own Circumstances; and, in short, if the Knowing in several Arts, Professions, and Trades will exert themselves, it cannot but produce a new Field of Diversion, an Instruction more agreeable than has yet appeared.

The *Spectator* expressed itself in an intimate manner – as if speaking conversationally to the reader; the published essay was the public version of a private conversation, a place in which familiar discussion was revealed. It both diverted and instructed, achieving its ends not by hectoring or sermonizing, but through agreeable, polite persuasion. In seeking to provide pleasure, its objects were aesthetic as well as moral. When Addison wrote on wit, he announced his desire 'to banish Vice and Ignorance out of the Territories of Great Britain' and to 'establish among us a Taste of polite Writing'; when Steele wrote on the abuse of the understanding, he blamed 'the abandon'd writings of Men of Wit ... but this false Beauty will not pass upon Men of honest Minds and true Taste'. In each case the aesthetic pleasures of the imagination were linked to the pleasures of society and the moral obligation to lead a virtuous life.

 Neither ponderous nor scholarly, prolix nor dull, the periodical essay, read quickly in a free moment or pondered during an idle hour, was considered an excellent means of polite and witty insinuation. It was the literary form of the busy, modern age. As Addison explained, with that self-consciousness which was so typical of the *Spectator*:

We must immediately fall into our Subject, and treat every part of it in a lively Manner, or our Papers are thrown by as dull and insipid: Our Matter must lie close together, and either be wholly new in itself, or in the Turn it receives from our Expressions ... notwithstanding some Papers may be made up of broken Hints and irregular Sketches, it is often expected that every Sheet should be a kind of Treatise, and make out in Thought what it wants in Bulk ... The ordinary Writers of Morality prescribe to their Readers after the Galenick Way; their Medicines are made up in large Quantities. An Essay Writer must practise in the Chymical Method, and give the Virtue of a full Draught in a few drops.

The assumptions on which the ideal of politeness was based were derived from the psychological insights and investigations into human character and mind that were part of the intellectual ferment of the late seventeenth century. First and foremost, it was assumed that men were creatures of powerful passions. These impulses could not be suppressed but should be either regulated or refined. As Richard Steele put it: 'The entire Conquest of our Passions is so difficult a Work, that they who despair of it should think of a less difficult Task, and only attempt to Regulate them. But there is a third thing which may contribute not only to the Ease, but also the Pleasure of our Life; and that is, refining our Passions to a greater Elegance, than we receive them from nature.' Because of man's inherent pursuit of pleasure and avoidance of pain, it was necessary to make virtue and the good life appear attractive and pleasurable. To be pleasing in company was to confer a double pleasure, to please the company and therefore to please yourself.

But the greatest and purest pleasures were those of the imagination, feelings provoked by imaginative literature and the fine arts. They were

44. *A Lady Seated at a Drawing Board* by Paul Sandby, 1760

therefore capable of having a powerful effect: Addison in the *Spectator* No. 421 remarked 'how great a Power ... may we suppose lodged in him, who knows all the ways of affecting the Imagination, who can infuse what Ideas he pleases, and fill those Ideas with Terrour and Delight to what Degree he thinks fit'. Dr Johnson took a similar view: 'Works of imagination excel by their allurements and delight; by their power of attracting and detaining the attention.' Works of art were of enormous importance because of their persuasive power. Used wisely they could teach people to follow the path of virtuous sociability; used wrongly they might cause irreparable damage. It was therefore difficult to distinguish matters of taste from questions of morality.

Man was a creature of his cultural and social environment, shaped by his changing circumstances and stimuli. As Addison remarked, 'There is scarce a State of Life, or Stage in it, which does not produce Changes and revolutions, in the Mind of Man', so that change 'in a Manner destroys our Identity'. The character and appearance of individuals were seen as mutable, the self in a constant state of flux. People did not have fixed identities but were constantly refashioned by their relationships with others. The task of understanding oneself could not therefore be achieved simply through self-examination. If individuals wanted to know themselves in order to learn how to live a good life, they had to understand society.

Politeness was created through the convivial patterns of social exchange, what Steele called 'The Commerce of Discourse', that occurred in polite society. Works that instructed their readers in politeness were concerned to teach the reader how to look at and interpret what he saw as well as how to behave. For seeing in the proper manner, seeing as a polite person, was one way to ensure that one's involvement in polite sociability had the requisite effect. It was important not to misinterpret the signs. Social knowledge had become a form of self-understanding. Personal conduct and the conduct of others were to be judged not according to their conformity to universal moral laws but on the basis of how they affected others. The sort of *impression* you made on other people, how you appeared to them, acquired new importance. Morality became embedded in the world of appearances.

The ideals of politeness therefore required that a person fashion a polite identity by regulating and refining his passions, a goal that could best be achieved through the medium of literature and the arts. But this

was not enough. Politeness and refinement had little value unless they were shared; they had to be put on display, to be shown to others. As a popular manual which was reprinted many times in the last decades of the century put it, 'To render us respectable in a social light, the accomplishments of the mind must be heightened and set off to advantage by proper ornament of the body, and the attractive graces of deportment and behaviour.' Politeness concerned both the means of personal refinement and the techniques for displaying it to greatest effect.

As a finely modulated repertoire of accomplishments – as a sort of performance that covered every aspect of appearance – politeness was as much concerned with the audience as with the actor. Using what Steele called 'the language of looks and glances', politeness needed spectators. Polite commentary was saturated with this concern: the female countenance 'never escaped an observing eye'; gentlemen were told that it was 'a just Rule to keep your Desires, your Words, your Actions, within the Regard your Friends have for you'. Politeness was about creating 'an admirable effect': the desire to please and to be admired was a prime motive. As Addison pointed out in the *Spectator* No. 73: 'however unreasonable and absurd this Passion for Admiration may appear in such a Creature as Man, it is not wholly to be discouraged, since it often produces very good Effects.'

The accomplishments that were admired had to be cultivated. Though they were often described as 'natural', they could only be acquired through education and be polished through habit. Musicians, painters and *littérateurs* were all recruited in the battle to shape the polite amateur. The instruction offered by dancing masters extended far beyond the steps required to dance at a fashionable ball. They taught comportment and manners, prescribing the placing and movement of hands, legs and wrist, the proper way to sit and walk, as well as gestures of greeting, thanks and complaisance towards people of every rank and station. Music teachers taught singing and keyboard instruments to young women, and singing, wind and stringed instruments to young men. A host of artists taught sketching, drawing and later watercolour painting (fig. 44). A growing body of manuals and works of general instruction told polite people what and how to read, both silently and aloud, and how to write elegantly, particularly when composing letters (fig. 45).

Still, the literature of politeness emphasized self-fashioning more than the instruction of experts. Above all, keeping a journal or diary, which

45. The epitome of an accomplished aristocratic household. *Children
of Henry Dundas, 1st Viscount Melville* by David Allan, *c.* 1783

Addison explicitly recommended, was the most important means by
which refinement might be cultivated. To write and read one's own
journal was to be a spectator of oneself. Such self-consciousness, a form
of self-examination that looked at appearances as well as the inner self,
helped shape a polite person. Today, reading these journals puts us in
the place of the eighteenth-century spectator, lets us see how their authors
– Anna Larpent, James Boswell, John Marsh and even John Yeoman –
reflected on their experiences and learned by them. Like any form of
politeness, the exchange between the author and his diary was seen as a
conversation. 'I love this conversation with myself', wrote Anna Larpent,
while the novelist Frances Burney called her journal 'My Life and
Opinions Addressed to Myself'.

Journals recording their authors' efforts to achieve good taste and
refinement were part of a tradition that valued, as never before, the
motives and opinions of ordinary individuals who were not statesmen,
courtiers, notorious murderers or virtuous saints. They marked an aston-
ishing incorporation of private life and personal reflection into the public
picture of the times, a sense that much that was valuable could be learned
by the exposure of the inner self and private sentiment to public view.

As Roger North, a Tory lawyer, autobiographer and chronicler of the lives of his three brothers, put it:

> The history of private lives adapted to the perusal of common men, is more beneficial (generally) than the most solemn register of ages, and nations, or the acts and monuments of famed governors, statesmen, prelates, or generals of armies. The gross reason is, because the latter contain little if any thing, comparate or applicable to instruct a private economy, or tending to make a man either wiser or more cautelous [sic], in his own proper concerns.

North advocated keeping a journal for the benefit of both kin and posterity:

> Whoever hath in mind either his family, or the public should profit by his example, and would be known to posterity truly as he was, ought to keep a journal of all the incidents that might afford useful remarks upon the course of his life; for the aid and encouragement of such a journal would engage a good pen to work fairly upon it, and draw his picture well, which otherwise could not be reasonably attempted.

For North, as for many later journal-keepers and biographers, ordinary lives mattered. They were illuminating and instructive. Recording one's life was not only justifiable but desirable.

Of course, seventeenth-century Protestants – Anglicans and Dissenters – had kept journals as a means of soul-searching and self-examination, setting down the details of everyday life to see whether they were worthy of salvation. And seventeenth-century biographers had invoked the authority of the classical historian Plutarch to justify the inclusion of intimate details and private actions in understanding their subjects, who were always public figures. Protestant accounts looked on the material and social world, the world of taste and the senses, as subordinate to questions of faith, conversion and salvation. A moral struggle between the forces of darkness and light, between the depraved body and the religious spirit, overshadowed all else; what mattered was universal truth, not the particulars of everyday life. In this they differed fundamentally from the later, polite journals, which were meticulous in their daily detail because reflection on the social world was seen as a way of better understanding oneself. Classical biography was not concerned, like the polite journal, with the private lives of ordinary men and women. At bottom

one tradition offered the story of an immutable Christian soul, the other a public account of a few great men. The new biographies and journals were accounts of the pursuit of a better life as a matter of self-explanation and understanding, not the interrogation of the soul before the divine inquisitor, or the pursuit of civic and political virtue.

An eighteenth-century journal describes personal feelings. The story it tells is of someone seeking to understand culture and trying to develop his own taste. Journals are not catalogues of events – though the impulse to write long lists is certainly present – but stories of struggles for refinement, of efforts to live a richer, better life through appreciation of the arts and imaginative literature. Every account has a hero or heroine, who is the author, seeking to fashion him- or herself as a cultured person.

These personal diaries collapse the distinction between active artist and passive audience, and became literary works in their own right. Though somewhat similar journals and autobiographies existed in earlier periods, they were newly abundant in the eighteenth century. Literary biographies and memoirs, autobiographies and volumes of correspondence all revealed, to an unprecedented degree, the desire to shape a person's identity around ideals of politeness, taste and refinement, while their publication showed how fascinated the public was with the lives of men and women of taste. Boswell's *Life of Johnson* was only the summit of a large biographical and autobiographical mountain.

The opening pages of Edward Gibbon's *Memoirs of My Life and Writings*, begun in Lausanne in 1788 or 1789, epitomize this admiration for the personal portrait as well as the public works of literary figures:

> Such portraits are often the most interesting, and sometimes the only interesting parts of their writings; and, if they be sincere, we seldom complain of the minuteness or prolixity of these personal memorials. The lives of Pliny, of Petrarch, and of Erasmus, are expressed in the epistles which they themselves have given to the world. The essays of Montaigne and Sir William Temple bring us home to the houses and bosoms of the authors: we smile without contempt at the headstrong passions of Benvenuto Cellini, and the gay follies of Colley Cibber. The confessions of St. Austin [sic] and Rousseau disclose the secrets of the human heart: the commentaries of the learned Huet have survived his evangelical demonstration; and the memoirs of Goldoni are more truly dramatic than his Italian comedies.

Frequently diaries and journals were ambiguous about their audience. Like Gibbon's own memoir, they sometimes claimed to be purely for their author's edification ('My own amusement is my motive'); often they recorded the desire to instruct members of their family; and occasionally they admitted the wish to reach a larger public – within a few pages of his modest disclaimer Gibbon was addressing posterity. So the writing of such works was neither fully public nor completely private. They recorded both a public cultural repertoire and a cultured private self, and the conversation between these two was what mattered.

Politeness created a complete system of manners and conduct based on the arts of conversation. It placed the arts and imaginative literature at the centre of its aim to produce people of taste and morality because they were considered the means of achieving a polite and virtuous character. Traditional Christian works saw life as a journey, a passage from this world to the next, observed by God; politeness represented the world as a theatre in which one was obliged to perform before one's fellow men.

But 'the art of pleasing in conversation' created great tensions. Politeness required a remarkable degree of self-discipline. As the author of *An Essay on Polite Behaviour* (1740) wrote: 'It requires the Conjunction almost of all Virtues to be *polite* and *complaisant*. A Man must be Master of Himself, and his Words, Gestures and his Passions, that nothing offensive may escape him, to give others just occasion to Complain of his Proceedings.' Similarly he must learn to control his response to others, 'to hear disagreeable things without any visible tokens of offence or displeasure . . . to hear pleasurable things without bursts of joy and frantic distortions of the face.' Eighteenth-century journals and diaries testify to these terrible pressures of performance. Anna Larpent upbraided herself repeatedly: 'One must conform to the World,' she wrote, 'let me hit the Medium, neither be too forward, nor too reserved nor too goodhumoured; but cautious and prudent, chearful and easy, know when to show a proper contempt & when to hide it; when to encourage and when to avoid.' She struggled to accommodate her own desires to the demands of polite society: 'I will do everything with the intention of doing right. I will endeavour to please all. Converse with the men unaffectedly without flirting – with the women with good humour and complaisance, attention and kindness.' As she uneasily concluded, 'I must learn to dissimulate in this world.'

The requirement that polite people shape their feelings according to their effect on others created a profound anxiety about their identity. Was there some genuine interior self, or was one only an artifact of polite society? These questions worried the critics of politeness, but they also troubled some of its most eloquent advocates. In his published writings, few figures were more effective proponents of politeness than Lord Shaftesbury, but his private notebooks reveal a man haunted by the fear that his desire to please others would destroy his identity, that his exterior appearance would consume his inner self. Repeatedly returning to the question, 'Who am *I*?' he often concluded, 'I [may] indeed be said to be lost, or have lost My Self.' 'Resolve therefore', he wrote on another occasion, 'Never to forget *Thy Self.*' This feeling that the self was under siege – 'must not I . . . prostitute myself in the strangest manner, be a Hippocrite in the horridest degree? . . . why lay this stress on their good opinion Esteem' – could lead even the most polite aristocrat to condemn 'the affected smiles, the fashionable Bows, the Tone of Voice, all those supple carressing and ingratiating ways'.

Thus was the ideal of natural politeness haunted by the ghost of artifice. When books such as John Harris's *An Essay on Politeness* (1775) wanted to exorcize this spectre, they merely drew attention to it by their insistent denial of its presence: 'By politeness I do not mean a set of refined phrases, a certain number of postures and dispositions of the body, nor the manoeuvres of sly dissimulation, of affected bluntness, or implicit reverence, or impudent assiduity.' His words summon up the array of tutors, music, dancing and drawing masters – the battery of figures that surround the young rake in the second of Hogarth's prints of *The Rake's Progress* – whose task it was to mould the polite person's taste, knowledge, conversation and deportment, to create artificially a person at his social ease (fig. 46).

The tension between interior self and public persona, so often explored in imaginative literature, was embodied in the two figures of the rake and the fop. The first, usually a man and quite often an aristocrat, disguises his malevolent and predatory designs beneath a polished veneer of politeness. He uses the exterior forms of politeness for his own ends, which are usually sex or money, sometimes both in the form of an heiress. The fop, on the other hand, does not manipulate politeness but is manipulated by it because he equates exterior appearances with the whole man. Such characters on the London stage as Froth, Sir Novelty Fashion,

Lord Foppington, Faddle, Flutter and Fribble personify this lightness and emptiness and the vain preoccupation with the latest fashion.

People considered these matters of disguise and fashion, like politeness, as features of the city. The critique of politeness drew on this association to condemn it as deeply implicated in the luxury, deception and vice of urban life, in contrast to the simplicities associated with rural and provincial life. Critics of politeness, even when they came from the most fashionable and refined parts of London society, came to look on those outside the culture of display and public performance as less corrupt and potentially more refined and virtuous. The cultural values they embraced were not so much those of politeness as those of sentiment and sensibility.

Sentiment and sensibility were technical terms employed in medicine, philosophy and psychology, but from the mid-eighteenth century they were widely and loosely used to describe the expression of heightened,

46. *The Rake's Progress*, plate 2, *The Levée* by William Hogarth, 1735

intense human feelings, of a new sort of refinement. The terms were vague and did not yet have the derogatory connotation they acquired at the end of the century and which they retain today. In 1749 Lady Bradshaigh, one of Samuel Richardson's admirers, wrote to him, 'Pray, Sir, give me leave to ask you ... what, in your opinion, is the meaning of the word *sentimental?*' Answering her own question, she concluded that sentiment applied to 'everything clever and agreeable'. By the time that Sterne had published his *Sentimental Journey* (1768) and the first issue of the *Sentimental Magazine* (1773) had appeared, sentiment was firmly associated with moral and aesthetic refinement.

The key figures in this development were George Cheyne, a Scottish physician and pedlar of health cures whose numerous editions of *The English Malady; or a Treatise of Nervous Disorders*, first published in 1733, popularized scientific views of associationalist psychology and medical theories of 'nerves', and his patient, correspondent and friend Samuel Richardson, whose novels, especially *Clarissa* (1747–8), incorporated Cheyne's ideas in depicting nervous female characters of excessive sensibility. Together they put sentiment on the cultural map. Though sentiment and feeling had always been important in the polite idea of taste, from the mid-century they began to have a new prominence in the arts and criticism. The refined person was portrayed not so much as someone who was discerning but as someone who had an overwhelming, spontaneous emotional response to art, an idea that was to culminate in the Romantic view of art. Speaking of great artists and composers in the 1790s, the Scottish writer on taste Archibald Alison remarked, 'we feel the sublimity or beauty of their productions, when our imaginations are kindled by their power, when we lose ourselves amid the number of images that pass before our minds, and when we waken at last from this play of fancy, as from the charm of a romantic dream.'

Great works of art elicited a response through aesthetic and emotional intensity, but sentiment and sensibility, like politeness, were not confined to the arts. They were part of a larger vision, which saw human affections rather than reason or judgment as the basis of moral life, and which regarded people of greater sensitivity as morally more virtuous. Sentimental art and literature were always concerned with a moral as well as an aesthetic response; the one depended on the other.

Many of the ideals of sensibility seem to contrast with those of politeness – authenticity rather than show, spontaneous feeling rather

than artifice, private retreat rather than urban sociability, the virtues of humble rank rather than high station. They appear to stand in opposition to the values of polite London society. Thus the Scottish novelist and doctor Tobias Smollett responded to a warm letter from his cousin by praising his 'language of the Heart [which] I prefer to all the Flippery of Eloquence, to all the Bribes of Ostentation'. Certainly such ideals were taken up by people outside fashionable society to attack urban vice and to justify provincial and rural virtue; they made refinement available to the humble as much as to the modish or rich. The authors of sentimental literature were often of humble origins, like the printer Samuel Richardson, or from provincial society, like the Yorkshire cleric Laurence Sterne and the Edinburgh lawyer Henry Mackenzie, or were genteel women, like Lichfield's Anna Seward and her friends, the literary ladies of Llangollen, Lady Eleanor Butler and Miss Sarah Ponsonby, who lived lives of rustic isolation, intellectual refinement and ardent female friendship.

Yet criticism of fashionable society was one of fashionable society's features; members of the London aristocracy were as much affected by sensibility as provincial merchants and gentlefolk in York or Cornwall. One of the most famous and frequently republished sentimental poems, *A Prayer for Indifference* (1759), was written by Frances Greville, an aristocrat to whom Sheridan dedicated his play *The Critic* and whose life as a gay wit and fashionable beauty was the very antithesis of sensibility. For all the tensions between them, sentiment and politeness coexisted, not least in the breast of many a refined person. Even between the 1760s and 1790s, at the height of the rage for sensibility, the language of politeness was never abandoned.

The values of sentiment and sensibility were found in many literary and artistic forms. They were not confined to such novels as Richardson's *Clarissa* and *Sir Charles Grandison* (1753–4), Rousseau's *Julie, ou la Nouvelle Héloise*, published in 1761 and first translated into English in the same year, Laurence Sterne's best-seller, *Tristram Shandy*, whose nine volumes appeared between 1759 and 1767, and Henry Mackenzie's *The Man of Feeling* (1771); they were also to be found in poetry, much of it written by enthusiastic women amateurs like Anna Seward, in sentimental comedies like Richard Cumberland's *The Brothers* (1769) and *The West Indian* (1771), and in paintings and engravings of 'affecting moments', often the fainting or death of a heroine, in which artists like Angelika Kauffmann specialized (fig. 47 and plate 8).

Sentimental works wore their heart on their sleeve. They were passionately engaged and highly sententious, not witty or satirical but overtly committed to a cause. In Richardson's novels they advocated a conservative, pious Christianity which rejected the world of fashion and show. Sterne celebrated the astonishing variety and evanescence of human character and feeling, while poets explored the different sentiments provoked by the contemplation of nature and celebrated the pleasures of rustic simplicity, as did novelists like Frances Brooke in *The History of Lady Julia Mandeville*. Many works idealized a felicitous sentimental domesticity, a warm companionate union in which a loving husband was complemented by a natural mother. Others, such as Henry Brooke's *Fool of Quality* (1767), Thomas Day's *Sandford and Merton* (1783–9) and Elizabeth Inchbald's *Nature and Art* (1796), drew a contrast between vicious aristocrats and the virtuous simplicities of the poor. Sentimental poems supported prison reform, the rescue of penitent prostitutes, the

47. *Andromache Mourning the Ashes of Hector*, by Angelika Kauffmann, engraved by Thomas Burke, 1772

abolition of slavery and the protection of animals and children from cruelty.

For all its different concerns, sentimental literature contained themes that are in marked contrast to those of politeness. Sentiment was a spontaneous emotion, a feeling whose value did not depend upon its being observed by others. It came naturally from within, unlike the artifice and show of polite society. Behaviour intended to impress others rather than generated spontaneously was considered unnatural and artificial. Thus, while politeness emphasized forms of public presentation in the creation of refinement, sentiment stressed inner feeling. If the danger of politeness was that the public person would consume the inner self, sentimentalism threatened to absorb the outside world into a realm of inner feeling.

The key to sentiment was the human heart, the centre of emotional life, which is touched and moved and throbs constantly in sentimental literature. The poet William Collins, in his *Ode to Fear* (1746), displayed his 'throbbing heart'; Richardson said his fiction was designed to 'soften and mend the Heart' and wrote in *Sir Charles Grandison*, 'A feeling heart is a blessing that no one, who has it, would be without; and it is a moral security of innocence; since the heart that is able to partake of the distress of another, cannot wilfully give it.'

Sensibility stressed the importance of bodily sensation. Henry Mackenzie, the author of *The Man of Feeling*, distinguished *'the sentiments of the heart'* and *'The disquisitions of the head'* in a essay in the periodical the *Mirror*. One of Wordsworth's earliest works, a sonnet to the radical, Helen Maria Williams, was a veritable catalogue of bodily sensation:

> She wept. – Life's purple tide began to flow
> In languid streams through every thrilling vein;
> Dim were my swimming eyes – my pulse was slow,
> And my full heart was swell'd to dear delicious pain.

Such feeling, it was often emphasized, could not be expressed verbally. As Mackenzie put it in a verse composed by Harley, the hero of *The Man of Feeling*, on his love of sentiment:

> ... ne'er was apparell'd with art,
> On words it could never rely;
> It reign'd in the throb of my heart,
> It spoke in the glance of my eye.

Sentimental eloquence was a matter of sighs, tears and palpitations, not words.

While politeness was about making a figure in the world, about sociability in the town, sentiment was a retreat from the artificiality of 'the world' and its conventions. According to Mackenzie: 'There are some feelings which are perhaps too tender to be suffered by the world. The world is in general selfish, interested and unthinking.' The place of retreat and renewal varied – in Richardson it was found in an unworldly Christianity, in Sterne it lay in the inner self, while others placed it in the bosom of the family or in rustic retirement – but it was never present in the giddy round of city life. Archibald Alison's man of taste was not the man about town but someone 'who, from the noise and tumult of vulgar joy, often hasten[s] to retire to solitude and silence, where they may yield with security to ... illusions of Imagination'. The call of a contributor to the *Caledonian Mercury* of 1790 was often reiterated elsewhere:

> Retire, ye Wise! Retire from towns,
> To flow'ry lawns and verdant downs;
> Shun Dissipation's charms,
> Let Virtue, still, your hearts improve;
> And Beauty, Innocence, and Love,
> Shall bless your longing arms.

Indeed sentimentalism lay not only behind the cult of rural retreat – a preoccupation since classical antiquity – but behind a new cult of rude, wild and authentic nature which, as we shall see, put the margins of the nation – the Scottish Highlands and Welsh hills – at the centre of its taste.

The desire for a simpler life, often exemplified in the rustic peasant, was paralleled by the desire to end the complex hall of mirrors that made up the changing personality shaped by politeness, to achieve a greater degree of transparency in human relations. In *Tristram Shandy* Sterne speculates that if there were a *'glass* in the human breast ... nothing more would have been wanting, in order to have taken a man's character, but to have taken a chair and gone softly, as you would to a dioptrical bee-hive, and looked in, – view the soul stark naked.' Here there is no reflection, just unencumbered sight.

In its emphasis on the unadorned soul and naked human heart, and

in its deliberate overlooking of external appearances and the trappings of society, sensibility could appear quite democratic. It could not be bought or inherited like the fine equipage or the intellectual baggage of a fashionable gentleman. Indeed, there was some suggestion that, because of the artificial ways of polite society, rich and modish people were less likely to have pure and unsullied sentiments than their humbler and less fashionable counterparts. As the Bristol milkmaid-turned-poet Ann Yearsley put it in one of her verses,

> Does Education give the transport keen,
> Or swell your vaunted grief? No, Nature feels
> More poignant, undefended; hails with me
> The Pow'rs of Sensibility untaught.

In fact the literature of sensibility repeatedly pitted the rich and worldly against the poor, the marginal and those with 'finer feelings'. As in Goldsmith's enormously popular novel *The Vicar of Wakefield* (1766), such characters as the pious daughter, the idealistic rural clergyman, the innocent youth, the noble slave and the humble servant are held in thrall by aristocratic rakes, hard-hearted and money-grubbing parents, or skilled confidence tricksters. The weak are given exceptional powers of feeling; the strong had power.

From the very beginning women were seen as especially prone to sensibility. After the publication of Richardson's *Clarissa* in 1747–8 a large number of formulaic novels dwelt on the theme of female sensitivity and on a woman suffering for her heart-felt feelings. In Frances Sheridan's *The Memoirs of Miss Sidney Bidulph*, which Richardson helped to publish in 1761, Miss Bidulph is an 'angel who deserved the first monarch of the universe', but suffers from a domineering mother, an uncouth brother, repeated illness, the discrediting of her suitor, a reluctant marriage and abandonment by her husband. Boswell, like many of the novel's readers, praised its 'pious heroine who goes to her grave unrelieved, but resigned, and full of hope of "heaven's mercy"'. Johnson told the author, 'I know not, Madam, that you have the right, upon moral principles, to make your readers suffer so much.' In such novels the heroines were often placed in the extremes of distress and either died a noble sacrifice, followed their duty and married those they did not love or, when there was a happier resolution, were rescued by a chivalrous, though usually not aristocratic, man.

Such renderings of moral virtue under stress were enormously popular and were believed to appeal especially to a female audience. Hannah More's tragedy *Percy*, first staged in 1777, was typical of this sort of sentimental literature. Anna Larpent greatly admired it and recorded her response when the meek Elwina, forced to the altar, places duty before her heart:

> The story of Percy is simple, pathetic, distressing, 'tis worked up to the most moving height of distress; the power of virtue on the mind is well contrasted with the mad sway of passion. Elwina's is an almost perfect character . . . A pure love of virtue appearing throughout, & filling the virtuous heart with glowing pleasure – Though it ends horridly, yet it could have ended no otherwise consistently . . . the mind is thrown at once into too great a scene of woe . . . there is charming delicacy, and elevation of sentiment.

Much of the literature of sensibility contains many old Christian themes: the superficiality, pride and wickedness of the worldly is opposed to the humility, modesty and suffering of the truly virtuous, who are often poor, physically weak or less fortunate. The common image of redemption through selfless sacrifice, usually that of a woman, is redolent of the life of Christ, and in some novels women are also able to convert the wicked (usually men) through their example.

Yet every bit as important as these Christian themes is sincerity and its associated virtue, patriotism. Like the rich and vicious Tommy Merton in Thomas Day's *The History of Sandford and Merton* (1783–9), the villains in sentimental literature have usually adopted the vices of the court, which are those of the aristocracy and of the French. They are arbitrary and dissembling, tyrannical and cruel, rather than frank and fair, compassionate and understanding; they compose a concatenation of vices rather than feelings. In contrast we are offered an embodiment of Britain: men who are earnest and sincere, pious and Christian; women who believe in their natural duties rather than in public show. This did not preclude them from all the accomplishments associated with politeness but placed them under constraint. It subordinated the imperatives of politeness to Christian and patriotic concerns and, in so doing, rendered them more acceptable.

Sensibility was never without its critics – Henry Fielding in his satirical novel *Shamela* (1741) was one of the earliest – but it was finally

wrecked by the storms over the French Revolution. Its attachment to benevolence, sympathy and strong feeling was condemned by conservatives like Hannah More, Jane Austen and the *Anti-Jacobin*, by radicals like the young Coleridge, and by such feminists as Mary Wollstonecraft. For those who opposed the French Revolution sensibility smacked of an indiscriminate benevolence which encouraged delusive optimistic notions of human nature and levelling ideas of equality. Radicals also criticized sensibility as woolly-minded and egotistical. As Wollstonecraft tartly remarked, 'misery demands more than tears', while in *The Watchman* Coleridge saw sensibility, personified in the female reader, as an obstacle to true benevolence: 'She sips a beverage sweetened with human blood, even while she is weeping over the refined sorrows of Werther and Clementina. Sensibility is not Benevolence. Nay, by making us tremblingly alive to trifling misfortunes, it frequently prevents it and induces effeminate and cowardly selfishness.'

As in Coleridge's condemnation, the usual object of sensibility's critics was a woman who indulged or was controlled by feelings provoked by literature and romance. As we shall see, the ill-disciplined reader of novels, the giddy girl who loses all practical sense of the world because she is misled by the romantic tales of sensibility was a figure repeatedly invoked, satirized and attacked, not least because it was feared that such women were easily seduced and likely to lose their virtue. The heroines of sentimental literature, physically feeble to the point of sickness, so sensitive as to have little or no control over their powerful bodily impulses and, because of their weakness, devastatingly attractive to young men, were also disliked by such female critics as Hannah More and Mary Wollstonecraft. Each advocated a different sort of woman, constrained by either a Christian sense of duty or a political sense of virtue. Both feared the powerful feelings and violent appetites present in sensibility which were fully explored by a great admirer of Richardson's novels, the Marquis de Sade, in his tales of male erotic and sexual pleasure at female pain and distress.

By the 1790s what had once been a steady murmur of criticism about the widespread cult of sensibility had become a vociferous challenge to the very idea itself. Critics condemned sensibility as effeminate, vicious and foreign – Rousseau and Goethe were two of its best-known proponents – and sentimental ideals as self-indulgent and anti-social, threatening to the social and domestic order. Ironically, then, what had been

seen in the 1760s and 1770s as a patriotic assertion of sincerity against the affectation and foppery of politeness had, in turn, become associated with the unfettered feelings and desires which culture and the refined person were supposed to transcend. This should not surprise us. For any British culture, while it aspired to taste and refinement, was also inevitably going to include elements of sex and commerce, display and artifice, wealth and distinction, just as any theory of taste was always going to include sentiment and feeling. There were repeated attempts to exorcize these undesirable elements, to claim them as foreign and alien. But of course they were not. They were both what sustained British culture and what it had to deny.

II

PRINT

CHAPTER THREE

Authors, Publishers and
the Making of Literary Culture

SAMUEL RICHARDSON (1689–1761), printer, sometime publisher and best-selling novelist, is best remembered as the author of three extremely long epistolary novels – *Pamela* (1740), *Clarissa* (1747–8) and *Sir Charles Grandison* (1753–4) – which brought him international fame and fortune in his middle age (fig. 49). Somewhat improbably, this pious, sober and sententious man, who travelled little and could hardly have been more English, was inundated with praise from French *philosophes* and German critics. Denis Diderot, in his hyperbolic *Éloge de Richardson* (1761), compared Richardson to Moses, Homer, Euripides and Sophocles, composing the most effulgent of the many panegyrics which sprang from the European press.

Richardson rose to literary splendour from the humblest beginnings. The son of a rural joiner, he was able by dint of hard work, good luck and astute connections, to make a comfortable fortune in the printing trade. Even before fame was thrust upon him in the 1740s he had attained a prosperity that contrasted with the poverty of his youth. He was the beneficiary, as both printer and author, of the remarkable transformation in British publishing that occurred between the late seventeenth and late eighteenth centuries.

When Richardson published his first novel, *Pamela*, he was more than fifty years old; by then there were few byways of publishing he did not know. He had worked as a proof corrector and as a hack, writing prefaces and compiling indexes; he had printed newspapers and conduct books and won the lucrative contract to be official printer to the House of Commons. He had worked for booksellers and published books on his own account. From his presses had rolled not only the finely printed folio *Journals of the House of Commons*, weighty tomes that only a

49. *Samuel Richardson*
by Mason
Chamberlin, *c.* 1750

successful printer at the peak of his trade could produce, but also the ephemera – handbills, advertisements and trade cards – that earned the daily bread of the humble jobbing printer.

In his early years, when he had little capital or clout, Richardson was often hired by a bookseller to print part of a work. He was a craftsman for hire, a cog in the publishing machine. To act on his own behalf, to escape the control of the booksellers who dominated publishing, he had to take risks. Printing the work of such government opponents and Jacobites as Francis Atterbury, the banished former Bishop of London, and Philip, Duke of Wharton, the mad-cap rake and sometime drinking companion of the exiled Stuart Pretender, invited the hostility of the authorities and the threat of arrest; but it was also profitable and helped the young printer to make his mark.

But as Richardson prospered in the 1730s, he grew more prudent, avoiding controversy and diversifying his business to include newspapers and government work. He bought a share in the *Daily Gazetteer*, a

paper which he printed, and began the profitable business of printing parliamentary bills and reports, work that in its best year grossed him nearly £600. He also printed literary works, including James Thomson's famous poem *The Seasons* and several editions of Daniel Defoe's *Tour Through the Whole Island of Great Britain*, which he re-edited to include his own material.

Richardson's career as a printer followed the path laid down in his first published work, the advice book *The Apprentice's Vade Mecum: or, Young Man's Pocket Companion*: it took him by dint of industry and virtue from the margins of his trade to the centre of his profession. Like Hogarth's Tom Goodchild in *The Industrious and Idle Apprentice*, Richardson married his master's daughter; and though, unlike Tom, he never became Lord Mayor, he did achieve high office, being elected Master of the Company of Stationers in 1753.

Yet none of Richardson's experience and success prepared him for the remarkable chain of events that followed the publication of his first novel. *Pamela*, the moralistic story of a servant girl whose determined defence of her sexual virtue is rewarded by genteel marriage (fig. 50), was a runaway best-seller in 1740. Within a year of its appearance it had gone through five editions, been pirated and parodied, notably in Henry Fielding's *Shamela*, dramatized on the London stage by Henry Giffard and put into verse by George Bennett.

Pamela's popularity was not confined to Britain. North American editions appeared in New York, Philadelphia and Boston. The novel swept Europe, being translated into French, Italian, Dutch, German, Swedish, Russian, Spanish and Portuguese. Voltaire and the Italian dramatist Carlo Goldoni wrote plays based on *Pamela*'s plot. Today when we think of an eighteenth-century novelist we think of Daniel Defoe and Henry Fielding, perhaps of Tobias Smollett or Laurence Sterne; in eighteenth-century Europe the English novelist was almost synonymous with Samuel Richardson.

Richardson's second novel was also a blockbuster. *Clarissa* appeared in seven volumes, devoting more than a million words to the conflict between the rake Lovelace and the virtuous heroine Clarissa Harlowe, a struggle which ends with their deaths. It was not a book for plot lovers – as Dr Johnson remarked, 'if you would read Richardson for the story, your impatience would be so much fretted that you would hang yourself. But you must read him for the sentiment' – nor was it a quick read.

But *Clarissa* followed its predecessor on to the bookshelves of Europe, being translated into German, French, Russian, Italian and Portuguese.

The success of Richardson's first two novels lay in his portrayal of female virtue under duress. His growing band of admirers – which included a coterie of literary and genteel women – urged him to create a comparable male portrait. Richardson complied in his last novel, *Sir Charles Grandison*. Though *Grandison* never achieved the success of his earlier fiction, male virtue proving less popular than its female equivalent, the novel was such a hot publisher's item that copies of its sheets were stolen from Richardson's press and spirited off to Dublin; an Irish edition appeared before its author and printer had published his own in London.

Commercial though it was, Richardson's fiction took the high moral ground. As Aaron Hill, Richardson's friend and mentor, declaimed, 'Who could have dreamt, he should find, under the modest Disguise of *a Novel*, all the *Soul* of Religion, Good-Breeding, Discretion, Good-nature, Wit, Fancy, Fine Thought, and Morality.' Critics claimed, somewhat prematurely, that Richardson had made the novel respectable; ministers praised the moral message of his fiction. Such approval delighted Richardson, who regarded his novels as exemplary works and repeatedly revised them to ensure that they conveyed the 'right' message. He even produced a one-volume digest of the 'Moral and Instructive Sentiments, Maxims, Cautions, and Reflexions' in his novels 'with References to the Volume, and Page, both in Octavo and Twelves, in their respective Histories', for those readers unable or disinclined to read the eighteen volumes of his collected fiction or doubtful of their moral purpose. Never a man to leave a stone unturned, he was thus able to put his earlier experience as a compiler and indexer to good use.

The success of his epistolary fiction transformed Richardson from a prosperous printer into a literary lion. He was inundated with fan mail, flooded with suggestions for his plots, and deluged with praise and criticism. His circle of acquaintance grew to include the bluestockings Mrs Mary Delany, Hester Chapone and Elizabeth Carter. Dr Johnson became a good friend, who may have borrowed money from Richardson but more than paid back his debt in the hard currency of critical acclaim. Johnson repeatedly lauded Richardson at the expense of Henry Fielding – 'Sir, there is more knowledge of the heart in one letter of Richardson's, than in all "Tom Jones"' – and enshrined the novelist's prose in his

50. *The Marriage Ceremony Performed in Mr B's own Chappel (Pamela is Married)* by Joseph Highmore, engraved by Benoist, 1745

Dictionary, including ninety-seven citations from *Clarissa*, almost double that of any other work by a living author.

In the 1750s Richardson looked back on his life and proudly remarked, 'Twenty years ago I was the most obscure man in Great Britain, and now I am admitted to the company of the first characters of the Kingdom.' If he had chosen to travel, he would have also graced the drawing rooms of Europe. The publishing industry had served him well; when he died in 1761 he left an enviable literary legacy and a comfortable fortune of £14,000. Richardson liked to imagine that his success as printer and author was the result of his exceptional moral probity and ferocious industry. But it was also a sign of the remarkable transformation of the publishing business that had taken place in his lifetime and was to continue into the nineteenth century.

In 1689, the year of Richardson's birth and the first year after the Glorious Revolution had toppled James II, the English press was still far from

free. Controls, enshrined in the Licensing Act of 1662 and reinforced in
the new charter that the Stationers' Company had been granted in 1684,
were designed to ensure that the government could monitor publications
and that the Stationers' Company could maintain a monopoly of commer-
cial publishing throughout England. This compact between a government
anxious to suppress dissent and a guild determined to retain control of
the book trade was secured by three provisions that tightly bound the
press: prior government censorship of all publications; mandatory entry
of all published works in the Registers of the Stationers' Company; and
limitation of the printing trade to twenty master printers.

These restrictions were not new. Press licensing had been introduced
by Henry VIII; Queen Mary had granted the Stationers a monopoly of
printing; and William Whitgift, Elizabeth's Archbishop of Canterbury,
had fixed the number of legal presses. A hundred years after William
Caxton had begun printing in England in 1476, the chief means of
restraining the press were in place. The political and religious conflicts
of the seventeenth century ensured that they remained. The Licensing
Act of 1662 itself harked back to the first half of the century, reiterating
many of the provisions made in a 1637 decree for the regulation of the
press issued by the court of Star Chamber.

In the late sixteenth and early seventeenth centuries the London
booksellers, controlling the distribution of publications, had overtaken
printers as the dominant interest in the Stationers' Company. Their
collective ability to restrict or promote the circulation of books gave them
the whip hand. Increasingly they monopolized the copyrights (secured
by entry into the Stationers' Company Registers) to books in print. The
booksellers were a cautious body. Their chief concern was to secure the
intellectual property of the books they owned, a right protected by the
company's royal charter, and to retain lucrative publishing monopolies
conferred by the crown. They were not about to alienate the government
by publishing political dissent, religious heterodoxy or salacious gossip.
Jealous of their privileges and aware of how they depended on the crown,
they needed little encouragement to restrict the activities of the press.

But the balance of forces in the struggle between the regulators
and those who wished to open up the press shifted decisively in the
mid-seventeenth century. The civil wars and Interregnum saw the col-
lapse of regulation and a tremendous outpouring of polemical religious
and political literature. During the 1640s and 1650s the enormous demand

for controversial and ephemeral literature, together with the feebleness of controls, enabled the printers to bypass their rivals the booksellers, to expand production and increase their profits. New printshops were opened; the number of printers nearly trebled.

When Charles II returned in 1660, so did the old restraints. The booksellers were back in control. The number of master printers was restricted to twenty, just as the absolutist monarch Louis XIV limited Parisian printers to thirty-five; the number of journeymen was also fixed: fewer than 200 men were employed in the London printing trades. But the entrepreneurs of the Interregnum refused to fade away: they had established a means, through networks of hawkers and street sellers, to distribute topical and controversial literature. After 1660 illicit publishing was contained but not eradicated.

The lapse of the Licensing Act in 1695 – something of a legislative accident – finally removed the major legal constraints on the expansion of the press, but it did not entirely eliminate government control or create a completely free market. Censorship before publication ended, but laws against blasphemy, obscenity and seditious libel were frequently enforced. After 1707 it was a capital offence, for instance, to publish the claim that the exiled Stuart monarchs, the Jacobite Pretenders, were England's true monarchs. John Matthews was the last and only printer to go to the gallows for such an offence – he was executed in 1719 – but many offenders against the libel laws were harassed, arrested, prosecuted and put in the pillory. Thomas Gent, who worked for Samuel Richardson as a journeyman printer and had strong Jacobite sympathies (he helped the cleric Francis Clifton to print Jacobite propaganda from a press inside the King's Bench prison), was repeatedly threatened, arrested on general warrants (being dragged on at least one occasion from his bed) and tossed into gaol. The Treasury Solicitor, who handled libels for the government, could cause great hardship and difficulty to all members of the publishing business – from large booksellers to printers' devils and hack writers.

Numerous taxes, including duties on paper, printed matter and advertisements, created a system of fiscal regulation that could also be used against printers and publishers. And periodic though not very effective attempts were made to regulate the distribution of the press. In 1782,

for instance, hawkers and street vendors were prevented from hiring out newspapers rather than selling them, a common means of increasing their circulation. But with the lapse of the Licensing Act and the consequent end of the system that registered all printed material with the Stationers' Company, and in the absence of a registry of printing presses (not required until 1799 in reaction to the French Revolution), it was impossible for the government to exercise any systematic control of publishing. Sporadic intervention, no matter how heavy-handed, was not the same as continuous policing.

The effect of the lapse of the Licensing Act on the Stationer's Company was twofold. First, it lost its legal monopoly on printing and publication, so that the major obstruction to the growth of provincial printing was removed. Response in the provinces was swift: a few weeks after the act lapsed the Common Council of Bristol asked William Bonny to set up a press there; in the next few years printers began business in Shrewsbury (a centre of Welsh language printing), Exeter and Norwich.

At first the provincial printer-publishers did not compete with the London booksellers. Not until the last quarter of the eighteenth century did they print and publish books in any numbers. Before this they produced insubstantial material of only local interest: occasional sermons for distribution among clerics' patrons, friends and parishioners; polemical songs and short pamphlets; materials sparked by electoral contests; and town histories. Most provincial printers' work took the form of job printing – handbills, advertisements, legal and commercial forms – or of producing a local newspaper.

These provincial newspapers were a very important development in the history of publishing. By the 1730s almost every substantial provincial printer ran a paper; by mid-century their distribution networks were so extensive that most of England, much of Wales and the Scottish Lowlands were served by at least one provincial news sheet. As Dr Johnson ponderously remarked in 'The Idler', 'almost every large town has its weekly historian, who regularly circulates his periodical intelligence'. More pertinently the provincial press created an advertising network that linked London with the provinces.

This development, though originally opposed by the Stationers' Company, eventually came to benefit the London booksellers. The earliest provincial papers needed to be distributed not only in one town but throughout at least a county or two if they were to be profitable. To do

this printers got local newsagents, including most retail booksellers, to distribute their newspapers and accept advertisements. London publishers used this same system to advertise such works as Richardson's novels, and provincial networks ensured the swift and effective circulation of their books. By the 1730s enterprising members of the London trade like Edward Cave, founder of the best-selling *Gentleman's Magazine*, and Robert Walker, who specialized in producing cheap part-books (editions sold a few pages or a chapter at a time, distributed every week or month), were using their provincial contacts to help disseminate their publications throughout England.

The second consequence of the lapse of the Licensing Act was that it threatened the existing system of copyright, which was the linchpin of the London booksellers' power. In practice the bookseller usually purchased an author's copyright in return for backing its initial publication, the intellectual property being assigned 'from hand to hand for valuable considerations'. But between 1695 and 1709, when a Copyright Act came into force, there was no legal mechanism to enforce existing copyrights and no means to determine who held the copyright in new publications. This did not deter the booksellers from claiming, both before and after the Copyright Act (which conferred twenty-one years' copyright on existing imprints; fourteen years for a new work), that under common law the author or his assignee had a *perpetual* copyright. Until perpetual copyright was declared invalid by the House of Lords in the case of *Donaldson v. Beckett* in 1774, London booksellers claimed it, and threatened printers and publishers who violated their copyrights with suits in the court of Chancery. For part of the century, then, statutory and common-law copyright were at odds, the former being for a fixed term; the latter appearing perpetual.

This legal mess, finally resolved by the 1774 decision against perpetual copyright, damaged the entrenched interests of booksellers much less than it might have, since for years they had developed restrictive trade practices to protect themselves. Since they held most copyrights, they took steps to ensure that they kept them. Copyrights were sold, but only at auctions which members of the London trade were allowed to attend.

This lively trade in copyrights, which were often made 'the subjects of family settlements for the provision of wives and children', centred on auctions held at the Chapter Coffee House in Paternoster Square (fig. 51). Here, in the heartland of London publishing, close to St Paul's

51. *A Book Auction* by Thomas Rowlandson, *c.* 1805–15

Churchyard, members of the trade gathered for a pleasant day of eating, drinking and hard bidding that made copyright auctions a major event in the booksellers' calendar. Competition for the copyrights was fierce, but the atmosphere was clubbable and convivial. Interlopers were not welcome and were thrown out unceremoniously on the few occasions when they managed to sneak in. So there was no open market. The most successful authors were able to retain their own copyrights, a few provincial booksellers owned some, but the overwhelming majority remained in the hands of the powerful London publishers.

The decision against perpetual copyright in 1774, not the Copyright Act of 1709, finally broke up the London booksellers' control of the trade. Legally powerless to enforce perpetual copyright, they continued to use restrictive practices in an attempt to retain control of publishing. But, as we shall see, by the last quarter of the century Irish and Scottish booksellers, supported by provincial retailers, were sufficiently strong to challenge their monopoly, undercut their prices and open up the trade, inaugurating a new era in bookselling.

A single copyright was rarely sold in its entirety. Copyright shares were often as small as one forty-eighth; they could be as tiny as one one-hundred-and-twenty-eighth. At an auction of 1766, when Samuel Richardson's widow sold off some of her shares in his novels, one twenty-fourth share of *Clarissa* fetched £25, a similar share of *Sir Charles Grandison* reached £20, and one sixteenth of *Pamela* went for £18. A year later a further seven twenty-fourths in *Clarissa* were sold for a total of £172. These were exceptional prices for fiction copyrights and show the staying power of Richardson's novels, but they were no match for the prices of canonical works of literature. In 1767 *Clarissa* was worth £600; in the same year the copyright of Pope's *Works* was valued at an astonishing £4,400, Shakespeare at £1,800 and Addison and Steele's *Spectator* as a part-book at £1,300.

Copyrights were sometimes shared out even before a work appeared in print. Wholesale publishers formed partnerships, or 'congers', to share in the cost of printing new books, and in such arrangements each publisher received a fraction of the copyright, whose size varied according to the amount he had invested.

Splitting a copyright amongst a group of investors was a clever way of raising capital, especially for a large and lengthy project such as Dr Johnson's *Dictionary*, commissioned by five London booksellers, which took nine years to complete and which required a capital outlay of between £4,000 and £5,000. But it was also important in creating a collective interest in honouring the trade's copyright practices. The wide distribution of copyrights kept the London trade united and enabled it to retain control of the book trade even after its legal powers diminished. No London printer could survive without work from the booksellers; no bookseller could stay in business without selling books which his colleagues published; and provincial retailers depended on the London wholesale trade. Anyone who challenged the booksellers' notion of copyright did so at his peril; they risked commercial ostracism and faced being driven out of business.

The London booksellers' concern with copyright was part and parcel of their desire to protect the most valuable asset that the Stationers' Company owned, the so-called English Stock. This fund bankrolled the publication of several types of book over which the Stationers' Company, by virtue of a royal patent, had monopoly rights: almanacs, psalters, catechisms, ABCs and elementary schoolbooks. Their control was some-

what like the monopoly privileges held by the *libraries-imprimeurs* in Paris. Such bread-and-butter publishing was, as it is now, extremely lucrative. The Stationers' Company sold between 350,000 and 400,000 almanacs a year, and tens of thousands of ABCs and psalm books. One of the perquisites of membership in it was the right to purchase a share in this monopoly. As Samuel Richardson rose through the ranks of the company he acquired an ever-larger chunk of the monopoly, holding £320 worth of shares by the 1750s. The shares offered an exceptional return, paying an annual dividend of 12.5 per cent, more than twice what an investor would earn from the interest paid on government securities.

Other extremely profitable monopolies, granted by royal patent, occluded the open market by granting exclusive printing rights, or patents, to certain types of literature. Like the copyrights, these patents became tradeable commodities in the publishing market. In 1760, for instance, Richardson bought a half share in the so-called Law-Patent from Miss Catherine Lintot, the daughter of a famous bookseller named Henry Lintot, which conferred exclusive rights to print books dealing with the common and statute law. It cost Richardson more than £1,000, but its value was obvious: it provided a substantial and steady source of income from legal guides and textbooks, editions of case law and statutes at large.

Publishing patents survived into the nineteenth century, as did the English Stock, although the notion of perpetual copyright did not. The London booksellers lost their monopoly but kept their grip on the trade until it was loosened by a new class of provincial publishers at the turn of the eighteenth century.

How did they manage this after the lapse of the Licensing Act? First, though the booksellers remained dominant, the old physical controls, which limited the size and scope of the industry, were replaced by commercial controls enforced by the trade. Single booksellers could no longer limit the scope of publishing in order to retain their powers, so they ensured that they dominated its expansion. Secondly, the end of licensing meant the end of prior censorship, which enormously stimulated the sorts of publication – polemical pamphlets on topical controversies, newspapers, periodicals and printed ephemera – which had first flourished during the Civil Wars and Interregnum.

The growth of printing in both London and the provinces made this

new literature profitable. The print revolution happened as much despite the booksellers as because of them, but once it had occurred they were quick to see its benefits. They understood that the growth of an intricate web of communications linking printers and booksellers throughout England gave them ready access to a national market. After the 1730s, when this had become clear to even the dimmest members of the trade, the London booksellers devoted their efforts to keeping intruders, notably the Irish and Scots, out of their new territories.

With constraints and controls loosened, publishing expanded rapidly. When Richardson finished his apprenticeship and set himself up as a master in the 1720s there were already more than seventy-five master printers in London; at his death in 1761 more than 120 were at work, and their premises grew as their work and numbers expanded. Every large house needed a compositor, two pressmen and a corrector, but the bigger establishments employed many more journeymen. By the 1750s Richardson was using nine presses, employing about forty journeymen and training a number of young apprentices. His leading rivals such as the Scot William Strahan ran enterprises of a similar size.

Provincial printing shops, though they increased in number, were not so large. Printers of newspapers usually operated two presses – though John White, the printer of the *York Courant*, had three – and employed only a few additional hands. When one of the most successful provincial newspaper proprietors, Robert Goadby of Sherborne, in Dorset, died in 1778, his shop, which had produced the *Western Flying Post* for more than thirty years, consisted of three journeymen and an apprentice.

The proliferation of provincial presses was paralleled by a growth in provincial bookselling, as shops spread from the South of England to the new commercial centres in the Midlands and the North. When *Pamela* was published there were about 400 outlets in nearly 200 towns. By the 1790s there were nearly 1,000 firms in more than 300 places (fig. 52). Larger towns acquired an enviable range of printing and publishing services. By 1790 Newcastle upon Tyne had not only twenty printers, but twelve booksellers and stationers, thirteen bookbinders and three engravers, including a master of the art, Thomas Bewick, the subject of Chapter 12.

In the year of Richardson's birth printing and publishing had been a collection of trades, dominated by a powerful guild and confined to a few streets and lanes in the city of London. Printing presses clattered in

52. Tradecard: Thomas Burnham, bookseller, Northampton,
artist unknown

Aldersgate Street, Bartholomew Close, Whitefriars and St John's Lane;
book- and printsellers displayed their wares on stands and in shops that
clustered in Little Britain, around St Paul's Churchyard and near Temple
Bar; and trade publishers' premises were concentrated near Stationers'
Hall on Warwick Lane and Paternoster Row. Business thrived but was
confined to a community in which nearly everyone was personally
acquainted and in which a short walk was all that was necessary to
complete a deal.

Nearly 100 years later the publishing industry was so diverse, complex
and dispersed that the bookseller John Pendred brought out the first
guide to English publishing, *The London and Country Printers, Booksellers
and Stationers Vade Mecum* (1785). Pendred's world extends far beyond
the confines of St Paul's Churchyard and Paternoster Row. His account
of the metropolitan trade lists nearly 650 businesses engaged in thirty-two
different occupations. In this highly specialized world, stationers and
booksellers outnumbered printers (fig. 53), who were enumerated along-
side engravers, map-, music- and printsellers, bookbinders (fig. 54),
paper-, card- and board-makers, typefounders and warehousemen. Fancy
booksellers listed their premises in Oxford Street, Piccadilly, Berkeley
Square and on Pall Mall; engravers worked in the artists' quarter of

Covent Garden as well as in the fashionable West End, and printers and publishers were scattered all over the city.

But the most important part of the guide was concerned not with London at all but with the provinces. For one of Pendred's main purposes was to provide the London trade with valuable information about how to exploit provincial advertising and distribution networks. When he listed the forty-nine country newspapers printed in thirty-four towns, he gave two crucial pieces of information: the names of newspaper owners and the addresses of their London agents. Booksellers could thus place advertisements in the provincial press through London agents, or they could contact the proprietors directly in order to exploit the distribution network they had established. What had begun as a London trade had become a national business.

53. Tradecard: John Seagood, stationer and bookseller, *c.* 1731, artist unknown

54. Tradecard: James Fraser, bookbinder, artist unknown

The world of eighteenth-century publishing is best understood as an expanding maze or labyrinth, and it offered the potential author many entrances and numerous routes to eventual publication, each full of hazards, pitfalls and dead ends. Presided over by the Cerberus-like figure of the bookseller, the maze was not difficult to enter but easy to get lost in, and the author needed both guides and a map. Richardson was an exception, for he knew the ways of publishing intimately, could print his books himself, and had good working relations with the booksellers, notably John Osborn and Charles Rivington, whose request that he write a book of morally instructive letters was the inspiration for his first novel. But few authors were either so fortunate or so well informed.

Still, the number and variety of authors who embarked on the journey into print was quite remarkable. Aristocrats who wanted to publish their poems and obsessions, clerics bent on controversy and preferment, women poets, essayists and novelists from every rank of society, and persons of 'low means' all succeeded in reaching the reading public. Books by the likes of Horace Walpole and Lord Chesterfield were sold side by side with those by agricultural labourers such as Stephen Duck, the thresher poet, and Ann Yearsley, dubbed 'Lactilla', the 'poetical milkwoman of Bristol'. Joining Pope and Locke on the booksellers' stall and shelves were former servants like Jane Holt, a maid of the Recorder of Oxford, whose books inspired her to write a tragedy first performed in London

in 1701; Robert Dodsley, a footman who wrote poems and plays and became a successful publisher; and Ignatius Sancho, the former slave and servant of the Duke of Montagu, who befriended the sculptor Joseph Nollekens, published poems and a tract on musical theory, and whose posthumous letters, printed for the benefit of his family, titillated London society in 1789 (fig. 55).

How did such a heterogeneous body of authors find their way into print? The crucial vehicle was the periodical press. Any aspiring author seeking fame, fortune or just the pleasure of seeing their words in print could send their work to a magazine proprietor, and many a career began with such an unsolicited contribution. Elizabeth Rowe, who became a successful author of pious verse much admired by Protestant Nonconformists, had her earliest poems published anonymously in John Dunton's *Athenian Mercury* in the 1690s. Lady Wortley Montagu's first publication was an essay in Addison and Steele's *Spectator*. And *Felix Farley's Bristol*

55. *Ignatius Sancho* by Thomas Gainsborough, engraved by Francesco Bartolozzi, 1781

Journal was the means by which Thomas Chatterton launched his brief, tragic career as poet and forger of medieval documents.

The authors' circumstances could hardly have been more various. Some, like Lady Wortley Montagu, were in no need of remuneration and even looked askance at their own activities as authors, deeming the press a trifle vulgar and somewhat beneath them. (Adopting a common literary device, they could always draw the veil of anonymity over their identity or place the fig leaf of a pseudonym over their ambivalence.) For others, like Chatterton, the periodical press was a lifeline, filling an empty stomach and feeding vaunting literary ambition. What brought them all to the periodical press was the unparalleled opportunity it offered to get into print.

Periodical editors were conscious of their importance in creating a republic of authors, a world of temporary equality, in what was otherwise a highly stratified society. In an essay on what he called 'periodical performance', the proprietor of the *Bee*, an Edinburgh magazine that first appeared in the 1790s, emphasized the open character of his periodical: 'full liberty is given for every individual to become a writer when he feels a propensity to it, without any further limitation than good manners and becoming politeness requires.'

Periodicals also made possible a career dedicated solely to writing. Magazine proprietors were inundated with unsolicited material, some of which came gratis, and the growing competition among the magazines meant that the demand for material exceeded supply. The professional author stepped into the breach with essays, reviews, poems and criticism that enlivened and enlightened the public; publication enabled him to earn a living. By the 1760s he could contribute to more than thirty London periodicals; by the end of the century there were more than eighty (fig. 56).

Still, while journalism may have been the first refuge of a writer, it was a perilous and insecure career. More regular employment was best found either by producing a section of the magazine – in effect writing a regular column – or by acting for a bookseller as the literary editor of a periodical. Hence the frequent proposals and schemes of aspiring literary projectors. In November 1734 Edward Cave, proprietor of the *Gentleman's Magazine*, was sent such a plan by a failed provincial schoolmaster: the young Samuel Johnson offered to write a regular literary column, complete with 'poems, inscriptions &c. never printed before . . . likewise

56. Titlepage, *Gentleman's Magazine*, January 1780

The *Gentleman's Magazine*;

ST. JOHN's Gate.

London Gazette
Daily Advertiſer
Public Advertiſer
Gazetteer
Morning Poſt
Public Ledger
Gener. Advertiſer
St. James'sChron.
London Chron.
General Evening
Whitehall Even.
London Evening
Lloyd's Evening,
Mond.Wedn.Frid.
Oxford
Cambridge
Reading
Northampton
Birmingham 2
Bath 2 papers
Coventry
Briſtol 3
Hereford
Whitehaven
Derby 2
Southampton

Dublin 3
York 2 papers
Newcaſtle 3
Leeds 2
Edinburgh 5
Dumfries
Aberdeen
Glaſgow
Lewes
Sheffield
Shrewſbury
Wincheſter
Ipſwich
Norwich 2
Exeter 2
Glouceſter
Salisbury
Liverpool 2
Leiceſter
Worceſter
Stamford
Nottingham 2
Cheſter 2
Mancheſter 2
Canterbury 2
Chelmsford

For JANUARY, 1780.

CONTAINING

More in Quantity and greater Variety than any Book of the Kind and Price.

Average Prices of Corn throughout Engl. 2
Meteorological Diary of the Weather *ib.*
Debates in Parliament on the Motion for an
 Addreſs 3
The Addreſs, with the Amendment propoſed *ib.*
THEATRICAL REGISTER 9
Memoirs of the Life and gallant Actions of
 the late Earl of Briſtol 10
His Marriage and Separation *ib.*
Sufferings of Quakers further confidered 15
The Fort of Omoa deſcribed, with the Uſe
 that may be made of it 16
Curious Remark from Thorn's Chronicle *ib.*
Liſt of the Society of Antiquaries at their firſt
 Incorporation ; with a Liſt alſo of their
 firſt Council 17
Hunter's Account of the FREE MARTIN *ib.*
Queries in Heraldry farther diſcuſſed 19
Jeffreys' Latin Oration on the Marquis of
 Rockingham's taking his Degree of Maſter
 of Arts at Cambridge 20
Particulars relative to Robert Scot, a famous
 Bookſeller in Little Britain 20

Utility of Scot's Digeſt of the Laws for the
 Preſervation of the Public Roads 20
Remarks on the Tables of equal and apparent
 Time 21
Illuſtrations of Obſcurities in Shakſpeare *ib.*
Account of Mr. Maittaire's learned Publi-
 cations 23
Bearblock's Delineations of Oxford Colleges 24
T. Row's Definition of the Word *Bleak* *ib.*
Reflections on the Diſtreſſes of the Poor, il-
 luſtrated by a ſingular Inſtance 25
On the firſt Introduction of painting in Oil 26
Note of the Bathe Buſineſs about Parliament 27
Parable againſt Perſecution, addreſſed to the
 Proteſtant Aſſociation *ib.*
Prior's Solomon. Strictures on that Poem 28
Humourous Epiſtle (a literary Curioſity) *ib.*
On the Feſtivities of Shrove-Tueſday *ib.*
REVIEW OF BOOKS—Eden's Letters to Lord
 Carliſle—Biographia Britannica, &c. 29--36
Variety of ORIGINAL POEMS 37--40
HISTORICAL CHRONICLE 41
Liſts of Births, Marriages, Deaths, &c. 50

Enlarged with Four Pages of Letter Preſs extraordinary, on the important Occurrences of
the Times ; and embelliſhed with a correct Plan of the Harbour of OMOA, by Captain
SPEER, and a Plan of the Fortifications now erecting.

By *SYLVANUS URBAN*, Gent.

LONDON, Printed for D. HENRY, at ST. JOHN'S GATE.

short literary dissertations in Latin and English, critical remarks on authors, ancient or modern, forgotten poems that deserve revival, or loose pieces ... worth preserving'. Johnson ended his letter in the urgent and importunate tone one finds echoed in many letters from authors to booksellers: 'If such a correspondence will be agreeable to you, be pleased to inform me in two posts, what the conditions are on which you shall accept it ... If you engage in any literary projects besides this paper, I have other designs to impart, if I could be secure from having others reap the advantage of what I should hint.' Though in later years Johnson

became a regular and distinguished contributor to the *Gentleman's Magazine*, composing many of its reports of parliamentary debates, he had yet to arrive on the London literary scene. Cave rejected this proposal from an unknown provincial correspondent.

But Johnson's plan was plausible: booksellers were eager to employ writers to compose, compile and edit periodicals or compendia of every sort. When Robert Dodsley began to publish periodicals in the 1740s and 1750s, he negotiated a number of agreements with authors to superintend magazines through the press. In 1746 he paid the poet Mark Akenside £100 a year to write a fortnightly essay and 'an account of the most notable, recently published books in English, Latin, French and Italian' for the *Museum: or, Literary and Historical Register*. Akenside also had to assemble all the materials for each number of the magazine and to correct the printed sheets. Similar agreements were negotiated with the dramatist Edward Moore to produce the *World* and with Edmund Burke, Dodsley's most famous compiler, to compose the *Annual Register*.

By the middle of the century, in large part because of the expansion of this periodical press, a small but growing band of professional writers was established in London. These authors, personified in the shambling, eccentric but indomitable figure of Samuel Johnson, were still outnumbered by amateur and occasional writers from every walk of life, for the very circumstances that had made professional authorship possible had also enormously increased the number of dilettante writers in print. But the inconspicuousness of professional authors was not entirely attributable to their low numbers. They laboured under a more severe handicap, often suffered by new figures on the social landscape: they did not fit into prevailing ideas about how the literary world was constructed.

Fifty years earlier the tribe of authors had been conventionally divided into two radically different camps. There were those who wrote to edify, amuse and instruct but who shunned monetary reward and there were those who wrote for money. In the former view writing was a 'liberal' pursuit, the occupation of persons of enlarged views and unbiased vision. Writing for money not only reduced authorship to a mechanical trade but subverted the value of the work. Literature for profit could not be unsullied and unbiased; tainted with lucre, it became a hideous grotesque – distorted, partial and blind. In such a view all true authors aspired to the status of persons whose independent means freed their capacity for true

judgement. It was therefore extremely important to deny or conceal any mercenary motive, to disavow and despise the temptations of mammon.

This was easily accomplished if writers enjoyed wealth and leisure. When Horace Walpole, whose exquisite taste was matched only by his exquisite snobbery, turned author he tried to avoid the commercial world of publishing by setting up his own press. He published thirty-four books from Strawberry Hill, his gothic revival mansion near Twickenham. Not all came from his own pen. His imprint included works by a number of writers, including many of the poems of Thomas Gray. But the first priority of the Strawberry Hill Press was the publication of its owner's literary endeavours: the first English gothic novel, *The Castle of Otranto* (1764); his *Anecdotes of Painting in England* (1762); and his controversial and misinformed defence of Richard III, *Historic Doubts on the Life and Reign of Richard III* (1768). Walpole sometimes used booksellers to distribute his works but most were simply given away to friends. The son of a former prime minister, with a comfortable fortune kept padded by government sinecures, he had no need to enter the commercial maelstrom of Grub Street.

Other aristocrats lacked Walpole's enthusiasm for printer's devils, typesticks and black ink. Though they avoided his mildly eccentric practice of buying his own press (a genteel hobby that was not imitated by amateurs until the late nineteenth century), gentlemen poets and literati went to almost any lengths to avoid what they regarded as the vulgar taint of writing for money. When they asked a bookseller to publish one of their works, they refused any reward and, more often than not, supported the cost of publication themselves. Richardson's patron and admirer Aaron Hill, a gentleman who secured his financial independence by marrying an heiress, devoted his life to the pursuit of letters. A worthy and plodding character with a commendable admiration for aspiring talent, he helped young poets to find publishers, corresponded with Pope, wrote tragedies and treatises on the stage, edited literary periodicals and ran up large printing bills at Richardson's shop. His literary work was regarded by his contemporaries as, at best, mediocre and, at worst, without merit. If he had written to live he would have starved. But as a man of means he could cut a reputable figure in the republic of letters.

Contemporaries contrasted the genteel camp of 'liberal' writers, populated by men and women of large vision and good taste, with what they saw as the squalid and impecunious quarters inhabited by authors of

partial vision, venal aspiration and grovelling subordination. In this view there was no intermediate niche between the liberal author and the Grub Street hack (fig. 57). The sad station of the petty writer is nowhere better described than in Johnson's *Rambler*:

> drudges of the pen, the manufacturers of literature . . . [these men and women] have set up for authors, either with or without regular initiation, and, like other artificers, have no other care than to deliver their tale of wares at the stated time . . . [They] have been too long hackneyed in the ways of men to indulge the chimerical ambition of immortality. They have seldom any claim to the trade of writing but that they have tried some other without success. They perceive no particular summons to composition except the sound of the clock. They have no other rule than the law or the fashion of admitting their thoughts or rejecting them. And about the opinion of posterity they have little solicitude, for their productions are seldom intended to remain in the world for longer than a week.

Johnson's half-sympathetic portrayal – he knew well the pains of the literary drudge – captures the qualities that enabled Pope to condemn Grub Street as the site of literary dullness. The hack lacks independence of thought and freedom to shape his work; 'the writer has not always the choice of his subject,' commented Johnson, 'but is compelled to accept any task that is thrown before him.' Writing prefaces, rewriting the work of others, translation, compilation, reviewing, abridging: this bread-and-butter work was necessary to all but a tiny minority of successful authors if they were to survive.

Many figures who reached the empyrean started in the gutter. Oliver Goldsmith, for instance, served his literary apprenticeship in a Gradgrindian workshop. He arrived in London as a penniless physician and began his literary career by churning out reviews for Ralph Griffiths's periodical the *Monthly Review*. He enjoyed some success as a journalist, but his fluctuating income, extravagant ways and financial ineptitude meant that he was haunted by the spectre of poverty. Frequent contributions to a variety of magazines, including the *Busy Body*, the *Bee*, the *Critical Review*, the *Ladies Magazine*, the *London Magazine* and the *Public Ledger*, were not enough to dispel the bailiffs and the prospect of debtors' prison. Goldsmith's parlous finances led him into every byway of authorship – into biography, translations, abridgements of

57. *A Grub Street Poet*
(detail) by Thomas
Rowlandson

such classics as Plutarch, and pastiche histories of England, Greece
and Rome.

Commentators considered these authors as shackled and imprisoned
by their trade. As James Ralph put it in his eloquent defence in 1758,
'there is no Difference between the Writer in his Garret, and the Slave
in his Mines; but that the former has his Situation in the Air, and the
latter in the Bowels of the Earth: Both have their Tasks assigned them
alike: Both must drudge *and* Starve; neither can hope for Deliverance.
The compiler must compile; the Composer must compose on; sick
or well; in spirit or out.' Hack work provided only enough to avoid

destitution. Pay was poor. A reviewer at mid-century, for example, would receive a standard fee of two guineas for writing eighty pages of reviews.

Pastiche, the periodical and compilation of every sort created publications whose parts were produced by writers but whose whole belonged to a bookseller. Their design was formed not by the literary inspiration of the fellow who scribbled the copy but by the publisher's sense of the market. Without means and control, the writer became a manufacturer of components in a factory of literature. Goldsmith described this specialization in the first number of his periodical the *Bee*: 'One writer . . . excels at a plan or a title page, another works away the body of the book, and a third is a dab at an index.' In such circumstances a text did not have an author; it was an artifact of literary production.

Such fragmentation undermined the integrity of the writer, who bore a marginal relation to the works which he helped to produce. What he wrote was not properly his: it was designed by another and had value only as part of a larger whole. He had no vested interest in a work, for it was not a thing he could or might wish to acknowledge as his own. The writer was not *the author* but a protean figure whose value lay in his ability to assume a number of authorial roles. This distance between writer and text was not conducive to honesty. In a publishing world where pirated editions, deliberate misattribution and outright literary theft were not unknown, the writer could benefit from literary disguise. Richard Savage's account of working for the notorious bookseller Edmund Curll shows how far the disintegration of authorial personality and integrity could go in a literary system devoted to mammon: 'Sometimes I was Mr. John Gay, at others Burnet or Addison; I abridged histories and travels, translated from the French what they never wrote, and was expert in finding new titles for old books. I was the Plutarch [i.e. biographer] of the notorious thief.'

It took time for Goldsmith to escape the servitude of the hack. In his first eight years in London he produced an enormous body of literature for the booksellers, but it was not until 1764, when he published his poem *The Traveller*, that his name appeared on a title page. And only after the publication of his sentimental novel *The Vicar of Wakefield* in 1766 did he begin to achieve authorial independence. The wounds inflicted in this struggle for recognition remained with Goldsmith throughout his life. They explain his sensitivity to the smallest slight and the absurd vaingloriousness that so exasperated his friends. They also

account for his ambivalence towards the literary world. At times he could be as hard-nosed as the toughest hack – 'I consider an author's literary reputation to be alive only while his name will insure a good price for his copy from the booksellers.' On other occasions he condemned himself out of his own mouth, denouncing the Grub Street scribbler: 'the author who draws his quill merely to take a purse, no more deserves success than he who presents a pistol.'

In offering these two versions of the writer, as a slave to the market and as an author above commerce, Goldsmith showed himself a traditionalist, aware of the inadequacy of the conventional categories but reluctant to abandon them. He was not willing to redefine the realm of letters in order to create a place for a professional writer like himself.

But how was this to be done? How was the author to escape the double-bind which James Ralph so clearly identified? The author's dilemma, Ralph pointed out, was that he was damned if he did take the money, and poor if he didn't:

> A Man may plead for Money, prescribe or quack for Money, preach and pray for Money, marry for Money, fight for Money, do any thing within the Law for Money, provided the Expedient answers, without the least imputation.
>
> But if he writes like one inspired from Heaven, and writes for Money, the Man of *Touch*, in the right of *Midas* his great Ancestor, enters his Caveat against him as a Man of *Taste*; declares the two Provinces to be incompatible; that he who aims at Praise ought to be starved; and that there ought to be so much draw-back upon Character for Every Acquisition in Coin . . . [The author] is laugh'd at if poor; if, to avoid that curse, he endeavours to turn his Wit to Profit, he is branded as a Mercenary.

Ralph's dyspeptic diatribe against professions that purported to be liberal but that were tainted with mammon reveals his frustration; he has no alternative vision that would place the professional author in a new setting. How could the writer be paid but respectable? This was the essential question.

The answer was slow in formulation and grew out of two related debates, one about artistic value, the other about intellectual property. The former focused on the high-minded issue of creativity, the latter on the prosaic question of copyright; both helped to formulate and clarify

the notion of the author as creator of a unique property which he owned by virtue of a singular, imaginative act.

The liberal criterion of what made authorship legitimate was social. Financial independence, the eighteenth-century equivalent of Virginia Woolf's '£500 a year and a room of one's own', produced good writing; the marketplace produced trash. Against this claim, Johnson and his allies argued that the ability to produce valuable literature was not determined by economic conditions but was rather a matter of individual ingenuity and originality. Literature was less a matter of uncovering and revealing traditional 'natural' truths than of creating an original – that is, new – literary artifact. This emphasis on creativity was not novel – it can be found in the work of the classical critic Longinus, and the notion of originality had a long history. But the association of creative genius with originality had never before been made so forcefully. 'The highest praise of genius', wrote Johnson in his *Life of Milton*, 'is original invention.'

Originality distinguished the true author from the hack. Both might be paid, both embark on projects suggested and financed by booksellers, like most of Johnson's major works, but an author had creative powers that the compiler and pastiche writer lacked. Above 'the drudges of the pen' and the 'manufacturers of literature' Johnson identified the few who 'can be said to produce, or endeavour to produce, new ideas, to extend any principle of science, or gratify the imagination with any uncommon train of images or contexture of events'.

The emphasis on originality and novelty, introducing as it did a new hierarchy of literary endeavour, underscored the special relationship that the author bore to his text. If a work was original it was also unique, the distinctive consequence of a writer's imagination. Each text bore the distinctive impress of its author's mind. In emphasizing the singularity of literary work, writers like Johnson threw the personality and character of the author into sharp relief. Literary criticism became more than an assessment of a work's conformity to a set of conventions and rules; it also set out to show how each individual author shaped a particular work.

Literary biography acquired a special status. In this, as in so many other respects, Johnson was a key figure. Though by no means the first literary biographer, in his *Lives of the Poets* he produced one of the most important works of eighteenth-century criticism. 'The biographical part

of literature', he commented, 'is what I love most.' There is no better epitaph for an author whose own life was the subject of a magisterial biography. As James Boswell's *Life* demonstrates, the author – or, at least, some authors – had become the object of public fascination. Their private affairs, temperament, leisure hours and foibles were of interest not in a trivial and prurient way (though prurience should never be underestimated where Boswell is concerned) but because they helped to explain the singular nature of the author's work. Johnson was the perfect subject for a literary biography because he had an exceptionally strong personality and such an eccentric demeanour. No doubt this is why Boswell, Mrs Piozzi and others so fiercely contested the right to memorialize him. (As Burke remarked to the bluestocking Hannah More, 'How many maggots have crawled out of that great body!') Johnson could personify the professional author because he seemed so conspicuously unique, an original who produced original masterpieces. The several biographies of Johnson were every bit as important as Johnson's own work in identifying him as the typical modern author. Though he was one of many writers, he stood out not just because of his work but because he could be commemorated as an exemplary figure, whose biographers offered a model life, which included personal weaknesses as well as strengths to which other writers could aspire.

By the late eighteenth century the professional author, the creator of unique works of literature, had become a recognizable type, distinguishable from both the liberal writer and the hack. His creativity not only shaped what he wrote but conferred on him a public authority to explain how it should be interpreted and how it differed from earlier writing. As in Johnson's case, the creative author was inclined to become the historical critic, concerned to reveal literary tradition in order to establish his own place in literary history.

Even if the author fabricated and fashioned literary works, there was still the question of what right he had to own them. It is one of the great ironies of this period that the establishment of an author's rights in his literary property should have been achieved largely with the help of his old enemy, the bookseller.

As we have seen, London publishers and booksellers wanted a form of *perpetual* copyright; for any given work, they wanted to keep the right to sell it in perpetuity, or to sell the right to sell it – including the likes of Shakespeare, Milton and Richardson. The booksellers rooted their

claim for perpetual copyright in the author's work, not because of an altruistic regard for writers (whose copyrights, after all, they snaffled up with indecent haste), or in order to screen their monopolistic interests behind the hapless figure of the individual writer, but because the author's property claims to his work seemed especially compelling. He had used his mental labour to create it and, having made it, was entitled to claim it as his own. The author's property right was based not on physical possession of the work or because he 'occupied' it as one might a house, but on the grounds that it was the product of his own literary labour. In Johnson's words, an author had 'a stronger right of property than that of occupancy; a metaphysical right, a right, as it were, of creation'. The literary argument about originality reinforced the commercial claim for ownership. Such a property right, the booksellers argued, was perpetual. An author could sell it, booksellers could trade in it, but it could not be alienated.

The booksellers' claims on behalf of authors were repeatedly challenged, both by the 1709 Copyright Act, which limited copyrights to a fixed number of years, and through litigation which culminated in *Donaldson v. Beckett*, whose decision did away permanently with perpetual copyright. The chief objections to perpetual copyright were twofold. It was argued first that perpetual copyright created a monopoly power. Playing on the longstanding hostility to special privileges and monopolies conferred by the crown – most of which had been abolished after the Glorious Revolution – opponents of perpetual copyright argued that it conflicted with a public interest in the free circulation of knowledge and information. Public good should abridge private privilege. This argument was all the more persuasive because everyone knew that the London booksellers were desperately trying to conserve their monopoly.

Secondly, it was said that a literary work could not be held as property because it was not a thing but a set of ideas, over which no one person could assert his rights. A book was therefore analogous to a mechanical invention and, like an invention, might be patented for a number of years but could not be held permanently. As one commentator put it: 'A literary Composition is *an Assemblage of Ideas* [my emphasis] so judiciously arranged as to enforce some one Truth, lay open some one Discovery, or exhibit some one Species of mental Improvement. A mechanic Invention, and a literary Composition, exactly agree in Point of Similarity.'

This version of literary composition aptly describes much of the scissors-and-paste work that comprised so much literary production. It did not cut much ice with the booksellers, however, who chose to ignore much for which they were responsible. Instead, they and their supporters responded by maintaining that literary activity was different in kind from mechanical ingenuity because it was purely mental. And, in order to counteract the view that literary composition was a form of concept assembly, they emphasized the importance not of ideas or content but of 'style and sentiment'. Focus was placed on the *manner* in which literary works were created. Two authors might use the same ideas, deploy the same material, but each would do so in a unique way. We see here once again the notion that we have already encountered in the debate about literary value: that what makes a literary work singular and original is its author's creativity, the impress of individual character or personality upon the text.

The booksellers' case corroborated and converged with the view of those who defined the professional author as the imaginative creator of literary work, and it linked conceptions of authorship with notions of literary proprietorship. But the fit was far from perfect. A tension existed between the ostensibly egalitarian impulse which gave all literary creators a right in their works because they produced them, and the aesthetic concern to use creativity as a means to distinguish good work from bad, the true author from the hack: all scribblers are equal but some, namely authors, are more equal than others.

The debates about literary creativity and intellectual property seem to have been conducted in an abstract world in which the author and the literary work flourished in snug, isolated symbiosis. Stripped of its social context, without the embarrassing presence of publishers, editors, compositors, printers and booksellers (not to mention literary rivals), literary production was given the pristine appearance of a heroic aesthetic struggle by an author to create a text.

But literary practice was a far messier business. Literary skill and financial independence were often a poor match, and the line between the author and the hack was exceptionally difficult to draw. More often than not today's hack was tomorrow's author. The circumstances that affected a book's commission, submission, publication and reception could not be reduced to a simple question of quality. Johnson, whom we think of as a man of strong and firmly held beliefs, confident in his ability to

discriminate and judge, was nevertheless painfully aware of the fragile position of the author and the volatility of public taste, the vagaries of Grub Street and the ease with which what Edward Young called 'the noble title of an *Author*' could be snatched away. 'No man,' he wrote, 'however high he may now stand, can be certain that he shall not be soon thrown down from his elevation by criticism or caprice.'

How then was a writer to be ennobled and how was he or she to retain the title? Establishing the legitimacy of the idea of professional authorship did not secure the careers and status of *individual* writers, which depended on how effectively each could exploit the resources and opportunities of the literary system. The author's first task was to seek entry into the labyrinth of publishing. Without the resources of a Horace Walpole and despite the opportunities afforded by the periodical press, the writer almost certainly needed to procure the services of a bookseller. Only such a commercial middleman had the resources necessary to produce and distribute books.

The first step to becoming an author was to find a publisher, an intimidating task best accomplished in person. Authors sought out publishers in the numerous booksellers' shops and offices that huddled in the shadow of St Paul's Cathedral and they took their manuscripts to the Chapter Coffee House in Paternoster Row, where many booksellers, stationers and printers carried on their business.

Confronting a bookseller directly was not possible for many provincial writers, of course. They had to use the postal service, choosing a bookseller, often with local advice, whose imprint they had seen in newspaper advertisements or on title pages. In 1759 Laurence Sterne, then an unknown cleric in York, sent his unsolicited manuscript of *Tristram Shandy* to Robert Dodsley, on the recommendation of John Hinxman, a local bookseller. His accompanying letter, with its grasshopper prose, is inimitable but typical in its anxiety to persuade the bookseller that the work had both literary merit and commercial value: 'If this 1st Volume has a run (wch. such Criticks as this Latitude affords say it can't fail of) We may both find our Account in it. – The Book will sell; – What other Merit it has, does not become me either to think or to say, – by all Accts. You are a much better Judge – the World however will fix the value for us both.' Dodsley was not convinced. He refused to pay the £50 that Sterne wanted for the copyright. Not for the first time *Tristram*'s entry into the world was thwarted.

Whether the writer approached a bookseller in person or solicited support through importunate correspondence, the author's reception was rarely warm, occasionally tepid and often cold. The arrogance and hauteur of the bookseller, brilliantly captured in Thomas Rowlandson's pen and wash drawing (fig. 58), was an authorial cliché and longstanding grievance. Still, Rowlandson's sneering bookseller, whose corpulent prosperity contrasts with the cringing emaciated figure of the imploring author, is a caricature. Though there were booksellers like Edmund Curll who abused their position and the writers they employed, most members of the trade were prudent, honest and conservative men of business who faced problems that many authors were eager to avoid. The bookseller bore the risk of publication and needed to make a profit. He was inundated with manuscripts, many of which lacked merit or commercial value. The sheer volume of material made it hard for him to discriminate, to pick out the work that would prove a success. He might claim, as James Ralph put it, to know 'best what Assortment of Wares will best suit the Market', but he knew that literary innovation was exceptionally chancy. It was much less risky to publish and trade

58. *The Bookseller and the Author* by Thomas Rowlandson, 1780–84

in the copyrights of established figures. Only the most adventurous booksellers preferred an unknown living author to a dead literary monument.

How, then, was the hapless writer to overcome the bookseller's reluctance to help him into print? One of the best stratagems was to appeal to the personal interests and sympathies of the publisher. Though Rowlandson, like many embittered authors, depicted booksellers as venal monsters and ruthless profit-seeking entrepreneurs, most held certain subjects and certain causes close to their heart. Jacob Tonson loved Whiggery and *belles-lettres*; John Wilkie admired conservative works on politics and religion; John Newbery and William Darton specialized in children's literature and Robert Dodsley in poetry. Authors needed to know booksellers. The more specialized or controversial the work, the more important it was to find the right publisher. John Millan would have been delighted to publish a manuscript on British antiquities that would have made most booksellers blanch, while the radical bookseller Joseph Johnson was willing to publish tracts that many others thought too hot to handle.

Such booksellers were intent not upon the ruthless maximization of profit but upon combining their cultural, social, religious and political interests with making a respectable living. They saw themselves, as Johnson, a man not prone to flattery, described them, as 'modern patrons of literature'. For though the historical cliché has emphasized their exploitation of authors, the historical record reveals many of them to have treated their clients and employers with a patience and charity which some writers barely deserved.

Reading the letters that Robert Dodsley received over a period of nearly thirty years, one is struck by the egotistical behaviour of authors, the exacting nature of their demands, and the ease with which they were provoked into discourtesy and open rudeness. Authors were condescending: 'I should be willing to have them [my works] pass through your hands'; absurdly vain: 'not only London, but every county in England is full of expectation; as it is the most unparalelled [sic] story, *founded on facts*, that appeared since the creation'; haughtily self-righteous: 'I am not a person to be bought and sold'; quick to rationalize failure: 'Be not discouraged at the moderate Demand for the first Part: A Work, even of true Merit, must have *time* to work its Way'; and peremptory: 'Be so good as to give me an answer in your next by return of the Post to the

following questions: what Number of my Books did you print? how many of 'em have you disposed of?'

Dodsley was besieged by requests for free or cheap copies of books and, from his provincial correspondents, for information on the London literary scene – 'If there is any thing extraordinary likely to appear this Winter in a literary Way, I should be glad to hear of it.' He was asked to pass on messages to friends, place advertisements in newspapers, collect packages and parcels, and provide literary intelligence, especially about the authorial identity of anonymous or pseudonymous works. When books failed he was blamed for neglect and commercial incompetence; when an author felt slighted, he reverted to clichéd abuse, what Dodsley called 'the uncharitable sneer on the morals of a Bookseller'.

Dodsley was not alone in suffering such abuse, though his origins as a footman may have made it easier for authors to treat him like a servant. But there is evidence in the dealings of other booksellers with authors to show that in literary quarrels the blame did not lie entirely with the publishers, many of whom were remarkably willing to tolerate authorial rudeness and misconduct.

Many booksellers were doubtless aware of the fragile status and insecure financial state of authors and made allowances accordingly. Some were more generous. They created literary salons and circles at which authors could satisfy their hunger and slake their thirst with good food, intoxicating drink and hearty conversation (fig. 59). The brothers Charles and Edward Dilly, whose firm published James Boswell's *Life of Johnson*, were famous for the literary dinners held at their shop in The Poultry and later at Charles's retirement home in Brunswick Row, Queen Square. Boswell and Johnson frequented the Dillys' shop; Oliver Goldsmith, the dramatist Richard Cumberland, and the radical scientist Joseph Priestley were among the guests at their table. At the end of the eighteenth century the bookseller John Nichols remembered the warmth and cheer spread by the brothers' liberality:

> Though neither of them had much pretensions to Literature, they were zealous in cultivating the friendship of the Literati ... To young and inexperienced authors, Mr. Charles Dilly in particular was a kind and faithful adviser; and to those who had occasion for it, his purse was at all times easy of access. The hospitable table, which Edward was famed for spreading, was continued by Charles – not with a prodigal, but with an unsparing hand. His parties were

> not large, but they were frequent; and in general so judiciously
> grouped, as to create a pleasantry of intercourse not often to be
> found in mixed companies. Here Johnson and Wilkes forgot the
> animosities of Whig and Tory. Here High Church Divines and
> Pillars of the Meeting House relinquished their Polemicks, and
> enjoyed uninterrupted conviviality ... Here many a writer of less
> eminence, after comfortably enjoying a mental and bodily repast,
> engaged in his allotted task with double pleasure, for the satisfaction
> he experienced from the liberality of his employer.

Though this retrospective account is suspiciously suffused with a senti-
mental glow, its plausibility is suggested by the philanthropic conduct of
other booksellers towards their authors. John Newbery kept Goldsmith
off the street and out of debtors' prison by paying his rent. Numerous
publishers advanced authors loans, helped to organize subscription
editions of their work, and tried to put their financial affairs in order.
The bookseller was first and foremost a businessman, but this did not
mean that he had no regard for authors and their works, any more than
the professional author had no regard for the content of his work as
long as it turned a profit. Both bookseller and author shared in the
balancing act between pecuniary reward and intellectual interest that
gave eighteenth-century publishing much of its energy. Yet the liberal
tradition of writing, which was so concerned to deny the legitimacy of
writing for money, died hard, even amongst those who became pro-
fessional authors. In their eyes the bookseller remained a dangerous and
dubious figure, essential to their livelihood but a constant reminder of
the pact they had made with mammon.

When the would-be author approached a bookseller he still needed
to allay the understandable anxieties of someone who knew how risky
it was to back a literary tyro. Reassurance took two forms. First, the
author could secure the support of someone whose critical acumen would
vouch for the value of the work and whose public endorsement would
help its sales. The best friend an aspiring author could have was someone
already experienced in the ways of Grub Street. For all the personal
rivalries and bitter quarrels that rent the community of authors, many
of their number heeded the advice of Johnson and of James Ralph that
writers should stand together, going to considerable lengths to help their
brother scribblers. Robert Dodsley's literary career began with the help
of Daniel Defoe; his first play, *The Toy Shop*, was recommended by none

59. *Thomas Payne, his Family and Friends* by Gerard van der Puyl, 1787. 'Honest' Thomas Payne (centre with spectacles) ran a literary coffee house at his shop in Mewsgate

other than Alexander Pope. Tobias Smollett, when he had achieved some financial security by editing the *Critical Review*, continued to support the hack writer Samuel Derrick, whom he had first employed as an amanuensis and to whose edition of poems he had subscribed in 1755. The flattering self-portrait that Smollett offers in *Humphry Clinker* shows how important he regarded such charity. The tribe of authors who dine at his table are all in his debt:

> One of them he bailed out of a spunging-house, and afterwards paid the debt: another he translated into his family, and clothed, when he was turned out half-naked from jail, in consequence of an Act for the relief of insolvent debtors: a third, who was reduced to a woolen night-cap, and lived upon sheep's trotters up three pair of stairs backward in Butcher Row, he took into present pay and free quarters, and enabled him to appear as a gentleman, without having the fear of sheriffs officers before his eyes. Those who are in distress he supplies with money when he has it, and with his

credit when he is out of cash. When they want business, he either finds employment for them in his own service, or recommends them to booksellers, to execute some project he has formed for their subsistence. They are always welcome to his table (which, though plain, is plentiful) and to his good offices, as far as they will go.

Dr Johnson showed similar generosity to his fellow authors. The story of his rescue of Goldsmith is famous. As Hester Piozzi, the former Mrs Thrale, recalled, Johnson was

> called abruptly from our house after dinner, and returning in about three hours, said, he had been engaged with an enraged author, whose landlady pressed him for payment within doors, while the bailiffs beset him without; that he was drinking himself drunk with Madeira to drown care, and fretting over a novel which when finished was to be his whole fortune; but he could not get it done for distraction, nor could he step out of doors to offer it for sale. Mr. Johnson therefore set away the bottle, and went to the bookseller, recommending the performance, and desiring some immediate relief; which when he brought back to the writer, he called the woman of the house directly to partake of punch, and pass their time in merriment.

Johnson's dramatic act, which no doubt grew in the telling, was a key anecdote about his life because it exemplified his position as professional author, demonstrating not only his generosity but his power as a literary figure; not only his philanthropic impulses but his clout with the book-sellers. He could help authors because Thomas Osborne, Andrew Millar and the Dilly brothers all sought his advice. Such was his reputation, especially after the publication of his *Dictionary*, that an author or cause he chose to promote was sure of a sympathetic hearing in the Chapter Coffee House or in the shops on Paternoster Row.

Johnson enjoyed his role as literary patron and played it with gusto. Though, as Hester Piozzi complained, he said 'very contemptuous things of our sex', he helped a number of female poets and novelists into print, notably Anna Williams, Frances Burney and Charlotte Lennox. Such was his enthusiasm for Lennox's writing that he induced fellow members of the Ivy Lane Club to throw an all-night party to celebrate the birth of her 'first literary child'. At times passion got the better of his judgement. Johnson was an early and ardent supporter of William Lauder's

attacks on Milton. Lauder, a Scottish classicist and Jacobite schoolmaster who had lost a leg after being hit by a golfball, castigated Milton as a feeble and politically misdirected plagiarist. Johnson, who had little sympathy for Milton's politics, wrote prefaces for Lauder's work and urged it on the booksellers.

But how was an unknown writer to meet the likes of Johnson? It was best to join one of the many informal coteries and circles which made up literary London. Some of these associations, like Johnson's Club, were only open to members and the occasional guest. But, as we have seen, throughout the period writers frequented coffee houses and taverns which were open to anyone who could pay the reckoning. In these informal surroundings an introduction or witty remark could lead to acquaintance, and acquaintance to friendship with an established author or critic whose circle of influence might include booksellers, newspaper proprietors and the literary managers of magazines. Fellow authors could rarely offer financial support (except, perhaps, for the occasional short-term loan) but had something far more valuable – influence and connections, the power to mobilize the resources that the aspiring author so desperately needed. Authors, then, were not only producers of literature but also among its most important patrons.

The support of a colleague made an author's work more credible to a bookseller, but it only marginally reduced the latter's financial risk. Risk reduction could be achieved in one of two ways: by getting someone else to bear the costs of publication, or by guaranteeing a number of sales by organizing a subscription of purchasers prior to publication. Both methods required the support of literary patrons.

The question of patronage was and remains a vexed one. For much of the eighteenth century authors had two contradictory complaints about the patronage of literature. On the one hand, they regretted the demise of what was vaguely imagined as an ideal past in which kings, nobles and gentlemen supported literary endeavour of the highest quality. Such nostalgia, rampant early in the century, was a hankering for a world that authors never had, and was in large part a hostile reaction to the growth of commercial publishing and a political response to the Hanoverian regime. Many writers, especially those who aspired to gentility and literary high-mindedness, were appalled by the growing trade in literary commodities. And many of them – notably the Scriblerian circle that included Pope, Swift, Arbuthnot and Gay – were also politically

opposed to George I and George II, resentful of their exclusion from royal patronage, and conscious of the court's declining importance as a centre of literary largesse.

Other authors were happy to see patrons fade away, however, and wished good-riddance to a putative golden age of patronage. The old relations between patron and client had, in the eyes of many, created a form of literary prostitution. Gentlemen, wrote the poet Charles Churchill, 'kept a bard, just as they keep a whore'. Henry Fielding's use of the whoring metaphor in his *Author's Farce* differed only slightly: 'Get a patron,' one of his characters advises, 'be pimp to some worthless man of quality, write panegyrics on him, flatter him with as many virtues as he has vices.' In the politically charged climate of eighteenth-century England, reliance on a private individual, even the patronage of the monarch, was deemed incompatible with the independent requirements of modern authorship. A professional writer, it was felt, should be servant to no one but the public. His work should not reflect the etiolated taste of a sybaritic aristocrat but rest on the firmer foundation of public approval.

These two attitudes to patronage, the one nostalgic, the other disapproving, are less signs of its decline than indications that it was changing. The days when monarchs and peers kept writers as members of their household, as part of their entourage and tantamount to servants, had not entirely vanished. After all, living in one of the grand houses of an Oxford, Burlington or Bathurst was not without advantages. The poet and playwright John Gay survived ruin in the aftermath of the South Sea Bubble of 1720 thanks to the Duke and Duchess of Queensberry; in his declining years he divided his time between the comforts of their London town house and their country seat at Amesbury, in Wiltshire. The poet James Thomson, who, unlike Gay, was an employee rather than a guest, kept body and soul together in a succession of country houses where he tutored young Scottish and English aristocrats. He finally escaped this drudgery when his patron, Lord Talbot, secured him a legal sinecure. Thomson had a talent for securing patronage. In 1738 he obtained a pension from Frederick, Prince of Wales, one of the most active mid-century supporters of the arts; six years later, thanks to the good offices of Lord Lyttelton, he was appointed surveyor-general of the Leeward Islands, a post that brought £300 and made no demands on his time.

A number of notable writers, including Addison, Steele, Congreve, Prior and Gibbon, held government posts, most of which required little or no work. But the number of sinecures were few and far between and were the objects of fierce competition. The spoils system was not big enough and Grub Street too populous to help more than a tiny proportion of the nation's scribblers. And government pensioners, as Dr Johnson discovered when he accepted £300 a year from George III in 1762, compromised their independence, because most writers supported by the crown were expected to pen political polemics in favour of the king's ministers.

Even if they took government money and employment or were forced to spend time in sycophantic attendance on a great man, most writers guarded their literary independence and resisted patronal intrusion upon their work. They were loath to suffer the embarrassments, petty slights and benign condescension that Pope describes on the occasion of reading his translation of Homer before a literary group that included the Earl of Halifax: 'in four or five places Lord Halifax stopped me very civilly, and with a speech each time much of the same kind: "I beg your pardon, Mr. Pope, but there is something in that passage that does not quite please me. Be so good as to mark the place and consider it a little at your leisure. I'm sure you can give it a better turn."' Pope's story of his response to this criticism – he satisfied Halifax's vanity and tricked the peer into approving his original by rereading to him the unaltered text while claiming to have made the requested emendations – puts the patron in his place: the patron cannot judge the true quality of the work; that power is reserved to the author. Pope may have mourned the passing of the patron but he was still eager to advertise his superiority to him.

In the complex and often fraught relations between patron and authorial client the balance of power slowly but irreversibly shifted in favour of the writer. Because authors increasingly had the alternative resources of a commercial literary world, they became less dependent on individual largesse. This did not make them any less eager to secure aristocratic support, but what they wanted was not, on the whole, the rather demeaning place of the household servant, but money – underwriting an edition, paying for its production costs – and, most important of all, someone to talk up their books in polite society. The influential cleric who 'went from Coffee-house to Coffee-house, calling upon all men of taste to exert themselves in rescuing one of the greatest geniuses that

ever appeared from obscurity' helped James Thomson every bit as much as Lords Talbot and Lyttelton. For what a writer most needed was reputation; from this all else, including financial independence, followed.

The greatest service, then, that a patron, whether aristocratic or not, could render an author was to laud his or her abilities, to praise the writer's work in fashionable society. Johnson's famous denunciation of Lord Chesterfield – 'Is not a Patron, my Lord, one who looks with unconcern on a Man struggling for Life in the water, and when he has reached ground encumbers him with help' – complained not about the noble lord's failure to fund the *Dictionary* (which was financed, after all, by the booksellers) or about his financial niggardliness to its author, who received a meagre £10 for dedicating its plan to him. What irked Johnson was Chesterfield's failure during the *Dictionary*'s seven-year gestation to provide 'one Act of assistance, one word of encouragement, or one smile of favour'. He should have been supporting the project, praising its aim and author in the literary circles and genteel drawing rooms he frequented. His job was not to commission a work nor to house and feed its author – acts that would have compromised authorial independence – but to encourage and orchestrate its praise. Chesterfield's meagre contribution to Johnson's enterprise showed that he knew what he was supposed to do. He wrote two short letters puffing the *Dictionary* in the newspaper *The World* in November and December 1754. It was a gesture, but Johnson felt that for seven years' labour it was not enough.

The shifting role of the patron from commissioner and controller of literary work to its promoter, consumer and distributor was best epitomized by the practice of book subscription which increased as the nature of patronage changed. The number of subscription volumes rose rapidly between the late seventeenth century and the 1730s, levelled off until the 1760s, and spurted again during the last two decades of the century. Poems, sermons, music, histories, medical and advice manuals, biography, theology, mathematics, husbandry and, by the end of the century, even novels and plays were published in this way.

The object of subscription was to secure down-payments on and promises to purchase a book before its publication. This ensured that production and distribution costs were covered before a work went to press, an arrangement that pleased the booksellers because it cut risks and could promise large profits. Authors solicited some subscribers by getting job printers to produce proposals and by hawking their wares in

the drawing rooms and at the assemblies of the great. But the booksellers and authors' friends handled many more. Richardson printed numerous subscription editions and helped to organize the 1730 subscription editions of James Thomson's *The Seasons*, printing proposals and taking down-payments and orders at his shop. Johnson was an inveterate organizer of subscriptions for those he admired or whom he found in distress. He spent more than fifteen years helping to organize a subscription to Anna Williams's *Miscellanies in Prose and Verse*, which eventually appeared in 1766. The blind Miss Williams, who for many years lived in Johnson's house, earned over £300 as a result of Johnson's benevolence. His efforts on behalf of Charlotte Lennox, the success of whose novel, *The Female Quixote*, did not prevent her from falling into penury, were no less assiduous though much less successful. Numerous proposals he wrote for her in the 1770s all came to nothing.

A high proportion of subscription publications included a list of subscribers. Occasionally they even indicated how many copies an individual patron had ordered. Thus the subscription list to John Gay's 1720 edition of his collected poems was headed by Lord Burlington and the Duke of Chandos with fifty copies apiece, followed by Lords Bathurst and Warwick who paid for ten each. The list was a fine way of advertising the subscribers' largesse, their willingness not just to purchase their own copy, but to circulate others among their wealthy and tasteful friends.

Subscription publication brought together the interests of author, patron and bookseller. For the author it helped to get into print works such as expensive and scholarly tomes which might otherwise never have been published. It was the main means of publishing a collected volume or volumes of a single author's works in either prose or verse. A well-managed subscription could also prove sufficiently popular and profitable to secure an author's financial independence. The subscriptions to Pope's works freed him from what he viewed as the clutches of the booksellers; the 1,200 subscribers to Elizabeth Carter's *All the Works of Epictetus* earned her almost £1,000, enabling her to devote the rest of her life to her bluestocking literary interests. From the subscriber's point of view it was an opportunity to patronize and to be seen to support an author without the difficulties that attended a more personal relationship between patron and client. For the publisher, not only was there a reduced risk but the chance of additional sales through the network of retail

booksellers, encouraged by the publicity provided by a list of distinguished subscribers.

As we have seen, the subscriber represents the patron not as the commissioner of a work, but as one of its consumers, a conspicuously identified member of the reading public. Up to this point our perspective on eighteenth-century publishing has been largely internal; we have examined the inner workings of publishing with only an occasional glance to the public outside. But what of those who looked in – what of the reader, the all-important figure addressed by authors without whose patronage writers and booksellers, whether friends or enemies, would both have starved?

CHAPTER FOUR

Readers and the Reading Public

SAMUEL JOHNSON, EVER the advocate of reading, wrote in the *Adventurer*,

> Books have always a secret influence on the understanding; we cannot at pleasure obliterate ideas: he that reads books of science, though without any desire fixed of improvement, will grow more knowing; he that entertains himself with moral or religious treatises, will imperceptibly advance in goodness; the ideas which are often offered to the mind, will at last find a lucky moment when it is disposed to receive them.

Johnson was convinced of the power and persuasiveness of reading books, just as he was a supporter of the new world of commercial print. Writers believe in the power of the word, authors in the power of publishing. Yet Johnson's picture of the book reader raises questions about the scope and nature of the reading public. Who were they? How did they obtain reading matter and what did they read? (fig. 60).

Answers to these questions have to begin with literacy. The ability to decipher a text is a crucial threshold that must be crossed before anyone can claim to be a member of the reading public. The long-term trend in Britain between the sixteenth and late eighteenth centuries was of growing literacy. The most reliable figures (and they are not very reliable) show a gradual, though not unbroken improvement in male literacy from 10 per cent in 1500 to 45 per cent in 1714 and 60 per cent in the mid-eighteenth century. Female literacy rates were lower – 1 per cent in 1500, 25 per cent in 1714 and 40 per cent in 1750. This large trend conceals considerable variation: an elite of aristocrats, gentry and rich merchants were far more literate than the poor – indeed, almost totally literate by 1600; below the elite, shopkeepers were the most literate

60. *A Gentleman Reclining (John Farr)* by François Xavier Vispré, *c.* 1765–70

with a rate of 95 per cent by the third quarter of the eighteenth century; at the same time, most labourers could not read at all. Market town-dwellers were more likely to read than country folk; the highest levels of literacy were recorded in London, where female literacy grew especially fast, rising from 22 to 66 per cent between the 1670s and 1720s. Overall, literacy does not seem to have greatly increased in the late eighteenth century and may even have declined.

The measure by which these conclusions are drawn is not altogether reliable. The only consistent data that survive over time are signatures, but is the capacity to sign one's name an index of the ability to read? We know that most people learned to read before they could write and signatures therefore probably underestimate readership. But we do not know if some groups were likely only to read and not to write, or whether the ratio of readers to writers changed over time. Could a higher proportion of the humbler members of society read but not write? If they could read, *what* could they read: a black letter ballad with its cramped, thick gothic print, a book with a roman typeface, a letter-writer's script? Is it true, as many commentators have suggested, that

the figures have a gender bias against women because they were more likely to read, even to a high standard, but not to be able to write? When asked these questions historians can only respond with uncertainty.

Perhaps we need to consider the problem rather differently. The growth in the reading public after 1700 would not have been possible without the gradual spread of literacy, which had been continuing for two centuries. Without readers the spurt in publishing that began in the late seventeenth century would have been impossible; literary seed would have fallen on barren ground or, more accurately, would never have been sown at all. What changed was less the demand for printed matter than the circumstances that affected its supply: the removal of restraints that crown and conservative booksellers had jointly imposed in the past. The transformation was wrought less by growing literacy than by an increased provision of reading matter, a development that changed the nature of reading itself.

This change has sometimes been described as a shift from 'intensive' to 'extensive' reading. Intensive reading, it is argued, takes place in societies where there are few books; because of their rarity and expense, they are treated as sacred objects, subject to repeated rereading and intense scrutiny. 'Extensive' reading, on the other hand, is the consequence of a well-developed print culture in which plenty of varied works are available. The individual book becomes less sacred, the reader more cursory, willing, as the bluestocking Frances Boscawen put it, 'not to read strictly, but *feuiller*'.

'Intensive' reading continued well into the eighteenth century, especially though not exclusively in poorer households where books were few and reading confined to works of piety. When the future bookseller James Lackington was apprenticed as a shoemaker in Taunton to Mr George and Mrs Mary Bowden in 1761, he joined an Anabaptist household in which everyone repeatedly read the Bible. On Sunday his master's boys, he recalled, 'read a few chapters in the Bible, took a walk for an hour or two, then read a chapter or two more', while his mistress 'would sit down for hours together, with her Bible in her lap, from which she would read such scriptures as proved the necessity of living a good life, performing good works, &c.' (fig. 61). This pious household owned just seven books. 'My master's whole library', Lackington remarks, 'consisted of a school-size Bible, Watt's Psalms and Hymns, Foot's Tract on Baptism, Culpepper's Herbal, the History of the Gentle Craft, and an

imperfect volume of Receipts [i.e. recipes] in Physic, Surgery etc and the Ready Reckoner.' Three books of piety, including the Bible, which were read repeatedly; four 'how-to' reference works, taken off the shelf as the occasion demanded: such was the literary stock of a poor shoemaker.

It is important to emphasize that the poor were not the only 'intensive' readers. Rich and affluent men and women were not cavalier about their reading, though they had access to books in unprecedented numbers. For the value and importance of books was not merely a consequence of high cost or scarcity. Members of all classes who were active Christians – which meant the overwhelming majority of people – read the Bible, collections of sermons and pious tracts with a care and assiduity that they did not often give to novels (fig. 62). They did so not because these works were the only ones available to them, but because they contained matters of special import that had to be thoroughly absorbed and digested.

Perhaps it is more accurate to say that the change in reading practices was not from 'intensive' to 'extensive' reading, but to more varied reading,

61. *Sunday Morning (Bible Reading at the Cottage Door)* by Alexander Carse

62. *The Bible Lesson* by Philip Mercier, 1743

ranging from repeated and careful examination of some texts to the perfunctory perusal of others. Obviously 'extensive' reading depended upon a flourishing world of books, but it never extinguished 'intensive' reading – which survives, not least in universities, to this very day. Nor should we assume that certain types of literature were invariably treated either 'intensively' or 'extensively'. Literary essays such as those in the *Spectator* were read again and again; sentimental novels absorbed their readers as much as the Bible, while sermons, except those by the most popular divines, were notoriously ephemeral.

What sorts of books were available to the eighteenth-century reading public? Not even our modern and extensive computerization of eighteenth-century bibliography can give us a very precise answer, though we have some indication of the numerical distribution of book titles. From the 'Eighteenth-Century British Bibliography', which records holdings in the British Library, the Bodleian and Cambridge University Library, we learn that most books fell into one of four categories: religion, with more than 50,000 titles; social sciences, with more than 47,000; literature, in excess of 45,000; and history and geography, with about 25,000. Compared with these, philosophy, science and technology, and languages were much less important.

But there are several problems with these statistics. For one, the classifications are modern and not from the eighteenth century. The category 'social sciences', which chiefly includes works on politics, is a particularly miscellaneous one that would not have been recognized at the time; conversely, many individual eighteenth-century works could belong to several categories but are arbitrarily confined to one. And, crucially, the number of titles does not tell us how many *copies* were in circulation, or anything about their influence and effect. To judge from surviving ledgers, most small books and pamphlets were printed in editions of between 100 and 500 copies, though many of these were never sold and were returned to be pulped and recycled as new paper. Certain sorts of literature – magazines and newspapers, for instance – had many readers per copy, while other works languished unread on bookshelves. In merely counting titles, a volume of sermons by Tillotson, Sherlock or Blair, which sold in the thousands, is treated as tantamount to a tract by a rural cleric which appeared in a few privately printed copies.

Still, with all these provisos, the trends are clear. The sermon was the single most important literary form. On average about three new sermons were published every week; their publication was especially concentrated at the beginning and end of the century. Poetry was far and away the most frequently published type of literature, accounting for 47 per cent of all titles. Works of history and geography were overwhelmingly national or Eurocentric, with a strong emphasis on understanding France. Texts in foreign languages or of foreign literatures were few and far between. The most common foreign works were in French, but these were outnumbered by titles in Latin. No foreign culture, except the French, exceeded the number of books in Greek.

The picture conveyed by these data is therefore highly conservative. Religion and theology dominate, poetry far exceeds any new literary forms of prose, classics lord it over the modern languages. It is a valuable reminder that the expansion of publishing in the eighteenth century increased the availability of traditional works and old forms as well as new types of literature.

This aggregation of titles does not however capture the effect of the periodical and newspaper press; it tells us little about reading habits; and it conceals the heterogeneity and full range of available books. Nor does it plot the interrupted growth of reading matter over the course of the century, though we know that after a rapid increase between the 1680s

and 1730s there was a levelling off, perhaps even a slight decline in publishing, before renewed growth in the 1760s accelerated rapidly during the last two decades of the century. There were not only more books in circulation than ever before, but new and varied means by which the reader could secure them.

As the number of books increased and the system for their distribution grew, it became easier to find them. Books could be bought, hired or borrowed either from commercial establishments and institutions or from individuals. The humblest literature – chapbooks, cheap abbreviated novels, almanacs and ballads – could be bought from itinerant pedlars and chapmen who travelled the countryside selling reading matter, trinkets, gifts, household goods and toys (fig. 63). Inside his heavy pack the chapman carried traditional stories, first widely printed in the sixteenth century, moral tales with such forbidding titles as *The Drunkard's Legacy* and *Youth's Warning Piece*, joke and riddle books like *Joaks upon Joaks*, and severely abbreviated versions of such novels as Defoe's *Robinson*

63. *Knives, Combs or Inkhornes*
by Marcellus Laroon, engraved by
Tempest, 1687

Crusoe and *Moll Flanders*, or Henry Fielding's *Joseph Andrews* and *Tom Jones*. These slim, small volumes, often printed execrably, were popular staples among all classes. What they lacked in substance they made up in good value: their greatest virtue was that they were cheap.

Itinerant salesmen carried only these sorts of book because any others would have been too bulky or heavy for them. But in the bookshops these small or penny 'histories' shared the shelves with books of every size – from slim duodecimos (one twelfth the size of a printing sheet), octavos (an eighth of a sheet), quartos (a quarter of a sheet) to large folios (the size of a sheet with a single fold). Then, as now, the number and quality of books fluctuated sharply from shop to shop. By the end of the century most booksellers' inventories were valued at between £100 and £500, but in smaller shops they were worth much less and would have consisted of Bibles and schoolbooks (two categories found everywhere), together with a motley collection of secondhand and out-of-date volumes.

Even the largest establishments stocked items other than books, for bookselling alone was rarely sufficient to make a prosperous living. In the humbler shops the stock of paper and pens would have been larger and more valuable than the book stock. A customer entering Patrick Sanderson's bookshop in Durham in the 1760s would have found 'all Sorts of Stationery Wares, as Writing Paper, Paper Books for Accompts, Ledgers, Journals, Waste Books, Musick Books, Letter Cases, Maps, Landskips, and Mezzotint Prints, Sealing Wax, Wafers, Slates, Quills, Pens, Pencils; Standishes, Japon Ink, Ink Powder, Indian Ink'.

Not all the commodities and services the bookseller offered were directly connected with the culture of print. John Hogben of Rye, in Sussex, was a bookseller, stationer and bookbinder who sold maps, prints, mathematical instruments, spectacles and globes. Like many booksellers he was an agent selling insurance for the Sun Fire Office; more unusually he sold fishing tackle and ran a small private school. Patent medicines were another booksellers' speciality. The bookseller in Bridport, Dorset, sold 'excellent Pills, Worm Cakes, Eye-Water and a remedy for Warts'. Booksellers all over Britain sold such compounds as Spilsbury's Antiscorbutic Drops, Stoughton's Elixir, Beaume de Vie and the best-selling Dr James's Fever Powder (fig. 64). So the provincial bookseller – there are 988 listed in 316 towns in the *Universal British Directory* for the 1790s – carried a varied stock that typically included not only books but stationery

Bristol

Seltzer

Pyrmont

Pouhon

William Owen,
Bookseller,
Near Temple Bar, Fleet Street.
Imports German Spa Water from ye Pouhon Spring
also Seltzer & Pyrmont in their utmost Perfection
Bath, Bristol & other English Waters fresh
every Week.

·64. Tradecard: William Owen, bookseller, artist unknown

and patent medicines; the shop might even carry groceries or sell tea, coffee and sugar.

Such shops lacked the space and their proprietors the capital to carry a huge stock of books. A customer clambering over fishing rods and in danger of upsetting patent medicines was unlikely to find the latest novel or polemical pamphlet on the shelf. In regional cities well-established bookshops carried a range of topical titles; elsewhere theology, Bibles, legal manuals and what the bookselling entrepreneur James Lackington dismissed as 'nothing but trash' were all that was to be found.

The adverse effects of such poorly supplied premises were greatly ameliorated by the ease with which booksellers could order from wholesale booksellers in London. The potential retail purchaser, who had probably seen a book advertised in a newspaper, would place an order with the local bookseller. Harvey Berrow, proprietor of the *Worcester Journal*, for example, acted as the link with London for booksellers in Worcester, Shrewsbury, Bridgnorth, Bewdley, Kidderminster, Stourbridge, Gloucester, Tewkesbury, Hereford, Ludlow, Coventry, Lichfield, Stafford, Warwick, Stratford-upon-Avon, Leominster and Evesham. As he explained to his readers in 1760: 'All Sorts of Books, Pamphlets, Acts of Parliament, The several Magazines, And All Other Periodical Publications, Are continued to be sold by H. Berrow, Goose Lane, Worcester; Who procures them from London as soon as possible after

they are bespoke, which is the usual Method with Country Booksellers, whose Orders are supply'd Weekly from thence.' A conscientious reader, who kept abreast of new publications by scanning the advertisements and listings in newspapers, periodicals like the *Gentleman's Magazine* and reviews, could collect a currently available title from the local bookseller within a week of having placed an order.

The parlous stock of most booksellers outside London and the use of 'mail order' to obtain books meant that a great many titles were requested by customers who had little knowledge of their contents. On the whole bookshops were not places to browse in. Retail booksellers sought to compensate for this absence by lending books to their customers at a nominal fee. As early as 1692–3, for instance, the Midlands bookseller William Bayley charged the Earl of Huntingdon two pence an item to borrow a number of novels, sermons and plays from his shop in Lichfield. Most were returned, but a few were purchased for an additional fee. As in the modern video store, items were available both for sale and for hire. William Bayley's practice was commonplace: nearly every bookseller kept a stock of books that patrons could borrow. This elision of borrowing into purchase makes it difficult to distinguish the growth of bookselling from the development of the first commercial libraries, or 'circulating libraries', which lent out books for their customers to read at home. Though in the long term bookshops and libraries emerged as separate institutions, for most of the eighteenth century their histories were intertwined. Even the larger libraries continued to offer customary bookselling services. Joseph Barber of Amen Corner in Newcastle, for instance, who had a fine circulating library of more than 5,000 volumes, one of the largest collections outside London, also offered his customers the Bibles and schoolbooks, commercial stationery and writing paper that were the staples of provincial bookselling.

The largest circulating libraries were more than adjuncts to a bookselling business. In the capitals of the three kingdoms, in the large provincial towns and in resorts such as Bath and Margate, circulating libraries offered comfortable, spacious surroundings in which the customers could gossip, flirt, browse, examine newspapers and reviews, and choose from a selection of every kind of book. The late eighteenth-century engraving of the library at Margate, sold jointly by its proprietor and engraver, conveys the ambience library proprietors wanted: one of leisure and display as well as learning (fig. 65).

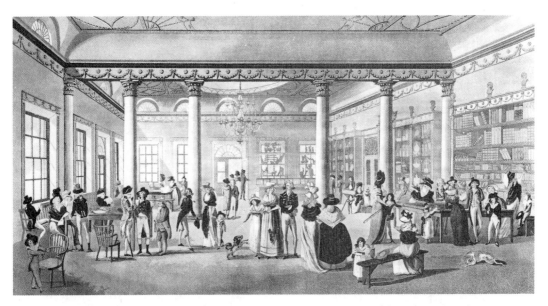

65. *Hall's Library at Margate* by Georgiana Jane Keate, engraved by Thomas Malton Jnr, 1789

The biggest libraries published catalogues: John Bell's famous London Library contained more than 8,000 volumes; Sibbald's in Edinburgh offered its patrons a choice of 6,000 titles in 1786; and Ann Ireland's Leicester Library, though not as large as Barber's in Newcastle, nevertheless housed 2,500 books. These libraries were not only repositories of fiction. The number of novels and romances was never as great as those of history, travel and geography; indeed for every 'frivolous' volume there were two of more serious reading matter. But these figures refer to books on the shelf: no records survive to reveal the pattern of *borrowing* in a major circulating library. It may well have been that the sober histories and detailed travellers' tales never received a second glance as readers hurried to the shelves of multi-volumed novels and well-thumbed romances. Isaac Cruikshank's *The Circulating Library* (fig. 66) certainly takes this view. The shelves for novels, tales and romances are empty – all the books are out – but the sections for history, sermons and voyages and travels are full, attesting to their unpopularity.

The patrons of circulating libraries were not poor. Both Joseph Barber in Newcastle and Francis Noble in London charged their customers three shillings a quarter. This amount would not have stretched the

budget of a gentleman, merchant, member of the professions or prosperous trader; it was even within the means of a skilled artisan, though it would have given pause for thought to someone who earned between £40 and £80 a year. Nevertheless circulating libraries were good value. New books were not cheap; by the third quarter of the century a bound duodecimo novel usually cost three shillings a volume; a substantial history or piece of travel literature or biography was more expensive than an annual subscription to a library. Lord Lyttelton's popular *History of the Life of Henry II*, which appeared in six volumes, cost £1. 10*s*. 6*d*. a volume; the two volumes of Chesterfield's *Letters* sold at a guinea each. In the last quarter of the eighteenth century book prices, which had been stable for half a century, began to rise steadily. Novels that had once been three shillings a bound volume cost a minimum of three shillings in sewn papers; three-volume novels, a common length, cost 10/6*d*. sewn. As prices increased, even affluent readers preferred to borrow rather than buy. So numbers of libraries increased: by the end of the century it is estimated that there were nearly 1,000 in the provinces and more than 100 in London.

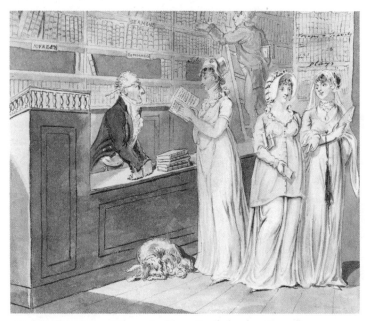

66. *The Circulating Library* by Isaac Cruikshank, 1800–1815

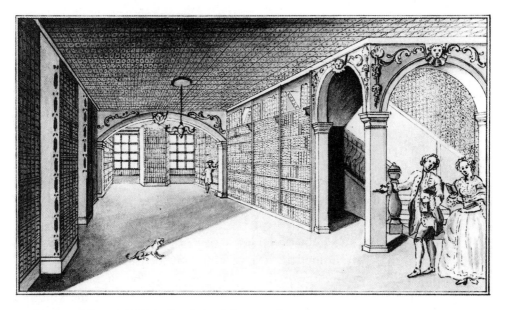

67. Interior of Francis Noble's Circulating Library, artist unknown

The received wisdom about circulating libraries was that they were repositories of fictional pap, served up to women of leisure who had little to do but surfeit themselves with romantic nonsense. This picture, corroborated by fictional and stage representations of the flighty patrons of such libraries, tells us more about male fears of the effects of eating from what Sir Anthony Absolute, in Sheridan's *The Rivals,* called 'that evergreen tree of diabolical knowledge' than about the diverse purposes and audiences which circulating libraries served. Women were not the main public of the circulating library, though they were more prominent there than in other book-lending institutions. Even at Marshall's circulating library in Bath, whose clientele included many young ladies of leisure, women subscribers were in a minority: 35 per cent of readers in 1793 and only 22 per cent in 1798. And even at Marshall's patrons were able to read a range of works that extended well beyond fiction. It may have been, however, that the rise in the price of novels meant that more of them were borrowed from circulating libraries, and their clients concentrated their book purchasing on what they regarded as more durable literature.

The larger circulating libraries such as Francis Noble's, with its

cavernous premises in Covent Garden (fig. 67), specialized in current publications and recent literature. They complemented two other institutions, the subscription library and the book club, the former specializing in serious non-fiction, and only few novels, while the latter usually featured the small pamphlets and printed ephemera in which contemporary political and religious controversies were vehemently rehearsed. Both of these were decidedly more male institutions than the circulating library.

Subscription libraries were founded throughout Britain's commercial and industrial towns in the late eighteenth century, eloquently expressing the local pride of rapidly expanding communities. The first library opened in 1758 in Liverpool and was quickly followed by establishments in Warrington (1760), Macclesfield (1770), Sheffield (1771), Bristol (1773), Bradford (1774), Whitby and Hull (1775), Leeds, Halifax and Carlisle (1778). There are estimated to have been 100 such institutions by 1800, of which the two finest were those in Bristol, which boasted 200 members and about 5,000 titles, and at Leeds, where more than 4,500 volumes were shared by 450 subscribers.

Subscription libraries were joined by the great and the good. A survey of the members of the Liverpool library recorded in 1760 conveys its strongly aldermanic flavour. Approximately half the members whose occupation was recorded were described as merchants, including those in wine, silk, sugar and iron. The remainder were a cross section of Liverpool's professional and mercantile classes: two brewers, two brokers, four attorneys, four drapers, a pottery manufacturer (who, incidentally, owned a share of the local newspaper), a hosier, chandler, grocer, sail-maker, rope-maker, cooper, cabinet-maker, painter, druggist, mercer, six surgeons, two doctors, a customs officer, teacher and schoolmaster, a woman innkeeper, one 'esquire', four 'gentlemen' and two members of the clergy. Apart from the small number of clerics, this profile is typical of those who supported subscription libraries all over Britain.

The holdings of these libraries mirrored the civic preoccupations and commercial interests of their members. Liverpool held an outstanding collection of works on the pros and cons of the slave trade; Manchester specialized in technical works; Bristol housed a large collection of travel literature on the Levant, the Mediterranean and North America, all areas important to the city's trade. The shape of collections in subscription libraries was fairly uniform: they all contained little fiction and many books of history, travel literature, *belles-lettres*, theology, natural history,

philosophy and jurisprudence. On the whole these libraries were not considered as strictly utilitarian, but they reflected the interests and pre-occupations of the merchant and trading classes.

BORROWINGS FROM THE BRISTOL LIBRARY, 1773–84

	Borrowings	Titles
History	6,121	283
Belles-lettres	3,318	238
Miscellaneous	949	48
Philosophy	844	59
Natural history	816	71
Theology	606	82
Jurisprudence	447	53
Mathematics	276	42
Medicine/anatomy	124	24

Thanks to a unique surviving record, we are able to reconstruct the borrowing habits of members of the Bristol library between 1773 and 1784. From these data we learn of a serious readership with an avid interest in history, travel and geography. This rather eclectic category – one that contemporaries found congenial – accounted for more than 45 per cent of all borrowings. Six of the ten most frequently borrowed books fall into this category: John Hawksworth's pastiche of several accounts of the adventures of Captain Cook, *Account of Voyages for making dis-coveries in the southern hemisphere* (three volumes, 1773), borrowed 201 times; Patrick Brydone's *Tour Through Sicily and Malta in a series of letters to William Beckford* (two volumes, 1773), regarded as a model of Mediterranean travel writing; David Hume's best-selling *History of Great Britain* (four volumes, 1754–62); the Abbé Raynal's *A Philosophical and Political History of the Settlements and Trade of the Europeans in the East and West Indies*, translated into English in 1776, with its sustained attack on slavery; William Robertson's *Charles V*, for whose three volumes published in 1769 the Scottish historian was paid the massive advance of £4,500; and Lord Lyttelton's worthy if dull *History of the Life of Henry II* (1767–71). The most popular single author was William Robertson, principal of Edinburgh University and author of three major histories. His *Charles V*, together with the *History of Scotland* (1759) and *History of the Americas* (two volumes, 1777), were borrowed on no fewer than 301 occasions.

In addition to this preoccupation with history, the members of the Bristol library borrowed many books classified as *belles-lettres*. Of these, by far the most popular was Chesterfield's *Letters to His Son*, though not far behind was Sterne's *Tristram Shandy* and Henry Fielding's *Works*. Sterne and Fielding, in their turn, were a long way ahead of their nearest fictional rivals. Indeed, there was little borrowing either of novels or verse; essays and criticism, like Dr Johnson's *Lives of the Poets*, were more to the members' liking. This preference is not necessarily an indication of the members' tastes, since they could also use the Bristol circulating libraries which had large selections of imaginative literature.

Subscription libraries were enduring institutions: they acquired their own premises, complete with padded armchairs; they printed their catalogues to boast of their holdings; and they saw themselves as one more star in the panoply of institutions – literary and philosophical societies, assembly rooms and theatres – from which emanated the bright glow of civic pride. Book clubs were altogether more evanescent, small associations of rarely more than twenty people: gentlemen, clerics, attorneys and tradesmen who wanted access to new books but did not want to pay full prices. In 1725 the Nonconformist minister and popular author Philip Doddridge explained the value of these small reading groups in a letter to his brother-in-law from the small village of Burton upon Tyne: 'It is my happiness to be a member of a society in which, for little more than a crown a year [i.e. five shillings per annum], I have the reading of all that are purchased by the common stock, amounting to sixteen pounds yearly. They are generally some of the most entertaining and useful works that are published.'

The book club was a phenomenon of small towns and large villages; it brought together the local elite of professional men, merchants, affluent farmers and minor gentry in the convivial environment of the local inn or tavern, where together they chose the club's acquisitions, debated the issues of the day and last, but by no means least, ate and drank. The books they bought were overwhelmingly controversial and topical, pamphlets and slim volumes on politics and religion. The ephemeral character of these books is indicated by the common practice of auctioning them or selling them to members by lottery at the end of each year. Lack of storage space for the books may also account for these sales, but the value of many of them was as shortlived as the controversies they contained.

A few clubs also bought more substantial volumes – best-sellers like Chesterfield's *Letters* and Brydone's *Tour*, as well as novels by Richardson and Sterne. Larger associations, like the Huntingdon Book Club Society, established in 1742, even purchased folios and quartos. But most annual purchases – in the Ely Pamphlet Club this meant about sixty titles a year – came from the monthly survey lists of current works on politics and religion included in the back of each issue of the *Critical Review* and the *Monthly Review*. Armed with this information, members of the book club would have their orders sent up from London. The Hampshire Book Club, set up in the 1750s, had an account with the London bookseller John Shuckburgh for this express purpose.

Circulating libraries, subscription libraries and book clubs were the chief means by which the moderately prosperous reader could secure a book without having to buy it. But they were far from being the only places where books could be consulted without having to be bought. Books, pamphlets, periodicals and newspapers could be found in cathedral and parish libraries, in the collections of Nonconformist congregations, and in taverns and coffee houses. The library of St Nicholas's Church in Newcastle grew so large that it had to be housed in a special extension; by 1745 it numbered nearly 5,000 volumes. More modestly, St George's Church in Doncaster offered more than 400 works to its parishioners. Though the collection was dominated by works of Anglican piety, the two most frequently borrowed books were secular: Rollin's *Ancient History* and *Chambers's Dictionary*. Dissenting and Methodist congregations had similar libraries. Though, as James Lackington complained in his virulently anti-Methodist *Memoir*, they ruthlessly excluded works regarded as pagan or irreligious, they offered laity and ministers alike a solid fare of tracts, spiritual biographies of Methodist converts and works of piety.

In 1742 the London booksellers complained of what they described as 'the scandalous and Low Custom that has lately prevail'd amongst those who keep *Coffee houses*, of buying one of any new Book ... and lending it by Turns to such Gentlemen to read as frequent their Coffee house'. These recriminations had little effect. More than thirty years later, in March 1773, the Irish cleric Thomas Campbell 'strolled into the Chapter Coffee House', in the heart of the booksellers' quarter, because he had heard it 'was remarkable for a large collection of books, & a reading society ... I subscribed a shilling for the right of a year's reading,

& found all the new publications I sought, & I believe what I am told that all the new books are laid in.'

The volumes in the Chapter Coffee House had to be read on the premises; like most books in coffee houses, they did not circulate. But the very low price for access to the Chapter's collection meant that it was accessible to a wide clientele. As he sat reading, Campbell saw what he called 'a specimen of English freedom'. To his surprise 'a whitesmith [a worker in tin] in his apron & some of his saws under his arm, came in, sat down and called for his glass of punch and the paper, both of which he used with as much ease as a Lord.' The whitesmith, though he was not using the Chapter's book collection, was free to use that other great literary resource of the coffee house, the newspaper, and, like a good freeborn Englishman, was eager to be politically informed.

The many institutions on which readers could draw were complemented by private collections of books, and by personal borrowing and lending. Any visitor to a gentleman and aristocrat's country house in the eighteenth century would expect to have the run of the library; books themselves had become such numerous and frequent guests that they were given their own rooms. In 1650 few country houses had libraries and few had such a room incorporated into their design, but by the late eighteenth century a house without a library was almost unthinkable (fig. 68). In older houses the long galleries, once used for recreation and conversation, were now lined with shelves and stuffed with folios, octavos, quartos and duodecimos. Cabinet-makers produced special furniture for libraries – bookstands, reading chairs, rotating shelving, ladders and writing tables – which were also embellished with busts, urns, globes and cameos. By the early nineteenth century the library had become the centre of indoor sociability for the house guest. J. C. Loudon, writing in *The Suburban Gardener and Villa Companion* of 1838, claimed that 'in the present day [in England] no villa, or suburban residence, having more than two sitting-rooms, can be considered complete without a library', which should contain 'two or three large easy chairs, with moveable desks' and which should double as 'the morning sitting-room for the gentlemen'.

But books were restless; they escaped from the library, spilling out into gentlemen's closets and ladies' dressing rooms, where piles of novels, travel literature and histories, often unbound, were kept in corners and in cupboards for masters to read to mistresses, for servants to read to

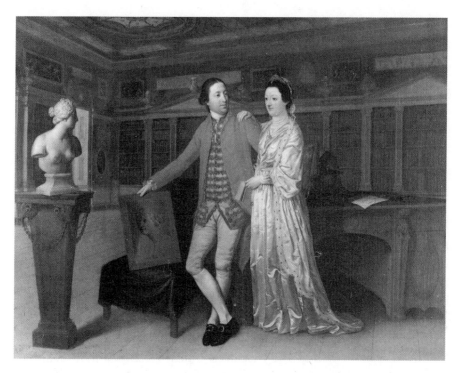

68. *Sir Rowland Winn and Lady Winn at Nostell Priory*, artist unknown, *c.* 1770

masters, for house guests to read to each other, or for the mistress of the house to read alone. When Garrick left Lord Lyttelton's seat at Hagley in the summer of 1771 he was disconcerted to discover that he had stolen one of his lordship's books:

> the case is this – I borrow'd at Exeter the 2d Vol: . . . of Dodsley's Miscellanies [an exceptionally popular poetry collection] . . . Mrs Montagu (at whose name I feel a certain Something) took it from me to read, whether she has it, or whether it is in the Library, yr Lordp may easily know by gentle Enquiry – in my hurry I brought away yr Lordship's 6th Vol: of Dodsley's Miscs instead of that I borrow'd.

Lyttelton returned the library book to Garrick and asked him to keep the book – 'which is only a broken volume' – he had taken in error. Guests, in turn, lent books to their hosts. Two summer visitors, the bluestocking Frances Boscawen wrote to her cousin, 'have been so good

as to leave with me General Dumourier's Memoirs, which amuse me much'.

Among the professional classes and minor gentry of provincial towns and rural villages, there was always a bibliophile or two who would lend out his books. John Marsh, a Chichester gentleman musician and composer, whose leisure time was almost totally absorbed with music, was able to borrow books from a neighbour: 'when we were at home of an evening by ourselves (which at this time happen'd but seldom) I usually read to the Ladies for an hour after tea whilst they work'd; I ... began a Selection of Voyages, commencing with that of Columbus, which we borrow'd from Mrs. Wroughton whose library being a pretty good one, we generally resorted to, when we wanted books.' Marsh himself left books lying about in his house. When a guest came back to his house in Nethersole in 1783 after a boisterous evening of drinking, he 'took up a volume of Clarissa Harlowe (wch we happen'd then all to be reading) but having sat about 10 minutes without turning over a leaf, suddenly clos'd the book and went off to bed'.

The practice of borrowing and lending books went further down the social scale. When in the first decade of the century John Cannon, the son of a butcher and grazier in northern Somerset, was sent by his father to market at Bruton, he would slip away to the house of Philip Whitacre and read the local gardener's copy of the 'large history of that learned and warlike Jew, Josephus Ben Gurion'. Cannon, whose life was greatly influenced by his reading – he even claimed to have learned to masturbate as a result of reading *Aristotle's Masterpiece*, a standard work of sexual instruction – found Josephus a revelation: it stirred in him, he wrote, 'a fervent desire to reading other authors more authentic and valuable than those I had been acquainted with, and was the first foundation of my steady and unwearied adherence to English history with which afterwards my closet plentifully abounded notwithstanding my several stations or occupations'. Cannon went on to be a revenue officer, schoolteacher and local scribe, lending books to friends in the spirit of his mentor Whitacre.

Shopkeepers and traders, who were inclined to own more books than other people of comparable wealth and who often acted as scribes for those who could not write, were at the heart of village reading. Thomas Turner, a shopkeeper in East Hoathley, in Sussex, had a sizeable personal library. Turner and his wife regularly read to one another, notably from

John Tillotson's sermons. He also read aloud almost daily to his friend Thomas Davy, a local shoemaker, borrowed magazines from his neighbour Mr Calverley, and also lent out books. In August 1755 he was vexed to learn that a local tailor's journeyman, to whom he had given a copy of Butler's *Hudibras* and lent the first volume of the *Tatler*, had absconded: 'I found out that Harrison has run away with the 1st volume of *The Tatler* which I, like a good-natured fool, lent him upon the 26th instant.' During his apprenticeship in Newcastle, the wood-engraver Thomas Bewick rose early in the morning to read either from his master's small library or from books that had been left at a friendly bookbinder's workshop; he also borrowed books from skilled artisans of his acquaintance.

Books, print and readers were everywhere. Not everyone was a reader, but even those who could not read lived to an unprecedented degree in a culture of print, for the impact of the publishing revolution extended beyond the literate. People who could not read were encouraged to buy a few books so that their literate guests and friends could read to them. Reading aloud, both in public and in private, was a universal practice that enabled non-readers to share in the pleasures of the literate. In homes, taverns, coffee houses, in fields and on the street, oral and literate cultures were married through the ministrations of the public reader. Reading often accompanied work:

> the excellent Lady *Lizard*, in the space of one summer, furnished a gallery with chairs and couches of her own and her daughters working; and at the same time heard all Doctor *Tillotson*'s sermons twice over. It is always the custom of one of the young ladies to read, while the others are at work; so that the learning of the family is not at all prejudicial to its manufactures. I was mightily pleased the other day to find them all busy in preserving special fruits for the season, with the *Sparkler* in the midst of them, reading over 'the plurality of worlds'. It was great entertainment to see them dividing their speculations between jellies and stars, and making a sudden transition from the sun to an apricot, or from the Copernican system to the figure of a cheese cake.

The facetious tone of this description from the *Guardian* does not detract from its veracity. We know from family correspondence that the burdens of housework were often lightened by reading aloud.

Even those who often read alone and in silence enjoyed the pleasures of reading aloud. When Henry Austen wrote a biographical appreciation of his sister for the 1818 edition of *Northanger Abbey* and *Persuasion*, he drew attention to her powers of reading: 'She read aloud', he wrote, 'with very great taste and effect. Her own works, probably, were never heard to such advantage as from her own mouth.' Public reading was not just a bridge between literate and illiterate but an attribute of a cultivated and genteel person. There were numerous manuals, like James Burgh's *The Art of Speaking*, published in 1768, and several of the works of Thomas Sheridan, which taught genteel readers how best to read aloud. It was one of the most important ways in which values and ideas were shared in an age before electronic media.

In his self-aggrandizing autobiography James Lackington looked back complacently on the growth of the book trade during his working life (fig. 69). 'I cannot help observing', he pompously remarked, 'that the sale of books in general has increased prodigiously within the last twenty years,' as if he himself had much to do with this development. He went on:

> The poorer sort of farmers, and even the poor country people in general, who before that period spent their winter evenings in relating stories of witches, ghosts, hobgoblins, &c. now shorten the winter nights by hearing their sons and daughters read tales, romances, &c. and on entering their houses, you may see Tom Jones, Roderick Random, and other entertaining books, stuck up on their bacon racks &c. If *John* goes to town for a load of hay, he is charged to be sure not to forget to bring home 'Peregrine Pickle's Adventures;' and when *Dolly* is sent to market to sell her eggs, she is commissioned to purchase 'The History of Pamela Andrews'. In short, all ranks and degrees now READ.

Lackington's remarks should be treated sceptically: they express the unexamined belief in progressive enlightenment and retreat from superstition that governs the story of his own life and the book trade. But they contain an important truth. Books were available as never before and not just in London or for the richest classes. A provincial shopkeeper like Thomas Turner owned more than seventy books and periodicals that included works by Addison, Milton, Locke, Congreve, Gay, Sherlock, Smart, Tillotson, Steele, Shakespeare, Sterne and Edward Young;

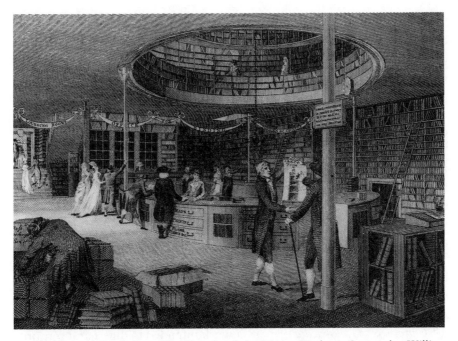

69. Lackington's bookshop, *The Temple of the Muses*, Finsbury Square by William Walker, date unknown

in his diary he alludes to a further fifty books that he read between 1754 and 1765, as well as periodicals and newspapers which he appears to have perused regularly.

Different sorts of literature escaped the printed page; they mounted the stage, were reproduced in prints and paintings, shaped the form and content of letter-writing, and provided a variety of narratives through which people described and understood their ordinary lives. This development was not new. Classical literature, the Bible and folk tales had all served these purposes for millennia and were to continue to do so. But stories that recounted heroic and moral actions given shape and meaning through a journey were now rivalled by other tales that emphasized psychological complexity, the fraught relationship between outward appearance and inner feeling. The number of possible narratives, ways of understanding and describing oneself increased enormously; the issue of who or what one was was rendered much more complex.

The book had ceased to be merely a text and had become an icon and object which conveyed a sense of its owner. In genteel portraits

books – and a book was almost as common a prop as a spouse, a house or an animal – no longer merely associated the sitter with a profession or vocation. Lawyers' portraits still sported legal tomes and clerics proudly held their sermons, but the book, almost any book, had become a sign of culture and gentility. The ubiquity of books and their central place in understanding the world, especially that beyond one's immediate experience, led to an intimate anthropomorphism. Books became familiar 'companions' and 'friends'. As Goldsmith put it in *The Citizen of the World*, 'the first time I read an excellent book, it is to me just as if I had gained a new friend: when I read over a book I have perused before, it resembles the meeting with an old one.' Books became one's intimates, with which one engaged in that most genteel of avocations, good conversation.

But for those who believed that true understanding required not local knowledge but a comprehensive and therefore impartial view, for those who strove for wisdom through unity and coherence, the explosion and fragmentation of knowledge was disconcerting and alarming. As the *Chambers's Cyclopaedia* of 1738, a work intended to digest and comprehend all modern knowledge, bemoaned in an extended discussion of the ill effects of the growth of printing: 'the *multitude* of BOOKS has been long complained of: they are grown too numerous, not only to procure and read, but to see, learn the names of, or even number.'

That, precisely, was the paradox. On the one hand, changes in the organization of publishing after the lapse of the Licensing Act had created a national, relatively unified and quite coherent literary system. Thanks to a highly developed network, a rural shopkeeper like Thomas Turner could own, borrow or read much that was on the bookshelf of many a London gentleman. The same links between metropolis and province made it possible, as we shall see in Chapter 15, for a poet and critic like Anna Seward to be one of London's most formidable literary figures while she continued to reside in the cathedral town of Lichfield. In the pages of the periodicals, notably the *Gentleman's Magazine*, she published poems and reviews, castigated James Boswell's sycophancy to Dr Johnson, and argued the merits of the great English poets.

On the other hand, in unity was diversity and division. Britain's literary system spawned a race of hacks who produced fragments of literature: as it grew, its constituent parts became specialized, with authors and booksellers working at distinctive and incommensurate sorts of

literature. More seemed like less: the wisdom of the great ancient texts was in danger of being buried under an avalanche of modern dross. The unity and intelligibility of learning was under threat. While some commentators revelled in an explosion of particulars, savouring the variety of myriad details that made up the fabric of modern learning, others looked back to a golden age whose order and manageability contrasted with the present, indiscriminate growth of information and lack of control over its distribution. Out of the publication revolution emerged questions that were to vex authors, critics and the public for the next 200 years: Who were the public? How could one affect their taste? How could you discipline and control them in the world of a free press? And how were you to reestablish firm boundaries in a culture which seemed in flux?

In the late eighteenth century writers and commentators had two responses to this dilemma. Many, like Samuel Johnson, devoted their efforts to works that gave shape and coherence to literature. As I show in Chapter 11, dictionaries, encyclopaedias, collections and critical histories helped to order and evaluate the proliferating genres of knowledge in ways that were not necessarily based on classical canons of taste. At the same time authors and critics wanted to influence and form the reading habits of the public. In the early eighteenth century this usually occurred in satires which tartly and sometimes viciously berated readers for their trivial and evanescent tastes and their neglect of works of lasting value. The nostalgic strain in this writing, the unexamined longing for a return to the mythical age of enlightened patronage, betrays a reluctance to accept the idea of a public outside a charmed circle of refined gentlemen.

By the second half of the century, however, authors had come to accept the public and realized that their independent standing depended on its support. A preface to the reader had become more important than a dedication to a patron. Authors bowed before a 'candid public, from whose judgment there is no appeal, and whose encouragement has never been wanting to further any attempt to promote THE PUBLIC GOOD'. They wooed and cajoled the public: the editor of a collection of verses published at mid-century claimed 'his Intention was to oblige the Publick, by shewing ... specimens of concealed GENIUS's [sic]' and asked 'to be pardoned by the Readers'; a magazine publisher in the 1780s told his readers, 'It is our place to *point out*, and to *submit* our author to the judgment of our readers.'

Johnson repeatedly confirmed the public's critical importance. As he wrote in a famous passage commenting on Thomas Gray's extremely popular 'Elegy written in a Country Church-Yard', 'in the character of his Elegy I rejoice to concur with the common reader; for by the common sense of readers uncorrupted with literary prejudices, after all the refinements of subtilty and the dogmatism of learning, must be finally decided all claim to poetical honours.' This was no casual remark but an instance of a repeated commitment to the public as the critical court of last resort. Writing in the *Rambler* No. 23, Johnson affirmed his view: 'There always lies an appeal from domestick criticism to a higher judicature, and the publick, which is never corrupted, nor often deceived, is to pass the final sentence upon literary claims.' Johnson saw his task as that of public instructor and educator who would teach the public to realize its better self. A discerning and tasteful public was all the more important because its support enabled writers to secure their independence from individual patrons like Lord Chesterfield.

Johnson was keenly aware that the growth in publishing had produced new ways of reading. He himself skipped and skimmed books, saw nothing wrong with beginning a book in the middle, and confessed that he often did not finish what he had begun. But on other occasions he could, as he himself put it, *'read like a Turk'*. Boswell recounts a dinner at a bookseller's in 1788 when Johnson read Charles Sheridan's *Account of the late Revolution in Sweden* 'ravenously, as if he devoured it, which was to all appearances his method of studying. "He knows how to read better than any one (said Mrs. Knowles); he gets at the substance of a book directly; he tears out the heart of it."' But he was also aware of the difficulty of reading with any care: 'People in general do not willingly read, if they can have any thing else to amuse them. There must be an external impulse; emulation, or vanity, or avarice . . . No man reads a book of science from pure inclination. The books that we do read with pleasure are light compositions, which contain a quick succession of events.' He was therefore less prone than some commentators to bemoan a general decline in reading standards. Ever the commercial realist, he knew that light literature could be the saving of authors of talent. But he did share the unease, common from the 1750s, about the novels and romances that seemed to be flooding the market.

John Brown, in his *Estimate of the Manners and Principles of the Time*, linked this sort of literature to frivolous reading:

Reading is now sunk at best into a Morning's *Amusement*; till the important Hour of Dress comes on. Books are no longer regarded as the Repositories of Taste and Knowledge; but are rather laid hold of, as a gentle Relaxation from the Tedious Round of Pleasure ... Thus it comes to pass, that Weekly Essays, amatory Plays and Novels, political Pamphlets, and books that revile Religion; together with a general *Hash* of these, served up in some *Monthly Mess* of *Dulness*, are the Meagre *literary Diet* of Town and Country.

Over the next fifty years such books, particularly novels and romances, were repeatedly condemned for encouraging this trivial and uninstructive reading.

Many instructional works, most addressed to the young and especially to girls, warned of the deleterious effects of novel-reading, and offered an alternative curriculum of history, geography, piety and improving essays. As the essayist, poet and Christian critic of Hume, James Beattie, wrote, 'A habit of reading them [novels] breeds dislike to history, and all the substantial parts of knowledge; withdraws the attention from nature, and truth; and fills the mind with extravagant thoughts, and too often with criminal propensities.' The author of *New and Elegant Amusements for the Ladies of Great Britain, by a Lady* (1772) urged young women to 'peruse the superior works of our finest Authors, such as Lord Lyttelton, Dr. Young, Dr. Goldsmith, Pope, Swift, Addison' and to avoid 'swarms of insipid Novels, destitute of sentiment, language, or morals', while a contributor to the conservative *Critical Review* complained: 'the booksellers, those pimps of literature, take care every winter to procure a sufficient quantity of tales, memoirs and romances for the entertainment of their customers, many of whom, not capable of distinguishing between good or bad, are mighty well satisfied with whatever is provided them: as their female readers in particular have voracious appetites, and are not over delicate in their choice of food, every thing that is new will go down.'

By the last years of the eighteenth century the female novel reader had become the epitome of the misguided reading public (fig. 70). She was depicted as filled with delusive ideas, swayed by false ideas of love and romance, unable to concentrate on serious matters – all of which would lead to frivolity, impulsiveness and possibly to sexual indiscretion. Such a woman embodied what critics saw as the literary marketplace rather than the literary public; as pure pleasure and the pursuit of private ends rather than as pleasure combined with moral virtue. But this figure

was, of course, a fiction. To judge from all we know about eighteenth-century readers – diaries, membership lists from circulating libraries and so on – the flighty novel-reader was just as likely to be male as female. And, as Anna Larpent's journal shows, reading romances did not necessarily produce moral degeneracy.

Yet the image of the young girl who loses her reasonableness, sometimes even her reason, and certainly control of her passions, became the focus of several anxieties. She represented the sort of unstable, morally feckless figure that a commercial culture threatened to produce but that authors and critics wanted to avoid. As critics like Johnson tried to establish their authority, they were threatened by the entrepreneurial initiatives, begun by proprietors of circulating libraries like Francis Noble, to sell large numbers of exciting and enervating romances. At the same time such literature and its readers had their uses for those who wanted to establish a literary hierarchy or standard. The romance and its reader defined what had to be avoided. They were both undesirable and necessary to the definition of a worthy reading public. The reader was not Johnson's common reader, but condemning her told the public what the common reader should be.

One such common reader was Anna Larpent. Her journal, begun in 1773, provides a unique record of an eighteenth-century reader, for in it she not only listed everything that she read, but frequently described the circumstances of her reading and her opinion of what she had read. The first ten years of her diary record her reading more than 440 titles, including forty-six works of English fiction, notably the sentimental novels by women authors that critics condemned. Works by Rousseau, Marivaux, Marmontel and Voltaire were among the twenty-two French novels she completed. Corneille dominated her reading of French drama – thirty-six plays in all – just as Shakespeare towered over other British playwrights. She read more than sixty histories, biographies and works of political economy, including Gibbon, Hume and Adam Smith, and forty-five volumes of *belles-lettres*, including Pope, Johnson, Boileau, Dubos, Swift and Lord Chesterfield. The English poetic classics did not escape her attention: Milton, Gay, Pope, Thomson, Young and Gray. She liked classical literature, which she read in either English or Italian, and did not neglect travel literature and natural philosophy. In addition she constantly read the Bible and repeatedly returned to her favourite sermons and pious tracts.

Larpent borrowed books from circulating libraries and from friends; she bought even more for her family library. She read at all times of day and in many different ways, treating different sorts of books with differing degrees of seriousness. She made a distinction between reading 'in a followed manner' and the more superficial perusal of a text. In the mornings, when she read the Bible or a work of piety, she read alone, in silence, and often reread works or passages with which she was very familiar. This private reading she never records having discussed with others. Though she also read serious secular works alone and with what she called 'humble attention', they were nevertheless part of genteel social life; she regularly talked about them with her own family and friends. She read novels and lighter works while a servant was dressing her hair or while out walking; she used fiction as a distraction as when, during the illness of one of her boys, she took up a novel, 'which just dissipated my Mind now and then'. But for most of the time her reading was purposive. She read French history, writing digests of what she had learned, in order to help her stepson, Seymour, while he was at school. When she started attending art exhibitions in the 1780s, she ploughed her way through the critical works of Joshua Reynolds, Allan Ramsay,

70. *The Novel* by James Northcote, engraved by James Parker, 1787. An illustration to William Hayley's poem 'The Triumphs of Temper':

Beneath the pillow, not completely hid,
The novel lay – She saw – She seiz'd – She chid;
With rage and glee her glaring eye-balls flash,
Ah wicked age! She cries, ah filthy trash!

Alexander Cozens, Mark Akenside and the Earl of Shaftesbury. An introduction to the Forsters, father and son – who, together with Sir Joseph Banks, played an important part in the botanical investigation of the South Seas – led her to read most of the available accounts of the voyages of Captain Cook. Her interest in flower painting nurtured her reading in botany. And, above all, the French Revolution stimulated voracious reading into French affairs in the early 1790s.

Larpent often read aloud, not only to her children but to her husband, who in turn read to her and to the entire household, including servants. Such readings were intended to stimulate discussion. In October 1792, for example, the Larpents were reading Joseph Priestley on *The Origin of Government*, 'rather to lead to conversation & observation than as a followed reading'. In a lighter vein, novels and plays were read and discussed 'in the family circle' of children and servants. Such readings were also common with friends: at a country-house party in the summer of 1780 Larpent and other guests read aloud extracts from Rolin's *Histoire Ancienne*, Marivaux's *Marianne* and a comedy by Henry Kelly, *School for Wives*.

The overriding impression from Larpent's diary is of the ubiquity of books. They entertain, instruct and amuse, bind together family and friends, create a common culture even as they reveal polemic and contro-versy. This situation, made possible by publishers and libraries, authors and book clubs, was comparatively new. It is impossible to imagine someone in the seventeenth century, regardless of their social position, being able to live this kind of literary life. No matter how well educated and no matter how readily they had access to books, they could not have obtained the number and variety of printed materials which Larpent secured with such apparent ease. And, though they might have had ready access to biblical, theological, classical, historical and polemical literature, other kinds – such as the novel, the periodical, the 'how to' book, classics in translation, works of literary criticism – would have been either unob-tainable or in very short supply. Readers had acquired privileges undreamt of a century earlier.

Anna Larpent was not, of course, a typical eighteenth-century reader. It took exceptional dedication to read so many books and record her reaction to them so meticulously. But she did personify the sort of 'common reader' that Johnson and other critics hoped would make up the reading public. She was the very opposite of the imagined 'woman

reader' – feckless, uncritical, volatile; she read widely but critically. She read romantic novels, but she knew the perils of being swept away by their sentiments: 'It is not right', she recorded in 1774, 'to encourage a taste for novels – they are too seducing, too trivial, too dangerous.' She knew their hazards not only because she had experienced them but because she had also read the critical works whose purpose was to teach her how to read differently, how to engage – in the words of a tract by Hannah More, which Larpent read in 1779 – in 'Serious study', to 'harden the mind' and lift 'the reader from sensation to Intellect'. Unlike the female stereotype, she read works of philosophy, criticism and politics. And, even when she was doubtful that she could adjudicate difficult issues, she persisted in her desire for refinement and self-improvement: 'I never throw aside a book because it makes me feel an ignorance I am ashamed of from its being one belonging to my Sphere as a female. I read on with humble attention & often reap much information from the mere introductions to scholars.' Anna Larpent had absorbed the lessons that Johnson and his colleagues wished to teach. She had become an exemplary modern reader, provided with an astonishing range of literature yet guided by the critic and deferential to the authority of authors.

III

PAINT

CHAPTER FIVE

The Market and the Academy

JOSEPH HIGHMORE, a twenty-two-year-old law student who was to become a successful portrait painter and illustrator of the works of his friend Samuel Richardson, was taken in 1714 to the house of a painter named Vanderstraeten in Drury Lane. In his painting room at the top of the house the Dutch artist had large pans of paint containing what he called 'cloud colour', blues and whites, as well as greens, reds and browns. 'He hired a long garret,' commented Highmore, 'where he painted cloths many feet in length . . . and painted the whole at once, continuing the sky . . . from one end to the other, and then several grounds etc., til the whole was one long landscape. This he cut and sold by parcels as demanded to fit chimnies etc., and those who dealt in this way would go to his house and buy three or four, or any number of feet of landscapes.' Despite the mechanical nature of his task, the painter impressed Highmore: 'And notwithstanding they were so slight even these pictures were not altogether devoid of merit, for he had something like genius and taste . . . and did all that could be done in the time he allowed himself. He was the first man I ever saw paint, and I may perhaps be partial to him on that account, having had great pleasure when young in visiting him.' Vanderstraeten's labours inspired Highmore: within a year he had left his legal studies, set up as a portrait painter and begun to attend the academy of art founded in 1711 by Sir Godfrey Kneller, Principal Painter to the king.

Highmore's first acquaintance with painting reveals much about the state of the British art market at the beginning of the eighteenth century. The first painter he met was a Dutchman; his first teacher, Kneller, was a German from Lübeck. The production of art in London was dominated by foreigners – French and Italian decorative painters, Dutch engravers and landscape painters, portrait painters from Sweden to Austria. In

1714 there was little or no English tradition of painting, though eventually Highmore contributed valuably to creating one.

As Vanderstraeten's piece-work reveals, art was a commodity whose chief market was the private patron or, perhaps more aptly, customer – a gentleman, merchant or member of the professions – who wanted painting as a form of decoration, as what at the time was often described as 'furniture'. The social standing of the people who commissioned pictures – whether landscapes, portraits or some sort of decorative work – varied greatly, but the function of the pictures was the same: they were intended for private use, not public exhibition.

Vanderstraeten's address and circumstances – in a garret near Drury Lane – is significant: poor rewards and low status were the lot of most modern painters. For the fruits of the art market went in the first instance to the dealer, not the artist; large profits were made through the sale of 'Old Masters', only in exceptional circumstances by contemporary painters. The Dutch painter, as the well-read Highmore was no doubt aware, resembled the Grub Street hack. He produced a commodity for a price; worked for hire, and he lived and worked on the top storey of a building in a district famous for its whoring, squalor and crime.

Highmore's anecdote reminds us that the history of the art market and of British painting in the eighteenth century had two distinct phases. The first saw the growth of a market for painting; the second, beginning in the 1750s, saw the development of a *public*. First there was an astonishing growth in the trade in pictures, then a proliferation of public exhibitions and venues for art. And, of course, the growth of an art public depended, in the first instance, on a lively and well-developed trade. But the nature of the British art world that blossomed in the second half of the century was decided less by market forces than by the outcome of a struggle among dealers, painters and collectors to shape it. The attempt to create a public for art – to form its taste and direct its interests – was part and parcel of a conflict over who should decide what was great art and who should be the arbiters of public taste.

Two features of the growth of the British art market at the beginning of the century stand out: its speed and its focus on Old Masters and works of classical antiquity. This was a market that depended on plunder from Europe. Between the 1720s and the 1770s many classical antiquities,

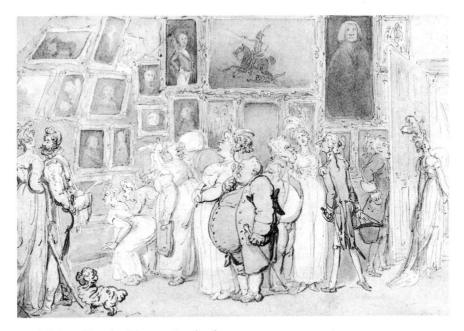

71. *A Private View* by Thomas Rowlandson

as many as 50,000 paintings, and half a million etchings and engravings were imported into Britain from Italy, France and Holland. In a boom year like 1725 more than 330 pictures arrived from Italy, almost 200 from France, more than 120 from Holland, thirty-three from Flanders and forty-seven from the Netherlands; total imports amounted to 762 canvases. In the same year more than 3,000 prints were imported from France, nearly 2,000 from Holland and almost 6,000 from Italy.

Private collectors brought home some of these pictures and prints, but most were the property of dealers, men like Thomas Maby, a landscape painter who bought a collection of pictures in Italy and auctioned 168 of them in London in 1686. Europe was thick with these international traffickers in works of art. In Rome alone no fewer than twenty-six English and Scottish painters were buying and selling pictures to subsidize their studies and curry favour with patrons back home. What began as individual speculative ventures blossomed into a heavily capitalized trade run by business consortia. Dealers like Andrew Hay, who made fifteen trips to France and six to Italy in the first half of the century, traded on their own account; the equivalent business in the 1790s, like that done by a group set up by William Buchanan, an Edinburgh lawyer,

had two rich financial backers, Alexander Gordon and Champerdowne of Dartington, as well as its own artist-dealer in Rome.

The size and sophistication of these enterprises was due in large part to the fierce competition among leading aristocrats and royalty for the greatest works of fine art. Every European prince and noble wanted paintings by Raphael, Titian and Rubens to hang in the galleries of his palaces and houses. One important consequence of the French Revolution and the wars it brought in its wake was an unprecedented dispersal of the major treasures in French and Italian art collections. The British collector – and therefore the British dealer – was the chief beneficiary, being able to acquire excellent pictures at favourable prices.

International dealers reached their clientele by several means. They bought abroad on private commission, sold in London from their residences and shops, traded with domestic dealers and, above all, used auction houses to disperse their wares. From the 1680s the auctions grew apace: in that decade alone there were more than 400. By the mid-eighteenth century five or ten major picture auctions were held every year. Between 1711 and 1760 more than 25,000 pictures were sold under the hammer. Towards the end of the century, and thanks to the efforts of the likes of James Christie, the centre of the European art market had shifted from Amsterdam to London (fig. 72).

What explains this development? Much of the answer lies in the collapse of legal controls on the trade in painting. Before the Glorious Revolution of 1688 the British market for painting, like the market for print, was subject to a series of restrictions: it was illegal to import foreign art (a law admittedly honoured in the breach as much as in the observance), sales and auctions were the monopoly of the corporation of the city of London, and painting itself was controlled by a city guild, the Company of Painter Stainers. By the time Queen Anne was on the throne all these constraints had been swept away. The ban on the import of pictures, which had been a dead letter since the 1680s, was ended in 1696; auctions proliferated illegally within the city of London and legally outside its boundaries, especially in Covent Garden; and the Company of Painter Stainers found it impossible to maintain its legal monopoly.

The rapidity with which the market grew attests to a pent-up demand for European painting and an acquisitiveness that were satisfied only when controls were lifted. This enthusiasm for art extended down the social scale. Though rich aristocrats made the most spectacular purchases,

72. *The Specious Orator*
(James Christie) by Robert
Dighton, 1794, captioned
'Will your Ladyship do me
the honor to say £50-000
– A mere trifle – A
brilliant of the first water.'

many clients were of much humbler origin. More than half of the painter-dealer Arthur Pond's customers were men below the rank of esquire, from the professions and from the higher ranks of trade and commerce.

The depth of the market is partly explained by the low prices of most pictures. The average price of paintings sold between 1738 and 1745 by Andrew Hay ranged between £7. 15*s*. and £11. 5*s*. At the sale of the effects of 'a gentleman, now upon his Travels to Italy' organized by the auctioneer Samuel Paterson in 1759, no picture fetched more than a pound, and all fetched lower prices than the miniatures, bronzes and curiosities that were part of the same auction. Compared with other luxuries, most old pictures were cheap. Only the most famous names like Raphael and Guido Reni commanded high prices.

At the same time few contemporary artists, and even fewer *British* artists, were exhibited in dealers' shops or sold at auction. The trade was not in the modern and the new, but in 'Old Masters' of the Renaissance and the seventeenth century (and in modern European copies of these), which seemed, in a way that much contemporary art did not, to live up to prevailing ideas of what constituted great art.

Great art, as connoisseurs and commentators understood it, did not please the viewer through a skilful imitation of the observable world but offered instruction by depicting universal ideas and ideals. Portraiture, landscapes and genre scenes of everyday life were therefore lesser forms of painting because they represented particular things; so-called history painting was the noblest art because it portrayed general truths. The former copied nature, the latter represented a higher, idealized Nature, and the great artist was less a technician than a philosopher and moralist. The equivalent of epic in poetry and tragedy in theatre, history painting usually represented a crucial moment of moral choice, often derived from a classical or biblical source – the most popular eighteenth-century example being that of Hercules choosing between Virtue and Vice. A proper subject for fine art was not the portrait of a wife or uncle, much less a tavern scene, but such pregnant moments as the death of Germanicus or Cleopatra.

Much Renaissance and seventeenth-century Italian art – the works of Raphael, Michelangelo, Domenichino, Guercino, Guido Reni and Nicolas Poussin – accorded with this view. Judged by critical standards that derived from French classical criticism and which canonized history painting, these Italian pictures were considered the apogee of art. Collectors and connoisseurs preferred to travel to Europe to view them rather than support native exhibitions. Committed to classical aesthetics and criticism, sure of the conspicuous virtues of the antique, and familiar with the language and literature of classical civilization, English gentlemen sharpened their predilections on the Grand Tour. Though the number of Englishmen (and women) who went on the Grand Tour was never great, it included more and more people whose wealth and power enabled them to act as patrons of the arts and as arbiters of taste.

As the numbers of tourists increased, the nature of the tour changed. What had begun as a male rite of passage became an edifying family holiday. The first Grand Tourists were aristocratic young men, usually accompanied by a *cicerone* or tutor, who ventured to the continent as part of their education in politics, diplomacy, languages and culture. They studied at learned academies in France (those on the Loire were especially favoured for the purity of their French diction), then visited the major sites of Italy, remaining abroad for up to three years. But over the century the tourist population diversified and the tour itself became shorter. Entire families, young women and old men would travel to Italy

for only a few months. Many undertook more than one tour. The drudgery of Loire academies was deserted for the pleasures of Alpine scenery. Prosperous burghers and minor gentry, members of the professions – including most notably painters and architects – joined refined patricians at the European inns and auberges, taverns and coffee houses catering to the tourist trade.

The tour confirmed for these visitors that classical antiquity was the exemplum of good taste, that the High Renaissance and the reign of Pope Julius II was the artistic apogee of the modern era, and that all who aspired to great art had to be familiar with the treasures of Italy. These tourists, in other words, acquired a history of art and a prescriptive criticism; they also, it should be added, acquired a good deal of cultural booty to support their views. On their return to Britain they built galleries to house their classical sculpture like that at Holkham Hall, and picture and print cabinets such as William Windham's at Felbrigg to show off collections acquired during the Grand Tour.

Many British artists found this taste for the antique and the foreign, together with the connoisseurship surrounding it, unhelpful, but few were as outspoken as Hogarth. Like Jonathan Richardson, they thought they had to come to terms with prevailing taste rather than subvert it. They might agree with Hogarth that the hegemony of Italy and antiquity was a burden, but they preferred 'the anxiety of influence' to all-out patricide. Thus, on the one hand they complained constantly about the ill effects of the tour: the Grand Tourists, wrote a correspondent of George Romney's,

> walk thro' palaces of pictures with as much edification as a boarding school girl would thro' a museum, or an upholderer thro' the Vatican. They have been told of the *gusto* of the *antique*, but where to find it, or how to distinguish it, they know no more than their mothers: Virtu however is to be purchased, like other superfluities, and in the end their *Cicerone* lays them in for a bargain, perhaps a patchwork head of *Trajan* set upon a modern pair of shoulders, and made up with *Caracalla's* nose and *Nero's* ears . . . Thus equipt with these imperial reliques, with a veritable daubing of *Raffaelle*, copied from the very print which is given to prove its originality, and a huge *cameo*, on a little finger, home they come privileg'd *Virtuosi*, qualified to condemn every thing that their own countrymen can produce [fig.73].

On the other hand, almost every one of them aspired to go to Italy and many of the most successful managed to do so. While they were there they copied masterpieces for English clients or traded in the painting whose inflated values undercut their own livelihood.

Collectors and critics who had been on the Grand Tour compared the art they had seen with the work of contemporary British painters and found the latter lacking technical skill and, above all, nobility of conception. These faults were usually explained by the inadequacy of artistic instruction in England and by the nature of the British political system. There was much to support this argument. No indigenous tradition of painting, apart from work in miniature, had flourished in England before the seventeenth century. No painting academy had lasted any length of time; royal and noble patrons patronized and collected Flemish, Dutch and Italian art; there was no domestic art market. The splendours of European painting were confined to a small number of magnificent collections, most notably those of Charles I, the Earl of Arundel and the Duke of Buckingham.

Then the defeat of the crown, the execution of the king and the costs of civil conflict dispersed these few great collections, and the Puritan regime reinforced the longstanding Protestant hostility to images. Commentators as diverse as William Hogarth and Horace Walpole agreed that the political struggles of the seventeenth century and the absence of a powerful centralized state did not encourage the patronage of the visual arts by crown and church. Britain was not a good place for a painter.

But this is only part of the story. British artists had failed to produce works as great as those of Michelangelo, Titian or even Guido Reni not only because they were untrained and unsupported by royal or ecclesiastical patronage, but because they could make a living doing much less elevated work – portraits, landscapes and decoration – and be paid staple commissions by prosperous traders, merchants and members of the British gentry and nobility.

The shape of this market – if it was a market at all – was altogether different from the trade in Old Masters. Most of the work was commissioned for a particular client, very little of it had resale value and few paintings ever appeared on the open market. Artists produced a customized commodity designed to cater to the whims and predilections of its commissioner. It was therefore unlikely that such painting would have much appeal to anyone other than the original client or his family.

73. One of the many satires on the grand tourist. *Cavaliere Inglese Dilettanti dell Antichità (Joseph Henry of Straffan, County Kildare)* by Pier Leone Ghezzi, *c.* 1750

This was especially true of the most common contemporary art work, the portrait. As many commentators remarked, bemoaning the narrow preoccupations of patrons, the English were infatuated with 'face painting': they filled their houses with portraits, gave portraits as gifts and used any number of occasions to sit for their picture. Any important moment in life was commemorated with a portrait: marriage, election to a club (including parliament), acquisition of an inheritance or a singular achievement for the men; coming of age, acquiring a lover, husband or family for women. Many paintings were commissioned not by the sitter but by relatives, spouses and friends. Frequently more than one was made and the copies were sent as gifts to friends, or as tokens of love and esteem to relatives. Miniatures worn as lockets and bracelets were similarly exchanged among family and friends.

A portrait of your husband, aunt, nephew or close friend and club companion, once commissioned, painted and paid for, hung in a family

portrait gallery, dressing room or parlour. It never really entered or left the art market and it was not acquired as a work of art or as a speculative investment. Occasionally such paintings were sold because of bankruptcy or death, but usually they remained within the family that had first commissioned them. And when they were sold, they fetched far less than the fee that had been paid for their original commission. This is unsurprising: why should anyone wish to purchase a picture of another person's uncle or aunt?

Different constraints kept other modern art out of the marketplace. Decorative painting was, by its very nature, largely immobile. Much English landscape painting in the early eighteenth century depicted not a generalized view but a particular place. It reflected the interests and often represented the property of the person who had commissioned it. Conversation pictures, which became fashionable in the 1730s, combined portraiture with landed and movable possessions. The British artist's chief and most lucrative employment was not therefore to represent some universal truth but to create a particular image on demand. The painter, then, was considered not as a creative figure but as a skilled craftsman, a 'mere mechanic', rendering in paint the aims and aspirations of his patron.

The fact that a painter dealt with 'things' rather than ideas meant that, according to most contemporary art theory, he was not qualified to judge the quality of art. Eighteenth-century criticism, which was literary and classical in tenor, conferred interpretative power not on artists, but on those whose classical learning and social standing enabled them to take a 'liberal' view of art. As one aristocratic commentator put it, 'the TASTE of Beauty', 'perfects the *character* of the GENTLEMAN'. The tactile and tangible world of colours and paint and the technical processes of putting paint on canvas were deemed far less important than the breadth of vision and critical acumen conferred by familiarity with classical civilization and its literatures. And if the material world of paint tainted artists, so too did their need for filthy lucre. It was thought that having to work for a living compromised the painter's capacity for a noble vision of art; he lacked the financial independence which ensured that his judgement would not be clouded by sordid considerations such as individual advancement or personal gain.

These attitudes were exemplified in the views of one of the most influential critics of the early eighteenth century, Anthony Ashley Cooper,

third Earl of Shaftesbury. He spoke of modern British artists as 'illiterate, vulgar and scarce sober', and instructed painters like John Closterman and the Neapolitan Paolo de Matteis about the composition and iconography of his portraits. He restricted their creative scope, treating them simply as the means by which to realize his own sense of what his portrait meant.

Modern painters, especially modern English painters, were therefore often viewed as marginalized figures in the early eighteenth century, dismissed by gentlemen patrons and collectors as 'mechanics' performing a 'servile art'. Largely excluded from the most rapidly expanding sector of the art market, and subordinated to the wishes of patrons, a painter laboured under the disadvantage that his training and background did not equip him to contend with prevailing aesthetic theory. Few painters had a classical education, even fewer had seen the great art works of classical antiquity and Renaissance Europe; their social origins were rarely genteel and more often than not were to be found in trade. Hogarth's father was a schoolmaster and hack, but William himself began as a commercial engraver; the portraitist Francis Cotes's father was an apothecary, Gainsborough's ran a wool manufactory, Romney's was a cabinet-maker and James Northcote's a watchmaker. A few painters, including Reynolds (the son of a cleric) and Richard Wilson, came from gentry families, but they were the exception rather than the rule. The great question for eighteenth-century English painters was therefore how to position themselves in relation to the classical tradition and its critical heritage. Were they to reject it, to embrace it wholeheartedly, or to shape it to their own ends? And how were they to reconcile the pressures of their marketplace – for portraits, pleasant landscapes and decorative art – with the high-minded injunction, reiterated in manuals on connoisseurship and art, to reproduce the virtues of classical history painting, to represent a critical moment from ancient or biblical history which aimed to edify and instruct?

The range of responses to these questions is exemplified in the careers of two painters, William Hogarth and Jonathan Richardson, who took diametrically opposite positions: Hogarth attacked the classical aesthetic and the social institutions that sustained it; Richardson was an assimilationist, seeking to incorporate them into the life of the modern painter.

Hogarth's criticisms were levelled on a broad front. He poured scorn on picture dealers who fed the fashionable appetite for old and foreign

painting; in both word and image he attacked them for their compounded ignorance and duplicity, and for their unwillingness to patronize native artists (fig. 74). In a letter signed 'Brito-phil', published in the *St James's Evening Post* of June 1737 in response to an article that compared British art unfavourably with the French, Hogarth lashed out at

> those . . . *Picture-Jobbers from abroad*, who are always ready to raise a great Cry in the Prints, whenever they think their Craft is in Danger; and indeed it is in their Interest to depreciate every *English* Work, as hurtful to their Trade, of continually importing Ship Loads of dead *Christs*, *Holy Families*, *Madona's* [sic], and other dismal Dark Subjects, neither entertaining nor Ornamental; on which they scrawl the terrible cramp [sic] Names of some *Italian* Masters, and fix on us poor *Englishmen*, the Character of *Universal Dupes*.

In seeking new places to exhibit art – the commercial space of Vauxhall Gardens, and the public-spirited space of the London Foundling Hospital

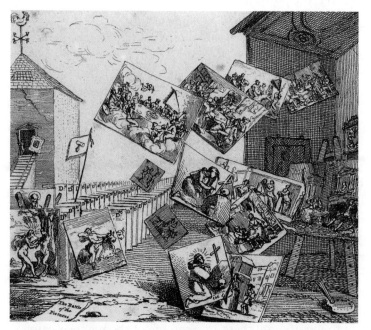

74. *The Battle of the Pictures* by William Hogarth. Copies of Old Master paintings lined up on the left attack and destroy Hogarth's paintings in this ticket for the auction of his pictures in 1745

– Hogarth tried to escape from the control of the dealers and reach the public directly. This did not mean, however, that he was anti-commercial or that he wished to conceal the origins of much painting in trade. On the contrary, he revelled in the world of commercial art, spending his time with theatrical scene-painters, skilled craftsmen and engravers, defiantly hanging a sign (a sure indication of art as a trade) outside his house in Leicester Fields, and even, at the end of his life, deliberately contributing to exhibitions of signboard painters held in 1761 and 1762.

As an unapologetic advocate of English art, Hogarth repeatedly criticized connoisseurship and its preoccupation with Italy, patriotically claiming, 'Everything requisite to compleat the consummate painter or sculptor may [be had] with the utmost ease without going out of London at this time going to study abroad is an errant farce and more likely to confound a true genious [sic] than to improve him.' Painters like William Kent, who returned from Italy with Italian manners as well as Italian taste, excited the contempt of an artist who was determined to found an English school.

But how was a native school of art to be formed? The usual answer was advocacy of a royal academy of art. Hogarth, however, believed that this would only compound the nation's artistic ills. He wanted artistic standards to emerge from the practice of artists, not to be imposed by a privileged body acting as an arbiter of taste. The very idea of such an institution was, in his eyes, exclusive and un-English, smacking of the regal academies of French absolutism. A native school could be nurtured only by a democratic professional association of practitioners such as his own academy in St Martin's Lane: 'I proposed that every member should contribute an equal sum to the establishment, and have an equal right to vote in every question relative to the society. As to electing Presidents, Directors, Professors etc., I considered it was a ridiculous imitation of the foolish parade of the French academy ... superior and inferior among artists should be avoided.' He was convinced that an academy would never succeed if it aped the attitudes of a club of discerning gentlemen or was an adjunct of the royal court.

Hogarth's aesthetic views complemented his criticism of the art world. In place of a classical aesthetic based on a hierarchy of genres and the idealization of nature, his aesthetic subverted them: it was modern, formal and firmly rooted in observable experience; it could not be acquired by following academic rules but was a matter of individual

talent and genius. Great art should look to the present, not the past. The transient particularities of modern-day life – commercial signboards, modern prints and topical allusions repeatedly turn up in his print series *A Harlot's Progress* (1732), *Industry and Idleness* (1747), and *The Four Stages of Cruelty* (1751) – were not frivolous distractions but a means to persuade viewers of moral truths. The representation in engraving of the contemporary, the observable and the tangible – the dirt and degradation of modern city life – could be used both aesthetically and morally. Hogarth mercilessly satirized an aesthetic that claimed dead statuary was more beautiful than a living young girl. 'Who', he wrote in *The Analysis of Beauty*, 'but a bigot, even to the antique, will say that he has not seen faces and necks, hands and arms in living women, that even the Grecian Venus doth but coarsely imitate.' He even sought to demystify the power of earlier great history painters by producing *Sigismunda* (1761), a tragic figure from Boccaccio's *Decameron*, which he claimed to prove that modern English artists could produce history paintings every bit as good as their predecessors' art if they were so inclined.

Hogarth's campaign was not successful. *The Analysis of Beauty*, his major treatise on aesthetics, met with a poor reception, not least from fellow artists; his painting of Sigismunda was rejected by Sir Richard Grosvenor, who had commissioned it, and was so criticized at the Society of Artists exhibition of 1761 that he withdrew it; and, though he was able to outwit dealers and pirates in the print trade, he did not succeed in liberating the painter from the shop. Despite his extraordinary popularity, which extended from epicene collectors like Horace Walpole to pot-boys and apprentices, Hogarth was unable to reshape the course of English painting. His impact on the generation of artists who trained at his St Martin's Lane Academy was considerable; the genres and forms he developed continued to be reproduced by subsequent painters and engravers; his prints (though not his painting) remained popular throughout the century. But the story of his life and how it expressed his critical values did not provide a narrative on which the tale of the successful artist might be based. He was too radical, too much a pugnacious individualist and too little a traditionalist. His vision of arts outlasted his death in 1764, but was marginalized, as we shall see, by the triumph of the Royal Academy, an institution whose aspirations were totally at odds with his views. In his last years Hogarth's increasingly cantankerous and curmudgeonly conduct alienated even his old friends and left him

isolated. Many artists realized that it would take more than one man to change the views of the entire class who patronized painters and collected art. A more conciliatory approach was required.

This was the tack taken by Jonathan Richardson, a portrait painter trained in the studio of John Riley, Principal Painter to the monarchs William and Mary (fig. 75). Richardson embraced rather than rejected the culture of the connoisseur. His three essays – *An Essay on the Theory of Painting* (1715), *An Essay on the whole art of criticism, as it relates to Painting* and *An Argument in behalf of the Science of a Connoisseur* (1719) – became standard works of art criticism, reprinted in 1725, 1773 and 1792. And, together with his son, Jonathan Richardson the younger, who was also a painter, he produced the first English guide to the treasures of Europe in their *Account of the Statues and Bas-reliefs, Drawings and Pictures in Italy, France etc, with remarks* (1722), a work that excited the grudging admiration of the greatest eighteenth-century connoisseur in Europe, Johann Joachim Winckelmann.

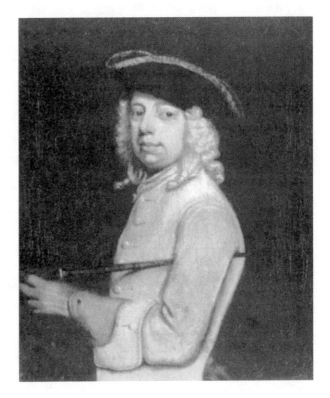

75. Self-portrait by Jonathan Richardson Snr, 1737 or after

Richardson's criticism was not particularly original. Its tenets were those of French classicism, borrowed from such critics as Roger de Piles, whose *The Art of Painting, and the Lives of the Painters* had been translated into English in 1706. Richardson placed history painting at the pinnacle of art, and, in a telling contrast between Raphael and Dürer, made clear that he regarded the generality and beauty associated with the Italian schools as far more important than the particularity and literal truth characteristic of their north European counterparts.

The commonplace, derivative quality of much of Richardson's commentary should not detract from its considerable achievements. In a manner that was noticeably different from the haphazard, confused format of earlier English works on painting, he provided a systematic and orderly survey of the several branches of art. He discussed painting philosophically, as an issue of the understanding; he urged that art should be studied historically; and he made painting a proper object of rigorous criticism. He then extended his approach in the pages of his European guide.

Of equal importance to Richardson's effort to introduce system into art criticism was his claim, which his life and work exemplified, that the painter could be just as important as a critic and judge as any gentleman collector. The liberty that aristocratic critics like the Earl of Shaftesbury considered to be their special prerogative, Richardson claimed as the property of any reasonable man. He was sensitive to the potentially compromising position of those who earned a living from painting, but he was also sure that their circumstances did not preclude them from acquiring the 'magnanimity' that produced great art. Indeed, in a famous passage in *The Theory of Painting* he issued a clarion call to English painters of the future: 'I cannot forbear wishing that some younger painter than myself, and one who has had greater and more early advantages would exert himself, and practice the magnanimity I have been recommending, in this single instance of attempting and hoping only to equal the greatest masters of whatsoever age or nation.' Richardson saw the worlds of the connoisseur and the painter as potentially complementary rather than inevitably antipathetic; he spent much of his life addressing the genteel traveller and noble connoisseur but did so on behalf of painters.

Richardson's life exemplified this belief that the trade of painter was not incompatible with the role of connoisseur. He built up one of the

finest collections of Old Master drawings in England, most of which was sold after his death for more than £2,000, an exceptional sum for the 1740s. Many of these works were purchased by his pupil and son-in-law Thomas Hudson and eventually found their way into the collections of Joshua Reynolds (Hudson's pupil) and of Thomas Lawrence. But Richardson's inheritance was more than a material one: as the first British artist, critic and connoisseur, as a modern painter who wrote and spoke knowledgeably about classical antiquity, as an artist who reconciled Old Masters and modern art, and as a painter who cultivated the company of important literary men (he was a close friend of Pope, Prior and Gay), he served as the model to which Reynolds was to aspire.

Though Richardson possessed almost all the qualities to be the successful painter he described, he lacked one crucial attribute: he did not change his matter or manner of painting to mirror the theory he supported. He remained a provincial English portraitist, working in a subordinate genre. He saw how the modern artist could reinvent himself to conform to academic and classical standards, but he did not accomplish this feat himself. He wrote the script, but it was Joshua Reynolds, in very different circumstances, who first acted it out.

By the 1750s it was apparent that English artists were following the path delineated by Richardson rather than the trail blazed by Hogarth. The signs were everywhere. More and more English painters seemed to accept the importance of history painting. This did not at first produce a plethora of historical pictures, for they lacked the experience and financial support to embark on such large-scale projects, but it began a long litany of dissatisfaction with the unwillingness of British patrons to commission history painting. As a commentator in the *London Chronicle* complained, 'such is the mean vanity and selfishness of the age, that most of our great personages would rather give two or three hundred pounds for their own dear likeness, than one half, or even one third of that sum for the noblest historical picture that was ever produced.'

Painters also set about redescribing the other genres with which they were familiar as if they were history. The most conspicuous example of this elevation of a more mundane genre was the attempt, first mooted by Richardson, to argue that portraiture was 'a species of history painting' because, as he put it, it was 'a sort of General History of the Life of the Person it represents'. Another sign was the enthusiastic reception of Joshua Reynolds and Richard Wilson on their return from Italy (1753

and 1757), the former for his 'Grand Manner' derived, it was claimed, from Michelangelo, the latter for a new style of landscape painting capable of Italianizing such unlatinate spots as north Wales. The success of these artists enormously increased the pressures on other painters to undertake the Grand Tour; from mid-century onwards the number of British artists who made the pilgrimage to the continent grew enormously. Last but not least, voices within the community of artists demanded the establishment of an academy – not merely a professional association, in the manner of Hogarth, but an exhibiting and teaching institution that would form public taste.

It was gradually dawning on British painters that, in order to escape the commercial control of the dealer and the interpretative power of the commissioning patron, they had to create their own public. Their problems and frustrations were well expressed in the title of a tart, anonymous pamphlet of 1761 by 'T. B.':

> A Call to the CONNOISSEURS, or DECISIONS of SENSE, with respect to the PRESENT STATE of PAINTING and SCULPTURE and their several PROFESSORS in these KINGDOMS, together with a REVIEW of, and an EXAMINATION into, their comparative MERITS and EXCELLENCIES. Intended to vindicate GENIUS and ABILITIES of the ARTISTS of our COUNTRY from the MALEVOLENCE of the pretended CONNOISSEURS or interested DEALERS.

Artists faced two dilemmas, one of access – how were they to reach the public? – and the other of interpretation – how were they to assert their authority over others? The answer to these problems – and, as we shall see, it was a controversial one – was the foundation of the Royal Academy in 1768.

The Academy fundamentally changed the character of the London art world; it created a brand-new environment for looking at art, one that was controlled by the leading painters of the day. The significance of this innovation is quickly apparent when we reflect on how very hard it had been for painters to exhibit to the public before this.

If you were an avid admirer of painting or an artist eager to learn from the works of great painters, past and present, where in early eighteenth-century Britain could you have gone to see painting? Britain had few of

the sites that one could find elsewhere in Europe. The comparative weakness of monarch and church and the earlier iconoclasm of the English Reformation and the civil wars meant that Britain's palaces, public buildings and churches were not elaborately decorated with works that celebrated the power, beneficence and taste of reigning kings and queens or the beauties of the Christian religion.

As we have seen, no new royal palace was built between the abortive project of Sir Christopher Wren to create a rural equivalent to Versailles for Charles II at Winchester (stopped in 1685) and the radical rebuilding of Buckingham House by George IV in 1825. The largest public building project of this period was Sir William Chambers's new Somerset House, not a palace but a government office building, indeed the one in which the Royal Academy was to be housed. Nor was it easy to see works of art in the royal collections. The most important royal purchase of art in the eighteenth century was George III's acquisition of the collection of the Venice-based merchant and diplomat Consul Joseph Smith, which included works by Canaletto, Zuccarelli and Rosalba Carriera, but these were hung in Buckingham House, which George treated as a private residence, accessible to only a few court officials and the occasional favoured guest. Nor did George normally permit artists to copy materials from the royal collections; he took the view that, once he gave one artist the privilege, he would be inundated with requests.

And there were few pictures in ecclesiastical buildings. Painted altar-pieces were viewed as papistical; ecclesiastical decoration and painting were persistently opposed not only by Dissenters but by the Anglican episcopacy. Though a number of paintings were placed in churches during the century and Reynolds designed stained-glass windows for New College, Oxford, the church hierarchy put paid to the most ambitious schemes, like the Royal Academy's plans for completing Thornhill's decoration of St Paul's. One could not perambulate London, as one could Rome, and admire a wealth of princely and ecclesiastical art.

Of course, many fine works of art were to be found in the collections of the English aristocracy. A century before, the most common form of wall covering had been the tapestry, but by the mid-eighteenth century the threaded images produced in Spitalfields and Paris had been replaced by paintings. At first these were usually kept in town houses. Most of the great collection accumulated by Sir Robert Walpole, and subsequently purchased by Catherine the Great, was housed not at his mansion at

Houghton in Norfolk, but in his London residences; an inventory of 1736 itemizes 114 pictures at Houghton, but 149 were in Downing Street, sixty-four in Grosvenor Street, and seventy-eight in his suburban retreat in Chelsea. As late as 1766 a popular guidebook could say of the Duke of Devonshire's house at Chatsworth, in Derbyshire, that 'very little in it . . . can attract the eye of the connoisseur', while his pictures in Picca-dilly, on the other hand, were described as 'unsurpassed by very few either at home or abroad'. The situation began to change in the later eighteenth century when a few outstanding country-house collections – Sir Andrew Fountaine's at Narford, the Earl of Exeter's at Burghley and, above all, the Earl of Pembroke's at Wilton – were joined by other carefully assembled groups of pictures, many of which were catalogued and displayed for public viewing. But the dispersal to country houses of collections that had originally adorned town houses was not completed until well into the nineteenth century. Guides such as Martyn's *The English Connoisseur: containing an account of whatever is curious in Painting and Sculpture in the Palace and Seats of the Nobility and Principal Gentry of England* (1766) focused on the great metropolitan collections, adding only a few from the provinces. Most country houses contained a mishmash of mediocre art: portraits preserved as family memorials; a number of feebly executed 'Old Masters' or copies (or both), acquired from dealers or while on the Grand Tour; a few landscapes and prints. Not until a spending spree that began in the 1780s did aristocrats acquire many paintings that were singled out and hung for their quality rather than being 'furniture'.

Artists and connoisseurs learned about the contents of these collec-tions by reading guides such as Martyn's and from series of engravings like John Boydell's *A Collection of Prints, Engraved after the most Capital Paintings in England* (there were nine volumes to 1792). They could also visit collections which, though private, would be opened on request. But to describe these pictures and buildings as open to the public would be an exaggeration. From the 1730s, when the issue was first rehearsed in pamphlet debate, the owners of major collections were encouraged to make their treasures available to interested connoisseurs and painters: the nation's art works, it was agreed, should be visible so that foreigners could appreciate the refinement and progress of English taste; and great art should not be concealed for the private pleasure of its owners but be displayed in order to edify and educate the public. As Reynolds wrote

to the Duke of Rutland when Poussin's *Seven Sacraments* was removed to the peer's country seat at Belvoir: 'I hear people continually regret that they are not to remain in London; they speak on a general principle that the great works of art which this nation possesses are not (as in other nations) collected together in the capital, but dispersed about the country, and consequently not seen by foreigners, so as to impress them with an adequate idea of the riches in virtu which the nation contains.'

The response to this concern was mixed. Some aristocrats opened their doors regularly: William Beckford's gothic palace at Fonthill could be visited daily between twelve and four; Chatsworth was open two days a week; and many houses were open to visitors as long as their owners were not in residence, which in practice meant for much of the year. But some proprietors were altogether less amenable. During his tour of 1785 the inveterate traveller John Byng, the future Lord Torrington, was summarily turned away by Lord Guilford and the Earl of Macclesfield from their country seats at Wroxton and Sherborne Castle. Other owners left the spoils of their Grand Tours locked up in boxes or, like the Duke of Somerset, put their best pictures on the back stairs. And a few aristocrats like the Earl of Stafford restricted access to 'persons of the first rank, to first rate connoisseurs and first rate artists'.

As Stafford's remarks make clear, painters were never certain of securing entry into the houses of the grand connoisseurs. Few such collectors would have begrudged a visit from Joshua Reynolds or Benjamin West, but a shabby provincial painter was another matter. He needed to muster the appearance of respectability, almost certainly required letters of introduction, especially if he wished to make copies, and would probably find himself out of pocket in tips to the servants if he wished to continue his studies uninterrupted.

Any visitor or artist would have been inspired by the splendid works to be seen in the picture galleries at Corsham Court or Blenheim, but he would also have realized the marginal status of contemporary British art, for it was extremely rare, before the second half of the century, that a gallery or picture cabinet would contain the works of living English painters. Old Masters and modern Britons were not usually hung together until the nineteenth century, when collectors like Lord Egremont and Sir Richard Colt Hoare mixed their holdings. When Charles Jennens, Handel's librettist, mixed Old Masters and works by Hayman, Gainsborough, Lambert and Monamy in his galleries at Gopsall and in Great

Ormond Street, he was derided. Even in the early nineteenth century a connoisseur and collector like Sir John Leicester, Lord de Tabley, was considered slightly eccentric for displaying nothing but British pictures in his specially designed gallery (fig. 76). He was rather like that odd but ferociously patriotic Englishman, George III, who had a gallery in Buckingham House hung solely with the works of Benjamin West, an American by birth but an Englishman by adoption.

The proper place for pictures by British artists was considered to be not in the gallery, with its masterpieces (though modern copies after Old Masters might sneak in), but on staircases (hung with family portraits), in the dining-room (the proper place for comic and humorous works) and in a parlour (suitable for landscapes). It was evident in the arrangement of their houses that connoisseurs and collectors did not regard British art as in the best taste or of the first rank. Old Masters enjoyed pride of place in aristocratic collections, while a piece of sculpture, gems or medals were more prominently displayed than works of British art.

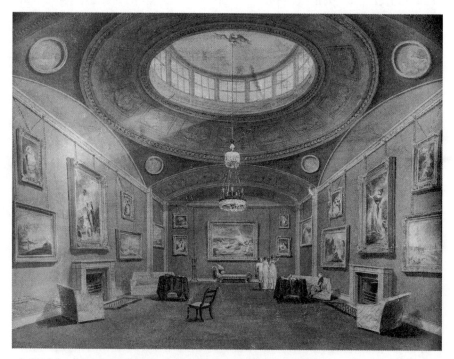

76. *Sir John Leicester's Picture Gallery* by Samuel Buckler, 1806

The paintings in town houses and country seats had first been viewed, as often as not, in auction houses. Most auctioneers, then as now, displayed their pictures for at least three days before a sale, and it was common for professional and amateur artists, as well as members of the public and potential purchasers, to visit the showrooms. The sale of large collections, like that of Edward Harley, second Earl of Oxford, in 1745, were major social events. But an auction was not a place where an artist could learn a great deal about painting. The early auctioneers had little knowledge of what they were selling; many were booksellers, not picture dealers; few specialized exclusively in paintings; sales catalogues were perfunctory and, with the exception of those produced by the gentleman dealer Robert Bragge, gave little information about the paintings and their provenance. Most catalogues did not even organize the pictures into schools or categories of art. Little prominence was given to the name of the artist, which was usually the last item in a catalogue entry; it was as if the auctioneer was tacitly acknowledging that he could not make accurate attributions. (Typical catalogue entries include, 'A landscape. Italian', or 'A scene with peasants'.) Copies and paintings in the manner of certain Old Masters were not distinguished from the originals, so that it is remarkably common to see the title page of catalogues claiming to include several works by Leonardo, Titian, Raphael or Giorgione. If the information was misleading and frequently mendacious, it was almost totally absent when it came to modern British art. Auctioneers, like dealers, were chiefly concerned with Old Masters and foreign art. They sold few English paintings and gave them no prominence, and in their catalogues they rarely identified English artists or included them on the title pages.

Without public spaces to show their paintings, artists had to fend for themselves. Most showed their work in their studios; the more successful of them, like Reynolds, had private galleries or what were known as 'show rooms'. Reynolds's 'show room' in Leicester Fields contained a selection of his portraits and volumes of prints as well as his own Old Master collection (sold after his death for more than £10,000). He also had many large busts (casts from the antique) and portraits by Lely and others. 'It was his opinion', wrote his pupil and biographer James Northcote, 'that it never did a painter much credit to have no other pictures than his own in a collection, as it became tiresome to the spectator from the want of variety, and also, that the painter's peculiar defects

became more conspicuous by seeing them so often repeated.' Reynolds
also had a large painting room, in which sitters and their friends gathered,
and many smaller rooms used by his assistants or to store uncollected
and incomplete pictures.

Reynolds's was not the only large studio. His close friend and fellow
academician Angelika Kauffman set up her first London studio in Suffolk
Street, a short distance from his house: 'I have four rooms, one in which
I paint, the other where I set up my finished paintings as is here the
custom ... the people come into the house to sit – to visit me – or to
see my work; I could not possibly receive people in a poorly furnished
house.' Francis Cotes, a portraitist in oils and crayons, and then George
Romney occupied a large house at 32 Cavendish Square in Marylebone,
where the painting room was big enough to entertain a crowd of guests.
Richard and Maria Cosway filled their quarters in the former Duke of
Schomberg's mansion on Pall Mall with three floors of pictures, held
large music parties and soirées attended by the Prince of Wales and
many foreign ambassadors, and built a garden and greenhouse on the
roof.

Though all these spaces had an important commercial function, they
were made to look like the galleries and cabinets of a gentleman con-
noisseur, lavishly (and expensively) decorated in the manner of a sumptu-
ous private residence: the fittings and furnishings of the newly established
miniaturist Ozias Humphry's studio in King Street, Covent Garden, cost
him £250 in 1768.

The artist at least controlled his studio but it was not strictly a public
space, being essentially a shop made to look like a private apartment,
showing works to potential clients and customers, not to the public. And,
for all the efforts of the likes of Reynolds and Humphry, the artist's
studio was never entirely respectable. It was said of Emma Hart, later
Emma Hamilton, that she was painted and drawn so frequently when
she was Charles Greville's mistress because she could go to the studio
but could not be received in polite company. When Sarah Bunbury, née
Lennox, left her husband but refused to marry the father of her illegiti-
mate child, the only place she could be seen by friends was in a painter's
studio. In short, the studio was a place where respectable and disreputable
people could mingle. Though artists tried to maintain distinctions –
Reynolds painted courtesans and mistresses early in the morning, at a
time when his aristocratic patrons were less likely to be about – the

studio's risqué reputation for sexual intrigue was not diminished by rumours of dalliance between artists and their female models.

Marginalized by the great and the auctioneer, restricted to the studio, how was the English artist to reach the public? William Hogarth, who was exercised throughout his career by this conundrum, was responsible for two of its most ingenious solutions. It appears to have been at his prompting that Jonathan Tyers, proprietor of the Vauxhall Pleasure Gardens, was persuaded to employ a group of artists in the 1730s and 1740s to decorate the garden's pavilions and supper boxes. The gardens already contained decorative pictures kept in recesses in the ceilings of the boxes to protect them from inclement weather; when the gardens opened they were lowered on pulleys. Fingered and poked by the curious – subject year after year to retouching and repair – they were the back-drop for an English *fête-champêtre*. As the *Scots Magazine* of 1739 put it: 'the paintings at the back of every arbour afford a very entertaining view; especially when the ladies, as ought ever to be contrived, sit with their heads against them. And what adds not a little to the pleasure of these pictures, they give an unexceptional opportunity of gazing on any pleasing fair-one, without any other pretence than the credit of a fine taste for the piece behind her.'

The Hogarthian plan replaced these paintings with a new decorative scheme. Altogether fifty boxes, filled nightly with visitors taking supper in the gardens, were hung with contemporary English paintings, most by Francis Hayman, some from designs of Hogarth himself. Other artists, most of whom belonged to Hogarth's circle at Slaughter's Coffee House in St Martin's Lane, helped to decorate the garden's rotunda, designed medals and tickets for admission, as well as vignettes and decorations for the very popular Vauxhall song sheets. Hubert François Gravelot, a young Frenchman who popularized the rococo style in England, the sculptor Roubiliac, and the medallist George Michael Moser, as well as Hogarth and Hayman, all participated in this collective artistic project, which proved to be extremely popular.

But these rococo decorations – even if they offered platitudinous commentary on the transitory character of human life and admonitions to incautious youth – were hardly the sort of elevated painting that would enhance an artist's reputation (figs. 77 and 78). The supper boxes were complemented by more serious works of art. A special arbour built in the late 1740s housed Roubiliac's statue of Handel, and between 1761

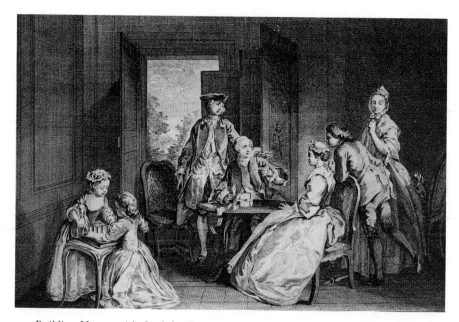

77. *Building Houses with Cards* by Francis Hayman, engraved by L. Truchy, 1743

and 1764, as part of Tyers's efforts to maintain the respectability of the gardens and show them as a place of public improvement, four patriotic modern history paintings by Francis Hayman – *The Surrender of Montreal to General Amherst*; *The Triumphs of Britannia*; *Lord Clive Receiving the Homage of the Nawab*; and *Britannia Distributing Laurels to the Victorious Generals* – were hung in the saloon to the musical rotunda.

Vauxhall Gardens unquestionably spread the fame of Hogarth and Hayman; its prominence as a tourist attraction and as part of the London summer season meant that people outside the charmed world of the connoisseur and collector would see their pictures. But Vauxhall was a commercial enterprise that had to struggle against its reputation for private profit and sexual commerce. A less tainted site was needed for modern art.

William Hogarth, restless and imaginative as ever, found the solution. In 1740 he became a governor of the new Foundling Hospital, a charity established by the retired sea-captain Thomas Coram to raise abandoned and illegitimate children. (Hogarth's post was no honorific: he subscribed £120 to the hospital, more than the donations from many aristocrats, and was an inspector of wet-nurses for the children.) In 1745, when the

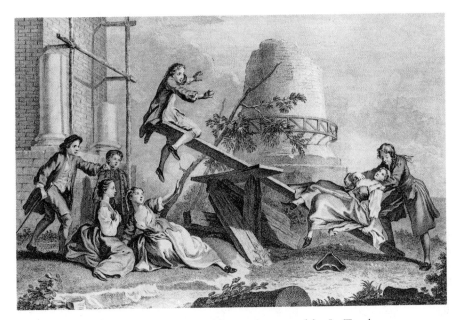

78. *The Exercise of See Saw* by Francis Hayman, engraved by L. Truchy, 1743

Foundling Hospital moved into a new building on the fringes of the city north of Holborn and west of Clerkenwell he, together with the sculptor Michael Rysbrack, launched a plan to make it a home not only for English foundlings but for the neglected work of British artists. It was announced at the end of 1746 that many 'Gentlemen Artists' (the term must have delighted the painters) had presented works or offered their services gratis for the decoration and adornment of the hospital: Francis Hayman, James Wills, Joseph Highmore, Thomas Hudson, Allan Ramsay, George Lambert, Samuel Scott, Peter Monamy, Richard Wilson, Samuel Wale, Edward Hateley, Thomas Carter, George Moser, Robert Taylor, John Pine and others. Over the next decade the list grew to include Reynolds and Gainsborough as well as almost every other prominent artist of the day.

In many respects the Foundling Hospital was an ideal site. It was accessible to the public; the pictures were displayed as an act of liberality and philanthropy, not for commercial gain, and the Court Room, where canvases by Hogarth, Hayman, Highmore and Wills were hung, was a perfect spot for history paintings representing the social virtues (fig. 79). Artists and their supporters were delighted. They spoke of 'works in

79. The Governor's Room in the Foundling Hospital showing
Hogarth's *Moses Brought before the Pharoah's Daughter*, 1745 and
Hayman's *The Finding of Moses*, 1746

history painting in a higher degree of merit than has heretofore been
done by English Painters' and of 'this exhibition of skill, equally com-
mendable and new'. But the enthusiasm of the English community of
artists and the alacrity with which they donated their pictures to the
Foundling Hospital only show how limited their opportunities for public
exhibition remained.

In sum, British modern art was still marginal. Its absence from public
and ecclesiastical buildings, its exclusion from the gallery of the collector
and the cabinet of the connoisseur, its confinement to the artist's
studio and to commercial places of public resort were symptomatic of
the weakness of the community of contemporary artists. They presided
over neither taste nor space.

The foundation of the Royal Academy, which changed the situation
radically, was not the consequence of a consensus among artists about
how to end the marginal status of modern British art but, rather, the
unintended consequence of rifts within the artistic community. These

divisions were skilfully exploited by an architect, William Chambers, who more than anyone else ensured that George III was able to fulfil his desire to found a painting academy.

In the late 1740s and 1750s painters, sculptors, architects and connoisseurs had all recommended the establishment of a public academy, preferably one sanctioned by royal charter. Calls for an academy, though not new – Thomas Atkinson in his *Conference between a Painter and an Engraver* had advocated an academy on the French model as early as 1736 – were sparked by the publication of Jean-Bernard le Blanc's *Letters on the English and French Nations* (1747), which pointedly explained the superiority of French art by the existence of a royal academy with its prizes and exhibits. Two years later John Gwynn, author of *An Essay on Design*, called for an academy ruled and judged by 'Painters, Sculptors, and Architects . . . to be supported by Voluntary Subscription (till a Royal Foundation can be obtain'd)'. A number of architects, including William Chambers, produced designs, and in 1755 a committee of twenty-six artists, led by Francis Hayman and including Reynolds (Hogarth was a conspicuous absentee), produced a plan 'of an Academy for the Improvement of the Arts in General' which they put to the leading club of connoisseurs, the Dilettanti Society, and to the recently founded Society for the Encouragement of Arts, Manufactures and Commerce, hoping for financial support.

Yet though it was generally agreed that a place to promote British art and have exhibitions was desirable, a number of artists, led by the redoubtable Hogarth, opposed a fully-fledged, royally sponsored academic institution which they saw as the harbinger of absolutism and an intolerant classicism. They wanted a professional voluntary association, like the many trade associations and friendly societies that furthered their members' interests; this body would organize artists' exhibitions, instruct pupils, and set up a charitable fund to give pensions to sick artists and artists' widows; its organization would be democratic, its membership as large as the profession itself. But it would not try to dictate public taste. For them, an exhibiting society was first and foremost a direct means of reaching a large clientele without working through middlemen and picture dealers who would all extract substantial fees: 'A new and pleasing prospect however seem'd now to open to the artists; connoisseurs and picture dealers were no longer in question; the public now knew where to find those whose labours had attracted their regards, and the former scene of iniquity was happily and entirely removed.' Exhibitions were a

commercial tactic that would change the structure of the art market, replacing the foreign painting and classical antiquities sold by dealers and loved by collectors with a native British art.

The supporters of a royal academy – particularly such fashionable painters as Reynolds, Benjamin West and Francis Cotes – had loftier ambitions. As Reynolds demonstrated in his later *Discourses* at the Academy, their chief concern was to set standards of taste, to shape a discerning public, and to establish the right of artists to do so. As T. B. put it – albeit rather more bluntly than his fellow painters –

> None . . . have the right to judge who have not Abilities to perform . . . a Man ought to be judged by none other than his Peers . . . As all Painters therefore improve this first Faculty [of judgment], at least in relation to their Art; so they alone of all Mankind are thereby enabled to judge from those Principles which that and their Studies have taught them to revere; and all Others who would intermeddle, or pretend to determine in their Works, must judge from no Principles at all.

Many painters, including Reynolds, took a less exclusive view, but they recognized that an academy to shape taste could not be a professional association embracing all practitioners; it had to be a smaller group of artists, singled out for their special skill and knowledge. Its aim should be public, not private: the moral instruction of the nation through the exhibition of fine art as well as the furtherance of a professional interest. As one pro-academy pamphleteer put it in his comparison of George II's England with Louis XIV's France, 'The Arts are to be considered as another means of communicating ideas, and holding up important facts to the senses, as History has recorded them, and as public faith has received them . . . their pursuits are the promoting of knowledge, and the disseminating of virtue among mankind.'

The artists' proposal of 1755, like any document produced by a committee, tried to reconcile these conflicting views. On the one hand it took the highly democratic, patriotic view of art that we associate with Hogarth. Humble and high art were compared:

> Of all Pleasures, those excited by Works of Art and Genius are of the most innocent, the most refin'd and the most laudable Kind. They are more or less the Objects of all Persons in all Circumstances; and, without any violence to Truth it may be affirm'd, that the

Wooden Prints and Bellman's Verses, which are the Pride of Garrets and Cellars, have their Rise from the same Origine [sic] which has introduc'd the Works of Correggio, Titian, Raphael, Rubens &c &c into the magnificent Apartments of the Great.

Connoisseurs were criticized as

those who set their Hearts on making Collections *only* instead of advancing the Art they profess to love or animating the Professors of it [they] have actually help'd to create the very Deficience [sic] they affect to complain of, for in order to justify the excessive Prices they have been artificially induced to give for Names and Characters, they have insensibly been led to decry and undervalue every modern Performance.

The proposal also linked the development of the fine arts 'to subordinate Branches of Design: In Utensils of all sorts, Plate and Cabinet-work, Patterns of Skills, Jewelling, Garniture, Carriage-Building and Equipage, down even to Toys and Trinkets'.

Yet, if the reasons given for the establishment of an academy breathed the spirit of Hogarth, there was much that was more redolent of Richardson and Reynolds. The declared object was 'the refining the Taste', its constitution to be 'a Royal Academy under the Direction of a Select Number of Artists', thirty in number, though they were to be elected by ballot from the whole body of artists. Professors, fellowships, prizes and 'Badges of Distinction ... in order to excite Emulation' were to be established on the French model.

This compromise plan of 1755 foundered, not because of differences among the artists but because the Dilettanti were not prepared to support an academy which was not controlled by gentlemen connoisseurs. In Hogarth's words, the Dilettanti wanted to be 'Lords and masters', electing half the members of the academy and monopolizing the office of president. Though the committee of artists was prepared to compromise and offer a share in the running of the academy, it refused to surrender control. Hogarth tendentiously recorded that 'when the schemers pretended to bear a part in the school ... they were rejected with scorn and the whole castle came to the ground and has been no more heard of'.

The failure of Hayman's committee seems to have led artists to turn their attention away from founding an academy and towards developing

public exhibitions. In April 1760, in the final months of George II's reign, the first public exhibition of modern British art opened in the Great Room of the premises of the recently founded Society for the Encouragement of Arts, Manufactures and Commerce. Seventy-four paintings and a further fifty-six sculptures, models and engravings were shown. The success of the exhibit, which was free, almost overwhelmed its organizers: the crowds that flocked in were almost uncontrollable; more than 6,500 sixpenny catalogues were sold. Clearly, a substantial public was desperately eager to view contemporary British art.

Still this did not solve the key issue of artistic control. The Society of Arts was devoted to the improvement of 'Arts, Manufactures and Commerce'. Its members were gentlemen improvers; it offered prizes and premiums for works that promoted British commerce not fine art. Yet it wanted to determine what should be shown, where it should be hung, and who was admitted to see the exhibit. It also insisted on hanging its own premium-winning pictures, mostly by amateur artists, in the exhibition.

All the artists, despite their differences, abandoned the Society of Arts within five years. Most painters immediately refused to accept the Society's conditions and set up the Society of Artists of Great Britain, later known, because of its royal charter of 1765, as the Incorporated Society of Artists. The rump that remained (the Free Society of Artists) grudgingly continued to cooperate with the Society of Arts, but it was soon embroiled in quarrels and in 1765 was ejected from the Society's building on the Strand.

The only other suitable premises were auction rooms, whose commercial purpose was incompatible with their high-minded views and whose hard-nosed proprietors were hardly regarded as kinsmen and friends. Nevertheless the Society of Artists and the Free Society, were both forced to turn to the auctioneers. The Society of Artists moved into James Cocks's auction rooms in Spring Gardens, selling more than 13,000 one shilling catalogues in their first exhibition of 1761. Relations with Cocks were cordial and the exhibitions were well attended as the surviving accounts show. In 1767, the Society's best year, nearly 23,000 visitors viewed their annual spring exhibition. The Free Society was less fortunate. After using several venues they struck a deal with James Christie, renting his new premises in Pall Mall for a month each year for forty-five guineas (fig. 80). But this arrangement was fraught with difficulty, as

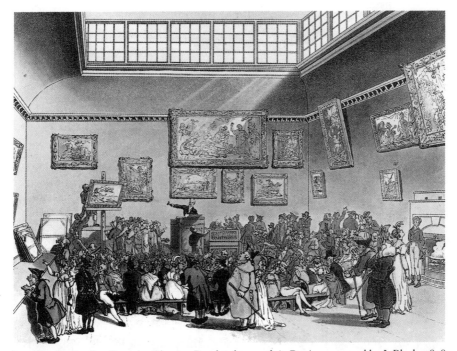

80. *Christie's Auction Room* by Thomas Rowlandson and A. Pugin, engraved by J. Black, 1808

Christie was unhappy about renting his auction house at the height of the London season. In 1774 he shunted the Free Society into less desirable premises in St Alban's Street. Its exhibitions became less frequent; its last was held in 1783. Even the Royal Academy, after its foundation in 1768 by artists who broke away from the incorporated Society of Artists, had at first to be content with exhibiting in an auction house, albeit one owned by the king's librarian (fig. 81).

Auction houses were sale rooms rather than exhibition halls. They were too small and did not have room for the school that most of the artists' groups wanted to run in tandem with exhibitions. The Incorporated Society put its school in an old billiard hall in Maiden Lane, while the Royal Academy schools were housed in the old Somerset House, a ramshackle palace described by the son of the Academy's keeper as 'adorned in a style of splendour and magnificence that was creditable to the taste of Edward VI', and which was some distance from the Academy's exhibition hall on Pall Mall. No available exhibition hall could cope with more than 1,000 visitors a day and that with considerable

discomfort; most could accommodate many less. The obvious solution was for a society to build its own premises, but this, as the Incorporated Society discovered, was extremely expensive. It required a large site in a fashionable part of town and a building of suitable size and grandeur.

The history of exhibition spaces in the reign of George III is intimately bound up with the quarrels that fractured the artistic community and led to the foundation of the Royal Academy. In the Incorporated Society of Artists a few experienced and successful painters and architects, many of whom had worked in Italy, dominated its directorate and used their oligarchical power to further their vision of the Society as an arbiter of taste. Fashionable painters like Reynolds wanted to secure their status in the narrow, lucrative market of aristocratic society. Their work had to compete with Old Masters, paintings whose quality was decided according to classical ideals and the science of connoisseurship. If they could persuade their patrician patrons that their work expressed the same values and embodied the same virtues, their painting would gain greater

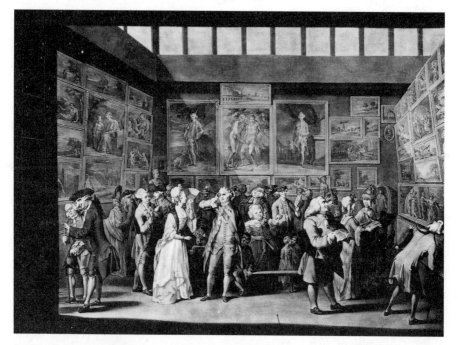

81. *The Exhibition of the Royal Academy of Painting in the Year 1771* by Charles Brandoin, engraved by Richard Earlom, 1772

prestige, and be collected as well as commissioned. Ironically, one of the most effective means to assert their authority in such a market was to claim a public purpose for their art. Founding a royal academy was not the only way to do this but it was certainly one of the best.

Most members of the Incorporated Society had more modest aspirations: to protect their members, to offer exhibiting opportunities to young unknown artists, and to distribute charity to aged and indigent painters and their families. They were prepared to settle for a better place in the existing market, which they took for what it was, a matter of securing private commissions for portraits, landscapes and decorative art, earning a decent living in a new profession that ranked just above a skilled trade. The membership embraced not only such painters in oils as George Romney, George Stubbs and John Mortimer, but practitioners of the 'lesser' arts working in crayon and pastel like Hugh Douglas Hamilton and William Marlow, such miniaturists as William Sherlock and Ozias Humphry, and well-known engravers, including William Pether, Valentine Green, Robert Strange and William Woollett. The public for their work was broad and certainly included the middle ranks of society.

In the mid-1760s these members defeated and ousted some of the Incorporated Society's directors and voted for a more open trade association. Driven from office, the Society's elite, led by Sir William Chambers, turned to the crown. Chambers, who had taught George III drawing, and Dalton, the king's librarian, had the monarch's ear as their rivals did not. They persuaded most of the leading artists to petition for the immediate establishment of a royal academy and managed to convince the king to respond promptly. In December 1768 George III signed the royal Instrument establishing the Academy; in January 1769 the twenty-eight members already appointed to some of its forty vacancies gathered at their first general assembly to hear their president, Joshua Reynolds, deliver the first of his famous *Discourses* on the nature of art.

The new Academicians now enjoyed tremendous advantages over their former colleagues. Ever since George III's accession there had been a struggle to acquire his public endorsement and patronage. Now it had been secured. The Academy did not quite enjoy a monopoly of royal favour, but it was a highly privileged body. The king, for example, stopped attending the Incorporated Society's exhibitions in Spring Gardens and went only to the Academy.

The constitution of the Academy limited its elected membership to forty painters, sculptors and architects, and required that all fellows resign from all other artists' societies. It was clear that, though a public body, the Royal Academy meant to sustain the power of a self-appointed elite within London's artistic community, a self-perpetuating oligarchy or patriciate under royal patronage. In the early years its role as a philanthropic institution was negligible; it focused on classical instruction and public exhibition.

The 200 members of the Incorporated Society, shorn of its old leaders, pursued the commercial interests of its members. It put its considerable resources into pension funds, lobbied parliament on behalf of engravers and arranged lectures on pigments and chemistry, the sort of craft work that the early Royal Academy seemed to downplay or avoid.

The foundation of the Royal Academy certainly did not mean the Incorporated Society's inevitable demise. True, the Academy had obvious advantages. It had the cream of the crop of painters. The list of Society members expelled for exhibiting at the first Royal Academy show of 1769 reads like a *Who Was Who* of eighteenth-century British art and includes Reynolds and nine other founder Academicians – Francis Cotes, Nathaniel Dance, Francis Hayman, Nathaniel Hone, Edward Penny, Paul Sandby, Benjamin West, Richard Wilson and Francesco Bartolozzi – as well as Thomas Gainsborough and the young Michael Angelo Rooker. And, of course, the Academy had the prestige associated with royal patronage. But it also had a number of weaknesses. When Chambers, Reynolds and company left the Society they left a financially healthy institution with more than £3,000 invested in government funds, able to dispense between £100 and £200 a year in charity and to earn an exhibition income of between £620 and £1,000 a year. The Academy, on the other hand, ran an annual deficit from its inception until 1780, receiving more than £4,784 from the king's privy purse. Without royal munificence it would not have survived as an exhibiting society. Besides, the Incorporated Society presented considerable competition. Its exhibition attendance and receipts were far from negligible, though they were exceeded by the Academy after 1770, and their school flourished with its special lecture series, life classes and exclusive access to the Duke of Richmond's sculpture gallery.

But the Incorporated Society made a number of errors. They passed a rule rejecting any member who exhibited elsewhere. Their aim was obvious: to deprive the Academicians of the paintings they needed to

mount large annual exhibitions. This move was about money as well as power, because exhibition receipts were the life blood of any artists' association. But the tactic was mistaken. As the attendance figures make clear (see table), there was ample scope for more than one exhibiting society in London. Besides, the temptation of a new exhibiting society,

SURVIVING FIGURES FOR ATTENDANCE
AT PUBLIC EXHIBITIONS IN LONDON, 1761–85

Year	Society of Artists, Spring Gardens	Royal Academy, Pall Mall	Total
1761	13,000		
1762			
1763	11,200		
1764	15,253		
1765			
1766	17,489		
1767	22,906		
1768	18,398		
1769	14,980	14,008	28,988
1770	12,503	19,428	31,931
1771	15,963	22,485	38,448
	Strand		
1772	15,657	19,527	35,184
1773	14,081		
1774	23,164		
1775	20,028		
1776	24,988		
1777	23,541		
1778	29,511		
1779	27,616		
	Somerset House		
1780	61,381		
1781	42,824		
1782	55,357		
1783	52,601		
1784	48,892		
1785	44,044		

especially one condoned by a royal academy, was too great for members of the Incorporated Society to resist. In 1769 the Incorporated Society expelled thirty-five of its members for exhibiting at the Royal Academy summer show; every year thereafter its support slowly but steadily haemorrhaged away. If it had let its members exhibit with the Academy, it would almost certainly have survived as a major (albeit the second) exhibiting society in London.

The Society's second error was to try to win the public away from the Academy by building a grand exhibition hall. In 1771 it bought land on the north side of the Strand at a cost of £2,552; here it erected a new gallery more than twice the size of Cocks's auction house in Spring Gardens and considerably larger than the exhibition room in Somerset House that opened in 1780. This building, designed by James Paine, president of the Society, consisted of an entrance vestibule, an academy room, committee room and, on an upper floor, an exhibition room eighty feet by forty feet; it cost the Society a further £5,000. The largest and most impressive exhibition space in London, it opened at a special ceremony in the spring of 1772, at which the celebrated soprano Mrs Weichell sang an ode which concluded, 'Behold the Arts around us bloom/ And its muse-devoted Dome/ Rivals the works of Athens and of Rome.'

Paine's scheme was bold but it soon foundered. Delays in construction meant that the spring exhibition of 1772 had to be curtailed. Daily attendance at the Strand quarters was higher than ever before, but total receipts were down on 1771. More seriously, the Society was in financial difficulties. It had bought the site at the height of a speculative property boom immediately before the financial collapse of 1772; it was left with an asset worth much less than its liabilities. The Society was unable to cope; its cashflow dried up, its pension fund was destroyed. Within a year it was forced to let the building to James Christie for £200 a year on condition that he allow an annual exhibition and take up the Society's mortgage. Three years later the Society was forced to sell and was driven back into the hands of the auctioneers. Its initiative had failed. Though the Incorporated Society continued to hold exhibits, it did so in the shadow of the Royal Academy.

The Academy meanwhile still had no large exhibition space, and its school and exhibition site remained apart. The former was in Pall Mall while the school, library and collection of casts occupied run-down rooms in the old Somerset House. Once again it was Chambers, the courtier,

wheeler-dealer and hard-nosed politician, who came to the rescue. When the government decided to demolish Somerset House and built a complex of government offices in its place, Chambers dearly wanted the commission; when he acquired it by default with the death of William Robinson, secretary to the Board of Works, he used the opportunity to the Academy's benefit. Chambers bore personal responsibility not only for the design of the building, which he and others wished to be 'an object of national splendour as well as convenience' and 'a monument to the taste and elegance of His Majesty's reign', but also for the building contracts. In his design Chambers placed the Academy in the most conspicuous spot – on the frontage to the Strand – gave it twice as much space as the Royal Society and the Society of Antiquaries and spent nearly £600 employing Academy members to decorate their own apartments (the Royal Society got about £63 of interior decoration) and to work on the embellishment and statuary for the entire building (fig. 82).

Chambers's object was not just the furtherance of the Academy. He was determined to erect an office building to rival those in Paris and Lyons. But he gave precedence as well as commissions to the part of the building occupied by the Academy:

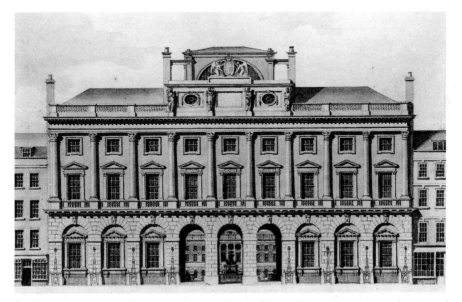

82. The North Front of Somerset House designed by William Chambers and engraved by J. Pass, 1780

Decorations have been more freely employed in the vestibule of entrance, and in all the public apartments of this building, than will be necessary in the remainder of the work; because the vestibule, open to the most frequented street in London, is a general passage to every part of the whole design; and the apartments are intended for the reception of useful learning and polite arts, where it is humbly presumed specimens of elegance should at least be attempted.

The importance of the Academy's new quarters, which opened in the spring of 1780, was immediately apparent. Receipts for the 1780 exhibit were £3,074. 6s., more than twice what had ever been collected before and more than for any Academy exhibition before 1796. Attendance reached 61,381; on the best day, Friday 2 June, 2,680 visitors crammed into Somerset House; the worst day was comparable to a best day at any previous Academy show (fig. 83).

83. Account Book, catalogue sales and attendance, Royal Academy, Somerset House, 1780

Press coverage of the exhibition was mostly about the new site, the crowds flocking to the exhibit and the sale of more than 60,000 catalogues. The *Public Advertiser* of 2 May spoke for many papers when it praised the 'happy arrangement of the Pictures and the Magnificence of the Apartments' which, it claimed, 'render it a very grand Spectacle, and not to be equalled in any Part of Europe'. The 1780 show finally put paid to the Incorporated Society as an exhibiting body. Though it mustered a rival exhibit, it managed only two exhibitions (in 1783 and 1790) in the next decade.

The greatest effect of the move to Somerset House was not immediately visible, for it was financial. Not only had the Academy been insolvent, it had virtually no capital or savings. (Between 1769 and 1780 the pension fund accumulated a mere £400, a sum made possible only by the generosity of the king.) But the new high levels of attendance at the Royal Academy exhibits brought an enormous increase in revenue, and whereas the Incorporated Society had been burdened by a large mortgage, the Royal Academy paid the crown no rent. No wonder that the Academician G. B. Cipriani published an engraving shortly before the opening of Somerset House entitled *Britannia Directing Painting, Sculpture and Architecture to Address Themselves to Royal Munificence, who Receives and Offers them, Protection and Rewards* (fig. 84). Never again in the century did the Academy have to go cap in hand to the crown. The receipts made possible by the new quarters at Somerset House made the Academy rich. The Academicians began buying large amounts of government stock: by the 1790s the pension fund contained nearly £4,000 in 3 per cent consols and an additional £9,800 was placed in a so-called solid fund. This saving was at a time when the Academy was reining in its activities and concentrating on its lucrative exhibitions. (In the decade 1779 to 1789 the number of students studying in the Academy schools was half that of the previous ten years.)

Somerset House inaugurated a new era of power and stability in the affairs of the Royal Academy, but its reception in 1780 was not an unmitigated triumph. Two complaints stand out: one about charging admission to a royal academy, the second challenging the propriety of exposing to public view the Academy's many casts of antique statuary used to teach the students (the Academy could not afford expensive original examples). This display of nude male sculpture created what critics called a 'temple to Priapus . . . to the terror of every decent woman'.

It seems to have been in response to these criticisms that the Academy produced an official account of the new building, *A Guide through the Academy by Joseph Baretti, Secretary for Foreign Correspondence to the Royal Academy*, in the following year, a tract that was sold at the door of Somerset House. (They also, I might add, put plaster fig leaves over the male genitalia of their casts.) In the advertisements for the pamphlet that appeared in the London press in April 1781 Baretti went to some lengths to thank William Chambers, Joshua Reynolds, Angelica Kauffman, Joseph Wilton, Benjamin West, James Barry, John Bacon, Giovanni Battista Cipriani, Agostino Carlini, Biagio Rebecca, Bonomi 'and all those gentlemen who have kindly assisted . . . in the composition of this little Piece.' The press quickly recognized the tract's importance: synopses and extracts of the pamphlet appeared in journals and periodicals, and passages were extensively extracted and plagiarized in the newspapers.

Guiseppe Baretti, a journalist and compiler of the standard English–Italian dictionary of the time, was an appropriate author for this apologetic tract. A member of Dr Johnson's circle who for many years lived in the house of Johnson's patron, Mrs Thrale, he was a good friend of Reynolds, knew much about painting, and was recognized in Europe as a distinguished literary figure. He fitted well into that circle of self-promoting critics and artists which exercised such influence in the last quarter of the century.

From the beginning Baretti's description portrays the Academy's new quarters as much more than a convenient site for artistic instruction and exhibitions. The building, he explains, is itself an artwork embodying the Academy's creative genius and good taste. He is at pains to identify the artists responsible for it, reminding the reader that Somerset House is the greatest architectural achievement of Sir William Chambers, whose timely intervention in 1768 had, more than any other event, brought the scheme for an academy to fruition. If the whole is credited to Chambers, each significant detail is attributed to its individual creator. Wilton, Carlini, Guiseppe Ceracchi, Joseph Nollekens, and Bacon, Baretti points out, were responsible for the sculptural reliefs on the façades and interior. The decorative painting on the walls and staircases was executed by Cipriani, Reynolds, Kauffmann, West, Charles Catton and Rebecca.

Though Baretti does not labour the point, all the sculptors and artists chosen to work on the building except Ceracchi were members of the

Academy, seven of them – Chambers, Carlini, Cipriani, Reynolds, Kauff-
mann, Catton and West – founding members. Their choice, as Baretti
later makes clear, demonstrated that the Academy had reached a complete
accommodation with the values of classical academicism: all the artists
except John Bacon, who had been educated in the Royal Academy schools,
and Charles Catton, George III's coach-painter, had studied or been
trained in Italy; most had spent their formative years in Rome.

In his opening words Baretti offers to guide the uninitiated viewer
through the building: 'He who enters [Somerset House], not knowing
what to expect, gazes a while about him, a stranger amongst strangers,
and goes out, not knowing what he has seen,' but the visitor who wishes
to learn how to see and understand can avail himself of a guide who
claims to be specially 'useful to those that love the Arts, and desire not
to love them blindly.' His perspective is not that of the expert or con-
noisseur, but of 'a common Beholder', making no claims to authority of
interpretation. Baretti's task is to transmit critical views and opinions to
the public, conveying not so much a generalized taste as artists' aesthetic
injunctions. Throughout he represents the arrangement of Somerset
House as an assertion of the critical supremacy of the Academicians.

84. *Britannia Directing Painting,*
Sculpture and Architecture to Address
Themselves to Royal Munificence, who
Receives and Offers them Protection and
Rewards by Giovanni Battista
Cipriani, engraved by William
Wynne Ryland, 1779

Thus Reynolds's *Discourses* are invoked when discussing classical statuary and the work of Bernini; or we are informed that 'the general opinion of Artists is, that this *Venus* de Medici is the most beautiful representation now existing of a female body'. The importance of Baretti's commonplace remark lies not in its banal critical judgement, but in the fact that he claims it as the opinion of *artists*.

Shaping the context in which the work and views of members of the Academy are presented, Baretti carefully places them in relation to connoisseurs and collectors and to classical antiquity. Much of his account is devoted to the casts of classical statuary which had been donated to the Academy by patrons and collectors. This munificence is not used, as we might expect, to praise the cultural discernment and elevated taste of the generous donors. The collectors he mentions – and there are a good many of them, including such notable figures as Sir William Hamilton and Charles Towneley, two major donors to the British Museum – are given no voice. They are represented simply as civic-minded individuals whose contribution to the improvement of taste is to provide the materials for artists to work on. Thus Lord Bessborough is described as 'a generous Encourager of Arts, and skilful Collector of such ancient and modern Pieces, as may be conducive to their forwardness in this Country'. The activities of a private man of taste are subordinate to the higher aim of helping the Academy to create a distinguished national school of art. The connoisseur is made the servant of the artist.

The Academy's claim to authority is nowhere more explicit than in the Greek inscription placed over the lintel of the Great Exhibition Room, which was variously translated as, 'Let no Stranger to the Muses enter' and, in a gendered version, as 'Let none but Men of Taste presume to enter here'. The implication is that visitors to the Academy should, like the readers of Baretti's pamphlet, be properly prepared. Otherwise they would fail to appreciate what they saw; they would, in Baretti's words, only 'love the arts blindly'.

Baretti's account also places the Academy historically in relation to Renaissance Italy and to classical antiquity. In a passage that was duplicated in many newspapers and periodicals, Baretti describes the frontage of Chambers's building on the Strand as 'an attempt to unite the chastity and order of the Venetian Masters with the majestick grandeur of the Roman', and compares it to the great works of Palladio. He represents Somerset House as neither Venetian nor Roman but as 'new modelled'

from both. The vestibule is based on the Farnese Palace in Rome, 'yet so altered in its forms, proportions and decorations, that scarce any resemblance of the original remains', and the exhibition hall lights are 'Dioclesian' windows, adapted from those in the emperor's baths in Rome. The antique is acknowledged, but it is not treated as something to be copied slavishly. Rather, knowledge of the antique enables Chambers to create a unique modern artifact.

This accommodation to the antique and the Old Masters is also apparent in Baretti's discussion of the Academy's collection of classical casts. Interpreted through the critical commentary of modern painters, they are not fetishized as works that can never be bettered, but praised for how well they conform to the standards of ideal nature, a criterion by which modern art should also be judged. Baretti's discussion gives the reader the impression that the casts are important only as a source of inspiration to British artists, as if the historic lines of western art lead to this new palace of the arts on the bank of the Thames.

Baretti's pamphlet also instructs the visitor to Somerset House about the qualities required of the great artist. Cipriani's painting of Minerva visiting the Muses on Mount Parnassus is meant to show that 'Artists will rise to excellence in proportion to the extension and variety of their knowledge, whereof Minerva and the Muses are symbols'; later Baretti points out that the figures of Cupid and Psyche, at the entrance to the exhibition room, are 'emblems of the mental and executive faculties requisite to constitute a perfect Artist'. This emphasis on knowledge, reason and imagination accords with the thrust of Reynolds's *Discourses*, which valued an artist's capacity to reason over his technical or mechanical skills, and recalls Jonathan Richardson's claim that 'We PAINTERS are upon a Level with Writers, as being Poets, Historians, Philosophers and Divines, we entertain and instruct equally with them.' The means by which this was possible, Baretti reiterates, is through history painting, which he especially associates with the work of Benjamin West.

Chambers's building, the Academicians' decoration and Baretti's account created a unique place for British art, a space of public edification and not of private commerce. The Academy found it necessary to reprint in its catalogue to the first Somerset House exhibition an apology that had last appeared in 1769, the year of the first Royal Academy show, explaining that an admission fee was not for profit:

As the present Exhibition is a Part of the Institution of an Academy
supported by Royal Munificence, the Public may naturally expect the
Liberty of being admitted without any Expence. The Academicians
therefore think it necessary to declare, that this was very much their
desire, but that they have not been able to suggest any other Means,
than that of receiving Money for Admittance, to prevent the Rooms
being filled by improper Persons, to the entire Exclusion of those
for whom the Exhibition is apparently intended.

The apologia was nonetheless disingenuous. Exhibition receipts may not
have been intended as commercial 'profit', but they were unquestionably
profitable – which is presumably why Academicians were so shaken by
a suggestion that they donate their receipts to a deserving charity.

This ambivalence was also expressed in the contents of the Academy's
exhibitions. Despite the formal, academic surroundings and Baretti's
arguments, the artists who exhibited at the Academy were not chiefly
concerned to 'instruct' the public: between 1781 and 1785 the proportion
of history paintings on show never reached more than a fifth, while
about 70 per cent of the exhibited pictures were portraits and landscapes
(fig. 85). (Even if we concede that the square footage of history painting
canvas would have been greater – such works were invariably bigger than
pictures in the other genres – this is a pretty poor showing.) Although few
of the paintings were announced as for sale or 'to be disposed of', as the
catalogue euphemistically described it, every exhibitor knew that Somer-
set House was the most prestigious exhibition space in London and that
public approval or praise from the newspaper critics helped to produce
private commissions. The links with commerce and cash were glossed
over. Somerset House could therefore present itself as different from
other overtly commercial spaces like the European Museum in King
Street, the Egyptian Room on Piccadilly, or the Shakespeare Gallery
on Pall Mall, where contemporary art, including history painting, was
exhibited for profit. This was in part because no other site presented its
paintings as works by the critical and historical inheritors of earlier
traditions of painting as a morally instructive art. The civic purpose of
the Academy was absent from the dealer's shop; and Somerset House's
stentorian message of edification helped to drown out the babble of
commerce and concealed the Academy's profits.

The dealers responded quickly to the challenge of the Academy. The
most important commercial equivalent of the exhibitions at Somerset

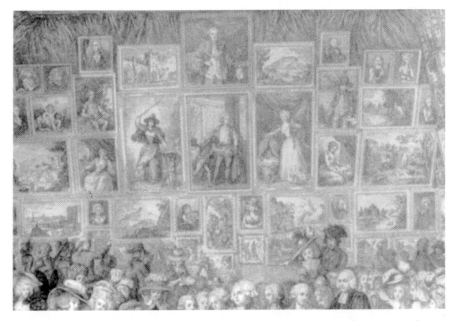

85. Detail from *The Royal Academy Exhibition at Somerset House, 1787* by J. H. Ramberg, engraved by P. A. Martini, 1788

House was the Shakespeare Gallery, planned in 1786 by John Boydell, a wealthy printseller and politician, as a shrine to William Shakespeare. Its avowed aim was to encourage a native school of history painting by commissioning British artists to paint historical works representing crucial moments in the plays of the Bard. Boydell appealed to painters to join a scheme 'where the national honour, the advancement of the Arts, and their own advantage are equally concerned'. He offered leading members of the Academy large fees – his down-payment to Reynolds was £500 – and not surprisingly secured the participation of most of them. When the Shakespeare Gallery opened in May 1789 in specially refurbished premises in Pall Mall it displayed thirty-four paintings by eighteen British artists; in the following year a further thirty canvases were added (fig. 86).

Boydell planned to defray his expenses by selling engravings of the paintings in Europe, the market where he had made his fortune with other prints of popular paintings. He employed forty-six printmakers to make the reproductive engravings and at first the Shakespeare Gallery was a success. Enthusiastically supported by patrons and artists, it became

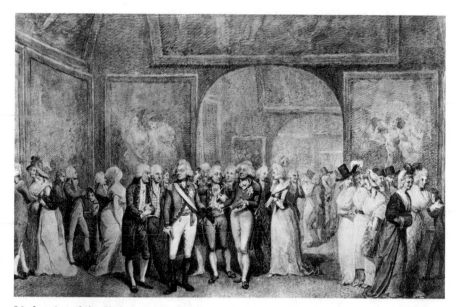

86. *Interior of the Shakespeare Gallery* by Francis Wheatley, 1790

a place of fashionable resort. When the German novelist Sophie von la Roche visited the gallery she found it crowded with pictures and a cosmopolitan clientele. But it foundered during the Revolutionary Wars of the 1790s, which closed the key market for Boydell's prints. Without his French and continental clients he could not make a profit. The Shakespeare Gallery was wound up in 1805, the building sold, and the pictures and engravings sold by lottery.

Boydell's was only the most famous scheme launched by dealers in response to the new milieu created by the Academy. In 1788 Thomas Macklin, a printer and bookseller in Fleet Street, hired fifteen artists, including Reynolds, Gainsborough, Fuseli and de Loutherbourg, to paint history paintings for his Poets' Gallery (fig. 87); three years later he commissioned no fewer than seventy-one paintings for an *Illustrated Bible*. These ventures, like Boydell's, linked the morally edifying activity of history painting to commercial publishing and engraving schemes to underwrite their cost. These enterprises all suffered from the contraction of the art market in Britain and abroad during the 1790s, but they shrewdly reconciled the Academy's public agenda to dealers' private concerns. They also mark the point at which art dealers no longer confined their attention to Old Masters.

Somerset House also provoked a response from the connoisseurs. For the new quarters of the Academy, unlike the individual studios of its members, did not even try to resemble the picture galleries or display rooms of a private house; the environment was one of austere but informative civic virtue, an ideal place in which to view history painting. There was no recognition of private intermediaries between the artistic arbiters of taste and the public.

Ideally, then, the Academy was a special place for the morally elevated instruction of students and public, an environment in which persons of taste could learn that, as British artists repeatedly claimed, their work was as fine as the modern art of any other country. Of course, this ideal was compromised in all sorts of ways. Most obviously, the paintings exhibited at the Academy were normally portraiture, landscape and the occasional still life rather than history paintings. And the viewing public did not always conform to the ideals of the man of taste as press commentary and critics make clear. They were acutely aware of the heterogeneity of the Academy's audience, its frequent ignorance and the variety of its response. Reynolds warned his fellow artists about the 'mischievous

87. Ticket for Macklin's Poets' Gallery by Thomas Stothard, engraved by William Skelton, 1790s

tendency' of Royal Academy exhibits, which seduced 'the Painter to an ambition of pleasing indiscriminately the mixed multitude of people who resort to them'. Shaping the public and its taste may have begun, but the task was far from complete.

Moreover, the Academy's authority to arbitrate taste and to speak for artists was not uncontested. Full membership of the Academy was confined to forty artists; engravers, for all their skill and importance in helping artists to achieve visibility and wealth, were entitled only to associate membership. Reynolds estimated the number of painters in London to be 800; the Incorporated Society of Artists from which the Academicians had seceded in 1768 had 200 members. The foundation of the Academy marked a triumph for an oligarchy among painters, a self-perpetuating body that decided what art should be exhibited as a public statement of good taste. Not surprisingly it was accomplished only in the teeth of vociferous opposition, especially from those who still carried the banner for a British art of the sort advocated by the recently deceased William Hogarth. During its early years the Academy was vehemently attacked by Robert Strange, an engraver of international renown and member of several French and Italian academies, who was appalled at its exclusion of practitioners of his art. At the same time a more general assault on the Academy as a despotic royal 'junto' led by a 'determined courtier' and 'master ... in the art of seduction' (i.e. Reynolds) was led by an anonymous newspaper polemicist who called himself 'FRESNOY'. Fresnoy was probably the Reverend James Wills, a history and portrait painter, former director of the Academy of St Martin's Lane, and chaplain to the Society of Artists. He published his essays in the most radical paper of the day, the *Middlesex Journal*, overtly linking criticism of George III as an arbitrary and politically biased ruler to royal sympathy for a foreign, 'Parisian' academy: 'You destain, then, sir, to mingle your royal favour with the vulgar, honest, ardent wishes of the people, in support of the society of artists of Great Britain; and therefore instituted the royal academy, so that the plumes of prerogative might wave in triumph over the cap of liberty.' Such critics had no time for what they condemned as 'the Mean, slavish, and selfish arts practised by the Foreign Academy in Pall-Mall'. Many artists resented and resisted the Academy's claims to represent all painters, to shape the public and to arbitrate taste.

But this opposition threatened members of the Academy much less

than the challenge to their interpretive authority posed by patrons and connoisseurs. The art world of the late eighteenth century and the early years of the nineteenth was therefore dominated by a struggle between patrons and artists to shape the artistic public, a battle that went back to the beginning of the century, but became ever more important at its end because the warring groups were more evenly balanced. The foundation and success of the Royal Academy made clear that artists could not be treated as mere mechanics. They had come far from the garret in Drury Lane and the manufacture of landscape by the yard. Of course, the painterly hack was far from extinct, but he was eclipsed in the public imagination by a far more elevated artist, who claimed the right not only to paint but, like the connoisseur and collector, to shape public taste.

CHAPTER SIX

Connoisseurs and Artists

IN THE AUTUMN OF 1759 Samuel Johnson urged his friend Joshua Reynolds to contribute a couple of essays to the weekly newspaper the *Universal Chronicle* under his own pseudonym of 'The Idler'. Johnson's request gave the painter a sleepless night but prompted some of Reynolds's earliest art criticism.

The neophyte critic chose as his first topic that old enemy and rival of the painter, the critic or connoisseur. 'To those who are resolved to be cricks in spite of nature', he wrote in No. 75 of 'The Idler',

> and at the same time have no great disposition to much reading and study, I would recommend to them to assume the character of connoisseur, which may be purchased at a much cheaper rate than that of a critick in poetry. The remembrance of a few names of painters, with their general characters, with a few rules of the Academy, which they may pick up among the painters, will go a great way towards making a very notable connoisseur.

Reynolds presses home his attack by describing a visit to Hampton Court with a connoisseur 'just returned from Italy', whose verbose 'cant of criticism' is 'emitted with that volubility which generally those orators have who annex no ideas to their words'.

Reynolds's sense that his first task was to challenge the opposition testifies to the power of those gentlemen collectors who claimed to have the discernment to be judges not merely of true painting but of good taste. Because the history of art has so often been written in the manner of Vasari as a history of artists, we tend to forget that, from the perspective of the connoisseur, the history of art is less the story of 'the artist' than a branch of another seemingly less exalted history, namely that of collecting.

In the late seventeenth century the market in 'Old Master paintings'

88. *The Yarmouth Collection, c.* 1665. Includes many items from the collection of curiosities owned by the Paston family of Oxnead Hall

was in its infancy, and British collectors often treated paintings as part of larger collections of objects gathered because of their value as 'curiosities'. In the earliest auction catalogues, where pictures were often mingled together with medals, antiquities, gems, shells and natural rarities, age (evidenced by the darkness of the painted surface) and rarity rather than beauty were singled out as distinctive features.

Throughout seventeenth-century Europe – in Italy, France, Germany, Holland, the Habsburg empire and Scandinavia – emperors, kings, princes and their followers accumulated and displayed what to the modern eye appear as an astonishing medley of natural and man-made objects in specially designed cabinets and museums, the so-called *Kunst und Wunderkammer* (fig. 88). Moved by 'wonder' and 'delight' at the 'marvellous', these royal collectors displayed what one contemporary summarized as 'pictures, statues, busts, shells, flies and reptiles' that satisfied 'blind curiosity', as Descartes disparagingly described it. The rare, the old, the grotesque and the unique were prized when acquisitive passions

were intent upon collecting microcosms of the external world that would
fit in the space of a single room. The aptly called 'Ark' of Sir John
Tradescant, which was to be the founding collection of the Ashmolean
Museum in Oxford, included, according to one commentator,

> a salamander, a chameleon, a pelican, a remora, a lanhado from
> Africa, a white partridge, a goose which has grown in Scotland on
> a tree, a flying squirrel, another squirrel like a fish, all kinds of
> bright coloured birds from India, a number of things changed into
> stone, amongst others a piece of human flesh on a bone, gourds,
> olives, a piece of wood, an ape's head, a cheese etc: all kinds of
> shells, the hand of a mermaid, the hand of a mummy, a very natural
> wax hand under glass, all kinds of precious stones, coins, a picture
> wrought in feathers, a small piece of wood from the cross of Christ,
> pictures in perspective of Henry IV and Louis XIII of France, who
> are shown, as in nature, on a polished steel mirror when this is held
> against the middle of the picture, a little box in which a landscape
> is seen in perspective, pictures from the church of S Sophia in
> Constantinople copied by a Jew into a book . . .

and much more besides. These objects were displayed not for their aesthetic
value or social utility. As Gimcrack, a character in Thomas Shadwell's play
of 1676, *The Virtuoso*, says, 'I seldom bring any thing to use, 'tis not my
way, Knowledge is my ultimate end.' The chosen items represented the
infinite variety and diversity of the human and natural words, qualities
best demonstrated by unusual or (even better) unique objects. By analogy,
correspondence and resemblance, the collection reconstituted the world,
placing it within the publicly visible power of its owner.

The virtuoso, usually defined as someone skilled and knowing about
rarities, was a much-satirized figure. His preoccupation with rarity and
uniqueness seemed indiscriminate and uncritical to those who viewed
nature as a realm of laws, categories and classes rather than one of
rampant heterogeneity. Such collecting came to be seen as 'a passion'
rather than a sensible pursuit. In *The Connoisseur: or, Every Man in his
Folly*, a play published in 1736, the collector Sir Godfrey Trinket justifies
it as 'Pleasure without Pain . . . it's my humour', but the fashionable Sir
Harry Gaylove responds, 'Let monarchs mention Humour – but let Men
be corrected by Reason.' Rational discrimination, he is saying, should
restrain and order indiscriminate impulse. This sense of the collector as

an amateur, a lover, rather than a reasoner, was expressed in engravings of seventeenth-century cabinets and collections that included a figure of Venus. In *The Connoisseur* the drama focuses on an equation between the avid pursuit of rarities and curiosities and the purblind pursuit of 'the gaudy glittering Meteors of the Sex', between the collector and the rake; women and items in a gentleman's cabinet are both 'collectibles', objects to be captured, displayed and discussed.

In this world of the virtuoso paintings could trigger memories about the past or convey information about something or someone who was absent; they were valuable for what they told. The purpose of contemplating an image was not to learn about its creator or to identify the marks of his creativity – issues of manner and style that were later to become so important – but to acquire knowledge about the world. Galleries such as the Brown Gallery at Knole, the seat of the Sackvilles in Kent, were hung with serried ranks of national figures and Protestant heroes – Chaucer, Thomas More, Sir Philip Sidney, Luther, Melanchthon and Pomeranus – whose portraits were intended to inform the mind rather

89. The Brown Gallery, Knole

than delight the eye (fig. 89). The artist was of far less consequence than the subjects of his portraits. (Indeed many of the pictures were not originals but copies of repeatedly reproduced portraits.) John Evelyn complained once to Samuel Pepys that painters did not identify their sitters by painting their names on the canvases. The presumption was that it was the sitter who mattered, not the identity of the painter.

But the eighteenth-century connoisseur believed he distinguished himself from the Renaissance virtuoso by his desire to develop subtle distinctions in order to develop a science of taste. Criticism replaced 'wonder' and 'delight'; critical evaluation according to standards laid out in manuals of connoisseurship superceded impulsive 'curiosity'. At the same time the world of collecting began to fragment, and new hierarchies evolved. At the top were the materials of the connoisseur: paintings, sculpture, prints and drawings, medals and gems, valued both for their taste and for what they revealed about the exquisite sensibility of the ancients; at the bottom were natural and manmade objects that had been the pride of a seventeenth-century *Wunderkammer*: shells and items of curiously wrought and exquisite workmanship. One commentator damned collecting them with faint praise as 'a not discommendable Amusement, tho' seemingly rather matter of Curiosity, than any useful Knowledge that appears to be gain'd thereby', a suitable pursuit 'for Workmen or Ladies, who are not so much ty'd down to Compleatness or Erudition, as to the Beauty and Perfection of Presentation'.

As this remark makes clear, gentlemen thought of connoisseurship as their prerogative, and not appropriate to artisans or women. 'Compleatness' and 'Erudition' could be acquired only by those of general vision, men whose independent fortunes enabled them to take the larger, 'liberal' view. But if all connoisseurs were gentlemen, it was not true that all gentlemen were connoisseurs. Connoisseurship depended, after all, on highly detailed and particular sorts of knowledge. This learning, apparently academic and theoretical, part of the classical inheritance absorbed by every proper gentleman through study or osmosis, actually depended upon certain sorts of experience, especially that of having visited distant lands and collected objects of 'virtu' from them. Connoisseurs gathered together and displayed their collections in London, but their haunts were in the Mediterranean, in Italy and Greece.

The first English institutional embodiment of the culture of the connoisseur was the Society of Dilettanti, established in 1734 (fig. 90).

90. *The Society of Dilettanti (Group I)* by Joshua Reynolds, 1779. From left to right clockwise: Sir Watkin Williams-Wynn; John Taylor (with garter in hand); Richard Thompson; Walter Spencer-Stanhope; John Smyth; Sir William Hamilton and Stephen Payne-Gallway. Hamilton, wearing the Order of the Bath and seated at the centre, points to a volume illustrating his Greek vases.

The rules of election to the Society recognized the central place of the Grand Tour in the making of a connoisseur, and its first members had all made their pilgrimages to the treasures of the Mediterranean. The Society was a place where acquaintances, often first made in Italy, could be renewed; where adventures, especially the sexual intrigues for which Italy and the Grand Tour were famous, could be retold; and where one's collections could be discussed in congenial company. Horace Walpole, who never became a member despite his antiquarian interests, sneered at the Dilettanti as a young bucks' drinking club – 'the nominal qualification for membership is having been in Italy, and the real one, being drunk'. And indeed, the Society included some of the most notorious rakes and topers of the day, but its high jinks, its schoolboy dressing up and the failure of some of its early projects (notably the patronage of Italian opera) should not lead us to underestimate its power and influence.

The Society's first members included Sir James Grey, who publicized

the findings from the excavations at Herculaneum; Lords Sandwich, Charlemont and Bessborough, who were among the first aristocrats to travel into Greece and Asia Minor in search of classical antiquity; a number of diplomats, like Lord Holdernesse, ambassador at Venice, who used their positions to forward the antiquities trade; and a circle of refined aristocrats associated with the court of Frederick, Prince of Wales. As years went on the membership became even more distinguished, including several major Whig aristocrats and a number of antiquaries whose private collections laid the foundations for Britain's nineteenth-century public museums and galleries: Sir Richard Worsley, resident of Venice, whose tour through the Levant, Greece, Egypt, Turkey and the Crimea beginning in 1785, produced a rich and sumptuously catalogued collection of antiquities; Sir George Howland Beaumont, the patron of William Wordsworth, who gave his collections of Old Masters and modern paintings to the nation to help found the National Gallery; and four collectors – Sir William Hamilton, Richard Payne Knight, Charles Towneley and C. M. Cracherode – whose vases, coins, medals, bronzes, drawings and paintings were vital to the early growth of the British Museum.

Collectors became more and more knowledgeable about technical aspects of ancient and modern art. Earlier it had been enough to explain why a particular picture was good or bad by referring to its pictorial qualities, what Jonathan Richardson in *The Science of a Connoisseur* (1719) enumerated as composition, colouring, handling, drawing, invention, expression, grace and greatness, advantage and pleasure; but understanding issues of attribution and provenance, of who had painted what and when, depended upon having seen many originals. As the author of an early catalogue of art in aristocratic town and country houses, *The English Connoisseur* (1766), put it, 'the only way, by which we can ever hope to arrive at any skill in distinguishing the stiles [sic] of the different masters in Painting, is the study of their works.' The concerns with authentication and with aesthetics created a persistent tension: was it more important to identify the artist or to explain a picture's virtues and beauties, and how, if at all, were the two questions connected? Different aims of connoisseurship involved different ways of looking at pictures: the first depended upon a general judgement formed of a painting in its entirety; the second often hinged on minor and obscure details. The connoisseur believed that he could judge art in a general way, but this skill seemed to depend more and more on an acquaintance with technical particu-

larities and details. So it seemed as if the connoisseur were acquiring bifocal vision, looking, as it were, through both the telescope and the microscope.

Whatever their point of view, individual members of the Society of Dilettanti were renowned as important collectors. And the Society itself was the forum in which they displayed their knowledge of aesthetic and cultural matters. For the cult of connoisseurship, no matter how much it spoke of the eye, placed a premium on talk: on being able to pronounce on art and to express the feelings provoked by viewing beautiful objects. As the Duke of Buckingham put it, 'any Man who drinks his Pot can judge a paltry Picture to be worth nothing, but how few can discuss the best Touches, and judge of a good Collection.'

Through their publications, the research they sponsored and the fame of the individual collections of members, the Dilettanti set the tone, shaped the language and decided the agenda for the conversation about antiquity and art during much of the century. At first their influence was confined to the charmed circle of aristocrats who had enjoyed the pleasures of the Grand Tour – theirs was essentially a private conversation – but, as interest in collecting pictures grew and as more and more merely well-to-do people made the Grand Tour, so they found themselves engaged in a more public debate about art and about their authority to interpret its value.

With its impeccable aristocratic credentials, the Society was never short on presumption. In the 1750s, when the committee of painters led by Francis Hayman asked for help in establishing a national academy, they graciously offered their aid provided that half the fellows would be Dilettanti members and that the president, with the casting vote, would always come from the Society. These conditions, which may seem egregious to us today, sharply reminded the artists that those rich collectors were still in control. Gentlemen scholars, critics and collectors were far from ready to concede their authority to mere painters who, since they merely per-formed the mechanical task of transmuting ideas and theories into tangible objects, were judged of little consequence. As Baron d'Hancarville, a French connoisseur who worked with collectors including Sir William Hamilton and Charles Towneley, put it, 'In every Art good models give birth to ideas by exciting the imagination, theory furnishes the means of expressing those ideas, practice puts these means in execution, and this last part which is always the most common is also the easiest.'

The Dilettanti began as a convivial dining society but soon became a very wealthy club. By the end of the century it had a running surplus of £10,000, which made it almost as rich as some of its aristocratic members. This meant it could patronize modern painters and support research. In 1774 it offered to pay the expenses of two students nominated by the Royal Academy to spend three years in Italy and Greece. Its support for the researchers by James 'Athenian' Stuart and Nicholas Revett to study antiquities in Athens was of even greater importance to the history of British taste: the four lavishly illustrated volumes of *The Antiquities of Athens*, which appeared between 1762 and 1814, shifted interest in classical art from Italy to Greece, nurturing that phil-Hellenism whose most famous exponent was Byron. Stuart's and Revett's discoveries prompted the Society to sponsor other expeditions, most notably to Asia Minor by Revett, Richard Chandler, an Oxford don, and the artist William Pars, whose work on the magnificent temples of Bacchus at Teos, Minerva at Pirene and Apollo near Miletus, were published by the Society as *Ionian Antiquities* in 1770 (fig. 91). Together *The Antiquities of Athens* and *Ionian Antiquities* inaugurated a new phase in the study and acquisition of classical antiquities in which European governments, notably those in England and France, vied to get the finest possible specimens. Connoisseurship became a branch of international conflict and imperial rivalry; antiquities acquired added status as a prestigious plunder of war.

The Dilettanti survived into the nineteenth century, but as more and more antiquities were brought to England by private collectors, their publications also came closer to home. The Society's last major eighteenth-century project, begun in 1799 and completed in 1808, celebrated these British collections. The *Select Specimens of Ancient Sculpture preserved in the several Collections of Great Britain* was dominated by works owned by Richard Payne Knight and Charles Towneley, two Dilettanti who sat on the Society's publication committee.

Whether publishing lavishly illustrated treatises, sponsoring expeditions in search of unfound antiquities, or learnedly elaborating on the different uses of colour by Titian and Giorgione, the connoisseur seemed altogether different from the serendipitous and scatter-brained virtuoso with his rag-bag of curiosities. But in one respect he retained the attributes of the passionate collector of valuable trifles. The association of collecting with the pursuit of 'the fair sex' persisted long after virtuosi went out of fashion.

91. *A Sepulchral Monument at Mylasa* by William Pars, 1765

Connoisseurship was not necessarily associated with libertinism, of course, and clearly not all collectors or Dilettanti were profligate or impious debauchees. But many influential connoisseurs, such as the Earl of Sandwich, had a reputation for an enthusiasm for sex equal to their enthusiasm for *virtu*. The court of Frederick, Prince of Wales, and the retinue of the Prince Regent, the two royal aesthetes of the century, were renowned for both. For young men the Grand Tour was not only an initiation into the pleasures of connoisseurship but also, as parents' anxious admonitions attested, an education in venery and fornication. For a young English gentleman the scented breezes of the Mediterranean were redolent of sex. The *cicerone*, the tutor who instructed young men, personified the Grand Tour's pursuit of culture, but the *cicisbeo*, the languishing young man mesmerized and subjugated by Italian female charms, exemplified its eroticism. As Caroline, Lady Holland, warned her sister Emily, Duchess of Leinster, whose eldest son was on the tour, 'don't leave him too long in Italy; except *virtu*, nothing is to be learnt in it. The women are dangerous in every respect, nothing to be learnt from them, vice and illness frequently got by them and if once a young man

92. *Sir Francis Dashwood
at his Devotions* by William
Hogarth, mid-1750s

becomes a real *cicisbeo* 'tis a lounging idle life which when once got into is difficult to get out of.' Even Horace Walpole, never known as a womanizer, became the *cicisbeo* of the beauty Elizabeth Capponi during his stay in Florence on his tour of 1739–41.

The very study of *virtu* was tainted with sex. The nude female figure, phallic objects, depictions of amorous intrigue and energetic copulation on Greek and Roman vases and wall paintings were often the object of the jests, puns and jokes that passed for humour in the world of the young collector and connoisseur. The Earl of Carlisle, writing to his epicene and androgynous friend George Selwyn from Naples in 1768, teased him with the promise of an erotic souvenir: 'I go to Herculaneum to-morrow. If I can possibly steal anything for you, I will. I have bought nothing as yet but two small landscapes of Gaspar Poussin, and two copies of pictures at Florence . . . I had a great mind to have bought you

a great ring of Priapus, that you might have something like a—about you; but I know you would have been ashamed to have hung out such false colours.'

In their clubby private world, collectors happily noted and mocked the association of the connoisseur's acquisitiveness and the rake's concupiscence. Sir Francis Dashwood, a founding member of the Dilettanti and a notorious debauchee, commissioned a portrait from Hogarth in which he is blasphemously depicted as a priest worshipping a piece of *virtu* in the form of a recumbent Venus (fig. 92). Hogarth's painting, which in turn alludes to an earlier portrait of Dashwood by George Knapton in his capacity as the official painter of the Dilettanti Society (fig. 93), epitomizes that version of the collector's gaze as the look of private sexual desire. Instead of reverencing Christ on the cross, he looks adoringly upon a fleshly, all-too-corporeal figure whose pose exposes her entirely to his vision. The collector's desired object and the beautiful woman are treated as one.

It might seem, in the light of Hogarth's hostility to connoisseurs,

93. *Francis Dashwood, Fifteenth Baron le Despencer* by George Knapton, *c.* 1745

that he intended his Dashwood portrait critically. He may indeed have enjoyed the irony of painting a connoisseur in such a poor light. But from Dashwood's point of view it certainly was not unflattering; on the contrary, Sir Francis and his friends enjoyed this sort of cabinet picture, hung either with portraits of fellow rakes and antiquaries or with pornographic pictures, as a ribald male jest.

By the late eighteenth century the equation of the object desired by the collector and a beautiful woman had become commonplace. The connection was reinforced by critical works such as Edmund Burke's *A Philosophical Enquiry into the Origin of our Ideas of the Sublime and Beautiful* (1756), which associated the sublime, defined by him as the pleasurable sensation of astonishment, with masculinity, and beauty with femininity. Hannah More used the link between contemplating the beautiful and admiring the feminine in her extremely influential and widely read *Strictures on the Modern System of Female Education* (1799) to criticize women who accepted the male view of them as decorative objects comparable to elegant pictures or beautiful sculptures:

> If, indeed, women were mere outside form and face only, and if mind made up no part of her composition, it would follow that a ball-room was quite as appropriate a place for choosing a wife, as an exhibition room for choosing a picture. But, inasmuch as women are not mere portraits, their value not being determinable by a glance of the eye, it follows that a different mode of appreciating their value, and a different place for viewing them antecedent to their being individually selected, is desirable. The two cases differ also in this, that if a man select a picture for himself from among all its exhibited competitors, and bring it to his own house, the picture being passive, he is able to *fix* it there: while the wife, picked up at a public place, and accustomed to incessant display, will not, it is probable, when brought home stick so quietly to the spot where he fixes her; but will escape to the exhibition room again, and continue to be displayed at every subsequent exhibition, just as if she were not become private property, and had never been definitively disposed of.

Hannah More's concern to free women from a public world of display and to enclose them in the bosom of the patriarchal family represented a radical alternative to the masculine world of libertines and dilettantes

so notoriously associated with two of the best famous Dilettanti, Sir William Hamilton, British envoy at Naples, and Richard Payne Knight. The collecting and sexual exploits of these two men were admired by aristocratic connoisseurs but attacked by artists and moralists for distorting the proper purposes of art and using it for their private, pornographic ends.

William Hamilton and Richard Payne Knight were prominent public figures. Hamilton, whose collections became the basis of the British Museum's major holdings in classical antiquity, had a profound effect on household taste by transmitting his ideas, in suitably decorous fashion, through Flaxman and Wedgwood. But in many ways Payne Knight was the more important figure, for his cultural power was prodigious. A leading figure in the Dilettanti Society, he also sat on the parliamentary committee for public monuments, the so-called Committee of Taste (1802); he was a founding member of the British Institution, an exhibiting society run by collectors that displayed Old Masters and modern art; he was vice-president of the Society of Antiquaries and a trustee of the British Museum. His own collections included coins, intaglios and gems, a magnificent group of bronzes, more than 1,000 Old Master drawings, and paintings by Claude, Rembrandt and Mantegna. He was, according to the *Quarterly Review*, 'the arbiter of fashionable virtu' and, as the entries in the diary of the painter Joseph Farington demonstrate, contemporary painters much feared his acidulous criticism and rigorous connoisseurship.

For Payne Knight was a man who knew his own mind and enjoyed controversy. Horace Walpole and Henry Giffard concurred in finding his manner 'arrogant', 'dictatorial' and 'assuming'. When Humphry Repton became embroiled with Knight in a controversy over taste in landscape, he was reported as being terrified at incurring 'Knight's enmity'. At a Royal Academy dinner of 1797 Payne Knight wounded Thomas Lawrence by commenting on the latter's painting of Prospero raising a storm '*loud* in the room. He was very sorry he had put in a picture which everyone condemned'. He lashed fellow connoisseurs as well as contemporary artists, claiming that Winckelmann had 'no knowledge of coins . . . [and] understood nothing of the Greek language'. In a discussion of Raphael at a dinner at Charles Towneley's 'Knight said the Cartoons at Windsor are not original that the Cartoon at Badminton is not original, neither is that which was in the possession of Mr Hoare of Bath'. Though

94. *The Charm of Virtue,
or a Cognoscenti
Discovering the Beauties
of an Antique Terminus* by
James Gillray, 1794

at times provoked into rashness, Knight's skills and knowledge were
much respected and his views were carefully scrutinized by artists, who
lapped up every anecdote about him, and leapt upon his occasional errors.
He may have been dubbed 'Priapus' Knight because of his notorious
study of phallic worship, *An Account of the Worship of Priapus*, but he
was nonetheless the most powerful gentleman connoisseur of his day.

This ambiguity is perfectly captured in a drawing by James Gillray
– never published as an engraving – which depicts Payne Knight as
triumphant connoisseur, admiring a piece of classical *virtu* which he
endows with a conspicuously upright member through the inadvertent
placing of his thumb (fig. 94). Gillray captures Payne Knight's exuberant
confidence in his judgement of ancient works of art, his pleasure in their
contemplation and his ability to sexualize these activities.

William Hamilton, long a collector, became famous through his
liaison with the beauty Emma Hart, who – having successively been
mistress to Sir Harry Fetherstonhaugh of Uppark and then the fashion-

able young connoisseur and man-about-town Charles Greville – was sent
in 1786 by the latter to his uncle, William Hamilton, in Naples. Con-
signing Emma to Sir William's care, Greville described her as one of
the finest objects of *virtu* he had ever collected. Hart was already famous
as a model in London, painted repeatedly by George Romney, who was
infatuated with her; rakes and connoisseurs like the Prince of Wales and
Sir John Leicester snapped up copies of his work. In Naples, under
Hamilton's tutelage, she ceased to be the subject of painting and herself
became an art object (fig. 95). Hamilton was completely smitten; he
married Emma in 1791. Goethe, visiting Hamilton in Naples in 1787,
recorded his astonishment and delight at the roles that Emma Hart was
asked to perform:

> He [Hamilton] has had a Greek costume made for her which
> becomes her extremely. Dressed in this, she sets down her hair and,

95. *Lady Hxxxxxx*, *Attitudes*
by Thomas Rowlandson

with a few shawls gives so much variety to her poses, gestures, expressions &c that the spectator can hardly believe his eyes. He sees what thousands of artists would have liked to express realized before him ... the old knight idolises her and is enthusiastic about everything she does. In her he has found all the antiquities, all the profiles of Sicilian coins, even the Apollo Belvedere.

He wrote later,

> I was greatly intrigued by a chest which was standing upright. Its front had been taken off, the interior painted black and the whole set inside a splendid gilt frame. It was large enough to hold a standing human figure, and that, we were told, was exactly what it was meant for. Not content with seeing his image of beauty as a moving statue, this friend of art and girlhood wished also to enjoy her as an inimitable painting, and so, standing against this black background in dresses of various colours, she has sometimes imitated the paintings of Pompeii or even more recent masterpieces.

Emma Hart, as she herself recognized, had been completely objectified. Goethe regretted when she spoke, for he thought her vulgarity spoiled her noble effects. Lady Palmerston commented in 1793, 'I do not wonder he [Hamilton] is proud of so magnificent a marble, belonging so entirely to himself.' And Horace Walpole, drawing on a story that had first circulated in the popular scandal sheet, the *Town and Country Magazine*, quipped, 'Sir William has actually married his Gallery of Statues.' Even before the notorious affair between Emma and Nelson, which led Thomas Rowlandson to satirize him as the cuckolded voyeur, reduced to watching the admiral enjoy his wife's charms (fig. 96), the envoy at Naples was famous not only as a great collector but as a connoisseur who cherished fleshly as well as antique *virtu*.

Hamilton's acquaintance with Richard Payne Knight, which began when the latter visited Naples in 1777, led to a public outcry when Payne Knight printed a report Hamilton sent to the Dilettanti Society about a surviving priapic cult in the village of Isernia in the Italian Molise, to which he added an extensive and learned comparative account of phallus worship down the ages. *An Account of the Worship of Priapus*, whose theses (in slightly bowdlerized form) Payne Knight developed further in his *Symbolic Language of Ancient Art and Mythology* (1818), is a study of Roman, Greek, Egyptian and Hindu rites and myths (fig. 97).

96. *Modern Antiques* by
Thomas Rowlandson

Payne Knight's argument, he freely conceded, drew extensively on
the work of a French connoisseur, Pierre François Hugues, the self-styled
Baron d'Hancarville, whose *Recherches sur l'Origine, l'Esprit et les Progrès
des Arts de la Grèce* Payne Knight had helped to publish in the previous
year. D'Hancarville was well known in connoisseurship circles. His skills
were acknowledged by Johann Joachim Winckelmann, whose *History of
Ancient Art*, first published in German in 1763–4 and quickly translated
into French, was the first thorough account of antique art. He had
produced – tardily and at great expense – the catalogue to Hamilton's
collection of antiquities; and he had been taken up by Payne Knight and
by Charles Towneley, in whose picture gallery he was depicted along
with Charles Greville and Towneley himself in a painting of 1781–3 by
Johann Zoffany (plate 5). D'Hancarville was a man of great learning, but
also a rogue. Like Casanova, he was one of those people who lived off

courtiers and aristocrats, catering to their appetites and desires: gambling, flattering, procuring and stealing. Imprisoned for debt on several occasions, accused of purloining the silver of the Duke of Württemberg, banished from Naples for publishing pornography, he nevertheless combined prodigious learning with great personal charm. In his work on Greek antiquities he led Payne Knight into the mysteries of orientalism and comparative religion.

Payne Knight's *Account of the Worship of Priapus*, more than an account of an atavistic religious cult, aimed to place the events at Isernia in a global religious context. Phallus worship appeared obscene when taken out of context, conceded Payne Knight, 'but . . . will be found to be a very natural symbol of a very natural and philosophical system of religion, if considered according to its original use and intention'. He set out to demonstrate, like d'Hancarville, that all religions were united by a common, universal creation myth that had been forgotten or suppressed by sectarian priests. Recovering this common origin, Payne Knight claimed, was to subvert the doctrinaire claims of most Christian theologians and endorse the Enlightenment's plea for religious toleration and an end to religious persecution. His target was 'Dogmatical Theology, and its consequent Religious Persecution . . . two of the greatest curses that ever afflicted the human race'. According to Knight, the creation myth divided nature into two powers: an active force, male and phallic, which expressed the 'idea of the beneficent power of the great Creator'; and a female one, symbolized by an egg, which was earth-like and inert, and which was 'the passive instrument' of God's 'most beneficial' phallic power. He then compared the sacrifice or initiation of bacchantes – 'fair victims' – into the ancient cult of priapus with the analogous Egyptian cult in which maidens are offered to a male goat. (It is no coincidence, incidentally, that the most frequent and popular role in which Emma Hart was painted was as a bacchante, as a priestess, usually identified by her tamborine, participating in an orgiastic bacchanal [fig. 99].)

Payne Knight derived his conclusions in part from the textual scholarship for which he was famous. But, as is always true for archaeologists, artifacts were even more important, for his argument depended upon a detailed examination of sculptures, coins, bronzes, medals and gems. These, not coincidentally, were from his own collection and those of other connoisseurs, notably that of his friend and collaborator Charles

Towneley. The implication was that these private collections held the hermeneutic key to mythology and religion.

Payne Knight was a formidable scholar, but his book is also deliberately provocative. With its engravings of the votive phalli, the so-called Toes of Isernia, its punning 'tail-piece' showing a satyr copulating with a goat, its ironic asides about the pleasures of the priesthood and its suggestion that the crucifix was a symbol of the organs of generation, it understandably provoked indignant condemnation. One apoplectic critic spoke for many when he excoriated it as 'the records of the stews and bordellos of Grecian and Roman Antiquity, exhibited for the recreation of antiquarians, and the obscene revellings of Greek scholars in their private studies.'

The Account of the Worship of Priapus, whose printing was ordered by the Dilettanti Society, was not exactly published but it was widely distributed. Copies were presented to the British Museum, the Society of Antiquaries, the Royal Society, the Royal Academy, the Royal Library

97. Frontispiece and title page of *An Account of the Remains of the Worship of Priapus* by Richard Payne Knight, 1786

and the Prince of Wales. (Not even Payne Knight dared to present a
copy to his prudish monarch and equally prudish queen.) An artist like
Thomas Rowlandson, who knew the raffish set in which Payne Knight
moved and whose own pornographic work seems sometimes to have
been commissioned by the Carlton House set around the Prince of Wales,
clearly had a detailed knowledge of Payne Knight's text; his *Modern
Antiques* (fig. 96) includes a number of objects specifically referred to
in it. And, as is so often the case with such works, many people knew
what the book was about or claimed to even if they had not read it.
It seemed an exemplary product of radical, Enlightenment scepticism,
not only an attack on priestcraft but a defence of the pleasures of the
male libertine sustained by a remarkably learned exposition of classical
antiquity.

To his critics, Payne Knight appeared to offer not Roman virtue or
Athenian politeness but a justification for the worst excesses of patrician

99. *Emma, Lady
Hamilton as a
Bacchante* by George
Romney, mid-1780s

misconduct. Conservative publications like the *British Critic* and the *Anti-Jacobin* saw his radical Whiggery, his pantheism and his social circle as closely connected. For Payne Knight was a follower of the rakish young set around Charles James Fox as well as a close friend and possible lover of Margaret Harley, Countess of Oxford, whose affairs were so numerous and notorious that her children were known as 'the Harleian miscellany'.

The interest of Hamilton and Payne Knight in the cult of priapus is sometimes dismissed as a mistake or aberration, but their preoccupations, also shared by the Catholic Charles Towneley, were a longstanding part of the culture of the aristocratic connoisseur, now acquiring new strength and even some scholarly respectability in the last part of the century by their association with a substantial body of literature concerned with the origins of myth and religion – works like Sir William Jones's *On the Gods of Greece, Italy and India* and Charles Dupuis's *Origine de tous les Cultes* – which appeared to convert the sexual predilections of the libertine into the pursuit of enlightenment by the modern intellectual. The cult of priapus and the intellectual baggage with which it was surrounded seemed to legitimate an essential, if threatened, aspect of male aristocratic culture. At the same time, Hamilton and Payne Knight were making public matters which the new public for art preferred to have kept private. Visitors to the Royal Academy and other public exhibitions, the people who objected to naked male statues, did not share the values of the libertine connoisseur. In the prudish and moralizing decades before and during the French Revolution, when political anxieties in England led to a call for a national reformation of manners led by a reformed aristocracy, these views became a liability. They might continue to flourish in private, but undermined the critical authority of collectors like Hamilton and Payne Knight with the gallery-going public, a circumstance that painters were eager to exploit.

Payne Knight and his friends flamboyantly proclaimed their superiority as arbiters of taste. In a series of reviews, pamphlets and books Payne Knight laid out his credo and assumptions. He was especially critical of artists' claims to be best at judging the provenance of a picture. Though a friend and admirer of Reynolds, whom he thought *'the great painter of the age'*, he condemned him for being hopeless as a connoisseur, duped into acquiring obvious fakes: 'no unfledged peer or full-plumed loan-jobber was more liable to be deceived, even in those branches of the art which he professed most to admire; false Coreggios, false Titians, and

false Michael Angelos swarming in his collections'. Painters, he was sure, should stick to painting.

Payne Knight was also far from happy with the obsession with history painting. He maintained that this preoccupation, born of a desire to elevate the artist as proponent of public virtue and morality, encouraged a painter to attempt work far beyond his education and ability, so that he became 'intoxicated with ideas of the grand style, and inflated with the truth of theoretical science, to a degree that has disqualified him for the art of the potter or the cotton-printer, without qualifying him for that of the academician'. Payne Knight had little time for the academic emphasis on morally-elevated art: 'conveying religious, moral or political instruction in pictures . . . is the most absurd of all absurd notions.' He scorned Boydell's attempt to encourage history painting: 'The Shakespeare Gallery! – which every man, conversant with art, and alive to the reputation of his country, rejoiced in seeing dispersed, and deprived of the means of collectively disgracing it.' And he condemned public academies of artists as false arbiters of taste and a constraint on true talent:

> One of the evils of academies . . . is the spirit of corporate pride and vanity engendered and nourished in them . . . An assembly of such dignitaries becomes, in their own estimation at least, a legislative synod of taste and science; which fixes arbitrarily the *criteria* of excellence, and thus sanctions and renders systematic every error, which the caprice of fashion or wantonness of theory may have accidentally brought into practice.

With their prizes, pensions and honours, academies were 'clogs to genius' which produced only 'blameless mediocrity'. In a notoriously tart essay in the *Edinburgh Review* he was especially scathing about James Barry's elaborate historical decorations of the Society of Arts building in the Adelphi. Artists, he argued, should accept their limitations. Better a good genre picture or a well-executed landscape than an execrable history painting.

Actually Payne Knight was less prescriptive than the artists of the Academy about what painters might properly do. As long as wielders of the brush and pencil knew their place, making art intended for the pleasure and critical contemplation of gentlemen of taste, they could legitimately work in any genre. What mattered was less pictorial content and public instruction than technique, skill and overall painterly effect.

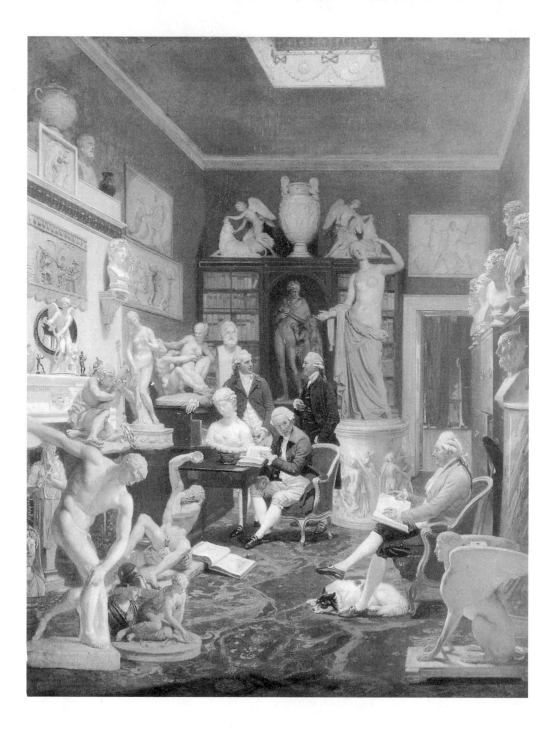

Charles Towneley in his Gallery by Johann Zoffany, 1781–3.
In this pastiche Zoffany includes the finest specimens from Towneley's collection.
Towneley himself is seated on the right; his collaborator and the friend of Payne Knight,
Baron d'Hancarville, sits at the table in the centre; Charles Greville, Emma Hart's former
lover, stands on the left and Thomas Astle, an antiquary, stands on the right

PLATE 5

Portrait of two children reading Bewick's *Quadrupeds*, attributed to
James Northcote, date unknown

PLATE 6

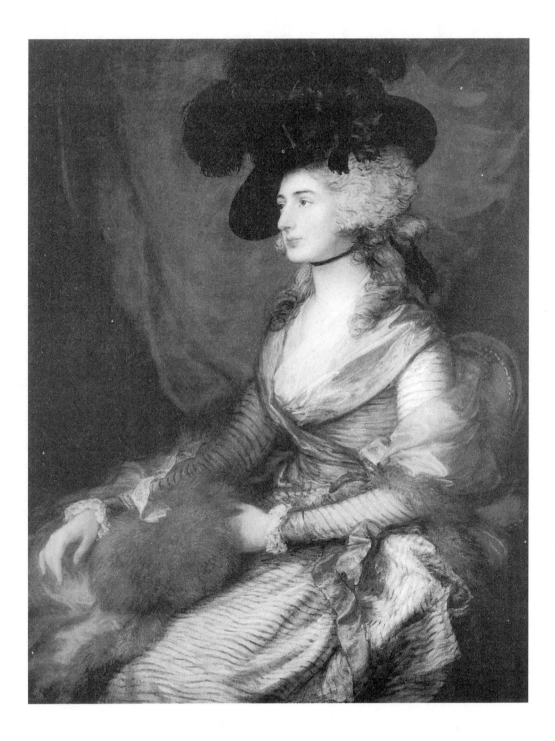

Mrs Siddons by Thomas Gainsborough, 1785

PLATE 7

Cupid's Revenge by Angelika Kauffmann, engraved by Gabriel Scoromodoff, 1778.
A typical stipple engraving of a sentimental subject

PLATE 8

Knowledgeable collectors, highly critical of individual artists, were deeply concerned with the features of a painting that were the signature of its creator. As one would expect with critics interested in attribution, individual distinctiveness mattered greatly to them. They encouraged the notion of artistic genius and placed creativity in a less moralized, more aesthetic, visual and sensual context: 'It is . . . intuitive feeling and perception for the possible and ideal perfection of art, joined to study, persevering, systematic exertion to reach it, which properly constitutes genius; and ought to be the criterion to guide patrons, parents and guardians, in encouraging students to pursue it.' Payne Knight was fascinated by colouring and by technique; he was as absorbed by the painters of northern Europe, especially Rembrandt and Rubens, and by the colourists of Venice as by the canonical artists of Rome, Florence and Bologna; he preferred antique bronzes to marbles because they were more likely to display the marks of their creator.

This mix of classical learning with a concern for creativity and genius we associate with Romanticism. What was absent was a sense of art as a form of public moral instruction, its role in creating a virtuous policy. Art and *virtu* might be instructive for these connoisseurs, but only in a private world of aesthetic pleasure, like their own collections. If it were properly instructed by gentlemen collectors and their collections of Old Masters (whenever Payne Knight discussed a picture he almost always referred to its owner), public taste might be improved but public morality would be unaffected.

From the academic painter's point of view this perspective seemed, as Thomas Lawrence said of Payne Knight's taste, to be based on 'sensual feeling' rather than reason and moral probity. This was the Achilles' heel that the Academy painters attacked. Much of the polemical literature written by proponents of the Academy deliberately contrasted the vitiated, sybaritic private world of the connoisseur with the edifying, instructive public realm they wished to create. The proper function of art, one pamphleteer platitudinously remarked, was 'the promoting of knowledge, and the disseminating of virtue among mankind'; but this was corrupted if art were subordinate 'to idle and vain purposes, made subservient to trivial pleasures, and ostentatious parade, in which neither sentiment, or dignity, or national virtue were appealed to, or intended to be applied. As those "baseless fabrics" begin, so they end, in Time abused, Money dissipated, Folly entertained, and Genius perverted.' This apologist laid

blame for the inadequate state of British art at the door of the connoisseur; the arts, he commented, 'have been wholly directed to local purposes, and the gratification of private taste' has prevented them from 'forming an object, to which the general eye can ... be turned'. The conclusion that the reader is asked to draw is obvious: only the Academy's public exhibition space could create a proper public art; only history painting, a genre which, as artists and commentators constantly bewailed, did not attract private patrons, could edify and instruct.

The struggle between the connoisseurs and the Academy was a quarrel about how art should be seen, an argument about ways of looking. Once public exhibitions, including the annual Royal Academy show, became commonplace, they were both concerned to teach a growing public for art how it ought to look at pictures. Their efforts were yet another phase in the contest between those who produced and those who collected art to decide who governed artistic interpretation. The frequent, often vituperative comments made on both sides about public intransigence, about the difficulty of instructing it, is testimony to the importance of the task.

From the 1760s on, magazines, newspapers and works on social accomplishment included more and more information about how to evaluate and look at pictures. On the whole the advice was hardly new, only its presentation to a larger public. Newspaper articles tended to confine themselves to descriptions of works on show and explanations of their classical iconography. General guidance and criticism, derived from the works of the French critic Roger de Piles and his English popularizer Jonathan Richardson, usually took the form of an inventory of pictorial features – the subject matter, appropriate expression, relation of parts to whole, just drawing, appropriate colouring, and foundation in Nature – which could be checked off by the neophyte viewer. At the same time newspaper critics in the 1770s and 1780s made a serious attempt to educate the viewing public in the importance of history painting.

Occasionally, however, a rather different sort of advice was offered, which had to do with the conduct of the viewer. *The Polite Arts, dedicated to the Ladies* (1767) takes the picture-goer in hand: 'when you view a painting, take particular care not to go, like ignorant people, excessively near; but rather beginning far off, approach gradually, till it appears rough; then recede a little, till it looks sweeter; it is what connoisseurs call finding the proper light of a painting.' What we observe is a woman

whose proper conduct we adduce through a contrast with the behaviour of others whose actions are less well informed. We are shown how to and how not to view pictures in the presence of others. Looking at pictures, we realize, is not just an aesthetic matter but a social activity, fraught with difficulty.

The question of how to look at pictures was addressed in images as well as words. The famous, much-reproduced engraving of the Royal Academy exhibition of 1787, published in 1788, speaks volumes about picture-viewing when compared with the commentaries in contemporary treatises on taste (fig. 100). This image, engraved by Pietro Antonio Martini, who also produced a print of the French Salon of 1787, was from an original drawing by Johann Heinrich Ramberg, a young Hanoverian who had come to London in 1781 and enrolled in the Royal Academy schools. Ramberg had excellent connections: he had been

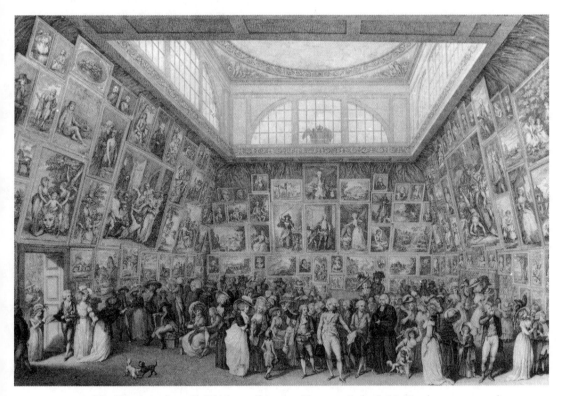

100. *The Royal Academy Exhibition at Somerset House, 1787* by J. H. Ramberg, engraved by Pietro Martini, 1788

patronized by George III and instructed by the monarch's favourite painter, Benjamin West. Ramberg presented the fruits of his education in three history paintings which he exhibited at the Academy in 1784, but he was not inclined to paint in the grand manner; his real interest and skill lay in satirical drawings, which he produced for most of his working life and exhibited in the Academy shows of 1782 and 1788. These satires playfully attacked the vices of the great, and several of them were directed against the pretensions of connoisseurs and collectors. His skill (as well as his proclivity for flagrant borrowing) have led modern critics to call him the German Hogarth or, more aptly, the German Rowlandson.

Ramberg's drawing and Martini's engraving fitted into a satirical tradition about a theme – the turbidity and heterogeneity of crowds of people at public gatherings – repeatedly explored by Hogarth and his contemporaries and by the graphic artists of the 1770s and 1780s. The Great Exhibition Room appears with the Greek motto over its door – 'Let none but Men of Taste presume to enter here' – but it depicts a changing, unstable environment: the pictures lean uneasily towards their viewers and the public flirts, gossips and plays with an energy that hardly seems compatible with the studious contemplation of art.

The satire is still more pointed than this. It is directed not just at the turbulent crowd but specifically at how visitors viewed or, as often as not, did *not* view the works of art on display. We can see in this engraving most of the ways of not looking or improperly looking at pictures that artists disliked, and implicit in the satirical admonition is the proper way of viewing.

One failure is that of not looking at the pictures at all. In this engraving (and it is also true of Martini's print of the Paris Salon) only a handful among more than forty figures are looking at the pictures. The Prince of Wales, in the centre, excites just as many admirers as the canvases (including his own portrait) on the walls; certainly more people are looking at other people than at the paintings. So a space of public edification has become a place of fashionable display, an occasion for the pursuit of private pleasure. Not looking or, at least, looking at other people and things instead, undercuts the aims of the Academy; visitors treat the pictures as decoration and artists as unimportant or, at best, less important than the giddy round of polite society.

Two ways of looking associated with the gentleman connoisseur

are depicted: the first pays excessive attention to detail, examining the particularities of a picture and failing to appreciate the whole, aiming not to understand the picture's larger meaning, but to identify the distinctive manner of its creator by examining minutiae. This technique, which in the nineteenth century was elevated into a science by the Italian physician Giovanni Morelli, was used by Winckelmann, the greatest of the European connoisseurs of classical antiquity, in his stylistic history of antique art. Through a study of how nipples and knees and other features were depicted he had established a chronology of stylistic development and attributed specific works to different artists. Payne Knight used similar methods on the many Old Masters he was asked to examine in London drawing rooms and provincial country houses. In this print, this way of looking is embodied by the diminutive macaroni (extravagantly dressed fop) who stands on a bench on the left, examining a painting through an eyeglass. He is not, of course, trying to make an attribution – he has only to look in the catalogue to learn this – but he is so taken with the cult of connoisseurship that he chooses to look at the picture erroneously, as if he were a connoisseur.

The second way of looking associated with the connoisseur is the unreasonable, passionate, acquisitive gaze of private desire, represented by the fashionable male figure on the right, gazing ostensibly at the pictures but also at a beautiful woman with a pudgy, bespectacled, older man. This familiar figure of the male connoisseur who equates the female beauty with an art object is in an unfamiliar context: no longer in the private world of Sir Francis Dashwood's cabinet or even Sir William Hamilton's Neapolitan villa, the connoisseur's prurient and lascivious gaze is now in a public space, in the realm of display that so worried Hannah More. And it is depicted not in a unique painting but in a widely reproduced and widely available engraving. This gazing connoisseur represents the antithesis of the high-minded attitude which Reynolds and his colleagues wished to encourage.

The intensity and effectiveness of this condemnation is best seen in the work of Thomas Rowlandson and nowhere more clearly than in his *The Connoisseurs* (fig. 101), where three men, one of whom has usurped the seat of the artist, examine a painting of Susanna and the Elders. The subject matter of the painting is appropriately 'historical', taken from a story in the Apocrypha. (Rowlandson often uses this tale in works which depicted connoisseurs or explored the more general theme of old men

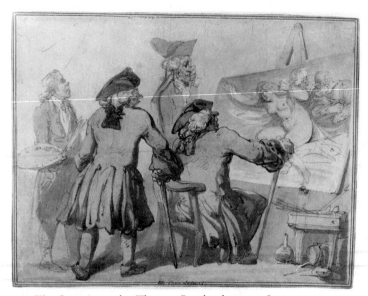

101. *The Connoisseurs* by Thomas Rowlandson, *c.* 1800

looking at young women or representations of young women.) But
Susanna is rendered not as an ideal beauty but naturalistically, as a
frightened young woman. Indeed she seems about to burst out of the
canvas in her efforts to elude her persecutors; but this affords her no
escape, for in avoiding the elders she thrusts herself into the arms of the
connoisseurs, who are themselves ugly elders.

The story of Susanna and the Elders perfectly expressed the notion
that male desire could threaten female beauty. Susanna (the name means
'lily' in Hebrew and is a symbol of purity) was accustomed to bathe in
her garden. Her unobserved nakedness is a sign of her simplicity and
virtue, but her unveiled chastity is vitiated by the ogling gaze of the
elders who are watching her covertly. Filled with desire, they demand
that she give herself up to them; otherwise, they threaten, they will testify
that they have seen her in adultery, a capital offence. Susanna refuses;
the elders carry out their threat; she is condemned to die. But she is
saved by Daniel, who is able to show that their testimonies conflict, and
her purity triumphs.

We are familiar with the lubricious gaze of the elders (and con-
noisseurs) who also desire (private) possession, either of Susanna or of
her picture. The way the elders regard Susanna corrupts her beauty, but

their lust also inhibits their vision and distorts their judgement. When asked to testify, they cannot give a consistent account of what they have seen. They cannot describe the truth of Susanna's purity because they are blinded by the way in which they look at her; they cannot even agree on how they misrepresent her, and this failure destroys their credibility. By analogy, the connoisseurs both mis-see and mis-describe.

Rowlandson's drawing exemplifies an attack that artists repeatedly made on connoisseurs in the late eighteenth and early nineteenth centuries. The critique was not without effect. The public, whose knowledge of taste and art was largely derived from the annual Royal Academy exhibitions and newspaper commentary about them, became disposed to accept the view that artists who aspired to paint public history and adhere to a classical aesthetic should have greater authority than private collectors, whose concerns sometimes appeared disreputable.

But the Academy's position was also inhibiting. They had stolen the connoisseurs' classical clothes, but they were a tight and uncomfortable fit. For, as we have seen, most English painters lacked a classical education; many never produced more than a handful of history paintings; and most were in the business of producing not universal truths of ideal nature but images of the persons and property of the English governing classes. Hogarth's aesthetic – modern, naturalistic, derived from the north European tradition of reproducing observable nature – may have vanished from art theory but it never lost its place at the centre of English artistic practice. England's most popular artists, painters like Zoffany and Joseph Wright of Derby, were praised not for their classical representation of an improved 'nature' but for their verisimilitude, their ability to reproduce the details of everyday life. Rowlandson and his contemporaries were fully aware of the tensions between theory and practice, history and nature. The figure of Susanna in *The Connoisseurs* immediately calls to mind Hogarth's pointed remark in which he preferred the living flesh of a lovely woman to the cold marble of classical statuary. Susanna is a figure from nature bursting out of a history painting. For artists like Rowlandson the problem was how to move towards nature without forfeiting the authority they derived from claiming, in the manner of Reynolds, that history was their métier.

*

The solution emerged in the early nineteenth century, most clearly expressed on the occasion which, I believe, marked a major triumph of the artist over the connoisseur, namely the appointment by parliament in 1816 of the Select Committee to enquire into the Elgin marbles (fig. 102). During the debate over the Elgin marbles all the issues of the previous century or more – about history and nature, antiquity and modern art, the authority of painters and connoisseurs – were aired in that most public of forums, the British parliament. And their resolution, in that most portentous of nineteenth-century documents, a Select Committee report, decisively conferred on the academic artist the title of arbiter of public taste.

On 15 February 1816, in a pause between a debate on speculative building in Pall Mall and a discussion of the autocratic conduct of the government in Spain, Nicholas Vansittart, Chancellor of the Exchequer, presented to the House of Commons a petition from Thomas Bruce, seventh Earl of Elgin and eleventh Earl of Kincardine. It called for 'an inquiry, upon such evidence as may be procured, into the merits and value' of the Elgin marbles, sculptures, medals and inscriptions which Elgin had accumulated while ambassador to the Turkish Port at Constantinople, and which included large parts of the frieze and metopes that had decorated the Parthenon in Athens.

The story of the Elgin marbles remains as contentious as it is well known. After British troops had driven the French out of Egypt in 1801, Elgin, a Scottish Tory and career public servant, had used Ottoman enthusiasm for Great Britain to obtain permission from the Turks, who ruled Greece, to investigate the antiquities on the Acropolis. The precise terms of this permission have been disputed ever since, but all agree that Elgin was allowed to make drawings, take casts of the sculptures and excavate part of the site; Elgin and his supporters say that he also had permission to remove materials. Whatever the case, over the next few years Elgin's minions removed an enormous amount of sculpture from the site and from the Parthenon itself. After a chequered history worthy of the plot of a tawdry thriller, the marbles (or most of them) eventually arrived in England, where they were first displayed in 1807 in a makeshift museum in the back garden of Elgin's town house on Piccadilly and Park Lane. Between 1810 and 1816 Elgin had periodic and protracted negotiations with the British Museum over the latter's purchase of the collection.

Though Elgin's name is now irrevocably linked to these masterpieces

of classical antiquity, there was no hint before his appointment as Turkish ambassador of the passion that came to dominate his life. Indeed, he would never be known as a connoisseur of classical antiquity. He had not been on the Grand Tour nor had he visited the Mediterranean; he was not originally a member of the Society of Dilettanti, and was twice blackballed, though eventually elected in 1831, when he understandably declined membership. There is no evidence that he had any special knowledge or interest in the cultures of classical antiquity. He was a collector who was not a connoisseur, an outsider who did not move in the intellectually precious, aesthetically fastidious, predominantly Whig and slightly epicene circles in which the study of classical civilization was more than a gentleman's pastime.

Indeed, in certain respects Elgin was not even a collector. His aims were not those of such important connoisseurs as William Hamilton, Charles Towneley or Richard Payne Knight. Elgin was outside their circle of conversation not only because of his ignorance but because he saw his task as providing the means by which Great Britain's fine arts

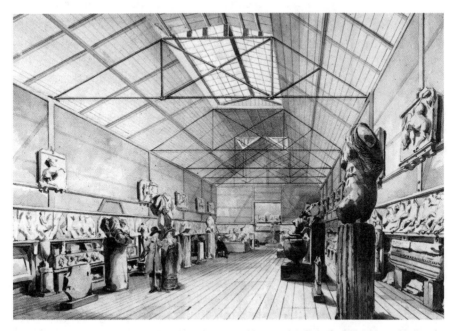

102. The Temporary Room for the Elgin Marbles in the British Museum, 1825, artist unknown

might be improved. His ambition was closer to that of Napoleon than that of Sir William Hamilton.

The parliamentary Select Committee of 1816, established as a result of Elgin's petition, had four objects – to assess Elgin's property right in the marbles, to determine their aesthetic merit, to judge their authenticity and to ascertain their commercial value – all four being related to the question of whether the British Museum should buy the marbles for the public and at what price. Taking the issue to a public, parliamentary body was something of a course of last resort for Elgin, since he had not been able to obtain what he considered a fair price due to persistent undercutting by a coterie within the Dilettanti Society led by Richard Payne Knight. This group maintained that the marbles were not, as had been claimed, the work of Phidias, the greatest architect and sculptor of Periclean Athens, but were manifestly second rate and included Roman copies from the time of Hadrian. As Payne Knight put it in his *Specimens of Ancient Sculpture* (1809), the marbles were 'merely architectural sculptures executed from his [Phidias'] designs and under his direction probably by workmen scarcely ranked among artists'. This less than enthusiastic response, heard repeatedly over the dinner tables of connoisseurs and reiterated in the Whig periodical press, contrasted markedly with the enthusiasm of artists who were among the first to examine Elgin's pieces and who, almost without exception, greeted them as the finest, most important surviving works of classical antiquity.

The Select Committee heard evidence from virtually every interested party. Apart from Elgin himself, the committee listened to painters and sculptors, including Joseph Nollekens, John Flaxman, Richard Westmacott, Francis Chantrey, Charles Rossi and Sir Thomas Lawrence; the ailing and aged Benjamin West, an enthusiastic supporter of the marbles, was allowed to submit written evidence. More hostile witnesses included a number of collectors and connoisseurs, notably Richard Payne Knight, the art dealer Alexander Day, the architect William Wilkins, and the keeper of the British Museum's department of classical antiquities.

The Select Committee's deliberations and final report marked an extraordinary victory for the artists who had proclaimed the aesthetic superiority of the marbles, not only vindicating their judgement but accepting that the artist could determine what made great art. The 1816 committee was the first occasion that many artists had been asked in a public forum to offer an opinion on a matter of public taste, and

the precedent was followed frequently in the nineteenth century.

Moreover, for reasons that are not entirely clear but that may have had to do with party politics, committee members drawn from the classes from which connoisseurs came heartily endorsed the artists' view. The committee, dominated by government supporters and Tories, also accepted the artists' reasons *why* the marbles were so valuable to Britain. The committee report, probably written by John Wilson Croker, a Tory journalist and critic of Payne Knight, accepted that the marbles' value lay in their power to form a 'school for study, to improve our national taste for the Fine Arts, and to diffuse a more perfect knowledge of them throughout this Kingdom'. It compared their arrival in England to the discovery of classical antiquities in fifteenth- and sixteenth-century Rome, a comparison made not to laud their collector, but to link contemporary artists to the heroic figures of the Renaissance. Modern painters and sculptors become the equivalent of what the report called 'an abundant harvest of the most eminent men, who made gigantic advances in the path of Art, as Painters, Sculptors, and Architects. Caught by the novelty, attracted by the beauty, and enamoured of the perfection of those newly disclosed treasures, they imbibed the genuine spirit of ancient excellence, and transfused it into their own compositions.' The finest antiquities, the committee concluded, should serve artists and the public, not the connoisseur, and they should therefore not adorn a collector's private gallery but be displayed publicly, where they could educate artists and help them create a new Renaissance and, in West's words, 'inform the public mind in what is dignified in art'.

This view of the marbles as a public good rather than a private asset became even clearer in the discussion of their financial value. The committee distinguished what it called 'intrinsic' value from the market value of the marbles. Several witnesses, both artists and connoisseurs, had pointed out that their damaged state and absence of 'finish' made them of little value to the private collector. Towneley's collection, acquired by the British Museum in 1810, comprised highly finished, in some cases restored pieces, but when the committee asked Westmacott to compare them with the Elgin marbles, he answered, 'you can make furniture of them; these [Elgin's] you could not, they are only fit for a school'; while Payne Knight, in discussing what was explicitly called 'furniture value', remarked that 'a corroded, dirty surface people [by which he meant collectors] do not like'. The report concluded,

> the mutilated state of all the larger Figures, the want either of heads
> or features, of limbs or surface, in most of the Metopes, and in a
> great proportion of the Compartments, even of the larger Frize,
> render this Collection, if divided, but little adapted for the decoration
> of private houses. It should therefore be considered as forming a
> whole, and should unquestionably be kept entire as a School of Art,
> and a Study for the formation of Artists.

The damaged and incomplete state of the marbles reduced their value
in the sale room, but did not affect their aesthetic value. Nollekens called
them 'the finest things that ever came to this country'; Flaxman thought
them, 'the ascertained works of the first artists of that celebrated age';
Chantrey noted in them 'individual excellence combined with grand
historical composition'; West declared that 'the whole does not appear
to be the efforts of the human hand, but those of some magical power,
which brought the marble into life'. The final report called them 'the
finest models, and the most exquisite monuments of antiquity'.

What qualities made them so? What led artists to rank these works
as equal to and often greater than the Apollo Belvedere or the Laocoön?
Westmacott gave the answer: they have 'all the essence of style with all
the truth to nature ... that which approaches nearest to nature, with
grand form, Artists give preference to' or, as the report put it, 'a degree
of close imitation of Nature is combined with the grandeur of Style,
while the exact details of the former in no degree detract from the effect
and predominance of the latter.' The same point was made by the irascible
painter Benjamin Robert Haydon in his pamphlet of 1816, in which he
made public the testimony he had been prevented from giving before
parliament: 'It is this union of nature with ideal beauty ... that rank[s]
at once the Elgin Marbles above all other works of art in the world.'

The Elgin marbles as construed by the artists perfectly resolved the
tension between academic knowledge and the artist's eye, for they showed
that observable nature was not at odds with the greatest works of classical
antiquity. The claim that these marbles, rather than more polished and
idealized works exemplified the pinnacle of classicism, therefore had a
twofold effect: it made antiquity the artist's ally rather than the collector's
friend and it undercut the value of earlier collections of antiquities which
were more finished and less heroic. The committee well understood this.
Nearly all the witnesses were asked to compare the Elgin marbles with
collections such as those of Payne Knight and Towneley.

In the Select Committee report the artist emerged as he had wished to be seen for several generations. Committed to a public agenda of artistic and aesthetic improvement and to the public exhibition of great ancient and modern art, he was granted the right to aesthetic interpretation and his taste was vindicated. The report seemed to place him on the side of the public interest and to tarnish the connoisseur as a man of private interests, and to recognize that the artist's special skills, his genius at combining nature and history, gave him unique authority over its successful accomplishment by others.

Of course, this triumph in 1816 did not mean the demise of the connoisseur or the end to challenges to the painter's interpretative power. But it did underscore the problem of how to recast or erase the connoisseur's 'way of looking', the erotic, sensual gaze, that had been safe enough in the privacy of a gentleman's cabinet or study, where it could be enjoyed without threatening one's reputation as a man of virtue, but that became a serious liability in the exhibition room.

CHAPTER SEVEN

Painters' Practice, Artists' Lives

BRITISH ARTISTS IN the last quarter of the eighteenth century knew that the road to success followed the path laid down by Jonathan Richardson. Membership of the Royal Academy or exhibiting paintings at its annual shows were the swiftest means to reach their goal. But the painter had some distance to travel before he could acquire respectability and fame. Richardson's sketch was only the merest outline, pencilled hints rather than a fully formed picture. There was as yet no exemplary life, no complete portrait, and certainly no biography on which the aspiring painter could draw to fashion himself as a successful artist.

The first history of British art, *Anecdotes of Painting in England* (1762), by the connoisseur and dilettante Horace Walpole, did not offer what the artist required. Based on the notebooks of George Vertue, an engraver who devoted his life to the collection of gossip, anecdote and personal observation, Walpole's work, as one would expect from a gentleman who frequently complained about the insubordinate behaviour of painters, writers and performers, was not intended to elevate the artist. Though he considered that the successful modern artist had to have classical training, connoisseurship, an interest in history painting, and critical as well as painterly skills, a skilled memorialist had yet to record these qualities in an artist's life.

Many artists aspired to play the leading role of exemplary modern painter, but all were understudies compared to the man who was offered first refusal. Joshua Reynolds, first president of the Royal Academy and London's most fashionable painter (though not, it must be added, the favourite of the court), was inevitably invited to perform the lead (fig. 103). He embraced the part with alacrity; most of his contemporaries thought his performance outstanding. When Reynolds died in 1792 his body lay in state at Somerset House in the Royal Academy. The final

103. Self-portrait by
Joshua Reynolds,
engraved by Valentine
Green, 1780

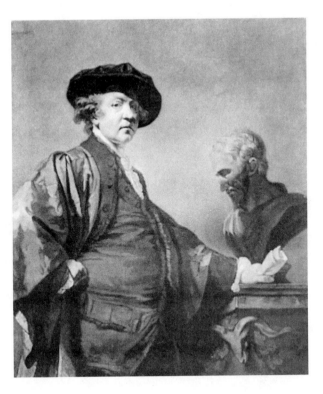

respects that his fellow Academicians paid to him are understandable; more remarkable was the homage offered by polite society: at the funeral before his interment in St Paul's Cathedral, forty-two mourning coaches attended the cortège, followed by nearly fifty carriages filled with nobility and gentry. Everyone who attended the obsequies was given an engraved memorial ticket after a drawing by Edward Francis Burney, Charles Burney's son, depicting Fame mourning over a tomb with the inscription 'SUCCEDET FAMA, VIVUSQUE PER ORA FERETUR' (fig. 104).

But Reynolds overcame a great deal to achieve this renown. Two incidents that occurred in the 1770s illustrate the prevailing prejudices against even the most famous English painter. The first, recorded by Frances Burney, the novelist and member of the circle encompassing Dr Johnson, Mrs Thrale, Edmund Burke and Reynolds himself, recounts the conversation of a 'Mr. B—'. This gentleman, Burney recalls, was

notorious for his contempt of all artists, whom he looks upon with
little more respect than upon day-labourers, the other day, when
painting was discussed, he spoke of Sir Joshua Reynolds as if he
had been upon a level with a carpenter or farrier ... I knew him
many years ago in Minorca, he drew my picture there, – and then
he knew how to take a moderate price; but not now, I vow, ma'am,
'tis scandalous indeed! to pay a fellow here seventy guineas for
scratching out a head!

When Burney responded by reminding him that 'he has improved since
you knew him in Minorca; he is now the finest painter in the world,'
he retorted, 'a very decent man he is, fit to keep company with gentlemen;
but ma'am, what are all your modern dabblers put together to one
ancient? nothing ... not even a Rubens among them.'

The second incident occurred at a meeting of the Society of Arts,
the body from which Reynolds and his fellow artists had seceded in 1761.
During a debate the Bristol cleric Josiah Tucker commented that a
pinmaker was more valuable and useful to society than a painter like
Raphael. Reynolds's response was eloquent and impassioned, a plea to
recognize the artist as a vital figure in any civilized society:

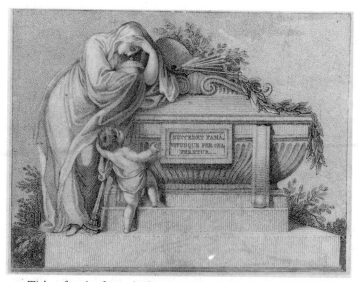

104. Ticket for the funeral of Joshua Reynolds, engraved by Edward
Burney, 1792

This is an observation of a very narrow mind, a mind that is confined to the mere object of commerce, that sees with a microscopic eye but a part of the great machine of the economy of life, and thinks that small part which he sees to be a whole. Commerce is the means, not the end, of happiness or pleasure: the end is a rational enjoyment of life, by the means of arts and sciences: it is therefore the highest degree of folly to set the means in a higher rank of esteem than the accomplished end. No man deserves better of mankind than he who has the art of opening sources of intellectual pleasure and instruction by means of the senses.

Mr B's comments about the menial status of artists reminds us how enduring such attitudes were, especially among gentry who did not move in fashionable circles; on the other hand, Burney tells the story in a way that shows that she considers Mr B's attitudes hopelessly old fashioned. In some quarters, at least, painters – or, at least, Reynolds – were taken seriously. Yet even in Johnson's circle the respect accorded him was not extended to painting as a whole. Both Johnson and Goldsmith blithely confessed their ignorance of painting and considered their lack of knowledge to be no stigma; if a painter had expressed similar sentiments about literature he would have been dismissed out of hand. The undoubted respect that Reynolds commanded within the group stemmed as much from his literary and social pretensions as from his fame as an artist.

Condemning a painter as a mechanic and comparing him adversely with great artists of the past was an old ploy. Tucker's complaint, formulated in terms of the new science of political economy and couched in terms of social utility, is more novel. Yet, like Mr B's traditional complaint, it resolutely refuses the artist a public function and denies that, as Reynolds put it, the painter who provides 'intellectual pleasure and instruction by means of the senses' serves the highest purposes not merely of the public but of 'humanity'.

Ascribing this exalted purpose to painters and painting was one thing; getting artists to fulfil it was another. Reynolds recognized that if they were to be treated as more than mere artisans or servants, it was less vital that painters change their practices (though this was important) than that they develop a justification to make their artistic endeavours acceptable to connoisseurs and patrons. Reynolds's ideal painter was a master of theory as well as practice: 'Like a sovereign judge and arbiter of art, he is possessed of that presiding power which separates and attracts

every excellence from every school; selects both from what is great, and what is little; brings home knowledge from the East and from the West; making the universe tributary towards furnishing his mind and enriching his works with originality, and variety of inventions'. A painter therefore 'stands in need of more knowledge than is to be picked off his pallet, or collected by looking at his model, whether it be in life or in picture. He can never be a great artist, who is grossly illiterate.' The ideal painter, according to Reynolds, shaped taste: 'he is yet so far able to communicate, as to raise the thoughts, and extend the views of the spectator; and which by a succession of art, may be so far diffused, that its benefits may extend themselves imperceptibly into publick benefits, and be the means of bestowing on whole nations refinement of taste.' This was Reynolds's object in the fifteen *Discourses* on art delivered at the Royal Academy's prize-givings between 1769 and his retirement in 1790. Though chiefly addressed to the Academy's pupils the *Discourses* were attended by what Charles Burney called 'people of fashion and dilettanti', and from the first Reynolds knew he had to appeal to the body he always referred to as the 'Visitors'. The *Discourses'* achievement in establishing the credentials of British art is as important as his corpus of painting.

From the very first the *Discourses* were criticized for their lack of internal consistency and for their incongruity with Reynolds's own practices. William Blake attributed their contradictions to their lack of originality: there were, he wrote, 'strong Presumptions that they are the Work of Several Hands, But this is no Proof that Reynolds did not Write them. The Man Either Painter or Philosopher who Learns or Acquires all he Knows from Others Must be full of Contradictions.' Blake resented Reynolds's public prominence and the exclusion of artists like himself, who worked as engravers, from the Academy. But to expect consistency over a period of twenty years is to permit the triumph of hope over experience; in any case, Reynolds acknowledged in his final discourse that he had not wholly followed the theoretical precepts he urged on his audience. Such incongruities did not prevent the *Discourses* from being an astonishing success, attended by the students of the Academy and the public, published individually and in collected editions, and translated into French, German and Italian.

Aesthetically Reynolds advocated history painting and the 'great style'. The object of the artist was therefore not 'to amuse mankind with the minute neatness of his imitations ... [but] to improve them by the

grandeur of his ideas'. As he explained in his ninth discourse, delivered at the opening of the Academy school in Somerset House in 1780:

> The Art which we profess has beauty as its object; this it is our business to discover and to express; but the beauty of which we are in quest is general and intellectual; it is an idea that subsists only in the mind ... which [the artist] ... is so far able to communicate, as to raise the thoughts, and extend the views of the spectator; and which, by a succession of art, may be so far diffused, that its effects may extend themselves imperceptibly into publick benefits, and be among the means of bestowing on whole nations refinement of taste ... till that contemplation of universal rectitude and harmony which began by Taste, may, as it is exalted and refined, conclude in Virtue.

This was 'the *gusto grande* of the Italians, the *beau idéal* of the French, and the *great style, genius,* and *taste* among the English' which depended on the visual expression of universal truths of nature rather than of the particularities of everyday life.

Just as important for our purposes, Reynolds imagined and urged upon his audience a public like themselves – men able to develop abstract ideas from raw experience – whose taste and virtue he might influence. In speaking simultaneously to aspiring artists and to collectors, connoisseurs and men of letters, he helped to create a coherent artistic community united by a common taste and presided over by the Academy.

Reynolds's *Discourses*, like the lectures of his successors at the Academy, dealt with both particular and general issues in art: they offered instruction about how to paint – or, more accurately, how to think about painting – but also laid down the path that Reynolds thought painters should follow if they were to become artistic inheritors of the Renaissance. His prescriptions – to follow in the path of the Old Masters, to 'disregard all local and temporary ornaments, and look only to those general habits which are every where and always the same' – were not always followed, of course, but the more they were reiterated – and Reynolds came back to them again and again – the harder they were to ignore. They came to shape the choices that British painters made – about what genres to paint in and what aesthetic values to embrace – and to define the hierarchy of artists. Individual artists could sometimes buck the rules – Thomas Gainsborough and Richard Cosway never ventured to Italy, George Romney never showed at the Royal Academy – but they were

exceptions, and it was recognized that they had chosen a dangerous course. And there were always others who never raised their eyes from their bread-and-butter portraits, decorative painting and landscapes. But as the path became clearer and the prizes it offered more lucrative (Reynolds left more than £60,000 in cash and securities at his death; his house and pictures were worth a further £20,000), this seemed either curiously wilful or blatantly unambitious.

The prescriptions of academic classicism created new opportunities but foreclosed on others. It was no longer possible, as it had been in the first half of the century, to practise as a sign- or coach-painter and to aspire to be an artist. The separation grew between commercial artisan and academic painter, though a number of famous artists, including Zoffany and Loutherbourg, worked as scene painters in the theatre (fig. 105). Artists found it ever harder to resist the pressures to produce history paintings, even if they lacked the money, gift or talent for the genre. As we shall see in the case of the fashionable miniaturist, Ozias

105. *Eighteenth-Century Scene Painter in his Workshop* by Michael Angelo Rooker, 1790

Humphry, they had to pay lip-service to the classical hierarchy of art or accept the consequences even if they were not claiming that their work conformed to its tenets. The Academy and its proponents had effectively won the right to determine the rules of the game.

The sorts of pressure that artists felt at this time can be seen in the career of Ozias Humphry (1742–1810), some twenty years younger than Reynolds and growing up in his shadow (plate 11). This dapper Devonian, a portraitist and miniaturist of some talent, elected to the Academy in 1791, bequeathed to posterity the largest surviving archive of any British eighteenth-century painter and, in consequence, we know as much about him as any artist of the period. In his enthusiasm for the written word and its preservation. Humphrey was quite unlike most of his colleagues. Only his friend and frequent dining companion Joseph Farington, whose diary of the years between 1793 and 1821 is an unsurpassed source for artistic gossip, showed a comparable enthusiasm for scribbling. While writers of course left detailed memoirs and numerous letters, painters were (and still are) notorious for their reluctance to put pen to paper. When James Northcote, the biographer and former pupil of Sir Joshua Reynolds, was asked in the early nineteenth century about the correspondence of Reynolds and his colleagues, he tartly remarked that painters were too busy for such trivialities as pen-pushing. Northcote's response, partly intended to put literary men in their place, contained much truth. What artists left to posterity were not texts but images, the visual equivalent of the literary archive. We see their vision but can only rarely hear their voice.

This was not true of Humphry. He assiduously collected and collated papers over a lifetime, beginning with his earliest exercises in penmanship at the age of twelve – he made meticulous copies of such homilies as 'Always put more Confidence in those who have oblig'd you, than in those you have oblig'd' (fig. 107) – and ending with a series of dyspeptic letters to his illegitimate son William Upcott shortly before his death in March 1810.

Like many artists (though not Reynolds, whose father was a well-connected but impecunious cleric), Humphrey grew up in a milieu of skilled artisans and people of commerce. His world was that of the shop. Like Reynolds, he was born in Devon (it is one of the mysteries of

107. *Youthful Homily. Always Put more Confidence in those who have Obliged You* by Ozias Humphry, 1754

eighteenth-century British art that so many English painters hailed from the West Country), where his mother ran a successful lace manufactory in Honiton. In 1757 she packed off her fourteen-year-old son to lodgings in Cannon Street in London, where he enrolled in William Shipley's drawing school, attached to the Society for the Encouragement of Arts, Manufactures and Commerce; their premises off the Strand were the site of the first public exhibition of modern British artists in 1761.

Though its pupils included other future artists like the sculptor Joseph Nollekens, the miniaturist Richard Cosway, and the watercolourist Francis Towne, Shipley's was not a school of fine art; its object was to teach technical drawing. In the newspapers it advertised its purpose as 'to introduce Boys and Girls of Genius to Masters and Mistresses in such manufactures as require Fancy and Ornament, and for which the knowledge of Drawing is absolutely necessary'. This aim accorded with his mother's desire to prepare Ozias for the family business but had the unintended consequence of stirring in him an ambition to create something other than elegant designs for textile manufacturers. He aspired to be a painter. To do that he had either to enrol in a school or academy

or to apprentice himself to a painter. He could not strike out on his own, for he had neither the innate gifts nor the financial resources that might have enabled him to teach himself.

Humphry's opportunities for academic instruction were few and far between. The Royal Academy was still only a subject of discussion among painters and connoisseurs. The only painting academy in London, the school in St Martin's Lane, was the direct descendant of one established by Sir Godfrey Kneller in 1711 in a ramshackle mansion in Queen Street. It had been fraught with financial difficulties and riven by artistic rivalries: Sir James Thornhill, William Hogarth's ambitious and restless father-in-law, had wrested control of it from Kneller in 1716 only to be ousted by Louis Chéron, a French history painter, and a dissolute English artist, John Vanderbank. Together they moved the school to St Martin's Lane, where it flourished until it fell foul of an embezzling treasurer and a grasping landlord. Only the intervention of William Hogarth in 1735 enabled the academy to stay in business.

Whether from choice or necessity we do not know, but Humphry did not attend the academy. He did, however, study in the sculpture gallery which the Duke of Richmond had philanthropically opened to artists and students in 1758. He described his first contact with classical antiquity in one of the drafts of his incomplete memoir:

> In a spacious room in Privy Gardens purposely built and filled up with appropriate lights this Nobleman had collected with princely Liberality the first large assemblage of Casts in plaister from the Trajan and Antonine Columns, as also the finest Busts then known, as well as Copies of a great Number of the finest Greek and Roman statues the Apollo Belvidere [sic], Venus de Medici, little Apollo, the fighting and dying Gladiators and many others, wch were all devoted to public benefit. Masters were also provided, to superintend & correct the labours of the students.

Working from copies of the antique rather than live models as were used at St Martin's Lane, Humphry was instructed by two future Royal Academicians, the Florentine Giovanni Battista Cipriani and the sculptor Joseph Wilton.

As we have seen, access to what were considered great works of art from classical antiquity and Renaissance Italy was highly restricted. Academic instruction, even after the foundation of the Royal Academy

schools, was the privilege of a few. The schools were too small to absorb
all those who wished to attend: in their first decade there were less than
fourteen painting students a year; between 1779 and 1789 the average
was nine. In sculpture the figures were three and one.

Pupillage or apprenticeship was therefore the most common way in
which an artist learned how to paint. Just as Reynolds began his career
apprenticed to the West Country portraitist James Hudson, the most
fashionable face-painter of the 1740s and 1750s, so Humphry became the
pupil of Samuel Collins, a miniaturist and portrait painter who worked
in Bath.

Apprenticeship had many traditional advantages. The master painter
gave not only instruction but ample opportunity for the pupil to practise,
to learn how to mix and make colours, to handle a brush (referred to
as a 'pencil') and to paint drapery and scenery while the master worked
on the face or main subject matter of the canvas. The apprentice might
also meet clients who could subsequently become patrons.

But pupillage had its drawbacks. Reynolds was not the only pupil
to end his apprenticeship prematurely because he felt that he had learned
all that his master could or would impart. Able pupils could be hampered
by their master's limitations; unambitious ones were liable to become
anonymous drudges for their masters. According to the poet William
Hayley, his friend, the highly successful portraitist George Romney, had
a pupil, Keeting, 'who lived with him I believe twelve years, and copied
his pictures very exactly'. Keeting may have been an invaluable part of
Romney's studio, but no work ascribed to him survives. So the value of
apprenticeship depended not only on the apprentice's skill but on the
attitude of the pupil's master. Many were reluctant to teach or even to
reveal their secrets. Northcote commented that Reynolds's apprentices
'were absolute strangers to Sir Joshua's manner of working and . . . he
made use of Colours and Varnishes which they knew nothing of and
always painted in a room distant from him. They never saw him unless
he wanted to paint a hand or a piece of drapery from them.' This
reluctance to impart technique accords with Reynolds's view of painting
as a mental rather than mechanical matter, but it must have been bitterly
disappointing to his pupils. For all the academic talk of the rational
powers of the painter, technical know-how was what the aspiring painter
wished to acquire.

Humphry was not neglected by his master, who taught him assidu-

108. *The North Parade, Bath* by Robert Dighton, c. 1780

ously. But the pupillage ended abruptly in 1762 when Collins, who had injudiciously begun an affair with one of his sitters and who was also in debt, fled to Ireland. Young and inexperienced, Humphry had to work on his own.

Bath was a good place for Humphry to begin. Crowded with valetudinarian politicians, retired soldiers, gouty squires and rich widows taking its medicinal waters, visited by mothers and daughters in pursuit of suitable husbands and frequented by young men in search of eligible heiresses, it was a city of quackery, leisure and intrigue (fig. 108). As metropolitan as London, from which it drew many of its visitors, it offered a variety of pleasures as a physic for the healthy and a diversion for the sick. It had exactly the right air of festivity and conspicuous consumption to stimulate the business of a young miniaturist. Young lovers needed tokens of their mutual passion, parting friends mementoes of their mutual esteem. Clients were likely to have more time at their disposal than in the hurry of London; they often took the occasion of a visit to Bath to sit for their portrait. Not surprisingly, plenty of artists worked in the town, of whom the most famous were William Hoare, a

portraitist who had been in Bath since 1739, and Thomas Gainsborough, who moved there from Ipswich in 1759.

Humphry did well in Bath. He lodged and worked in the household of the Linleys, a famous musical family who were close friends of Gainsborough (fig. 109). Comfortably ensconced with a family whose fame doubtless helped his custom, he made a clear profit of £140 in his first year on his own, commemorating his success with an engraved gold watch which cost twenty guineas.

Bath was the best market for a provincial painter. Certainly it was a better spot to begin a career than Plymouth Dock (now Devonport), where Reynolds spent much of the 1740s painting naval officers and local gentry. Bath's clientele was not confined to bumpkin squires and fussy members of provincial professions but included persons of fashion and taste. But commissions there, as in other provincial resorts, were seasonal. Like most painters outside London Humphry needed to travel to keep himself in work. When trade at the spa was slack he toured the West Country looking for sitters. In 1762, for instance, he spent two months working in Exeter, earning thirty-six guineas before moving on to his birthplace, Honiton.

Such tours were common. Some artists, like Humphry and Reynolds, returned to the haunts of their youth. For many years Thomas Beach, a Dorsetshire portrait painter, set out from Bath in June and travelled round Dorset and Somerset painting the local gentry and squires. Similarly, George Romney returned to his native Kendal in 1765 and again in 1767. Other artists did little else but travel, looking for commissions. Adrien Carpentiers, a portraitist who eventually settled in London in the 1770s, spent a lifetime on the road, touring Kent in 1739, moving briefly to Bath in 1743, on to Oxford in 1745 and then across the country to East Anglia and Norwich, which was an important regional centre for painters. Like the many skilled artisans who travelled around the country in search of work, painters found that one market alone was insufficient to sustain a good livelihood.

By 1764 Humphry, though only twenty-one, had become successful. His progress and reputation was typical of the many artists who worked in a provincial town of any size. Most of their work consisted of portraits and the occasional decorative painting of interiors, their clients were local gentry and merchants, and they supplemented their income by selling art supplies and by giving drawing and painting lessons. Most of them

109. *Miss Linley* by Ozias Humphry, 1762–64

were content to remain valued members of local society; they mingled with members of the professions and prosperous traders and shopkeepers and established local dynasties. Two generations of the Stringers of Knutsford painted animals and landscapes and portraits; four members of the Cave family of Winchester helped to decorate local houses, churches and the theatre; and all three Smith brothers of Chichester painted virtually indistinguishable landscapes in the manner of Claude Lorrain (fig. 110).

Sometimes these artists went up to London and exhibited their work at the Society of Artists, the Free Society of Artists or, more rarely, the Royal Academy. But their outlook was essentially provincial and regional. The purpose of exhibiting in London was to enhance their local reputation, not to make the leap into the national art market.

But Humphry, like Reynolds before him, was more ambitious. He was already complaining that, except for Corsham Court, whose newly built picture gallery housed the collections of the diplomat Sir Paul Methuen, and the Hoare family seat at Stourhead in Wiltshire, there were no gentlemen's country houses with Old Masters for him to examine. He was delighted when Lord Pembroke gave him permission to copy works

at Wilton, which had one of the finest collections in England. He knew that he needed to see more fine painting if he was to improve his art.

Humphry was determined to make the transition from province to metropolis; the question remained, how was this to be done? His first plan was prompted by a fortuitous opportunity to paint a figure of national renown. This kind of chance could drag even the least-known artist out of the shades of obscurity; an accomplished young painter could acquire fame if he found the right sitter. The best commissions came, of course, from royalty. But artists vied with one another to paint beauties like the Gunning sisters, who were the rage in the 1750s, the ladies Waldegrave, whom Reynolds and Humphry were both to paint in 1780 (figs. 111 and 112), and Emma Hamilton, née Hart, who was the desired subject for every portrait painter in the 1780s and 1790s, her picture the preferred collector's item for gentlemen's private cabinets.

Humphry believed he had an opportunity to paint the most notorious man of his day. In 1764 John Wilkes, author of the outspoken opposition paper the *North Briton* and the flamboyant critic of George III and his

110. *A View of Chichester, the Isle of Wight in the distance* by George Smith, 1750

unpopular favourite Lord Bute, was the talk of the town. Humphry, having just completed a portrait of Wilkes's lawyer and political ally Serjeant John Glynn, the MP for Honiton, tried to persuade Glynn to allow him to paint Wilkes. Humphry's concern was not with the portrait itself, but with its value as a source for engraving. As we shall see, the way for a little-known painter to reach a public that ranged from the patrons of taverns to the private collector was through reproductive engraving. Humphry knew that such a portrait as Wilkes's would be copied, and the engravings would sell in large numbers; the prints would make him money, and more importantly bring him fame. But the scheme came to nothing, so he resolved to try his luck in London.

In August 1764 Humphry, like his fellow West Countrymen Reynolds and Northcote, and like almost every provincial painter who became nationally famous, turned to the centre of the nation's artistic life. His trip to London was a pilgrimage as well as a journey in pursuit of fame and fortune. Spending a night at Upton, in the inn made famous by Henry Fielding in *Tom Jones*, Humphry visited Hagley Hall, the country house of Lord Lyttelton, the aristocratic author and patron of the poet James Thomson, and the Leasowes, the natural landscape garden designed by William Shenstone, the poet and essayist. He stopped at the birthplace of Shakespeare, toured Blenheim Palace (where he saw what he believed to be his first Raphael), the royal quarters at Windsor Castle, Cooper's Hill, the subject of Sir John Denham's famous seventeenth-century topographical poem, Runnymede, the site of the signing of Magna Charta, the poet Abraham Cowley's residence and Pope's villa at Twickenham. By the time he reached London he had garnered and gleaned a rich harvest of information about some of the nation's cultural heritage.

It took Humphry four years to move permanently to London. Like Reynolds before him, he eased himself into the capital, spending long periods back in the West Country. And appropriately enough, his first visits were to Reynolds himself. At first he was encouraged by his reception. Reynolds praised his work, encouraged him to move to London, allowed him to copy pictures in his collection, and bought one of his most admired early paintings, a head of King Lear. Like many an aspiring painter before and after him, Humphry was treated generously. But as his star rose so he found Reynolds increasingly cold and distant. 'At first', Humphry wrote to his mother, 'he appear'd to have my welfare much at heart, ask'd me frequently if I wd undertake work wch I declined as

111. *The Ladies Waldegrave* by Joshua Reynolds, 1780

I was in an improper Lodging, but lately tis quite otherwise ... he is very civil now but too ceremonious for a friend.' The causes of this coolness are obscure. Possibly Reynolds became leery of a potential rival but, as we shall see, Humphry frequently bit the hand that fed him and it is more probable that the young painter unknowingly offended his patron. Humphry received a number of private commissions from the royal family, and in 1767 George III paid 100 guineas for a large minia-ture of John Mealing, the model at the St Martin's Lane Academy. In the following year Humphry moved into 21 King Street in Covent Garden, long the most popular haunt of painters. (The anecdotal George Vertue recorded no fewer than eleven artists resident on the Piazza in Covent Garden in the 1720s.) The most successful phase of his career now began.

A fashionable painter in the 1760s needed at least two attributes in addition to skill with his brush: a well-appointed studio which reassured his sitters that he was able to live somewhat as they did; and an agree-able, refined social manner. Studios, as we have seen, were designed to resemble the sumptuous rooms, private cabinets and galleries of an aristo-

cratic house. They were intended to make the sitter feel at home and to convey a sense of the wealth and taste of the artist. An eccentric history painter like James Barry could live in filth and chaos and dress in a old wig and a torn coat. But if a portrait painter lacked a good studio, like Dr Johnson's unfortunate friend Mauritius Lowe, his sitters were likely to flee in horror.

Humphry, who had already had to refuse commissions because he lacked adequate premises, was determined to have a studio to match his rivals'. He had his King Street house redecorated from top to bottom, spending an enormous sum (£257. 12s. 6d.) on furnishings: this paid for more than ninety yards of rich blue carpet, ten French chairs, six matching stools and a sofa all decorated in fashionable blue and white, two

112. *The Ladies Waldegrave* by Ozias Humphry, 1780

pembroke and two card tables, three large mirrors, a library bookcase, blue-and-gold decor with blue silk fittings, and blue-and-white curtains. No detail was overlooked: the fireplaces were cleaned and the chimneys repaired, the stairways covered with a new wallpaper. His fashionably blue decor was doubly valuable: it proved him a man of exquisite and expensive taste and gave him what people thought of as the perfect colour to show off his miniatures (plate 9).

Setting up such an expensive establishment was the only way in which a painter could become rich, but it was a risky business. It loaded painters with debt and made them desperate for a quick return in a market where tastes could change with great speed. As William Parsons, an amateur painter and comic actor, wrote to Maria Hatfield, the future wife of the miniaturist Richard Cosway in 1777, 'most of the young painters launch out on their first setting off – and few or any of them have a sufficient business to do it with.' But Humphry more than stayed afloat. In the first three years in his London studio he made an annual profit of more than £850.

As George Vertue commented, artists, especially portrait painters, needed 'an affable and obliging Temper, with a share of pleasant Wit'. Good conversation was a sign of a true gentleman. Samuel Richardson wrote to his friend Joseph Highmore that Edward Young, author of the poem *The Complaint, or Night Thoughts on Life, Death and Immortality* (1742–5), was persuaded to sit for him not by the artist's painterly gifts but by his ease of address. 'The pleasure he has received this evening at your house,' he wrote to the artist, 'and particularly in your conversation, has greatly contributed to his assent.' Conversation put the sitter at ease and made the subject lively and animated. Even Romney, who was much less gregarious than his great rival Reynolds, knew how essential conversation was to a successful portrait. Romney's son tells of his father's efforts to interest one sitter: 'To remove a settled dulness that pervaded his features, Mr Romney made many attempts, starting every topic of conversation; but all in vain; at length by some uncommon chance, he happened to mention *hunting*; at the sound of which word, a ray of animation immediately sparkled in the eyes of his sitter, and imparted a certain degree of vivacity on his countenance.' Portraitists often liked their sitters to be accompanied by friends for it relieved them of what Romney called 'the double task – of painting, and of keeping up a forced conversation'.

A good public demeanour was not just a matter of character but also a question of knowledge. A good painter was expected to have more than a passing acquaintance with history, classical literature and antiquity and to feel at ease talking about them. When the West Country clergyman and novelist Richard Graves wanted to praise his friend the Bath artist William Hoare, he described him as 'not only one of the most friendly, virtuous and inoffensive of men, but one of the best classical scholars, both in Greek and Latin, with whom I was ever acquainted'.

With a few notable exceptions – Jonathan Richardson early in the century and Henry Fuseli, the Swiss artist who translated Winckelmann's *Reflections on the Painting and Sculpture of the Greeks* (1765), at its end – most artists lacked this sort of education. Some had attended grammar schools and had a smattering of Greek and/or Latin, others rather desperately mugged up their learning from translations. They were understandably defensive about this sensitive issue. The poet William Hayley, who helped Romney find subjects from antiquity for his pictures, was enraged when Richard Cumberland, a playwright and translator of Aristophanes, claimed that Romney's lack of education explained why 'he was never seen at any time at any of the tables of the great, Lord Thurlow's excepted'. Hayley claimed that this was tantamount to calling Romney a 'low, vulgar being, who had no relish for the enjoyments of highly polished society', and countered by listing Romney's acquaintance with Thomas Warton, the author of *The History of English Poetry* (1774–81), the historian Edward Gibbon and the poet William Cowper.

The issue was a social as much as an intellectual matter. The painter could not appear to be socially stigmatized by ignorance; it was something he had to overcome. No one succeeded at this better than Reynolds. As Northcote conceded, 'A correct classical scholar ... he could not be considered in any part of his life', but Reynolds compensated by surrounding himself with scholars and literary men, by creating an ethos of scholarship which made up for the gaps in his education. Reynolds was an exceptionally 'clubbable' man. As he told Boswell, 'Everyone has their taste. I love the correspondence of *viva voce* over a bottle with a great deal of noise and a great deal of nonsense.' He enthusiastically supported a number of associations, including the Dilettanti Society; he delighted to entertain wits and men of learning at Leicester Fields or at his country retreat in Richmond. And it was at his suggestion that the club centred on Dr Johnson was set up in 1764.

Reynolds's conviviality and politeness made him invaluable in such circles, reconciling Burke and Johnson after a quarrel, and bringing Garrick and Goldsmith together after a spat. His friend James Boswell singled out for commendation his 'equal and placid temper, your variety of conversation, your true politeness, by which you are so amicable in private society' as well as 'that enlarged hospitality which has long made your house a common centre of union for the great, the accomplished, the learned, the ingenious'. Northcote appreciated the significance of Reynolds's example:

> There was a polish even in his exterior, illustrative of the gentleman and the scholar. His general manner, deportment and behaviour, were amicable and prepossessing; his disposition was naturally courtly. He always evinced a desire to pay a due respect to persons in superior stations, and certainly contrived to move in a higher sphere of society than any other English artist had done before him. Thus he procured for Professors of the Arts a consequence, dignity and reception, which they had never before possessed in this country.

Humphry never moved in the literary and social circles where Reynolds felt at home. His friends included a number of musicians, notably the Exeter composer William Jackson, who was an intimate friend of Gainsborough, but his chief company was that of artists. As a close friend of Joseph Farington, Humphry also revelled in the intrigues of the Royal Academy and devoted much of his life after 1791, the year of his election, to Academy politics. When he died two of the first men informed of his demise were its president, Benjamin West, and Francis Towne, the landscape painter who had studied with him at Shipley's drawing school. He never moved out of the narrow world of painting, and many of his friends remained linked with the West Country of his youth.

But Humphry knew well enough the importance of cultivating both himself and his customers. Despite his origins in trade, he repeatedly and, in the eyes of his friends, boringly described himself as from an ancient landed family from the West Country, claiming to be descended from Edward the Confessor's chamberlain. He spent his spare time in antiquarian researches tracing his family pedigree and the estates which he believed his ancestors once held. He dressed himself smartly, mostly like an affluent tradesman or minor merchant, but he owned a remarkable number of ruffled shirts, muslin stocks and silk stockings. And he

studied the five volumes of Ripa's *Iconology*, the standard work on emblems and iconography, and read Quintilian, Plutarch and Sophocles in translation, as well as Spenser, Shakespeare, Milton and Pope.

From his earliest days in Bath Humphry went out of his way to get business, remarking of two early patrons, 'I have ever made a point of mixing with them in all their Amusements, they consider me one of them and always recommend me at every Opportunity.' But his relations with patrons and sitters were mixed. He seems to have taken offence easily, to have stood on his dignity when it was not wise to have done so, and to have acted in ways that patrons felt presumptuous.

By the 1760s it was unusual for an artist to be in the employ or household of a single patron, and in the age of exhibitions most painters did not want to be confined to major projects for a single patron. When in 1764 the Marquess of Rockingham tried to get Benjamin West to do a series of decorative paintings at Wentworth Woodhouse, his enormous country house, West bluntly told him that that was no way for a modern artist to make a living. Nevertheless painters, especially portrait painters, though they needed to please a broad range of customers, usually had one or two patrons with whom they had special connections. Such was the family of the Earl of Albemarle, the Keppels, for Reynolds; and so were the Sackvilles, the Dukes of Dorset, for Humphry.

Reynolds maintained excellent relations with the Keppels, in characteristically diplomatic fashion, even when doing work for their political rivals, but Humphry's relations with the Duke and Duchess of Dorset were often fraught. Before he employed Humphry the duke had been an important patron of Reynolds, purchasing his first history painting, *Count Hugolino and His Children in the Dungeon* for 400 guineas, as well as portraits and fancy pictures. In the 1780s he gave Humphry many commissions, asking him to paint miniatures of family members (and his mistress, the famous Italian dancer Signora Baccelli), and to make copies from his extensive collection. But by 1796 the painter and diarist Joseph Farington was reporting: 'Humphry is quite out of favor at Knole [the Sackville family seat in Kent]. He went to Knole when the Duke was not there . . . and took possession of a room without previously showing proper attention to the Duchess. This has lost him her favor. The Duke is equally disgusted on some account. One charge is that he painted copies of the Portraits at Knole, & demanded payment for them as having been ordered by the Duchess, which she denied.'

Humphry was equally disgusted with his patrons, and drew up a valuation of all the work he had done for the family for which he had never been paid. The 'reward', as he sarcastically put it, amounted to more than £1,400. He spent the rest of his life in unseemly haggling with the Sackvilles, asking first for an annuity and then for a government place as compensation. He never handed over the copies to the family, and the Duchess of Dorset and Humphry's executors were still squabbling over the miniatures after his death in 1810.

This was only one of several clashes Humphry had with his clients. He made a habit of pressing his aristocratic patrons for payment in circumstances when it was not clear that he was in a position to do so. No doubt his sitters, as they were wont to do, behaved badly and failed to pay him promptly, but Humphry lacked the tact and social acumen to turn this to his advantage, a skill that lay behind Reynolds's success. It was always hard to satisfy the commissioner of the portrait, who was frequently not the sitter. He could always complain that a suitable likeness had not been produced and refuse to pay. As Humphry wrote to one dissatisfied customer, 'as I know a portrait not like does not answer the End, so I will most willingly return your money'. But 'a likeness' was not the same as verisimilitude. Jean-Étienne Liotard, a Swiss painter of pastel portraits who worked in London between 1753 and 1755 and whose technique greatly influenced English miniaturists, was said to have suffered for his virtuoso accuracy. 'His likenesses were very strong, and too like to please those who sat to him; thus he had great employment the first year and very little the second.' The trick was to understand how the portrait should be presented. Usually the client had a sense of how he wanted the sitter to appear. Part of a good portraitist's skill lay in discerning this; otherwise the commission could go disastrously wrong. One of Humphry's clients, the collector of Old Master paintings Richard Udney, complained bitterly of a portrait of his young wife: 'you have forgot that she is between 30 and 40, and that I am 70, and that the character of a smirking Girl is very unfit for her situation, as I should have liked to have made her of more Importance. and I find some of my friends ridicule me upon it.'

Udney wanted a matronly wife; she, as she made clear in a letter to Humphry, did not entirely agree. Mrs Udney's attitude was in line with that of most sitters, who wanted blemishes and weaknesses to be elided or erased: men had to appear aptly martial or thoughtful, women suitably

beautiful or maternal. Sometimes the instructions were explicit, often not. Naturally this provoked considerable cynicism among the artists. As Northcote said of Reynolds, 'the desire to perpetuate the form of self-complacency crowded his sitting room with women who wished to be transmitted as angels, and with men who wanted to appear as heroes and philosophers.'

Against such tawdry notions the portrait painter could only arm himself with a theory of character, with the idea that what was being represented was somehow the inner person rather than mere outward appearance; and this, in turn, could be used to claim that portraiture was a form of history. In the words of Jonathan Richardson, the most eloquent proponent of this view,

> A Portrait is a sort of General History of the Life of the Person it represents, not only to Him who is acquainted with it, but to Many Others, who upon Occasion of seeing it are frequently told, of what is most Material concerning Them, or their General Character at least ... *Painting* gives us not only the Persons, but the Characters of Great Men. The Air of the Head, and the Mien in general, gives strong Indications of the Mind, and illustrates what the Historian says more expressly, and particularly.

The studio of every portrait painter was littered with pictures that had been left on his hands. Pictures of discarded mistresses – 'a *chère amie* having been brought to sit for her portrait, both she and the picture were deserted before the latter was finished' commented Romney's biographer – were stacked alongside paintings of unloved relatives and canvases that the artist himself considered failures. Humphry's most successful full-length in oil, a double portrait of two of the three Walde-grave sisters, exhibited at the Royal Academy in 1780 (fig. 112), was refused by their mother, who had remarried and become the Duchess of Gloucester, 'on account of the Figures being too much seen through the Draperies'. The duchess, who was the illegitimate daughter of Horace Walpole's brother and whose second marriage to the king's brother forced the prince into exile, had more reason than most to want her daughters to appear scrupulously proper. Despite Humphry's efforts to get other members of the family to buy the picture (Horace Walpole wanted to cut an oval of the heads from the original canvas), it languished in his studio until his death.

For all his difficulties, Humphry was extremely successful, but in
1771 he was involved in an accident that damaged his sight. The exact
nature of the injury is obscure, but the disorder that followed was a
common affliction for painters – Reynolds, Paul Sandby, Joseph Faring-
ton, and Joseph Wright of Derby all had serious problems with their
vision – and was a particular occupational hazard for miniaturists. As
work grew more and more difficult Humphry decided to abandon minia-
ture painting and to retrain as a portraitist in oils. Aware of the change
in fashionable portraiture brought about by Reynolds when he had
returned from Italy in 1752, he decided to emulate his mentor and
enhance his painterly credentials by visiting the cradle of classical civiliz-
ation. In 1773 he set off with his fellow painter George Romney on a
Grand Tour that was to last four years.

The advantages of going on tour were obvious. The successes of
Reynolds in portraiture and the Welsh artist Richard Wilson in landscape
after their return from Italy in 1752 and 1757, respectively, had made
this kind of Italian education more desirable than ever. By the 1760s
clients were repeatedly asking painters if they had studied abroad, and
a negative answer threatened loss of the commission. Most artists dealt
in pictures and prints as well as producing their own work; to have seen
many original masterpieces of the Italian Renaissance and seventeenth
century, to have copied and studied them, improved an artist's skills as
a connoisseur and gave him cultural cachet as an arbiter of taste. If an
artist had not seen the treasures of Italy and contemplated the great works
of classical antiquity, then he laboured under a permanent disadvantage
vis-à-vis the clients and patrons he served. One could not claim the
expertise or authority of interpretation, the power to say whether ancient
and modern works of art were good or bad, fraudulent or original.

Like many other artists, Humphry and Romney began by visiting
the great collections in Paris. They spent several days studying works
at the Palais de Luxembourg, Versailles, and the Palais Royal, where
Philippe, Duc d'Orleans, had assembled one of the finest collections in
Europe. Both painters made detailed notes on the pictures, paying special
attention to technical matters which, like the 'recipes' for colours which
artists exchanged and copied in their notebooks, were a vital part of an
artist's education. Mastery of these techniques was necessary to produce
good copies of Old Masters, a common means of making money on the
Grand Tour, and would give their own pictures an 'Italian' air.

From Paris the two painters made their way to Florence and then to Rome to the city which Mary Moser, artist, flower painter and member of the Royal Academy, described as 'that nursery of the arts and raree-show of the world'. Humphry was overwhelmed. He wrote to a friend, 'My senses are benumbed in a Manner by the Syght of the Pictures and other Works of *Art* in this City as the eyes are blinded by excessive Light – I tread with reverence wherever I go it seems to be Holy Ground and I feel a kind of Inspiration. I reverence those Churches and Palaces where the great Masters of our Art have acquired immortal glory and pray for some portion of their Merit.' Like most of his fellow artists he focused his studies on particular paintings – notably Titian's *The Graces* and *Sacred and Profane Love* in the Borghese Palace – beginning to copy them in January 1774 (fig. 114).

As a result of what we might call 'the Reynolds effect', the community of British artists in Italy was well developed. They lodged together (notably in the Palazzo Zuccari which offered accommodation to home-less artists), shared models, and frequented the Caffè degli Inglesi – when a Welsh artist arrived there in November 1776 he counted nineteen

114. *Venus* by Ozias Humphry after Titian, undated

British artists among its clientele. In the summer those who could obtain permission crowded into the galleries of the Vatican. The pope, who disliked the smell of paint, was absent; the papal court was not in session; the painters were free to practise their craft. In their idle hours they met and occasionally socialized with English aristocrats who frequented the English quarter centred on the Piazza di Spagna, but they were just as likely to be found in the diverse community of painters who had come from all quarters of Europe to learn from Italian art. In Italy Humphry formed friendships that were to endure long after his departure from the Mediterranean. Antonio Poggi, an Italian painter with an English wife, the sculptor Thomas Bankes, Maria Hatfield, Johann Zoffany, Joseph Wright of Derby, Allan Ramsay, the miniaturist Alexander Day, who studied under Humphry, the architect James Paine and Henry Fuseli, the leader of a community of artists in Rome, were all to be found in the circles Humphry frequented. Most lived frugally, for though Italy was much cheaper than London, they had to get by on their savings (sometimes accumulated by a lottery or sale of their pictures before departing for the continent) and on the occasional commission either from a visiting milord or from a patron back in Britain.

The most common commission was for a copy of an Old Master. This was not a popular task – Reynolds completed a number but came to disapprove of the practice, which he discouraged in others – but it often meant the difference between a short and a long stay in Italy. Painters also made money as dealers, buying and selling pictures and antiquities, as well as executing commissions for friends and patrons in England. Some did astonishingly well out of this trade. The elder Nollekens made a fortune out of shipping classical antiquities to London, and Thomas Jenkins, an undistinguished painter, became one of the most powerful foreigners in Rome by acting as an art dealer and banker for Britons on the Grand Tour.

Humphry and Romney's activities were more modest. Humphry bought prints of Old Masters to be sent back to London, and Romney was given detailed instructions by his friend and patron Richard Cumberland for a commission for the Earl of Warwick. Lord Warwick, Cumberland wrote, wants 'a picture of consideration . . . according to the proportion of 63″ by 43″ wide, or near upon . . . the historical subject, where more than one figure is employed'. Romney was not to spend more than £100 and could draw on the peer's bank in London for the money.

Such peremptory commands of aristocratic acquaintances were part of an elaborate network of patronage that spread from London to Rome. To secure access to the Vatican or to any major collection, artists needed letters of introduction or even, in some cases, a licence from an Italian official. Special permission was required from the authorities to export items purchased from an Italian noble or dealer. These could most readily be secured with the help of an English aristocrat, preferably a noble of consequence. Humphry and Romney had the support of the king's brother, the Duke of Gloucester, the Duke of Richmond and Richard Cumberland. Gloucester got them access to the Vatican but his help came at a price: in return Humphry had to paint portraits of the pope and of the queen of Naples. This sort of exchange, with favours and patronage conferred in return for pictures or services – at one point Humphry was asked to commission a Neapolitan opera singer for the London season – bound together the hodgepodge of Englishmen in Italy and linked them with friends and clients back home.

Humphry returned to London in 1777, some two years after George Romney, and the subsequent course of their careers offers a sharp contrast. Romney, at the peak of his powers, quickly established himself as a leading portraitist, enjoying the sort of critical reception that had greeted Reynolds more than twenty years earlier. Ensconced in a large house at 32 Cavendish Square, which had formerly been the studio of Francis Cotes, who had died in 1770, Romney was almost overwhelmed by his success, working thirteen hours a day during the spring season. In later years he was to expostulate, 'This cursed portrait-painting! How I am shackled with it!' but in the 1770s he was happy to wear such fetters of gold. In a letter that produced paroxysms of envy, Romney's benefactor Thomas Greene told Humphry of his friend's success:

When I enter his House I tremble with *I know what not*! I can scarce-believe my Eyes! Such *Pictures*! and the pictures of such *People*! I am lost in wonder and astonishment how all these things should be! how so short a Travel could give such Excellence to his Pencil! how an almost *unfriended* Man should at once contract so *noble* and so *numerous* a Patronage. When I see his Shew Room filled from *Top to Bottom*, his Painting and *Drawing* room crowded with Pictures of People of the first Fashion and Fortune, I can scarce believe the Transition from *Richter's* to Coates's.

Humphry, on the other hand, did not reap the advantages that were supposed to flow from his years abroad. His sitters complained about the quality and verisimilitude of his portraits; he had difficulty collecting his fees. Part of Humphry's problem had to do with the state of the art market. These were generally difficult years for London's artists. Humphry's friends complained about lack of work and the tardiness with which their clients paid their bills. By the end of the American War the painting market seemed glutted. Horace Walpole wrote to William Mason: 'The town is overrun with painters, as much as with disbanded soldiers, sailors and ministers, and I doubt half of all four classes must be hanged for robbing on the highway, before the rest can get bread, or anybody else eat theirs in quiet.' But this did not alter the business of a Reynolds or a Romney. Though times were hard, Humphry's greatest difficulty lay in the poor reception of his works in oil. As one friend bluntly told him, 'you will be utterly undone both in your Reputation as an Artist and your Fortune as a Man, if you continue to persist in Oil Painting: Can you have any *Ambition*, where no *Applause* can follow?' Humphry may have wished to follow in the footsteps of Reynolds – his double portrait of the ladies Waldegrave depicts them in the classical costume and cloud-filled Olympus that we associate with Reynolds's grand manner – but after Italy he seems to have lost his way.

The rest of Humphry's career was devoted to recovering the status and success he had enjoyed before his departure for Italy. He took on several aristocratic pupils, giving them lessons in painting and chaperoning them round private collections. He began a protracted but somewhat diffident courtship of Mary Boydell, the niece of John Boydell, a fabulously wealthy printseller. Eventually, like Johann Zoffany, who had also returned from Italy to find himself out of favour, Humphry decided to recoup his fortune in India.

An artist travelled to Italy to help make his fortune; he travelled to India to save himself from penury. Humphry's move was exceptionally risky, and shows the parlous state of his affairs. Many friends tried to dissuade him from the journey, for they knew that though fortunes could be made, it was just as likely that a life would be lost in an unfamiliar and unhealthy climate. But Humphry was determined to make enough money to be 'independent'. He had, in effect, abandoned the idea of being a professional artist. He aimed either to make a killing and retire on the proceeds or to die in the attempt. It was a desperate strategy.

In December 1784 Humphry sold the furnishings of his lodgings at 25 Newman Street, realizing over £130; in the New Year he packed his belongings, including the rolled-up canvas of the Waldegrave sisters which he planned to show potential clients to prove his skills, and set sail for the subcontinent. Sick and depressed when he arrived and shocked by the number of artists looking for custom, he was forced to revert to miniature painting. He finally thought his fortune made when he obtained a commission from the governor general, Sir John Macpherson, to produce a series of miniatures of the Nabob of Oude and his court. But the vizier, instead of paying him in gold, gave him a bond worth £4,500 which Humphry found impossible, despite many efforts, to redeem. Right up until his death Humphry persisted in trying to extricate his fee (half of his surviving papers are devoted to the litigation, petitions and begging letters in his cause), but his efforts were futile: India failed to disgorge its riches.

Humphry returned to England in 1788 a much chastened but not much richer man. Yet in the next few years his career revived. He exhibited miniatures at the Royal Academy, was elected a fellow in 1791 and was engaged by his old patron the Duke of Dorset to copy in miniature the collections at Knole. But in the same year his sight failed him and he was forced to abandon miniature painting. He was back in the world of making-do, of fitful expedients. Now he had 'recourse to crayon painting . . . I derived from the practice of that branch of my profession £800 a year upon the average of the last four years.' Crayon painting, or working in pastels, had been popular for decades since foreign artists, most notably Jean-Étienne Liotard, had made them fashionable. Pastel portraits could be completed quickly, were composed with the sort of informal pose of which the times were fond, cost the sitter about one guinea, and were commissioned by a clientele that ranged from royalty and rich aristocrats to the merely well-off. They served Humphry well until his sight deteriorated even further and he abandoned all forms of painting and drawing in 1797.

In his declining years Humphry became more and more cantankerous, exchanging recipes for quack medicines with his ageing friends and bothering aristocrats with importuning letters for a sinecure or for help in getting his Indian debt paid. He had an income of £200 in annuities, which left him far better off than some of his colleagues, but which he repeatedly complained of as insufficient and sought to supplement

by an artist's time-honoured by-employment, namely picture dealing.

As we have seen, it was common for artists to buy and sell pictures and prints. As more and more British painters went to Italy and professed to be familiar with the works of the Old Masters, so they could claim to be connoisseurs, able to spot a fine picture and, even more importantly, to attribute paintings correctly. Humphry collected a number of paintings over the years; at his death he possessed works attributed to Domenichino, Van Dyck, Bartolommeo and Titian. But the pride of his collection was a putative Raphael, a portrait of Francesco Maria della Covere, nephew of Julius II, which he had bought from an English collector who had, in turn, acquired it from an 'Italian Man of Fashion'. In 1805 Humphry offered the picture for 600 guineas to the third Earl of Egremont, the patron of Turner and the owner of one of England's finest art collections at his country seat at Petworth. The price, as Egremont was quick to point out, was high – a more clearly authenticated Raphael sold at the Orleans sale of 1800 fetched £525 – and its provenance was obscure. When questioned about its authenticity, Humphry claimed to have 'purchas'd it upon its internal Evidence, never having recourse to the opinion of any person whatever. Its authority has never been doubted.' He added, for good measure, that Reynolds, Mengs and Batoni all believed it authentic and that he himself was 'as well acquainted with the stile and character of this Master as with my own handwriting'. Egremont, pleading poverty, offered Humphry £100 a year for his life. Humphry accepted; his so-called Raphael was transformed into a pension. It is difficult to know whether Egremont or Humphry got the better of the bargain: when the painter died in 1810 the earl had paid him £500.

Towards the end of his life Humphry began to compose his autobiography. His first draft begins with the sort of apology that often prefaces eighteenth-century autobiographies and memoirs: he claims that 'he could not have been prevailed on to submit any of these particulars to the public but that he has more than once been solicited to do so by authors or persons who write Biographical Notices of living Characters for Magazines and other periodical works.' The claim is not disingenuous: by the time he was writing curiosity about the lives of painters was as commonplace as interest in the biographies of statesmen. A periodical launched in the 1790s, the *European Magazine*, specialized in the biographies of modern artists. The social prominence of the Academy and of the quarrels among artists focused on Somerset House and its exhibitions had made

painting part of London chit-chat; the eminence of Reynolds had made a painter's life a proper object of critical curiosity This interest was part of a larger change, one that joined criticism to biography in a manner made famous by Dr Johnson in his *Lives of the Poets*. Establishing the link between life and work was taken to justify the view, found in Plutarch and elevated into a cliché as the business of biography grew by leaps and bounds that, in the words of William Seward in his *Anecdotes of Distinguished Persons* (1795–7), 'nothing is trivial in the history of genius'.

The result of this was to aggrandize the picayune and make worthy of note even the most unimportant life. As Humphry noted in his apologia, even if his own work had not been distinguished, his life was important for what he had witnessed; its consequence was vicarious. Humphry had a point: today, the best-known extract of his life is that which describes in detail the techniques and circumstances of Gainsborough's painting. Similarly, James Northcote's autobiography remains unpublished and largely unread; yet his *Life of Reynolds*, which contains much of the same material, went through numerous editions and became the standard biography.

Northcote's autobiography is complete; Humphry never finished his own life, producing several truncated and mangled drafts. No doubt his indolence – for he was known as a lazy man – partly explains his failure to write in much detail about his life beyond the Grand Tour. Yet it did not stop him from assiduously collecting myriad details in his correspondence and memoranda. It is more likely that he cut short his autobiography because he failed, after 1777, to follow the narrative path laid out for the successful artist. He could gather information, muster evidence, but there was no heroic story to tell. The scattered particulars of the rest of his life did not add up to a whole.

Humphry's success in painting miniatures required certain skills: accuracy, an attention to minute detail, deft draughtsmanship, the ability to achieve a likeness. He displayed these same skills in his account of his life; its strength lies not in its coherence or vision, but in its vivid anecdote. The world of the miniaturist, much like that of portrait painters, was dominated by private commissions; its artifacts were customized and not intended for a larger marketplace. Miniatures were by their nature private, not public: they were worn about the body – on wrist bracelets, in lockets, on the lid of pocketed snuff-boxes or around

the neck; they were displayed in cabinets and dressing rooms, not in public places. They could not aspire, like the full-scale portrait, to the realm of history. Yet miniatures achieved some public visibility. They were exhibited at the Academy shows in Somerset House, being hung around the fireplace in the Great Exhibition Room (fig. 115); miniaturists like Humphry enlarged their works to accommodate this new, more public viewing. But in prints of Academy exhibitions they are shown being examined by children, who could hardly be expected to understand academic theory but who could spot a good likeness.

When Humphry turned from private to public art, from miniatures to portraiture in the grand manner, he failed. His technical skills – and he could draw far better than Reynolds, whose draughtsmanship was notoriously poor – hindered boldness of conception and execution; contemporaries described his pictures as 'insipid'.

The contrast with Reynolds is obvious. Though he never composed

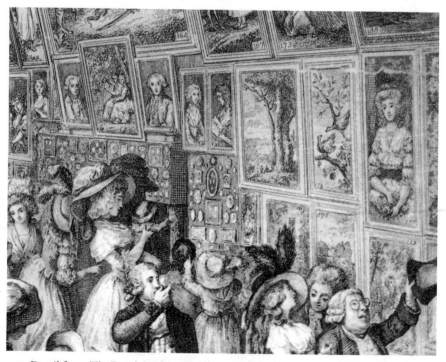

115. Detail from *The Royal Academy Exhibition at Somerset House* by J. H. Ramberg, 1787, engraved by P. A. Martini, 1788

an autobiography, Reynolds wrote biographical fragments, including sketches of Oliver Goldsmith, Samuel Johnson and David Garrick, and, like his portraits, they represent individuals and reveal their character, but also reflect more generally upon human nature. They aspire to the preoccupation with general effects, often repeated in his *Discourses*, rather than 'circumstances of minuteness and particularity'. The inconsistencies of Reynolds's practice, the technical weakness of some of his work, were overridden by the largeness of his design and the coherence of his conception.

By the early nineteenth century the ideal life of the modern artist, cursorily sketched by Jonathan Richardson, had been fleshed out into a full portrait of painterly life. Richardson's claim that portraiture was a sort of history had been vindicated in the form of modern biography. Represented in the 'great style' by Reynolds, whose work raised portraiture to new heights and whose life, graphically recounted by Northcote, epitomized the artist as genius, the exemplary narrative was repeatedly reproduced in countless biographical vignettes drawn for such periodicals as the *European Magazine*. The overall effect of this literary transformation of painter into artist was very like that of the two types of portrait – the one intimate, the other heroic – that Sir Joshua painted: it made the public more and more aware of the individuality of painters, the oddities and foibles that helped to explain their 'genius'; but also reminded them that the professional artist was a public figure whose life was as interesting as the statesman's or the politician's. As Reynolds had reminded Josiah Tucker in the 1770s, 'No man deserves better of mankind than he who has the art of opening sources of intellectual pleasure and instruction by means of the senses.' Once this had become the object of the painter, he could aspire to be an artist.

IV

PERFORMANCE

CHAPTER EIGHT

The Georgian Stage

AT FIVE O'CLOCK on the afternoon of the 14 November 1769 the doors
of the Royal Drury Lane Theatre opened to the public. Passing through
streets in a rough neighbourhood full of garrets, brothels, whores and
thieves, liveried servants sent to reserve seats and other theatre-goers
pushed and shoved their way through the narrow doors to buy their
tickets and grab the best places for the evening's performance (fig. 117).
The great attraction, listed in the playbills published in the newspapers
and 'puffed' by the management, was a new performance by the theatre's
proprietor, manager and star actor, David Garrick. The play was to
enjoy the longest run of any in the eighteenth century and gave Garrick
his most frequently performed role.

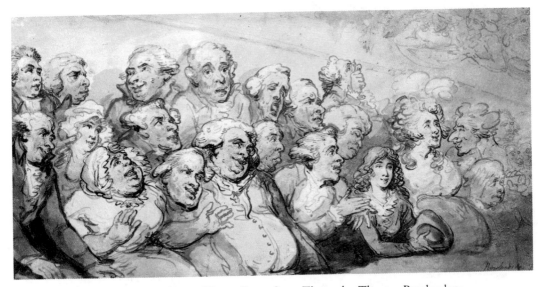

116. *An Audience Watching a Play at Drury Lane Theatre* by Thomas Rowlandson

Critics and raffish young men-about-town paid three shillings each
to squash on to a bench in the pit; honest citizens and visitors to town
crammed into two-shilling places in the first gallery; servants and the
hoi polloi looked down from the upper gallery, price one shilling, while
the whores cruised the upper boxes and orange-sellers offered fruit at
exorbitant prices. Shortly before the evening's entertainment began at
six, the richer patrons with reserved box seats began to trickle in. In the
green room, immediately to the side of the stage, actors, singers and their
invited friends mingled before the performance began.

During the hour before the curtain rose the theatre was filled by
what a bemused German visitor, von Archenholz, called 'noise and bom-
bardment': the audience chatted, cheered and sang, threw fruit at one
another, flirted and preened themselves. A few years earlier James
Boswell, waiting with a Scottish friend for a Drury Lane performance
to begin, 'entertained the audience prodigiously by imitating the lowing

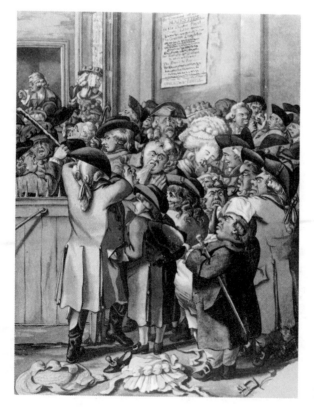

117. *The Pit Door* by
Robert Dighton, 1784

of a cow.' As he later proudly remarked, 'I was so successful in this boyish frolic that the universal cry of the galleries was "*Encore* the cow! *Encore* the cow!"'

Drury Lane, London's oldest theatre, was an intimate space with a capacity of about 1,000. Eager to avoid distractions, Garrick had recently introduced a number of innovations to make the audience focus on the stage. In 1762 he expanded the auditorium and removed spectators from the stage itself, where they had often proved troublesome and obstructive. A clear line was drawn between dramatic action and audience. Three years later he dispensed with the large hooped chandeliers that had illuminated both stage and auditorium, increased the number of footlights, and mounted batteries of light on moving poles with reflectors in the wings. Now the auditorium was darker, the stage brighter and the opportunities for special light effects greater.

But the audience needed little encouragement on this November evening to focus on the stage. They had not come to hear the overture played by the theatre orchestra, or to hear the main piece of the evening, Elizabeth Griffith's *The School for Rakes*. They were there for Garrick's afterpiece. For Garrick's most popular theatrical performance was not a Shakespeare tragedy like *Richard III* or a comedy such as Vanbrugh's ever-popular *The Provok'd Wife* but a common play, dreamed up during a conversation with the painter Benjamin Wilson in a coach between Stratford-upon-Avon and London. *The Jubilee* was a commercial wheeze designed to cash in on the publicity surrounding the Shakespeare Jubilee that Garrick had organized at Stratford the previous summer (fig. 118), and to recycle the festival's expensive costumes and fittings for use on the stage.

The plot of *The Jubilee* – 'I suppose an Irishman ... come from Dublin to See the Pageant – he is oblig'd to lye in a post Chaise all Night – undergoes all kinds of fatigue & inconvenience to see the Pageant, but unluckily goes to Sleep as the Pageant passes by' – provided a low comic counterpoint to a glittering procession of nineteen pageants depicting scenes from Shakespeare's most popular plays. The *tableaux vivants* were as much an advertisement for Drury Lane productions as for the Bard himself. Actors appeared in the roles for which they were well known. Garrick himself was Benedict in *Much Ado about Nothing*, his most frequently performed Shakespearean part. The spectacle, with music by the composers Thomas Arne and Samuel Arnold, included

118. Shakespeare Jubilee Ticket, 1769

popular songs such as 'Sweet Willy O!' sung by the fashionable beauty Sophia Baddeley, and ended with Garrick's 'Ode to Shakespeare' and a roistering chorus (fig. 119). At the finale, according to the stage directions, 'Every character, tragic and comic, join in the chorus and go back, during which guns fire, bells ring. &c. and the Audience applaud – Bravo, Jubilee, Shakespeare forever!'

The audience loved it. The diary entry of the Drury Lane prompter William Hopkins swells with pride when he describes *The Jubilee*'s reception: 'It was received with bursts of Applause the Procession of Shakespeare's Characters &c. is the most Superb that ever was Exhibited or I believe ever will be, there never was an Entertainment produc'd that gave so much pleasure to all degrees Boxes pit, and Gallery.' As Garrick wrote to friends, 'the world is mad after it ... [it has] more success than any thing I Ever remember – it is crowded [in] 15 minutes after the Doors are open'd.' At a time when a run of more than a dozen nights was considered a success, *The Jubilee* ended the season after ninety performances.

The Drury Lane company was a sizeable business, owned by a group of shareholders, employing about 150 people, including eighty actors,

spending as much as £40,000 a year and making a net profit, if Garrick's experience as manager is anything to go by, of between £3,000 and £6,000 a year. Drury Lane had to be commercial because, unlike many of its counterparts on the continent, it received no royal subsidy. As one of the two theatres licensed to perform spoken drama in London (the other was at Covent Garden), it was officially a royal theatre, but crown control never extended to financial support. Publicity and profit were therefore crucial. The costs of the Jubilee celebrations at Stratford alarmed Garrick's partner, James Lacy, but they were subsequently more than recovered, thanks to the extensive publicity they gave to Garrick and the Drury Lane company. Though the ostensible star of the Stratford Jubilee was the Bard himself, the press paid far more attention to Garrick and his company for propagating the virtues of England's first playwright. The Drury Lane audience was well primed when the curtain rose in

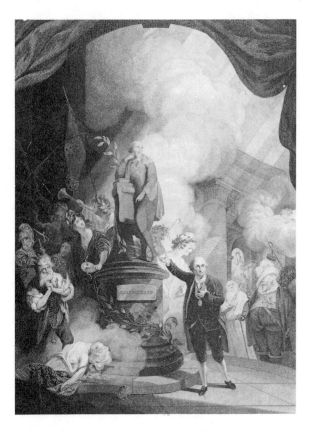

119. *Garrick Speaking the Ode* by Robert Edge Pine, engraved by Caroline Watson, 1784

November 1769; it would have been a surprise if *The Jubilee* had not been a hit.

A commercial theatre must appeal to a broad audience, in this case one almost as socially diverse as the nation itself. Drury Lane and Covent Garden had a joint monopoly on spoken drama in London, but they could never have survived on a repertory of comedy and tragedy: music, spectacle and entertainment were essential too. An evening's performance ran for three or four hours and usually consisted of an overture played by the theatre's orchestra, a main piece – a play, musical or opera – followed by an interlude (perhaps music or dance) and then a second shorter afterpiece. Afterpieces and interludes were at best comic, often farcical, and sometimes included stage-tricks and special effects (fig. 120). They ranged from such comedies as Samuel Foote's enormously popular satire of high and low life, *The Mayor of Garratt*, to light opera like Samuel Arnold's *The Agreeable Surprise*. It was generally said that the main pieces, especially tragedies, were for the quality and the afterpieces for the common people. Certainly, the upper galleries of the theatre often filled up after the main performance, when late-comers could gain admission at half price. Many of the century's most popular plays and entertainments, including *The Jubilee*, were afterpieces, and many were also performed at aristocratic amateur theatricals.

Garrick wanted to be known for staging the great works of British drama, of course, and above all to be remembered as the interpreter of William Shakespeare. He worked tirelessly to link his own reputation to the Bard's, but he could not avoid the commercial pressures to offer lighter fare to the public. Early in his career as a manager he had been appalled by the prospect of mounting stage-tricks and pantomimes, with their acrobatics, dance-routines, music and song: 'I . . . dislike . . . *Maddox's* rope-dancing upon our stage. I cannot possibly agree to such a prostitution upon any account; and nothing but downright starving would induce me to bring such defilement and abomination to the *house of William Shakespeare*.' (Garrick got his way: Maddox never appeared at Drury Lane (fig. 121).) But like every other manager, Garrick soon tempered his high-minded ideals, hired dancers, singers and musicians, and mounted spectacles. His ill-fated *Chinese Festival* of 1755 was a ballet and pantomime of European dancers brought from Paris, which a chauvinistic audience, incensed by the employment of French performers, drove from the stage. For more than a decade until his retirement in

120. *Mr Lort*, artist unknown

1776 he put on masques and musicals, pastorals, interludes, pantomimes and farces, staging nearly twice as many afterpieces as his rivals at Covent Garden. He seems to have pursued a conscious plan of mixing a repertoire of classical drama with more popular material. *The Jubilee* epitomizes this strategy. Its serious and high-minded purpose was the promotion of Shakespeare as the greatest British dramatist, but its presentation was deliberately undemanding: a farce, a spectacle, a musical show, closer to what we would think of as music-hall.

The development of a safe repertory was part of Garrick's general strategy to secure the reputation of the stage; throughout his career he consciously sought to raise the public standing of plays and their performers. He tried to tame and educate a boisterous audience, to teach it to listen in silence and appreciate the small gestures of a performance, and to raise the actor's social standing by setting himself up as a model of polite affability and modern refinement. According to Dr Johnson, who often carped at Garrick's inveterate affability, he was a man who, 'by

an uncommon assemblage of private virtue, adorned the highest eminence in a public profession'. Edmund Burke went further: in an epitaph he described Garrick as the man who single-handedly 'raised the character of his profession to the rank of a liberal art'.

ANTHONY MADDOX the Surprizing English Posturemaster, that performed before his MAJESTY at the New Theatre in Convent Garden, and exceed the Performances of ye GREAT TVRK and all other foreigners in that Art of Dexterity

Engrav'd for the New Universal Magazine 1753. *B. Cole sculp.*

An EXPLANATION of the COPPER-PLATE, exhibiting Mr. ANTHONY MADDOX, the ENGLISH POSTURE-MASTER, and his surprizing FEATS.

IN the centre is a lively portrait of Mr. ANTHONY MADDOX, who is allow'd to excel all the masters in the art of *ballancing* and *dexterity* of the human body, that ever appear'd on the stage at home or abroad.

At No. 1. He tosses 6 *balls* with such dexterity, that he catches them all alternately, without letting one of 'em drop to the ground, and that with a surprising activity.
— No. 2. He ballanceth his *hat* upon his chin.
—— 3. He ballanceth a *sword* with its *point* on the edge of a *wine-glass*.
—— 4. He at the same time plays on a violin.

—— 5. He lies extended on his back upon a small *wire*.
—— 6. He ballanceth a *coach-wheel* on his chin.
—— 7. He standeth *on his head* upon the *wire*.
—— 8. He ballanceth a *chair* on his chin.
—— 9. He ballanceth *seven pipes*, one in another: And
—— 10. Blows a *trumpet* on the wire.
—— 11. Ballanceth several *wine-glasses* full, on the wire.
—— 12. Ballanceth *two pipes* across a *hoop* on the wire.
—— 13. Tosseth a straw from his foot to his nose.

121. *Anthony Maddox the Surprising English Posture Master* engraved by B. Cole, 1753

As we shall see when we return to Garrick's contribution to the British stage, his friends' view was a trifle optimistic. But Garrick's efforts have to be understood as a determined effort to make the theatre respectable in the face of a widespread and longstanding belief, which the conduct of players and the ambience of the playhouse did little to dispel, that the stage was not a force for good. For of all the problems the theatre confronted the greatest was persistent prejudice against drama, actors and playhouse. Hostility to the stage was deeply embedded in the English Protestant consciousness. The stage was viewed as a place of trickery and deceit, full of illusions and magic similar to those which the Roman Catholic church had used to bamboozle ignorant observers into becoming credulous believers. For many Protestants, especially clerics, it was a cardinal principle that play-going and going to mass were both forms of idolatry.

The seventeenth-century Puritan hostility to the playhouse continued throughout the eighteenth century, but it focused more on morality than theology. When the schoolteacher, reformer and Scot James Burgh (1714–75) used the occasion of the Jacobite Rebellion of 1745 to rant against the immorality of a profligate age, he singled out the theatre for particular rebuke. He confessed he did not know where to begin in enumerating the depravities of the stage: 'whether [it be] . . . the Lewdness or Impiety of most of the Plays themselves, or the infamous Characters of the Actors and Actresses, or the scandalous Farces they commonly tag the gravest plays with, or above all . . . the inhumanly impudent Dances and Songs, with which they lard them between the Acts.' Indeed, he concluded, 'the theatre is at present on such a footing in England, that it is impossible to enter it and not come out the worse for having been in it.' The idea persisted into the nineteenth century. In 1809 a devout layman wrote to *The Times*, 'The stage has proved, and will ever prove, subversive of the order, peace, and purity of morals, and consequently, of Christianity itself'.

Moralizing critics condemned the performers as well as the performance. The high-church cleric William Law, in his *The Absolute Unlawfulness of the Stage Entertainment fully demonstrated* (1736), declared, 'a Player cannot be a living member of Christ, or in a true state of Grace, till be renounces his Profession'. The aptly named *Players' Scourge* (1757) asserted, without the slightest hint of irony, that 'Play-actors are the most profligate wretches, and the vilest vermine [sic], that hell ever vomited

out; . . . they are the filth and garbage of the earth, the scum and stain of human nature, the excrements and refuse of all mankind, the pests and plagues of human society, the debauchees of men's minds and morals.' Actors were particularly criticized for portraying low or morally reprobate characters in a sympathetic light. The representation of vulgarity or immorality was admissible to some critics provided they were satirized or condemned; but to seduce the audience into liking a rake or a bawd was beyond the pale. As Collier said of Dryden's *The Mock-Astrologer*, 'we see what a fine time lewd People have on the *English Stage*.'

As its critics understood, the danger of theatre lay chiefly in the skills of its actors. Players made the stage seductive: their glamour and beauty, the virtuosity of their performances, their private lives, at once the focus of polite society and yet disreputably on its margins, all made the theatre a place of exciting dreams, fantasies and illusions. Actors enjoyed the privilege of behaving on stage in ways which thrilled the audience with their impropriety, but this meant that many theatre-goers, happy to enjoy their performances, also considered them morally compromised. Actors and especially actresses were damned by sententious critics for the very qualities that made them famous and successful. It seemed almost impossible to combine a successful stage career with respectability. Paradoxically, actors both were the theatre – individual actors' skills changed the repertory and how plays were interpreted, and the fame of performers packed the auditorium – and were its greatest liability.

For much of the century the spoken drama was dominated by the extraordinary public attention paid to every aspect of the lives of its most famous players – Betterton and Elizabeth Barry early in the century, Colley Cibber, James Quin, Peg Woffington, Hannah Pritchard, Garrick, Kitty Clive and Susannah Cibber in mid-century, and Sarah Siddons, Kemble and Mrs Jordan at its end. Their fame in certain roles ensured that some plays were performed repeatedly. The success of Shakespeare's *Pericles*, a Restoration revival despite the hostility of the critics to it, was largely attributable to Betterton's brilliant portrayal of its hero. Charles Macklin's Shylock, a part he prepared by spending time among the Jewish stockbrokers in the city's 'Change Alley', not only popularized the play but transformed the merchant of Venice from a comic into a tragic role (fig. 122). Garrick's Richard III, in which he made perhaps the most sensational debut of any actor, made even more popular one of Shake-

122. *Shylock and Tubal from The Merchant of Venice, Act III, Scene 2*
attributed to Herbert Stoppelaer, 1767–9

speare's most regularly performed tragedies. In the 1740s *Twelfth Night*, *As You Like It*, *The Winter's Tale* and *All's Well That Ends Well* were all staged for the first time in the century. Their revival and subsequent popularity owed much to the talents of three famous comic actresses – Kitty Clive, Hannah Pritchard and Susannah Cibber. Their rival, the ebullient Peg Woffington – who often went on in 'breeches' parts, wearing male dress to display her elegant legs – kept up the popularity of Farquhar's *The Constant Couple* by her performances as Sir Harry Wildair, 'an airy gentleman, affecting humorous gaiety and freedom in his behaviour'(fig. 123). And at the end of the century Sarah Siddons's portrayal of Lady Macbeth was one of the most discussed and analysed roles of the era.

The interest in actors' interpretations of major roles was fuelled by debates throughout these years about the nature and merits of different styles of acting. Though certain ways of performing predominated – intimate intensity in the days of Betterton, bombast and rhetoric under Cibber and Quin, a more 'natural' style under Garrick, and a mannerly, sedate neo-classicism under Siddons and Kemble – performers were trained in more than one tradition. In December 1746 the orotund Quin

and the quicksilver Garrick played opposite one another as Horatio and
Lothario in Rowe's *The Fair Penitent*. According to Garrick's biographer,
'The shouts of applause, when Horatio and Lothario met on the stage
together in the second act, were so loud, and so often repeated, before
the audience permitted them to speak, that the combatants seemed to be
disconcerted. It was observed, that Quin changed colour, and Garrick
seemed to be embarrassed.'

This sort of confrontation, like the simultaneous mounting of rival
productions of *Romeo and Juliet* four years later, was excellent box office.
Yet Garrick, at least, was eager to portray such rivalries as matters of
method and principle. His anonymously published *An Essay on Acting*,
which appeared in 1744, not only attacked Quin's version of Macbeth
and defended his own production of the play, but tried to explain how

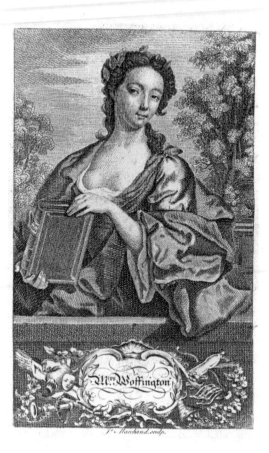

123. *Mrs Woffington*,
engraved by J. Marchand

124. Mrs Barry and Mr
Garrick in the character
of Donna Violante and
Don Felix in *The
Wonder*, engraved by
Jean Louis Fesch

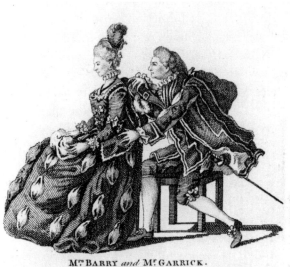

M.ʳˢ BARRY *and* M.ʳ GARRICK.
in the Characters of Donna Violante *and* Don Felix *in the* Wonder.

he was elaborating a new manner of performance, to persuade his audi-
ence that they should see his interpretation of Macbeth as part of a more
general reshaping of acting.

In fact the press and the public cared far more for individual perform-
ances than for theories of acting. Published criticism focused on the actor,
not on the part or the play, revelling in the particularities of individual
performances (fig. 124 & 125). Thus Thomas Wilkes describes Garrick's
King Lear in *A General View of the English Stage* (1759) (fig. 126):

> The spirit which he exerts, the endeavouring to collect all his
> strength to preserve his dear daughter from the hands of the assassin,
> are not to be described. His leaning against the side of the scene,
> panting for want of breath, as if exhausted, and his recollecting the
> feat, and replying to the fellow who observes, that the good old
> King has slain two of them. 'Did I not, fellow?' have more force,
> more strength, and more propriety of character than I ever saw in
> any other actor.

From mid-century critics published similarly detailed descriptions of
the gestures, expression and individual foibles of almost every major
performer. Actors developed distinctive repertories not so much to express

particular emotions, though this was important, but to develop their own *interpretations*. As John Hill wrote in his *The Actor: a treatise on the art of playing* (1750), 'The great thing in which [excellent] players distinguish themselves is the expressing to the audience such sentiments as are *not* deliver'd in the play, yet are not only agreeable but necessary to be understood of the character they represent.' Interpretation came from the actor's performance, not from the play's text.

This message, repeatedly reiterated by David Garrick and strongly endorsed by others, claimed the stage rather than the page as the place where drama was interpreted. Entire plays as well as individual roles were to be understood through their enactment. As Garrick explained to Boswell in 1772: 'Speeches and mere poetry will no more make a Play, than planks and timbers in the dock-Yard can be call'd a Ship – It is Fable, passion & Action which constitute a Tragedy, & without them, we might as well exhibit one of Tillotson's Sermons.' The implications of this argument alarmed writers, who quite rightly thought that they were being sidelined. As James Ralph complained, on the stage 'exhibition stands in the place of composition, the manager whether player or Harlequin [Garrick or John Rich] must be the sole pivot on which the whole machine is both to move and rest.'

It is not surprising, then, that during the 1750s journalists and authors

125. Delftware tiles after engravings by Jean Louis Fesch

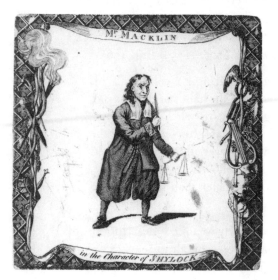
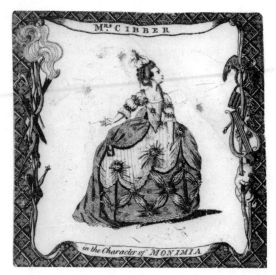

repeatedly mounted venomous attacks on Rich and Garrick. They complained bitterly about the trends in drama that had been brought about by the Licensing Act and the patent managers' prudent policies. They resented that there were so few new plays, such rare opportunities for a writer to turn dramatist. 'Is the credit of our age nothing?' remonstrated Goldsmith. 'Must our present times pass away unnoticed by posterity?' And they disliked the cult of the actor with its emphasis on certain important roles and classic plays, complaining that even when new works were staged, the actors stole the limelight. As Francis Gentleman wrote, Garrick, 'fond of something critical and new/A meaning gave beyond the author's view'. This kind of behaviour did not sit well with the likes of Goldsmith, who believed that plays were best understood through reading them rather than in performance: 'All must allow that the *reader* receives more benefit from *perusing* a well-written play than by seeing it acted ... Nay I think it would be more for the interests of virtue if stage performances were read *not* acted; made rather our companions in the cabinet than on the theatre.' This literary attitude did not impress managers who were actors, and it never caught on with the public. A great player was a far stronger attraction than a fine author.

Actors lived exceptionally public lives, constantly exposed to observation, comment, praise and ridicule. As Colley Cibber drily remarked at

the beginning of his *Apology*, 'the publick very well knows that my life has not been a private one; that I have been employed in their service, ever since many of their grandfathers were young men.' Papers like the *World* and periodicals like the *Monthly Mirror* and the *Town and Country Magazine* were filled with gossip about theatrical politics and salacious tittle-tattle about actors' private lives. The public's appetite for news, gossip and scandal about the stage was insatiable, its sense of intimate acquaintance with actors unique. A successful player could only have a public private life.

Of course, the actors created much of the publicity themselves. A great deal of what passed for theatrical criticism was mere puffery, articles written by friends in Grub Street to praise certain players and performers. Equally, adverse criticism was often produced by theatrical rivals and enemies. When Sarah Siddons and Mrs Yates both played Euphrasia in rival productions of Arthur Murphy's *The Grecian Daughter* during the 1782–3 season, their husbands published anonymous reviews in their wives' favour, a ploy that was in turn satirized in prints. Players had many connections with the press and publishers, while managers like Garrick, who needed to advertise performances, owned shares in London newspapers. As the radical journalist William Cobbett wrote, speaking of Sheridan, 'There is, and always has been in this country, a sort of family compact between the press and the theatre.' Sheridan, he added, referring to his notorious anonymous puffs for his theatre, had 'long had the press in all its branches, completely at [his] command'.

It was easy for a theatrical squabble to find its way into the news. Actors, so used to public exposure, were happy to publish their memoirs and lives, and theatrical biography quickly became a major genre. Colley Cibber's *Apology for the Life of Mr. Colley Cibber, written by himself*, which appeared in 1740, was the prototype. This extraordinary mishmash, part history of the theatre, part intimate self-portrait, was 'a mere ragoust', as he himself conceded, its principal ingredient 'one eternal egoism'.

Turning private lives into public performance became a thespian habit. The Irish playwright, novelist and actress Elizabeth Griffith published what purported to be the correspondence of her courtship with her husband. In 1755 Charlotte Charke, Colley Cibber's rejected daughter, wrote a remarkably candid memoir, more revealing than anything penned by her father, in which she recounted her life as actress, grocer, oil dealer, puppeteer, strolling player, waitress, novelist, transvestite and

lesbian lover. She published her sensational life in order to escape poverty – she had tried to persuade her father to give her money in return for suppressing it – but she died destitute in a Grub Street garret five years later. Towards the end of the century still more theatrical memoirs and biographies appeared, mostly written by men and women more successful than Charke had ever been. A few, like the six-volume life of Sophia Baddeley, were sensationalist, but more and more were intended to show players in a respectable light.

The life of the actor was engaging, demanding and full of pleasure, but difficult to represent as reputable. The actress Harriet Mellon (fig. 127), who married the Duke of St Albans, was bored by her aristocratic life 'in the treadmill . . . toiling in the stupid, monotonous round of what they call pleasure, but which is, in fact, very cheerless and heavy work', and she looked back nostalgically to the actor's life: 'The society in which I formerly moved was all cheerfulness, all high spirits – all fun, frolic,

126. *Mr Garrick in the Character of King Lear* by Benjamin Wilson, engraved by James McArdell, 1761

and vivacity; they cared for nothing, thought of nothing, beyond the pleasures of the present hour, and to those they gave themselves up with the utmost relish.' Filled with drinking, impulsiveness and a casual attitude to the marriage vows, an actor's life could be presented as sober, regular and industrious only by its most imaginative apologists. In his *Memoirs* of 1806 the sentimental playwright Richard Cumberland claimed, 'The profession of the actor is laborious in the extreme; it is only to be upheld by habitual temperance and incessant study: indolence cannot retain it, dissipation must extinguish it.' But even he was not convinced by his own argument. 'They, who are for ever in the public eye', he rather despairingly remarked, 'can surely estimate the value and advantages of private character.' The truth was, they often could not.

Many players were violent, quarrelsome, unrefined and lewd. Harriet Mellon remembered the theatre's high spirits, but in her nostalgia she suppressed its frequent and violent quarrels. Actors' rivalries and petty spites often led to blows. Charles Macklin may have pioneered the more naturalistic style of acting with which Garrick came to be associated, but he was also notorious as a quarrelsome, overbearing and violent man. He claimed to have given his rival tragedian, James Quin, a good thrashing in a brawl. In 1735 he stabbed a fellow actor, Thomas Hallam, in the eye with his cane during a quarrel over a wig; Hallam died. Quin was charged with murder and, after his manager had organized a parade of respectable character witnesses, was convicted of manslaughter. The actress Elizabeth Barry, who had been tutored by Rochester, used a stage dagger to stab Mrs Boutel in a scene in Nathaniel Lee's *The Rival Queens* after a quarrel over a veil. In 1756 Peg Woffington used a similar weapon to wound her rival Anne Bellamy while performing in the same play. The call for theatrical decorum was honoured as much in the breach as in the observance.

Actresses, who had been first allowed on the stage only at the Restoration, quickly became the focus of censorious critics, prurient play-goers and youthful libertines. John Evelyn complained about the 'foul and indecent women now (and never till now) permitted to appear and act', which inflamed 'several young noblemen and gallants', while Pepys typically took a more voyeuristic view: 'met with Knepp [an actress] and she took us up into the tiring rooms and to the women's shift where Nell [Gwyn] was dressing herself and was all unready and is very pretty, prettier than I thought . . . But Lord! to see how they both were

127. *Miss Mellon* painted and
engraved by S. I. Stump, 1803

painted would make a man mad and did make me loath them; and what
base company of men come among them and how lewdly they talk!'

These actresses were aggressively pursued by rakes and roués. In
December 1692 William Mountfort, a popular actor, was murdered by
two young libertines, Lord Mohun and Captain Hill, whom he tried to
prevent from abducting the actress Anne Bracegirdle. They were enraged
that a mere actor should stand between them and their victim. By the
reign of George III there was less of such rakish violence, but the stage
was still the roué's hunting ground. In the 1760s James Boswell could
benefit from the misfortunes of a Covent Garden actress, Louisa Lewis,
who was down on her luck and in search of a generous 'friend', and
who, after receiving gifts and a little money, became his mistress: 'A
more voluptuous night I never enjoyed,' he boasted in his journal. 'Five

128. *Horace Walpole's Memorial to Kitty Clive* by Joseph Farington

times was I fairly lost in supreme rapture'; Louisa's 'exquisite mixture of delicacy and wantonness', he added, was what he especially enjoyed. But his tone soon changed when he discovered he had been clapped: 'Am I, who have had safe and elegant intrigues with fine women, become the dupe of a strumpet?' In a ludicrously sententious letter he demanded she return money which he claimed they had both understood was a 'loan'. Dr Johnson was more cautious. He told David Hume that, after frequenting the Drury Lane green room, he had said to Garrick, 'I'll come no more behind your scenes, David; for the silk stockings and white bosoms of your actresses excite my amorous propensities.'

Boswell's predatory conduct was encouraged by a press that painted the actress as at best a lady of easy virtue and at worst a whore. In almost every generation there were famous players whose much-publicized lives were surrounded by intrigue and illicit romance. For every woman who assiduously cultivated an air of impeccable respectability – Anne Betterton, Hannah Pritchard, Kitty Clive (fig. 128), Sarah Siddons or Mrs Jordan – another enjoyed a raffish reputation. Anne Oldfield, the

129. *Mrs Baddeley* by
Johann Zoffany,
engraved by R. Lowrie,
1772

greatest comic actress of the first half of the century, was buried beneath
the monument to Congreve in Westminster Abbey but refused a mem-
orial of her own because of her illegimate children by two fathers. Peg
Woffington, whom Garrick loved but never married, was said by the
playwright Arthur Murphy to have every virtue – 'honour, truth, benev-
olence, and charity' (she spent her wealth on her mother, her sister's
education and in endowing almshouses) – but was best known as a
vivacious beauty and witty conversationalist who enjoyed a succession of
wealthy and aristocratic lovers.

In the next generation the actress and singer Sophia Baddeley, who
performed in the stage version of Garrick's *Jubilee*, achieved similar
notoriety, her many exploits and tragic early death retailed to the public
in a long drawn-out biography. In addition to a succession of affairs
with actors and a theatre manager, she had a number of liaisons with
aristocrats, including two sons of Lord Coleraine, Lord Melbourne and
the Duke of York. In 1774 the *Morning Post* published a part of her
romantic correspondence with 'a noble lord' and two years later she

featured in the gossipy *Town and Country Magazine* after she had been refused entrance to the Pantheon as a woman of doubtful character but had been 'escorted . . . in triumph to the rooms' by a bevy of aristocratic admirers whose drawn swords secured her admission. The lives of such women, universally regarded as beautiful, talented, vivacious and impulsive, rather than sober, chaste and discreet, were of much greater interest to Grub Street hacks and to the public than any biography celebrating domestic virtues. But these women were subject to a double standard, condemned for the very qualities that brought them public admiration. Typically, satirists and critics treated Sophia Baddeley's premature death as the just reward for a life of vice, though her peccadilloes had in fact brought the public much pleasure (fig. 129).

Sarah Siddons succeeded as well as any actress during the century in overcoming the presumption that every female player was at heart a whore (plate 7). During the 1780s and 1790s, when she enjoyed the enthusiastic support of George III and Queen Charlotte, her admirers touted her as an exemplary Englishwoman of noble feelings and high moral character. After her triumphant return to the London stage in 1782 she became *the* muse of tragedy. Painted by Reynolds in a portrait exhibited at the Royal Academy show of 1784 as *Mrs Siddons as the Tragic Muse*, she appeared the following year in a revival of Garrick's *Jubilee* in the pose of Reynolds's picture. By 1789 she had become the female symbol of the entire nation, dressed as Britannia at the service in St Paul's to celebrate the recovery of George III from his madness.

Siddons assiduously cultivated her appearance of patriotic respectability. She refused roles and lines that she thought might compromise her moral integrity and exalted station. She would not read the comic dialogue in Robert Jephson's *Julia, or the Italian Lover* of 1786, objecting, for example, to the lines 'The charms of English worth who can discover, and never wish for an *Italian Lover*.' She avoided comic roles and encouraged a personal mystique to develop around her in the drawing rooms of her admirers. On the two occasions when indiscretions were attributed to her – a reputed affair with the painter Thomas Lawrence and another with the fencing master, Galindo – she loftily refused to respond to the rumours, claiming that the accusations were beneath contempt. Siddons was by no means universally popular – like Garrick before her, she was attacked for miserliness, and her Tory politics did not endear her to radical critics – but she took the values of unblemished respectability

adopted by some of her predecessors and shaped them into a popular ideal of English womanhood. The German novelist Sophie von la Roche, on visiting London in 1786, was told one of several stories designed to prove that, though a great actress, Siddons was also 'a good mother and housekeeper':

A large party, which was recently fascinated by her acting, decided at supper to send her a gift the next day, accompanied by verses in her praise. One of the gentlemen paid her a visit himself on this day, and found Mrs. Siddons at her sick child's cot, rocking it with her foot and holding another at her breast, her new role in hand, which she was learning. The company were so affected by this tale that it wants to publish an engraved portrait of this estimable lady in this position, without any alterations.

Sothard pinx¹. *Published May 5ᵗʰ 1783. by T.& W. Lowndes.* *Sharp sculp*

M.ʳˢ *SIDDONS* and her *SON* as *ISABELLA* &c.

My bury'd husband rises in the face
Of my dear boy,& chides me for my stay:
Canst thou forgive me child?

131. *Mrs Siddons and her son as Isabella &c.* by Thomas Stothard, engraved by William Sharp, 1783

Sarah Siddons's claim to represent virtuous womanhood was a bold move (fig. 131). In the past actresses had been held up as examples of what women should not be; Siddons offered not only to play the great tragedian but to embody the ideal British woman. Her success is shown by the large, respectable female following she was able to command.

The theatre was not only stigmatized because of the actors. Playhouses were also condemned as places of sin and vice. As William Law explained, 'It is unnecessary to tell the Reader, that our *Play-house* is in fact the *Sink* of *Corruption* and *Debauchery*, that it is the present Rendezvous of the most profligate Persons of both Sexes: that it corrupts the Air, and turns the adjacent Places into publick Nuisances [sic]; this is as unnecessary, as to tell him that the *Exchange* is a Place of Merchandize.' Libertine ways were not confined to those who appeared on the stage. Prostitutes were always to be found in the theatre. In the *Connoisseur* of November 1754 Bonnell Thornton described the so-called 'green boxes' at Covent Garden as 'that division of the upper boxes properly distinguished by the name of the flesh market'. Forty years later the *Theatrical Guardian* was still complaining that the same theatre had 'been made little less than a public brothel'. Walter Scott endorsed this view early in the following century: 'One half [of the audience] come to prosecute their debaucheries so openly that it would degrade a bagnio.' Not surprisingly, the heroine of *Intrigue à la Mode: or the Covent Garden Atlantis*, a thinly fictionalized collective biography of well-known ladies of the town published in 1767, rises from common bawd to polite and well-kept courtesan through the good offices of an acquaintance at a playhouse.

The association of theatre with brothel was reinforced by the proximity of almost every London theatre to bagnios and houses of ill fame. Which came first – playhouse or whorehouses – is a moot point, but the connection was firmly established by the seventeenth century. The theatres at Drury Lane, Covent Garden, Lincoln's Inn Fields and Goodman's Fields were all in neighbourhoods marked by poverty, violence and crime as well as prostitution. Only the Haymarket, site of the small theatre and the opera house, was relatively free of such stigma.

Drury Lane and Covent Garden especially were associated with prostitution (fig. 132). 'Drury Lane ague' was the slang term for syphilis, 'Drury Lane vestel' for a whore, 'Covent Garden abbess' for a procuress

132. Covent Garden, artist unknown

who worked with a 'Covent Garden Nun'. Drury Lane was the more downmarket and dangerous of the two – Moll Hackabout's arrival there in *The Harlot's Progress* is Hogarth's way of signalling her demise: petty thieves, pickpockets and sharpers worked around the theatre. Covent Garden, on the other hand, was the centre of a major industry. One commentator described it as

> the greatest square of Venus, and its purlieus are crowded with the votaries of this goddess ... One would imagine that all the prostitutes in the kingdom had pitched upon this blessed neighbourhood for a place of general rendezvous. For here are lewd women in sufficient numbers to people a mighty colony. The jelly houses are now become the resort of abandoned rakes and shameless prostitutes.

These and the taverns afford an ample supply of provisions for the flesh; while others abound for the consumption of desires which are thus excited. For this vile end bagnios and lodging-houses are near at hand.

So extensive were the district's sexual services that a guide, *Harris' List of Covent Garden Ladies*, was published annually. It gave details of each woman's attractions, mixing graphic description with many hunting metaphors.

In districts of crime and prostitution, filled with pickpockets and whores, the theatre and theatreland fed off one another. Crime spilled out of the theatre and on to the streets and then spilled back again. In January 1737

> it appeared that one Francis Cooke, a gentleman's coachman, who had picked up a woman, did in a very impudent, saucy manner assault the sentry who had the care of His Royal Highness's chair in the playhouse passage and would force into the said chair the woman he had picked up to make, as he has the impudence to call it, a bawdy house of the Prince's chair . . . [This behaviour started] so great a disturbance and mob that the Captain of the Guard had much ado to quell the disturbance and prevent the mob from breaking into the playhouse where His Royal Highness, the Prince of Wales and the Princess of Wales were.

As Francis Cooke's conduct shows, playhouses raised issues of public order as well as of sexual morality. A play was not like a book or a picture; it was not a thing but an event. Printed works sometimes advocated disobedience and threatened rebellion, an erotic painting might excite lewd feelings, but any theatrical performance could itself be disorderly and bawdy. Its opponents have always understood that 'the theatre' was more than a play or even a performance by a group of actors; it was the place in which players and spectators colluded in a pleasurable deception. As the sixteenth-century Puritan Anthony Munday explained in his *Second and Third Blast of Retrait from Plaies and Theatres* (1580), other forms of wickedness 'pollute the doers onlie, not the beholders, or the hearers . . . Onlie the filthines of plaies, and spectacles is such, as maketh both the actors & beholders giltie alike.' The theatre was a palace of shared illusions which is precisely what made it dangerous. Knowing

that playhouse performance was not confined to action on the stage, critics of the theatre were deeply alarmed by this potential instability.

The eighteenth-century audience was not like its twentieth-century English or American counterpart, watching and sitting in silence, confining its involvement to final applause. Less conscious of being in the presence of 'culture' and more mindful of being part of the theatrical experience, it was boisterous, voluble and occasionally violent. People in the audience looked on drama as their property. They took the view expressed by Charles Churchill in *The Rosciad* (1761):

> The stage I choose – a subject fair and free,
> 'Tis yours – 'tis mine – 'tis public property.
> All common exhibitions open be,
> For praise or censure to the common eye.

Though Churchill exaggerated – the theatre was certainly not free nor was it a common exhibition – he captured the spirit of a place that brought together all classes, from the richest noble to the humblest servant, and that permitted everyone to express enthusiasm or hostility to the drama.

Many viewed the theatrical audience as a cross section of British society and an epitome of its mixed constitution – a combination of king, lords and commoners. As Theophilus Cibber, the son of Colley, put it: 'Noble, Gentle, or Simple, who fill the Boxes, Pit, and Galleries ... as K—ng, L—rds and COMMONS ... make the great body of the Nation.' And any policy that smacked of discrimination against the humbler members of the audience provoked a violent reaction. In 1763 angry theatre-goers prevented Garrick and his rivals at Covent Garden from stopping the half-price concession after the third act or at nine o'clock, a practice which had first been introduced in the 1690s. And when John Kemble tried to raise prices after the opening of the new Covent Garden Theatre in 1809, he provoked sixty-seven nights of rioting and a public controversy that raged in the press for several months; he was eventually forced to give way to the supporters of 'the Old Price'.

It is not surprising that dramatists and actors recognized the power of the public, especially in the cheap galleries, to shape theatrical taste and interpret theatrical performance. Samuel Johnson put it eloquently in the prologue he wrote for Garrick when his former protégé became manager of Drury Lane in 1747:

Ah! let no censure term our fate our choice,
The stage but echoes back the public voice.
The drama's laws the drama's patrons give,
For we that live to please, must please to live.
Then prompt no more the follies you decry,
As tyrants doom their tools of guilt to die;
'Tis yours this night to bid the reign commence
Of rescued Nature and reviving Sense;
To chase the charms of sound, the pomp of show,
For useful mirth, and salutary woe;
Bid scenic Virtue from the rising age,
And Truth diffuse her radiance from the stage.

Playwrights in prologues and actors on the stage courted, flattered and cajoled their aristocratic and plebeian patrons, for they knew that a disapproving audience could force a production's closure. A drama's success depended upon a benign exchange between players and public in which the audience might be as eloquent as the actors. The final stage direction of *The Jubilee*, when the entire cast is joined by the audience in a united chorus of praise for William Shakespeare, perfectly expressed the harmony every manager sought but some had great difficulty in achieving.

This dialogue between the audience and the actors was considered distinctively English. Foreign tourists visiting London went to the theatre as much to observe play-goers as the players. And, though they knew what to expect, they were repeatedly surprised. A French visitor to Covent Garden in 1763 was shocked that 'the gallery controlled the acting and thanked the players'. In March 1775 angry exchanges between gentlemen in the pit and on-stage actors about the decision to omit the prologue and epilogue to Robert Jephson's *Braganza* led an Irish cleric, Dr Campbell, to remark that 'the smallest fraction of such language w[oul]d have produced a duel in the Dublin Theatres – And the millioneth part of the submissions made by the players w[oul]d have appeased an Irish audience – yea if they had murdered their fathers.' Visitors came to see the English stage as a microcosm of English society, a place which accorded much liberty to the ordinary man.

Managers had a repertory of plays; the audience had a repertory of its own, which involved the lobby and the auditorium as well as the stage. Early in the century, when gentlemen of the audience were still

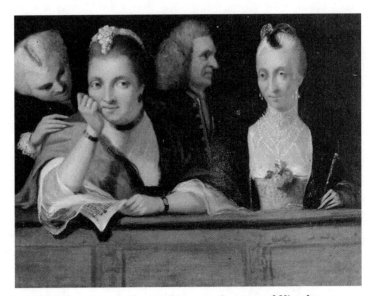

133. *Ladies and Gentlemen watching a performance of King Lear*
attributed to John Hamilton Mortimer, undated

seated on the stage, they would sometimes mingle with the players, interrupting the performance. When Garrick removed them in 1763 privileged audience members still fraternized with the evening's cast in the green room, off the side of the stage. In the lobby and auditorium the audience put on a display of its own. The pit offered criticism and comment, the galleries songs, cheers and flying fruit; in the boxes fashionable society peered at itself as if in a mirror (fig. 133). As the *Theatrical Monitor* of 1768 complained: 'During the time of the representation of a play, the quality in the boxes are totally employed in finding out, and beckoning to their acquaintances, male and female; they criticize on fashions, whisper cross the benches, make significant nods, and give hints of this and that, and t'other body.' Mr Lovel, the beau in Frances Burney's novel *Evelina* who declares that he 'has no time to mind the stage' and affectedly asks his theatrical companions, 'Pray – what was the play tonight?' had many living counterparts.

But most play-goers were less insouciant. People seated in the pit or squeezed into the galleries interrupted performances, shouting witticisms at the actors and showering them with personal and political allusions. Thus when actors inserted a ballad satirizing the Duke of Marlborough's

avarice in a performance of Farquhar's *The Recruiting Officer* in 1710, the audience turned the show into a public attack on the duke:

> The people are very bitter against the whole family, even the Duke himself, laughed prodigiously and bandied about monstrous insults, although Marlborough's daughter, the Duchess of Montagu, was herself at the play and was so greatly ashamed that she was coverd in blushes ... when the song was at an end, there was such a clapping and yelling that the actors were unable to proceed for nearly a quarter of an hour.

The opening performance of a politically controversial work like Addison's *Cato* (1713) was likely to be ridiculed or cheered by factions in the pit – catcalls, booing, whistles and groans being met by cheering and applause. Early in the century the Shakespearian scholar and critic Lewis Theobald complained that audiences 'sit stupidly listening for accidental expressions struck out of the Story, which speak the sense of their Principles and Perswasion. Such an Application of Passages is grown so epidemical, that a War of *Whig* and *Tory* is carried on by way of *Clap* and *Hiss*.'

Plays like John Gay's extraordinarily popular *The Beggar's Opera*, whose history I discuss in Chapter 11, were repeatedly performed partly because they lent themselves to topical political allusion, which the performers often provided in improvisations or elaborations on the play's text. The comedian Samuel Foote, for instance, made a career out of mimicking politicians, fashionable figures and recognizable 'types' in plays he wrote to show off these bravura performances. But more often than not the audience itself gave the performance its political resonance. It was not the players but the public who dubbed the unpopular politician Lord Sandwich 'Jemmy Twitcher', after the thief involved in the betrayal of the highwayman hero of *The Beggar's Opera*. This sort of allusion eluded the censorship that governments and moralists repeatedly tried to impose, requiring that theatres submit the text of plays before performing them: dramatic interpretation was shaped not on the written or printed page but by the play between performers and audience in the theatre.

Audience interventions during a performance included merciless bullying or cheerful support. In good humour they made performers repeat their favourite songs, dances and speeches. When the German

novelist Sophie von la Roche attended the Little Theatre in the Haymarket in the summer of 1786 she was struck by the boisterous reaction to a youthful actress:

> A twelve-year-old girl dressed as a poor boy who walks round with a bundle of rushes, straw and reeds to patch up old chairs, then really sits down to work on one, sang and played unusually well; indeed, was obliged to give two encores; the third time however, announced with dignity and candor that it would not be possible, and that she feared she might be unable to take her part the next day ... Everyone clapped and praised her aloud.

Less charitably, a bad play, an unpopular production, an out-of-favour actor or, most heinous of all, the presence of foreign players and singers could unleash a riot in which the performance was ended and the theatre wrecked. As I have mentioned, Garrick's *Chinese Festival* was driven from the stage. On another occasion at Drury Lane in January 1750 when the management proposed to repeat a play which the audience had driven from the stage the evening before, 'the Audience ... pull'd up the Benches, tore down the Kings Arms, and would have done more mischief if Mr. Lacy [Garrick's partner] had not gone into the Pit, and talk'd to 'em, what they resented was giving out a piece again after they had damn'd it.' *The Blackamoor Washed White*, a comic opera written by the notoriously quarrelsome and much-disliked journalist and cleric Henry Bate, suffered a similar fate in 1776. After four nights of opposition during which 'numbers of the pit and boxes got upon the stage and blows passed between some of them', Garrick was forced to withdraw the play. Such fracas occurred throughout the eighteenth century. Theatre historians calculate that London's two major theatres had to be totally redecorated at least once every decade because of damage caused by audiences.

The theatrical milieu – its politics, disorder, lewdness and vice – did not endear it to the authorities. Magistrates and clerics attacked the stage in print and used the law to ban plays and close theatres. But the theatres also had to deal with a higher power, the authority of central government or the crown: between 1642, when the parliamentary Puritans had closed the playhouses, and 1660, when Charles II was restored, there had been no legal public drama in England. Charles and his successors, regardless of their personal attachment to drama, wanted a regulated theatre that

offered no political challenge to their regimes. They most feared a theatre that was a hotbed of dissident politics (later they became equally concerned about public morality), and their preferred solution was to control the theatre directly, permitting only companies with a royal licence to perform and vetting their plays. This system of controls, though it collapsed in the 1730s, was powerfully reinforced by a Licensing Act of 1737, which remained in place into the nineteenth century. Not only did the act legitimate the prior censorship of plays but it restricted the number of theatres that could legally stage spoken drama. It was the strait-jacket every theatre manager had to wear.

A manager had to defend his theatre against moralists and reformers who wanted to shut him down; he needed to placate and win over a vociferous, active and opinionated theatre-going public; he had to deal with actors, actresses and patrons whose conduct might well compromise his work; and he had also to work within the system of legal controls imposed by the crown. Above all, the theatre had to turn a profit.

How, then, was this to be achieved when the theatre was evolving from a court institution shaped by the taste of the monarch and his followers and regulated by one of his officials, into a commercial business formed by the taste of a general public?

The Theatre, Power and Commerce

THE REOPENING OF the theatres in 1660 did not mark a return to the flourishing days of English Drama in the Elizabethan and Jacobean era. Charles II loved the theatre dearly (just as he dearly loved some of its performers), but he wanted it regulated and loyal, not encouraging of opposition or dissent. Though he did not revert to the enclosed, illusory theatrical realm of the palace masque, which had flourished in his father's court, neither did he choose to return to the situation a century before with many companies, large open-air theatres and audiences that included 'Water-men, Shoomakers, Butchers and Apprentices'. As in so many matters, Charles went for compromise. The elaborate court masques were replaced by plays performed on stages in London, but theatre in the town was restricted to companies under royal control, whose performances catered to the tastes of courtiers rather than citizens.

The theatre was regulated in two ways: the right to perform was restricted to those to whom the crown granted patents or licences, and the content of performance was subject to the approval of a royal servant, the Master of the Revels. This system remained in place for more than a century, though its forms changed and its levels of enforcement fluctuated. The patent system survived in law until the Theatre Regulation Act of 1843, which ended such restrictions but retained censorship, though it had largely died in practice some years earlier. The official approval of plays endured until the abolition of the Lord Chamberlain's authority in the liberal 1960s.

The regulations that governed the Restoration stage were part of the king's prerogative powers, so their enforcement depended upon neither parliament nor the common law but upon the interest that the monarch took in the stage. From the first, Charles II was active in shaping the theatre. Not content with going to plays and playing with the players,

he became the most active royal theatrical patron since Elizabeth I, recommending works for translation and adaptation, and commissioning a whole series of plays, including many comedies and the first rhymed heroic play in English.

In 1662 and 1663 Charles II conferred patents on two courtiers, Sir William Davenant (the Duke's Company, named after his brother, the Duke of York) and Thomas Killigrew (the King's Company), granting them a monopoly of theatrical production. Both were being rewarded for their loyalty to the royalist cause during the years of Charles's exile, and they stood to make a tidy profit from their sovereign's grant. Davenant, a poet and dramatist, claimed Shakespeare as his godfather, was rumoured to be his illegitimate son, succeeded Ben Jonson as poet laureate in 1638, and had been granted a theatrical patent by Charles I in the following year. Killigrew was a courtier playwright, a rake and a close friend of the king's. Though less experienced in the theatre, he received performance rights to most of England's older plays, including the works of Beaumont and Fletcher, and employed a company of players some of whom had acted before the Civil War. Davenant's company was younger and had a smaller repertoire, which included his own work and a number of Shakespeare plays – *Hamlet*, *Romeo and Juliet*, *Twelfth Night*, *King Henry VIII*, *Macbeth* and *The Tempest* in its Dryden–Davenant adaptation as an opera.

Charles's shrewd act of benevolence ensured that the theatre remained within the purview of his court, but he was not always faithful to his two companies (though was he ever faithful to anyone?). Between 1660 and 1663 he conferred a royal licence to perform plays in London on the actor George Jolly, and this temporarily infringed the Killigrew and Davenant monopoly. Still, the king on the whole guarded their privilege and even defended them in their disputes with his own servant, the Master of the Revels. Indeed, in Charles's reign the power of the Master of the Revels was severely curtailed. When the patentees agreed with the Master in 1662 after more than two years of squabbling and litigation, they promised to pay him performance fees; in return he relinquished his licensing powers. This meant that the two theatres avoided prior censorship but, since only two royal companies were permitted, Charles ensured that the content of the repertory was broadly in line with court taste. The Master of the Revels intervened occasionally to alter or ban plays, but only at the urging or with the approval of the king.

Thus did the court dominate the theatre throughout Charles's reign. At no time in British history have so many playwrights been drawn from the ranks of the aristocracy and gentry. Two dukes – Newcastle and Buckingham – several earls, including Orrery and Bristol, and a smattering of knights like Robert Howard, Samuel Tuke, George Etherege and Charles Sedley wrote or co-authored popular plays, some of enduring quality. Spanish 'intrigue' dramas, whose lively heroines offered good roles for women who were for the first time permitted on the stage; French comedy, most notably adaptations or translations of Molière's works; heroic plays in rhyming couplets with elaborate sets that drew on French staging as well as the tradition of early seventeenth-century court masques – all these Restoration fashions, though some had English antecedents, had been shaped during the royalist exile in Europe and were vigorously supported by the king and his followers on their return to power.

The values of the Restoration stage were those of the court. Its heroic dramas celebrated an idealized kingship to which Charles II aspired; the early comedies, like John Tatham's *The Rump* which was later refurbished by Aphra Behn as *The Roundheads* (1681), put the Puritans in their place; its semi-operas, notably the Dryden–Davenant version of Shakespeare's *The Tempest*, offered spectacles reminiscent of Inigo Jones's masques; and many Restoration plots, avoiding simple resolution and happy endings, expressed a clear-eyed scepticism about fallible human nature, moral complexity and the persistence of conflict between the classes and the sexes. The stage mirrored the court in acts of concealment, deception and intrigue, in admiration of grand effects as well as of wit and lively conversation, in a willingness to admit strong female characters, whether amorous widows, adulterous wives or young women of spirit, like Harriet in Etherege's *The Man of Mode* (1676), and in sexual licence – best exemplified by one of Charles's favourites, Tom Duffey's *A Fond Husband* (1677).

The theatrical audience was no more homogeneous than the plays it watched. More and more patrons came from outside the charmed circles of Whitehall, especially towards the end of Charles's reign, but this was of little consequence. What mattered was the courtly ethos, which remained largely unaltered until it was shattered by the political crises of the 1680s.

From the beginnings of the Exclusion Crisis in 1679 until the

accession of George I in 1714, the theatre was in an almost constant state of upheaval. Politics made the stage more dangerous and less fashionable, and events in the 1680s – the emergence of party divisions, plots and rebellions, and the overthrow of James II in 1688 – rendered tragedy, whose plots lent themselves to contemporary allusions, prone to censorship and suppression. Charles and his courtiers paid less attention to the theatre and more to politics as they struggled with their Whig foes; the threat of assassination kept Charles out of public places.

After Charles's death in 1685 no succeeding monarch offered comparable support to the stage. His successor, James, had more pressing matters on his mind; William and Mary and then Queen Anne had no particular appetite for the theatre. They were publicly reclusive by the standards of Charles and of other European monarchs, and they sympathized with critics who thought the stage immoral and licentious. The theatre became less popular: as its court supporters drifted away it ceased to be the most conspicuous playground for fashionable society but also failed to find a new clientele. Without a royal patron or the court's protective environment, the theatre was exposed to hostile critics and the exceptionally chilly economic climate of the 1690s.

The system of courtier patentees began to fall apart. Killigrew's less well managed company folded, and merged with Davenant's to form the United Company in 1682, which for the next thirteen years was the only operative London theatre company. In 1693 a shrewd lawyer, Christopher Rich, acquired control of the surviving patent from Sir William Davenant's disreputable and insolvent son. A courtier patentee was replaced by a businessman with no direct knowledge of the stage but a great deal of interest in its profits. From the beginning Rich was deeply distrusted by actors, who viewed him as an ignorant upstart: 'an old snarling Lawyer Master and Sovereign; a waspish, ignorant, pettifogger in Law and Poetry; one who understands Poetry no more than Algebra', as one critic put it. He may not have been the ogre painted in the actor-manager Colley Cibber's autobiographical *Apology* – 'as sly a Tyrant as ever was at the Head of a Theatre; for he gave the Actors more Liberty, and fewer Days Pay, than any of his Predecessors' – but his ignorance of the stage made it easy for actors to brand him as venal and self-serving.

Rich had secured his power by accumulating shares in the royal patent, which were sold as a way of raising money for the theatre and

to ease the financial needs of the patentees, but this practice converted a part of the royal prerogative into a commodity, bought and sold like a share in any other company. Rich thought he had acquired a monopoly along with the patent, but he was wrong. His sharp practices and tough dealings with his employees produced a walk-out led by the most famous actor of the day, Thomas Betterton. The rebels of Drury Lane had friends at court, and they secured a temporary licence to set up a rival company. In 1695 Betterton's cooperative of players opened at the theatre in Lincoln's Inn Fields and a ferocious theatrical war ensued.

The rivalry between Rich and the renegade actors was compounded by other developments. In 1704 the architect and playwright Sir John Vanbrugh opened a new theatre, the Queen's, in the Haymarket, with the help of his friends in the Kit-Cat Club, and offered it to Betterton and his allies. In effect Vanbrugh and his partner, the playwright William Congreve, acquired the licence of the actors' company in return for giving them a new theatre, on which they could stage larger, more lavish productions before bigger audiences. This new alliance renewed the theatrical war against Rich, and both sides spent more and more on productions.

Over the next decade (1705 to 1715) no fewer than eight managerial changes occurred in the London theatre. The quarrel divided actors and singers, foreign stars and domestic performers, different shareholders in the patents and licences as well as the two companies. Eventually Congreve and Vanbrugh abandoned the struggle – too much money was being lost on all sides – and the Lord Chamberlain closed Rich's theatre. This was a war with no victors.

Meanwhile support for the theatre was declining. In the six seasons between 1697 and 1703 seventy new plays failed, including Nicholas Rowe's *The Fair Penitent* (1703) and Cibber's version of Shakespeare's *Richard III* (1700), which subsequently enjoyed great success. The old went the way of the new, and the Restoration repertory of modern tragedy and witty bawdry was dropped. Yet the picture was not totally bleak, for many of the great staples of eighteenth-century performance first appeared during these years of theatrical hardship. Major works by Congreve, Centlivre, Cibber, Vanbrugh and George Farquhar, all produced in this period, were repeatedly performed for the rest of the century. It is tempting to say that the theatre and its repertory had not yet adapted to changes in public taste, but it also seems that public taste

had not yet caught up with changes on the stage. In the lean years plays were produced that were to run and run in the commercial theatre.

In the fiercely competitive climate of a newly commercialized theatre, rival managers began to offer their patrons a more varied evening's entertainment. The German traveller Zacharius Conrad von Uffenbach, visiting Drury Lane in 1710, was struck by the range of diversions that accompanied Charles Shadwell's new comedy, *The Fair Quaker of Deal*:

> Between every act they introduced several dances for variety ... [Mrs Sandlow] danced charmingly as Harlequin, which suits her excellency and much pleases the English ... After her a man appeared as Scaramouche, but he was far from being as elegant a dancer, though he excells in droll attitudes, leaping and contortions of the body, in which I never saw his equal ... Finally a person with a horse, who was dressed as a mountebank or gipsy, came on to the stage and sang very well a long song, which was much clapped by the English.

Such entr'acte entertainment was not new. The Restoration theatre had often included dancing and instrumental music between acts, as well as the occasional song. But now play-goers were offered greater variety, and the afterpiece became a frequent though not yet regular item on the playbill. The desire to attract custom encouraged varieties of every sort: French dancing, Italian *commedia dell'arte*, tumblers and acrobats, rope dancing and farce. At Drury Lane on 22 August 1702, for instance, the audience saw Richard Brome's early seventeenth-century satire, *The Joviall Crew*, along with a

> Dance between Two Frenchmen and two Frenchwomen. Night Scene by a Harlequin and a Scaramouche, after the Italian manner, by Serene and another person lately arrived in England ... [as well as entertainment by] ... the famous Mr Clench of Barnet, who will perform an Organ with 3 Voices, the double Curtell, the Flute, and the Bells with the Mouth; the Huntsman, the Hounds and the Pack of Dogs. With Vaulting on the Horse.

With the competition between the two spoken-drama companies after John Rich opened Lincoln's Inn Fields in 1714, the afterpiece came into

134. *Shakespear, Rowe, Jonson, Now are Quite Undone/These are thy Tryumphs, Thy Exploits O Lun! (Harlequin Helping Punch to Kick Apollo)* by G. Van der Gucht

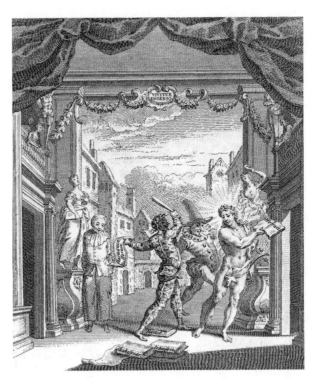

its own. Within a few seasons about a third of Rich's evenings included an afterpiece; in the 1720s the success of two pantomimes, *Harlequin Doctor Faustus* at Drury Lane and *The Necromancer; or, Harlequin Doctor Faustus* at Lincoln's Inn Fields, entrenched the afterpiece as part of the eighteenth-century repertory. Combining music, dance, brilliant costume and special staging and effects, these pieces were designed to appeal to the ear and the eye (fig. 134).

The afterpieces challenged straight plays, and so, too, did the second and most controversial innovation of this period, the Italian opera. The first London performance of an opera in the Italian style was a pastiche by Thomas Clayton entitled *Arsinoe, Queen of Cypress*, sung in English at Drury Lane in 1705. Within a few years Italian opera had become all the rage, replacing plays as the preoccupation of the court and fashionable society. By 1711, when Handel's opera *Rinaldo* was first performed – in an elaborate staging that included the release of a flock of sparrows and finches which later much discomforted the audience – Italian opera sung

in its original language by Italian stars such as the castrato Nicolini was well established.

The elaborate settings, the public spectacle, the novel Italian singers created enormous interest, especially among the rich and aristocratic. Moreover the opera was not just a new fashion to rival drama; it transformed the theatrical repertory, leading managers to mount rival musical productions. In the 1716–17 season, for instance, there were thirty-one opera performances mounted by the impresario J. J. Heidegger at the King's Theatre in the Haymarket; at the same time Rich staged thirty-six performances of operas (albeit in English and without Italian stars) at Lincoln's Inn Fields, some of them semi-operas, all sung in the new Italian style.

In continental Europe most operas were financed by courts and princes. A ruler dug deep into his pockets and wrote off the cost as another item on the balance sheet of princely conspicuous consumption. But this was not true in Britain, at least until the establishment in 1719 of the Royal Academy of Music, the closest that Britain came to direct royal subsidy. The Academy was not a school or a society of performers but a joint-stock company under royal charter created to promote opera, to which George I gave £1,000 and the company raised £15,000. Masquerading as a business, it was also a courtly institution. The 'governor' of the Academy was the Lord Chamberlain, who had a veto on all matters of policy. A survey of directors of the Academy in the 1720s has shown that several were ministers and ambassadors, even more were government officials, and that almost half held posts in the royal household, particularly in the bedchamber of the king. The Academy was George I's pet project. He showed no interest in subsidizing spoken drama but was happy to pay for Italian opera, especially the works of the composer he most admired, George Frideric Handel.

Artistically the Academy opera was a tremendous success. Handel was its musical director, and in the castrato Senesino (Francesco Bernardi) and the two sopranos Francesca Cuzzoni (fig. 135) and Faustina Bordoni it had three leading European singers. Handel and his rival, Giovanni Bononcini, who was brought from Rome to compose for the Academy, created most of the repertory. No native English composer's works were performed, and most of the works were *opera seria*, heroic classical tales of moral import which included Handel's *Giulio Cesare in Egitto*, *Tamerlano* (both in 1724) and *Riccardo Primo* (1727), a homage to the

new king, George II. This was court opera as it was supposed to be.

Despite its standing as the latest craze about town, Italian opera did not make money. The costs of mounting new productions were enormous and the fees commanded by the best Italian singers were crippling. Nicolini, the first Italian castrato to become an English star, was paid ·800 guineas a season, plus the receipts of a benefit. And opera was not only expensive but exclusive. Patrons paid half a guinea for a ticket and five shillings for the gallery; boxes could only be rented for additional fees. But still, managers rolled from one financial crisis to the next. Opera then, as today, could not survive without a subsidy. And, as the fluctuating fortunes of the Royal Academy and its successors demonstrated, even then its finances were extremely precarious.

Opera's success had a profound effect on the London music scene. Before its arrival, music was not a conspicuous or fashionable recreation. It played an important role in several aspects of public life but was normally an adjunct of some other activity. Concert performances where an audience gathered solely for the pleasure of hearing music were rare. Music was played in the theatre as a part of a dramatic

135. *Cuzzoni with Farinelli and Heidegger* by Dorothy, Countess Burlington, *c.* 1730

performance; at court as part of the rituals of kingship; in some but by no means all churches as part of the liturgy; and convivially in taverns and coffee houses.

Most music was played informally in clubs and societies made up of amateur enthusiasts. Inns and taverns, like the Crown and Anchor in Arundel Street, had public rooms that could be hired for concerts where amateur groups, perhaps 'stiffened' with a professional or two, met every week or month to play, drink and eat together. Ned Ward, a chronicler of London tavern life, describes a visit to one such tavern, 'a famous Amphibious House of Entertainment' in Wapping, 'half *Tavern* and t'other *Musick-House* . . . we no sooner enter'd the House, but we heard *Fidlers* and *Hoitboys* [sic], together with a Humdrum *Organ*, make such incomparable Musick'. Though many of these groups were socially exclusive – the Castle Society at the Castle Tavern on Paternoster Row excluded 'vintners, victuallers, keepers of coffee houses, tailors, peruke makers, barbers, journeymen and apprentices' – humbler taverns and ale houses had musical clubs in the city, Spitalfields and the suburbs, charging sixpenny admission to artisans and weavers.

These lively tavern and ale house societies, in which performers and listeners were barely distinguishable, mounted occasional concerts, notably on the Day of St Cecilia, the patron saint of music, and sometimes permitted outside guests. The music they played was similar to the repertory heard in London's few public concerts, such as those at the theatre in Lincoln's Inn Fields and at York Buildings in Villiers Street; they played baroque music from Italy, notably that of Corelli and his followers, a taste that was largely reflected in the teaching manuals and scores published by the London music-sellers. There were amateur fiddlers in Westminster and Wapping, choral groups centred around churches and clubs, and a few professional musicians, including Italians, who staged occasional concerts and taught affluent amateur pupils. But music had no major public forum outside the court and the church, and was not the first topic of fashionable conversation until the opera arrived – after which the situation changed radically.

Developments between 1690 and 1720 – the loss of royal patronage, changes in taste and moral climate, the fashionable challenge of opera and growing commercialism – produced a bellicose debate about the nature of British theatre. After the Glorious Revolution of 1688 the licentious Restoration repertory had come under bitter attack from such

moralists as Jeremy Collier, whose *A Short View of the Immorality and Profaneness of the English Stage* (1698) began a running debate about how to purge the repertory of ambiguous and amoral comedy. Collier complained that 'The Stage-Poets make their Principal Persons Vitious, and reward them at the End of the Play' – and wanted to replace amoral humour with highminded neo-classical tragedy. At the same time playwrights, critics and actors inveighed against the new elements of 'sound and show' that they felt debased the stage into a place of vulgar entertainment, and replaced instructive, refined language with an undisguised appeal to the senses. Authors feared that written drama was being displaced from the centre of theatrical performance by music, special effects, fairground entertainments, and all forms of what Aristotle had taught critics to see as the lowest form of drama, spectacle. As Richard Steele complained in the prologue to his first comedy, *The Funeral* (1701):

> Nature's deserted, and dramatic art,
> To dazzle now the eye, has left the heart;
> Gay lights and dresses, long extended scenes,
> Demons and angels moving in machines,
> All that can now, or please, or fright the fair,
> May be performed without a writer's care,
> And is the skill of carpenter, not player.

The playwrights and critics blamed the impresarios for this lack of public taste. Commercially minded managers, they thought, had converted a serious medium into a tawdry popular festival. Alexander Pope and his arch-enemy the critic John Dennis were agreed that the drama had been betrayed by the likes of John Rich, Colley Cibber and William Penkethman, who had succeeded in introducing 'the lowest diversions of the rabble at Smithfield to be the entertainment of the town', creating an audience which 'could never attain to any higher entertainment than Tumbling and Vaulting and Ladder dancing, and the delightful diversions of Jack Pudding'. Actors were similarly disgruntled. As one wrote from Drury Lane to a friend in the country in 1706:

> the two sisters, Music and Poetry, quarrel like two fishwives at Billingsgate ... Though Farquhar meets with success, and has the entire happiness of pleasing the upper gallery, Betterton and Wilks, Ben Jonson and the best of them, must give place to a bawling Italian woman, whose voice to me is less pleasing than merry-

andrew's playing on the gridiron. 'The Mourning Bride,' 'Plain
Dealer,' 'Volpone,' or 'Tamerlane,' will hardly fetch us a tolerable
audience, unless we stuff the bills with long entertainments of
dances, songs, scaramouched entries, and what not.

The greater fear, expressed in works like John Dennis's *An Essay on the
Operas after the Italian Manner* (1706), was that opera would sweep all
before it. Pantomimes and afterpieces were condemned as tawdry, spec-
tacular or vulgar, but they were a mere supplement to the main drama;
they did not seem greatly to depart from the conventions of the Restor-
ation stage, with its frequent musical interludes and songs and occasional
semi-operas by the likes of Henry Purcell. Opera, on the other hand,
truly challenged the dramatic power of the spoken word. Its complete
integration of libretto, music and spectacle threatened to displace spoken
drama as the main public recreation of fashionable society. Opera epitom-
ized the threat to drama because it was the most modish and aristocratic
musical form – 'it is not the Taste of the Rabble, but of Persons of the
Greatest Politeness'.
 The counter-attack of the actors, playwrights and critics came swiftly.
In 1711 the *Spectator* of Addison and Steele, playwrights of tragedy and
comedy, attacked opera as 'extravagantly lavish in its Decorations, as its
only Design is to gratify the Senses, and keep up an indolent Attention
in the Audience'. 'Common Sense', they added, 'requires, that there
should be nothing in the Scenes and Machines which may appear Childish
and Absurd', before going on to list the palpable absurdities of the
operatic condition. This assault on the 'false Taste the Town is in' was
repeated unrelentingly. Opera was artificial and contrived, a spectacular
performance that appealed to the senses but not to the mind. It harmed
playwrights and left players dumb. It was unnatural and above all foreign,
a luxurious import, a sign of modern luxury. They complained about
the tawdry effects – 'a Sea of Paste-Board' – grandiose pretensions,
'tedious Circumlocutions', mock-heroism and 'forced Thoughts, cold
Conceits, and unnatural Expressions'. And they claimed that opera's
language and sense was untranslatable into plain English, comparing it
to such mindless exhibitions as displays of dancing monkeys, puppet
shows and the exhibition of lions. They blamed it for the death of tragedy
and fulminated about its humiliation of English actors, reduced to playing
mute furniture props. In a mock letter 'William Screne' writes to the

Spectator, 'I have acted several Parts of Household-stuff with great Applause ... I am one of the Men in the Hangings in the *Emperor of the Moon*; I have twice performed a third Chair in an *English Opera*; and I have rehearsed the Pump in the *Fortune Hunters*.' 'Musick is certainly a very agreeable Entertainment,' wrote Addison in the *Spectator* No. 18, 'but if it would take the entire Possession of our Ears, if it would make us incapable of hearing Sense, if it would exclude Arts that have a much greater Tendency to the Refinement of Human Nature; I must confess I would allow it no better Quarter than *Plato* has done, who banishes it out of his Common-wealth.' Addison began by attacking opera, but soon slipped into criticizing music as a whole.

Like other new types of performance opera was often attacked as foreign – similar accusations were levelled against pantomimes, spectacles and afterpieces – because they were frequently based on Italian *commedia dell'arte*, used foreign dancers and fancy scenes and had no spoken parts. Critics of opera contrasted its alien sounds to English spoken drama, which was intelligible, virtuous and instructive. Supporting the latter was patriotic; one virtue of English dramatists was that they expressed English values. If opera was a gaudily dressed, showy foreigner, drama came in sober or witty native garb. The point was made repeatedly but never better than in William Hogarth's *Masquerades and Operas*, a print published in February 1724 and called in the newspapers 'The Bad Taste of the Town' (fig. 136). A crowd of masqued and costumed revellers are led by a fool and devil into the opera house on the left; opposite, a genteel crowd pushes its way into the Lincoln's Inn Fields Theatre on the right to see Rich's hit pantomime, *The Necromancer; or, Harlequin Doctor Faustus*; behind them three more isolated and aristocratic figures admire the Italianate gateway to Burlington House. In the centre foreground a rustic figure with a staff scratches his head with bemusement at the fashionable scene, while a wheelbarrow passes by, pushed by a street seller crying, 'Waste paper for Shops!' and filled with the plays of Shakespeare, Dryden and Ben Jonson. The caption of the original print reads:

> Could new dumb *Faustus*, to reform the Age,
> Conjure up *Shakespear's* or *Ben Jonson's* Ghost,
> They'd blush for shame, to see the *English Stage*
> Debauch'd by fool'ries, at so great a cost.
> What would their *Manes* say? should they behold

Monsters and *Masquerades*, where usefull Plays
Adorn'd the fruitfull *Theatre* of old,
And Rival Wits contended for the *Bays.*

Hogarth's print is dense with allusion. He links opera with aristocratic masquerades by depicting the ugly figure of J. J. Heidegger leaning from an opera house window. Heidegger's productions at the King's Theatre in the Haymarket included, as the sign marked 'Faux' indicates, performances by the conjuror and magician Isaac Fawkes. The reference to Lord Burlington, the most vigorous supporter of Italian taste after his return from the Grand Tour in 1715, is both a general critique of aristocratic taste – for Palladian architecture, foreign artists and the opera, of which Burlington was a major patron – and a more personal attack on the protector of the artist and designer William Kent, the rival of Hogarth's future father-in-law, the painter James Thornhill.

Hogarth's print caught the imagination of the public. It sold quickly, was copied and then pirated in a cheaper version by a printseller named Thomas Bowles, praised in the papers and approvingly alluded to on the stage. It captured a popular sentiment, inflamed by the patriot and opposition satirists of the 1720s and 1730s and repeated for the rest of the century, which contrasted native plays with foreign music, English 'sense' with foreign 'nonsense', and patriotic moral instruction and entertainment with foreign frivolities and luxury. Because the early Hanoverians were such strong supporters of opera, this sentiment had a sharp political edge; many of the opponents of Italian opera and supporters of native spoken drama – epitomized by the works of Shakespeare – were opponents of the Whig regime. Yet the larger issue transcended party politics: Italian opera exemplified what British drama should avoid. And opera itself could only shed its stigma if it managed to conceal its Italian sources and origins.

Only four years after the appearance of Hogarth's print the Academy opera folded and John Gay's *The Beggar's Opera*, a topical English musical satire staged by John Rich at Lincoln's Inn Fields during 1728, became the talking point of the chattering classes. Gay, a friend of Pope and Swift who had had little literary success and lost what money he had during the financial crash of the South Sea Bubble in 1720, combined ballads, snatches of operatic arias, a love story and tales of crime and betrayal to create a brilliant satire on the depravity of politicians, the

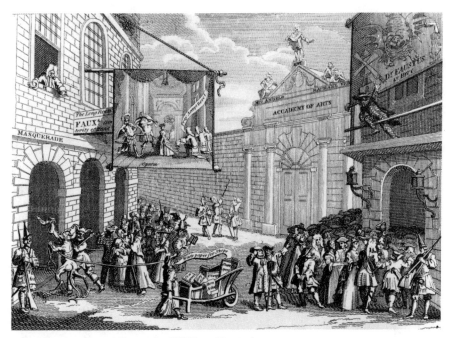

136. *Masquerades and Operas* by William Hogarth, 1724

absurdity of Italian opera and the venality of Hanoverian society. We have to leave a full discussion of *The Beggar's Opera*'s appeal – based on an exceptionally skilled manipulation of the audience's interest in crime, politics and musical controversy – to a later chapter. But, though we cannot say whether this musical pastiche, with its mockery of operatic conventions, contributed to the demise of the Italian opera, it is clear that *The Beggar's Opera* epitomized a trend which was to be found in many cultural forms of the time: the deliberate mixing of genres from high and low culture – what else was a ballad opera? – the creation of art works whose chief features were their topical reference to current issues and their preference for variety of expression rather than formal unity or coherence. Earlier works had often displayed one or more of these elements, but the success of *The Beggar's Opera* with an audience that ranged from peers to artisans made clear that works of pastiche and variety could be both fashionable and popular. Many ballad operas during the next decade imitated *The Beggar's Opera*, and though they were never able to match Gay's success, the enthusiasm for the values they

represented showed that the most fertile cultural opportunities lay in the territory between high and low life, between popular and elite forms.

Gay's ballad opera heralded an extraordinary decade in the history of the English theatre as government controls collapsed, the Lord Chamberlain failed in his attempt to prosecute unlicensed theatres, and a torrent of new music and drama was unleashed, revealing what an unregulated London theatre was able to offer. Rich had opened a larger theatre in Lincoln's Inn Fields in 1714, John Potter had built the Little Theatre in the Haymarket in 1720 and the gentleman dramatist Aaron Hill made plans to start a company there in 1721, but it needed a success like *The Beggar's Opera* to transform the scene. Within two years another theatre had opened up to the east of the city in Goodman's Fields near the Tower of London, and the Little Theatre at the Haymarket, used chiefly by foreign actors and visiting troupes, was offering a full season that included a number of new plays, among them a pirated *The Beggar's Opera*. The repertory of the 'Great Moguls Company of Comedians' at the Little Theatre was dominated by performances of scathing satires by Henry Fielding, including *The Author's Farce*, *Rape upon Rape*, *Tom Thumb*, and *The Grub Street Opera*. These dramatic initiatives affected the patent theatres at Drury Lane and Lincoln's Inn Fields, which responded to their rivals' innovative repertory with an unprecedented number of new plays.

Most new plays were full of topical political allusions, a practice that reached a peak in the 1736–7 season. Robert Dodsley's egalitarian *The King and the Miller of Mansfield*, Francis Lynch's *Independent Patriot*, William Havard's specially commissioned work on 'majesty misled', *The Tragedy of King Charles I*, and Fielding's *The Historical Register* referred, more or less explicitly, to the influence of the prime minister, Robert Walpole, over the king, to the rift between George II and his heir, Frederick, Prince of Wales, and to the corrupt state of national politics.

In 1732 John Rich opened a new theatre at Covent Garden, and the converted commercial premises at Goodman's Fields were replaced by a custom-built theatre. At least two other proposals to build an additional theatre were floated in the London press. By 1736 Rich was so confident about the growing audience for drama that he was prepared to let his now little-used theatre in Lincoln's Inn Fields to a rival company. If Rich, known for his caution, was prepared to take such a risk, the outlook must have been exceptionally good.

At the same time important changes were taking place in the musical world. Though opera continued to be performed in the 1730s, it suffered from internecine rivalries – Handel's opera was locked in a struggle with a rival opera company, the Opera of the Nobility, between 1733 and 1737 – from 'the vile taste of the town', which preferred ballad opera, and from other musical offerings such as 'subscription concerts and private parties' as well as in the newly opened pleasure gardens. The opera war was cripplingly expensive: throughout these years the newspapers were full of rumours of impending bankruptcy, and in its final season the Opera of the Nobility, which had brought the castrato Carlo Broschi (known as Farinelli) to London for a fee of £1,500 a year, was said to have lost £12,000, while Handel was £10,000 out of pocket.

The way of the future was set by the first of Handel's oratorios, *Esther*, performed at the Crown and Anchor Tavern and then in the King's Theatre, Haymarket, in 1732. Yet, despite being urged by friends to 'deliver us from our *Italian bondage*; and demonstrate, that *English is soft enough for Opera*', Handel was extremely reluctant to turn his back on Italian opera, and abandoned it only after 1741 and the failure of *Deidamia* at the Lincoln's Inn Fields Theatre. Indeed it needed the success of a series of oratorios in Dublin – including the first performance of the *Messiah* – during the 1742 season to convince him that his future lay with oratorios in English using native singers. For the next ten years, until he lost his sight shortly after the first performance of *Jephtha*, Handel produced an astonishing repertory of oratorios, including *Samson* (1743), *Semele* and *Joseph and His Brethren* (1744), four martial works composed in the heat of war and the Jacobite Rebellion – *Occasional Oratorio* (1746), *Judas Maccabaeus* (1747), *Joshua* and *Alexander Balus* (both 1748) – *Solomon*, a paean to the Hanoverian regime, and the pious *Theodora*, first performed in 1750.

Other composers tried their hand at oratorios – William Defesch's *Judith* (1732) and Niccolò Porpora's *Davide e Bersabea* (1734) were offered as counter-attractions by Handel's rivals, and a number of English composers, including Maurice Greene, William Boyce, John Christopher Smith and Thomas Arne, composed oratorios on biblical themes – but the form became Handel's special property. Staged in the London theatres and, after 1745, open to all individuals and not just subscribers, offered to the public at prices between 10/6d. and 3/6d. (which was a little cheaper than the opera though more expensive than spoken drama), oratorios

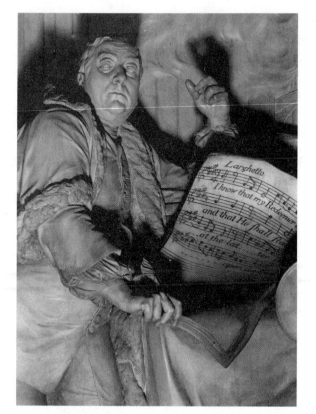

137. Handel's funerary
monument by Louis
François Roubiliac

were usually performed on Wednesdays and Fridays during Lent, when
there were no other entertainments to rival them. They combined piety
and entertainment, fine music with English texts sung by native per-
formers, transforming Handel from the presiding composer of foreign
music into a British national hero (fig 137).

Though there were some dissenting voices – 'the playhouse', wrote
one young woman, 'is an unfit place for such a solemn performance' –
most critics were delighted to hear works performed in English with
serious patriotic and religious themes. As Handel explained in a letter
published in the *Daily Advertiser* in 1745, 'As I perceived, that joining
good Sense and significant Words to Musick, was the best Method of
recommending *this* to an English Audience; I have directed my Studies
that way, and endeavour'd to shew, that the English Language, which
is so expressive of the sublimest Sentiments is the best adapted of any

to the full and solemn Kind of Music.' The words of his oratorios were taken from the Bible, classic British authors such as Milton (*Samson* and *Occasional Oratorio*), Dryden (*Semele*) and Spenser (*Occasional Oratorio*), or religious texts, such as *The Messiah*, written by the gentleman author Charles Jennens, or *Joseph and His Brethren*, penned by the Reverend James Miller. The religious and moral sentiments were ecumenical, designed to appeal to Anglicans and Dissenters alike.

By mid-century it was commonly argued that oratorios, unlike other sorts of entertainment, 'must necessarily have some effect in correcting or moderating at least the levity of the age'. Eliza Haywood, novelist and editor of the *Female Spectator*, maintained that they 'go a great Way in reforming an Age, which seems to be degenerating equally into an Irreverence for the Deity, and a Brutality of Behaviour to each other', and percipiently argued that oratorios should be performed throughout the nation.

The respectability of oratorios as an art form was reinforced by their frequent use as benefit concerts for charities. The receipts from the first performance of the *Messiah* in Dublin in 1742 were for 'Relief of the Prisoners of Several Gaols ... the Support of Mercer's Hospital, and of the Charitable Infirmary'. From 1750 annual concerts raised funds for the London Foundling Hospital, of which Handel was a governor. Oratorios, successfully combining pleasure with use, private entertainment with public utility, seemed the very antithesis of the frivolous Italian opera despite their employment of many Italian and operatic figures and forms.

Though Jacobites and anti-Hanoverians did not like the politics in his triumphal works of the 1740s, though lovers of the Italian opera condemned his desertion of the highest art for a more popular form, and though he was never without personal enemies, Handel had moved beyond the opera crowd and acquired a more popular audience. Operas were too difficult for amateurs to sing and too lavish for them to stage; oratorios, on the other hand, were within their powers. Though the passion for performing his works, especially the *Messiah, Judas Maccabaeus, Samson, Alexander's Feast* and *Acis and Galatea*, was greatest in the last half of the century, it had already begun before his death; as we shall see in Chapter 14, the Three Choirs festival – held at Gloucester, Hereford and Worcester – became the model for provincial musical festivals, at which Handel's works predominated.

In 1738 Jonathan Tyers had unveiled a life-size statue of Handel by

the relatively unknown young sculptor Roubiliac in his pleasure garden
at Vauxhall (fig. 138). The posture of the seated figure, lyre in hand, his
slipper falling from his foot, was strikingly informal. We do not know
what Handel thought of it, though he may well have been ambivalent
about its presence in a place of vulgar entertainment. Tyers's commission
was a bold and prescient move that seems to anticipate Handel's later
popular fame. This was the first public statue of a British artist, erected
in the composer's lifetime, commissioned by a cultural entrepreneur to
publicize and enhance the respectability of what was becoming one of
London's most popular sites of entertainment. Handel's statue presided
over what Tyers hoped would be orderly, innocent recreation. As a

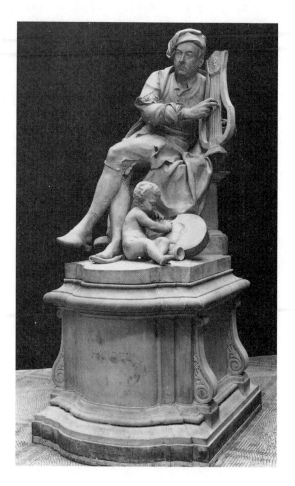

138. George Frideric
Handel by Louis François
Roubiliac, 1738

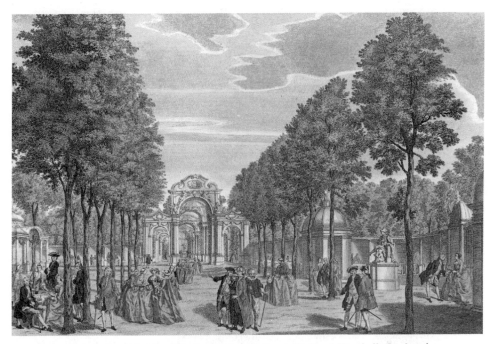

139. *Triumphal Arches, Mr Handel's Statue &c. in South Walk of Vauxhall Gardens* by Samuel Wale, engraved by John Gottard von Muller, 1751

newspaper puff put it, 'His harmony has so often charm'd even the greatest Crouds into the profoundest Calm and most decent Behaviour' (fig. 139).

Tyers chose Handel because music was one of the pleasure garden's main attractions. He had acquired Vauxhall in 1728, the year of *The Beggar's Opera*, and progressively remodelled the gardens. He wanted them to be an urban pastoral, a place of leisure and harmony, in which customers could stroll in the grounds while listening to instrumental and vocal music. But the pleasure gardens, a new kind of musical venue – informal, open-air, relaxed – were also slightly risqué since their alleys, supper boxes and dark corners offered opportunities for sexual intrigue (fig. 140). Their clientele was every bit as mixed as that of the theatre – 'the company is universal', as Horace Walpole put it – and was often equally exuberant.

The pleasure garden was in many ways a natural successor to *The Beggar's Opera*, a living embodiment of the play's values. It offered a mixed audience a variety of entertainments from opera arias to ballads

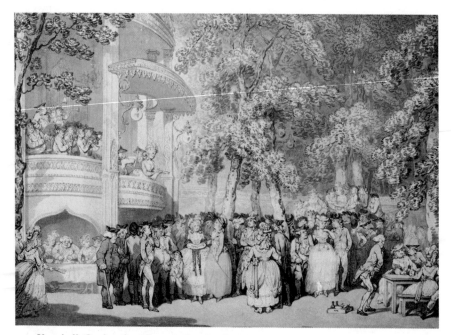

140. *Vauxhall Gardens* by Thomas Rowlandson, 1784

in a place where high and low life, respectability and intrigue could combine. Hence its rapid rise to fashion. Tyers's example was soon followed by other proprietors, who offered increasingly elaborate musical facilities in their gardens. Tyers had built a raised orchestra in the gardens in 1735 and installed an organ in 1737; song sheets of Vauxhall music were available from the printsellers (fig. 141). John Beard, a star singer of Handel's oratorios, was also a popular figure in concerts at Vauxhall. Marylebone Gardens and Cuper's Gardens, on the south side of the Thames, both installed organs and had regular concert programmes (fig. 142). The opening of Ranelagh Rotunda and Gardens in 1742, underwritten by a group of aristocratic investors, showed how fashionable and popular the pleasure garden had become.

There was no cheaper way of hearing professional musicians than at the pleasure gardens, and the proprietors, conscious of the mixed nature of their clientele, encouraged a varied repertoire. At Cuper's Gardens in 1741 an evening concert began with the overture and some choruses from Handel's oratorio *Saul*, followed by an organ concerto by Henry Burgess, the harpsichordist at the Drury Lane Theatre. Handel's

fifth concerto grosso, two concertos by Johann Hasse – one for French horn, the other for oboe – Corelli's eighth concerto, a number of songs by Thomas Arne and a piece entitled 'Port Bello' ascribed to Handel made up the rest of a long concert.

The programme, typical in including vocal and instrumental pieces, is characteristic of mid-century English taste. It includes Corelli's concerto, a traditional work of a slightly earlier time and extracts from a recent oratorio (*Saul* had first been performed in 1739). Two concerti from Hasse add a lighter *galant* style; a patriotic piece that celebrates Admiral Vernon's capture of Portobello from the Spanish in 1739 (it was probably accompanied by fireworks for which Cuper's Gardens were famous). The programme is completed by songs by Thomas Arne, who wrote the music to James Thomson's 'Rule, Britannia!' and was the most successful song-writer of the day. This pattern was followed for the rest of the century – varied and eclectic programmes of solo songs, duets, glees and choruses, even an occasional opera, alternating with overtures, symphonies and concertos. The old and the new rubbed shoulders; there was much pastiche. Love songs and patriotic airs were especially popular, and their scores were widely disseminated in songbooks.

The pleasure gardens were notably the home of English music. Nearly all the players were English, though foreign stars like Mozart and Ignaz Pleyel made occasional appearances. English tenors were especially popular; the castrati associated with Italian opera hardly ever appeared. Almost every well-known English vocalist performed at Vauxhall, and many London composers, including Arne, J. C. Bach, Samuel Arnold and William Shield, wrote pieces especially for the gardens.

The increasing popularity of both the oratorio and the pleasure gardens is attributable to changes occurring in the wake of *The Beggar's Opera*. Together they helped to shape an indigenous British musical tradition, ostensibly separate from foreign, especially Italian, musical forms but in practice very dependent upon them. By the 1760s the performers and composers associated with the oratorio and the pleasure gardens were to make English stage musicals almost as popular as the spoken classics.

The changes that followed *The Beggar's Opera* occurred because it became clear that the Lord Chamberlain was powerless to stop them. Though he retained a great deal of power over the licensed theatres, if he chose to exercise it, it was unclear how he was to regulate theatres

141. *Song Sheet: Sung by Miss Stevenson at Vauxhall, 1757* engraved by B. Cole

142. *Song Sheet: Polly of the Plain. Sung by Mrs Chambers at Marybon Gardens*, engraved by B. Cole

like the Little Haymarket and Goodman's Fields, whose companies, offering new satirical plays, operated without a patent. The Lord Chamberlain tried threats and bluster. In 1730 he ordered the theatre at Goodman's Fields to stop performances 'as you will answer the contrary at your Peril'. The theatre was briefly closed but, on the advice of lawyers, then quickly reopened. It soon became apparent that the Lord Chamberlain had no means of carrying out his threats. He did not even try to challenge the Little Theatre in the Haymarket. As far as these companies were concerned, the Chamberlain was a toothless tiger.

The government then tried another tack. In 1731–2, with the help of Westminster magistrates, it began harassing the actors in the Little Theatre in the Haymarket, claiming that as unauthorized performers they were liable to arrest, whippings and hard labour under the Vagrancy Laws. Yet this initiative also failed in the courts. There seemed to be no legal constraint on the number of theatres, and it was unclear what action could be taken against the robust political commentary that came to fill the stage, apart from invoking libel laws.

Magistrates and city politicians – even though many of them were political opponents of the government – then took up the battle against the theatres. Their antipathy was moral rather than political. They had opposed the opening of the theatre at Goodman's Fields in 1729. They looked askance at the London theatre, though they just about tolerated it as long as it was confined to the corrupt West End; its presence in their midst they could not stomach. Goodman's Fields soon became like its West End counterparts. As Sir John Hawkins complained, 'its contiguity to the city, soon made it a place of great resort, and what was apprehended from the advertisement of plays to be exhibited in that quarter of the town soon followed: the adjacent houses became taverns, in name, but in truth they were houses of lewd resort.' Weavers and 'the industrious poor' were driven out by rising rents and replaced by brothelkeepers and criminals.

The powers in the city turned to parliament. In 1735 Sir John Barnard, a well-known city MP and opponent of the government, introduced a 'Bill to Restrain the Number of Playhouses', thereby triggering a lively public debate about the theatre and its value. A number of commentators, most notably Samuel Richardson, were in favour not only of restricting the number of theatres, but of establishing a board of censors, a body of the great and the good (such as today survives for the British cinema) which would monitor theatrical taste on behalf of the public. The bill received bipartisan support in parliament but when Walpole tried at the last minute to confine censorship powers to the Lord Chamberlain, the alliance between the predominantly oppositionist city MPs and the government broke down. Deadlock ensued; the bill failed.

Because theatrical managers knew that the failure of the 1735 legislation meant that they could act with virtual impunity, during the next two years more and more political and topical satires were produced. But the prim and the powerful did not give up, and the dramatists'

increasingly provocative conduct did not always best serve their cause.
In 1737 a new bill to regulate the theatre was introduced. In a *coup de
théâtre* worthy of the London stage Walpole produced a manuscript play,
The Golden Rump, and read its most scurrilous and scatological passages,
chiefly about George II's piles and flatulence, to a shocked House of
Commons (fig. 143). Even the strongest opponents of the bill 'were
ashamed that the Liberty of the Stage and Press should be prostituted
to such vile Purposes, and so much infamous Scurrility'. The bill quickly
became a new Licensing Law. Though Lord Chesterfield made a famous
speech against censorship in the House of Lords, there was almost no
resistance in parliament. The opposition press attacked the new law as
part of a general plan to destroy liberty of expression but was unable to
prevent its passage.

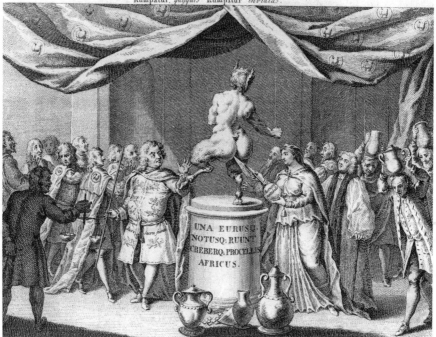

143. *The Festival of the Golden Rump*, 1737. A print based on the play. Walpole on the
left and Queen Caroline on the right worship the buttocks of George II, depicted as
a satyr

The powers conferred by the act were very considerable. All plays had to be submitted for censorship fourteen days before performance; the Lord Chamberlain could ban the performance of any play at any time, even if he had previously granted it a licence; playhouses required either a licence from the Lord Chamberlain or a patent from the monarch and were restricted to the city of Westminster; actors working outside the legal theatre were liable for arrest as vagrants. The system of prior censorship meant that the stage was more rigorously controlled than any other artistic medium. Authors of non-dramatic works could be prosecuted for seditious and obscene libel, graphic artists – usually the makers of satirical prints – were sometimes dragged through the courts, but only players were subject to *prior* censorship. The many corrections and deletions in surviving manuscripts of plays from the period submitted to the official examiner show the extent of state intervention. The government controlled what (and also where) a theatrical company could perform. The age of the licensed theatre had begun.

CHAPTER TEN

Performance for the Nation

THE LICENSING ACT of 1737 created a two-tier theatre in England, in which licensed plays were separated from all other sorts of performance. London's spoken drama was confined to two theatres for the rest of the century. But the proliferation of theatre companies and stages in the 1730s had shown a greater public demand for plays than could be met by two licensed companies. The new restrictions meant that the only way the public could be accommodated was by expanding the theatres, which was also the easiest way for the patentees to increase profits. Rich's Covent Garden, which originally held 1,335 people, was redesigned in 1782 and further expanded by Henry Holland in the 1790s to hold about 3,000 spectators. When it burned down in September 1808 it was replaced by a new building on an even larger site designed by Robert Smirke which had 2,800 seats as well as many private boxes. The Drury Lane Theatre, built by Christopher Wren in 1674 for an audience of less than 1,000, was redesigned by Robert Adam in 1775; in 1791 it was knocked down, and Henry Holland began work on a new auditorium with a capacity of 3,600 which opened three years later. In 1809, the year after Covent Garden burnt down, this Drury Lane Theatre also went up in flames. Its replacement, not completed until 1811, was yet another grand venue.

The bigger theatres of the 1790s would probably not have been built if an earlier, even grander scheme had not failed. In 1778 Thomas Harris, the patentee of Covent Garden, and the playwright and politician Richard Brinsley Sheridan, who had recently bought Garrick's patent at Drury Lane, jointly purchased the King's Theatre in the Haymarket; together, therefore, they controlled London's opera and theatre. In 1784 they launched a plan to develop a new site at Hyde Park Corner to consist of 'a Theatre with an adjoining Grand Rotunda with contigious [sic] lesser Rooms for Balls, Concerts, etc ... surrounded with gardens of

great Extent'. This complex would have combined the facilities of the theatre, concert hall and pleasure gardens, creating a major complex for the performing arts. But the plan, though it had been put to the Lord Chamberlain, was abandoned in 1791 for reasons that remain obscure, though they were probably connected to Sheridan's precarious finances.

Big auditoria were not popular. The travel writer John Byng was one of many who complained of Drury Lane that 'The nice discrimination of the actors' feelings are now all lost in the vast void of a new theatre'. Playwrights and critics thought the vast caverns detracted from the actors and the play. The actors struggled to make their performances accessible to the large, distant audience, and both new theatres underwent several alterations to improve their sight-lines and acoustics. The dramatist Richard Cumberland's comments were echoed by many others:

> Since the stages of Drury Lane and Covent Garden had been so enlarged in their dimensions as to be henceforward theatres for spectators rather than playhouses for hearers, it is hardly to be wondered at if managers and directors encourage those represen-tations, to which their structure is best adapted. The splendor of the scene, the ingenuity of the machinist and the rich display of dresses, aided by the captivating charms of the music, now in great degree supersede the labours of the poet. There can be nothing very gratifying in watching the movement of an actor's lips when we cannot hear the words that proceed from them, but when the ani-mating march strikes up, and the stage lays open its recesses to the depth of a hundred feet for the procession to advance, even the most distant spectator can enjoy his shilling's worth of show.

It was even claimed that the somewhat more declamatory and posed neo-classical style of acting – made famous at the end of the century by John Philip Kemble and his sister, Sarah Siddons – was in part a way of projecting the performance to these larger and more distant audiences.

The privilege of the exclusive right to perform spoken drama was a valuable asset and, not surprisingly, many who were not patentees tried to appropriate it. The Licensing Act did not apply to purely musical performances, nor did it cover free, private dramatic performances. Man-agers and impresarios wishing to attack the Licensing Act's duopoly exploited these provisions: the theatre at Goodman's Fields reopened briefly in 1740–42, claiming to charge a fee solely for the music and

to offer the play gratis. Charles Macklin and Theophilus Cibber tried similar tactics, charging for music, refreshments and even, in one case, snuff, while also inviting the public to enjoy a rehearsal, lecture or school demonstration of the dramatic arts. But the authorities would not tolerate these ruses and in almost every case they acted swiftly to stop performances.

The duopoly of the theatres was modified in 1766, when the comedian Samuel Foote was granted a patent to stage drama at the Little Theatre in the Haymarket, a privilege conferred at the request of the Duke of York and some aristocratic friends whose foolish japes had led to a riding accident in which Foote had lost a leg. But Foote could use the theatre only in the summer, when Covent Garden and Drury Lane were not performing.

In 1787 a more serious challenge was mounted by the actor John Palmer, when he opened a new theatre, the Royalty, at Wellclose Square, just east of the Tower of London. Palmer's theatre fell under the jurisdiction of the governor of the Tower, who approved the construction of the building. In accordance with an act of 1752 which required the licensing of all places of popular entertainment in London, Palmer had also obtained a licence from the local magistrates, and he thought he had the tacit acceptance of the patentees of Drury Lane, Covent Garden and the Little Theatre in the Haymarket. He was wrong. The managers of the licensed theatres published threats in the papers and served formal notice on Palmer, as they were entitled to under the Licensing Act, that they would have him and his actors arrested as vagabonds and put to hard labour.

The first dramatic performance on 20 June 1787, which comprised Shakespeare's *As You Like It* and Garrick's popular comedy *A Miss in Her Teens*, was also the last. A distraught Palmer explained to the audience that proceeds of the night would be donated to the London Hospital, pleaded for mercy from the patentees and closed the theatre. As he pointed out, it was ironic that 'Tumblers and dancing dogs might appear unmolested before you, but the other performers and myself standing forward to exhibit a moral play is deemed a crime.' Public sympathy was with Palmer, who was also supported by many newspapers, but the patentees stood firm. The fate of the Royalty demonstrated the fragile legal position of any unpatented theatre, which could have no real hope of sustained success.

This did not stop players mounting a wide range of amusements, usually licensed under the 1752 act for musical entertainments, in theatres, taverns and music rooms, and at fairs and pleasure gardens. In 1758 the comedian Samuel Foote put on the first of many satirical puppet plays; one-man shows, like James Alexander Stevens's famous satirical *Lectures on Heads*, in which he used a series of busts to make witty comments on characters of the day, avoided the Licensing Act because there was no dialogue (fig. 144); and 'burlettas' – described by the theatre-manager and playwright George Colman as a species of *'drama in rhyme . . . which is entirely musical; a short comick piece, consisting of recitative and singing, wholly accompanied, more or less, by the orchestra'* – became popular at the pleasure gardens in Marylebone, Sadler's Wells and Bermondsey.

For much of the century sketches, skits and satires were performed in August at St Bartholomew's Fair near Smithfield Market by West End actors for whom a summer stipend was worth the risk of being condemned as a strolling player or vagabond. So it was that a succession of actors came to work beside English and Italian rope dancers, tumblers, elaborate pieces of theatrical machinery, freaks like the giant Dutch

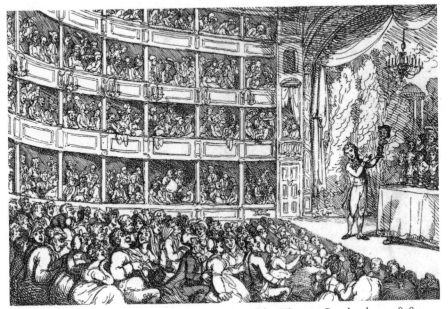

144. *A Lecture on Heads* by Woodward, engraved by Thomas Rowlandson, 1808

woman and puppet shows like the modestly titled 'Creation of the World and Noah's Flood' (fig. 145).

A small island of legitimate spoken theatre was in this way surrounded by a mass of popular entertainment which, to the modern eye, seems very like the music hall, burlesque and light operatic entertainment that we usually associate with the nineteenth century. The two were not sealed off from one another. Performers moved back and forth between them: such famous stage players as Charles Macklin and Mrs Hannah Pritchard made their London debuts at the city fairs, and a succession of popular comedians – William Penkethman, Thomas Doggett, Henry Norris (known as Jubilee Dicky) and Ned Shuter – took small troupes of Drury Lane and Covent Garden actors to Smithfield; the patent companies mounted operettas and afterpieces, that were also performed in fairground tents, pleasure gardens and burletta theatres. But the patentees jealously protected their rights. If a playhouse like the China Hall Theatre in Rotherhithe or a garden like Sadler's Wells allowed a performance of something that seemed like a play, it was liable for prosecution.

John Palmer's attempt to break the monopoly with the Royalty Theatre of 1787 and his impassioned plea to the public did, however, begin to break down the stranglehold created by the Licensing Act. In 1788 parliament, mindful of the anomalies in the law, tried to loosen its restrictions. These were most conspicuous in the provinces, where the Licensing Act had made all theatre illegal. This had not stopped performances in the main provincial towns – some of these were occasionally prosecuted – or inhibited the building of theatres in such towns as Ipswich (where Garrick first performed in 1741), York, Canterbury, Bath, Bristol, Norwich and Portsmouth. The counties thus enjoyed a flourishing cultural form, patronized by local elites, that was beyond the law. In the 1760s Edinburgh and a number of English towns legalized their theatres by securing local licences, obtained through act of parliament. But not until 1788, when parliament passed the Enabling Act and magistrates were permitted to license theatrical performances for up to a year, did these theatres achieve legitimacy (figs. 146 and 147).

The provincial theatre was freed, but the London stage remained constrained. The Enabling Act did not apply to the metropolis, which was still controlled by the Licensing Act and the law of 1752 governing entertainments. In the same parliamentary session of 1788 an effort to liberalize the law in London, though it passed the House of Lords, failed

This did not stop players mounting a wide range of amusements, usually licensed under the 1752 act for musical entertainments, in theatres, taverns and music rooms, and at fairs and pleasure gardens. In 1758 the comedian Samuel Foote put on the first of many satirical puppet plays; one-man shows, like James Alexander Stevens's famous satirical *Lectures on Heads*, in which he used a series of busts to make witty comments on characters of the day, avoided the Licensing Act because there was no dialogue (fig. 144); and 'burlettas' – described by the theatre-manager and playwright George Colman as a species of *'drama in rhyme . . . which is entirely musical*; a short comick piece, consisting of *recitative* and *singing*, wholly accompanied, more or less, by the orchestra' – became popular at the pleasure gardens in Marylebone, Sadler's Wells and Bermondsey.

For much of the century sketches, skits and satires were performed in August at St Bartholomew's Fair near Smithfield Market by West End actors for whom a summer stipend was worth the risk of being condemned as a strolling player or vagabond. So it was that a succession of actors came to work beside English and Italian rope dancers, tumblers, elaborate pieces of theatrical machinery, freaks like the giant Dutch

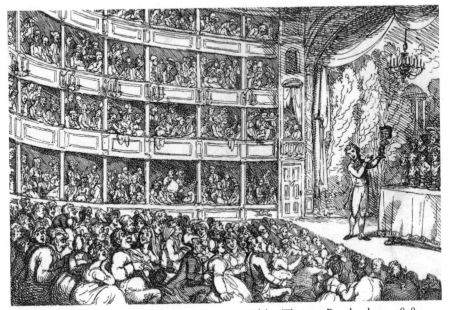

144. *A Lecture on Heads* by Woodward, engraved by Thomas Rowlandson, 1808

woman and puppet shows like the modestly titled 'Creation of the World and Noah's Flood' (fig. 145).

A small island of legitimate spoken theatre was in this way surrounded by a mass of popular entertainment which, to the modern eye, seems very like the music hall, burlesque and light operatic entertainment that we usually associate with the nineteenth century. The two were not sealed off from one another. Performers moved back and forth between them: such famous stage players as Charles Macklin and Mrs Hannah Pritchard made their London debuts at the city fairs, and a succession of popular comedians – William Penkethman, Thomas Doggett, Henry Norris (known as Jubilee Dicky) and Ned Shuter – took small troupes of Drury Lane and Covent Garden actors to Smithfield; the patent companies mounted operettas and afterpieces, that were also performed in fairground tents, pleasure gardens and burletta theatres. But the patentees jealously protected their rights. If a playhouse like the China Hall Theatre in Rotherhithe or a garden like Sadler's Wells allowed a performance of something that seemed like a play, it was liable for prosecution.

John Palmer's attempt to break the monopoly with the Royalty Theatre of 1787 and his impassioned plea to the public did, however, begin to break down the stranglehold created by the Licensing Act. In 1788 parliament, mindful of the anomalies in the law, tried to loosen its restrictions. These were most conspicuous in the provinces, where the Licensing Act had made all theatre illegal. This had not stopped performances in the main provincial towns – some of these were occasionally prosecuted – or inhibited the building of theatres in such towns as Ipswich (where Garrick first performed in 1741), York, Canterbury, Bath, Bristol, Norwich and Portsmouth. The counties thus enjoyed a flourishing cultural form, patronized by local elites, that was beyond the law. In the 1760s Edinburgh and a number of English towns legalized their theatres by securing local licences, obtained through act of parliament. But not until 1788, when parliament passed the Enabling Act and magistrates were permitted to license theatrical performances for up to a year, did these theatres achieve legitimacy (figs. 146 and 147).

The provincial theatre was freed, but the London stage remained constrained. The Enabling Act did not apply to the metropolis, which was still controlled by the Licensing Act and the law of 1752 governing entertainments. In the same parliamentary session of 1788 an effort to liberalize the law in London, though it passed the House of Lords, failed

145. Advertisement for
John Harris's Booth in
Bartholomew Fair, artist
unknown

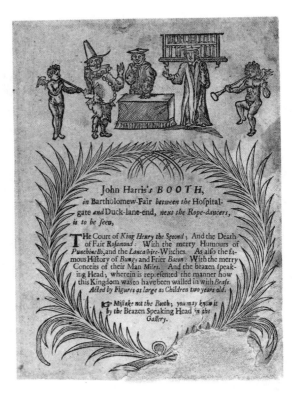

John Harris's *BOOTH*,
in Bartholomew-Fair *between the* Hospital-
gate *and* Duck-lane-end, *next the Rope-dancers*,
is to be seen,

THe Court of *King Henry the Second*; And the Death
of Fair *Rosamond*: With the merry Humours of
Punchinello, and the *Lancashire*-Witches. As also the fa-
mous History of *Bungy* and Frier *Bacon*: With the merry
Conceits of their Man *Miles*. And the brazen speak-
ing Head; wherein is represented the manner how
this Kingdom was to have been walled in with *Brass*.
Acted by Figures as large as Children two years old.

☞ *Mistake not the Booth*; *you may know it
by the* Brazen Speaking Head *in the
Gallery.*

in the Commons. But the closing of the patent theatres for rebuilding
and because of fire, together with the commercial pressures of a larger
public, eventually led the Lord Chamberlain to loosen his grip. By the
first decade of the nineteenth century he was using his discretionary
powers to license new theatres, like the Olympic and the Adelphi on the
Strand. Over the next twenty years the patentees' monopoly became a
dead letter. In the 1830s no fewer than fourteen new theatres opened in
London. It had taken nearly a century for legitimate spoken drama to
escape the restrictions imposed by the law of 1737.

The ferocious struggle among different companies before the Licens-
ing Act, which had led to changes in theatrical format and to innovations
in the repertory at the beginning of the century, was largely over. Rivalry
between the two theatres became more restrained and was even turned to
good account. Competition to stage new plays was replaced by competing
interpretations of a standard repertory in which rival actors and actresses

146. *The Theatre at Chichester* by James Winston, 1805

staged different productions of the same work. For instance, two versions of Shakespeare's *Romeo and Juliet* ran against each other in 1750, pitting Garrick against Spranger Barry as Romeo and Anne Bellamy against Susannah Cibber as Juliet; the competitive run lasted for thirteen nights, finally ending with victory for Drury Lane. Garrick was cock-a-hoop, writing to the Countess of Burlington, 'the Battle is at last Ended, & in our favour – our Antagonists yielded last thursday Night & we play'd the same Play (Romeo and Juliet) on the Friday to a very full house to very great applause; Mr. Barry & Mrs Cibber came incog to see Us, & I am very well-assur'd they receiv'd no little Mortification.' The managers encouraged these comparisons, which were also popular with the newspaper critics, because the audience had to see both performances in order to adjudicate between the actors.

The Licensing Act also gave the managers greater powers over their actors. Since the non-patent companies and their actors were put out of business, there were plenty of performers looking for work, though their bargaining power was diminished, especially if they were not stars. This

147. *The Theatre at Newcastle-upon-Tyne* by James Winston, 1804

enabled managers to exert more authority over their companies. Under poor managers like Charles Fleetwood, Garrick's predecessor at Drury Lane, this proved catastrophic, but in a well-organized company it led to more rehearsals, better training and to what contemporaries were largely agreed was an improvement in the general level of acting. Though it was the prompter who prepared the scripts and controlled the action on the stage during rehearsals and in repertory, the actor-manager was responsible for raising the level of ensemble performance.

From the outset the highly restrictive provisions of the Licensing Act affected the repertory. The years before the act had been a heyday for authors, busy as never before writing new topical satires and comedies. Competition among the different companies and theatres had overcome the resistance of managers and actors to the staging of experimental new plays. But with the Licensing Act the incentives to novelty were swept away and writers had better opportunities elsewhere. Prose fiction and essay-writing became the unintended beneficiaries of the Licensing Act. After 1737 Henry Fielding left the stage and turned to writing novels.

Managers reverted to their longstanding cautiousness. New productions, after all, were expensive, risky and time-consuming. They needed rehearsal, possibly new sets and costumes, and they could be damned into oblivion by the audience on the first night. The actor-manager Barton Booth 'often declared in public company, that he and his partners lost money on new plays; and that if he were not obliged to it, he would seldom give his consent to perform one of them.' As Thomas Davies, Garrick's biographer, explained, 'The time bestowed in rehearsing the piece, and the expense of new scenes, dresses, music and other decorations, make it often very ineligible to a director of a theatre to accept a new play; especially when it is considered that the reviving of a good play will answer his end of profit and reputation too perhaps.' Both might have added that a dead playwright was favoured because he could not claim the usual benefit of the proceeds of the third night's performance.

Under the new regime it made far more sense to work from an established corpus of English drama, to rely on Shakespeare for tragedy and on the still popular turn-of-the-century works by Farquhar, Congreve and Cibber for comedy. The repertory was increasingly divided into this stock of old favourites, which were to become 'classics', and bland and formulaic new plays.

This realignment of the repertory can be seen in the changing fortunes of Shakespeare's plays. During the 1730s they were rivalled though never entirely eclipsed by the spate of contemporary drama. In 1736–7 some London 'Ladies of Quality' were concerned enough to establish a 'Shakespeare Ladies Club', which organized a subscription for 'the Revival of Shakespear's Plays', mounting revivals or new adaptations of *Cymbeline*, *Much Ado about Nothing*, *King John*, *Richard II*, *Henry V* and the first part of *Henry VI*. Eliza Haywood claimed in the *Female Spectator*, admittedly with some exaggeration, that they had rescued 'the admirable, yet almost forgotten *Shakespear*, from being totally sunk in Oblivion'.

However overdrawn the accounts of Shakespeare's demise, the Bard's fortunes certainly changed after the passage of the Licensing Act. During the 1740–41 season a quarter of all performances in London were Shakespeare plays. The two patent theatres vied, as never before, to link their houses with the name of the Bard. Garrick's Drury Lane was the more successful. A quarter of the tragedies and a sixth of the comedies performed under his management were by Shakespeare.

148. *Dr Arne*. After Bartolozzi

D.ᴿ ARNE.

A staple repertory of well-regarded works was never sufficient, because the public still demanded novelty. But new drama tended to be safe drama – comedies or farces with stock plots and familiar devices. Satirical works mocked such easy targets as fops and headstrong young lovers, foreigners (which the London stage took to include Jews, Irishmen and Scots, as well as Frenchmen and Italians) and what they called enthusiasts – whether Methodists, like George Whitefield, or feminists like Catharine Sawbridge Macaulay. Sentimental comedy – which Goldsmith in a famous critical riposte defined as 'a new species of dramatic composition . . . in which the virtues of private life are exhibited rather than the vices exposed, and the distresses rather than the faults of mankind made our interest in the piece' – avoided wit, scurrility and bawdy for tearful moralizing in the manner of the popular sentimental novel, reminding some of its critics more of the pulpit than the theatre.

At the same time the licensed theatres did not confine themselves to

spoken drama. What began as a trickle of musical comedies in the 1760s turned into a flood as a generation of commercially minded English composers, most notably Thomas Arne (fig. 148), brought the pleasure gardens' light music and operetta back into the theatre. The key moment in this development was the interest that the star tenor John Beard acquired in the Covent Garden Theatre in 1760. With Garrick producing drama at Drury Lane, Beard opted for making Covent Garden a musical centre. The effect of his new management was quickly felt. During the 1765 season eighty-one of their 189 nights included musical comedies and operetta. Arne's *opera seria Artaxerxes*, an English version of Metastasio's *Arterse*, was the surprise hit of 1762, but most of the Covent Garden repertory was lighter in tone, combining the depiction of ordinary life common to the ballad opera with the musical techniques and dramatic conventions of Italian *opera buffa*.

The new formula was tremendously successful with the public. Arne's *Thomas and Sally, or The Sailor's Return* (1760), a romantic tale of war, courtship and gentlemanly villainy; his *Love in a Village* (1762), loosely based on a ballad opera of the 1720s (fig. 149); and Samuel Arnold's *The Maid of the Mill* (1765), a version of Richardson's novel *Pamela*, were all great hits and remained in the repertory for years. Over the next generation a succession of enterprising composers – Charles Dibdin, Thomas Linley, William Shield and Stephen Storace, many of them entrepreneurs with important connections to the pleasure gardens – wrote equally successful operas and afterpieces. Very few of these works were composed entirely by a single hand, being pastiches that combined original music by the composer-arranger with popular Italian arias, British ballads and folksongs. *The Duenna*, a romantic tale in which youth outwits old age, with words by Sheridan and music by his father-in-law, Thomas Linley, was more successful than any of Sheridan's own comedies. But Linley, aided by his son, actually wrote less than half the music, which included arias from Italian operas by Giordani, Rauzzini and Sacchini, and works by at least five other British composers, as well as several Irish and Scottish songs.

Twentieth-century critics, preoccupied with artistic originality and with the issue of the artist's control over his work, have not always given these potpourris a friendly reception. Their composition seems too commercial, too concerned to popularize music and make it accessible to a large audience. Arne, as we have seen, wrote numerous songs for

outdoor performance. Charles Dibdin composed two operas, *The Recruiting Sergeant* and *The Ephesian Matron*, for Ranelagh, where he was the concert organizer in the 1770s; he also worked at Sadler's Wells. Samuel Arnold was the proprietor and musical director at Marylebone Gardens between 1769 and 1776. Linley, the composer of numerous ballad operas, was a concert impresario from Bath. These men shaped an eclectic popular repertory of old and new music, Italian and English, recitative and ballad. Operettas and musical comedies brought the music of Italian *opera buffa* to large audiences in the theatres and pleasure gardens. Sung in English, combined with English ballads and songs much in the manner of *The Beggar's Opera*, this Italianate music seemed to shed its alien and elite guise and became British and popular.

149. Frontispiece to Thomas Arne's *Love in a Village*, artist unknown

150. Subscription ticket,
Carlisle House, engraved
by William Sharp

As music flourished more and more within the theatre it affected
the London musical scene beyond the stage. Italian opera persisted, as
expensive and difficult to finance as ever – between 1741 and 1778 there
were no fewer than twelve different managements at the opera house in
the King's Theatre, Haymarket. Though Italian opera went on being
fashionable and socially exclusive, its modishness, already challenged by
the Handelian oratorio, was steadily diminished as opera spread to the
theatres. It was also challenged by new musical fashions, notably the rise
of the concert hall.

Just as operatic pastiche was invading the theatre, rich patrons, find-
ing opera no longer novel, bored with Lenten oratorios, and tired of
rubbing shoulders with the hoi polloi in theatres and pleasure gardens,
turned to a new musical experience. Beginning in the 1760s rich and
modish Englishmen and women satisfied their desire for novelty and
exclusiveness by going to performances of advanced and technically
difficult foreign music, played by imported professionals at extremely

expensive concerts. The classical symphony arrived; the age of Haydn and Mozart began in London.

Theresa Cornelys – a singer, impresario and mother of an illegitimate child of the Venetian libertine Casanova – organized London's first successful professional concert series in the 1760s. Cornelys, like Casanova, was someone who made her living on the margins of aristocratic society, treading a fine line between notoriety and fashionable renown. Like Heidegger a generation earlier, she offered her aristocratic clientele a mixture of fashionable music and masquerades (fig. 150). The assemblies at Carlisle House, her mansion in Soho Square, began with a concert, but her guests, often dressed in masquerade, continued to dance into the small hours of the morning. Subscribers had to apply to a committee of aristocratic women who kept lists of those they thought worthy of admission (fig. 151). After 1764 the concerts were separated from the masquerades and junkets of Cornelys's ladies' 'Society', and from 1765 they were organized by Johann Christian Bach, music master to the queen, and Carl Friedrich Abel from Dresden, the two musicians who were responsible for familiarizing London audiences with modern music from Mannheim, whose use of *crescendo* and *diminuendo* and sudden contrasts between *forte* and *piano* created a lighter and livelier sound than the

151. *The Promenade at Carlisle House*, engraved by John Raphael Smith, 1781

traditional works of the baroque, and earned it the name of the *galant* style.

Bach and Abel broke away from Theresa Cornelys and became the centre of an expanding London concert life; by 1775 they had built a new concert room in Hanover Square. In Burney's words, 'As their own compositions were new and excellent, and the best performers of all kinds which our capital could supply, enlisted under their banners, this concert was better patronised and longer supported than perhaps any one had ever been in this country; having continued for full twenty years with uninterrupted prosperity.' In the 1780s, after the Bach-Abel orchestra was reorganized as the Professional Concert, now directed by the violinist Franz Cramer, it built an enthusiastic following, largely based on its performance of Haydn's symphonies, whose scores were just beginning to appear in London music shops.

The concerts in Hanover Square were not without rivals. In the 1770s the Pantheon in Oxford Road opened to a blaze of publicity, mounting masquerades, balls and public exhibitions, as well as a concert series with a deliberately Italian flavour to counteract the popularity of Bach and Abel (fig. 152). Its proprietors, unable to compete with the instrumental brilliance of the Professional Concert, turned to singers such as Gertrud Elisabeth Mara, offering the public a vocal equivalent to Hanover Square's virtuosi players. But the greatest challenge came from the musical publisher and impresario Johann Peter Salomon, whose coup in bringing Joseph Haydn to London twice in the 1790s led to the eventual demise of Cramer's subscription series (fig. 153).

Haydn was overwhelmed by London. He praised England as a 'land of opportunity' and wrote lyrically of his newfound liberty. He presided over fifty subscription concerts and wrote twelve symphonies, as well as composing for private patrons and concerts. He was thrilled to escape the humdrum routines of being a court composer and astonished by the amounts of money he could make as an independent artist. In 1791 a benefit concert he conducted netted him £350; in 1794 he cleared £800. He was fêted in private houses and patronized by royalty, while his public concerts were received with rapture: 'Passages often occur which render it impossible to listen to them without becoming excited. We are altogether carried away by admiration, and forced to applaud with hand and mouth . . . In every symphony of Haydn the adagio or andante is sure to be repeated each time, after the most vehement encores.'

Burney believed that the Haydn concerts enhanced the status of instrumental music, which was listened to with unprecedented attention:

> Haydn himself presided at the piano-forte: and the sight of that renowned composer so electrified the audience, as to excite an attention and a pleasure superior to any that had ever, to my knowledge, been caused by instrumental music in England. All the slow middle movements were encored; which never before happened, I believe, in any country ... his presence seems to have awakened such a degree of enthusiasm in the audience, as almost to amount to a frenzy.

Every effort was made to keep these concert series as exclusive as possible. Individual tickets could sometimes be obtained from subscribers or the occasional music publisher, but they were difficult to come by; patrons were expected to buy for an entire series, not just a single concert. In its

152. *The Inside of the Pantheon on Oxford Road* by Charles Brandoin, engraved by Richard Earlom, 1772

153. Benefit Concert Ticket for Mr Salomon, Hanover Square
Rooms, 1794

1774 season the Pantheon sold groups of twelve tickets for six guineas;
the Professional Concert's rate was only a guinea less. The transfer of
tickets, though it certainly occurred, was discouraged. At the same time
star performers were prevented by contract from appearing before a
different public.

As concert series became ever more popular, frequently publicized
and reviewed in the newspapers, so the pressure to restrict their audiences
was maintained. From the 1780s onwards aristocrats began to stage private
concerts; these were announced and reviewed in the newspapers but open
only to invited guests. The *Morning Chronicle* in February 1792 recorded
no fewer than five private concerts on a single Sunday: at the Duchess of
Gloucester's, Lady Hampden's (the so-called Nobility Concerts), Mrs
Sturt's, General Townshend's and Mrs R. Walpole's. As this list makes
clear, aristocratic women were the chief sponsors of these events. This
new kind of concert life deliberately separated itself from the theatre. Its
patrons came to hear the best foreign players play modern music which
made unprecedented demands on the performers' skills. They tended
to look down on older musical traditions and on Handel's popular
oratorios, which were still being performed in the theatres at Lent.

But there were also moves to create concert series for 'ancient music',
most notably in the Concert of Antient Music, begun in 1776 by gentlemen

instrumental concerts at the Hanover Square rooms, were attended by
high society – indeed, sometimes by the same people – their repertory
was very different. No work less than twenty years old was performed;
catches, ballads and *opera buffa* were also excluded. Handel, whose work
took up between half and two thirds of every programme, dominated the
repertory. His operas and oratorios were especially popular. Instrumental
music consisted chiefly of concertos composed by the late seventeenth-
century Italians Corelli, Geminiani and Sammartini, while Purcell's odes
and theatre music were the most popular English works. Though the
concerts included less sacred music than in the earlier Academy of
Ancient Music, their purpose was resolutely serious: to conserve and
perform a traditional repertory of the best in European music. Their
supporters considered this reassertion of an older tradition as a patriotic
act, designed to counter the criticism that aristocratic patrons were solely
interested in orchestral music that was flashy, modish and foreign.

Many musical commentators portrayed the two concert traditions –
one of modern instrumental music, the other of older, chiefly vocal music
– as sharply opposed. Certainly contemporary music, then as now, had
its opponents. Sir John Hawkins opened his *A General History of the
Science and Practice of Music* with a swingeing attack on 'the instrumental
music of the present day':

> notwithstanding the learning and abilities of many composers, the
> characteristics of it are noise without harmony, exemplified in the
> frittering of passages into notes, requiring such an instantaneous
> utterance, that thirty-two of them are frequently heard in the time
> which it would take moderately to count four; and of this cast are
> the symphonies, periodical overtures, quartettos, quintettos, and the
> rest of the trash daily obtruded on the world.

And other critics, especially high churchmen and evangelicals, strongly
objected to music that was 'Light and Frothy', appealing to the feelings
rather than sense. As a tract on musical education written by a cleric
and dedicated to the Concert of Antient Music put it: 'Music is not an
amusement for the careless or idle vulgar; the musician is somewhat
more than a Mountebank or Rope-Dancer; he should preserve his dignity,
he must not trifle and play tricks, he must not be gay, he must be serious.'

But if critics viewed ancient or modern music as embodying different
attitudes, the audiences for both sorts of music were usually more tolerant.

and aristocrats interested in establishing a performance tradition for an enduring body of great, serious music (fig. 154). The Concert of Antient Music could scarcely have been more exclusive. Their directorate consisted of aristocrats led by the Earl of Sandwich, a great promoter of private concerts, and Sir Watkin Williams Wynn, an avid collector of musical manuscripts. The directors granted subscriptions only on personal application and subscribers were not allowed to transfer tickets to anyone outside their immediate family. Between a third and a half of the concert public were families of peers, knights and baronets, and subscribers included many members of parliament and a number of bishops. In the 1780s, after the success of the Handel centenary, the king and court became prominent supporters of the concerts. According to the sister of their conductor, Joah Bates, the concerts 'are conducted in a most magnificent stile. The band is quite perfection and the best music is performed there. The presence of the royal family, and all the state court attendants make the room look grand. The room is beautifully lighted, the subscribers number three hundred, all are people of high rank and fashion.' Though the performances by the Concert of Antient Music, like the

154. *Bishop of Ely's ticket to the Concert of Antient Music* by Nathaniel Dance, engraved by Bartolozzi

Burney believed that the Haydn concerts enhanced the status of instrumental music, which was listened to with unprecedented attention:

> Haydn himself presided at the piano-forte: and the sight of that renowned composer so electrified the audience, as to excite an attention and a pleasure superior to any that had ever, to my knowledge, been caused by instrumental music in England. All the slow middle movements were encored; which never before happened, I believe, in any country ... his presence seems to have awakened such a degree of enthusiasm in the audience, as almost to amount to a frenzy.

Every effort was made to keep these concert series as exclusive as possible. Individual tickets could sometimes be obtained from subscribers or the occasional music publisher, but they were difficult to come by; patrons were expected to buy for an entire series, not just a single concert. In its

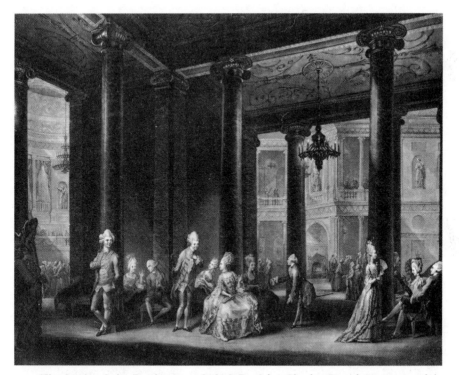

152. *The Inside of the Pantheon on Oxford Road* by Charles Brandoin, engraved by Richard Earlom, 1772

153. Benefit Concert Ticket for Mr Salomon, Hanover Square
Rooms, 1794

1774 season the Pantheon sold groups of twelve tickets for six guineas;
the Professional Concert's rate was only a guinea less. The transfer of
tickets, though it certainly occurred, was discouraged. At the same time
star performers were prevented by contract from appearing before a
different public.

As concert series became ever more popular, frequently publicized
and reviewed in the newspapers, so the pressure to restrict their audiences
was maintained. From the 1780s onwards aristocrats began to stage private
concerts; these were announced and reviewed in the newspapers but open
only to invited guests. The *Morning Chronicle* in February 1792 recorded
no fewer than five private concerts on a single Sunday: at the Duchess of
Gloucester's, Lady Hampden's (the so-called Nobility Concerts), Mrs
Sturt's, General Townshend's and Mrs R. Walpole's. As this list makes
clear, aristocratic women were the chief sponsors of these events. This
new kind of concert life deliberately separated itself from the theatre. Its
patrons came to hear the best foreign players play modern music which
made unprecedented demands on the performers' skills. They tended
to look down on older musical traditions and on Handel's popular
oratorios, which were still being performed in the theatres at Lent.

But there were also moves to create concert series for 'ancient music',
most notably in the Concert of Antient Music, begun in 1776 by gentlemen

The elite that went to Hanover Square was not that different from the aristocratic subscribers to the Concert of Antient Music. Contemporary and older works were performed in the same programmes of musical societies in London and the provinces. John Marsh, the composer and impresario who is the focus of my discussion of provincial music in Chapter 14, deliberately counterpointed ancient and modern music in his Chichester concerts because he believed the contrast emphasized their respective virtues.

For all their differences, concert-goers who listened to either ancient or modern music, and even those who listened to both, were concerned to establish the distinctiveness of a musical world separate from the playhouse. It was not so much because special halls offered a less distracting environment – audiences continued to chat and to walk about during musical performances (when Frances Burney first went to the Pantheon she was 'quite astonished to find how little music is listened to in silence, for though everybody seems to admire, hardly anyone listens') – but because they offered a venue free from the hoi polloi. But the Concert of Antient Music, every bit as socially exclusive as instrumental concert series, was less cut off from the musical mainstream of theatres and pleasure gardens. In particular, its organization of the Handel commemoration concerts, first held in 1784 and repeated in five of the next seven years (the break in 1788–9 was prompted by George III's bout of illness), brought together theatrical oratorio, which had a broad public, with an aristocratic determination to treat music seriously as a patriotic and useful recreation.

In 1784 three members of the Concert of Antient Music – Lord Sandwich, Sir Watkin Williams Wynn and Joah Bates – proposed a centenary commemoration of Handel's birth, won the enthusiastic support of the king, and staged three spectacular concerts, the first a selection of Handel's sacred music performed in Westminster Abbey, the second of opera selections in Italian at the Pantheon, and the third a climactic performance of the *Messiah* in the abbey again (fig. 155). The proceeds of the concerts, donated to the Society of Decayed Musicians, a charity which Handel had helped to establish in 1738, raised 2,865, 1,619 and 3,049 guineas respectively. Altogether the commemoration was a huge success: the rehearsals were so packed that admission at half a guinea was charged; the first and last concerts were repeated to accommodate enthusiasts who had been unable to cram into the abbey; a subscription

for the publication of Handel's collected works was launched with the support of the king; and even sceptics, who included Charles Burney, were overwhelmed by the power of music produced by more than 500 singers and instrumentalists. Burney wrote in his official history of the commemoration:

> The totality of sound seemed to proceed from one voice, and one instrument; and its powers produced, not only new and exquisite sensations in judges and lovers of the art, but were felt by those who never received pleasure in Music before ... the best Operas and Concerts are accompanied with a buz and murmur of conversation, equal to that of a tumultuous croud, or the din of high 'Change; yet now, such a stillness reigned, as perhaps, never happened before in so large an assembly. The midnight hour was never sounded in a more perfect tranquillity, than every note of these compositions. I have long been watching the operations of good Music on the sensibility of mankind; but never remember, in any part of Europe, where I attended Musical exhibitions, in the Church, Theatre, or Chamber, to have observed so much curiosity excited, attention bestowed, or satisfaction glow in the countenances of those present, as on this occasion.

As Burney makes clear, the commemoration was a patriotic event: 'the number of eminent musical performers of all kinds, both vocal and instrumental, with which London abounded ... was far greater than in any other city of Europe'; they had been combined so that 'a performance might be exhibited on so grand and magnificent a scale as no other part of the world could equal'. So much was planned by the organizers. Yet the composition and conduct of the audience also struck those present. Here was the polite nation as it wished to imagine itself: respectful, silent, serious, harmonious and united – no discord was heard. Hierarchy was made visible by the elaborate seating plan, with special boxes for royalty and peers, but all, regardless of rank, enjoyed the spectacle. It is a tribute to the power of the event that Sylas Neville, a radical republican in his youth, was overwhelmed by this representation of the monarchical nation: '*Le spectacle bien magnifique*', he wrote in his journal.

The commemoration revived Handel's flagging reputation and also initiated the performance of his favourite oratorios with large choirs and orchestras – in 1791 the commemoration employed 1,068 musicians! – a

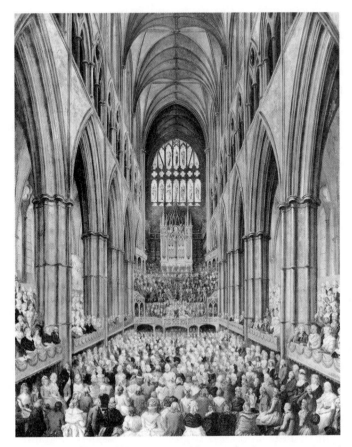

155. *Interior View of Westminster Abbey on the Commemoration of Handel's Centenary* by Edward Edwards, *c.* 1793

practice that continued into the twentieth century. It also created a point of unity in a musical culture that had become fragmented for political as well as musical reasons. After the loss of the American War and, still later, with the outbreak of the French Revolution, the oratorio became an essential ingredient in Britain's patriotic repertory of 'ancient' and pious music, a repertory that stood against foreign innovation and invasion. Handel's sacred oratorios, initially written to be performed in theatres, made their way into concert halls and, above all, into churches.

Handel and Haydn had a profound effect on the musical audience. Throughout the century serious musical critics had complained about the difficulty of getting audiences to listen. At the opera, oratorio,

theatrical overture and instrumental concert the public chatted, moved from box to box and seat to seat, and paid only intermittent attention to the performance. Yet, as Burney pointed out, the tremendous sound of Handel's commemorative oratorios and the virtuosity of Haydn's symphonies led the audience to listen with rapt attention. The 'sublime' sound of Handel provoked silent awe, the surges of Haydn's music unprecedented waves of feeling: the composers had finally secured the reverence that in their day was associated with Christian worship and which today we still find in the concert hall.

If Handel dominated musical performance in the second half of the century, Garrick dominated the stage. But while the German composer's achievement was to shape a musical tradition fashioned in the image of a patriotic and pious nation, Garrick created a respectable patriotic identity for the stage based on edifying spoken drama and, above all, on the works of Shakespeare. His efforts culminated in the widely publicized events of 1769 – the Shakespeare Jubilee at Stratford-upon-Avon and the unprecedented success of *The Jubilee* on the London stage – but they had been the work of many years. For Garrick had striven assiduously to establish himself as the model thespian – an actor-manager who was a public figure, a theatrical impresario who chose the repertory, a performer whose interpretation of great drama rivalled the literary critics', a gentleman of taste and discernment who led a respectable, domestic private life, and an Englishman with impeccable patriotic credentials.

It had become apparent that an increasingly commercial stage needed a patentee who knew the business from the inside and could understand its minutiae and complexities. Theatres were best run by practitioners rather than investors. The considerable demands made on theatre managers meant that even those who were well qualified for the work found it arduous. Colley Cibber described the duties in his autobiography:

> Every manager is obliged in his turn to attend two or three hours every morning at the rehearsal of plays and other entertainments for the stage, or else every rehersal would be but a rude meeting of mirth and jollity. The same attendance is as necessary at every play, during the time of its public action ... A manager ought to be at the reading of every new play when it is first offered to the

stage ... and upon such occasions the attendance must be allowed to be painfully tedious, as the getting rid of the authors of such plays [as are rejected] must be disagreeable and difficult. Besides this, a manager is to order all new clothes, to assist in the fancy and propriety of them, to limit the expense and to withstand the unreasonable importunities of some who are apt to think themselves injured, if they are not finer than their fellows. A manager is to direct and oversee the painters, machinists, musicians, singers and dancers, to have an eye upon the doorkeepers, under-servants and officers who, without such care, are too often apt to defraud us or neglect their duty.

During the 1730s and 1740s the theatre at Drury Lane was ill served by a succession of amateur proprietors who provoked actors' revolts and caused financial chaos. In 1732 an amateur player, minor poet and rake, John Highmore, bought into the Drury Lane patent. This enraged Theophilus Cibber, who had hoped to acquire his father's share of the patent, and within a year the actors, led by Theophilus, were in open revolt, complaining that Highmore and his fellow patentees, because of their ignorance of the stage, took care 'to make their purchase turn to the most *advantage* to themselves, and not to the reputation, interest, or encouragement of their own company, or the authors'. Even more importantly, from the actors' point of view, 'They will certainly allow as small an income as possible, even to the best performers.'

Highmore fought back, but soon he was driven out, only to be succeeded by Charles Fleetwood, a Staffordshire landowner. Despite his theatrical inexperience, Fleetwood survived his early years as a patentee and seems to have been a conscientious manager. But in 1739 the playwright David Mallet complained about Fleetwood's neglect of his tragedy *Mustapha*: 'He even carries away the actors that are to play in it, from the rehearsals, to boxing matches at Totenham [sic] Court where he himself presides as umpire.' Then, in the 1740s, he took up gambling and a 'passion for low diversions'; soon he was siphoning off the theatre's money to pay his gambling debts. In 1743 he provoked an actors' revolt led by Garrick and Macklin; a year later he tried to rescue his finances (he had already mortgaged his patent and used the theatre's costumes, scenes and properties as collateral for a £7,000 loan) by raising the prices for pantomimes. This unwise move united the audience with the players.

Following two nights of rioting in November 1744 during which the 'theatre was most shockingly demolished, even to the gutting of the Pit, and the fleecing of the boxes', Fleetwood sold out and fled to the continent. It took another two seasons for his partner, James Lacy, to stabilize Drury Lane by bringing in Garrick as a partner.

Garrick was not the first actor-manager – he had been preceded by the triumvirate of actors who ran Covent Garden between 1713 and the early 1730s, John Rich at Lincoln's Inn Fields and Covent Garden between 1714 and 1761, and Henry Giffard at Goodman's Fields and Lincoln's Inn Fields (1731–5, 1736–7) – but he was the first to advertise his role flamboyantly by advocating a particular repertory and to vaunt his status by persistently associating himself with Shakespeare. Rich, his greatest rival for many years, was tainted by his association with pantomimes and afterpieces; after 1761 the Covent Garden management, as we have seen, surrendered the field of spoken drama to Garrick, opting for a strong musical repertory.

When Garrick joined James Lacy at Drury Lane they shared the work: the actor dealt with strictly theatrical matters and Lacy with the rest. 'Mr Lacy took upon himself the care of the wardrobe, the scenes and the economy of the household; while Mr. Garrick regulated the . . . business of treating with authors, hiring actors, distributing parts in plays, superintending rehearsals.' The working relationship, which included provision for a mediator if the two disagreed, worked well and the partnership was lucrative, making net profits in the seven seasons for which records survive of between £3,000 and £6,000. But the work was not easy. Garrick's surviving correspondence overflows with a superabundance of theatrical business. It is full of complaints from playwrights about his forthright criticisms and frequent rejection of their work – as he remarked to Arthur Murphy, one of his more successful authors, 'I could send you a waggon load of Writers (scurvy ones) to be duck'd & drench'd for their own & the Public Benefit.' Actors, actresses, dancers and musicians complained about their wages, benefits, colleagues and the manager himself. And Garrick, who was extremely thin-skinned about criticism, often responded with wounded pride to newspaper critics and private correspondents who found his repertory or performances not entirely to their choice. His letters are filled with the rush of theatrical business: 'all is hurry from Morng to Night' . . . 'I am this moment going upon the stage, but am at all times & in all circumstances Most truly

yrs'. The pace is relentless; so is Garrick's desire to show that he is a busy and famous man.

Garrick's claim that the theatre was the crucible in which a play's interpretation was forged was largely sustained by his performances of Shakespeare. At first the critics were grudging in conceding that Garrick had supplemented old interpretations of the Bard. As Dodsley's *Museum* of 1747 put it, 'His [Garrick's] action is an excellent comment upon Shakespeare and with all the pains you have taken with your favourite author, you don't understand him so well as if you knew the supplemental lights which Garrick throws on him.' But a generation later, shortly before Garrick's retirement, critics had come to appreciate the compelling power of an actor to explain what a play meant. An anonymous poem, 'To Mr. GARRICK, On the Report of his leaving the Stage', published in the *Universal Magazine* for June 1775, claimed that 'One meaning glance of eyes, like thine, can show / What lab'ring Critics boast in vain to know'. Even the cantankerous George Steevens, who published a revised edition of Johnson's *Shakespeare* in 1773, admitted, 'often when I have taken my pen in hand to try to illustrate a passage, I have thrown it down again with discontent when I remembered how able you were to clear the difficulty, by a single look, or particular modulation of voice, which a long and laboured paraphrase was insufficient to explain half so well.' The textual critic deferred to the actor, whom he called 'the Poet's High Priest'.

Garrick made his mark on the texts of Shakespeare's plays as well as their performance. He claimed to be the great restorer of the Bard's original words, the person who could discern the Bard's true meaning. An anonymous poem of 1750, in which Shakespeare's ghost addresses Garrick, confirms Garrick's special mission:

> To thee, my great restorer, must belong
> The task to vindicate my injur'd song,
> To place each character in proper light,
> To speak my words and do my meaning right.

To that end Garrick consulted editors, collected and collated early texts, and wrote justifications of his productions. Yet his so-called restorations were as much concerned with developing economical dramatic effect as with Shakespeare's language. His version of *Macbeth* cut parts of the 1623 text and added an extended dying soliloquy for Macbeth of Garrick's

own making. The restoration of *The Winter's Tale* left out three of its five acts. He wrote to Pierre-Antoine Laplace of his 1772 version of *Hamlet*, 'I must tell You that I have ventur'd to alter Hamlet, & have greatly Succeeded; I have destroyed the Grave Diggers, (those favourites of the people) & almost all of the 5th Act – it was a bold Deed, but the event has answer'd my most sanguine expectation: if you correspond with any of the Journalists, this circumstance will be worth telling, as it is a great Anecdote in our theatrical history.'

Garrick's relations with Shakespeare became proprietorial. In 1769 the new town hall of Stratford-upon-Avon acquired a portrait of Garrick by Gainsborough. (The opening of the new town hall and Garrick's gift were the occasion for the Jubilee.) Fashionably dressed and posing informally in the grounds of a country house, a prosperous but pensive Garrick wraps his right arm round a bust of Shakespeare; the gesture is at once protective and possessive. The Bard seems to incline his head towards the actor, as if acknowledging Garrick's special place as his guardian and friend (fig. 156). This was Garrick as he wished to be remembered, a model of the modern actor, not just a respectable and respected performer but an interpreter who guarded a hallowed national figure.

So close was the association of the actor with the playwright that Garrick came to be seen as not so much the interpreter of Shakespeare as his living embodiment. His performance was less an interpretation of one of the Bard's plays than a conjuring up of the author himself. As *A Poetic Epistle from Shakespear in Elysium to Mr Garrick at Drury-Lane Theatre* (1752) put it:

> THOU art my living monument; in THEE
> I see the best description that my soul
> Could ever wish: perish, vain pageantry, despis'd!
> SHAKESPEARE revives! in GARRICK breathes again!

Literary conceit or not, it was an idea that Garrick took to heart. The temple to Shakespeare that he erected in the grounds of his house at Hampton contained a statue of the playwright by Roubiliac. Garrick himself was the model for the figure of the Bard; its pose, appearance and gestures – all carefully orchestrated by Garrick – were those of the eighteenth-century actor (fig. 157).

The 1769 Jubilee, then, was not an isolated incident but one event in

156. *Garrick with the Bust of Shakespeare* by Thomas Gainsborough, engraved by Valentine Green, 1769

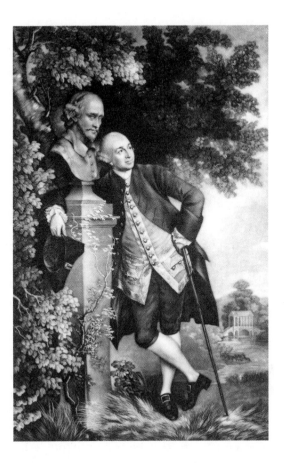

the repertoire of publicity used by Garrick to develop the cult of Shakespeare, promote the theatre and further his career. The cult was a cult of the author, not of his plays. The Stratford Jubilee consisted of balls, masquerades, dedications and a horse race – the Jubilee Cup; fireworks were also planned but were washed out by the summer rain. But not a single work of Shakespeare's was read or performed. The celebrations culminated in the steward and organizer of the jubilee, Garrick, reading his ode to the Bard:

> To what blest genius of the isle
> Shall Gratitude her tribute pay? . . .
> Swell the choral song.
> Roll the tide of harmony along.

> Let Rapture sweep the strings,
> Fame expand her wings,
> With her trumpet-tongues proclaim
> The lov'd, rever'd, immortal name,
> *Shakespeare! Shakespeare! Shakespeare!*

The Bard had become a god, Garrick's 'god of his idolatry' or, as Voltaire put it in less complimentary terms, 'Ce goût-là devient une réligion; et il y a dans ce pays-là beaucoup de fanatiques à l'égard de cet auteur.'

Garrick's cult of Shakespeare was symptomatic of the theatre's attempts to establish its respectability. In less than a generation theatre managers were transformed from being the proponents of scurrilous contemporary satires lashing the monarch and the nation's political leaders into the respectable guardians of a national literary treasure. And they represented Shakespeare not just as a playwright of genius but as a peculiarly English figure. His imagination, his literary inventiveness, even his 'faults' in transgressing the rules of the classical unities, were thought of as uniquely British, in contrast to the cold classicism of a Racine or a Corneille. A central character in the drama of Garrick's Shakespeare Jubilee at Stratford was a fashionable Frenchified fop, played by the actor Tom King, who condemns both the Bard and the celebration before being bested in a public debate on Shakespeare's virtues.

The patriotic card was an important one for any theatre manager to play. As we have seen, Garrick made a costly error in 1755 when he provoked several nights of rioting by bringing French dancers to London to perform his *Chinese Festival*, but thereafter he rarely put a foot wrong. His *Harlequin's Invasion*, a Christmas pantomime first performed in December 1759 at the height of the Seven Years War with France, linked a patriotic call to arms with quintessentially British spoken drama and the Bard. Comedy, tragedy, and Shakespeare defend the nation against a French invasion led by Harlequin. As Mercury warns the British:

> To Dramatica's realm, from Apollo I come,
> Whereas it is feared a French trick may be play'd ye
> Be it known Monsr Harlequin, means to invade ye . . .
> Let the light Troops of Comedy March to attack him,
> And Tragedy whet all her Daggers to Hack Him.
> Let all hands, and hearts, do their utmost endeavour;
> Sound Trumpet, beat Drum, King Shakespeare forever!

The show was full of stirring patriotic songs, including the extremely popular 'Hearts of Oak', and ends with an effigy of Shakespeare chasing the French from the stage.

Garrick was equally eager to defend the Bard from critics in the international republic of letters. He was a tireless advocate of Shakespeare and British drama among his friends from the circle of Baron d'Holbach in Paris, wrote on several occasions to Voltaire hoping to convert the *philosophe*'s hostility to Shakespeare into admiration – 'No enthusiastick Missionary who had converted the Emperor of China to his religion would have been prouder than I, could I have reconcil'd the first Genius of Europe to our Dramatic faith' – and attacked French critics in his friend Jean-Baptiste-Antoine Suard's *Gazette littéraire de l'Europe*. He sent copies of his 'Jubilee Ode' to Voltaire and Suard, and made special arrangements so that Diane-Adelaide de Rochechouart, Comtesse de Châtelet, the French ambassador's wife, should be sure to see the stage

157. *Mr and Mrs Garrick by the Shakespeare Temple at Hampton* by Johann Zoffany

version of the Jubilee. Though Garrick won a few French converts to his cause – Necker and his wife came to London in 1776 to see Garrick's final performances at Drury Lane – much of this work was in vain. Voltaire ridiculed *The Jubilee* and Garrick's temple to Shakespeare at Hampton in a letter to the Académie française published in 1776, and most critics, including Suard, thought Shakespeare too vulgar, rough and low to be ranked with Corneille and Racine. Yet, though it galled Garrick, the failure to convert neo-classical critics did him no harm with the British public, which was happy to know that its greatest actor was busy defending its greatest dramatist from hostile foreign commentators.

By 1776, when Garrick retired, the figure of the actor-manager-proprietor had become well established, not least because of his own astonishingly successful career. English theatre was in the control of actors, and the thespian patentee had become a public figure, not only a theatre proprietor but an arbiter of public taste. The original patentees had been courtiers, and they had reproduced court taste; the entrepreneurs who replaced them were money-makers; but the actor-proprietor presented himself to the public as an artist, shaping theatrical experience through his choice of repertory and his interpretation of plays. He was a literary figure as well as a great performer, his stature to be measured by his ability to interpret Shakespeare. A succession of leading men have followed in Garrick's footsteps: John Philip Kemble at Drury Lane at the end of the century, Henry Irving at the Lyceum in the nineteenth, Laurence Olivier and, even more recently, the youthful Kenneth Branagh.

It would be a mistake, of course, to see the cult of Shakespeare as entirely of Garrick's making. The Shakespeare Ladies Club had actively promoted the Bard in the 1730s, and in 1741, the year of Garrick's first performance, a committee that included Alexander Pope and Lord Burlington unveiled Peter Scheemakers's statue of Shakespeare in Westminster Abbey. In the same year Henry Giffard, the manager of the theatre in Goodman's Fields, staged a pantomime, *Harlequin Student: or the Fall of Pantomime, with the Restoration of the Drama*, which prefigured Garrick's *Harlequin's Invasion* in its patriotic themes and use of an effigy of Shakespeare, in this case a copy of Scheemakers's abbey monument. Jupiter's stirring speech before revealing the figure of the Bard could have been written by Garrick:

> Too long, *Britannia*, hast thou blindly err'd,
> And Foreign Mimes to *English* wit preferr'd!
> Eunuchs to Sloth your senses have betray'd,
> And *British* spirts (as they sung) decay'd.
> But see, behold! a better Time returns,
> Each Bosom now, with nobler Rapture burns!
> Immortal SHAKESPEAR's matchless Wit revives,
> And now the Bard in speaking Marble lives:

The revival of Shakespeare's plays owed as much to the gifts of such comic actresses as Kitty Clive, Hannah Pritchard and Susannah Cibber as to Garrick's performances. *Twelfth Night*, *As You Like It*, *The Winter's Tale* and *All's Well That Ends Well* offered leading female roles which the actresses seized with alacrity. Clive and Pritchard made Olivia and Viola, Katharina and Bianca, and Celia and Rosalind parts to which future actresses aspired. And Garrick's reworking of Shakespeare's plays – removing vulgar characters like *Hamlet*'s gravediggers – was in line with the desire of other impresarios and critics to make Shakespeare more proper and genteel, a trend that notoriously culminated in the expurgated *Family Shakespeare* of Henrietta and Thomas Bowdler, two evangelical friends of Anna Larpent.

What distinguished Garrick was not so much his attachment to the Bard and his unquestionable acting ability as his unstoppable charm, astonishing energy and genius for self-publicity. He was a constant performer, whether on stage, dining with friends or writing a letter. His contemporaries were astonished by his constant animation, his brilliance as a mimic, and his ability to capture every sort of sentiment in his expression. No one caught Garrick better than the critic and philosopher Denis Diderot:

> Garrick pokes his head through the folding doors and, in the space of four or five seconds, his expression moves from unrestrained to moderate delight, from delight to tranquility, from tranquility to surprise, from surprise to astonishment, from astonishment to sadness, from sadness to despondency, from despondency to fear, from fear to horror, from horror to despair, and goes back from this low to the expression where he began.

Johnson, who often found Garrick's perpetual vivacity tiresome, remarked in 1775, responding to Burney's comment that Garrick was

beginning to look old, 'no man's face has had more wear and tear.'

No man, Johnson might have added, was more assiduous in cultivating his image, no man so jealous of his public reputation. When Thomas Francklin, dramatist, cleric and contributor to Tobias Smollett's *Critical Review*, was critical in print and uncharitable in coffee-house conversation, Garrick snubbed him:

> My late Conduct & Behavior (as you are pleas'd to call them) were the Consequence of Your very insincere & unfriendly behavior to Me about the Play of Barbarossa; & what you publickly said in the Bedford Coffee house before Men of the first Character for Letter & Integrity, convinc'd Me, that my Success was unpleasing to you, & that all my Good Wishes & Friendly intentions to you were not return'd as I expected & as I thought they might deserve.

The tone of this letter – righteous, wounded indignation – was often repeated for, though Garrick often professed to be impervious to newspaper critics – 'I read their Malignity', he wrote to Colman, 'with as much sang froid as Plato himself would have done' – in fact he dwelt on criticism. He annotated his copy of the hostile *Theatrical Monitor* – 'What vulgar trash is this!' – and complained to the editors of newspapers and reviews when he got bad notices.

Though he did not have the controlling power that some of his critics accused him of wielding over the press, he certainly had influence. Like any theatrical proprietor he had at his disposal the advertising that was essential to a thriving paper and, at one time or another, he owned shares in the *Public Advertiser*, *St James's Chronicle*, *Morning Post* and *London Packet*. He certainly used his influence to insert items in the press and he cultivated good relations with newspaper editors like Henry Bate of the *Morning Post* and review editors like Smollett of the *Critical Review*. Thus he helped Bate to secure a post in the church and deferred to Smollett, even writing to thank him for a favourable mention in the *Continuation* of Smollett's best-selling *History of England*.

Garrick was also determined to keep himself in the public eye. He commissioned numerous engravings, supervising their composition as strictly as the statue of Shakespeare in his Hampton garden. Altogether Garrick was portrayed in 450 different paintings and engravings. A picture like Reynolds's enormously popular *Garrick between Tragedy and Comedy*, painted in 1761, was copied in oils, engraved almost immediately

158. *Garrick between Tragedy and Comedy* by Joshua Reynolds, engraved by Edward Fisher, 1762

after its completion, displayed in print rooms and collected in family albums (fig. 158). It even circulated in France. The playwright and theatre manager George Colman wrote to Garrick from Paris in 1765. 'There hang out here in every street, pirated versions of Reynolds' Picture of you which are underwritten, "L'Homme entre le Vice et la Vertu".'

Garrick himself often gave such prints as gifts to friends and admirers. In 1764, when in Paris on his way back to London from a tour of Italy, he had written urgently to his brother asking for a consignment of images:

> I am so plagu'd here for my Prints or rather Prints of Me – that I must desire You to send me by the first opportunity *six* prints from Reynolds' picture, You may apply to the Engraver he lives in Leicester Fields, & his name is Fisher, he will give you good ones, if he knows they are for Me – You must likewise send me a *king Lear* by *Wilson*, Hamlet do *Jaffier* & Belv[idera] by *Zoffani*, speak to him for two or 3, & what else he may have done of Me – There is likewise a print of Me, as I am, from Liotard's picture Scrap'd by

MacArdel, send me two or 3 of them, speak to MacArdel, & any
other prints of Me, if tolerable, that I can't remember . . . pray, dear
George, don't neglect this for I am worried to Death about them.

Garrick's image management extended to paintings. He seems to have
been responsible for the development of the theatrical conversation piece,
a painting depicting a scene with several actors in a play. There are a
few earlier examples of this genre – most notably Hogarth's version of
Garrick as Richard III in his tent on the night before the battle of
Bosworth – but it became popular only at the hands of Zoffany, a German
painter whom Garrick patronized shortly after the artist arrived in
London in 1760. Over the next decade Zoffany painted many theatre
pieces that were exhibited at the Society of Artists and the Royal Academy
and subsequently engraved. Collectively they chronicled Garrick's career.
They included portraits of him in his most highly regarded tragic parts:
Jaffier in Otway's *Venice Preserv'd* and Macbeth (in which he appeared
with Mrs Pritchard); in two favourite comic roles – Sir John Brute in
Vanbrugh's *The Provok'd Wife* (which Garrick performed 105 times) (fig.
159), and Abel Drugger in Ben Jonson's *The Alchemist*; and scenes from

159. *David Garrick as Sir John Brute in Vanbrugh's 'Provok'd Wife'* by
Johann Zoffany, 1765

two of his own plays, *The Farmer's Return* and *Lethe*. Though much of this art commemorates Garrick the actor, it also presented him as a figure of domestic virtue. The numerous portraits of Garrick and his wife, the Viennese dancer Eva Marie Violetti, evoke a domestic felicity which Garrick also retailed in his correspondence. In the summer of 1749 he wrote to the Countess of Burlington of his new bride: 'I am Now sitting very near her, she is over head & Ears in her Family concerns, & is so vastly busy, and so well pleas'd, that I defye all the Painters, Ancient and Modern, to shew Me such a Picture of true domestick Happiness and Content! That I am a part of this Picture, tho but the Shade or back ground, to set it off, is my greatest Joy & Satisfaction!'

While other actors went their raffish ways, Garrick assiduously cultivated a domestic propriety that did not go unnoticed. When Dr Johnson suggested to the failed actor and failing bookseller Tom Davies that he might redeem his fortunes by publishing a life of Garrick, he offered to write the first sentence. 'All excellence has a right to be recorded,' he wrote. 'I shall therefore think it superfluous to apologize for writing the life of a man who, by an uncommon assemblage of private virtue, adorned the highest eminence in a public profession.' In Johnson's eyes Garrick's achievement was inextricably linked to his private rectitude.

Yet there was more to establishing a private reputation than cultivating the tone of moral virtue. For an actor or actress to be accepted by high society they had to display the refined attributes of a gentleman or lady. Garrick worked very hard to acquire these qualities. His house at Hampton on the Thames, where he entertained the cream of society, was a display cabinet of good taste, a little theatre in which he could perform the part of connoisseur and gentleman (fig. 160). Its large library boasted a remarkable collection of plays and fine illustrated books; his print collection had more than 1,000 engraved portraits as well as several series of engravings of famous works of art. His paintings, more than 200 in all, included works by or attributed to Frans Hals, Rembrandt, Guido Reni, Van Dyck, Watteau, Pietro Perugino and many contemporary British artists. The first house guests at Hampton in 1755 were the 'Duke of Grafton, Lady Holdernesse, Lord and Lady Rochford, Marquis D'Abreu & Mr. Walpole.'

Garrick cultivated a wide circle of acquaintances. He spent much time with a coterie of aristocratic Whigs centred around Lord Burlington and the Duke of Devonshire, and, as a compulsive performer off as on

160. *The Late Mr Garrick's Villa* drawn by Joseph Farington, engraved by Stadler, 1793

the stage, was in demand at country-house parties. In 1775, for example, he and his wife were guests at Oatlands, the seat of the Duke of New-castle; Chatsworth, the home of the Duke of Devonshire; and Ampthill, Bedfordshire, the residence of Lord and Lady Ossory. But he also had many literary friends: booksellers like Thomas Becket and critics like William Warburton as well as writers and politicians in Johnson's club. In his support of booksellers, his loan of library books to scholars, and his correspondence with critics and gentlemen collectors, Garrick played the part of the cultivated gentleman scholar with as much skill as he ever acted Richard III.

The energy that Garrick devoted to securing his standing, while a tribute to his vivacity and determination, showed how difficult it was for actors to become respectable. Actor-managers, linked to a classic repertory which they constantly reinvented and reinterpreted, could be figures of renown and welcome in polite circles. Good actors and actresses, provided they avoided scandal and stayed respectable, were acceptable. But most players, whether in the patent companies, in provincial theatres,

or just 'strollers', remained marginal to genteel society. Although Edmund Burke claimed that Garrick 'has raised his profession to the rank of a liberal art', this was, like so many remarks made by members of Johnson's circle about each other, an exaggeration. Garrick's achievement was not of great benefit to ordinary actors. He did far more for Shakespeare than for any minor Drury Lane player. But what Garrick did create, and what is institutionalized in British theatre even today, is the ideal of a national theatrical tradition that sanctifies the enactment of spoken drama and that requires actors and actresses who seek greatness to play a repertory of canonical roles.

Yet already in the early nineteenth century much of the Garrick inheritance was in tatters. The theatres were too big for intimate acting, the proportion of theatrical budgets devoted to actors was shrinking, and managers, trying to compete with a growing number of spectacles like Burford's Panorama in Leicester Square, offered the public lavish entertainments designed for the eye not the ear. Competition from the likes of Astley's Circus with its performances by its equestrianized Bluebeard led even the legitimate theatre towards novelties such as dwarf, animal and child performers. In 1812 the first elephant appeared on the London stage, an event satirized by George Cruikshank's print *The Rehearsal, or the Baron and the Elephant*, in which an elephant crushes a bust of Shakespeare (fig. 161). Spectacle, melodrama, farce were not confined to the illegitimate theatre.

In 1809 Kemble's attempt to hike prices in the newly opened Covent Garden and to compete in this increasingly spectacular and commercialized environment produced sixty-seven nights of riots and demonstrations in and outside the theatre. The riots were highly complex, bound up with city and theatrical politics, with objections to high salaries (especially that paid to the opera singer Angelica Catalani), with resentment at the high-handed conduct of John Kemble himself, and fuelled by anger at the repressive response of the authorities. For some, these so-called Old Price riots were a plea for the restoration not only of old prices but what they took to be the old English theatre. One of the Old Price leaders, the once radical then Tory Henry Redhead Yorke, addressed Kemble as follows: 'I am for rebellion; and let me tell King John [i.e. Kemble], that if he will not give us the English spirit of David Garrick, we will give him and his Frenchified crew, the spirit of Marat. The spirit of Garrick was this, bless his English soul!' Other Old Price

supporters repeatedly invoked Shakespeare, contrasting the grandeur of
his theatre and plays with the tawdriness of the modern commercial
stage.

So, though stage practices changed quickly from the ideals and values
of Garrick, the sense that England's national theatre should guard a
national poet and that public performance of his works was the standard
by which drama should be measured went on flourishing. Thomas Gilli-
land, in his pamphlet *A Dramatic Synopsis, containing an Essay on the
Political and Moral Use of the Theatre* (1801), claimed:

> The Stage has always kept pace with the state of public morals, and
> therefore at various periods of history it has been offensive to the
> rigid moralist; but while the people of this country continue vigorous
> enthusiasts for the maintenance of their religion, liberty, and the
> honour of the crown; the Stage must float on public favour, as the
> mirror of a nation's virtue, and the enlightened and polished school
> of a free people.

Gilliland believed in the ideas of 'the National Theatre' and of the
'National use of . . . Drama', and regarded plays whose sole object was

161. *The Rehearsal, or the Baron and the Elephant* (detail) by George Cruikshank, 1812

162. Medal: *David Garrick. He united all your powers* by L. Pingo, 1772

to entertain as 'a prostitution of the National Theatre, which should never be converted to a useless purpose'.

The idea that plays should be useful and moral was, of course, as old as classical antiquity. But during the eighteenth century this moralism was firmly linked to the peculiarities of the British political system and the English stage and to the singular genius of William Shakespeare, a moral inheritance that was not monopolized by one political group or view. Radicals and conservatives, critics of government and supporters of the regime all used both the drama and Shakespeare as a touchstone for their beliefs. They drew on an inheritance which was not purely the work of David Garrick. But in beginning the cult of what Bernard Shaw first called Bardolatry, Garrick shaped what is still regarded as a central tenet of British culture (fig. 162).

V

MAKING
A NATIONAL
HERITAGE

Borrowing, Copying and Collecting

IN THE EIGHTEENTH CENTURY the pleasures excited by art and litera-
ture were celebrated in the intimate language we today more usually
associate with describing people's relations to their family and friends.
Favourite works of literature were 'companions' and 'friends', a journal
was 'a conversation' with oneself. Addison's man of taste 'can converse
with a picture, and find an agreeable companion in a Statue'. Jonathan
Richardson argued that 'By conversing with the Works of the Best
Masters our Imaginations are impregnated with Great, and Beautiful
Images.' An 'amateur' was someone who loved art. The relationship was
at once unashamedly aesthetic, deeply personal and politely sociable.

As English culture expanded so intimacy came under increasing
pressure. The sheer quantity of information, the number of publications
to read, pictures to see and performances to attend – not to mention the
critical commentary that surrounded them – put a strain on the ideal of
the refined person, well versed in the arts and imaginative literature and
their most fashionable manifestations. Though this tension could not
destroy the closeness that a person of taste felt for individual works of
art, the realms in which one shared one's pleasures had become so exten-
sive that one could only know a few of them. Comprehensive knowledge
seemed to be impossible, for the farther a person of taste explored, the
more distant he became from the intimacy he desired. As William Oldys,
the antiquarian, biographer, compiler and collector of miscellaneous
information, complained:

> The vast Number of Books which the Pen and Press have produced,
> has made all Lovers of Literature desirous of knowing by some
> compendious Methods, what has been written in the several Sciences
> to which they have appropriated their Studies: And this Desire

grows more importunate, as the Difficulty encreases of satisfying it; the Works of the Learned multiplying so much beyond the Accounts that are given of them.

This problem was compounded as the audience for culture grew. A larger public inevitably contained many people who were unfamiliar with the canons of taste and did not know how to read, look or listen properly – or, to be more precise, they read, looked and listened in different ways. The task of ensuring agreed standards of taste, which the editors of the *Spectator* and their fellow advocates of politeness had undertaken, seemed ever more difficult. Polite conversation was being drowned out by a louder 'babel' of different voices. There could no longer be – if there ever had been – a single community of conversation.

The speed at which these changes took place over the century disconcerted everyone. The feeling that there was more of everything was brilliantly captured by Alexander Pope in his *Dunciad* of 1728:

> our Poet . . . lived in those days when (after Providence had permitted the Invention of Printing as a scourge for the Sons of the learned) Paper became so cheap, and printers so numerous, that a deluge of authors cover'd the land: whereby not only the peace of the honest writing subject was daily molested, but unmerciful demands were made on his applause, yea of his money, by such as would neither earn the one, or deserve the other.

Pope's tart remarks also expressed the widespread anxiety among artists and writers that changes in the scale of culture would change it in threatening or offensive ways.

What were the nature and effects of this expansion? Individual works of art were connected to each other, reproduced and collected so that artists, critics and the public might see them as parts of a single, national culture. The deliberate borrowing and incorporation of other works of art within a given single work, a process of allusion that critics now often call inter-textuality, was hardly new in the eighteenth century, but there were new and distinctive kinds of borrowing and pastiche. John Gay's original and inventive creation in *The Beggar's Opera* is characteristic of many works of the early eighteenth century in its use and deliberate satire of the new cultural world it inhabited. It not only deliberately drew attention to its sources, to its nature as a modern pastiche, but

163. *John Gay* by William Aikman, engraved by F. Milvus, *c.* 1729

included references to an astonishing variety of activities from Grub Street scribbling to the Italian opera (figs. 163 & 164). In doing this, works like *The Beggar's Opera* reinforced the sense that the cheap pamphlet and the highly paid castrato were somehow connected; the ballad opera made this new, heterogeneous world of high, low and commercial art coherent. *The Beggar's Opera*'s use of topical materials and of literature and music from high and low life was a response to an extraordinary cultural expansion, to the growth of new kinds of audience and to the development of hybrid cultural forms. Artists were using new sorts of material to reach and to shape a new audience.

Yet, as the later history of *The Beggar's Opera* shows, it was difficult for an individual work to retain its integrity in this environment. Any success was likely to be copied, parodied, plagiarized, reworked in other media and broken apart, split into fragments and extracts for easy consumption. Artists had to consider how the form, status, content and interpretation of an individual work was affected by being one artifact

164. *A New Deceptio Visus* engraved by George Bickham Jnr, 1729

among so many, by being part of a large, somewhat volatile milieu. They became aware that culture was not fixed but dynamic, a realm whose boundaries were fluctuating and subject to change.

John Gay's *The Beggar's Opera* was first performed at the Lincoln's Inn Fields Theatre in 1728, the year that also saw the publication of Pope's *The Dunciad*. *The Beggar's Opera*'s entry into the world was not easy. Colley Cibber, the flamboyant manager of Drury Lane and astute theatrical businessman, turned it down, and John Rich, his rival at Lincoln's Inn Fields Theatre, was persuaded to put it on only at the urging of Gay's influential patron, the Duchess of Queensberry; the leading actor, Quin, refused the part of Captain Macheath because he did not like the play, and it was reported that during the rehearsals Rich thought the play would flop. Certainly Gay's work had no English precedent, though rather similar pastiches of high and low music had been performed on the Paris stage. What sort of a hybrid was a 'ballad opera'? What was 'Newgate pastoral', as Swift called it? And what would the

audience make of a play punctuated by more than sixty musical airs taken from popular songs and well-known operas, that satirized but did not condemn the criminal world, that appeared to mock leading English politicians, and mingled forms of high and low art?

The plot line of *The Beggar's Opera* was weak. Putatively staged by a 'Beggar' to celebrate the wedding of two ballad singers, it portrays the fortunes and vicissitudes of a highwayman, Captain Macheath, who is loved by Polly Peachum, a thief-taker's daughter, and by Lucy Lockit, whose father is the turnkey (gaoler) at Newgate Prison. Macheath is betrayed by the grasping Peachum, angry at the highwayman's marriage to his daughter; incarcerated in Newgate, he escapes with the help of his other paramour, Lucy, but his freedom is brief. He is again turned in, this time by Jenny Diver, one of a bevy of whores whose company he cannot resist. As the play moves to its seemingly inevitable tragic end, Macheath is convicted on the evidence of one of his own gang, Jemmy Twitcher, and condemned to die. Shackled in irons and mourned by his two lovers, he is reprieved at the last minute by the author of the piece, the Beggar, who justifies this unexpected twist of the plot by maintaining that 'an opera must end happily' and 'in this kind of drama 'tis no matter how absurdly things are brought about'.

The play is more a series of low-life tableaux than a coherent dramatic narrative. It lacks shape and form, consisting of bits of music and song, extracts, précis and parodies of other published works. It is a work of bricolage, of pastiche, strung and stuck together out of bits and pieces. It looks like the 'medleys' published by engravers in the early decades of the century, prints that combined in a single plate overlapping images of landscapes, cartoons, maps and portraits (fig. 165).

Yet this 'fault' was the very source of *The Beggar's Opera*'s success. In its density of allusion, its topicality, its celebration and satire of different cultural forms – tragedy, the opera, ballads and criminal literature – it invited its audience to enjoy the arch knowingness that pervades the play. The public for *The Beggar's Opera* did not share a direct familiarity with the criminal underworld, or personal acquaintance with politicians, or attendance at socially exclusive operas. But they could see known criminals like Jonathan Wild and Jack Sheppard in the characters of Peachum and Macheath, recognize 'Bob Booty' as the prime minister, Sir Robert Walpole, and compare Polly Peachum and Lucy Lockit to the rival opera singers Cuzzoni and Bordoni. The torrent of publications

that flowed from Grub Street made this possible: the audience for *The Beggar's Opera* had read attacks on politicians and the opera in newspapers, pamphlets and periodicals, seen prints depicting Jonathan Wild's execution and the spectacular escapades of the highwayman Jack Sheppard, heard ballad tunes sung on the street, snapped up cheap biographies of criminals, and discussed all these topics in the coffee house. *The Beggar's Opera* did not so much portray the criminal, political and operatic worlds as recycle representations of them. Its bits and pieces were not slices of life but of the music, words and images of commercial publishing. It was as much a product of Grub Street as the literature and music it so skilfully manipulated. Though it used low life to satirize rich and politically powerful men, its medium was not low life itself, but what Gay and the audience recognized as Grub Street's version of it. To watch *The Beggar's Opera* was to see highwaymen, beggars and whores at two removes. This contributes to the double irony that many critics have seen as a main feature of the play, its self-conscious artificiality. The audience looks at this contrivance and sees it as real, not because it is taken in but because it knows that that is how the world according to Grub Street is constructed. Gay was playing with the genres that shaped the representation of low life. His opera drew from a large body of literature, using its forms and conventions to create expectations in the audience which were then manipulated by the author for his own ends. Gay relied on Grub Street and its public, while simultaneously keeping his distance from both.

The Beggar's Opera's exceptionally broad frame of reference partly explains the many varied interpretations that have been offered of its meaning: as a patriotic satire on the infatuation with Italian opera, as a political attack on the manners and morals of Britain's leaders, as literary burlesque of heroic drama and sentimental comedy, as parody of aristocratic ideals (expressed by the thieves) and of the shopkeeper mentality (personified in the Thief-taker and the Prisonkeeper), and as critique of the values of commercial society. Almost all these interpretations were canvassed at the time. *Thievery à la Mode*, published a few months after *The Beggar's Opera*'s première, was the first of a series of commentaries emphasizing its satire on opera. And the government certainly believed Gay was attacking politicians, for it banned his sequel, *Polly*, without explanation. But contemporaries were most struck by the portrait of criminal life, and it is here that we can best see Gay brilliantly

165. Trade card: Robert Sayer, printseller, artist unknown

manipulating the preoccupations of his audience and the conventions of Grub Street.

The 1720s was a decade notorious in England for crime in both high and low life. In 1720 Whig politicians and financial speculators, all deeply involved in manipulating the stockmarket, had swindled the public (including Gay, who lost most of his wealth) out of enormous sums in what came to be known as the South Sea Bubble, a pyramid scheme of crazed speculation. Five years later the Lord Chancellor was convicted of embezzling public funds to the tune of £80,000. In the same year Jonathan Wild, a former pimp and protection racketeer who, under the

166. *Jonathan Wild Thief-taker General of Great Britain and Ireland* engraved by Cook, 1725

OPPOSITE
167. *An Exact Representation of ye Holes Shepherd made . . . In making his wonderfull escape out of Newgate* engraved broadsheet, 1724

guise of a 'thief-taker' – indeed, one who claimed to have sent seventy-five criminals to the gallows – had run the largest criminal network in London, was hanged at Tyburn, to the joy of the attending crowd (fig. 166). Wild's techniques had been similar to those of Gay's Mr Peachum: he controlled criminals through his knowledge of their crimes, which he himself orchestrated, and his unpopularity partly stemmed from his role in the capture and execution of another famous criminal, Jack Sheppard. Sheppard had started his criminal career working 'the buttock and file' – robbing men lured by a 'buttock', or prostitute, into a darkened corner or alley; he became a successful housebreaker, was betrayed by his brother, but then made the first of four spectacular escapes from prison. He broke out of St Giles Roundhouse and, when recaptured, climbed over the twenty-two-foot wall of the New Prison. He then

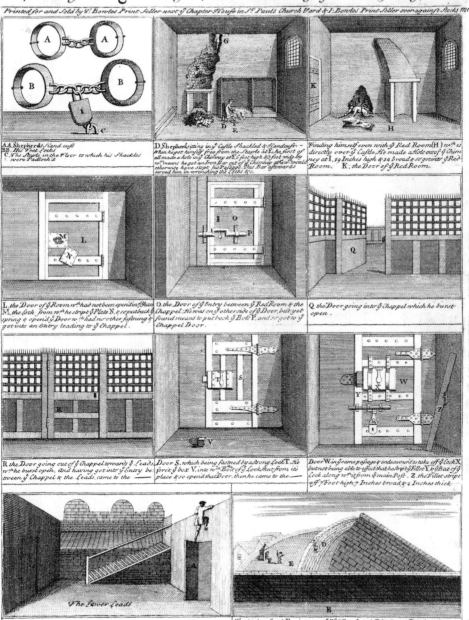

escaped twice from Newgate, on the second occasion removing his irons and chains and breaking through six doors (fig. 167). Found drunk in a gin shop in Drury Lane, he was finally hanged in 1724. His dying speech, possibly written by Daniel Defoe, became a best-seller when published; it attacked thief-takers like Wild.

Grub Street made the most of politicians, spectaculars and thieves like the South Sea directors, the Lord Chancellor, Wild and Sheppard. Prints and satires, many derived from Dutch engravings, portrayed the speculative mania and chaos provoked by the boom and slump of the South Sea Bubble. Popular ballads linked the Lord Chancellor and his nefarious activities to the careers of Wild and Sheppard. The year 1724 saw the publication of two lives of Sheppard and three plays based on his exploits, as well as the sale of engraved sheets depicting his most elaborate escape. Six versions of Wild's life, including one written by Defoe, were published in 1725. Opposition journals like the *Craftsman* were quick to point out analogies between the London criminal underworld and the sleazy politics of the Whig leaders. By the end of the decade the link had become a cliché.

Crime was topical, but it was not a new subject of journalism or literary comment. Gay was drawing on well-established conventions about how to depict a life of crime. In the earliest examples of the genre, sixteenth century 'cony-catching' literature, readers were warned of the ruses and tricks of the town. The focus was on the theft, not the thief. But in the mid-seventeenth century this form was superseded by that of criminal biography. Criminal lives appeared in two versions, one official, the other illicit. To write or publish the first was a perquisite of the Ordinary, the Anglican chaplain of Newgate Prison, who presided over the last rites of the capitally condemned, and had a legal monopoly to publish the last dying speeches and the lives of executed criminals, a profitable perk earning him between £100 and £150 a year. The second sort of life was produced by journalists like Defoe, varying in format from single sheets to substantial volumes. The most famous example was Captain Alexander Smith's *Complete History of the Lives and Robberies of the Most Notorious Highwaymen*, first appearing in 1713 and going through five editions by 1719; it was reprinted in 1720, 1726, 1734, 1736 and 1742, when an edition was also published in Birmingham. This literature was supplemented by the publication of transcripts of Old Bailey trials, a commercial business undertaken by the shorthand writers

of the court, who by the 1720s made available quite detailed accounts of the proceedings, and by dictionaries that purported to explain criminal language. (The 1719 edition of Captain Smith's *Lives* contained such a dictionary, while the *New Canting Dictionary*, published in 1725 to cash in on the fame of Sheppard and Wild, was a reissue of a dictionary that had first appeared in 1699.) These unofficial works used all the Grub Street stratagems: they were topical and sensational; they stole from one another as well as from the Ordinary himself; and they were written by hacks for profit.

Both the Ordinary of Newgate's narrative accounts and the criminal lives included the death of their central character: the only famous criminal was a dead criminal; minor offenders and those who were transported overseas rather than hanged featured only as supporting cast. And because these stories all culminated in the climactic deaths of their protagonists,

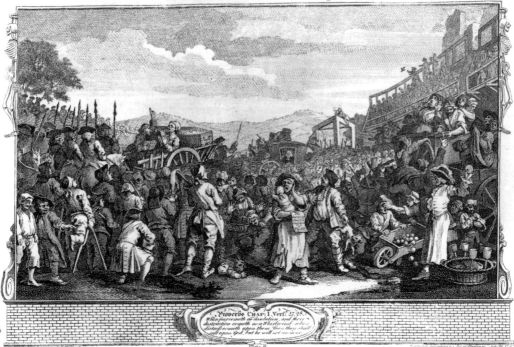

168. *The Industrious and Idle Apprentice*, Plate II, *The Idle Prentice Executed at Tyburn* painted and engraved by William Hogarth, 1747

contemporaries called them tragedies, or 'Dramatical Pieces, some of which are a mixed or tragi-comical kind, but, for the most part, are entirely Tragical' (fig. 168).

An audience's familiarity with this criminal literature meant that it almost certainly expected Macheath, *The Beggar's Opera*'s hero, to end dangling from 'Tyburn tree'. Indeed, much in the play reinforces this expectation. The entire action of *The Beggar's Opera* takes place in the shadow of the gallows, and death is invariably equated with hanging; it is seen as the inevitable fate of the malefactor. As Matt of the Mint says to Macheath, hanging is something 'we all must come to'. In the play the criminal characters are obliged to act out their fate: it is their 'duty' to conform to the tragic plot.

Yet there was more than one version of this story. Though the tragedies of the Ordinary of Newgate and of the popular journalists had much in common, they also contained important differences. The Ordinary's account, intended to achieve moral reform as well as a tidy profit, had its rules: there were good and bad stories, containing good or bad performances. And it is the *story*, not the hero, that matters. The best of them recounted not only a life of crime but the protagonist's abundant, full and contrite confession, preferably one that implicated other criminals. This restored the offender to the fraternity of the righteous, paid the debt he owed to society and might even permit him, despite his sins, to achieve a state of grace and to enter heaven. Such penitence was deemed even better when accompanied by a dignified death on the scaffold. John Estrick, a house robber executed in 1703, gave a classic performance:

> Good People, take warning by my Fall; you see I am a young Man, who by my Sins, have shortened my Days, and brought my Self to this shameful but deserved Death ... Live not as I have done, lest you come to the like sad and untimely End. Break not the Sabbath Day and keep not Company with wicked Men and lewd Women, as I have done ... Avoid all manner of Sin, even the smallest; for from one little Sin Men easily fall to the Commission of greater ones.

Of course, not every criminal wanted such a part in this public theatre. Many malefactors preferred to write their own lives. And thieves, as opposed to murderers, were not easily convinced that they deserved to

die for their crimes. Moreover, few took the view that betrayal was a Christian duty, an attitude mocked by Gay when he depicts Jenny Diver betraying Macheath with a Judas kiss.

But in picaresque literature such as Captain Smith's *Lives of the Highwayman* the highwayman is not a moral emblem but a person of distinction, the source of fascinated admiration, like an aristocrat or a person of exceptional talents. Many such highwaymen, like Macheath, use titles; they call themselves 'Gentleman' or 'Captain', and claim to act chivalrously according to a code of honour. They are depicted as witty and gallant, elegantly dressed, handsome and sexually alluring. They seem dangerous, but are made unthreatening: they are careful in choosing their victims, courteous to those they rob, and given over to force only when necessary. Often they represent themselves as victims who have been forced on to the road and into a life of crime through personal misfortune or because the times are out of joint. As the readers of such literature knew, there was a political purpose here: one of the first famous gentlemen of the road was James Hind, a Cavalier who claimed to have robbed Oliver Cromwell; many later highwaymen were portrayed as Tories or Jacobites and their victims as Dissenters, Whigs and republicans.

These picaresque accounts resembled *The Beggar's Opera* because they were episodic, concerned less with the 'primrose path' than with a series of detailed criminal vignettes. While the Ordinary of Newgate made the confession and execution the climax of his narrative, criminal biography emphasized the character and crimes of individual highwaymen. The portraits it painted were sympathetic: the often virtuous highwayman was at worst a person with a tragic fatal flaw – like Macheath's weakness for women – or someone led into making a tragic error of judgement.

The Beggar's Opera uses both the Ordinary of Newgate's moralizing narrative and the picturesque criminal biography to manipulate the audience's expectations to dramatic effect. The audience does not know which sort of story they are seeing because Gay mixes them together. The twist at the end, when the Beggar releases Macheath, is all the more astonishing because it defies the expectations the play itself establishes. Gay's patrons, the Duke and Duchess of Queensberry, together with their aristocratic friends, were doubtful about this ending, and felt that Macheath should have got his just deserts. This became a common criticism of the play, especially from critics who thought Macheath's escape was an incentive

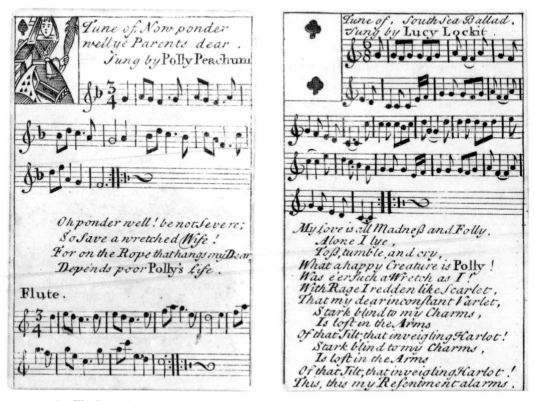

169. *The Beggar's Opera* playing cards

to crime. But the twist in the plot reiterates *The Beggar's Opera*'s artifice, reminding us that, like the products of Grub Street, it is just another story, one with its own special form and ending.

So *The Beggar's Opera* took its materials from works that were vernacular, topical, sensational and commercial, that dealt with the particularities of everyday life. The materials its audience needed in order to understand its meaning were songbooks, a city gazetteer and a canting dictionary; its author presumed that his audience knew about contemporary politics, graphic murder, intrepid crime and fashionable controversy – the stuff of the newspaper and pamphlet press and of the printed ephemera that had proliferated so rapidly after the lapse of the Licensing Act. The new milieu was not so much London itself, though it was certainly that, as a world of sounds, words and images, a sort of Tower of Babel – that could be pillaged, satirized and celebrated

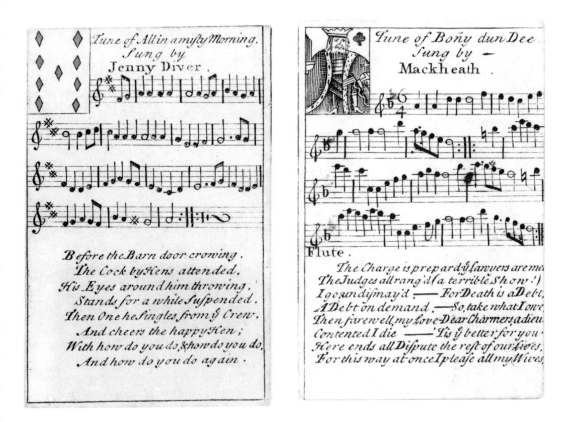

Tune of *All in a misty Morning*.
Sung by
Jenny Diver.

Before the Barn door crowing,
The Cock by Hens attended,
His Eyes around him throwing,
Stands for a while suspended.
Then One he singles from y̌ Crew,
And cheers the happy Hen;
With how do you do, & how do you do,
And how do you do again.

Tune of *Bony dun Dee*.
Sung by —
Mackheath.

Flute.

The Charge is prepar'd y̌ Lawyers are met,
The Judges all rang'd (a terrible Show!)
I go undismay'd —— For Death is a Debt,
A Debt on demand, —— So, take what I owe.
Then farewell, my Love Dear Charmers adieu,
Contented I die ——'Tis y̌ better for you,
Here ends all Dispute the rest of our lives,
For this way at once I please all my Wives.

but not avoided. What modern critics call inter-textuality had arrived with a vengeance.

For all the anxieties of its producer and despite the first-night nerves of Gay's friends Swift and Pope, *The Beggar's Opera* was an immediate success; it took off and never stopped running. At a time when most productions endured for less than a dozen performances, it lasted for an unprecedented sixty-two nights in its first season. A footnote in *The Dunciad* recounts its subsequent success:

> It spread into all the great towns of England, was play'd in many places to the thirtieth and fortieth time, at Bath and Bristol fifty, &c. it made its progress into Wales, Scotland and Ireland, where it was performed twenty-four days together. It was lastly acted in

Minorca. The fame of it was not confin'd to the author only; the ladies carry'd about with 'em the favourite songs of it in fans; the houses were furnish'd with it in screens. The person who acted *Polly*, till then obscure, became at once the favourite of the town; her *pictures* were engraved and sold in great numbers, her *life* written; books of letters and verses to her publish'd; and pamphlets made even of her *sayings* and *jests*.

The Beggar's Opera became a craze, a subject of conversation among 'all tastes and degrees of men, from those of the highest quality to the very rabble': allusion to its characters, plot, songs and language were commonplace. When the play opened in Dublin, the *Dublin Intelligence* reported: 'it is now so far the Topick of General Conversation here that they who have not seen it are hardly thought worth Speaking to by their Acquaintance, and are only admitted into Discourse on their promise of going to see it at the first Opportunity.' Ladies sang the opera's songs at their morning toilet, the Duke of Wharton and his friends took nicknames from the highwaymen in the opera and the Duke of Richmond went further, arranging an elaborate jest in which he and his companions disguised themselves as 'gentlemen of the road' and robbed his own coach, much to the terror of his wife and her companions. It was possible to buy not only the decorated house screens and fans mentioned in *The Dunciad*, but packs of playing cards engraved with the words and music of the opera's airs, and the names of the characters who sang them (fig. 169). As a result of John Rich's commission William Hogarth produced a series of paintings about the moment in the third act when Macheath, in irons, faces the dilemma of recognizing one of his lovers, Polly or Lucy, as his wife.

The Beggar's Opera was controversial as well as popular. Poems, ballads and graphic satires attacked it as a low and immoral drama distracting the public from the best works of the English stage. *A Satyrical Poem: or, the Beggar's Opera Dissected*, published in 1729, appealed to the virtuous play-goer:

> Rouze then ye Britons! Rouse at Shakespear's Call,
> His Hamlet suffers, by this surious Droll.
> A Beggar Poet, now has found an Art,
> Of pleasing Thousands, with a Tyburn Cart.

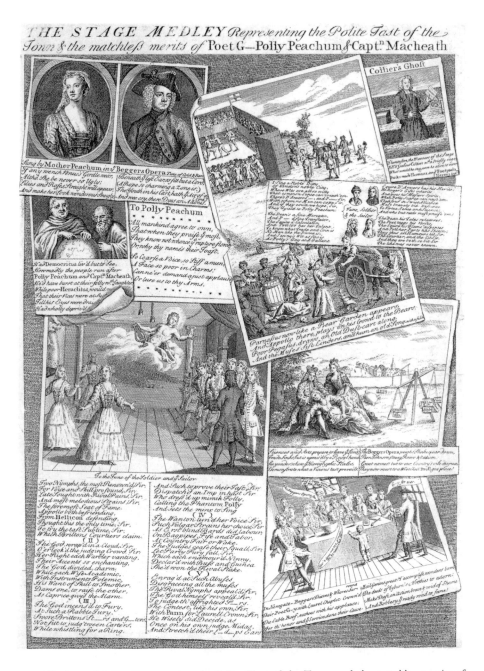

170. *The Stage Medley Representing the Polite Tast of the Town and the matchless merits of Poet G–, Polly Peachum and Captn Macheath*, 1728. One of the first attacks on *The Beggar's Opera* as a morally corrupting performance that harmed the old repertory of spoken drama

171. Theatre Ticket: *For the Benefit of Mrs Cantrell. The Beggar's Opera, Lincoln's Inn Fields,* 4 May 1730

Gay and his work were denounced from the pulpit, attacked in *Mist's Weekly Journal* and the *London Journal*, and castigated in moralizing pamphlets like *Thievery à la Mode*, which complained that the 'Cant of Newgate, and that sort of behaviour which some Malefactors are guilty of, even when under Condemnation . . . is now a matter of Mirth, and charms the British genius more than Shakspear [sic], or that Otway ever could.' The debate about its morality, which was to continue throughout the century, began with its first performance (fig. 170).

In the short run, the music, images and language of *The Beggar's Opera* saturated social life; in the longer term, the play established itself as the most popular performance in the eighteenth-century repertory. Productions were mounted on the London stage in every season until the end of the century, with renewed surges of interest in 1759–60 (two years which saw seventy-six performances, including a highly successful production at Covent Garden) and again between 1777 and 1781, when two new and controversial versions were performed. Only in the 1790s did *The Beggar's Opera*'s popularity begin to wane (fig. 171).

From the 1770s the character of *The Beggar's Opera* began to change. Though the play had always had moral critics, it was only then that their views gained more general acceptance. The *Dramatic Censor* of 1770 condemned *The Beggar's Opera* as 'a loathsome, infectious carcase, cloathed in angelic garb'. Three years later the London magistrates, led by Sir John Fielding, asked Garrick and Coleman to drop the opera from their repertory because it was a nursery of crime (they refused to do so), while that bell-wether of genteel opinion the *Gentleman's Magazine* condemned it as 'the Thief's Creed and Common Prayer book'. In the same year the young Anna Larpent saw a production which she found 'too shocking to please me. Such vice laid open'. Taste changed with morality. Verses in *The Egg, or the Memories of Gregory Giddy, Esq.* condemned *The Beggar's Opera* not just for its immorality, but because 'not one sentiment there can touch the heart'. Gay's satire did not fit well with the earnest age of sensibility.

This reforming zeal of the late years of the century affected the play

172. Mrs Farrell as Captain Macheath in *The Beggar's Opera*, 1778

in two ways: its satire was interpreted in a moralizing tone that would have made Gay wince, and it was increasingly performed as a burlesque. The effects were apparent in productions of 1777 and 1781. The 1777 Covent Garden performances offered the popular and statuesque singer Mrs Farrell in the role of Macheath, and a new sententious ending, in which the highwayman is sentenced to heave ballast on the Thames for three years, acknowledges the lenity of his punishment and resolves to be a virtuous member of society (figs. 172 & 173). A rival production at Drury Lane dressed Macheath as a fop – 'a finished Macaroni', as the *Whitehall Evening Post* put it – and also added a moral homily to the final scene. But these liberties were dwarfed by the changes made by George Colman in his 'topsy-turvy' production at the Haymarket in 1781, when the male roles were played by women, and the female by men. Not to be outdone, Covent Garden followed this with performances by an all-woman cast (figs. 174, 175, 176). This penchant for cross-dressing, which can be found in other productions of the period, was probably stimulated by the debate about the role of women and the effeminacy of men which, though it had not reached the intensity of the 1790s, was nevertheless much discussed in the 1770s.

The overall effect of these changes was to blunt the opera's edge. Its ambiguities were recast as a simple moral tale. (Not coincidentally, the only licensed performances of *Polly*, Gay's sequel to *The Beggar's Opera*, in which Macheath and his fellow criminals do get their just deserts, were staged in 1777 and 1782.) The burlesque, drawing attention to the nature of the performance, distanced it from the criminal and political worlds the play had originally satirized, and if there was any social comment in these later productions it concerned the respective roles of men and women, an issue that had not been a concern of Gay's. This bowdlerizing continued into the nineteenth century, when the opera was usually performed in two rather than three acts; the tavern scenes in which Macheath fondles, flirts and dances with his molls were cut because they were deemed too louche. *The Beggar's Opera* had never been very dangerous but it was rendered even safer.

Yet the later life of *The Beggar's Opera* consisted of much more than performances in the licensed theatre. The text of the play went through thirteen English editions in forty-five different printings. It remained one of the most popular works performed at amateur theatricals, and its songs were sung at private concerts and musical evenings. Even in the

173. Playbill. *The Beggar's Opera*, Theatre Royal, Covent Garden, 17 October 1777

174. Playbill. *For the Benefit of Miss Cateley, The Beggar's Opera*, Theatre Royal, Covent Garden, 24 May 1782

1790s *The Beggar's Opera* continued to sell well in the bookshops. The text was included in two major collections of English plays, *Bell's British Theatre*, which appeared in twenty volumes between 1776 and 1778, and in Elizabeth Inchbald's twenty-five volume *The British Theatre* (1807). Yet in line with the moralizing view of the opera that was to lead to a sharp decline in the number of its performances, Inchbald felt obliged to warn her readers about the play's depravity, even as she recognized it as the finest English opera: 'At such high estimation, a certain discount is, however, taken from its value. It fails of moral percept. – Nor is that accusation all; it has the fatal tendency to make vice alluring' (this from a former actress who had played male roles in the transvestite productions staged at Covent Garden and the Little Theatre at the Haymarket!).

In short, the popularity of *The Beggar's Opera* had transformed it into a source of allusion as well known as the characters in Shakespeare's

175. *The Beggar's Opera.*
Performed at a Little
Theatre with Great
Applause, 1786

plays or the poetry of Milton. Its thieves and whores, songs and famous lines acquired a life of their own, separate from their stage performance. The parts of the opera became as important as the whole. By the end of the century they were indeed better known than the play, cropping up in cartoons and caricatures, on sheet music, in other plays and music compositions, as well as in general conversation. As we have seen, when in 1763 the aristocratic libertine and rake the Earl of Sandwich denounced John Wilkes, his drinking companion who had shared in the orgies organized by their friend Sir Francis Dashwood, for writing the pornographic *Essay on Woman*, he quickly became known as 'Jemmy Twitcher', the thief involved in the second betrayal of Macheath, a soubriquet he could never shed.

Like his friend Alexander Pope, Gay had tried to transcend the commercial culture he wrote about by means of satiric distance and deliberate irony. (Indeed, he seems more removed from Grub Street than Pope, whose splenetic and scatological attack enmired him in the very filth he professed to despise.) By incorporating so much of this culture

into a work that depicted it with a distanced irony, it seemed to escape beyond or outside a squalid commercial world. But its freedom was fleeting, for the forces that Gay portrayed – the commercial system of fragmenting, copying and reproducing – snatched *The Beggar's Opera* back, and its forms and cunning devices which Gay himself had done so much to reveal devoured it.

Dramatic works like *The Beggar's Opera* thrived on borrowing; copying was even more vital to the visual arts. In his *Memoirs*, written in the early nineteenth century, the radical Whig politician and lawyer Samuel Romilly recalled how he had come to love pictures:

> [My father] was an admirer of the fine arts, but pictures being too costly for his purchase, he limited himself to prints; and in the later part of his life, as he grew richer, indulging himself in this innocent

176. Mr Bannister in the character of Polly Peachum, artist unknown

luxury to a degree perhaps of extravagance, he had at last a very large and valuable collection ... My father's taste for pictures and prints could hardly fail of being communicated to his children [fig. 177]. I found a great deal of amusement in turning over the prints he was possessed of, became a great admirer of pictures, never omitted an opportunity of seeing a good collection, knew the peculiar style of almost every master, and attended the lectures on painting, architecture, and anatomy, which were given at the Royal Academy ... I love to transport myself in idea into our little parlour, with its green paper, and the beautiful prints of Vivares, Bartolozzi, or Strange, from the pictures of Claude, Caracci, Raphael, and Corregio [sic] with which its walls were elegantly adorned.

Romilly's father was a jeweller of Huguenot descent who lived first in Soho and then in suburban Marylebone. He was neither a gentleman nor, until the very end of his life, wealthy. Yet he had his own little gallery with engraved images of the most famous and fashionable Old Masters.

The use of metal type to reproduce many copies of a text is the most obvious instance of mechanical reproduction of a work of art. The eighteenth-century printing press, now operating in a commercial society and unconstrained by prior censorship, ensured that once *The Beggar's Opera* had been published, it would be read anywhere in Britain, thumbed through in a gentleman's library or read on the deck of a merchantman. As we have seen, the spread of print was the bedrock on which British culture was built. But Romilly's comments reveal an equally significant and equally radical proliferation of reproduced images – prints, woodcuts and engravings. Before the eighteenth century thousands of such images produced in a variety of ways had circulated in Europe: woodcuts, first produced in fifteenth-century Germany, in which a crude but strongly defined image was produced by cutting away from the wood the parts which were to remain blank in the print; and engraving, etching and mezzotint (first developed in the seventeenth century), all intaglio processes, in which a metal plate was scored, scratched or roughened, and the design cut or etched on to the plate.

They were, however, much rarer in England, where such imagery was confined to an occasional engraving in a finely illustrated book or carefully preserved in a gentleman's cabinet or to crudely executed wood-

177. *The Caricature Portfolio* by Thomas Rowlandson

cuts adorning ballads, almanacs and broadsheets. Britain did not have a rich graphic heritage, for it did not have skilled engravers and etchers. (The best-known seventeenth-century British engraver was Wenceslaus Hollar, a Bohemian patronized by the collector Thomas Howard, Earl of Arundel and Surrey.) Engravings were luxury goods collected by aristocratic virtuosi. There was no tradition of popular imagery to compare with much of Catholic Europe. English Protestantism, peculiarly iconoclastic, did not foster the circulation of pious religious woodcuts – depicting saints, the Virgin, Christ or the martyrs – often printed in large numbers and found in even the humblest Catholic households on the continent.

So the new proliferation of images in the eighteenth century must have been striking. By the mid-century every type of image was being produced, at first by foreign engravers – Italian, Dutch and French – and then by English craftsmen. Fine art reproductions – of Old Masters, contemporary portraits and modern British painting – the political caricatures and satirical prints which foreigners admired as distinctively English, together with numerous topographical and landscape views, were

178. Trade Card: Dorothy Mercier, printseller
and stationer

179. Trade Card: Archd. Robertson, printseller
and drawing master

at the top end of a print market that extended to book and magazine
illustration, musical scores, single sheets, advertisements and trade cards,
as well as the more traditional woodcuts. In the late seventeenth century
there were only two London printsellers whose shops were of any size,
but Pendred's *Directory of the Book Trade* of 1785 listed sixty-one London
engravers and copperplate printers and twenty-four print-, map- and
music-sellers (figs. 178 & 179). London had become the home to some
of Europe's finest graphic artists: William Hogarth, admired throughout
the continent for his moralizing commentaries on contemporary life;
Benjamin Woollett, the engraver of Richard Wilson's *Niobe*, which sold
8,000 copies in its first year, who spearheaded the British invasion of the
continental print market; Francesco Bartolozzi, a Florentine trained in

the Veneto, whose London workshop produced exquisite stipple engravings that were the rage in Paris and London; James Gillray and Thomas Rowlandson, whose satires were collected by dukes and princes (fig. 180).

Indeed, by the end of the century London had become the centre of the European print trade, eclipsing Amsterdam, Venice, Augsburg and even Paris. Its biggest dealers like Boydell were part of an international network distributing British prints through agents in Paris and in most of the larger continental cities, including St Petersburg, as well as in the Americas – Boston and Rio de Janeiro – and India. Foreign princes sent apprentices to work with English masters in the printshops. In 1773, for instance, Catherine the Great sent Gavril Skorodumov to London to study stipple engraving. He remained there for six years, returned to St Petersburg as the chief engraver to the empress and became keeper of engravings at the Hermitage.

British connoisseurs collected high-quality and rare prints throughout the eighteenth century, and a growing number of dealers offered fine engravings, usually produced on the continent. Thomas Bowles's 1720 catalogue advertised that 'Gentlemen may be furnished with all sorts of

180. Detail from *A Man and a Boy Looking at Prints* by John Hamilton Mortimer, *c.* 1765–70

fine French and Dutch prints neatly fitted up on frames or without, viz. Alexander's Battles, Luxembourg Gallery, Girardon Gallery, Prospects of Versailles, with great variety of Historical pieces both Profane and Sacred.' The trade thrived on this import business; in 1730, for example, British customs recorded the arrival of 17,809 prints, including more than 4,000 from Italy (fig. 181).

The trade was supported by the same sorts of institution that sustained book publishing. Dealers like Bowles and Overton published extensive catalogues; several auctioneers sold prints, usually in coffee

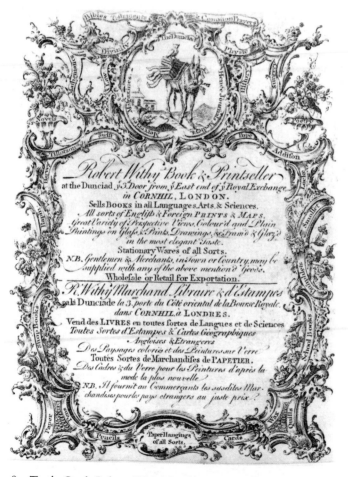

181. Trade Card: Robert Withy, book and printseller

houses; and expensive prints, especially those designed as a series, were marketed through subscriptions such as Henry Overton's and Thomas Bowles's proposal of 1717 to publish engravings after Louis Laguerre's frescos at Marlborough House of the major battles of the Duke of Marlborough. Between 1746 and 1750 the *British Magazine* even published lists of new prints, just as the *Gentleman's Magazine* listed new books. Soon a number of aristocrats and gentlemen, like Horace Walpole or Sir George Clarke, formed large collections of fine prints. Wood-engraving sold by bookshops and pedlars remained the most frequent medium for popular illustration, particularly at the top of ballad sheets and in chapbooks. But a few wood-engravers, notably Elisha Kirkall, whom Thomas Bewick greatly admired, worked for higher-quality book-sellers, illustrating such works as Samuel Croxall's *Fables of Aesop*, which first appeared in 1722 and went through fifteen editions by 1790.

But the most important changes in British engraving occurred not at the top or bottom of the trade but in the middle: in an enormous increase in inexpensive copperplate book illustration and in the marketing of inexpensive but ably executed individual prints, often published in series. Nicholas Dorigny's series of fine engravings after the Raphael cartoons at Hampton Court, which cost subscribers five guineas, was the sort of project supported by aristocrats throughout Europe; more distinctively English were the sets after Dorigny – Bowles's series priced at one guinea, the cruder set where each engraving cost a mere 1/6d., and the woodcuts marketed by Dicey. Prints whose techniques imitated the manner of paintings were particularly popular: mezzotints, which could suggest the grades of shading in oils, and later, aquatints, like those developed by Paul Sandby, or stipple reproductions of drawings such as those that came from Bartolozzi's workshop.

Elisha Kirkall's career, which immediately preceded that of Hogarth, exemplifies these trends. The son of a Yorkshire locksmith (like most engravers he was of humble origins), he worked for publishers like the Tonson family and Bernard Lintot, engraving frontispieces and plates to such classics as Ovid's *Metamorphoses*, Homer's *Iliad* and the collected works of Terence, as well as modern works like Dryden's *Plays* (1717) (fig. 182). His mezzotints included views of shipping after seascapes of van de Velde the younger, several contemporary portraits, among them the famous opera singer Senesino, and thirty plates of flowers after van Huysum. His twelve 'chiaroscuro' prints after Italian master drawings,

published in the 1720s, were one of the first of a growing number of series copying Old Masters.

The illustrative engraving and mezzotint work of Kirkall and his colleagues made prints of many famous works of art available to a large public. Almost no British tradesman in the early eighteenth century could have boasted a print collection to compare with the one admired by the youthful Romilly; such images were not available in quantity and at a price that anyone but the very wealthy could afford. But a succession of engraver-printsellers orchestrated series of engravings that made what contemporaries thought to be some of the best Old Masters in Europe available in facsimile. The first, a print dealer named Arthur Pond, collaborated with the engraver Charles Knapton in a book of seventy prints after Old Master drawings in the 1730s. He was followed by John Boydell, London's most powerful printseller, who in 1769 launched *A Collection of Prints engraved after the Most Capital Paintings in England*, a project eventually completed in nine volumes in 1792; the prints could be purchased individually, at prices of between two and twelve shillings, or in bound volumes. They were on sale through agents in Paris, Venice and Amsterdam. At the end of the century Bartolozzi, who worked in London for more than forty years, opened up the riches of the royal collection to general view in 152 prints of drawings by Guercino, many of which were in the possession of George III. The set cost four guineas; individual prints could be brought for between one shilling and 2/6d.

The importance of these reproductive engravings was not lost on British painters. The era of exhibitions after the 1760s was also a period in which British art was reproduced as never before. Recognizing that the sale of mezzotint copies of their work might be just as profitable as the fee earned from the original painting, such painters as Reynolds, West and John Singleton Copley did their best to keep control over the reproductions of their paintings, rather than letting the profits fall into the hands of the engravers. Engravings of the portraits of statesmen, national heroes, fashionable beauties and celebrities of stage and scandal were all profitable, especially after the collector and cleric James Grainger popularized the practice of interleaving the printed text of books of history and topography with prints – what came to be called grainger-izing. A portrait by Reynolds may have belonged to the sitter, but any-one could buy a small mezzotint copy from a printseller like Carington Bowles for as little as sixpence 'plain' and one shilling coloured.

182. *Dr Sylvester Partridge's Predictions* engraved by Elisha Kirkall

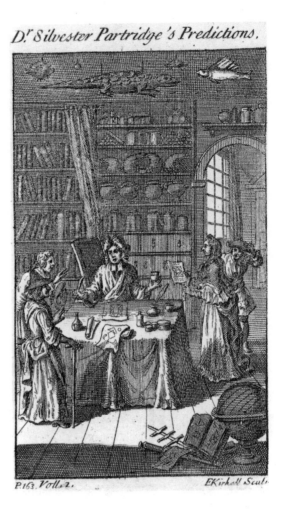

Unlike portraits, history paintings were rarely commissioned by aristocratic patrons, because they were too large and their public didacticism unsuitable for hanging in private houses. But a history painting could become profitable if its exhibition was combined with the sale of high-quality reproductions of it. Ironically, what was regarded by Reynolds and his colleagues in the Royal Academy as the highest form of visual art now came to depend for its success on mechanical reproduction. And the engraving of history paintings freed the painter from the individual grand patron: the original canvas, which took months or years to finish, could be shown at a public exhibition like the Royal Academy

show or privately, when the artist would charge for admission to a tent or showroom. (Copley, for instance, charged one shilling to view his massive *Death of Chatham*, which was displayed in a tent in Hyde Park.) Visitors viewing the painting could then order engraved copies of it, and these were sold to adorn numerous parlour walls. The simulacra also found their way into aristocrats' print collections, though the paintings themselves were unlikely to be seen in an aristocratic country or town house.

Engravings of Old Master paintings and drawings or, increasingly, of the finest works of British painters, were complemented by topographical or landscape prints, most of which were also copies of paintings, watercolours or sketches. The earliest, drawing on a Dutch topographical tradition, intended to inform rather than please; they represented places rather than imitating paintings of them. Such were the copperplates of the *Nouveau Théâtre de la Grande Bretagne*, first issued in 1707 and worked by Dutch engravers, and a more famous series, drawn and engraved by Samuel Buck and his brother Nathaniel, eventually including more than 400 views, which began publication in 1711 and were finally gathered in three folio volumes, *Buck's Antiquities or Venerable Remains of above 400 Castles, &c in England and Wales, with near 100 Views of Cities*, shortly before the artist's death in 1779 (fig. 183). Some of Bowles's *British Views*, which first appeared in 1723–4, were repeatedly incorporated into other series, and impressions were still being made in the early nineteenth century.

But landscape prints of the late eighteenth century were different from their predecessors. The fashion for paintings by Claude, Salvator Rosa and Gaspard Poussin shaped a new look: landscape was now aestheticized, the image intended to please rather than inform. John Boydell, a pioneer in this field, published more than 100 one-shilling views of England and Wales in the 1750s and a more sophisticated set of landscapes in the 1770s. By the end of the century these landscape prints, whether sold individually, in series or as illustrations to travel books, had become ubiquitous. Take, for instance, the newly fashionable centre of picturesque tourism, the Lake District. William Bellers's *Six Select Views in the North of England*, published in 1752 and sold for one guinea, included the first published images of Windermere, Derwentwater and Ullswater. Other artists soon followed in Bellers's footsteps. Thomas Smith of Derby, a pioneer who had earlier published prints of the prospects and wonders of Derbyshire and Staffordshire as well as *Four Romantick Views* in 1751,

183. *The North-West View of Donstable Priory, in the County of Bedford* engraved by Samuel and Nathaniel Buck, 1730

issued two series of Lakeland views in the 1760s; Joseph Farington's *Views of the Lakes*, a folio series of twenty prints – the first 'coffee-table' book on the Lakes – appeared in 1789, while three years later a Liverpool artist, Peter Holland, published the first book of Lake District aquatints. Guide and travel books included more and more plates. The two volumes of William Gilpin's extremely influential *Observations, relative chiefly to picturesque beauty made in the year 1772 . . . particularly the mountains, and lakes of Cumberland and Westmorland* (1786) contained thirty; Thomas Newte's *Prospects and Observations*, published five years later, had twenty-four.

This proliferation of reproduced images created a public at one remove, able to enjoy art they had little or no possibility of ever seeing in the original. For every visitor on the Grand Tour, for every tourist in the picturesque Lake District, for each connoisseur who had admired an original Raphael, Guido Reni, Claude Lorrain or Joshua Reynolds, there now existed a much larger public that approximated their experiences. In a single room, cabinet or portfolio one could enjoy reproductions of pictures scattered throughout Europe. Romilly's green-papered parlour, its walls covered with facsimile Old Masters, its cabinets filled with prints and engravings, was a little museum, a tradesman's compendium of European culture that the family could dwell on at leisure. Fine art was brought within a small compass.

It is often asserted, especially by those fortunate enough to have access to original works of art, that reproductions create two arenas of taste for visual art, one true and authentic, which appreciates the singularity of the original, the other false and fake, which is satisfied with a simulacrum. But the realm of the reproduction should be seen as not inevitably inferior but simply different. The boundary between the two, as Samuel Romilly's response to his father's collection shows, was highly permeable. Prints led Romilly, a lawyer, to exhibitions of painting and to lectures given by the president and professors at the Royal Academy. They spurred his interest and shaped his taste; even before he had seen any 'originals', he knew something of Europe's artistic heritage and its major practitioners. From the prints he derived a sense of a canon of great art, one largely shaped by what works were available in reproduction. As the author of *The Polite Arts* (1767) pointed out, engraving 'is of great use, as it multiplies the copies of fine pictures, and the impressions may be circulated all over the world. This must give great satisfaction to the curious, who cannot afford to purchase fine pictures, and many others that would but cannot purchase them.'

Aristocratic connoisseurs had long used prints to learn about art, but as reproductive engravings became more widely available connoisseurs like Richard Payne Knight emphasized the importance of the features of painting – texture, nuance of colour and brushstrokes, handling of paint – that could not be replicated in an engraving and that were the unique signs of its creator. Each engraving tried to suggest the uniqueness of the original, giving it what Walter Benjamin in his famous essay on 'The Work of Art in the Age of Mechanical Reproduction' called 'aura'. So the print simultaneously debased the original image by increasing its circulation and enhanced its value by suggesting its uniqueness.

Engravings shaped public taste, but who decided what was to be engraved? On the whole the printsellers determined this, though there is little reason to suppose that their tastes differed from those of artists or connoisseurs. Raphael was 'divine' before engravings of his work were published after Dorigny, but he was more frequently invoked as *the* great artist thereafter, and prices for his paintings rose accordingly.

A printseller's patronage was especially important for living artists. At a Royal Academy dinner in 1789, the year that John Boydell opened his Shakespeare Gallery with an exhibit of works by British artists depicting scenes from Shakespeare, Edmund Burke passed a note to Sir

Joshua Reynolds, who headed the table as president of the Academy: 'This end of the table, at which, as there are many admirers of the art as there are many friends of yours, wish to drink to an English Tradesman who patronizes the art better than the grand Monarque of France.' The message was passed on to the Prince of Wales, at that time the most important royal patron of the arts, who 'for the honour of the arts and in recompense of Mr Boydell's zeal in their support ... gave the toast of the Alderman himself'. Prints had earlier prompted paintings: many of Hogarth's works were painted as showpieces for his engravings; but Boydell, especially in the Shakespeare Gallery, used his commercial power as a printseller to commission many new works of British art. Artists quarrelled with Boydell and resented his powers – Reynolds's relations with him were cooler in the sober light of day than in the convivial atmosphere of a bibulous feast – but their conduct towards him begrudgingly recognized his power.

Prints empowered the purchaser as well as the printseller. Examining prints in one's own parlour was not the same as looking at them in an exhibition or in a country house. A humble collector could hang, sort and annotate them at his pleasure. He could arrange them historically, or according to artist, subject matter or genre. Aristocratic connoisseurs had expressed their taste and judgement through such arrangements and in the way they talked about the prints. Now this was possible for much humbler collectors. Addison may have felt that the 'charms' of looking were as great as the 'pleasures' of 'possession', but possession enabled the owner to put his mark on prints, not only literally (there was a long tradition of print collectors identifying 'their' prints by adding a cipher or symbol) but by placing them in a context that shaped their interpretation. The growing popularity of 'graingerizing', of interleaving books with prints, is one sign of how engravings enabled their purchasers as well as producers to shape culture.

In the last quarter of the eighteenth century, a number of important changes occurred in the print trade. Increasingly prints were not kept in a portfolio or framed and mounted but used as domestic decoration. These so-called furniture prints were often framed in gilt circles and ovals, and displayed as elements in a tasteful decorative scheme. 'Stipple' engravings, which used patterns of etched or engraved dots to create areas of tone and made colour reproduction easier, were especially popular because they were softer in their effect than mezzotints or line

engravings and had the added advantage that their plates were more durable and did not require frequent reworking.

A second related change was the improvement and increase in prints for book illustration. Before the 1760s few works of imaginative literature had been published with illustrations. (One famous exception was Richardson's *Pamela*, although his expensive illustrated edition was not a commercial success.) It was only in the last quarter of the century that illustrations, largely inspired by the example of the publisher John Bell, began to appear in any numbers. His volumes – *The Poets of Great Britain*, an edition of Shakespeare (dedicated, inevitably, to Garrick), and *British Drama*, which included Gay's *The Beggar's Opera* – were all marketed as pleasing objects, decorated with prints made from sketches and pictures commissioned from Angelika Kauffmann, Philipp de Loutherbourg, John Hamilton Mortimer and Francis Wheatley. A puff for a new edition of Bell's Shakespeare in the *World* of January 1787 outlined the appeal of these finely produced but relatively inexpensive books.

> It is to be remarked, that this Edition has been honoured with the most marked and flattering approbation from all classes of readers, and in every country where it has been seen, the EMBELLISHMENTS are numerous and beautiful, consisting of not less than eighty scenes and characteristic prints, designed, originally and on purpose for this work, by Loutherbourg, Burney, Ramberg, Hamilton and Sherwin in England; and by Morceau of Paris – they are engraved too by Bartolozzi, Sherwin, Delattre, Heath, Cook, Collyer, Hall and Thornthwaite, and are esteemed by the *Connoisseur* as the most perfect and beautiful set of prints, that ever was executed of the same extent, in any country.

Bell's trim little texts, illustrated by some of the most fashionable artists, were widely copied, and readers came to expect that collections of poems, plays and novels would contain well-executed engravings.

Furniture prints and book illustrations had much in common: their subject matter tended to be sentimental – moments of pathos and suffering, of unrequited love and anguished grief, focusing on women rather than men, in affecting scenes from literature and British history. Many derived from novels. Joseph Moser described the exceptional success of William Ryland's stipple after Angelika Kauffmann's *Maria*, depicting Maria of Moulines exactly as Sterne describes her in *A Sentimental Journey*

Through France and Italy: 'The prints from it were circulated all over Europe. In the elegant manufactures of London, Birmingham, etc. it assumed an incalculable variety of forms and dimensions, and was transferred to numerous articles of all sorts and sizes, from a watch case to a tea waiter.' More than thirty different prints were published in England of scenes from Goethe's *The Sorrows of Young Werther*, but it was English literature that predominated – not only Sterne, but Goldsmith (both *The Deserted Village* and *The Vicar of Wakefield*), the plays of Shakespeare, the poems of Thomas Gray, William Mason, James Thomson, Milton and William Hayley, and the ballads collected in Thomas Percy's *Reliques of Ancient Poetry*, as well as incidents taken from Rapin's *History of England*. These prints were the domestic equivalent of the larger engraving projects – Boydell's Shakespeare Gallery, Thomas Macklin's Poets' Gallery, and Henry Fuseli's ill-fated Milton Gallery – which capitalized on the growing sense of a British national heritage, a history and culture whose recovery was important in shaping a sense of British identity.

Only at the end of the eighteenth century did writers and critics set out to 'order the arts', to give a coherent, critical and historical account of literature, music and painting that placed present-day achievements in a larger context. At the same time the number of published collections of British literature and biography markedly increased. Culture, so long the handmaiden of commerce, was becoming institutionalized. By the end of the century books of critical authority – that told you what was important and why – not only spoke of the merits of individuals but conveyed a general sense of British literature and history, while the extensive practice of anthologizing made available many well-edited and carefully prepared texts at affordable prices.

The critical works came thick and fast. Horace Walpole's *Anecdotes of Painting in England*, the first history of English art, was published in 1762; Sir Joshua Reynolds's *Discourses*, which as we have seen laid the foundation for academic theory and painterly practice, appeared between 1769 and 1791 and were gathered in Edmund Malone's edition of Reynolds's *Works* of 1797. In music the densely packed mix of quotations and textual analysis that made up the five volumes of Sir John Hawkins's *A General History of the Science and Practice of Music* (1776) was matched in the same year by the appearance of the first volume of Charles Burney's

elegantly turned *A General History of Music: from the Earliest Ages to the Present Period*, whose four volumes were completed in 1789. Thomas Warton's *History of English Poetry* (three volumes, 1774–81), an antiquarian work that delved into the medieval roots of English verse, complemented the tart criticisms and measured evaluation of Dr Johnson's *Lives of the Poets*, which first appeared as prefaces to a ten-volume edition of *Works of the English Poets* (1779–81) and was then published independently.

The authors' varied backgrounds and different aims suggest the disparate forces working to shape the history of British culture. Horace Walpole was an aristocratic antiquary concerned to write an elegant history printed on his private press, 'to assist gentlemen in discovering the hands of pictures they possess'. He addressed fellow aristocrats as a fastidious aesthete, and his history was more of a catalogue than a work of history or criticism, a work of reference rather than analysis. Yet the sources of the *anecdotes* came not from the researches of a languid amateur scholar, but from within the artistic community itself. Most of Walpole's material had been culled from the thirty-nine manuscript notebooks assembled by the engraver, gossip and inveterate recorder of facts George Vertue, whose widow sold them to Walpole in 1758. Walpole omitted much of this 'material' – he did not want to appear a fact-grubber – and he polished what remained for polite readers. But his *Anecdotes* conveys the impression that Britain's artistic heritage is best understood through the eyes of gentleman amateurs who are also the best interpreters – as well as owners – of the paintings that make up the nation's native artistic tradition.

In contrast, Reynolds's *Discourses* asserted the right of painters – or, more precisely, Royal Academy painters – to arbitrate history and shape taste. A critical manifesto for the 'grand manner' as the culmination of British art, the *Discourses* projected the vision of a public of taste and virtue presided over by the Academy. Like polemical works of criticism and politics, the *Discourses* were published as pamphlets (Reynolds sent copies to influential friends); only after his death did they appear in a single volume. They were, as we have seen, a salvo fired in the battle between artists and connoisseurs to arbitrate taste. Reynolds put his case more subtly than some of his colleagues. In the tradition of Jonathan Richardson rather than Hogarth, he did not so much attack the authority of the amateur as place the academic artist on an equal footing.

Just as the amateur Walpole and the professional Reynolds had different versions of the art world, so a gentleman amateur and a professional performer and teacher had differing notions of the history of music. Sir John Hawkins (fig. 184), best remembered for his rather tedious biography of Johnson (1787), resembled Horace Walpole in having the leisure and wealth to assemble a learned history. An enthusiastic musician and retired attorney whose wife had inherited a fortune, he filled his vacant hours by plunging into an ocean of literary archives and musical arcana. But Hawkins, like many antiquarians, did not wear his learning in the light and elegant manner advocated by Walpole. Though his chief aim was to demonstrate that music was a science, the torrent of detail with which he drowned the reader also submerged the outline of his argument. Hawkins wanted to absolve music of the accusation of frivolity but, as we shall see, his work was not a success, for he was unable to find or create a constituency willing to accept his authority.

Hawkins's history seemed all the more cumbersome and complex when compared with the elegant prose and emollient exposition of

184. *Sir John Hawkins* by S. Harding, engraved by R. Clamp, 1794

Charles Burney, a professional musician of humble birth (fig. 185). Burney, eager for social success and anxious about his origins, had acquired his engaging manner in aristocratic drawing rooms while tutoring his numerous genteel pupils in King's Lynn in the 1750s and after settling in London in 1760. (As William Hazlitt acerbically remarked, Burney was 'an historian and a musician, but more of a courtier and man of the world than either'.) Not surprisingly, he presented his readers with a history of music as an 'innocent luxury' that was tasteful, polite and sociable. If for Hawkins music was a science, for Burney it was like conversation in its 'art of pleasing'. He wanted its history to be accessible and clear, not cramped and obscure, a subject fit for polite society rather than for the study of the antiquary. Unlike Hawkins, Burney found an audience eager to accept his view: amateurs and professionals embraced a history that created a consensual and refined conception of musical performance. So Burney's history, so very different in form from the *Discourses*, nevertheless resembles Reynolds's work in helping to create a

185. *Charles Burney* by Joshua Reynolds, engraved by Bartolozzi, 1784

Through France and Italy: 'The prints from it were circulated all over Europe. In the elegant manufactures of London, Birmingham, etc. it assumed an incalculable variety of forms and dimensions, and was transferred to numerous articles of all sorts and sizes, from a watch case to a tea waiter.' More than thirty different prints were published in England of scenes from Goethe's *The Sorrows of Young Werther*, but it was English literature that predominated – not only Sterne, but Goldsmith (both *The Deserted Village* and *The Vicar of Wakefield*), the plays of Shakespeare, the poems of Thomas Gray, William Mason, James Thomson, Milton and William Hayley, and the ballads collected in Thomas Percy's *Reliques of Ancient Poetry*, as well as incidents taken from Rapin's *History of England*. These prints were the domestic equivalent of the larger engraving projects – Boydell's Shakespeare Gallery, Thomas Macklin's Poets' Gallery, and Henry Fuseli's ill-fated Milton Gallery – which capitalized on the growing sense of a British national heritage, a history and culture whose recovery was important in shaping a sense of British identity.

Only at the end of the eighteenth century did writers and critics set out to 'order the arts', to give a coherent, critical and historical account of literature, music and painting that placed present-day achievements in a larger context. At the same time the number of published collections of British literature and biography markedly increased. Culture, so long the handmaiden of commerce, was becoming institutionalized. By the end of the century books of critical authority – that told you what was important and why – not only spoke of the merits of individuals but conveyed a general sense of British literature and history, while the extensive practice of anthologizing made available many well-edited and carefully prepared texts at affordable prices.

The critical works came thick and fast. Horace Walpole's *Anecdotes of Painting in England*, the first history of English art, was published in 1762; Sir Joshua Reynolds's *Discourses*, which as we have seen laid the foundation for academic theory and painterly practice, appeared between 1769 and 1791 and were gathered in Edmund Malone's edition of Reynolds's *Works* of 1797. In music the densely packed mix of quotations and textual analysis that made up the five volumes of Sir John Hawkins's *A General History of the Science and Practice of Music* (1776) was matched in the same year by the appearance of the first volume of Charles Burney's

elegantly turned *A General History of Music: from the Earliest Ages to the Present Period*, whose four volumes were completed in 1789. Thomas Warton's *History of English Poetry* (three volumes, 1774–81), an antiquarian work that delved into the medieval roots of English verse, complemented the tart criticisms and measured evaluation of Dr Johnson's *Lives of the Poets*, which first appeared as prefaces to a ten-volume edition of *Works of the English Poets* (1779–81) and was then published independently.

The authors' varied backgrounds and different aims suggest the disparate forces working to shape the history of British culture. Horace Walpole was an aristocratic antiquary concerned to write an elegant history printed on his private press, 'to assist gentlemen in discovering the hands of pictures they possess'. He addressed fellow aristocrats as a fastidious aesthete, and his history was more of a catalogue than a work of history or criticism, a work of reference rather than analysis. Yet the sources of the *anecdotes* came not from the researches of a languid amateur scholar, but from within the artistic community itself. Most of Walpole's material had been culled from the thirty-nine manuscript notebooks assembled by the engraver, gossip and inveterate recorder of facts George Vertue, whose widow sold them to Walpole in 1758. Walpole omitted much of this 'material' – he did not want to appear a fact-grubber – and he polished what remained for polite readers. But his *Anecdotes* conveys the impression that Britain's artistic heritage is best understood through the eyes of gentleman amateurs who are also the best interpreters – as well as owners – of the paintings that make up the nation's native artistic tradition.

In contrast, Reynolds's *Discourses* asserted the right of painters – or, more precisely, Royal Academy painters – to arbitrate history and shape taste. A critical manifesto for the 'grand manner' as the culmination of British art, the *Discourses* projected the vision of a public of taste and virtue presided over by the Academy. Like polemical works of criticism and politics, the *Discourses* were published as pamphlets (Reynolds sent copies to influential friends); only after his death did they appear in a single volume. They were, as we have seen, a salvo fired in the battle between artists and connoisseurs to arbitrate taste. Reynolds put his case more subtly than some of his colleagues. In the tradition of Jonathan Richardson rather than Hogarth, he did not so much attack the authority of the amateur as place the academic artist on an equal footing.

The Macaroni Painter, or Billy Dimple sitting for his picture by Robert Dighton,
engraved by Richard Earlom, 1772. A satire on the fashionable painter and his sitter,
directed at the miniature painter Richard Cosway

PLATE 9

Sir Brooke Boothby by Joseph Wright of Derby, 1781

PLATE 10

The Macaroni Painter, or Billy Dimple sitting for his picture by Robert Dighton,
engraved by Richard Earlom, 1772. A satire on the fashionable painter and his sitter,
directed at the miniature painter Richard Cosway

PLATE 9

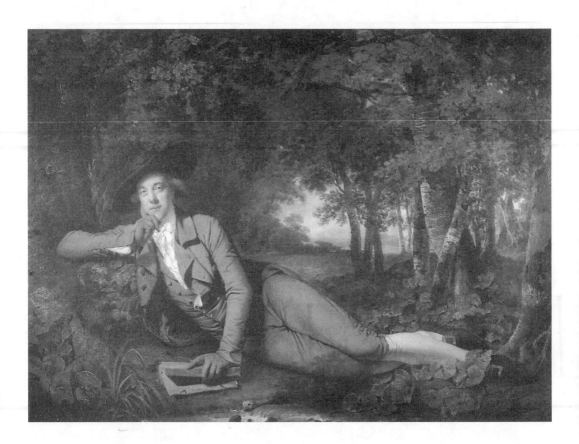

Sir Brooke Boothby by Joseph Wright of Derby, 1781

PLATE 10

Self-portrait by Ozias Humphry, *c.* 1780

PLATE 11

Cader Idris by Richard Wilson, *c.* 1765–67.
Wilson has softened and rounded the wild Welsh mountain's contours to make the
remote scene appear more harmonious and orderly

PLATE 12

186. *The Reverend Doctor Thomas Warton* by Joshua Reynolds, engraved by William Holl

broadly based sensibility fashioned by practitioners who called themselves gentlemen.

Gentlemen amateurs and professional artists far outnumbered academics as contributors to these histories. The only university don to write such a work was Thomas Warton, an Oxford cleric and antiquary who moved in Jacobite circles (fig. 186). His *History of English Poetry* (1774–81), vastly learned (though less learned than it appeared) and nostalgic about England's literary past, drew on a large body of antiquarian materials for a dense and detailed history that unearthed the medieval and Renaissance roots of English verse. As Edward Gibbon remarked, it displayed 'the taste of a poet and the minute diligence of an antiquarian'. Its appeal extended beyond the academy, its readership including local historians and antiquaries and an even larger number of poets, almost all of them amateur, who wanted to place their versifying within a national literary tradition. Warton was a vast source book for those who wished to use earlier literary forms and English history to develop their own poetic expression.

Warton's wide-ranging, uncritical antiquarianism contrasted vividly with Johnson's sharply focused *Lives of the Poets*, as careless of historical detail as it was unashamedly determined to pass judgement on the men and work that made up what Johnson considered the central figures in the history of British poetry. Though Johnson had written some of the lives much earlier – his famous *Life of Savage* had first appeared in 1744 – the writing of the *Lives* was prompted by a Grub Street commission in 1777. A group of thirty-six booksellers, seeking to scotch a rival collected edition of poetry, recruited Johnson to give their volumes greater cachet by writing short biographical sketches about each of the poets whose work they had selected; as was so often the case, Johnson's book – though it far exceeded the publishers' requirements, for each life was too long, and they came out too slowly – was written for money. Johnson was paid 200 guineas at the outset and a further 200 guineas when the *Lives* appeared as a separate volume. As with all his writing, Johnson's audience was broadly conceived. He wrote for the public and hoped to shape the judgement of the general reader.

So the histories seem to fall into two groups: one, written by professionals – Reynolds, Burney and Johnson – was critical and intended to persuade and educate the public; the other, produced by amateurs and 'scholars' – Walpole, Hawkins and Warton – was more antiquarian and was directed towards a more specialized audience. Yet there were similarities: all the writers, except Horace Walpole, were members of Johnson's Literary Club and active participants in London's critical and literary scene; even the amateurs, except Sir John Hawkins, reached a large public. They were all part of the same circle of conversation, a sort of cultural establishment setting the tone of debate about arts and literature and placing it in a historical perspective. Indeed writing such critical histories and gaining recognition for them is one means by which a cultural establishment is constituted and comes to recognize itself. This was the body that, as we have seen, Johnson described to Boswell as a 'collection of conspicuous men, without any determinate character', a group united by their self-proclaimed position as arbiters of public taste and conservators of a national heritage. When Boswell and Johnson visited the decayed university of St Andrews, on their Scottish tour in 1773, they fantasized about how their club could revive its fortunes: 'If . . . our club should come and set up in St Andrews, as a college, to teach all that each of us can, in the several departments of learning and

taste, we should rebuild the city: we should draw a wonderful concourse of students.'

Sir John Hawkins came to be excluded from this charmed circle. His *History*, the work of neither a professional critic nor a true gentleman amateur (Hawkins was the son of a carpenter grown rich through a judicious marriage), appealed to neither group. Too serious, too turgid and too inelegant for the likes of Walpole, it was too antiquarian and lacking in critical perspective for the professionals. Hawkins might have overcome these reservations if he had been willing to ingratiate himself with polite society and literary London. But he did not comport himself well in the drawing room or tavern, and everyone agreed in finding him extremely disagreeable. Though he remained one of Johnson's oldest friends and was his executor, he was described by Johnson, who was apt to defend Hawkins in company, as 'a most *unclubable* man' and as having 'a degree of brutality, and a tendency to savageness, that cannot easily be defended'. At the Literary Club he was conspicuous for his absence, attending very rarely and eventually removing himself altogether. According to Boswell.

> Sir John Hawkins represents himself as a '*seceder*' from this society, and assigns as the reason of his '*withdrawing*' himself from it, that its late hours were inconsistent with his domestick arrangements. In this he is not accurate; for the fact was, that he one evening attacked Mr. Burke, in so rude a manner, that all the company testified their displeasure; and at their next meeting his reception was such, that he never came again.

Hawkins, lacking powerful defenders, was vulnerable to attack. His *History of Music* was savaged by reviewers, and their vituperative onslaught, largely planned by Charles Burney, left his work fatally wounded in the eyes of the public. When he later published a *Life of Johnson* he met with similar treatment from other members of the Literary Club. The leaders of literary society quarrelled frequently, of course, but these were squabbles among insiders; Sir John's social ineptitude and turgid scholarship placed him beyond the pale.

Hawkins's failure underlines the obvious fact that histories of the arts and literature had to shape the taste of a defined public, and derived authority not just from their authors' reputations, but from the promotional efforts of the luminaries who liked them. All the writers,

whatever the subject they addressed, wished to be accepted as arbiters of taste. Burney or Reynolds did not want to be thought of merely as musicians or painters, but as 'men of letters', which meant that they were entitled to be seen as leading critics.

The making of an establishment also creates outsiders. The success of these histories of the arts provoked much hostility. William Blake – visionary, radical artist, the habitué of the artisanal world of engravers which Reynolds marginalized in his *Discourse* and as craftsmen to be kept out of the Royal Academy – covered his copy of *The Works of Sir Joshua Reynolds* with angry annotations pithily summarized in his opening remark – 'This Man was Hired to Depress Art'. His response is as much concerned with the authority of Reynolds and his fellow Academicians and their effects on his own position as with the nature of art:

> Having spent the Vigour of my Youth & Genius under the Oppression of St Joshua & his Gang of cunning Hired Knaves . . . Without Employment & as much as could possibly be Without Bread, The Reader must Expect to Read in all my Remarks on these Books Nothing but Indignation & Resentment . . . The Enquiry in England is not whether a Man has Talents and Genius. But whether he is Passive and Polite & a virtuous Ass & obedient to Noblemen's Opinions in Art and Science. If he is, he is a Good man. If not, he must be Starved.

Other attacks were similarly vituperative. Warton was savaged by the antiquary Joseph Ritson in *Observations on the three first volumes of the History of English Poetry* (1782). Ritson's scholarship revealed many errors on Warton's part and he provoked an extended controversy in the *Gentleman's Magazine*, but this only served to acknowledge the authoritative power of Warton's *History*. Likewise, a succession of critical commentators complained about Johnson's interpretations in *Lives of the Poets* especially what they considered his lack of generosity towards Milton, but what principally aggrieved them was his success in establishing himself as the leading literary authority of the age. For it was soon received wisdom that, in Burney's words, 'Dr. Johnson, in his admirable Lives of our Poets, though his opinions concerning the merit of some of them are disputed and have never satisfied my own mind, has manifested such powers of intellect, and profound critical knowledge, as will probably

settle the national opinion on many subjects of literature upon an unmoveable foundation.'

Though no earlier critical histories achieved the authority of those written in the last quarter of the eighteenth century, efforts to write them were not new. Walpole, Reynolds, Hawkins, Burney, Warton and Johnson all relied, in varying degrees, on the research and ideas of their predecessors, occasionally stealing their words and sometimes acknowledging their debt. So their histories were less a beginning than the culmination of more than a century of research and criticism. Jonathan Richardson's writings on connoisseurship were used by Walpole and Reynolds; the *Essay on Musical Expression* (1752), by the Newcastle composer, conductor and organist Charles Avison, foreshadowed the work of Burney in discussing music as 'this pleasing Art'. And since the seminal works of John Dryden – including *An Essay of Dramatick Poesie* (1668), *A Discourse concerning the Original and Progress of Satire* (1693), and in prefaces to literary works – many poets, playwrights, essayists and editors had published literary criticism in prose and verse. Alexander Pope, his friend Joseph Spence, and Thomas Gray all sketched out proposals or schemes for a literary history, though none came to fruition.

Equally important were the collectors of data and compilers of facts. Walpole, Hawkins, Warton, Burney and even Johnson drew on collections of pedigrees, scraps of verse, engravings, classical texts and inscriptions and on local histories that dated back to the sixteenth century and the foundation of the Society of Antiquaries in 1572, all of which had been lovingly conserved by amateur scholars and antiquarians. William Oldys, an antiquary, librarian and hack whose debts forced him to live in the Fleet Prison before a patron secured him a position in the College of Arms, was the most notable of these men. Described by one contemporary as 'an excellent picker-up of facts and materials' whose industry was put to good use by others, he spent his life collecting and annotating books and manuscripts. Oldys became the librarian of the great collector and bibliophile Edward Harley, second Earl of Oxford. During the three years before the nobleman's death in 1741 he catalogued his library of more than 20,000 volumes and, together with the young Johnson, worked on the *Harleian Miscellany*, an annotated collection of some of the library's rarest items.

Oldys contributed materials to no fewer than three literary collections – Thomas Hayward's *The British Muse* (1738), Mrs Cooper's *The Muses*

Library (1737) and *The Lives of the Poets of Great Britain and Ireland in the Time of Dean Swift* (1753), whose five volumes appeared under the name of Theophilus Cibber. In addition, he was the first editor of the *Biographia Britannica* (1747–66), and contributed more than twenty long entries in this best-known of the several biographical dictionaries that appeared in the mid-eighteenth century. He also worked on Thomas Birch's *A General Dictionary, Historical and Critical*, which was intended as a supplement to the great *Dictionnaire historique et critique* of Pierre Bayle. Oldys advised Pope on his edition of Shakespeare, and his annotated texts and antiquarian volumes were later used by Warton and other critics. A hewer of wood and drawer of water, with little or no ability to order his voluminous findings, he was an invaluable mine of information for others.

The prodigious labours of Oldys and his fellow antiquarians made the later histories possible: their often indiscriminate riffling through the rubbish of history revealed much that was believed worth salvaging and also, through its very copiousness, gave critics a feel for the diverse complexity of the materials they wanted to shape and mould. The desire for comprehensiveness, the wish to enumerate the world – an impulse that prevented the likes of Oldys from writing analytically – made the later critical cultural histories possible.

It is sometimes said that the cultural histories written by Johnson and his friends created a pantheon or national shrine for Britain's great artists, and certainly some of the writers were interested in canonization. Burney spoke of 'HENRY PURCELL, who is as much the pride of an Englishman in Music, as Shakespeare in productions for the stage, Milton in epic poetry, Lock[e] in metaphysics, or Sir Isaac Newton in philosophy and mathematics'. Prompted by a patriotic desire to assert that Englishmen were as talented as their modern French rivals, Burney wanted to ally Purcell with a select band of seventeenth-century giants whose achievements reflected well on the nation. This impulse was hardly new. Antiquarians had long justified their researches on the grounds that they would reveal England's cultural superiority; similarly, the claim that British poets were a match for all comers, though heard more often in the eighteenth century, had been made before, as by Dryden's Eugenius in his *Essay of Dramatick Poesie* of 1668: 'I am at all times ready to defend the honour of my country against the French, and to maintain, we are as well able to vanquish them with our pens, as our ancestors have been with their swords'.

Biographical dictionaries, critical editions, panegyric verses and all sorts of criticism trumpeted the claim that a modern zenith had been reached on the shores of Albion. But the frequency of these protestations suggests an underlying insecurity, and particularly an awareness of the cultural power of France. By the end of the century these anxieties had largely been allayed: Britain had vanquished France in the Seven Years War that ended in 1763, domestic institutions for the fine arts and imaginative literature were well established, and British artists, authors and performers were admired throughout Europe. Claims for British culture were now seen, both in Britain and abroad, as altogether more plausible.

It had been argued since the Renaissance that the enduring reputation of the ancients was proof of their genius and value. As David Hume put it, 'the same *Homer*, who pleased at ATHENS and ROME two thousand years ago, is still admired at PARIS and at LONDON. All the changes of climate, government, religion, and language have not been able to obscure his glory.' Such sentiments were now expressed about native English authors. The critic John Dennis observed, 'Tis now a hundred years since *Shakespear* began to write, more since *Spencer* flourished, and above 300 years since *Chaucer* died. And yet, the Fame of none of these is extinguish'd.' During the 1720s English authors and works in English were first referred to as 'classics'. A national tradition embodied in the work of a number of key authors was beginning to take shape.

The idea of a patriotic shrine memorializing national heroes was not new. The Poets' Corner in Westminster Abbey had begun with the interment of Spenser and others near a monument to Geoffrey Chaucer, erected in the 1550s; by the late eighteenth century it had become crowded. A temple of British worthies, erected in the 1730s by the Earl of Cobham in his gardens at Stowe, contained busts of Shakespeare, Francis Bacon, Milton, Newton, Locke, the architect Inigo Jones, together with politicians (Sir Thomas Gresham, John Hampden and Sir John Barnard), military heroes (Sir Walter Raleigh and Sir Francis Drake), and the royal figures of Alfred, Edward, Prince of Wales (the Black Prince), Elizabeth and William III. The trade cards of London booksellers displayed a similar panoply of heroes, albeit one affected by the commercial interests of individual tradesmen (fig. 187). Thus John Wilkie, whose business flourished in the 1760s and 1770s, includes Shakespeare, Milton, Dryden, Addison, Pope and Edward Young – a

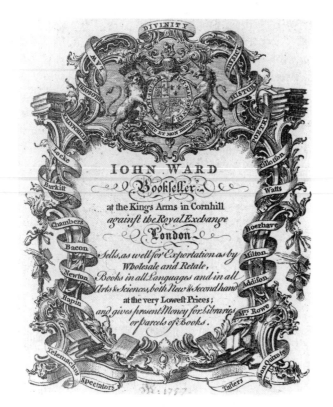

187. Trade card: John
Ward, bookseller, 1757

conventional literary pantheon – but adds philosophers and theologians
such as Locke, Newton, Boyle, Samuel Clarke and John Tillotson (fig.
188). As these examples indicate, the pantheon was not confined to literary
and artistic figures. Locke and Newton were in a way more obviously
canonical figures than Shakespeare who was much criticized by Restor-
ation critics and whose reputation reached its height later with the age
of Garrick, or Milton, whose republican politics still made him suspect
a century after the defeat of the English Revolution. The key figures
were giants in an international republic of letters rather than of native
English literature, and artists were not privileged over politicians,
scientists, philosophers or theologians.

As the century progressed this situation was subtly transformed with
the growing emphasis on English literature, rather than the classic Greek
and Roman texts, in education and instruction. Not that the classical
languages declined in importance (though perhaps this was true of Greek)

but they were now complemented by English works, while the proliferation of translations of the classics into English meant that classical literature was in many ways anglicized. Again, the desire to use English authors was a patriotic impulse. The Irishman Thomas Sheridan, an influential teacher of elocution, described English as the third and superior 'classical' language, and argued in his *British Education: or the Source of the Disorders of Great Britain* (1756) for using Britain's literary heritage as the basis for polite instruction:

> as models of style, Milton in the poetic, and Shakespeare in the dramatic, Swift, Addison, Dryden, and Sir William Temple (in some of his works) in prose, may be considered as truly classical, as the Virgil, Caesar, Tully, and Sallust of the Romans; nor is there any reason that they should not be handed down as such equally to the end of time . . .

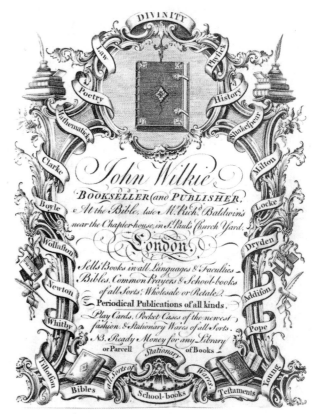

188. Trade card: John Wilkie, bookseller and publisher

> And shall we not endeavour to secure to future generations, entire and unchanged, their birthright in Milton, in Addison, and Swift? Or shall we put in the power of a giddy and profuse age to dissipate, or render of no value, the heaps of treasure now collected in the many excellent books written by English authors?

Sheridan's claim was not novel – Addison and Steele, too, had argued that imaginative literature in the native tongue was one of the best means of stylistic and moral instruction – but it was becoming a commonplace. Perhaps most important of all, Sheridan writes of a 'birthright', a tradition that should be 'handed down' from generation to generation. He was pressing for the idea of a cultural heritage, a collective property whose value would be enhanced by repeated use. He also argued that certain institutions – schools, publishers and critics – should preserve and distribute this inheritance. For him the issue was not whether Britain's luminaries were more distinguished than those of the rest of Europe or had advanced further than the great figures of ancient Greece and Rome, or who should be in the pantheon – though he was certainly concerned about all these questions. What mattered, rather, was to create a shared set of values, a shared inheritance, best expressed by the ablest exponents of the English language.

Understandably, Shakespeare was central to this heritage. As Edward Capell explained in his 1768 dedication of his edition of Shakespeare's works to the Duke of Grafton:

> The works of such great authors as this whom I now have the honour of presenting to your Grace, are part of the kingdom's riches: they are her estate in fame, that fame which letters confer on her; the worth of and value of which sinks or raises her in the opinion of foreign nations, and she takes her rank among them according to the esteem which these are held in: It is therefore an object of national concern, that they should be sent into the world with all the advantage which they are in their own nature capable of receiving ... The following great productions stand foremost in the list of these literary possessions.

This way of thinking, which treats culture as a special sort of property owned by the public or nation, raised the central question of who was to effect the all-important processes of cultural inheritance and transmission. Here a radical change occurred in the 1770s. It is only a mild exaggeration

to say that before the House of Lords made its decisions (notably in the case of *Donaldson v. Beckett* in 1774) which effectively ended perpetual copyright and the London monopolies in the book trade, the transmission of Britain's cultural heritage in its printed forms had been under the exclusive control of London's major booksellers. Their claim to perpetual copyright in the works they published, which was defended successfully in the courts and sustained with restrictive trade practices, kept the works of Shakespeare, Milton, Addison and Steele firmly under their control. The literary heritage was in their hands; for all Sheridan's rhetoric, it was not the property of the public. Ordinary people – whether commoner or nobleman – could, of course, buy the books, but only those which a small coterie of booksellers chose to put on the market.

These restraints profoundly affected the idea people had of which writers were in the pantheon. It was not possible for just any bookseller to produce an edition of Shakespeare, Milton or Addison; only those who held shares in the copyrights could do so. A copyright owner in Milton or Shakespeare had every interest in promoting 'his' author, and no interest in seeing competing editions of that writer's works. He was prepared to publish and promote, but to do so exclusively. Jacob Tonson who, as we have seen, was a member of the Kit-Cat Club and one of the original petitioners for the Copyright Act – he was called the 'Chief Merchant of the Muses' – held the copyrights to *Paradise Lost*, which he had bought up in 1683 and 1690, as well as to works of Shakespeare, Waller, Cowley, Dryden (whom he published during the poet's lifetime), Congreve, Beaumont and Fletcher, Waller and Spenser. Between 1712 and 1714 his partner and nephew Jacob Tonson junior purchased the copyright of the *Spectator* from Addison and Steele. This family business, which continued into the reign of George III, owned outright what we see in retrospect as a sizeable chunk of Britain's literary heritage, and this is no coincidence, for the Tonsons' publishing strategies helped to make the literature they owned acceptable as classics.

The practice of publishing an elaborately produced edition in order to enhance an author's reputation was a well-tried stratagem, especially for playwrights. Ben Jonson had carefully supervised the folio edition of his works that appeared in 1616; two generations later William Congreve similarly presided over the transformation of his plays into works of literature. The Tonsons promoted 'their' authors with high-quality editions of Milton, Virgil, Ovid and Racine, substantial and beautifully

produced in elaborate formats with fine typography, and sold as objects of permanence and quality.

Shakespeare was accorded similar treatment. Between the Restoration and Tonson's 1709 edition only a few rag-bag collected editions and quarto copies of his most popular plays had been published. His popularity and reputation were no greater than those of Beaumont and Fletcher or Ben Jonson, the only other pre-Restoration playwrights whose works were published in folio. Successive imprints of his plays were intended to cash in on the popularity of particular performances; they addressed audiences rather than readers, and were occasional pieces, not books for posterity.

But in the 1709 edition the Tonson publishing house produced the first of a series of prestigious critical editions which they commissioned over the next sixty years. The six-volume *The Works of Mr William Shakespeare*, edited by the tragic dramatist Nicholas Rowe, was followed by those of Alexander Pope (1725), Lewis Theobald (1733), William Warburton (1747), Samuel Johnson (1765) and Edward Capell (1768). The Tonsons' choice of editors was shrewd. They picked Rowe at a time when Shakespeare's tragedies were his most popular works; Pope was a famous literary figure; Theobald had excited controversy by his criticisms of Pope's edition; Warburton and Johnson were accepted as the greatest critics of their generation. Capell was an exception, an outsider with radical views about editing the texts, and the Tonsons went along with his edition only reluctantly.

Rowe's edition set the pattern for other Tonson volumes. It was published in six small octavos rather than in a large single folio, but it was clearly intended for posterity. In addition to the plays, it included the first lengthy account of Shakespeare's life, an engraved frontispiece taken from the Chandos portrait of the playwright, and engravings illustrating each play. Rowe's introduction vigorously maintained the superiority of Shakespeare over his rivals, Beaumont and Fletcher and Jonson.

The fame or notoriety of Shakespeare's editors, and the literary controversy their decisions provoked, ensured that each edition, though of the same text and from the same publishing house, was welcomed as something new. And by choosing well-known critics the Tonsons marshalled the full critical weight of the times behind the Bard. Since each editor-critic referred to his predecessors, Shakespeare's works

became the site of major battles, where principles of editing, the nature of taste, and the shape of Britain's literary tradition were argued out.

Shakespeare was taken to represent qualities that were distinctively British. His plays may not have been as formally correct as Racine's and Corneille's, yet his minor imperfections were as nothing when compared to his free creativity. His imaginative powers and original genius allowed him, the critics thought, to transcend the strict rules of classical and neo-classical drama and to rise above the carping criticism of foreigners. As the biographical entry in *The British Plutarch* (1776) put it, 'William Shakespeare, the immortal father of the British theatre; the glory of his age and of his country; whose dramatic works have stood the test of the severest criticisms, especially from foreigners, and, with all their imperfections on their heads, still remain unrivalled by any modern bard.'

Shakespeare's freedom, like the liberty of the British political system, was contrasted with the rigid etiquette of French absolutism and the formalism of his great French rivals. When the French Revolution replaced royal despotism with radical republicanism, the argument was subtly adjusted. Now Shakespeare's work was viewed as natural and as developing organically, like the British constitution as described in Burke's *Reflections on the Revolution in France* (1790); by contrast the Jacobin regime, like the dramas of Corneille and Racine, was governed by rigid and formal rules. As Jane Austen commented in *Mansfield Park*, 'Shakespeare one gets acquainted with without knowing how. It is a part of an Englishman's constitution.'

Thanks to the attentions of Tonson and his editors, by the 1720s Shakespeare had become 'a Classic writer'. By mid-century the cult of the Bard had, as we have seen, reached unparalleled heights. One of Garrick's early promoters, Lord Lyttelton, wrote in his *Dialogues with the Dead* that 'If Human Nature were quite destroyed, and no Monument left of it except [Shakespeare's] Works, other Beings might know what Man was from the Writings.' As the lawyer-playwright Arthur Murphy put it rather more sardonically: 'SHAKESPEAR is a kind of establish'd Religion in Poetry.'

The assiduity with which the Tonsons nurture their property helps to explain why Shakespeare came to play such a central part in the drama of English literary history. The Tonson booksellers, who moved to new premises at 'Shakespeare's Head' in the Strand in 1710, created an institutional framework within which the Bard's reputation could flourish.

Shakespeare became famous not as a dramatist but *as an author*. His editors progressively removed him from the theatre and confined him to the page. In Pope's edition of 1725 the best passages were identified by double commas in the margin, and readers had analytical indexes to help them extract, as the play-goer could not, favoured scenes and speeches; a play's dramatic unity, perceived in performance, was lost. In 1752 the Reverend William Dodd, a fashionable cleric and friend of Dr Johnson (who was later hanged for forgery), published *The Beauties of Shakespeare*, an anthology that survived into the twentieth century, in which the plays of Shakespeare were cut up into easily digested segments and pieces.

The booksellers' handling of Shakespeare's texts was duplicated, though not quite so spectacularly, with other authors. The London book trade, cautious, conservative, yet keenly interested in elevating the writers it 'owned', produced a succession of quality editions, and they generally promoted the sense that Britain had a small, well-defined pantheon of literary deities, whose minders would ensure that they did not stray into the wrong hands. Britain's literary heritage was the property of the booksellers, and they were determined to keep it.

This proprietary interest, which its opponents condemned as a monopoly, came under repeated attack. 'Pirates' in London stole and reprinted copyrighted texts, but the chief invaders of property came from Scotland and Ireland, where booksellers were not under the jurisdiction of English law. Their editions, often taken directly from their English counterparts, were not illegal, provided they did not export the books to England. But the ambitious booksellers of Dublin and Edinburgh, where the book trade was growing rapidly from mid-century, were not content with local clienteles; they challenged the law, exporting numerous books to England, distributing them through the network of provincial booksellers. The London publishers, ever mindful of their property, mounted a campaign against the Celtic pirates in the 1750s and tried to tighten their grip on the provincial trade.

One Edinburgh bookseller, Alexander Donaldson, who had made a good living from exporting Scottish editions to England, decided to take on the London trade in the most provocative manner possible: in 1763 he established a bookshop in London and openly sold his Scottish editions, boasting of how he undercut the prices of his rivals between 30 and 50 per cent. The provocation could not go unheeded. With the help of other

publishers, Andrew Millar, one of London's most powerful booksellers, took Donaldson to court. The case was one of several Millar brought to defend one of his most valuable properties, James Thomson's enormously popular blank verse poem *The Seasons*, the copyright of which he had purchased many years earlier for more than £300. Millar was a bookseller of the old school. He owned a number of important copyrights, including those to Henry Fielding's *Tom Jones* and *Amelia*; he was a major figure in the consortium of booksellers that had published Johnson's *Dictionary* – 'I respect Millar, Sir,' said Johnson, 'he has raised the price of literature'; and he had been the chief undertaker behind David Hume's *History of England*. He professed to despise such publishers as John Bell, who had taken to producing small cheap editions for a larger readership. 'It is as bad as robbery', he complained, 'for Bell to supply the market with every book.'

Millar's prosecution led to protracted litigation that ended only after his death. He thus avoided the disappointment of seeing a decision that ended perpetual copyright and, by breaking up the cartel of London booksellers, radically transformed publishing. In the aftermath of *Millar v. Donaldson* and a number of related cases, some publishers, notably John Murray, Longmans and Rivingtons, ceased to be booksellers and devoted themselves exclusively to publishing. Individual specialist wholesale booksellers replaced the old consortia that had held the copyright monopoly together. A new breed of booksellers emerged, no longer concerned with publishing but with developing sophisticated, fashionable retail outlets like Hatchard's which opened on Piccadilly in 1797. Publishers, wholesalers and retail booksellers emerged as discrete links in a chain forged by a far more competitive, unprotected trade.

The debate about perpetual copyright and the aftermath of the *Millar v. Donaldson* case profoundly affected the idea and form of Britain's national literary heritage. During the pamphlet war that had accompanied the litigation, important arguments were advanced against the booksellers' assertion that a perpetual copyright was a form of inalienable property, arguments that the free circulation of ideas was a matter that deeply affected the public weal. As Donaldson's lawyers argued, '*Public Utility* requires that the Productions of the Mind should be diffused as wide as possible, and therefore *Common* Law could not, upon any principles consistent with itself, abridge the Right of multiplying Copies.' From this point of view, once a text was published it became a sort of

property held in common by its readers. As one of the judges put it in another case brought by Millar, 'the very matter and contents of . . . books are by the author's publication of them, irrevocably given to the public; they become common; all the sentiments contained therein, rendered universally common; and when the sentiments are made common by the author's own act, every use of those sentiments must be equally common.'

The argument against the property rights of booksellers held that general access to freely circulated ideas encouraged progress, a plea appropriately voiced most eloquently in Scotland, where the free-market arguments of political economists, notably Adam Smith, had gained great currency. As Donaldson's Scottish lawyers argued, 'In every kind of commerce, and in every art, there ought to be competition. Without this industry will not prosper; and any monopoly or restraint must nourish tyrants, to oppress the country, and to annihilate ingenuity.' Open rivalry made for better literature. It was also good for readers. As the Scottish judge Lord Kames pointed out, perpetual copyright would 'unavoidably raise the price of good books beyond the reach of ordinary readers. They will be sold like so many valuable pictures. The sale will be confined to a few learned men who have money to spare, and to a few rich men who buy out of vanity as they buy a diamond or a fine coat.'

Scottish political economists and their followers believed that property acquired value not because it was a 'thing' that was owned but through its circulation and exchange in a system of commerce. The application of this view to literature not only bolstered the case against monopolizing booksellers, enriching themselves at the 'expense of the whole nation', but focused public attention on a *literary system*, rather than on individual works. As the author of *An Enquiry into the Nature and Origins of Literary Property* put it, 'The Learning of the present Age may be considered as a vast Superstructure, to the rearing of which the Geniuses of past Times have contributed their Proportion of Wit and Industry; to what Purpose would they have contributed if each of them could insist that none should build on their Foundations?'

Literary genius was no longer isolated but grew out of a tradition; as literary histories had shown, it inhabited a crowded history, not a lonely Parnassus. Because literary progress depended on copying, learning, imitation and emulation, much writing was derivative and unoriginal. 'Very few Productions of modern Authors', one critic wrote, contain 'Sentiments . . . new and original'. But this inevitable feature of literary

culture did not preclude originality and genius. It meant only that originality had to be defined in the context of established conventions and traditions, becoming less a question of what was said than of the manner of its expression.

The end of perpetual copyright helped to clarify the idea of a national tradition and simultaneously created a commercial environment in which it could be realized. Any enterprising publisher could now compile his own anthologies of plays, poems or essays. Hannah More was soon complaining of 'the swarms of *Abridgements, Beauties* and *Compendiums* . . . This extract-reading . . . illustrates the character of the age in which we live.' A recent study shows an astonishing increase in the number of anthologies, readers and books used to learn English after 1770: thirty-four were recorded in the fifty years 1721–71 and 173 in the next half century. The later books were also cheaper, as rival publishers put out competing versions of the national literary heritage.

The most popular authors in the anthologies published between 1770 and 1800 are no surprise. They included Pope, Thomson, Shakespeare, Addison, William Cowper and John Milton. Only John Cunningham (1729–73), a now forgotten Irish poet whose tomb was etched with the words HIS WORKS WILL REMAIN A MONUMENT TO ALL AGES, strikes a discordant note to the modern ear.

Though many anthologies were didactic, intended for tutors, schoolmasters, dame teachers and their pupils, others were promoted to a broader market of readers. John Bell, whom Millar branded a thief, produced a number of such books, notably *Bell's British Theatre* (twenty volumes, 1776–8) – to go with *Bell's Edition of Shakespeare* – and *Bell's British Poets*, which appeared in 109 volumes in 1777–82. In his advertisements Bell made much of the idea that purchasers of these collections were buying part of a valuable national tradition. In his *British Theatre* he wrote of 'THE ESTABLISHED STERLING MERIT which composes the literary part of this Work'; it was 'the ornament of literature, and the stock of English entertainment'. Such a precious commodity, he emphasized, should be properly decked out and suitably adorned. His *British Poets* were advertised as

> an edition superior in beauty, purity, and convenience, to all preceding publications; . . . The size resembles the admired editions of the Latin Classics, by *Elzevir*; the types were cast on purpose on

189. Frontispiece to Bell's Edition of *The Poets of Great Britain, Spenser Volume 1* by John Hamilton Mortimer, engraved by William Sharp, 1778

EDMUND SPENCER.

Improved principles; the paper is writing post of the finest quality, and the embellishments will be designed from the subject of each volume, principally by the eminent Mr. *Mortimer*, and executed by engravers of the greatest merit; besides an original engraving of the portrait of each author, finely executed from pictures or busts of the best authority (fig. 189).

Similarly, in *Bell's Theatre*, 'every fifth play will be given a general Title and a Beautiful Vignette, adapted to the subject of the Volume, by one of the first Artists in Great Britain – Each Play will be embellished with at least one lively DRAMATIC CHARACTER, painted from the life, by Permission, on purpose for this work only, and executed by the best

Engravers in London' (fig. 190). The physical appearance of the text mattered as much as its content, and the engravings would link the two.

Bell's customers were acquiring commodities they could proudly display to friends. His advertising repeatedly emphasized this: in a puff for the Spenser volume in *Bell's British Poets* he pointed out that although a single volume was 'A WORK most beautifully and correctly printed, in an uncommon and delicate size, calculated for a lady's pocket', the entire series when complete would 'form a truly elegant ornamental appearance, in the drawing-room, dressing-room, or study, and may be cased so to render them a portable and complete travelling poetical, biographical and critical library' (fig. 191). The novelist Sophie von la Roche was delighted at this 'neat arrangement for collecting all the English poets, charmingly bound and printed, into a case like a large book'. The folio slip-case could be used to give the small books the appearance of a large volume for a library, yet it also enabled readers to transport heritage on the hoof.

Bell cared about the uniformity and completeness of his editions, and

190. *Suspicious Husband. Mr Garrick and Mrs Abington in the characters of Ranger and Clarinda* by James Roberts, engraved by Thornthwaite, 1776

191. Titlepage to Bell's edition of *The Poets of Great Britain, Spenser, Volume 1*, engraved by Cook, 1778

gave a standardized format and size to all his volumes. To own Bell was to be able to survey the whole of 'esteemed' literature. The reader of *Bell's Theatre*, it was claimed, 'may render himself master of the DRAMA of his COUNTRY'. Bell sold his books in relatively inexpensive single parts, offering each volume to the public as it came off the press. Parts of his *Poets* cost 1/6*d.*; each play from his *Theatre* was a mere six pence. A complete, unbound version of the *Poets* was available for a mere eight guineas for all 109 volumes, though Bell also produced other editions of higher quality and with more elaborate bindings 'adapted to different pockets and disposition – *Elegant copies* being printed for those who prefer them.'

Bell's books were a typical product of the new commercial environ-
ment created by the end of perpetual copyright, and they provoked a
counter-attack from the consortia of booksellers that had once controlled
the copyrights of the authors Bell was now publishing. A group of
twenty-seven London booksellers published a twelve-volume *New English
Theatre* (1776–7) to compete with Bell's twenty-volume *British Theatre*.
Another group hired Johnson, as we have seen, to write the introductions
for their *English Poets*, which was sold as more authoritative than Bell's.

Perpetual copyright may have ended, but this did not prevent the
bookseller cartels from using restrictive practices to try to cut Bell out
of the market. No newspaper, apart from the *Morning Post*, which Bell
himself owned, accepted his advertisements, and other booksellers refused
to stock his books. Neither of the two main reviews, the *Monthly* and
the *Quarterly*, deigned to notice his publications. There was even an
attempt to stop his trade credit. Bell accused his rivals of revolting 'from
their allegiance to the public', but they could not prevent his success.

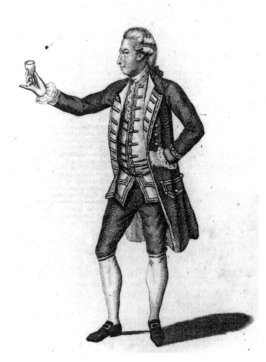

192. *Mr Vernon in the
character of Macheath* by
I. Roberts, engraved by
James Roberts, 1777

For Bell's operation was a national, not just a metropolitan one. His books were printed in Edinburgh at the Apollo Press, circulated via a network of newspaper distributors throughout the provinces and beyond the reach of the now weakened London booksellers. It is symptomatic of the two rather different visions of their respective enterprises that Bell's rivals described their plays and authors as *English* while Bell published volumes of *British* theatre and *British* poets. It was not that Bell included Scottish, Irish and Welsh authors that the London booksellers omitted – though his collections included more authors than those of his rivals, – but he knew that the book market and reading public were not confined to London or indeed to England. He was one of the first booksellers to see how the topography of publishing had been decisively redrawn and, because of his Scottish and provincial connections, he could see how it could be exploited. He did not see why the English should have a monopoly on Britain's literary heritage. Bell's enterprise was the model which many other booksellers followed for the next fifty years.

In the ninth volume of his *British Theatre*, devoted to English operas, Bell reprinted *The Beggar's Opera* as performed at Drury Lane in 1777. This was the production that dressed Macheath as a macaroni and added a new, moralized ending. Bell decorated the text with an engraving after a portrait by James Roberts, a specialist in small-scale theatrical portraits, of Mr Vernon as the macaroni Macheath (fig. 192). The text and image reproduced a topical version of *The Beggar's Opera* as refashioned in the commercial theatre. But the frontispiece of the book has a very different image, after the artist John Hamilton Mortimer, in which a figure standing in front of a theatre or opera house, either Mercury or Fame, crowned with laurel wreaths, places his arm around a classical bust of John Gay, while his other hand extends to a kneeling figure holding sheet music, a text and a lyre (fig. 193). The first engraving shows how easily *The Beggar's Opera* could be adapted to current taste, while the frontispiece claimed Gay for posterity. By printing Gay's opera in a slim volume with five others (one of which, *Polly*, was also by Gay), and by giving Gay pride of place on the frontispiece, Bell consecrated the author as part of the national literary heritage. The engravings which helped to make the book desirable to own were, in turn, part of a popular visualization of British culture that was propagated in other book illustrations, in furniture prints and in picture galleries dedicated to British literature. Bell's entire series exemplified the trend to present culture as a 'treasure',

193. Frontispiece to *Bell's British Theatre; Operas* by John Hamilton Mortimer, engraved by John Hall, 1777

a selection of pleasing gems that one might buy cheaply and share with others. At the dawn of the nineteenth century it had become possible to imagine, to hold and even to own the works of literature and art, or at least copies of them, which had been enshrined by London critics, commercial booksellers and art dealers as Britain's cultural heritage.

VI

PROVINCE
AND NATION

CHAPTER TWELVE

The English Provinces

THOUGH I HAVE FOCUSED principally on Britain's cultural history as it was experienced in London, culture in the eighteenth century was scarcely confined to the capital: in other towns and in country houses, at regional assemblies and in local theatres, British men and women were shaping a national culture which, though it bore more than a passing resemblance to the refined entertainments of London, was nevertheless quite distinct from them.

Before the eighteenth century Britain had not been a very urban country. London was its one metropolis, only a small proportion of the population lived in a town of any size, and few cities rivalled the numerous rich towns of the Netherlands, Italy and France, with populations of more than 20,000. In 1700, when London's population was over 500,000, making it the largest city in western Europe, only Norwich and Bristol had more than 20,000 inhabitants. It was possible, if not to know everyone in one's own community, at least to know where almost everyone belonged.

This changed radically during the course of the eighteenth century, when England became the most rapidly urbanizing part of Europe. In the first half of the century England was responsible for more than half of all European urban growth; between 1750 and 1800 it accounted for a remarkable 70 per cent. Provincial towns grew even faster than London. At first nearly all of them, including market towns, expanded at about the same rate, but soon a few cities far outstripped the rest. By the time of the first national census in 1801, seventeen cities besides London had populations between 20,000 and 90,000; more than one quarter of the inhabitants of England and Wales lived in towns. The new urban giants were chiefly those we associate with the Industrial Revolution – Liverpool, Manchester, Newcastle, Leeds, Birmingham, Sheffield and Nottingham – although the fastest growing town in late Georgian England was

the fashionable resort of Brighton. The growth of these towns was fuelled by an expanding economy of coal, textiles, metal goods, manufactures, shipping and trade, and their wealth went into the private refinement of their richer citizens and on lavish projects of civic improvement.

These rich and populous towns rooted their cultural innovations in local soil: set up their own theatre companies, arranged art exhibitions showing local artists and formed concert groups with local professional musicians. Their culture was dominated by their own elites of gentlemen, merchants, doctors and lawyers, but in the larger towns shopkeepers, artisans and skilled craftsmen established their own institutions. Gentlemen and shopkeepers were sometimes found in the same book clubs and debating societies, though events like assemblies, balls and concerts, which were vital to genteel courtship and marriage, tended to be more socially exclusive.

The new institutions of provincial cultural life were grafted on to existing local traditions. A town's feast day, a local election or assize court or race meeting when gentry and farmers from the surrounding countryside flooded into town, became the occasion for concerts, assemblies and balls. Even book clubs and other learned societies relied on the local calendar to organize their meetings.

Seen from London, provincial culture looked marginal, most useful for its provision of talent best realized in the big city, most notable for its *sotto voce* imitation of London's confident voice. Lichfield was considered important not for itself but as the birthplace of Dr Johnson and David Garrick; the Scottish universities and academies gave London journalists, philosophers and historians such as David Hume and Tobias Smollett; the conversation of the Irish diaspora – Swift, Burke, Goldsmith and the Sheridans, father and son – graced London drawing rooms and tavern clubs. The lure and lucre of London was hard to resist, but Londoners were intolerant of signs of provincial culture. Talent had to be shorn of its regional identity. Scots in London took elocution lessons from the elder Sheridan to efface their derided native accent; Reynolds's claim to be a metropolitan gentleman was undercut by the vestiges of his Devonshire burr.

From this perspective, provincials were absorbed by London rather than changing it; culture travelled only one way, out from London rather than in from the provinces. For several months of the year aristocrats, prosperous gentry and rich merchants all over Britain decamped to enjoy

the social pleasures and cultural excitement of the London season. The wealth of the provinces – the rents of landed proprietors, the profits of merchants – went with them, and in London it was traded for urban sophistication, modern fashion and refined taste. These intangible assets they then brought back to their own communities, creating smaller versions of the polite culture they had enjoyed in London. Imitation and emulation, amply demonstrated by the names chosen for provincial venues – Drury Lane Theatre in Liverpool; Vauxhall Gardens in Norwich, Bath and Bristol, a Ranelagh Gardens in Norwich and Newcastle – fuelled local ambition. Polite culture used London's resources: provincial theatres employed London players, their concerts relied on professional performers from the London pleasure gardens and theatres, portraits hung in provincial parlours were painted by London artists during their summer tours. The provinces followed metropolitan fashion: the theatre repertory mimicked that of the London houses, local orchestras bought their scores from London sheet-music sellers, and images from London's printshops affected taste in the graphic arts all over Britain.

Cultural change followed patterns that were first apparent in London. These changes were spatial and architectural as well as social and institutional. They involved reshaping city environments, building new streets and squares with open vistas and clear classical lines that were pleasing to the eye. Developers in Bristol, for instance, built six new squares in the city – the first was Queen Square, begun in 1700 and completed in 1727, and the last Brunswick Square, finished in 1784. This remodelling – covering old irregular façades with Georgian frontages, straightening and widening narrow, crooked streets, opening vistas and views (developments in Stamford, Chichester, Warwick and Northampton, for example) – went along with new civic and public building – mansion houses, assembly rooms and theatres, walks and pleasure gardens. Such architecture is today associated with the city of Bath, but it also survives in Whitehaven (the most remarkable planned English town of the period) and, of course, in the New Town in Edinburgh. Civic improvement created spaces where people could look and be seen: their most conspicuous features were the sites for plays, concerts, assemblies and balls. A calendar of cultural events evolved in every sizeable town and city, supported by numerous local associations – the masons, 'free and easy' societies, debating, reading, literary and drinking clubs which met in

inns and coffee houses – and advertised in local newspapers which also preached the virtues of urban refinement and politeness.

This improving tale of imitation and emulation, in which rough-hewn, irregular and sometimes rude appearances were overlaid by smooth, uniform urbane façades conceals as much as it reveals. Like the many Georgian street fronts that hid a vernacular architecture that was quickly apparent once you crossed their thresholds, the provinces' ostensible conformity to the cultural values of London concealed their varied foundations. What we see depends on the place from which we look. From the provinces themselves, from behind the Georgian façade, local culture appears more diverse and much less derivative.

The experiences of three different figures in three different English towns exemplify the variety and vigour of Britain's cultural life outside London. Thomas Bewick was an engraver, a delineator of 'nature', a craftsman, who lived almost all his life in the industrial north-eastern city of Newcastle. John Marsh, a lawyer and an independently wealthy gentleman, was a prolific amateur composer and musical performer, who lived in the southern cathedral cities of Salisbury, Canterbury and Chichester. And Anna Seward, a cleric's daughter, spinster, bluestocking, poet, letter-writer, biographer and literary polemicist, was a resident of the Bishop's Palace at Lichfield in the west Midlands.

Bewick grew up in one of Britain's largest industrial towns, a centre of coal mining, industrial processing and long-distance trade. The other two lived in much smaller cities, market, church and county towns whose social life was dominated by the local gentry and, above all, by the ecclesiastical society which flourished in the shadow of the cathedral tower or spire. Any of the towns where Marsh or Seward were resident could have provided the setting for Trollope's Barchester nearly a century later.

Bewick was an artisan, albeit one who achieved comfortable prosperity; Marsh was a rich gentleman; while Seward, though of equal social rank to Marsh, was a spinster of modest means who spent much of her time managing the household of her aged and then invalid father. Yet for all these differences, they shared one important feature: they all recorded their lives for posterity, and they all emphasized their cultural activities. Bewick wrote a memoir, Seward collected and rewrote her correspondence for posthumous publication, and Marsh wrote a massive 'private history', probably the most detailed surviving account of

eighteenth-century English provincial life. These documents are more
than historical sources; their composition was a creative act which consti-
tuted that culture itself. For the three recognized what London's histori-
ans and critics also knew, that culture needs to be interpreted and
preserved, that it needs to be understood and transmitted as a heritage
or tradition. Bewick, Marsh and Seward wanted to speak for themselves
and not to leave the invention of a tradition to others.

We might expect these figures to praise and elevate the particularities
of local life against the grander claims and bright lights of metropolitan
culture. There is certainly a strong element of local pride in the graphic
images of Bewick and verses of Seward, but all three were emphatically
not parochial. Their aims and ambition were every bit as large as those
of London's critics, and none of them wanted to imitate London culture.
Bewick, a Whig and a deist, aspired to be a philosopher of natural
religion who enlightened and educated through his depiction of nature.
He drew on the radical traditions of the Enlightenment but expressed
them in a popular medium – wood-engraving – that related local tra-
dition and memory to a firm commitment to the powers of reason.
Marsh, a devout and conservative Anglican country gentleman, wanted
to create social and religious harmony through his music, to create a
traditional but tolerant community. And Anna Seward, ardently commit-
ted to sentimental poetry, wanted to recapture literary criticism from the
London professionals and return it to genteel amateurs like herself. All
three used London's cultural resources – Bewick had its publishers dis-
tribute his books of engraved animals and birds, Marsh regularly went
to London concerts and Seward published her criticisms of the literary
establishment in London magazines – but they never chose to reside in
London or embrace its values. London was only one of many stars in
Britain's cultural firmament. Their perspective was more broadly
national: they never forgot other English cities or the cultural and intellec-
tual life of Scotland, the circles in Edinburgh and Glasgow. While a
London artist or critic saw the nation as a cultural hierarchy with London
at its pinnacle, the provincials saw it as a collection of roughly comparable
places, comprising a more egalitarian nation.

Cultural life was more varied in the provinces than in London. While
culture in the metropolis became increasingly professionalized, in the
provinces amateurs remained key figures. The smaller scale and limited
scope of provincial society meant that culture depended on the disparate

talents of individuals, on amateur polymaths who devoted themselves, like John Marsh, to a single art or science, but who also put up money for theatres, joined book clubs and debating societies, and enjoyed sketching and painting. When Bewick described Newcastle he wrote about people as much as about ideas; the line between performer and audience, between a creator of culture and those who enjoyed it, was less significant for, more often than not, they were one and the same person. There was no equivalent in the London drawing room to manufacturers and Dissenters like Josiah Wedgwood and Matthew Boulton, whose Lunar Society in the west Midlands made important contributions to science, the applied arts and literature. When Bewick worked in London he was a figure of no importance. Marsh could only have run his own orchestra and enjoyed performing his own works in a provincial cathedral town. And Anna Seward stayed in Lichfield because she correctly believed that her national influence would be greater if she stayed away from London. But the context in which these people placed themselves was *national*. They saw themselves not as distant extensions, much less poor imitations, of metropolitan culture, but as integral and important parts of a national, even international, culture.

Tired of what they saw as the excessive refinement and artifice of London society, provincials were the ardent supporters of sentiment and sensibility. If politeness valued 'the world' – conversation, external appearances, the surfaces of metropolitan life – then sensibility, with its elevation of interior sentiment, feelings of the heart and the value of intimacy, accorded better with the more sober, domestic character of provincial life. As we have already seen, this shift in taste was not simply a challenge to London, nor, for that matter, a middle-class challenge to aristocratic values. Sensibility flourished in London, politeness was valued in the provinces; some aristocrats embraced sensibility, just as many bourgeois wished to be polite. But if we want to appreciate how people's understanding of the arts and imaginative literature was changing, we need to look outside London – to provincial literary and philosophical societies, to book clubs and assemblies, and to the nation at large.

Thomas Bewick: 'The Poet who Lives on the Banks of the Tyne'

ON I OCTOBER 1767 two fourteen-year-old boys, Kit Gregson and Thomas Bewick, rode eastward with their fathers from the village of Ovingham along the banks of the river Tyne towards the city of Newcastle. It was a momentous journey, for they were both about to embark on a new life as apprentices to tradesmen in the city. Excitement and apprehension mingled with sadness. Thomas recalled it as 'a most grievous day ... to part from the country & to leave all its beauties behind me ... I can only say my heart was like to break, and as we passed away – I inwardly bid farewell, to the whinney wilds – to Mickley Bank, the Stob Cross hill, to the water banks, the woods & to particular trees.' As they left the scenes of Thomas's youth, his father, a minor landowner and coal miner, spoke to him of the importance of leading a virtuous and Christian life: 'he began & continued a long while ... on the importance & the inestimable value of honour and honesty ... He next turned his discourse on another topic ... Religion – & pressed this also upon me in a way I did not forget.' A few hours later at the Cock Inn on The Side, a steep street that led from the Tyne to the city, his friend Kit was apprenticed to Messrs Doughty & Wiggins, chemists and druggists. Thomas, in deference to his passion for drawing on flagstones and sketching in the margins of his schoolbooks, was bound for seven years to Ralph Beilby, a prosperous engraver.

Thus began the career of a man whose wood-engraving was to bring him international fame and to lure doting admirers to his workshop in the churchyard of St Nicholas's, Newcastle, from as far afield as Germany and North America. Bewick's illustrated natural histories and narrative vignettes of rural life excited the praise of poets like Wordsworth, the admiration of such artists as William Sharpe, Benjamin Robert Haydon

and James Northcote (who painted a portrait of two children reading Bewick's *Quadrupeds*, plate 6.), and the later acclaim of critics like John Ruskin and Thomas Carlyle. Several novels allude to his work, most notably Charlotte Brontë's *Jane Eyre*, and contemporaries compared his work to that of Shakespeare, James Thomson, William Cowper, Robert Burns and Sir Joshua Reynolds. Such was his later fame that his portrait was exhibited at the Royal Academy, widely distributed as an engraving, and reproduced in literary and naturalist magazines. His bust was the first to grace the Newcastle Literary and Philosophical Society.

Bewick's fame rested on three publications. His *A General History of Quadrupeds* (1790), an illustrated history of four-footed beasts, went through eight editions in Bewick's lifetime. His equally successful two-volume *History of British Birds*, a more complex and scientific study, appeared in 1797 and 1804; it was reprinted six times before his death in 1828. Lastly the *Fables of Aesop*, a project conceived during a nearly fatal illness in 1812 and finally published in 1818, combined Bewick's love of nature with his penchant for trenchant moralizing. As Bewick himself recognized, these three lavish books transformed his life.

Such fame and fortune seemed far from likely to the young apprentice whose early working life was dominated by the commercial engraving done at Beilby's workshop. Long before he achieved public recognition Bewick had served out his apprenticeship, worked in London (which he hated), served Beilby as a journeyman, and become his partner (in 1777), taking his brother John as an apprentice. Looking back over his career in a letter written in 1819, he commented, 'I . . . date the Quadrupeds to be my commencement of Wood Engraving worthy of attention. Before that period I was engaged in the general work of a Country Engravers Shop; one hour employed on Copper, another on Wood, another on Silver, another on Brass, another on Steel – indeed ready and willing to undertake any description of work.'

Such was the task of the apprentice engraver; such indeed was most engraving work done in any city. The business records of Beilby and of Bewick and Beilby reveal the astonishing range of tasks performed in their shop. They engraved mottoes on rings, ciphers on spoons and seals, names or crests on coffee pots, tea sets, punch ladles, silver services, candlesticks, watch cases, dog collars, whip handles, horse bridles, hair-combs and lockets. Door plates, fireplaces and gentlemen's carriages were inscribed with insignia and monograms. The workshop even engraved

195. Cash account book, February/March 1787 of Thomas Bewick

buttons for the uniforms of the local militia (fig. 195). Besides working directly on metal, Bewick and Beilby prepared plates and cuts for work on paper: bookplates, insurance certificates, banknotes, trade and shop cards, bills and invoices, bar and tavern bills, receipts for the coal trade and decorative mottoes and borders for the handbills and newspapers produced by the local press. They also worked as book illustrators, producing engravings for works which recorded Captain Cook's voyages and for several children's books, most notably fables and *Tommy Trip's History of Beasts and Birds*, published by the Newcastle printer and newspaper proprietor Thomas Saint.

The widespread use of cheap engraving as an advertising medium and form of decoration meant that Beilby and Bewick did work for

many different sorts of business. In addition to the printers, booksellers and gold- and silversmiths who commanded so much of their time, the workshop dealt with tea dealers, grocers, upholsterers, watchmakers, ironmongers, woollen drapers, chemists, gun manufacturers, oculists, inn and tavern proprietors, shippers, musical instrument-makers, brass founders and plumbers, cabinet-makers, bankers, coal merchants, wine and spirit merchants, a portrait painter, a drawing master and an umbrella manufacturer. Beilby and Bewick's workshop – together with two other engraving businesses in the town – produced the visual language of Newcastle's commerce.

Beilby and Bewick's success as commercial artists depended upon their skill in creating visually appealing works that communicated information clearly. Their engravings advertised circulating libraries and musical instruction and told people about the city's cultural and social life, its concerts, balls and assemblies, its clubs and associations (fig. 196). For their private customers – farmers and tradesmen, gentry and merchants – they offered marks of ownership: names, mottoes and insignia to identify the objects on which they were engraved as someone's special property, transforming a commonplace or standardized object into something unique. A teapot or haircomb bought at the silversmith or jeweller became a special gift, an item like no other. Beilby and Bewick's business records reveal a steady flow of customers who waited

196. Concert Ticket. *Recreation is sweeter when mingled with Charity* by Thomas Bewick, 1795

197. Vignette: *Staithes on the Tyne* from Bewick's workshop

in the shop as an apprentice engraved their names or ciphers, or left objects, large and small, to be customized.

Engraving work required skill and great strength. Because of its difficulty engravers enjoyed high status and, if they managed their shop well, a comfortable income. But for someone with Bewick's restless ambition this was not enough. To be of greater consequence an engraver had to enter into the community's civic life and become a local worthy; and to achieve a reputation beyond the horizon that bounded the city, needed to claim the status of an artist.

> Bout Lunnen then Div'nt ye mak sic a rout,
> There's nouse ma winker to dazzle;
> For a the Fine things ye ate gobblin about,
> We can marra ir canny Newcastle

What was life in eighteenth-century Newcastle like, and what part did Thomas Bewick play in it? Newcastle was a city of some size – perhaps the fourth largest town in the kingdom. It was dominated by the coal trade; the mines of the north-east and Newcastle's ships furnished most of the domestic fuel burned in London hearths (fig. 197). As the regional capital of the north-east – what one contemporary called 'the very eye of all the towns in this country' – it attracted Northumberland gentry

to its races, assizes and assemblies. The cheapness of fuel encouraged industries such as pottery and glass-making, brewing, dyeing and soap-making. And, with 180 taverns and coffee houses, including the huge coaching inns on Pilgrim Street that catered to trade from three daily coaches to London and more than fifty commercial carriers, it was an important stopping place on the road between London and Edinburgh, linking Northumberland to the nation's entire communications network. Dominated by an oligarchy of politically powerful and extremely wealthy coal merchants and colliery proprietors – the Fenwicks, Blacketts and Ridleys – it retained a strong sense of regional identity and a vigorous political life.

Newcastle became the most important printing centre in England outside London, Oxford and Cambridge. When the Licensing Act had lapsed in 1695 there were no printers in the town; but by the end of the century it had twenty. Together with twelve booksellers and stationers, thirteen binders and three engraving shops, Newcastle printers published more books than any other provincial city. The Newcastle trade produced songs and schoolbooks, histories and sermons, works in all shapes and sizes, as well as Bewick's *Quadrupeds* and *Birds*.

The many printers ensured an abundance of news. Few towns had more than one local newspaper; Newcastle usually boasted three, the most enduring being the *Newcastle Courant* (1711–1902), the *Newcastle Journal* (1739–88), the *Newcastle Gazette* (1744–55), the *Newcastle Chronicle* (1764–present) and the *Newcastle Advertiser* (1788–1814). Local periodicals outside London, Dublin and Edinburgh were rare, but no fewer than ten were published in Newcastle during the course of the century.

And the town was well endowed with books. Readers who did not want to buy books could use three circulating libraries, patronize the town's seven subscription or private libraries, or turn to St Nicholas's parish library, a stone's throw from Bewick's workshop, which contained more than 5,000 volumes (fig. 198). As in other cities, taverns and coffee houses carried local papers and pamphlets. When the Shropshire barrister and keen naturalist John Dovaston first visited Bewick, he found him not in his workshop but in a nearby tavern, smoking a pipe and reading the daily news.

Newcastle's social calendar was built around six special occasions – the annual Barge Day, a local holiday marked by a pageant that blessed the city's largest and busiest thoroughfare, the river Tyne; the quarterly

assizes, which brought justices and judges into town for a week; and a horse race week in June, begun in the late seventeenth century, which marked the major summer holiday. All of these were celebrated with assemblies, balls, concerts and theatrical performances. The first Newcastle assemblies were held in 1716 in what had once been the home of Sir William Creagh in Westgate Street. By 1736, when annual subscription concerts began, the town had acquired a public assembly room in the Groat Market, and within a decade assemblies were being held not only during race week and the assizes, but on city guild days and on alternate Tuesdays during the winter; they become a regular feature of Newcastle's polite society. A suite of magnificent new assembly rooms (which today survive as a gambling casino) was opened in 1773, erected by public subscription and commemorated in an engraving from the Bewick and Beilby workshop (fig. 199). The building, described as 'the most elegant and commodious edifice of its kind in the Kingdom, except the House of Assembly in Bath', included a high-ceilinged ballroom ninety feet long, a saloon, card room, coffee room, news room and library. Its foundation stone celebrated, albeit in halting words, the rise of the arts in eighteenth-century England:

198. Trade Card: Joseph Barber & Son, booksellers and stationers, by Thomas Bewick

In an age
When the polite arts
By general encouragement and emulation
Has advanced to a state of perfection
Unknown in any former period;
The first stone of this edifice
Dedicated to the most elegant recreation.

The assembly rooms were intended for balls, concerts and convivial meet-
ings, but not for theatrical performances. The first city theatre was in the
Turk's Head Inn: by 1790 the city boasted two theatres, the New Theatre
and the Theatre Royal, which contained 1,350 seats and was proudly
described as 'not surpassed by any other provincial house in the kingdom'.

Bewick's workshop was kept busy producing tickets for all these
concerts, plays and charity balls, and Bewick himself attended concerts:
'My Master', he wrote in his *Memoir*, 'belonged to a Musical Society held
at Moore's in the Close & when I had any message to take, or other
errand to him, I was commonly invited to remain – The two Sons (Edwd

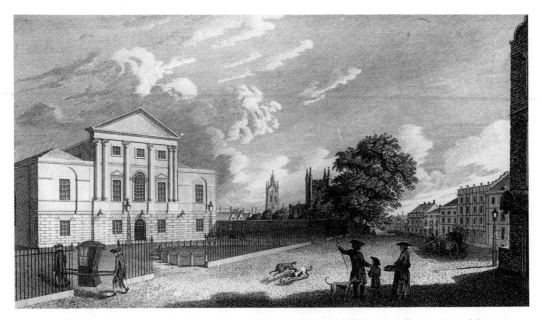

199. *View of the Assembly House, Newcastle-upon-Tyne* by William Beilby, engraved by
James Fittler, 1774

200. Bookplate: Richd.
Swarley, Newcastle. From
Bewick's workshop

& Charles) of Charles Avison, the great musical composer, belonged to
this Society ... I also occasionally heard the Band at the Theatre.' In
later years, when Bewick was famous and rich, he regularly patronized
plays, lecture series, concerts, oratorios and, in the company of his daugh-
ters, the occasional ball. He liked to support charitable performances
held to benefit institutions such as the local hospital. He relished acting
as a local figure of consequence, enjoyed performing his civic function
and philanthropic duty, and derived great satisfaction from publicly
demonstrating his generosity and refinement.

But Bewick's greatest social pleasure was Newcastle's associational
life. There were abundant opportunities to indulge it: nearly fifty clubs
and societies, ranging from masonic lodges to floral societies, from
debating clubs to political associations, met in coffee houses, club rooms
and taverns. All were convivial, many were lubricious and some were

concerned, like the Society for Mental Improvement, with the cultural edification of their members.

In 1778 Bewick was elected to Swarley's Club, which met at the Black Boy Inn. 'This', he recalled, 'was the most rational Society or meeting I ever knew ... it was expected that every member should behave with decorum & like a Gentleman ... Conversations among the friends, thus associated, consisting of Merchants or respectable Trades-men, was carried on without restraint.' He also spent time with members of a literary club 'who kept a library of Books & held their meetings in a Room at Sam: Allcocks, at the Sign of the Cannon, at the foot of the old Flesh Market'. This society, which included some woollen drapers and the cashier of a local bank, may have served as the model for the Philosophical Society that Bewick, together with a bookseller, land surveyor, coach-painter, engineer and dissenting minister, founded in the 1770s to debate literature, philosophy and politics.

The tenor of these associations was usually Whig, liberal or radical, though individual members differed in their political views. The book-plate of Richard Swarley, proprietor of one of Bewick's clubs, proudly declaimed, 'Libertas Auro Pretiosior' (Liberty is more precious than gold); government spies broke up the club because of its radical, oppositionist views during the Napoleonic Wars (fig. 200). The first occasion on which the radical bookseller and numismatist Thomas Spence set forth his views on the collective right to rural property was at a meeting of the Philosophical Society. His agrarian socialism was controversial and Bewick, who was a firm believer in the virtues of private property, disliked it. On one occasion their differences led to a fight with cudgels in which the strongly built engraver gave the slender radical a terrible drubbing. But they remained friends throughout their lives: Bewick visited Spence after he had left Newcastle, and the Bewick–Beilby work-shop gave Spence the tools and type he needed to publish his new and simplified alphabet. Another of Bewick's clubs, which met during the 1790s at the Bell Tavern and its news room, comprised 'a set of staunch advocates for the Liberties of Mankind' who debated 'the political enor-mities of the times'. Bewick, as he explained on their first meeting to a slightly embarrassed John Dovaston, who had hoped to meet a simple lover of nature, was unashamed to call himself 'a strong whig' (fig. 201).

These clubs which Bewick frequented were for men of business; few gentlemen of the leisured classes belonged to them. The club at the Bell

201. Vignette: *Veritas, Libertas, Vertus, Bonum Publicum* from Bewick's workshop. The vignette combines all the symbols of a radical Whig view of politics

included one gentleman, but even he had worked in banking and the wine trade; Bewick's closest companions – 'Ralph Crawford, Shoe Maker, Joseph Bulmer, builder – Phineas Crowther, Founder, Michael Charlton White Smith, John Mitchell Editor of the "Tyne Mercury," Count Raymond, French teacher and fencing Master' – were all, as he observed, 'tradesmen, Bankers Clerks, Artizans & Agents of various kinds'.

The civic, moral and cultural aims of these clubs were all of a piece: literature and the arts were not considered to be separate from morality but to encourage wisdom and shape better citizens. They were an aspect of general enlightenment, what Bewick termed 'the march of intellect'. So the debates and publications of such clubs were not confined to literature and the fine arts. All knowledge was their province; 'taste', as one contributor to a literary and philosophic journal put it, 'is only acquired by . . . general and miscellaneous knowledge'. Lectures on science, botany, antiquities, technical drawing and geology were welcomed, as were debates on the nature of taste and the aesthetic, the relative merits of monarchical and republican government, and the composition of the canon of English literature.

Bewick's club associates had little interest in imitating London's cultural fashions. Their chief correspondence was with other provincial societies, and their points of reference were cosmopolitan and international: the library of the Newcastle Literary and Philosophical Society, which Bewick joined in 1799, contained works in French, Spanish, German and Latin; its members debated the issues of American science or of Scottish political economy as raised in the works of Adam Smith, Adam Ferguson and Lord Kames; they borrowed books on German literature and aesthetics, French theory about the ancients, travels in the South Seas and the Far East, as well as French, Italian and Swedish works on botany and the natural world. Though they were understandably absorbed with the locally important questions of mining and subsidence, they found time to learn about Dante and theories of taste.

In setting up debating societies and lecture series, in publishing their proceedings in annuals and periodicals, these merchants, tradesmen and skilled artisans claimed it as their right to acquire and interpret literary and philosophical knowledge. Bewick's *Memoir*, written at the end of his life, exemplifies this uncompromising pursuit of knowledge and culture, his determination to make his opinions known. The mundane details of his autobiography are overshadowed by extensive discussions of his views on politics, morals, education, the natural world and the nature of art. In offering them, Bewick, like his companions in the literary and philosophical societies, directly challenged any presumption that only gentlemen could be cultured and refined. Inverting this formulation, they maintained that only a refined person could be genteel: 'A taste for polite literature, and the works of nature and of art', as one lecturer put it, 'is essentially necessary to form the Gentleman, and will always distinguish him more completely from the vulgar, than any advantage he can have derived from wealth, dress, or titles.'

For these bluff rather than genteel men of commerce cultural and moral refinement was a matter of knowledge and wisdom, not rank and fashion. Much more was at stake than social accoutrements: 'The natural tendency of a cultivation of polite learning', Thomas Henry Read commented in 1781, 'is, to refine the understanding, humanize the soul, enlarge the field of useful knowledge, and facilitate the attainment of the comforts and accommodations of life.' These tradesmen and merchants desired the cultural authority – the status – of gentlemen, but they did

not wish to emulate them; rather they wanted to change the criteria for gentility itself.

The frequency with which they addressed the question of 'the consistency of LITERARY and PHILOSOPHICAL with COMMERCIAL PURSUITS' betrays both the novelty of their claim and their uncertainty of its success. They needed to reassure themselves that they were entitled to enjoy the fruits of literature and philosophy, and it was comforting to be told by club lecturers that the English literary classics – 'Shakespeare, Milton, Pope, Addison, Thomson, Gray, Mason with a long list of excellent writers in prose and verse' – 'justly demand' a tradesman's notice, and that they would 'prove most delightful companions, refine his taste, polish his manners, and meliorate his morals'. As another speaker put it:

> This union, of mercantile and mental accomplishments, is certainly of unspeakable importance to those, whose fortunes and prospects destine them to move in the higher spheres of life. The respectable and superior tradesman may well be allowed to have his mind furnished, and his sensibilities refined, without injury – nay, with very great advantage, even to his trade itself. By means of superior education, he will be enabled to appear in the world, in that line, to which an honourable ambition should prompt him to aspire. His connections will be more advantageous. To his customers, to his friends, to his fellow citizens, to foreigners, to the world is general, he will appear with greater consequence and respectability. His advice, his example, his influence, will have a weight, which *mere fortune*, without mental cultivation, can never, of itself, command.

Mental cultivation, though an individual matter, was best accomplished through collective, public endeavour. Bewick used the example of the animal kingdom to argue the benefits of association, the value of social intercourse in cultivating the self. When the Newcastle Literary and Philosophical Society was founded, it justified its work in similar terms:

> men by their united labours accomplish undertakings far superior to the efforts of individual strength; and this is particularly the case with intellectual pursuits. 'Knowledge, like fire, is brought forth by collision'; and in the free conversations of associated friends many lights have been struck out, and served as hints for the most important discoveries, which would not, probably, have occurred to

their authors, in the retirements of private meditation. Societies of this nature have, besides, been instrumental to draw forth those talents, which would otherwise have been buried in obscurity. Many excellent writers have been encouraged, through the medium of their transactions, to make their first entry into the world of letters, who would never have ventured, but under some such sanction, to have appeared before the public in a literary character at all.

The twofold argument – that public conversation is more fruitful than private introspection to the furtherance of knowledge, and that sociability, getting on with others, conducting civil and reasonable argument, is itself a form of self-improvement – is composed in the familiar language of politeness, but associated no longer with gentlemen but with people in trade, and is as much concerned with the spread of knowledge as with good taste. The precepts of Addison and Steele's *Spectator* were taken up and, in the process, given a new purpose.

This liberal optimism depended upon cool and orderly debate, studied reasonableness rather than irrational passion or inebriated dispute, and most club rules included measures to ensure civilized conversation. Members were fined for such offences as insulting their colleagues or drunkenness, encouraged to show toleration and understanding of positions which they did not accept and, if all else failed, required to take a voluntary oath of silence about subjects that were too hot to handle. The Philosophical Society broke up when it foundered on the rock of political disagreement. Its successor, the Literary and Philosophical Society, established when debate about the French Revolution was raging, took a more prudent course: its Rule VIII excluded discussion of 'Religion ... *British* Politics, and indeed *all* Politics *of the Day*'. The realm of reason required boundaries.

Bewick was deeply committed to these ideals. His *Memoir* repeatedly asserts the importance of reasonable and unprejudiced deliberation, the value of being able to understand and tolerate others. He exults in the company of men whose religious beliefs differ but who respect one another and remain friends. The progress of mankind, he believes, lies in the hands of groups of enlightened men; the greatest despot is ignorance, which has to be unthroned. Bewick's model of good government is a literary and philosophical society of the sort he patronized in Newcastle: 'kings ... & their ministers ought to consider themselves as

a Royal society for the promotion of Arts and sciences & of every thing that can enlighten the minds and ameliorate the condition of their Subjects [.] they would then do right.'

Bewick's cultural ethos, with its emphasis on high-minded improvement, did not preclude his enjoyment of the circus and the theatre – it did not even prevent him from enjoying the occasional assembly or ball – but the improving clubs and associations were his first concern and coloured every aspect of his life. In this he was by no means unusual. Members of the Lunar Society in Birmingham, the Dilettanti in Edinburgh, the Manchester Literary and Philosophical Society, the United Friars in Norwich all subscribed to a creed of cultural, moral and technical improvement in which culture, science and philosophy, harnessed by reason and brought to the public through the press, would ensure the progressive enlightenment of the nation. Like Diderot in the preliminary discourse of the *Encyclopédie* and Hume in his essays, they saw the progress of arts and sciences as inextricably linked. Doers and makers rather than thinkers and critics, men of business rather than leisured gentlefolk, they never disparaged the useful arts, and when they spoke of painting, they used not only the language of genius but the vocabulary of chemistry. They valued technique and did not disparage commerce. They espoused not the classical values that sustained the academic vision of a morally elevated art, so eloquently advocated by Sir Joshua Reynolds, but a progressive social theory first set forth in the clubs of Edinburgh and the lecture halls of Glasgow. Bewick's vision may have been embedded in the social institutions of his native Newcastle but, as he was to discover when he published *Quadrupeds*, he was part of a much larger movement, one of provincial enlightenment.

Have we forgotten in our hurried and imperfect enumeration of wise worthies – have we forgotten 'the genius who dwells on the Tyne' the matchless inimitable Bewick? No. His books lie on our parlour, bed-room, dining room, drawing room, study table and are never out of place or time Happy old man! The delight of childhood, manhood, decaying age! – A moral in every tailpiece – a sermon in every vignette.

The publication of *A General History of Quadrupeds* in 1790 marked a watershed in Thomas Bewick's life. The preceding decade had been

eventful: his parents had died; he had married and become a father; his brother John, another remarkably skilled wood-engraver, had left for London. Most important of all, he had spent five years working on the cuts that were to make *Quadrupeds* such a success. He was about to become one of the most famous engravers in Britain.

Bewick had produced wood-engravings ever since the first months of his apprenticeship, working on cuts for Charles Hutton's *Treatise on Mensuration*, simple geometrical diagrams with little pictorial content. But over the years, while illustrating children's books for a local printer, Thomas Saint, Bewick's engraving grew in skill and complexity. In 1779 his abilities were recognized in the award of a premium to his engravings for a book of fables from the London-based Society for the Encouragement of the Arts, Manufacturers and Commerce. A technique he had developed of working against the grain on hard boxwood, using a tool usually employed in copperplate engraving on this very hard wooden surface, produced distinctive images of remarkable clarity. But his work, confined chiefly to children's books, was still not well known beyond a small circle of engravers and booksellers. Though it was to become a model for much nineteenth-century book illustration, the public had not seen it in grand or elevated form, and the circumstances of its production and distribution made it difficult to call it 'art'.

This changed with the publication of *Quadrupeds*. Here was a large, beautifully printed book, totally and extensively illustrated by one man and his apprentices. Bewick and Beilby had originally intended to publish *Quadrupeds* as a children's book, but their shrewd partner in this enterprise, the printer and newspaper proprietor Solomon Hodgson, urged them to be more ambitious. The 1,600 copies of the first edition of *Quadrupeds*, which finally appeared in 1790, were published in two different formats: on royal paper for the book collector, gentleman and naturalist; and on demy octavo for children and ordinary readers. Bewick continued to produce different editions of his *Birds* and *Fables* in three different trim sizes – imperial, royal and demy – to cater to differing tastes and needs of several public constituencies.

Bewick followed the format of *Quadrupeds* (derived from children's books) in his other major publications. The texts were divided into brief, easily readable, discrete entries, each headed by a large engraving and ending with a visual vignette, or 'tail-piece'. These easily digested short texts encouraged the reader to wander from one entry to another; they

also had the effect of making the engravings far more prominent than the letterpress. Contemporaries rarely commented on the texts of *Quadrupeds* or *Birds*, apart from a few fanatical naturalists, and when they did they were not complimentary. As for Bewick's *Fables*, the text of which he laboured over at great length and whose commentary reveals his reformist politics, it was and has been almost totally overlooked. For most readers his works are picture books. One critic among many wrote, 'Is is not, indeed, exactly as a book that I love it, but rather as a series of delightful pictures . . . The language was little or nothing – the pictures every thing.'

Bewick and his partners marketed *Quadrupeds* in three different ways. Like many other publishers of expensive works, they launched a

202. Advertisement. Proposals for publishing by subscription *A General History of Quadrupeds*, engraved by Thomas Bewick, 1788

subscription, advertising in the press for customers who would promise
to buy a copy before printing the book (fig. 202); they also sold copies
to G. G. J. & J. Robinson, wholesale booksellers in London, and kept
some to sell themselves. So the book began as a provincial publishing
venture with a London outlet; advertising for the first edition was con-
fined to Newcastle and to booksellers in Newcastle, Durham, Sunderland,
Stockton, Nottingham, York and Edinburgh. To the surprise and delight
of Bewick, the edition quickly sold out. As he commented in December
1790, 'the work has met with such a reception from the world as I never
looked for nor expected. The whole 1600 impression both on the Royal
and common paper are sold some months since tho only published on
26 April last – we coud (sic) have sold many more if we had had
them.'

The success of *Quadrupeds*, appearing a year after Gilbert White's
A Natural History of Selborne, an evocative account of the Hampshire
countryside, its landscape and wildlife, is not difficult to understand.
Bewick placed his animals in familiar surroundings rather than rep-
resenting them as abstract shapes or as dead meat on a plain background.
Together with the vignettes, nearly all of which depicted scenes and
stories from country life, the animals never seemed remote or removed
from the experience of the observer. They were easily anthropomorphized
– a tendency the text encouraged – and could be used to draw the sort
of lessons from nature that Bewick wished to encourage.

Yet *Quadrupeds'* success was a revelation to Bewick and his partners.
They were inundated with enthusiastic letters of praise from amateur
naturalists, print connoisseurs and book collectors. Correspondents urged
Bewick to engrave the entire realm of natural history, begged for proofs
and early states of the engravings, and offered to subscribe to any new
volumes he was planning. Bewick had stumbled on to a national market
for finely produced books about the natural world.

The booksellers were not far behind the amateur enthusiasts. During
the 1790s, and as a direct result of the success of *Quadrupeds*, Bewick
was contacted by booksellers all over Britain. His ledgers and debt books
reveal dealings with bookmen in Carlisle, Durham, North and South
Shields, York, Leeds, Hull, Preston, Liverpool, Chester, Manchester,
Nantwich, Birmingham, Hereford, Worcester, Yarmouth, Norwich,
Cambridge and Bath as well as Scotland and Ireland. Most wanted to
buy copies of his books, but others, like George Nicholson of Manchester

and Walker of Hereford, wanted to commission him to do illustrative work that would boost the sale of their own publications.

The London booksellers were as eager as their provincial colleagues. They struggled with one another and quarrelled with Bewick over distribution rights and prices. As the Dillys, the joint London publishers of the second edition of *Quadrupeds* put it, they all wished 'much to have a hand in the Pye'. Members of the metropolitan trade were eager to secure exclusive rights of wholesale distribution and to purchase Bewick's copyright in his work. But Bewick, despite his close working relations first with Robinson's and then with Longmans, always retained his independence from these publishing giants. As he wrote to J. Payne in 1807 about a new edition of *Quadrupeds*, 'I am determined to throw the sale open to the whole trade upon equal terms.' Such tactics provoked repeated complaints from his London publishers and prompted his London friends to warn that he might be losing sales. But Bewick, whose business practices were marked by a robust and shrewdly self-interested sense of probity (he eventually quarrelled with all his business partners), was not to be tied down to one big London publisher. By 1809 no fewer than ninety-five London booksellers were dealing in the demy edition of the first volume of *Birds*. Bewick had reaped the harvest sown by publishers like John Bell, who had recently helped to deregulate and so transform the London book trade.

Bewick's determination to preserve his independence was not forgotten. In *A Treatise on Wood Engraving*, published in 1839, his refusal to be bound by the booksellers was seen as a sign of artistic integrity:

> As an engraver Bewick's life affords a lesson to all who wish to attain distinction in art, and at the same time preserve their independence. He diligently cultivated his talents, and never trusted to booksellers or designers for employment. He did not work according to the directions of others, but struck out a path for himself; and by diligently pursuing it according to the bent of his own feelings, he acquired both a competence with respect to worldly means and an ample reward of fame.

The enthusiastic and widespread response to *Quadrupeds* reveals how deeply the culture of book and print collecting had penetrated British society. Purchases of Bewick's books came from all quarters of the land, especially from the commercial and professional classes of provincial

towns. (Subscribers to *Quadrupeds* included a printer, bookseller, linen draper, surgeon, engineer, attorney, doctor and even a comedian; to *Birds*, a chemist, plumber, architect, wharfinger, organist, tobacconist and schoolmaster; and to *Fables* a solicitor, banker, armourer, stationer and doctor.) Later editions of Bewick's work also attracted subscribers from abroad – Paris, St Petersburg, Hamburg and Philadelphia – but most subscribers came from the North of England and the Midlands, from growing industrial towns and cities. Londoners – like some provincial customers as well – could obtain copies from the London booksellers and are therefore probably underrepresented in the subscription lists, but Bewick's financial records show that by the end of his life provincial sales of his work were far more important than those in London. Not all his purchases were burghers: many were country gentlemen and prosperous farmers, the sort of men who sent Bewick the specimens he copied for the engravings in his *Birds*. But the cult of Bewick was largely sustained by the sort of city-dweller who belonged to improving associations, book clubs and literary and philosophical societies, who shared both Bewick's attachment to the countryside and his belief in the instructive value of contemplating nature.

Bewick became rich as well as famous, the cumulative earnings from his books, combined with income from his workshop's job work, making him much richer than most skilled artisans. He calculated the net profit on the second volume of his *Birds* at £1,312 on an expenditure of £600 in printing and paper costs. By 1810 he had several thousand pounds invested in government stock and a further £2,000 lent on mortgage to a local landowner. In 1827 he was able to transfer large sums of government stock to his children. His investment ledger is not that of an ordinary provincial engraver.

How do we explain the widespread and enthusiastic reception of Bewick's work in late Georgian Britain? Much of his appeal is captured by William Wordsworth, who envied Bewick's 'truest feeling for nature', and wrote of a 'poet who lives on the banks of the Tyne,/ Who has plied his rude tools with more fortunate toil/ Than Reynolds e'er brought to his canvas and oil'. Wordsworth's Bewick was a rude, untutored lyricist, whose direct representation of the wonders of nature he deemed far more powerful than the greatest works of the first president of the Royal Academy. Bewick represented what was local and particular – 'on the banks of the Tyne' – fashioned in a humble medium, and his natural,

203. Mr Thos. Bewick, the
Celebrated Engraver on Wood
by Miss Kirley, engraved by
T. A. Kidd, 1798

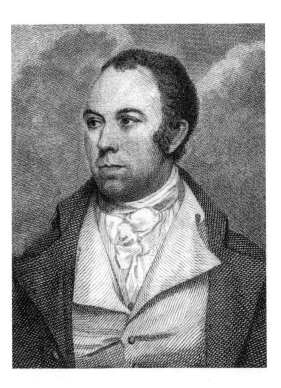

untaught genius enabled him to depict the sublimity and beauty of nature
as no other (fig. 203).

This sense of Bewick was corroborated by visitors who made the
pilgrimage to his Newcastle workshop. John Dovaston, describing his
first meeting with Bewick, said the artist's 'countenance and conversation
assumed and emitted flashes and features of absolutely the highest sub-
limity; indeed, to an excitement of awful amazement, particularly when
speaking of the works of the Deity'. The American naturalist John James
Audubon called him 'purely a son of nature, to whom alone he owed
nearly all that characterized him as an artist and a man'. Visitors noted
his dialect, simple dress, direct manners and rustic appearance (fig. 204).

In many ways Bewick was the figure of his admirers' fancy. In
his *Memoir* he idealized rural life, encouraging aspiring artists to retreat
to the countryside and to shun the city's unhealthy atmosphere. Urging
his schoolboy friend and fellow Newcastle apprentice Kit Gregson to
leave London and return to his native city, Bewick wrote, 'I wonder
how you can . . . let the opportunity slip of contemplating at your ease

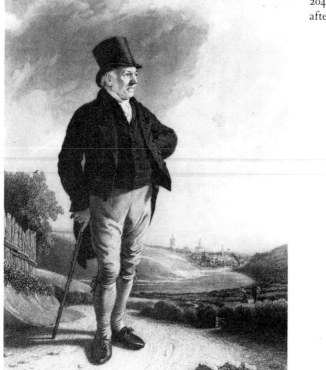

204. *Thomas Bewick*,
after Ramsey

the beauties of nature so bountifully spread out to enlighten, to captivate
and to chear the *hearty man* – for my part, I am still of the same mind
that I was in when in London, & that is I would rather be herding sheep
on Mickley bank top, than remain in London although for doing so, I
was to be made the Premier of England.' Proudly provincial, unashamed
of local dialect, fascinated by local tradition, glorying in the achievements
of his native city, Bewick used his work, especially his vignettes, to show
his deep affection for particular places and things – a tree, field or
scarecrow – rather than love of a generalized countryside or abstract
nature.

In his pronouncements on art Bewick disparaged academicism and
praised nature as the true source of artistic inspiration. 'Had I been a
painter,' he wrote in the *Memoir*, 'I never would have copied the Works
of "Old Masters" ... I would have gone to nature for all my patterns,
for she exhibits an endless variety – not possible to be surpassed and

scarcely ever to be equalled.' And, he added, 'in art nothing is worth looking at but such productions as have been faithfully copied from nature'.

This idea of Bewick as untutored rustic genius was taken up even in his own lifetime, by people who viewed the countryside as a sentimental repository of the values and feelings they believed they had lost in town life. Critics praised Bewick for his ability to take the jaded city-dweller out of himself and into a nostalgically aestheticized rural idyll. 'Wearied and exhausted in the "busy hum of men",' wrote one paean to Bewick's work,

> the eternal discordant noises of the streets grating harshly on his ear [the reader of Bewick] . . . will recur with tenfold delight to the recollection of rural sounds – to the cries of animals or the songs of birds – to the fall of waters, whether murmuring gently in the 'trotting brooks', or dashing fiercely down the rock – to the sounds drawn forth by the winds in their endless courses, whether as sighing and whispering in the leafy woods, or whistling and roaring in their strength.

But there is much more to Bewick and his work than this rural nostalgia would imply. He lived and worked for almost all his life in a big, industrial city. He was a hard-nosed businessman (too hard-nosed for some of his acquaintances) with a flair for publicity and for seizing the main chance. Audubon may have been impressed with Bewick's rude appearance, with his cotton cap (G. C. Atkinson, Bewick's first memorialist, claimed it was silk) and his grey worsted stockings, but he had many of the pretensions of the upwardly mobile tradesman. He did not stint on clothes (especially silk stockings), his daughters learned French and mixed with local gentry, his house was well stocked with pictures, prints and books.

What are we to make of this *homo rusticus* whose *Memoir* quotes Dr Johnson, uses the poet James Thomson as a model for its rural descriptions, praises Francis Bacon and John Locke, refers to the verse of Thomas Gray, Allan Ramsay and Oliver Goldsmith, casually mentions that Bewick does not need to read David Hume on miracles, and obliquely compares his own work with that of John Milton? Or of the untutored artist who collected catalogues of art exhibits in London and Newcastle, owned treatises on perspective and a print collection that

included works by Stubbs, Hogarth, Piranesi, Woollett, Rembrandt, Hollar, Callot and Thomas Rowlandson? Bewick was more knowing and less ingenuous than many of his admirers supposed. The habitué of archetypal institutions of urban life – the improving association, debating club and philosophical society – concealed himself behind notions of rural simplicity.

Bewick's life and work were shaped by his romance with the Northumberland countryside, and by a carefully thought-out philosophy whose precepts could have been – indeed, sometimes were – the subject of discussion in societies devoted to cultural and moral improvement. For 'the poet who lives on the banks of the Tyne' held strong views about moral and religious duties and about his own obligation to ensure they were followed. He saw himself not just as a provincial artist but as a teacher and philosopher. 'The highest character a Man can hope to attain to, in this life', wrote Bewick in his *Memoir*,' is that of becoming a religious Philosopher.' The *Memoir*, with its long disquisitions on morality, religion and education, laid out his creed.

'It is of the utmost importance to the wellbeing of society,' Bewick wrote in a collection of aphorisms, 'that youth be early initiated in the true principles of Religion, Morality and Patriotism.' These principles were not hard to see, provided the viewer's vision was not clouded by ignorance, prejudice or passion, but readily perceptible. 'Commonsense only', Bewick commented in his *Memoir*, 'is necessary for all that is required for us.' The sources of moral and religious instruction were threefold: the Bible, provided it was read allegorically and not literally in the manner of the Methodists; 'Fables, parables and Allegories' of the sort he spent his life illustrating and writing; and, above all, nature – 'the still more sublime and amazing works contained in the great book of the Creation ... made up of the living and visible Words of God'. Nature was the supreme moral text – 'I have always thought that there was nothing deserving of being called knowledge but knowledge of nature' – and had to be read rightly.

Understood from this perspective, Bewick's fables and works of natural history take on a moral, religious and didactic, rather than aesthetic and sentimental, light. On a number of occasions – in his correspondence, in an article published in the *Monthly Magazine* in 1807, as well as in his *Memoir* – Bewick made his aims explicit. Writing shortly after the publication of *Birds*, he explained:

> From my first reading, when a boy at school, a sixpenny history of Birds and Beasts, and then a wretched composition called the History of three hundred animals, to the time I became acquainted with works on Natural History written for the perusal of Men, I never was without the design of attempting something of this kind myself; but my principal object was (and still is) directed to the mental pleasure and improvement of youth; to engage their attention, to direct their steps aright, and to lead them on till they became enamoured of this innocent and delightful pursuit.

Natural history may have been innocent but it was also instructive. The aim of his books was to 'make youths of the present generation, pursue the lessons in the great book of nature so amply spread before them', because natural history, more than any other pursuit, afforded 'endless pleasures . . . to all who wish to trace nature up to Nature's God'. The technical ability to reproduce nature's works accurately and in all its detail was vital, for nature should not be misrepresented and misunderstood; verisimilitude opened up God's design to viewers, 'the more readily to allure their pliable, though discursive, attention to the Great Truths of Creation'. 'Truth to nature' was not so much scrupulous accuracy as the tracing of the Creator's designs as faithfully as possible. Technique was moral. Bewick's books of beasts and birds, with their pastoral and marine vignettes, were anatomies of the divine purpose, and their beauty and intricacy were intended to excite the viewer to admiration and worship of the Creator.

Bewick's way of depicting nature as a means of moral instruction is most obvious in the vignettes, or tailpieces. They repeatedly remind us of human vice and folly, of the perils on life's journey, of the evanescence of our existence. Sometimes these cautionary tales are depicted allegorically, with pride and vanity as a cockerel or peacock; more often the vignettes show a suggestive moment of vice or folly: a blind man and illiterate child fail to follow the right path and stumble into danger (fig. 205); a housemaid's sexual desire leads her to neglect her young charge, who is about to pull a horse's tail and be felled by its hoof (fig. 206). These didactic images are less a true representation of nature (though contemporaries certainly saw them as that) than an imaginative use of it to instruct and inform.

The distinction between these vignettes and the larger woodcuts of birds and animals, where Bewick strived so hard to render their physical

205. Vignette: *Blind Man and Illiterate Boy* by Thomas Bewick

appearance accurately, is less great than might at first appear. Many of Bewick's admirers believed that his skill lay not merely in presenting the animals' physical appearance but in conveying their character. John Dovaston remarked of Bewick's birds, 'The moral habits of each are as distinctly marked as if he painted portraits of individuals' for Lavater, the student of human physiognomy, while James Wilson, in a long essay in *Blackwood's Magazine*, treated Bewick's anthropomorphism as one of his finest qualities:

> It needs only to glance at the works of Bewick, to convince ourselves
> with what wonderful felicity the very countenance and air of his

206. Vignette: *Maid, mother and child* by Thomas Bewick

animals are marked and distinguished. There is the grave owl, the silly wavering lapwing, the pert jay, the impudent overfed sparrow, the airy lark, the sleepy-headed gourmand duck, the restless titmouse, the insignificant wren, the clean harmless gull, the keen rapacious kite – every one has his character.

Attributing moral qualities to birds and beasts, a tendency which was especially pronounced in *Quadrupeds*, made it easy to moralize them.

Bewick's view of nature had its politics. As a rationalist, a believer in a natural religion that smacked of deism, and a 'warm whig', Bewick was an astringent critic of autocratic government, proud aristocrats and narrow-minded clerics of the Church of England. He was a strong

207. Vignette: *Old soldier and dog before country house gate* by Thomas Bewick

supporter of the American colonists, an admirer of the aims of the French Revolution (though he regretted its later excesses), an advocate of parliamentary and legal reform, and a critic of grasping landlords whose enclosure of common land hurt less fortunate members of rural society. He expressed these views not only in the text of his *Memoir* and his *Fables* but also in his vignettes.

Bewick considered that the aristocracy had failed in their duty to be exemplars and guardians of moral virtue; seduced by a vainglorious militarism (Bewick was a persistent critic of war and violence), led by avarice to be exacting landlords and enclosers of commons, they neglected public virtue for private gain. In Bewick's vignettes this dereliction of

duty is indicated by the gentry's closed carriages and by the high walls around estates that cut off their owners from the rest of society and keep out the poor and needy. In one of several treatments, the biblical story of Dives and Lazarus in which the rich man forfeits his place in heaven because he neglects the poor man at his gate, Bewick depicts a soldier who has lost his leg in battle and is accompanied only by his faithful dog. His misfortunes are so great that he is reduced to gnawing

208. Vignette: *Peacock before park gate* by Thomas Bewick

a bone. He sits, neglected, before the gates of a distant mansion whose occupant (his vanity and pride are symbolized by the peacock on the wall) ignores the sacrifice this unfortunate man has made for nation and public (figs. 207, 208).

Many of Bewick's vignettes suggest that enclosure and emparkment, the building of walls and hedges, are acts of separation. Man is cut off from man; those who should display moral probity shut themselves off from the source of virtue – nature. Walls separate the park from open country as surely as they separate the aristocrat from those to whom he is obliged. The consequence of such moral blindness is apparent from one picture in which a corpse picked by carrion crows hangs from a gallows on a wild moorland hilltop; in the cultivated valley below we see a village church, and a closed carriage disappears out of the picture frame: church and aristocracy alike are distanced from the consequences of their deeds (fig. 209).

209. Vignette: *Gibbet, coach and church* by Thomas Bewick

Nature represents freedom – the freedom to worship, to farm and to fish. (Bewick opposed the laws which confined the right to kill game to landed proprietors and the restrictions imposed on salmon fishing on the Tyne.) This freedom is embodied in natural law whose precepts can be seen in 'the great book of nature' spread out and open for all to read. Bewick contrasts natural liberty with the shackling, man-made proscriptions of the aristocracy and church. Militarism and man-made religion have all too often 'disfigured' what Bewick calls 'the comely face

210. Vignette: *Boys climbing ruined wall* by Thomas Bewick

of natural religion'. They have, he adds, become rigid and systematized, 'interwoven into all the different Governments, – And thus fenced, barricaded and fortified, few [men] ever dared to say that any thing these laws promulgated, was wrong.' It is no surprise, then, that Bewick represents palaces, abbeys, churches and castles – the symbols of this moral fortification – in states of ruin and decay. Time, his vignettes show, inevitably reopens the enclosing walls of castles and churches to the freedom of the natural world (figs. 210, 211).

Bewick's concern for openness extended beyond his social prescriptions and into the formal construction of the vignettes themselves, which are borderless, unenclosed and open. Though the images are composed within an invisible frame, Bewick allows the viewer to determine their boundaries. Art, like nature, is open to everybody and is open to interpretation. Just as the content of 'natural religion' is decided by each person with the help of common sense and rationality, so the viewer must interpret the vignettes in his own way.

Not everyone who enjoyed Bewick's books shared these views or understood his message. Bewick could be read in many different ways: as a skilled presenter of the natural world, as the vivid depicter of a sentimentalized provincial rural life, as an exemplar of a naturalistic aesthetic. There are signs that gesture to all these views, as well as some indication, especially in his later years, that Bewick was not averse to playing the part his Romantic admirers assigned him. But in his valedictory

211. Vignette: *Ruined seashore abbey* by Thomas Bewick

212. Vignette: *Solomon Exhorts to Shun the Wicked* by Thomas Bewick

Memoir, written to ensure that his life's work was not misunderstood, Bewick's sense of what gave his vision coherence is clear. He claimed to be more than a simple transcriber of nature; he avowed that his greatest aim was to reconstruct, orchestrate and present God's great design. As mediator between God and man, he was purposefully selective about what elements of nature he showed and about what they represented.

Many of his friends understood this. G. C. Atkinson, in a lecture to the Natural History Society of Northumberland, Durham and Newcastle upon Tyne, praised Bewick on the grounds that it was more noble and reasonable 'that a child should derive its first ideas from representations of the works of our Creator, than that the young mind should be over-charged with frightfully distorted images of humanity, endowed often with preternatural attributes, and acting according to the rank fancy of the author, rather than to any reasonable or moral and exemplary motive.' Rather more pithily, Dovaston remarked that Bewick 'fully felt that organized orbs or atoms tell equally of their ineffable Architect: and this it was his incessant desire to impress on the minds of all'; *Blackwood's*

Magazine commented on the 'moral in every tail-piece – a sermon in every vignette'.

One engraving, not in Bewick's major works, epitomizes his aims. It shows human figures whirling off a globe that is afloat in the universe, a scene overlaid by a slip of paper held down by an engraving of Bewick's thumbprint, which he sometimes used as his special signature. On the paper is a verse from the Book of Proverbs: 'Wisdom *is* the principal thing: *therefore* get wisdom: and with all thy getting get understanding (fig. 212).'

'The Harmony of Heaven': John Marsh and Provincial Music

THE MEMORY OF Thomas Bewick endures, albeit in sanitized, commercalized form. Purged of its reformist associations and transformed into the celebration of a rural idyll, his work adorns tea towels and toasters as well as works of rustic nostalgia; his vignettes assuage the pastoral longings of the urban sophisticates who read the *New York Review of Books* and they are taken, in both Britain and North America, to embody Englishness. His birthplace, Cherryburn House, is now a museum managed by the National Trust. He has become an official part of Britain's 'national heritage'.

No such popular recollection survives of John Marsh (1752–1828), a contemporary of Bewick who, in a very different medium and place, made a vital contribution to the cultural life of the English provinces. Marsh was a musician, an amateur and a gentleman, not a 'man of business' whose livelihood depended upon his skill and craft, which may explain why his reputation has not survived his lifetime. English composers of the eighteenth century – once we except that naturalized Englishman George Frideric Handel, born in Germany and trained in Italy – are best known for their obscurity, remembered only as the shadowy inhabitants of a penumbra between the dazzling achievement of the great seventeenth-century Italians and the brilliance of the Germans and Austrians – Mozart, Haydn and Beethoven – who shaped classical music as we now know it. A vibrant English musical tradition of church music, embodied in the works of such sixteenth- and seventeenth-century composers as William Byrd, Thomas Tallis and Orlando Gibbons, had suffered nearly as severe a blow as the visual arts from the hostility of the Puritans. Eighteenth-century English composers could not even be praised as distinctively English, minor figures who nevertheless

developed a national idiom, for the notably English form of the day, the oratorio, was dominated by the substantial figure of Handel. English concertos, symphonies and chamber works appeared to derive from the much better-known compositions of continental composers or, like the *galant* style, to have entered Britain from such German and Italian musical centres as Mannheim or Genoa. Even London, the great metropolis, seemed musically provincial: a lucrative stopping place for the many performers and composers from Italy and Germany, the centre of a vibrant concert culture, but not a nursery of native genius and composition.

If the standing of British musicians was not of the highest, the status of an amateur musician like John Marsh was even lower. English musicians resented the presence of performers who believed that their social standing compensated for their limited abilities or entitled them to embellish works in a way that might well detract from the performance. As the West Country composer William Jackson remarked, a propos of that passionate musical amateur Thomas Gainsborough, 'How often do presumptive amateurs spoil the success of a concert by contributing their efforts under the mistaken conviction that they are adding to the enjoyment of the affair, whereas in reality they are only giving offence to the unfortunate composer of the music?' Such remarks, made about a good friend but a less than average performer, suggest that it is fortunate for amateurs that surviving comments by professionals on their performance are so few.

British commentators on genteel education assigned musical skill a low status on the list of polite accomplishments. John Locke ranked music in 'the last place' of gentlemanly talents because 'it wastes so much of a young Man's time, to gain but a moderate Skill in it, and engages often in such odd Company'; other writers viewed musical performance, being essentially a manual skill, unbefitting for a gentleman, and potentially effeminate because it might mean associating with unmanly foreigners. The study of music as a science was legitimate, but the passions aroused by musical performance were more troubling. As one commentator remarked, 'don't over-rate these Talents, nor place 'em among the first Rate Qualifications of a Gentleman; for in reality they only fit you up for a modish Address and a female Entertainment. Let a Man rather trim up his Mind, than his Body: Those Embellishments are more *noble* and *rich* that lie in the Brain, than those that sink into the Feet, or *perch* on the Finger's End.'

The comparatively low status of amateur music-making is revealed in this derogation of it as a predominantly female accomplishment or one associated with female seduction. Though this was not always true of every sort of musical performance, playing the keyboard and singing were considered, together with proficiency in French, needlework and dancing as fashionable skills whose mastery displayed young women to men in the most attractive and desirable light. The ability to play the harpsichord or pianoforte, to sing in tune and with feeling, was a requisite for young women in search of a husband, for music-making was part of the rituals of courtship. Musical ability was subordinate to the imperatives of the marriage market; excessive talent was deemed too showy or demonstrative, appropriate for certain professional performers but unsuitable in an attractively demure young woman.

All this did not stop men and women from playing, but it affected the status of music when compared with other genteel arts. The contrast between the reputations of the 'gentleman-fidler' and the 'man of letters' could hardly be more pronounced. In the eighteenth, as in later centuries, the British man of letters, whether amateur or professional, towers over the diminutive but numerous figures populating the musical landscape. Amateur musicians were just as common as minor literati – perhaps more so – but their achievement has remained obscure. In most instances they did not compose music, though many arranged the work of others, an important skill before the advent of recordings when hearing music depended on live performance. And new compositions, like those of John Marsh, often did not survive their composers. A great deal of music circulated in manuscript but was not published; a century later, when English music publishing flourished as never before, prevailing tastes disregarded these eighteenth-century compositions for the more fashionable giants of European romanticism and for the folkways of ballad and song.

But, if English music contributed little to the evolving performance of European classical music and is easily forgotten, when we turn to the grander accounts of Mozart's precocious genius, Haydn's shaping of the modern symphony and Beethoven's tortured greatness, we should not neglect Britain's flourishing tradition of composition and performance. Composing and playing music were emphatically not the prerogative of professionals, though it depended on their skills and services, but was stitched together by a heterogeneous band of amateurs, woven out of the

fabric of provincial social life. The result was often not of the latest
fashion, but it was a collaborative endeavour whose satisfactions flowed
as much from the sociability of music-making as from the quality of its
performance. Musical talent contributed to the social pleasure of collective
appreciation, to the creation of harmony.

This was not always easy in the small, tightly knit communities of
gentry and rich merchant families in English provincial towns. For music,
more than any other cultural activity, defined the social realm of those
elites. Music-making was a badge of gentility, a sign of refinement enacted
in private drawing rooms and public assemblies on convivial occasions

213. Trade card:
Jno. Johnson, musical
instrument maker

when the local 'quality' gathered together. Tradesmen and artisans might occasionally be found in bands and musical circles playing fashionable music, but not often, and the barriers to their entry were social.

Making music also placed a burden on the pocket. Though string and wind instruments were not expensive – a West Country physician, Claver Morris, paid £2 and £3.5 for two violins and £5 for a violoncello in the first decades of the century; he had earlier spent £1.7s. for an oboe and £2.10s. for a bassoon – harpsichords and pianos were costly. At mid-century the price of the former ranged, according to the instrument's quality and complexity, between thirty-five and fifty guineas. The latter were even more expensive: by the end of the century, when pianos had become generally available, a grand piano cost about seventy guineas and the cheapest uprights still fetched twenty. Of course, instruments could be purchased more cheaply on the thriving secondhand market, but when the cost of lessons was added to that of the instrument, the outlay was far greater than that for an amateur artist or author and more than what was needed to accumulate a decent collection of books, prints or even paintings (fig. 213).

Concert-going was also not cheap. As in London, most concerts in the provinces were organized as series for which one had to pay a full season's subscription. Even clubs in which enthusiastic amateurs played and sang catches (a round or canon in unison for three or more male voices) or glees (simply harmonized songs for the same voices but without accompaniment) charged substantial dues. The catch clubs in Salisbury and Chichester, for example, required a fee of 7/6d. a quarter in the 1770s. Grand musical occasions, such as the St Cecilia's Day concerts held in Salisbury Cathedral and in the assembly rooms, charged entrance prices in excess of the seasonal fee to a subscription series.

In these socially circumscribed venues, proper conduct was at a premium. Failure to bow, the unauthorized borrowing of a colleague's instrument, disputes over who should lead a band and what was the correct tempo could all provoke vituperative hostilities, which subverted the integrity and threatened the very existence of the social circles on which the musical societies depended. Harmony was the object but discord was often the result.

*

John Marsh was the son of a sea captain and worked as a solicitor in Romsey and Salisbury before inheriting land and securities which enabled him to live as a gentleman of private means with an income of more than £1,000 a year. According to his 'history of my private life', his passion for music began in early childhood, matured with his first lessons in Romsey as an adolescent, and flourished unabated throughout his long life. After eight years of pupillage to a lawyer – who described him as 'a Clerk whose head was so full of crotchets and quavers, instead of Law, that whenever he had occasion in his draughts to make a reference to the margin &c instead of an Asterisk or common note or mark, he wd put a sharp or flat, or select some Musical Character for the purpose' – he became a partner in a law firm in Salisbury in 1776 and an active member of the local orchestra and musical societies.

In 1781 he came into his inheritance and moved into Nethersole, a house a few miles outside Canterbury, where he became the leader of the concert series there. Finding the life of a country gentleman too insular and expensive, he sold his estate and moved to a town house in Chichester in 1787, when he was thirty-five, and remained there for the rest of his life. He became a civic dignitary, serving repeatedly as an overseer of the poor and organizing public subscriptions for the indigent during the terrible dearths of the 1790s. He helped to establish a charity school and a savings bank, served as an officer in the Volunteers during the French Revolutionary Wars, and as an income-tax commissioner. But these responsibilities did not keep him from leading Chichester's orchestra or organizing catch clubs and private concerts. Marsh's choice of residences – in Salisbury, outside Canterbury and in Chichester – underscores the importance he attached to music, for these cathedral cities, with their choirs, grand organs and snug 'society' gathered round a cathedral close, had the best environments for music to flourish in (fig. 214).

Yet for Marsh this was not enough, and the provincial music scene could not contain his restless and unflagging talents. The composer of at least twenty-eight overtures and symphonies and twelve concerti grossi, numerous services, chants, anthems, voluntaries, catches, glees and songs, Marsh heard his music performed all over the country. His psalm tunes, chants, anthems and voluntaries were performed in abbeys, churches and cathedrals, including St Paul's, St Martin-in-the-Fields, St Margaret's, Westminster, and Westminster Abbey in London: his secular works were

214. View of Chichester, artist unknown

played in theatres, pleasure gardens and musical clubs. In the spring of
1798, for example, Marsh joined the band at the Drury Lane Theatre to
play his sixth symphony between the acts of a new play; in 1784 the
orchestra in the rotunda at Ranelagh played some of his overtures; six
years later they performed his fourth symphony, which was also part of
the programme at the Anacreontic Society, a prestigious club of gentle-
men amateurs which met at the Crown and Anchor in the Strand, in
the spring of the following year.

So Marsh was part of a national music scene. On his annual spring
visits to London he regularly attended the concerts staged by Wilhelm
Cramer, Muzio Clementi and Johann Peter Salomon at Hanover Square;
he also frequented performances at the Philharmonic Society and the
Concert of Antient Music. He attended operas at the Pantheon in Oxford
Street, at Drury Lane and at the Lyceum or English opera house. From
1801 he was a member of the Royal Society of Musicians, and he made
a special point of attending benefit concerts for musical societies and
individual performers. In the summer and autumn he packed his
instruments and journeyed to one or more of the numerous provincial

music festivals. At Winchester, Chichester, Salisbury, Oxford, Hereford, Worcester, Gloucester, Norwich, York, Derby or Liverpool he played his violin or listened enthralled in the audience. Sometimes, as in 1778 at the St Cecilia's Day festival in Salisbury, he was both auditor and performer, choosing to play the kettledrums in *The Messiah* so that he could move from the stage into the nave of the cathedral to enjoy the full sound of the performance during the parts without drums.

In his energetic pursuit of musical pleasures Marsh met the leading amateur and professional musicians of his day, and some became good friends. In Salisbury he often played with James Harris, a philosopher, aesthetician, one-time treasury minister, amateur composer and keyboard player who orchestrated the town's musical life and whose library, containing more than 1,000 folio pages of manuscript scores from Italian composers, was the source of pieces arranged for local performance. In London Marsh was on good terms with the Scottish musician William Napier, founder member of the Royal Society of Musicians and publisher of Haydn's *Scots Songs*. Napier introduced him to the London impresarios whose concert series and publishing activities promoted 'modern' music, notably the symphonies of Joseph Haydn and Ignaz Pleyel. Marsh was to be found in the shop of Longman and Clementi, buying sheet music to take back home or offering his own works for publication.

But most of Marsh's musical acquaintances, especially those who became friends, came from the provinces. In 1778 he met John Mahon, a great popularizer of the clarinet in England, because Mahon's regiment, the Dorset militia, had been posted to Salisbury. When their paths later crossed they often played together. Marsh claimed that the virtuoso wind and horn playing of John and his brother William Mahon inspired him to write his concerto for two orchestras. He also composed a special horn concerto for them. The Mahons, like the Corfes of Salisbury, the Linleys of Bath and the Reinagles of Oxford, came from families of professional musicians who were talented enough to perform in the major festivals and on the London concert stage.

A few of Marsh's friends were even grander. He played with Gertrud Elisabeth Mara, a German soprano and prima donna who frequently gave concerts at Bath, but who first gained fame at the Handel commemoration in Westminster Abbey in 1784. And he exchanged scores and ideas with William Crotch, whom he had first seen as a child prodigy on the keyboard, and later came to know when Crotch was professor

of music at Oxford and the composer of *Palestine*, the most successful English oratorio since Handel's *Messiah*.

Though Marsh was unusually passionate about music, he also enjoyed all the accomplishments of the refined and cultured gentleman – drawing, good conversation, dancing and assemblies (though not cards). He was a shareholder in the Chichester theatre, erected in 1792, and a close friend of a poet, William Hayley, who lived just outside the town and whose verses he often set to music (fig. 215). Marsh also published a number of instructional works on music, astronomy and accounting. In the early years of the nineteenth century he contributed regularly to musical magazines, commenting on the state of secular and sacred music. And in his later, more religious years, he wrote a remarkable treatise on the fate of the human soul after death, *The Excursions of a Spirit*, which was published anonymously in 1821.

Marsh was especially interested in astonomy and scientific instrument-making. He records attending six series of philosophical and scientific

215. *William Hayley* by George Romney, *c.* 1779

lectures, the first in Romsey in the winter of 1775 and the last in 1810 in
Chichester. He was a close friend of the lecturer and instrument-maker
Adam Walker, whose lectures he attended at Canterbury in 1785 and
again in Chichester in 1800, and to whom he dedicated *Astrarium
Improved*, an astronomical treatise showing the heavens in each month
of the year, published in 1806. His enthusiasm for astronomy and
instrument-making was closely linked to his interest in music, of course:
the skills and technologies that went to produce the large refracting
telescope that Marsh bought from Walker in 1810 were essential in
producing precise and tuneful instruments; the science of mathematics
underpinned both musical theory and an understanding of the stars.

When he was not performing or composing Marsh was an avid
reader, helping to found a book society in Chichester in 1789, which he
was still attending a few weeks before his death in 1828, and a library
society set up in 1794. He and his wife read for several hours a day,
'taking each always a Book at Breakfast & at Tea Time . . . and also for
sometime after Dinner & Supper, by whc means we each read about 2
hours or more every day, in common'. The Library Society provided
Marsh with books of non-fiction – history, biography and travel literature.
He loved novels and romances, which he borrowed from circulating
libraries and invariably slipped into his pocket whenever he travelled.
In January 1799, for instance, he went from Chichester to Salisbury,
'taking with me for my amusement there and in the coach, the little
Novel Maria or the Vicarage, wch I had seen well spoken of in a Review'.
Marsh also acquired books from James Lackington's London emporium,
where he exchanged books he had bought at a cut price from the Book
Society or made purchases outright.

Throughout his life Marsh loved mock-heroic and picaresque fiction.
As early as his fifteenth year he was translating Lesage's *Le Diable
Boiteux*. His enthusiasm for Lesage remained unabated. At fifty he was
delighted to find both French and German versions of *Gil Blas* in the
library while on holiday in Worthing. His favourite English novels were
by Fielding (especially the quixotic *Tom Jones*, which he read on many
occasions) and Smollett, the translator of Cervantes. When he married
in 1774 Marsh bought 'a small assortment of books' to read aloud to his
bride, beginning with Fielding's works and *Don Quixote*. In 1795 Marsh
was able to while away the time when caught in a shower of rain by
reading *The Adventures of Ferdinand, Count Fathom*, which he 'had in

his pocket'. These picaresque novels, with their emphasis on action rather than character and on the contrast between human aspirations and their realization, affected the style and form of Marsh's extraordinary journals, which give us such a detailed picture of his life, just as they inspired his fictional mock-heroic travel book *A Tour Through some of the Southern Counties of England. By Peregrin Project and Timothy Type*, published in 1804.

Marsh records beginning his 'History of My Private Life' in 1796, though for years he had been keeping a detailed journal: 'At the beginning of this year (1765) I bought a Pocket Book & began keeping a Diary, which (except the omission of the greater part of the following year 1766) I have continued ever since, so that in future I can be more particular as to dates &c.' He wrote at regular intervals thereafter, usually transcribing his history while on holiday or when travelling about the country. He presented the first twenty-eight volumes to his son, Edward Garrard, in the summer of 1811. No other surviving source gives such a vivid and detailed account of the world of Georgian music (fig. 216).

John Marsh's 'History of My Private Life' is a memoir of no fewer than thirty-seven manuscript volumes covering his entire life (the final pages were completed after his death by his son Edward). Marsh did not call it a 'memoir' but a 'private history'. He might have called it an autobiography – the term had first been used in 1797 by William Taylor of Norwich when reviewing Isaac d'Israeli's *Miscellanies* in the *Monthly Magazine* and had quickly come into general usage – but instead he opted for an oxymoronic title. Like a history (and unlike a novel or memoir), the text contains marginalia to guide the reader and regulate the narrative's tempo. Marsh exercised extraordinary care in recording the facts of his life. No detail was too picayune to be omitted. The death of a family dog, the birth of a litter of kittens, the silent inebriation of a neighbour, a nosebleed, visits to the dentist, a shave from a female barber, an overturned chamber pot full of urine, the discoloured fingernails of a school friend – these were all recorded with the same exactitude Marsh brought to his descriptions of a concert programme or a local election.

When he wrote up his fair copy from rough notes Marsh listed what he considered to be the most important events in his life. Though musical performances and compositions predominate, he included occurrences that ranged from the outbreak of war and the death of kings to teaching

216. John March, *A History of My Private Life*, 1798

his grandson to play the piano and observing a solar eclipse. It is *his* history, informed by an unapologetically parochial perspective in which local detail looms as large as the most important national event.

By the late eighteenth century it had become a critical commonplace to note that the small details of someone's life recorded in a biography or autobiography helped the reader to understand the subject. But Marsh's attention to detail does not seem designed to explain his own character or that of others around him. The telling detail is corporeal rather than psychological, as when we learn of his father's girth when told that he always booked two places when travelling by stagecoach, or of his valetudinarian wife's obesity when he mentions the small stool she carried so that she could rest while walking. This sort of detail is reminiscent of Bewick's graphic vignettes, though Marsh's history is quite unlike Bewick's *Memoir*. Marsh sticks to his narrative and rarely pauses to offer

moral commentary or any criticism. His position is that of the seemingly dispassionate observer, recording events of which he was a part but also distancing himself from them. He never pauses, like Bewick, to offer a homily or sermon on a moral or political issue.

What was Marsh up to? Why did he devote himself to this prodigious work which, as he sometimes complained, took up so much of his time? Marsh hints at the answer, but there is more evidence of his intentions in his published writings, notably his essays on musical performance, *A Tour Through some of the Southern Counties of England* and his study of the intermediate state of the soul. Almost all these published writings drew on the manuscript of his private history; in the case of *A Tour* he quoted large chunks verbatim. But they were published anonymously; we learn of their author only through the history itself. (However, most of Marsh's circle of acquaintances knew him to be the author of these works; several of them read drafts of the different manuscripts.)

One of the first impressions one has from the private history is of a world of accidents, absurdities and thwarted intentions. Concerts are spoiled by players who cannot keep time; Marsh's wife is excluded from Salisbury's polite society because of an incomprehensible piece of etiquette; 'A fellow of a most consummate impudence' who mounts 'the orchestra to perform an imitation of dfft [i.e. different] birds' spoils the earlier pleasure of listening to the divine Miss Linley; the last night's performance in the old theatre in Salisbury degenerates into a riot, and a drunk cleric makes a fool of himself on stage. The lord of misrule is often present in Marsh's account of polite society.

Marsh's history is full of the comedy that he admired in Fielding and Smollett. He reminds us of the high price paid for the pursuit of social and aesthetic cultivation: how easily harmony turns into discord, how difficult it is to observe the proprieties of cultured life. His frequent invocations of the banal and the carnal and his repeated demonstrations of human imperfection subvert his attempt to be cultivated but, by emphasizing its unattainability, make its pursuit heroic, if not tragic. The culture of the provinces, Marsh implies, can be understood only as a mock-heroic story in the manner of one of his favourite books, *Don Quixote*.

In his *Tour* Marsh adopted the persona of Peregrin Project, a bookseller deluded by reading travel literature into believing he can make a fortune by publishing his own travel account. Accompanied by his Sancho

Panza, a printer named Timothy Type, Project visits the cathedral towns that Marsh knew so well, gathering materials for his narrative. But, instead of offering his readers lists of Old Masters and memorials to the great, Project records the prints in tavern parlours, the subject-matter of Delft tiles around the tavern fireplace and the epitaphs of drunken soldiers and women shellfish-sellers. In both fiction and history we have a mock-heroic character in pursuit of an unattainable end.

Marsh's self-deprecation seems at odds with the seriousness and enthusiasm with which he pursued his music, but it is of a piece with his desire to escape censure as a social oddity who considered music more important than anything else. By treating himself humorously he managed to keep his distance, to imply that he was not so totally absorbed by his musical passions as might appear at first sight.

Throughout his life Marsh looked askance at all forms of conflict. During a protracted quarrel between two organists in Salisbury which began in 1780 he refused to take sides and signed a paper asserting his neutrality. Similarly, in electoral conflicts in Chichester in the late 1780s he would not pledge himself to either party. He found both high church and radical dissenting views inimicable, though, quite typically, he enjoyed close friendships with high churchmen and Nonconformists. He was ecumenical and tolerant of people, though he regarded opinions outside the broad consensus of moderate, mainstream Anglicanism as perverse. His first instinct in almost every conflict was to seek reconciliation, to secure an agreement acceptable to all parties. This served him well in local government and explains why he was so often chosen as a leader of convivial and musical societies. But it also brought home to him the difficulty of ensuring unanimity, of obtaining what he called 'perfect harmony'.

In an essay on that subject in the *Quarterly Musical Magazine* for 1826, Marsh wistfully longs for an unattainable perfection: 'whatever approach we may make towards perfection in this or any other science, whilst in this sublunary state, they are yet *but approaches*, or attempts to attain what we shall ever find to be beyond our reach.' All we can do is obtain a foretaste 'of that heavenly harmony with which we may hope to be hereafter gratified in the realms of bliss'. So his private history was not only a mock-heroic story but a Christian tale about the imperfectibility and incompleteness of the human state, didactic as well as droll, a work he could present to his evangelical son as a study in the vanity of human

wishes and as a saga of one man's pursuit of musical and Christian harmony. The foibles and intimate details of provincial life were important because of what they revealed about the nature of man and his earthly existence; they were also invaluable in revealing one man's inevitably flawed struggle to lead a virtuous Christian life and to achieve musical perfection. Throughout his life Marsh had composed didactic works: books on astronomy, bookkeeping, musical notation and composition. The private history was another, offering instruction and illumination. But the private history was never published. The lengthy manuscript does, however, contain many editorial markings, all designed to reduce the length of the text. One suspects that its sheer bulk prevented its appearance in print.

Towards the end of his life Marsh wrote a treatise on what he called the 'intermediate state of the soul'. *The Excursion of a Spirit* revealed his grandest aspirations. In outlining the fate of the virtuous Christian soul between death and the day of final judgement, Marsh imagined a heavenly world devoid of conflict and filled with musical harmony. Instead of squabbling religious factions, 'all controversy is at an end, and every thing that is revealed by the holy Scriptures, is fully and compleatly understood by every individual, and . . . *all*, however different may have been their religious creeds and opinions upon earth, here join in one and the same kind of worship of their Creator and Redeemer.' Instead of musical quarrels between inept amateurs and temperamental professionals, heaven makes 'no distinction of professor and amateur; and . . . not the smallest idea, or notion of competition; as every spirit wishing to become proficient . . . will soon arrive at the *ne plus ultra* of perfection, and, of course, will find himself upon a level with all other practitioners therein', avoiding 'the prevalence of the malignant passions of envy, jealousy, hatred, &c so as to poison most of the enjoyments of life'.

Marsh's heaven offers an infinite variety of music and the finest organs ever built. Its epiphany is a sacred oratorio performed by thousands united in their celebration of perfect harmony: 'What therefore would you think of an orchestra of a thousand (or ten thousand if you please) vocal and instrumental performers, the abilities and powers of every one of which are so nearly equal, as to be scarcely distinguished from each other by the nicest ear, each of which is likewise infinitely superior to any one that was ever heard on earth?' The sensations he describes at hearing such a perfect concert remind us of the words he used in his private

history to describe his feelings when he first heard Handel's *Messiah* and
on the occasion of the Handel commemoration of 1784. It was, he says,
'the most sublime and interesting sight I had ever yet witnessed; that of
many thousands of spirits, actuated as it were by one soul, uttering their
united praises and thanksgivings, and afterwards joining together in one
grand and universal chorus of simple and expressive melody and perfect
harmony, the force and effect of which filled me with the most exquisite
sensations I have ever yet experienced.' Moral completeness, social har-
mony and musical perfection were all united in a single ecstatic moment.
But, Marsh realized, such a climax could not be achieved in the mundane,
querulous and sharply divided society that he had worked so hard to
transform into a realm of social and musical harmony.

On a visit to Canterbury from Salisbury in the spring of 1783, Marsh
played in a small ensemble arranged by his host, Mr Bunce, 'who was
so good as to invite Messrs Porter the Organist, Philpot the dancing
Master (a very good Fiddle player), old Mr Tuck (a Brazier, who had
formerly played a good fiddle of the old school), Mr Gore of the choir,
&c to make up a concert for me'. This little group of enthusiasts, brought
together when Bunce told them that Marsh would be visiting, included
most of the key figures in the organization of Canterbury's music. Its
music parties, assemblies and concerts could only flourish if they were
supported by such men – the dancing master, the church or cathedral
organist, the singer who trained and conducted the choir, and ardent
amateurs like 'old Mr Tuck'. These were not the sole ingredients in the
pot-pourri of local performance – off-duty men from military bands
were vital too – but without them there could be no musical dish to
serve the public.

 Though English country dances and Scottish reels were coming into
fashion in the late eighteenth century, the formal dances that began most
assemblies and balls were of Italian and French origin. Dancing masters,
who gave lessons to young men and women in the cotillion and the
minuet, were often French or Italian or, at least, pretended to be.
Instructing English youths in a skill which was central to courtship and
therefore to a man or woman's future felicity, dancing masters were vital
to the social life of a local community, but they were also looked on
askance as too foreign, fashionable and effeminate. Dancing masters

taught more than the dance steps one needed to learn before attending assemblies and balls. They trained their pupils in deportment and genteel gesture, and their manuals, like that of Giovanni-Andrea Gallini, the century's most famous maestro, contained not only dance steps but instructions on how to stand, sit, greet people of different social rank, accept gifts and generally comport oneself like a lady or gentleman.

In schools like Mr Philpott's academy in Canterbury, which arranged annual dances to show off its young pupils' accomplishments, dancing masters often organized concerts for a fee. Required by their work to play a stringed instrument, usually a violin, they also offered themselves to local bands and concerts. Some played a more important part: when Marsh joined the orchestra in Salisbury in 1775 it was led by Mr Tewkesbury, a dancing master from Wincanton, while the Salisbury dancing master, Mr Burgat, organized concerts to rival those of the amateur gentlemen led by James Harris. Dancing masters also put on assemblies, when genteel company gathered to have tea or supper or take a turn or two on the floor – arranging them, hiring musicians, providing food and refreshment and acting as masters of ceremonies. Taken together, these activities enabled the dancing master to make a modest, sometimes comfortable living.

At the assemblies the dancing master's work was shown off to the world. The results of his private lessons in dance and comportment were displayed on the dance floor and at the tea table; his rules of decorum were honoured; and his importance as an arbitrator of decorum was recognized in his office of master of ceremonies.

The assemblies, held either at regular intervals during a winter season or on special occasions such as the local assizes or town races, became a regular feature of provincial life by mid-century; we know of more than sixty towns and spas which had assemblies by 1770, and there were almost certainly many, many more than that. Not all, of course, were presided over by dancing masters, though they usually had someone who acted as master of ceremonies, the most famous being Richard Nash, a master of emollience whose discreet enforcement of strict decorum at the resorts of Tunbridge and Bath, according to Oliver Goldsmith's biography of 1762, 'diffused a desire of society and an easiness of address among a whole people'.

The management of these assemblies was a delicate task. The assembly brought together the leading members of the provincial

community, demarcating 'the quality' from others, providing their children with opportunities for courtship and affording the occasion for collective admiration. In most English towns, which had no more than a few thousand people, the inhabitants who saw themselves as 'in the first rank' numbered no more than a few hundred. These communities were small, exquisitely snobbish and exclusive, and governed by extremely complicated rules of etiquette. The ball held at the Crown Inn at Highbury in Jane Austen's *Emma* was typical. The guests are all familiar with one another's ways and able to detect the meaning of the smallest gesture. When Mr Elton pointedly fails to dance with Miss Harriet Smith, all present know that a slight is intended, just as they recognize the chivalry of Mr Knightley in coming to her rescue. Maintaining the harmony in such a society was not easy, for acrimonious conflict lurked beneath the smooth but brittle surface of social unity, periodically erupting with devastating effect. Provincial assemblies followed a strict code of conduct not only to emulate the social life of Nash's Bath – to create a local polite culture – but to reduce the possibility of conflict. The assemblies that Marsh attended were more modest than the grand gatherings at aristocratic spas. The ones he patronized as a young man in Romsey were often attended by less than ten couples: what he describes as 'a capital assembly' numbered thirty-five. In Salisbury, during his residence there in the 1770s, he subscribed to an assembly regulated by Mr Burgat, the local dancing master; here a 'great assembly' in October 1780 consisted of less than eighty people. The numbers at the Chichester assembly which Marsh joined in 1787 were equally small.

Marsh's journal expresses well the pleasures and hazards of these intimate but public gatherings. He revelled in the music, strongly preferring more boisterous country dances to the formal minuets, and enjoyed the company of young women he found attractive. But as Marsh discovered, quarrels over partners could produce the threat of a duel; if a lady refused one partner and accepted another, instead of sitting out the dance, as the assembly's rules required, she could provoke a breach between families.

Two of many incidents Marsh recorded are especially vivid in depicting this world. In 1769 Marsh, then working as a gentleman clerk in the office of a Romsey attorney, Mr Daman, befriended the organist at Southampton, Mr Day. They practised the violin together, played some of Carl Abel's recently published concertos at a subscription concert

in Winchester and jointly organized an annual concert in Southampton. Marsh was temporarily acting as master of ceremonies at the assembly in Romsey, and Day asked if he could be admitted. He was barred from the larger and more fashionable assembly in Southampton 'which being a public place he cd not be admitted if he had desired it to the Balls, as being Organist & ranking in their opinion with Tradespeople'. Marsh's characteristically generous decision to include his friend as a member of the Romsey assembly provoked a quick and sharp reaction. His employer's wife was the first to object: 'she was much surprised to hear that *Day the Shoemakers Son* (as she call'd him) had been suffer'd to become a Subscriber to the Assembly & that therefore she should not now be surprised if all the Shoemakers and Coblers in Romsey were to come to it.' Others joined the complaint: Day could hardly be present at the same assembly as one attended by such local notables as Lord Palmerston. Within a short time Day heard of the clamours for his exclusion. Standing on his dignity, he removed himself from the subscription and refused to accept his admission fee when Marsh, highly embarrassed and angered by the affair, tried to return it to him. Day may have played in orchestras with gentlemen, spent time in private with them, but he was not going to be admitted to their polite society. These clergymen, professional men and minor gentlefolk were too anxious about their status, too close to Day in rank, at least when compared with Lord Palmerston, to dare to breach the exaggerated punctilio and exclusiveness that propped up their social standing.

The second incident occurred in November 1779 at one of the Salisbury assemblies, when Mr Burgat, the master of ceremonies, was

> assaulted by Captain Mitchell of the Dragoons (for some interference as MC deem'd I suppose impertinent by the Captain) drag'd out of the room & kick'd down stairs. As however Burgat was appointed by the Subscribers as their Agent as it were, it was thought very wrong by many of them, whatever might have been the provocation that he shd have been used in that manner, on wch account Mr Hussey, the Member [of parliament for Salisbury], went and brought him back again. But the little man being very indignant, the next day sent the Captain a Challenge, who thought it beneath him to notice it, tho' there were some Gentl I know of opinion that having condescended to insult a Dancg Master he ought not to be above giving him Satisfaction.

Even Marsh, who was charitable in these matters, commented that as master of ceremonies he 'did not give quite the general satisfaction that had been expected, being too particular & officious in enforcing the rules at Country dances & also too peremptory in his manner of desiring the Ladies &c to stand up, that happen'd to sit down for a minute or two, to rest, wch occasion'd frequent bickerings.' Burgat lacked the emollient social grace that masters of ceremonies needed, creating rather than alleviating tensions on the dance floor.

But Captain Mitchell's abuse of Burgat has a larger significance. Dancing masters were objects of hostility and anxiety because they embodied an anomaly: polite manners and comportment were supposed to emanate 'naturally', but the work of the dancing master uncomfortably reminded everyone that this was not so, that a gentleman's 'easy dignity' and 'unaffected air' were not innate but the result of assiduous study. This unease was compounded by the way in which pupils moved and marched to the beat of the dancing master, invariably their social inferior and often foreign. The English anxiety about the culture of comportment being alien (a perception that correctly identified its Italian and French origins) and, as such, unmanly and un-English, together with the gentleman's worry that the graceful dancing master might seduce his wife and daughters, exacerbated the apprehension of parents and young male suitors.

We do not know if Burgat was French (his name suggests it) but it is probable that, like many English dancing masters, he gave himself the airs of his profession, which observers would have viewed as Frenchified or foreign. And it is not surprising that, at a time when Britain was engaged in an unsuccessful war with France, an officer in the dragoons would not take kindly to the officious conduct of a social inferior whose calling was a conspicuous reminder of the national enemy.

One reason, apart from obvious pecuniary advantage, why dancing masters were eager to offer their services to amateur bands and orchestras is that there they enjoyed a very different relationship with local gentry, a less complex familiarity. And, where there were tensions between professionals and amateur players, the dancing master could always side with fellow professionals who worked not in dancing schools or assembly rooms but in the house of God.

For any roll call of popular composers and prominent performers in Britain must include men who worked for part or all of their musical

careers as organists and choirmasters. These were the English *kapellmeis-ters*, such well-known eighteenth-century figures as William Croft and William Boyce, who enjoyed royal patronage, or the blind John Stanley, whose precocious skills led to his appointment at the age of eleven as organist of All-Hallows, Bread Street, and who worked in London churches or in the Chapel Royal. Provincial chapters and parishes employed organists like Capel Bond in Coventry, Charles Burney in King's Lynn, Joseph Gibbs in Ipswich, Charles Avison in Newcastle, Thomas Chilcot at Bath and William Jackson in Exeter; the reputation of all these men extended beyond the communities they served.

Even if they had wanted to, few of these talented men could confine their activities to the organ loft and choir. Their pay was rarely great and often paltry. Though the composer Capel Bond, for example, was so admired at Holy Trinity in Coventry for his 'superior merit and regular attendance' that in 1770 his salary as organist was raised from £30 to £40 a year, this amounted to less than many artisans' yearly earnings. The meanness of the church encouraged pluralism (Bond was also organist at St Michael's Coventry, which had an especially fine organ) and led many of its employees to look for secular work: to teach young ladies, take apprentices, copy music, repair musical instruments and set up subscription concert series – as Bond did in Coventry.

Amateurs like John Marsh were the chief beneficiaries of the financial pressures that forced musicians to look outside the church. Mr Wafer, Marsh's first violin teacher, who also taught his sister the spinet, was organist of Gosport chapel; his first playing companion, Mr Day, was, as we have seen, organist at Southampton. And organists and choir-masters played in most of the ensembles of which Marsh was a member.

But the church also offered a home for laymen interested in music. In his younger years Marsh was a passionate bell-ringer, eager to learn about the bells of any church he visited. (On a trip to relatives in 1760 he was surprised to discover that the bell-ringers of Dorking were playing the tune 'Britons Strike Home'.) He also enjoyed choirs or congregational singing of every denomination and faith, including Anglicans, Dissenters, Jews and Catholics. When he moved to Bishop's Waltham in 1766 he was disappointed in the organ but delighted by the singing:

> it seemed to make ample amends, as besides the Psalms, which were
> well sung in 4 parts, we had almost always a verse Anthem of an

Afternoon & sometimes a Solo for a Counter Tenor of which kind
there was then a very good Singer. They also used generally to
practise after Evening Service, which I (with some few of the Con-
gregation & particularly old Mr Horner) used generally to stay &
hear and was much pleased; the effect of singing in 4 parts accom-
panied by a soft Organ, being quite new to me.

But Marsh's greatest passion was for the organ, an instrument which he
played throughout his life and for which he composed many pieces of
music. At Canterbury and Chichester he often deputized for the cathedral
organist, playing services and voluntaries of his own composition. His
quarrel in 1788 with the cantankerous Mr Walond, the organist at Chich-
ester Cathedral, mortified him deeply, not least because it excluded him
from the organ loft until Walond's final illness in 1799. But in most
churches and private chapels Marsh was warmly welcomed. Whenever
he travelled he carried copies of his music to present to local choirmasters
and organists. As often as not this gift would elicit an invitation to play
in a service, during which Marsh performed his own works. When he
visited his son in Oxford in 1800 he played in the chapels of Wadham,
Magdalen and New College, as well as at Christ Church, whose organ
he found woefully inadequate. During his annual visits to London
he played at the Foundling Hospital, St Paul's (where he was a friend
of the sub-dean), Westminster Abbey, St Margaret's, Westminster,
St Martin-in-the-Fields, Chelsea College (where Burney was organist)
and the Roman Catholic chapel in Duke Street.

Marsh was interested in the technical development of the organ; he
spent much time in organ-makers' shops and commented on the quality
and technical specifications of the organs he played. He performed on
the only English parish organ with pedals, at St Mary Redcliffe in Bristol,
and tried out similar instruments in London shops. One of his first
indulgences, when he came into his inheritance in 1781, was an organ
for his music room. (At his house in Nethersole he had an organ fitted
in the wall between two rooms so that it could be played in one and
heard in another.)

At first sight Marsh's enthusiasm for the organ and for sacred music
may appear as nothing more than an innocent musical recreation. But
the question of what music should be played in church and what instru-
ments should be allowed was a matter of great controversy. The form

of a service was as much a theological as a musical issue, and it aroused great passions. Organ music lay at the centre of this debate.

At the Restoration there were no organs in English churches, for the Puritan regime had removed the lot. Only gradually were they returned, first to cathedrals and prosperous town churches and much later to rural parishes. Not until the 1760s did most of the city of London's parish churches have organs. Old ecclesiastical towns may have soon reacquired magnificent organs and reorganized the choirs in their cathedral, but in many parish churches, as in Norwich or York, there were precious few. Only one of York's twenty-eight parishes, for instance, had an organ before 1790. Newly expanding industrial communities in the Midlands and North were similarly ill served, and the situation in rural parishes was even worse until the introduction of barrel organs in the nineteenth century: it is estimated that in 1800 less than 10 per cent of English parish churches had a functioning organ. As late as 1821 a commentator on psalm music could write, 'In the majority of churches there are no organs, as they are seldom to be met with except in towns.' Only middle-sized market towns with large parish churches were likely to have several well-maintained and effective instruments.

Before 1770 any form of instrumental music in rural parishes was conspicuous by its absence; thereafter a small band was more likely than a large organ. These groups consisted of two to six instruments, of which one would be a bass bassoon or cello and the others treble. The parish of Swalcliffe, for example, bought an oboe, vox humana and bassoon from London in 1783, two years later adding a 'bass viol' and a second oboe; like many other parishes it did not get an organ until the nineteenth century.

Marsh's interest in church organs has therefore to be seen in the light of their rarity. An organ in a parish church could not be taken for granted, and it was the occasion for celebration when one was installed. In May 1782, for example, Marsh attended a special concert at St James's Church in Bath to celebrate the first use of a new organ. Conducted by William Hershel, the celebrated astronomer and organist at the Octagon Chapel, it included choristers from Salisbury, singers from Lady Huntington's Methodist chapel and voices from the local theatre. Though this was an unusually ecumenical occasion – rarely did Methodists sing with theatrical performers – it followed the pattern of many special services and concerts.

Parishioners and priests opposed organs on both financial and liturgi-
cal grounds. In the fashionable urban setting of a town like Bath or in
the parishes of Westminster it was not difficult to raise the money for
an organ. Rich patrons and wealthy local subscribers could afford to be
generous, though few were as munificent as George I, who donated an
organ to St Martin-in-the-Fields in 1726 which cost a princely £1,500.
But in rural parishes it was hard to raise the several hundred pounds
necessary for even the simplest organ; nor did many parishes wish to
bear the continuous cost of an organist (about £20 a year), a bellows
blower and outlays on repair and maintenance.

Financial constraints were compounded by liturgical scruples. The
Puritan hostility to church organs survived the Restoration. Quakers
never had music in their services, of course, but Baptists, Presbyterians
and Congregationalists, though they encouraged the congregational sing-
ing of psalms and hymns – and had in Isaac Watts one of the great
hymn writers of the eighteenth century – did not introduce organs until
the nineteenth century. Even in the Church of England organs were
opposed on religious grounds. In 1745, for example, an organ that had
been erected by voluntary subscription in St Luke's, Chelsea, was
removed because of the objection of some parishioners.

Organs were chiefly advocated by high churchmen who believed in
the beauty of holiness, led by the clergy of the cathedral churches. After
the Restoration the reinstallation of organs and the revival of choirs
perspicuously denied the word- and sermon-centred austerity of the
Commonwealth and Protectorate. But another impulse was at work:
the desire of genteel church-goers to hear music that was fashionable
and polite, more akin to what they heard in the concert hall. Dr Richard
Banner expressed the sentiments of this group in a sermon he preached
at the Three Choirs festival held at Worcester in 1737:

> For why should the harsh unpleasing voices, and unskilful singing
> of the common people, be thought more agreeable to *gospel worship*,
> than the grave and melodious instrumental music which tends to
> regulate the time, and rectify the tune, checks and prevents the over
> eagerness of some, drowns and mollifies the clamorous harshness
> and untunableness of others . . . And would men bestow as much
> of their time and pains in being instructed in the more *sublime* parts
> of church music, as they do in this *low branch* of it, they might have

the assistance of an *organ*, and those other helps which always attend it, be able to revive the practice of our first reformers, and to make our *parochial* music in some sort resemble that of the *cathedral* or *mother* church.

More genteel and less 'clamorous' music was achieved with an organ and a choir, one dominated by the treble voices of boys. Together they produced a light and airy sound like that of a violin sonata or operatic aria or duet. Youthful choirs, often made up of charity school children, replaced traditional psalm singing by tenors and basses. This music of the deanery and cathedral close, which Marsh played and performed throughout his life, differed from singing in rural parishes; it was unashamedly genteel, resembling the fashionable music of the assembly room and concert.

Throughout the eighteenth century high and low Anglicans proclaimed the superiority of this genteel (and more difficult) church music over the 'old way of singing', which they considered slow, lacking rhythm, and at its worst producing a kind of demotic dirge. But having specially trained choirs sing praises to the Lord rather than the entire congregation, not to mention the addition of anthems and organ voluntaries which made the service even more like a concert, disturbed church-goers who wanted a religion of the spirit and who believed that music should be a means for all worshippers to express their deeply felt piety.

Throughout the century evangelicals criticized voluntaries as frivolous and secular, looked askance at anthems (they were banned by the Methodist conference of 1787) and argued that choirs should not perform separately from the congregation but lead it in full and harmonious voice. Though they wanted to escape formulaic, lifeless incantations, associated with the old way of singing, they were suspicious of the worldliness of cathedral music. The Methodists and groups like the members of the Society for Promoting Christian Knowledge prided themselves on the power of congregational singing. John Wesley's laudatory account of a Methodist congregation in 1757 emphasized what he wished to avoid as well as what he hoped to achieve:

Their solemn addresses to God are not interrupted either by the formal drawl of a parish clerk, the screaming of boys who bawl out what they neither feel nor understand, or the unseasonable and unmeaning impertinence of a voluntary on the organ. When it is

seasonable to sing praise to God, they do it with the spirit and the understanding also ... all standing before God, and praising him lustily, and with good courage.

The evangelicals created choirs that led congregations rather than performed for them. These choirs flourished first in Yorkshire, south Lancashire and the north Midlands, then later in East Anglia and the West Country; by the end of the century they could be found everywhere in Britain. But they did not always stick to their evangelical mandate. The choirs wanted to sing more complex and difficult music, an aim which separated them from the congregation and was furthered by the popular enthusiasm for oratorios, especially after the Handel commemoration of 1784. William Mason, a poet and precentor at York Minster who assiduously encouraged church music, complained in an essay of 1795 that 'Psalmony is become not only despicable to persons of refined Musical taste, but is now hardly tolerable to our Village Practitioners ... [who] since the rage for Oratorios has spread from the Capital to every Market Town in the Kingdom, can by no means be satisfied unless they introduce Chaunts, Services, and Anthems into their parish churches.' The tension between the church as a place for performing 'art music' and as a site for Christian worship remained unresolved throughout the century.

As an evangelical Christian and proponent of genteel church music, Marsh was much exercised by this conflict. On the one hand he was an enthusiast for the music of Corelli, Handel, Geminiani and Mozart, whose works he arranged as voluntaries, a composer of anthems, psalms and hymns scored for children's voices and organ, and an organist who often played in cathedral services. On the other hand, as treasurer of the West Sussex Bible Society, member of the British and Foreign Bible Society, the Africa Institution and other associations concerned with evangelical reform, he was familiar with the objection to services that reminded people of concerts.

In the struggle between organist and evangelical, the organist triumphed. Marsh's religious fervour came to him late in life, much prompted by his clerical son; his more deeply rooted passion for music had been with him since childhood. But he was critical of organists whose desire to impress the congregation led them to overshadow choirs and to produce elaborate, embellished compositions. This, he argued,

detracted from the service as a celebration of Christian divinity and produced poor music. Here, as in so many instances, Marsh sought a compromise: organ music acceptable to at least some evangelicals. In comments in his journal and in two articles he wrote for the *Quarterly Musical Magazine* he condemned what he called 'the *in*-judicious accompaniment of the organ-*ist*, who holding himself superior in rank to the generality of singers usually employed in country Cathedrals, is too apt to consider himself as a *principal* instead of an auxiliary'. An organist, he said, '*without the least failure* in respect to *execution* or mere *accuracy* of performance, [can] either greatly . . . *heighten*, or . . . *mar* the effect of the composition he accompanies'. But when properly played, 'an organ so far from diminishing the effect or solemnity of cathedral service, would tend greatly to increase it'. Abuse of the organ was not an argument for its exclusion but the occasion for reforming erroneous practices.

As he grew older Marsh became increasingly concerned with the state of Anglican worship. He was aware of the faults of an established religion that attended to the formalities of worship but lacked fervour or commitment. He knew that the musicians who worked in the church often did not share his evangelical enthusiasm. But he also recognized that organists and choirmasters were vital not only to the church but to his own enjoyment of both spiritual and secular music. He needed their expertise to make up the local concerts. He needed the church to create and enjoy the quotidian music of matins and evensong. And he and his fellow musicians needed the grand nave of a big church or cathedral for the sublime and moving effects of large-scale performances at annual musical festivals.

When Marsh and his friends gathered to play music one day in Canterbury in 1783 one stock figure was missing, for on that night they had no member of a military band. The need for this player is easy to explain: a typical military group of the late eighteenth century consisted of players of trumpets, horns, bassoons, clarinets and oboes, and the role of wind and brass players in domestic and private music-making was very small. English chamber music retained the traditional baroque form of two violins, cello and harpsichord until very late in the century, and it had little place even for woodwind instruments, apart from the flute which was the preferred wind instrument for gentlemen. (When Gentlemen's

Concerts began in Manchester in the 1770s it was discovered that all those wishing to take part were flautists.) There was little repertory available for those enterprising enough to learn other wind instruments, except for a few sonatas for oboe or bassoon. So few amateurs played these instruments at all, and even fewer with distinction. Wind and brass instruments, especially the latter, were considered unsuitable for the music round the harpsichord or in the sitting room. We get some sense of this from Marsh's anecdote about the fate of General Johnson's bassoon: 'The General sometimes amusing himself with playing on the Bassoon (his notes on wch not probably pleasing the chaste ear of Lady Cecilia) she one day, in his absence, put his Bassoon into an auction in the neighbourhood and sold it.'

But all these wind and brass instruments were important in the eighteenth-century public concert repertory, and amateur players therefore had to turn to the professionals for help. Musicians who earned their living by giving private lessons to ladies and gentlemen were usually adept only at keyboard and strings. A military band was therefore a boon to the organizers of provincial concerts.

The military musicians who helped Marsh and his fellow amateurs to make up an orchestra were often players of the highest quality. As we have seen, Marsh first met his friend the clarinet player John Mahon when he was playing for the Dorset Militia in 1778; he claimed that the finest bassoonist he ever heard was Major Gardiner, an officer in the 16th Light Dragoons. The number of these instrumentalists greatly increased at the end of the century, when the French Revolutionary and Napoleonic Wars meant that more regiments were quartered in Britain, especially in areas where invasion threatened. The unprecedented scale of military conflict led to the establishment of militia and volunteer regiments that could afford good bands, because they were financed by local aristocrats and gentry. In south-eastern England, an area with a high concentration of troops, Marsh's concerts drew on the help of wind and brass players from the West Essex and South Gloucester Militias, the Montgomery regiment and the 1st and 25th regiments of Dragoons. But the greatest resource was the Sussex Militia, a private regiment of the Duke of Richmond, whose excellent band practised regularly in Chichester, performed Marsh's works at private concerts, played the music at the local assemblies, and performed an extensive repertory which included Haydn's symphonies. The band of the Sussex Militia

was tantamount to the private orchestra of the Duke of Richmond. As Marsh explained,

> This band was then intirely kept by the Duke, the Colonel, who used to have some of them instructed in playing string Instruments as well as Wind ones so as to form a Band by themselves for playing symphonies, Concertos or Quartettos together, for which purpose he sometimes had Borghi, & at other times Salpietro down, in the Autumn, and one of them, Hyler, a German, he had then lately instructed by Crosdill on the Violincello, who had given him 18 lessons.

As Marsh found to his cost, in the regiment's absence the powerful Chichester orchestra deteriorated into a scratch band unable to command much support.

The dancing master, organist, singer and military band player were all necessary to create a good provincial concert, but none of them was as vital as the gentleman amateur, at once player, impresario and social secretary of the provincial concert scene. Only a person of some standing could ensure that 'the quality' would subscribe to a concert series or support an ambitious musical festival. Only a gentleman could organize the private concerts that brought together 'professors' and amateurs in preparation for public performances.

Gentlemen amateurs like Marsh tended to congregate where opportunities for the public performance of music were greatest. London and fashionable resorts like Bath were the most important centres, together with cathedral towns. Typical of such men was the doctor and Oxford graduate Claver Morris. Moving to the cathedral town of Wells in 1686, he remained there until his death in 1727. He helped to found a music club which met weekly and gave annual concerts on St Cecilia's Day; he accumulated a large musical library which included works by Purcell, Byrd, Croft, Clarke, Scarlatti, Albinoni, Handel, Visconti, Vivaldi, Fiore, Petz, Tibaldi, Bassani and Geminiani; and he played not only keyboards, violin and flute – instruments any gifted amateur might know how to play – but also the bassoon and oboe. Morris regularly organized private concerts at his house. In July 1726, for example, he recorded:

> I had a Consort of Musick at my House & I invited Mr Taylor, Mr Prickman, Mr Nikells, Mr Boulting, Mr Tutton, Mr Broadway, Mr Slade, Captain Penny, Mr Lucas, Mr Burland, & Mr Comes junr,

who all came: I gave them for Supper a Cold Shoulder of Mutton, a Cold Breast of Veal, a Sallet, a Couple of Neat's Tongues; & I had for them a Bowl of Punch, a Bottle of Claret, many Bottles of October-Beer, & Ale. We play'd all Tibaldi's Sonates. And the Company, many of them stay'd till past 1 a clock.

Music dominated Morris's life and memorialized his death. During his final illness he requested 'that there might be no Appearance of Concernment or Grief amongst even my nearest Relations and Friends. But if it might be possible, there might be a Concert of Musick of three Sonatas at least in the Room where my Body is placed before it be carried out of my House to be Interred.'

One is struck, in these surviving accounts written by musical amateurs, by the repeated and enthusiastic expression of their passion for music. But one also detects an anxiety that their conduct might seem excessive, immoderate, perhaps even impolite. A passion for poetry and letters, even a love of sketching and drawing was more reputable than an obsession with music. Marsh abandoned country society for the snug comforts of a town house in Chichester partly because he could not afford to keep up the appearances that landed society demanded; but he also knew that his preoccupation with music and his lack of interest in 'expensive dining, Fox Hunting & Cards' (the indoor and outdoor pleasures of boorish county society) made him something of an outsider, charitably regarded as eccentric or less hospitably seen as decidedly odd. Most gentlemen did not, like Marsh's friend Mr Howard of Winchester, play nightly summer concerts with their sons and daughter 'with their windows open, during which Company used generally to walk backwards and forwards under the Windows', nor did they spend their holidays playing in the orchestra at Vauxhall Gardens. When Marsh and his brother William played duets while riding in a coach it convinced their neighbours that they were music-mad.

Yet the enthusiasm of musical amateurs animated England's provinces. For more than a generation the music of Salisbury was nurtured into maturity and kept vigorous by James 'Hermes' Harris, who brought musical scores from London, ensuring that the repertory was varied and fashionable, offered his rooms for private concerts and dress rehearsals, chose the pieces for the subscription concert series (including many of Marsh's works), led the local orchestra, composed for and played the

harpsichord, and brought fashionable performers from London to the annual Salisbury festivals.

After his death in 1780 musical life in Salisbury collapsed. Though this demise was largely prompted by a quarrel between two musicians over the post of cathedral organist, Marsh was sure that a schism within the musical community would have been avoided if Harris had lived. A strong leader, a gentleman who could command support through his status, patronage and personality, was necessary to provincial musical life. When Marsh came to lead the Canterbury and Chichester orchestras he applied the lessons he had learned from Harris in Salisbury.

To create a flourishing musical life the amateur impresario of England's provinces needed to nurture three connected institutions: private musical performances, a catch and glee club, and a subscription series of concerts. Their energies sustained each other and their collective strength made possible annual music festivals or special concerts which could bring performers and spectators from other parts of Britain.

Throughout his life Marsh joined in private concerts organized by formal invitation or arranged spontaneously. When he lived in Romsey he often walked with a group of friends to the mansion at Broadlands to play in the parlour or conservatory. As a law student at the Inns of Court he played trios with other lawyers in Dyers Buildings in Holborn. Working at Winchester assizes in January 1774, he 'got Messrs Tombes, White & Rogers to come to the George, where we amused ourselves with Corelli's sonatas &c one of us sitting out in turn, & alternately taking the 1st fiddle, 2d and bass (upon the tenor) the 1st fiddle always chusing the particular sonata, after wch we had a Welch Rabbit &c together'.

These occasional concerts and scratch bands were formed because Marsh was committed to music; they marked not a desire to form enduring musical circles but a determination to play at every opportunity. But after his marriage to 1774 he joined with families in Salisbury, Canterbury and Chichester to form circles of men and women who played together regularly and occasionally invited professionals to join in. By the winter season of 1777–8 Marsh was attending almost daily private music parties for flute, piano and harpsichord in Salisbury. In Canterbury small music parties had become 'quite the rage' by 1785, though Marsh disapproved of a fashion that attracted ignorant and inattentive listeners.

These concerts mixed vocal and instrumental performance and allowed ladies, who did not perform in public, to demonstrate their

accomplishments. At a private concert near Canterbury attended by Marsh and his wife in September 1786 many couples were present, and in the course of the evening 'we did Hershel's celebrated Eccho [sic] Catch (the Eccho Voices for wch were placed in an Inner Room wch the door ajar which went off very well).' On such occasions it was usual for young women to sing and to play either the piano or the harpsichord.

These regular private musical meetings arranged by two or three families were the bedrock on which provincial musical life was built. The concerts held at the homes of the Marshes, Pilkingtons and Toghills in Chichester brought enthusiasts together in convivial surroundings; players rehearsed new and difficult pieces without exposing their errors to public scrutiny; and a repertory of works for public performance was shaped.

Players at these private gatherings depended upon a steady supply of published scores, and supplying sheet music was one of the most important contributions that a prosperous amateur like Marsh could make. He regularly brought newly published works back from his trips to London, enabling friends to practise the most recently performed and fashionable pieces. A number of London publishers – Marsh favoured Longman and Broderip and Robert Bremner – sold large quantities of sheet music from an extensive catalogue of instrumental and vocal works: harpsichord and chamber music, sacred music and songs from opera, oratorios and the pleasure gardens. Quite often these scores were adaptations of pieces originally intended for an orchestra. In 1798, for instance, Marsh brought the scores of a number of quintets rearranged from Haydn symphonies. When scores were not available in parts, they had to be transcribed. Marsh had been unable to secure Mozart's *Magic Flute* in parts, so he borrowed a full score from Lady Louisa Lennox, the second Duke of Richmond's sister-in-law, copying the overture and rearranging it for a small band.

Like many skilled amateurs, Marsh arranged pieces for private performance. In 1778 he recorded that 'My adapting the Overtures in Artaxerxes & Astarto &c for 2 performances seeming to give universal satisfaction, all the musical young ladies of our acquaintance requested copies, amongst whom were the 2 miss Arundells, where we drank tea on the 2nd May, when they played those 2 pieces very neatly together.' In similar fashion he arranged Haydn's symphony in E minor for the harpsichord and adapted Handel's *Messiah* for three to six instruments.

Private musical evenings, larger parties and what Marsh called the occasional 'grand crash' were of enormous importance to amateur musicians. They combined what Marsh described as 'conviviality' and 'Harmony', uniting social virtues with musical skills. In the entry under his name in the two-volume *Dictionary of Musicians* (1824), which he submitted to the publisher, Marsh dwells on the extraordinary pleasures afforded by playing quintets with his brother and three sons. This was the apogee of a social and musical ideal, in which a family worked in unison to create a work of beauty.

But the purpose was not mere domestic edification. A musical public developed during these private drawing-room evenings. The concerts subscribed to by the local elite were little more than the usual gathering of musical friends, but now playing in public before an audience who paid for the pleasure of hearing them; even their scale was not much different from the private musical party, and normally included between ten and twenty-five performers. One of the first concerts that Marsh organized was held in 1772 in the Romsey town hall. It attracted an audience of nearly 100, while the orchestra consisted of five fiddles, two oboes, a flute, cello and bassoon. Even the much grander orchestra that Marsh joined in Salisbury in 1776 had only five fiddle players, a double bass, oboe, two flutes, two horns or trumpets, organ and harpsichord. The orchestra at Chichester was still larger, though in 1794 the number of players had shrunk to ten and by 1805 to eight.

The public concerts these orchestras performed did not consist solely of instrumental music. Thus the last concert of the 1806 season in Chichester, conducted by Marsh, included a Haydn overture, a Corelli concerto, two songs, a glee and a chorus from the *Messiah*, an overture by Marsh, a violin concerto, another song, glee and duet, with the overture of Arne's opera *Artaxerxes* as a finale. The vocal part of a public programme could not use the voices of amateur ladies, as it was considered improper for them to perform in public; professional women singers had to be imported for the occasion. But the male voices were the familiar ones from private concerts and the distinctively masculine glee and catch clubs.

These singing societies were a further key constituent of provincial music. The clubs Marsh joined in Salisbury and Canterbury, and the catch club he founded in Chichester, all had the same format: they met regularly on a fixed night of the week, often at a tavern or music room, proceedings beginning at 6.30 in the evening with orchestral pieces, many

of which they also performed at public concerts. Supper and singing then followed. At Salisbury members played until after eight 'at wch time a large Table was set out with Loaves ... Cheese & Porter, after partaking of wch in rather a rough way, the Company form'd a Circle round the fire & Catches & Glees were perform'd by Messr Corfe Goss Barrett & Wellmen with now and then a Song from some other Member till 11 or 12 o'clock'. At Chichester the instrumental part of the evening was longer, ending at 9.30, when a supper of oysters and 'welsh rabbits' were served followed by catches and glees round the fire with punch and wine.

These were exclusively male gatherings of chiefly amateur gentlemen. Women were excluded on the ostensible ground that some of the songs were too scurrilous or obscene for female ears. But guests were often admitted: professional musicians, visitors and, on special occasions, even women.

Membership of a catch and glee club was not cheap, but was not so expensive as to exclude tradesmen who, if they did not play an instrument, liked to join in the singing. The Canterbury catch and glee club, with between fifty and sixty members, was a larger, more boisterous body than its counterparts in Salisbury and Chichester. Its members enjoyed late-night carousing while the club's president called on individual members for a song. Marsh found it too much like an ale house for his taste. The sixpenny fee not only bought an evening's music but

> an unlimited quantity of Pipes and Tobacco and Beer ... in consequence of which many of the Members, amongst the lower kinds of Tradesmen ... used by way of having a full pennyworth for their penny, to go at 6 & smoke away till 11 or 12. On accompt of this fumigation from 40 or 50 pipes (which was always enough to stifle a person at 1st entering the Room & was very disagreeable to the Nonsmokers) there were 3 ventilators in the ceiling ... to get rid of the smoke, but the room was so low pitch'd & bad that notwithstanding this, it appeared as if we were in a fog there.

The masculine realm of the tavern, with songs and the malodorous stench of beer and tobacco, joined hands with the feminine world of the drawing room, with its harpsichords and duets, tea kettles and piles of sandwiches 'about a foot high each', to create the public concert. The fit between the two could obviously not be perfect: the presumption that women's

217. Chichester concert,
To admit a Lady

music was merely a private accomplishment kept even the most talented women, unless they became professional singers, off the stage and placed them in the audience.

Not that their presence as auditors was unimportant. Indeed, it was vital because a concert series could be mounted only at considerable expense and therefore depended upon a paying public. No orchestra could rely entirely on amateur talent to play overtures and concertos, songs and catches, that required brass players and women singers as well as violinists and flautists. Professionals – the local dancing master, choirmaster, organist, members of the military band, as well as male and female singers and instrumentalists from London, the spas and resorts – were all necessary, and they cost money. These performers were paid a fixed fee for each concert and were also allowed to play one benefit concert, whose total net receipts they would receive. These arrangements were usually underwritten by a guarantee that, whatever happened at the benefit, the professionals would receive a fixed sum for the entire

season. Thus in 1799 the Chichester orchestra offered the string player and composer Joseph Reinagle one and a half guineas a concert, a benefit, and a guaranteed fee for the season of £30. Reinagle did not like these terms, but as he had recently lost his job in Oxford he felt he had to accept. The system encouraged performers who appealed to the subscribers as socially graceful as well as musically skilled. Popular performers could hope to make a tidy sum from their benefit: in 1787 Miss Barclay cleared £40 from her benefit in her first season as a singer in Chichester, though in later years her following waned because her manners were thought to be no match for her singing.

The fees for professionals, together with the hire or rental of premises, explain why the gentlemen players as well as the audience often paid for subscription concerts. In Salisbury, Canterbury and Chichester the financial arrangements were similar. The Salisbury series cost the concert-goer two guineas a year for concerts given every other Thursday through-out the year; every subscriber could bring two women guests to every concert, and there were therefore few women subscribers. The arrange-ments at Canterbury were a little more complex. Marsh explained,

> Subscribers paying a Guinea for 12 Concerts, once a fortnight throughout the Winter alternately Public and Private, the former (for wch every Subscriber had 2 Tickets to give to Ladies) being always on Moonlight nights, the subscribers only being admitted to the private concerts, except Non Resident gentn who were admitted at 2/6 to the public & 1/6 to the private concerts; no resident gentn being at any time admitted without subscribing for the season.

Similar rules, designed to exclude casual local visitors but to permit out-of-town guests, obtained in Chichester, though the way payment was structured encouraged many more women subscribers (fig. 217).

The number of subscribers and the size of audiences fluctuated con-siderably. At Chichester subscriptions reached a high of more than 150 in the early years of Marsh's stewardship but plunged to a low of eighty-seven in 1806, when the concert made a loss and Marsh considered retirement. The numbers attending concerts were even more volatile. In 1807 a benefit for Mr Cudmore, the son of a local tradesman who had been trained as a violinist by Salomon in London, brought a crowd of 300; but at its nadir the orchestra outnumbered the audience, which, commented Marsh, 'consisted of only two ladies'.

Musical festivals and special concerts attracted the largest audiences. Festivals had begun as celebrations of the patron saint of music, St Cecilia. By 1700 Oxford, Salisbury, Winchester, Bath, Wells and Norwich all had St Cecilia's Day concerts and celebrations. The most famous festival, shared among the cathedral cities of Hereford, Gloucester and Worcester and later called the Three Choirs festival, began in 1715 and, like the annual celebration in Newcastle upon Tyne, was intended to raise money for impecunious clergy.

At first these pious celebrations featured liturgical music and anthems, notably Henry Purcell's *Te Deum and Jubilate*, which was first performed in 1694 at the annual meeting of the St Cecilia's Society of St Bride's Church in London. The tone was strongly Anglican, Tory and often high church. But by the time Marsh attended and played in such festivals the focus had altered. After the 1740s the repertory was dominated by Handel, particularly his *Dettingen Te Deum*, which celebrated George II's victory over the French at Dettingen in 1743, the last occasion on which British troops were led into battle by their monarch. Though the repertory of Handel's oratorios, masques and odes varied from festival to festival, certain works were performed repeatedly: *Messiah*, *Judas Maccabaeus*, the coronation anthem from *Zadok*, and *Acis and Galatea* were particular favourites. In the festivals Marsh attended at Winchester, *Messiah*, *Judas Maccabaeus*, *Zadok*, *Alexander's Feast*, *L'Allegro* and *Il Penseroso* were performed in the 1770s and 1780s; in Salisbury the same works, together with Handel's *Samson* and, rather less expectedly, Gluck's *Orfeo*, were the centrepieces until the first years of the nineteenth century, when Haydn's *Creation* came to rival but never supersede the *Messiah*.

These musical meetings mixed the secular and the sacred. Secular works were performed in cathedrals and churches; sacred works (at least the sacred oratorios) were heard in public assembly rooms and concert halls. In Salisbury public rehearsals and miscellaneous concerts were performed in music rooms, the larger choral pieces in the cathedral. The festival that Marsh attended there in 1782 began on a Tuesday with a rehearsal of Gluck's *Orfeo*, continued with a rehearsal of *Samson* and a miscellaneous concert in a concert room on Wednesday, Thursday performances of *Samson* and *Orfeo*, *Messiah* on Friday morning in the cathedral, and another miscellaneous concert in the evening, where many of the principal musicians gathered together for a 'grand crash' on Saturday morning.

Just as the repertory became more secular, so the festivals themselves ceased to be special events for the clergy and became occasions on which 'the quality' demonstrated its taste, philanthropy and civic pride. Not every festival was marked by this parade of gentility: the festival tradition in northern parishes with large choirs was altogether more demotic. But festival audiences in the cathedral and county towns of southern England of the sort frequented by Marsh and in large commercial cities were dominated by members of polite society, who organized balls and assemblies during the festival week. The audience came from all over Britain. Civic dignitaries and gentry competed with the organizers of other festivals to attract famous performers and large choirs.

The festivals grew in scope and grandeur, especially after the Handel commemoration of 1784 made them both patriotic and fashionable. The Salisbury festival of 1800, which included Haydn's *Creation* as well as works by Handel, attracted an audience at the cathedral which Marsh estimated at 970. The dance held after the first concert was packed, and the first performance in the concert rooms was so crowded and hot that the windows had to be broken by a carpenter to let in the air. In 1804 and 1807, when Marsh was also present, the crowds in the cathedral numbered more than 1,000. Even if the organizers had wanted to hold concerts in a secular venue they could not have done so. The demand for space far exceeded that of any assembly room or concert hall.

Though musicians like Marsh played at these festivals, the success of the concerts depended upon the presence of star performers recruited from London. By the last quarter of the century singers like Elizabeth Billington, Gertrud Elisabeth Mara and Nancy Storace and famed instrumentalists like J. C. Bach and J. C. Fischer progressed from festival to festival during the London off season. The rewards were considerable. In 1779 Marsh went to London on behalf of the Salisbury concert to negotiate a fee for a single performance with Sarah Harrop, a former Halifax factory girl and now a fashionable soprano. She responded to his offer of £60 by saying that she never left town to sing for less than £100. When she came to Salisbury she sang a rehearsal and a performance of *Messiah*, and joined in a few glees the next day, before returning to London with a fee she insisted be 100 guineas, not pounds. When she married Joah Bates, Lord Sandwich's private secretary and one of the directors of the Handel centenary, in

1780, it was said that she brought a dowry of £7,000, the fruit of four years' performance.

Performed with panache by increasingly large choirs and orchestras, adorned by an audience of aristocrats and gentlefolk, and accompanied by parties and junkets, the music at these provincial festivals comprised a familiar but exhilarating canon of music, chiefly works by Handel. They gave music – or, to be more accurate, one sort of music – a reassuring niche in British social life. Patriotic but pleasurable, genteel but exciting, musically sublime but consummately unthreatening, these musically and socially conservative festivals were the provincial equivalent of the grand London concerts organized in the 1780s and 90s in the wake of the Handel centenary, and they overshadowed the musically heterogeneous and socially more fragile world of the music club and subscription series. Before the emergence of professional city orchestras in the nineteenth century, music in the English provinces was a delicate and evanescent growth; it may have flourished in many places, but its roots were shallow. Its finances lacked solid foundation: profits were low and the loss of a few disgruntled subscribers or a demand, like that of the Chichester professionals in 1804 for more money, could force a concert series into debt.

Much depended upon a few individuals. The few amateurs at the music club of Romsey lost their most ardent member and inveterate organizer when John Marsh left for Salisbury in 1776; it took them years to recover. Twenty-five years later Marsh was mortified when the best flautist in the Chichester orchestra left to take up a new job in London. New arrivals could have as deleterious an effect as unwanted departures. What was the Salisbury orchestra to do about the Bristol cleric who insisted on joining the orchestra as a flute player in 1780 despite his audible incompetence? How could he be removed without causing offence?

The greatest danger was that of a quarrel. In 1781 the ferocious rivalry between Mr Corfe and Mr Parry for the position of cathedral organist at Salisbury created a schism not only in the orchestra but in 'the quality' of the town. According to Marsh, 'it divorced many of the principal families there as much as if it had been a contested Election for Member of Parliament'. Parry was appointed; the orchestra

compensated the impoverished Corfe by making him their leader; a bitter quarrel ensued. Parry started a rival concert series; Corfe prevented him from booking a room; in retaliation the church authorities barred the choir from taking part in Corfe's concert series. Pamphlets and squibs were published, and more quarrels ensued. In 1781 the annual Salisbury concert had to be held in a church because the orchestra was banned from the cathedral. The performance of *Judas Maccabaeus* was judged a failure because without the cathedral choristers the chorus was too weak. Two years later Marsh left Salisbury; he was no longer 'as well & happily situated as I cd wish'. He could no longer find the social concord and musical harmony that had attracted him to Salisbury.

The programmes performed at major festivals are, I have suggested, a misleading guide to the actual range of the repertory. The extraordinary popularity of Handel at festivals was well established in the last quarter of the century, as was the custom of playing at least part of *The Messiah* at the last concert before Christmas, but this was part of a more varied, modern repertory which included works by J. C. Bach and Carl Abel, Haydn, Mozart and even Beethoven. The enthusiasm of amateurs, the strength of the music publishing business in London and a national network of contacts – sustained by the festivals that brought London professionals to the countryside – kept the repertory of small provincial orchestras remarkably up to date. A Haydn craze, first kindled by musical publishers and ignited, as we have seen, by the composer's visits to London, quickly spread. His *Creation* was performed at many festivals and Marsh and his colleagues played his symphonies repeatedly.

Then, as now, the chief constraints on the repertory were the conservative tastes of some amateurs and the difficulty of performing the more demanding pieces. Marsh began playing in the 1760s when the stately, not to say ponderous, manner of baroque composers was being challenged by the livelier (and more difficult) works of composers influenced by the *galant* style of musicians from Mannheim. Later he grappled with the major changes in symphonic composition which culminated in the works of Beethoven, pieces that made ever heavier demands on amateur players. In 1799, for instance, Marsh bought the scores of six Mozart quartets, 'but we found them so very difficult, that (except for Reinagle [the only professional in the group]) none of us could do them anything like justice'. Amateurs feared, perhaps rightly, that the technical demands of modern music would reduce them to mere auditors.

Changing musical fashions caused conflict among players. Those brought up with the Italianate works of Corelli, Handel and Geminiani, the standard fare of a mid-century ensemble, were often disconcerted by Johann Christian Bach and Carl Abel. Marsh described their impact on a small concert group at Gosport:

> The Modern Symphony or Overture with Hautboys & Horn parts, instead of Bassieno Violins, having been introduc'd not long before this time, Mr McArthur soon brought the 2 first sets of Bach and Abels to our Meetings as a valuable addition & variation of style, which he used to lead with great Spirit and Rapidity. It was however sometime before he cd bring over any but Mr Chapman to his opinion as Mr Ducket used to twist about in playing the 2nd fiddle & wanted to rest at the end of every quick Movement. Little Wafer too grumbled at the reiterated quavers upon one Note for several Bars together, which not being used to, he cd hardly manage to play at sight, & did not like quitting Corelli, Handel & the most of which he was well acquainted with, the Basses of which were also of much more consequence than those of the modern Symphony.
>
> Messr's Philips Clarke and I too, whose lot it was to play the Hautboy parts, as Bassienos, did not much like them, tho' for different reasons the two former complaining of the quickness of the Allegros, & last Movements in particular (in wch they used to say they cd scarce get a Note in edgeways) & I not liking the long holding Notes for several Bars together but rather wishing for something more to do with the Bow. I also did not like the Middle Strains being almost always marked *Jacet* for the Hautboys & I by no means wish'd to be unemploy'd with the fiddle in my hand. As to the quickness of the Testos &c I did not at all care about but felt myself rather flatter'd in being able to keep up with them (& leave the old gentlemen behind) in the few notes I had to play.

Marsh eventually became reconciled to the moderns and dissatisfied with a repertory that excluded them in favour of much-loved ancients. As ever, he advocated compromise and conciliation, publishing an important essay in the *Monthly Magazine* in which he compared 'Ancient and Modern Styles of Music' and suggested that the best concert repertory had both: their virtues were best demonstrated by juxtaposition, their weaknesses alleviated by the strength of the other; and a concert was

made more entertaining by deliberately contrasting musical styles, a practice that Marsh followed in his programmes in Chichester.

Marsh's career as a provincial musical performer, conductor and impresario illustrates both the strengths and weaknesses of English musical life. On the one hand it underscores the strong amateur tradition of performance not only in the drawing room and parlour, where it was to be found all over Europe, but on the public stage. On the other hand this tradition, as Marsh and his colleagues sensed, came under great pressure as the technical demands on players of symphonies, concertos and operas grew. It was hard for amateurs to cope with Beethoven or, later, Schubert, and it was difficult for professional English performers to free themselves from the amateur tradition, especially as it was the amateurs and their peers who paid for provincial orchestras. In this respect the English differed from the German principalities and towns where orchestras, also made up of amateurs and professionals, were funded by local princes, dignitaries or the town itself.

But the British choral tradition, built around but not confined to Handel's oratorios, which accommodated amateur singers, and even amateur players, was unique. At the time when the English oratorio was creating a national tradition of pious and serious music, church music in Germany was in decline. With the rise of professional orchestras in the nineteenth century, amateur orchestras struggled to remain central to British musical life, but the oratorio and choral music, whether performed in the grand Victorian manner with a huge choir, a practice that began in the 1780s, or the smaller bands of players with 'original' instruments which are now fashionable, remain with us today.

CHAPTER FIFTEEN

'Queen Muse of Britain': Anna Seward of Lichfield and the Literary Provinces

ANNA SEWARD WAS a lame spinster, amateur versifier and critic, who lived her entire life (1742–1809) in the Bishop's Palace in Lichfield, the sleepy Midlands town not far from Birmingham, which was the birth-place of both Dr Johnson and David Garrick and where her father, Thomas Seward, was a canon of the cathedral. Unlike the lexicographer or the actor, Seward is largely forgotten, though in her lifetime she was a figure of considerable renown. Scribbling in her writing room or on her terrace, receiving famous visitors like Johnson, Mrs Piozzi, Erasmus Darwin, Walter Scott and Robert Southey in her drawing room, and writing her forthright opinions which were published in magazines and reviews, she exerted a powerful influence on the critical and poetic views of her day (fig. 218). Her poems were greatly admired – notably her *Elegy on Captain Cook* (1780) and *Monody on the Death of Major André* (1781) – as was a highly sentimental epistolary verse novel about female misfortune and thwarted love, *Louisa* (1784), which ran through five editions in Britain and one in North America.

Seward was a precocious and sensitive child – reciting Milton at the age of three and forming strong attachments to her sister, who died prematurely, and then to her adopted sibling Honora Sneyd, who was her constant companion until 1773, when Richard Lovell Edgeworth took Honora as his second wife. Seward was traumatized by the loss of her sister, who moved to Ireland and died shortly afterwards, and remained bitterly hostile to Edgeworth for many years to come. She turned her back on the institution of marriage, which she blamed for her misfortunes and, despite several proposals, resolved to lead a retired,

573

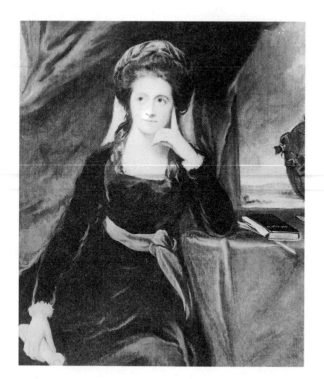

218. *Anna Seward* by George Romney, 1786

spinster life. She wrote verses from her earliest years, but it was not until the 1780s, when she was in her forties, that she began to publish her work.

Over the following decade Anna Seward rose to the height of her fame and popularity, repeatedly winning poetry prizes offered by the Batheaston literary circle, carrying on a lively correspondence with critics and poets all over the country, and presiding over a literary circle which received frequent visitors. A correspondent in the *Gentleman's Magazine*, an important publisher of verse, challenged its readers to 'Produce me any female writer who equals that lady'. Though in her later years she lost favour, she remained a redoubtable figure, and in 1804 published a controversial biography of her friend Erasmus Darwin in which she incidentally memorialized the cultural circles of Lichfield where she played such an important part. She supported a number of younger poets and writers, including Walter Scott (whom she persuaded to edit her collected verse and who wrote the verses inscribed on her tomb), Robert Southey and Samuel Taylor Coleridge. After her death

in 1809 her collected poems appeared in three volumes, followed by six volumes of correspondence, 'only a twelfth part of what she had written', in 1811.

How did this provincial gentlewoman, who spent years nursing her ailing father and, after his death in 1790, lived in splendid isolation with an inheritance of £400 a year, have such an impact on British literary life? Though Seward's success is partly explained by the power of her personality, it is also a tribute to the rich resources of eighteenth-century provincial life. An efficient postal system, supportive networks of local literati, and a press that opened its columns to correspondents enabled an energetic but sedentary bluestocking like Anna Seward to cultivate a national audience. Her success also suggests that poetry was important to a large public. Reading and writing verse were not isolated or solitary pleasures but activities to be shared at social gatherings and in letters to friends.

Anna Seward was a woman with strong loves and enmities, an uninhibited willingness to say what she thought and felt, an affected but emotive manner and a good deal of charm. Such, at least, was the view of her contemporaries, who sometimes regretted her candour, excused her 'appearance of affected enthusiasm', but generally praised the warmth and generosity of her friendship. Robert Southey's account of his first meeting with Seward in 1808 captures both her charm and affectation:

Miss Seward was at her writing desk; she was not far short of seventy, and very lame ... Her headdress was quite youthful, with flowing ringlets: more beautiful eyes I never saw in any human countenance; they were youthful, and her spirit and manners were youthful too; and there was so much warmth, and liveliness, and cordiality, that except the ringlets, everything would have made you forget that she was old. This, however, was the impression with which I left her. The first scene was the most tragi-comic or comico-tragic that it was ever my fortune to be engaged in. After a greeting, so complimentary that I would gladly have insinuated myself into a nut-shell, to have been hidden from it, she told me that she had that minute finished transcribing some verses upon one of my poems, – she would read them to me, and entreated me to point out anything that might be amended in them. I took my seat, and, by favour, of a blessed table, placed my elbow so that I could hide my face by leaning it upon my hand, and have the help of that hand to keep

down the risible muscles, while I listened to my own praise and
glory set forth, in sonorous rhymes, and declared by one who read
them with theatrical effect.

Southey's mixture of embarrassment and admiration, his sense that
Seward was both laughable and to be taken seriously, was a common
reaction, especially among men, to her determination to be treated seri-
ously as a critic and commentator. Her combative outspokenness and
high seriousness were at odds with conventions about female passivity
and in breach of prevailing ideas of genteel politeness. Deportment
manuals for young women urged them to behave modestly, to defer to
others (especially men and their elders) and to insinuate rather than
assert their views. Seward repeatedly violated these forms of discretion.
Throughout her life she engaged in controversy and polemic, and though
she was often bitterly wounded by the criticism and hostility she pro-
voked, she never showed the slightest reluctance to speak her mind.
When friends sent her poems and she did not like them, she returned
them with criticisms of breathtaking candour. When Dr Johnson attacked
the rebellious American colonists – 'I am willing to love all mankind
... *except an American*' – she upbraided him to his face. She did not
flinch from telling what she believed to be unpalatable truths.

Seward carefully cultivated her reputation as a bluestocking and
principled critic. In her correspondence, which she preserved and then
rewrote for publication, she offered opinions on aesthetics and modern taste
as well as on poets, past and present; she tried out ideas which later appeared
in essays and letters published in periodicals. Though the tenor of her letters
was highminded, it was also unapologetically provincial. She portrayed
herself as a dutiful daughter and a conscientious friend, a busy gentle-
woman caught up in 'the mill-horse round' of daily life. When Thomas
Christie, the editor of the *Analytic Review*, asked her for a contribution to
his new periodical, she complained that she had no time to write:

> To maintain household economy, social intercourse, and the estab-
> lished claims of a very large correspondence, I am obliged but very
> seldom to admit the visits of the Muses. With great fondness for
> literature, my life has been too much devoted to feminine employ-
> ments to do much more than study, in every short and transient
> opportunity, but with eager avidity, and intense attention, that
> science [of poetry], the first and fairest.

But, quite typically, she then offered him an extended account of her talents as a critic of music, painting and literature, concluding, 'I have no scientific, or rather, experimental philosophy; – but moral philosophy was always the favourite subject of my meditations.'

Seward's attachment to provincial life may seem odd in someone so obviously ambitious to hold the public stage. Her repeated condemnation of London as 'Babylon', her aversion to high society and aristocratic assemblies, and her refusal, despite the urging of her friends, to move to London or Bath after her father's death in 1790, might be interpreted as uncharacteristically timorous, but these responses were also shrewd. By her early forties, when it had become clear she would not marry, she had become the effective head of her household, the chief tenant of a fine building, the Bishop's Palace, in which local luminaries gathered for literary conversation and to play music. Her mother had died; her father, a prosperous cleric, was ailing. Her early mentor, the poet, doctor, botanist and inventor Erasmus Darwin, whose presence in Lichfield over-shadowed her – many of her early poems were attributed to him – had gone with his new wife to live in Derby. Her published poetry and the verses submitted to the Batheaston Society nursed her growing national reputation. By staying in Lichfield Anna Seward ensured that she had what she most needed – a room of her own.

In her letters and poems Seward repeatedly portrayed herself in her domestic surroundings. She gives us a sense of place. At the very beginning of her published correspondence she mentions to Miss Powys, a spinster friend in Bristol, 'writing upon this dear green terrace, feeding, at intervals, my little golden-breasted songsters. The embosomed vale of Stow, which you know it overlooks, glows sunny through the Claud-Lorraine-tint, which is spread over the scene, like the blue over a plumb.' Appended to her sonnet 'December Morning' is a note that explains that 'it was written in an Apartment of the West Front of the Bishop's Palace at Lichfield, inhabited by the Author since her thirteenth year. It looks upon the Cathedral-Area, a green Lawn encircled by Prebendal houses, which are white from being rough-cast.' She betrays a complacent satisfaction that her father's modest prosperity and her inheritance after his death, as well as 'the generous moderation of my episcopal landlord', enabled her to devote herself to poetry and criticism.

If Seward had moved to London she might never have cut the striking figure in its salons that she became in Lichfield. She would have

been poorer; she would have had to temper her opinions and govern her conduct more strictly by the rules of metropolitan polite society. She might have become yet another London literary lady. And like those women, she would have had only limited access to the coffee house and club culture that dominated the London literary scene. Her singularity flourished better at the private assemblies and literary gatherings of a country town that tolerated idiosyncratic characters, and it was spread abroad through a stream of private correspondence and letters to the press. She did not go to the literary world; it came to her, to see and hear 'the Swan of Lichfield'. As she told Walter Scott, 'Such visits are the most high-prized honours which my writings have procured for me.'

Seward's writings, apart from her poetry, share a number of connected obsessions. She is best remembered as an ardent critic of Dr Johnson, for she consistently refused to bow down and worship at the shrine of the 'Great Cham' of literature. But she was also a vigorous proponent of modern poetry, an enlightened Whig who believed in progress and was determined to assert that recent verse produced by the likes of Thomas Gray (whose famous 'Elegy' she regarded as 'one of the most perfect poems ever written'), William Mason, William Collins, William Hayley (the most fashionable poet of her day), James Beattie, William Cowper, Thomas Chatterton and Robert Burns ranked with the best of the past. 'Never', she wrote to her friend Miss Scott, 'was there so rich a galaxy of poetic stars as have shone out, with perpetual augmentation to their number, within the last half century . . . It is true, we have not a Shakespeare and a Milton, but that is not owing to nature having become more penurious respecting the gift of genius, but to the fastidiousness of refinement, and the severity of criticism.'

Seward's taste was typical of many poets and critics of the late eighteenth century. The poems she admired were also the youthful reading of William Wordsworth. Her taste was for the sentimental lyric poetry that Gray and Collins had first made fashionable in the 1740s and that reached a large public in Robert Dodsley's series of contemporary poetry, popularly known as *Dodsley's Collection*, which was first published in three volumes in 1748 and had become six fat tomes by 1758. This 'Poetry of the Heart', as it was called by the critic Hugh Blair, portrayed the poet as an original genius of heightened sensibility, a person of greater sensitivity to joy and pain than ordinary men. Often melancholic, pre-

occupied with death and the transitory nature of human pleasures, the poets exalted the virtues of a withdrawal from urban sociability into rural solitude. Here the wonders of nature – a major theme of such poems – excited noble and uplifting feelings in what James Beattie in his influential poem *The Minstrel* (1771) called 'the lone enthusiast'.

Again like most of her contemporaries, Anna Seward took a patriotic view of Britain's verse. She viewed modern lyric poetry as the culmination of a native British tradition that drew its strength from Spenser and, above all, from John Milton. 'Religiously do I believe', she wrote, 'that the mass of genius, accumulated in this country since Spenser's time, is far greater than any other nation can boast.' Spenser was admired for what the critic Joseph Warton called 'the careless exuberance of a warm imagination and strong sensibility', but it was Milton, 'the greatest poet the world has produced, Homer and Shakespeare excepted', according to Seward, who excited her greatest enthusiasm. 'The sweet effusions' of his 'juvenile years' – especially 'L'Allegro', 'Il Penseroso' and 'Lycidas' – fitted well with her modern interest in the evocation of moods and feelings, whether mirthful or, more usually, melancholic, and the expression of these sentiments in the description of landscape. Seward, who loved 'Lycidas', used it as a touchstone of taste, and took Milton's sonnets as a model of poetic form which combined 'elevated sentiments with majestic simplicity, and domestic feelings with energetic tenderness'. One of her quarrels with Dr Johnson stemmed from his less than adulatory view of Milton. Seward believed that critical envy and conservative politics had led him to underestimate a genius and a republican: 'He hated the man for his party, and his poetry for its pre-eminence.' Seward's enthusiasm for Milton was less a matter of political sympathy – though she certainly was far less hostile that Johnson – than a commitment to a poetry expressive of strong feeling and high sentiment.

She stood at the centre of that tradition which vaunted sensibility as the key to taste in the late eighteenth century. Like many other poets of the time, she saw lyric verse as a means of exploring the byways of her imagination. Pity, sadness and sympathy – sometimes affliction and woe – were the feelings her verses most frequently expressed. They invoked sympathy, an understanding of misfortune and suffering, either in themselves or, more usually, in others. The titles of some of the most popular verses of Seward's most admired poets – Thomas Warton's 'The Pleasures of Melancholy' (1747), and Thomas Gray's 'Ode to Adversity' (1753)

and his 'Ode on the Pleasure Arising from Vicissitude' (1775) – reflect this preoccupation, as does the first of Wordsworth's published verses, a 'Sonnet, on seeing Miss Helen Maria Williams [a close friend of Anna Seward's, incidentally] weep at a Tale of Distress'.

Such sentiment can seem self-regarding and self-indulgent, with its escapist emphasis on withdrawal, and came to be condemned as narcissistic and lacking a sense of social responsibility. But the same poets who wrote of the intense, sublime pleasure to be had in contemplating nature and death were also concerned with social virtues and sentiments, wanting to provoke the reader's moral as well as aesthetic response. Occasionally sentimental verse was explicitly linked to issues of the day. The poet Helen Maria Williams, whom Wordsworth so greatly admired, turned her sympathy to account in *Peru* (1784), a historical poem condemning slavery and the colonial exploitation of South America. The iniquities of slavery were, of course, a common concern of Enlightenment philosophy, voiced by Montesquieu, Voltaire, Raynal and Condorcet, but it was also a theme of much English poetry: the eccentric Thomas Day, another of Seward's literary circle in Lichfield, published a popular poem intended to further the anti-slavery cause, 'The Dying Negro' (1773), dedicated to Jean-Jacques Rousseau, which went through many editions; similar verses were penned by the bluestocking Hannah More and her humble protégé the milkmaid poet Ann Yearsley. When the industrialist Josiah Wedgwood converted Anna Seward to the anti-slavery cause in 1788 she rejected his plea for some poems on the grounds that so many had already appeared. Poetic sensibility and a social conscience could go hand-in-hand.

Critics like Seward believed that the poet's heightened sensibility stemmed from individual genius, an inherent creativity that could nevertheless be cultivated. Seward enumerated the powers of genius as 'creative fancy, – intuitive discernment into the subtlest recesses of the human heart; – exhaustless variety of style; – the Proteus ability of speaking the sentiments and language of every character'. This belief in individual genius and imagination had the paradoxical effect of making it possible to argue that potentially anyone could be a poet, even while it enhanced the poet's status as someone not like ordinary men and women. If, in the words of the critic Joseph Warton, a true poet had 'a creative and glowing imagination' rather than the cultivated values of wit and sense, and if fine poetry was characterized as much by feeling as by form, then

and his 'Ode on the Pleasure Arising from Vicissitude' (1775) – reflect this preoccupation, as does the first of Wordsworth's published verses, a 'Sonnet, on seeing Miss Helen Maria Williams [a close friend of Anna Seward's, incidentally] weep at a Tale of Distress'.

Such sentiment can seem self-regarding and self-indulgent, with its escapist emphasis on withdrawal, and came to be condemned as narcissistic and lacking a sense of social responsibility. But the same poets who wrote of the intense, sublime pleasure to be had in contemplating nature and death were also concerned with social virtues and sentiments, wanting to provoke the reader's moral as well as aesthetic response. Occasionally sentimental verse was explicitly linked to issues of the day. The poet Helen Maria Williams, whom Wordsworth so greatly admired, turned her sympathy to account in *Peru* (1784), a historical poem condemning slavery and the colonial exploitation of South America. The iniquities of slavery were, of course, a common concern of Enlightenment philosophy, voiced by Montesquieu, Voltaire, Raynal and Condorcet, but it was also a theme of much English poetry: the eccentric Thomas Day, another of Seward's literary circle in Lichfield, published a popular poem intended to further the anti-slavery cause, 'The Dying Negro' (1773), dedicated to Jean-Jacques Rousseau, which went through many editions; similar verses were penned by the bluestocking Hannah More and her humble protégé the milkmaid poet Ann Yearsley. When the industrialist Josiah Wedgwood converted Anna Seward to the anti-slavery cause in 1788 she rejected his plea for some poems on the grounds that so many had already appeared. Poetic sensibility and a social conscience could go hand-in-hand.

Critics like Seward believed that the poet's heightened sensibility stemmed from individual genius, an inherent creativity that could nevertheless be cultivated. Seward enumerated the powers of genius as 'creative fancy, – intuitive discernment into the subtlest recesses of the human heart; – exhaustless variety of style; – the Proteus ability of speaking the sentiments and language of every character'. This belief in individual genius and imagination had the paradoxical effect of making it possible to argue that potentially anyone could be a poet, even while it enhanced the poet's status as someone not like ordinary men and women. If, in the words of the critic Joseph Warton, a true poet had 'a creative and glowing imagination' rather than the cultivated values of wit and sense, and if fine poetry was characterized as much by feeling as by form, then

occupied with death and the transitory nature of human pleasures, the poets exalted the virtues of a withdrawal from urban sociability into rural solitude. Here the wonders of nature – a major theme of such poems – excited noble and uplifting feelings in what James Beattie in his influential poem *The Minstrel* (1771) called 'the lone enthusiast'.

Again like most of her contemporaries, Anna Seward took a patriotic view of Britain's verse. She viewed modern lyric poetry as the culmination of a native British tradition that drew its strength from Spenser and, above all, from John Milton. 'Religiously do I believe', she wrote, 'that the mass of genius, accumulated in this country since Spenser's time, is far greater than any other nation can boast.' Spenser was admired for what the critic Joseph Warton called 'the careless exuberance of a warm imagination and strong sensibility', but it was Milton, 'the greatest poet the world has produced, Homer and Shakespeare excepted', according to Seward, who excited her greatest enthusiasm. 'The sweet effusions' of his 'juvenile years' – especially 'L'Allegro', 'Il Penseroso' and 'Lycidas' – fitted well with her modern interest in the evocation of moods and feelings, whether mirthful or, more usually, melancholic, and the expression of these sentiments in the description of landscape. Seward, who loved 'Lycidas', used it as a touchstone of taste, and took Milton's sonnets as a model of poetic form which combined 'elevated sentiments with majestic simplicity, and domestic feelings with energetic tenderness'. One of her quarrels with Dr Johnson stemmed from his less than adulatory view of Milton. Seward believed that critical envy and conservative politics had led him to underestimate a genius and a republican: 'He hated the man for his party, and his poetry for its pre-eminence.' Seward's enthusiasm for Milton was less a matter of political sympathy – though she certainly was far less hostile that Johnson – than a commitment to a poetry expressive of strong feeling and high sentiment.

She stood at the centre of that tradition which vaunted sensibility as the key to taste in the late eighteenth century. Like many other poets of the time, she saw lyric verse as a means of exploring the byways of her imagination. Pity, sadness and sympathy – sometimes affliction and woe – were the feelings her verses most frequently expressed. They invoked sympathy, an understanding of misfortune and suffering, either in themselves or, more usually, in others. The titles of some of the most popular verses of Seward's most admired poets – Thomas Warton's 'The Pleasures of Melancholy' (1747), and Thomas Gray's 'Ode to Adversity' (1753)

even an untutored imagination might show poetic genius. When creativity was inherent rather than learned, those who could express themselves spontaneously and naturally were likely to be the best poets. No special education or knowledge of the classics was required; poetry was open to all and could assume many forms. Women and the poor were not excluded from natural genius; the popular ballad was as much a poem as a classical epic. Not fortuitously, these views gained hold at a time when more and more amateurs, provincials and women were writing and publishing verse.

Like many of her contemporaries, Seward patronized and admired poets of humble origin. She praised 'the beautiful compositions which uneducated Poverty has produced in this age', citing the works of Ann Yearsley; John Frederick Bryant, the Bristol tobacco pipe-maker; William Newton, the 'Derbyshire minstrel' whom she herself aided; Robert Burns, the Scottish agricultural labourer and exciseman; and Thomas Chatterton, the youthful genius whose suicide in 1770 Seward blamed on the cruel neglect of the London literary establishment.

Burns was from Dumfriesshire, while Yearsley, Bryant and Chatterton all came from Bristol. They, like Thomas Bewick in Newcastle, spoke to local experience as well as to larger values, and were part of a trend of turning to what was called 'the sentiment of the place' for inspiration. 'Local poetry', with its celebration of particular landscapes and views, even when got up in classical garb or populated with nymphs and dryads, asserted the importance of provincial life and local genius as against metropolitan urbanity.

The one sort of verse that Seward actively disliked was satire of political, social and cultural life – including, of course, the cult of sentiment – of the sort written by such London wits as Charles Churchill and John Walcot. Though a fervent admirer of the brilliant but unstable evangelical poet William Cowper, she condemned his satire: 'it is ill for the interest of a muse, at least with people of benevolent taste, when she quits the mazes of sportive invention, pathetic description, and generous sentiment, for those thorny paths of acrimonious satire.' Harsh London wit subverted the pleasures of a sympathetic imagination.

Provincial poets used visions of landscape as metaphors of poetic meditation. As Mark Akenside, a Newcastle poet, put it in his *The Pleasures of the Imagination*, the poet strove to behold

> in lifeless things,
> The inexpressive semblance of himself
> Of thought and passion

But certain sorts of landscape were thought to affect the imagination more powerfully than others. Picturesque scenes, in which sinuous variety and romantic setting engaged the eye, and sublime views whose grandeur provoked a frisson of combined awe and fear, were far more moving and aesthetically powerful than a tame, orderly landscape. As the critic Hugh Blair put it, 'What are the scenes of nature that elevate the mind in the highest degree, and produce the sublime sensation? Not the gay landscape, the flowery field, or the flourishing city; but the hoary mountain, and the solitary lake; the aged forest, and the torrent falling over the rock.'

For poets like Seward such places embodied history as well as nature. The hermit's cave, ruined abbey or derelict castle were as much a part of the British landscape as any craggy precipice or tumbling torrent – 'we consider [a ruin] . . . as a work of nature, rather than of art' – and were cherished for the way they triggered memories, prompting the poet to explore the past. Ancient British ruins not only provoked melancholic reflections on the transitory nature of life, in the manner of Thomas Bewick (fig. 219), but conjured up obscure and often frightening images of a barbarous and brutal past. They also stood as the surviving fragments of a native culture whose recovery was a matter of national and regional pride. Poets, scholar-critics and antiquarians set out to recover (and in some cases to restore or even fabricate) the monuments, history and literature of Britain's medieval, gothic past. The owners of castles and abbeys made them more accessible yet kept them suitably ruinous, old ballads were recovered and reformed to accord with modern poetic taste, and a number of brilliant faked ancient texts helped to sustain the belief that modern poets had their forebears among the ancient bards. Gothicism was inspired by verses like Gray's enormously popular *The Bard* (1757) and Collins's *Ode to Liberty* (1746), scholarly works such as Thomas Percy's *Reliques of Ancient English Poetry* (1765) and Thomas Warton's *History of English Poetry* (1774–81), and by the forgeries of Chatterton's Bristol verses and James Macpherson's *Fingal, an Ancient Epic Poem, in Six Books* (1762) (figs. 220, 221, 222).

Anna Seward believed that Macpherson's epic, whether written by

219. *A Philosopher in a Moonlit Churchyard* by Phillippe de Loutherbourg, 1790

ancient bards or by its modern compiler, was one of the greatest British poems. Its verses combined sublime feeling and historical romance:

Never yet have I opened the Erse volumes without a poignant thrill of pensive transport. The lonely scenery of a barren and mountainous country rises before me. By turns I see the blue waves of their seas, rolling in the light; and then, by the dark storm, lashed into foam, and bursting upon the rocks. I view the majestic and melancholy graces, in the persons of the warriors and their mistresses, walking over the silent hills. The tender consecration of the memory of their lost friends, and of the vanished years, are in unison with all the feelings of my soul; and their machinery, sailing upon the blasts of the deserts, at once awes and delights me.

It may seem curious that Seward, so passionately committed to modernity, should have been so interested in the distant past. But her desire to find the sources of modern English poetry in a native tradition, and not in the influence of the ancient classics or French and Italian verse, stimulated her enthusiasm for patriotic medievalism. Her idea of Britain's gothic past had a political dimension: ruined castles and abbeys were a reminder that monarchical tyranny and religious superstition had since been vanquished, while the pre-Christian druids were poet-priests of liberty, the medieval bard personified poetic vision, and ancient texts and verses revealed the gothic sources of British liberty. The Bard, in Gray's poem which Seward so admired, inveighs against the tyranny of Edward I and praises the true kingship of King Arthur, just as another English king, Alfred, represents enlightened monarchy which supported the propagation of knowledge and the patronage of literature as well as the establishment of that most British of institutions, a powerful navy (fig. 223).

Anna Seward's taste for sentiment, her enthusiasm for sublime landscape and for medievalism, and her search for the British origins of a modern poetic tradition were typical of many poets and writers of her time, and these interests, while not found solely in the provinces, heralded a curiosity about provincial life that figures like she and Bewick were eager to promote. As the localities of Britain became objects of taste, so the shaping of that taste became more and more important to them. They did not want their localities merely to be objects of metropolitan curiosity; they wanted a say in how these places would be understood, though they could achieve this only by engaging in London's cultural life, albeit as outsiders. Their taking on this task was intended to assert their claim not only to be the proper voice of taste but that regional culture should be treated as central to British culture as a whole. There was a certain ambiguity about this. Provincial critics and authors continued to glory in not being of London, but they also wanted to abolish the invidious distinction between their provinciality and metropolitan sophistication.

These issues lay behind much of the quarrel between Anna Seward and Samuel Johnson, which began in Johnson's lifetime and which grew more intense as Seward struggled to affect his posthumous reputation. From one point of view the conflict was little more than a family quarrel of the sort John Marsh worked so hard to contain in Salisbury, Canterbury or Chichester. Seward and Johnson were strong, self-regarding

220. *The Bard* by Thomas Jones, 1772

personalities, distantly related and moving in similar social circles: Johnson had been taught by Anna's grandfather; his stepson, Henry Porter, was engaged to marry Anna's sister Sarah (she died before the wedding). Johnson – poor, socially inept and for much of his life a person who struggled for success – may have envied Seward's comfortable and somewhat complacent life. He seems also to have been uneasy about her knowledge of his youthful infatuations and early failures. Seward, for her part, believed that Johnson, once his fame was secure, treated his Lichfield acquaintances, particularly her father, with unmerited neglect and scornful condescension. In her life of Erasmus Darwin she complained bitterly that Johnson never mentioned 'any of the ingenious and *lettered* people who lived there; while of its mere commonplace characters there is frequent mention, with many hints of Lichfield's intellectual barrenness, while it could boast a Darwin, and other men of classical learning, poetic talents, and liberal information.' And though she cast her complaints about his conduct in terms referring to the intellectual bullying for which he was famous, she also thought him socially uncouth: he was this 'Fe Fa Fum of Literature', 'the old growler', 'the old elephant' as well as a bear.

221. *The Friary at Burnham Norton, Norfolk* by Thomas Hearne. Hearne was a well-known watercolourist and antiquarian who travelled throughout Britain to record its antiquities and ruins

But there was more to their quarrel than an acrimonious small-town squabble between strong personalities. Seward was a polite lady amateur, an habituée of local drawing rooms, a sentimental lady of fashion. Johnson, turning his back on Lichfield and striking out for London, became a shabby professional writer who struggled out of the gutter of Grub Street to become one of the nation's most famous authors. She was a person of passionate and sometimes misplaced enthusiasms; he personified tough-minded, sceptical criticism. She believed in progress and enlightened Christianity; his views of man and his religion were altogether darker.

One of Johnson's greatest achievements was to establish the position of the professional writer as an honourable one, as a public critic in the literary marketplace. Anna Seward saw this as clearly as any, and her attacks on Johnson explicitly acknowledged that his life's work – the *Dictionary*, his numerous periodical essays, *Lives of the Poets* and his edition of the works of Shakespeare – had helped to shape Britain's literary heritage. Her hostility to this contribution of his was twofold: she disagreed with his views, and she also felt that a professional, London

critic was not the right sort of person to form public taste. She was fighting a rearguard action in favour of the amateur of letters.

Seward's repeated, almost obsessive attacks on Johnson have usually been described as highly personal, which they unquestionably were. Over and over again she wrote of his reprobate character, his 'pride', 'jealousy', 'illiberal narrowness of mind', 'spleen, envy, boundless haughtiness, and utter callousness to all the mental sensibilities of others', dubbing him 'the imperious and gloomy Intolerant'. The anecdote about him which she most often repeated was the story of Johnson's attack on Jenny Harry, a convert to Quakerism ('I hate the odious wench, and ever shall hate her'), which took place at a dinner given by Dilly the bookseller in 1778. Seward was present, which made her version of the incident all the more credible. She and the Quaker Mrs Knowles had spent the evening arguing with Johnson about the inequality of the sexes ('Mrs Knowles affected to complain that men had much more liberty allowed them than women', as Boswell put it), the American colonists, Mandeville's views on luxury, and fear of death before Johnson launched into a tirade against Miss Harry which even Boswell conceded 'attacked the young proselyte in the

222. *Cockermouth Castle* by Thomas Hearne

severest terms of reproach, so that both the ladies seemed to be much shocked'. (Mrs Knowles, supported by Seward, published her own version of the incident after Boswell had refused to include it in his *Life*.)

Seward used such stories to castigate Johnson's moral character. No doubt spite played a part here but Seward's attacks were also intended to undermine Johnson's credibility. She almost always linked his moral failings to what she saw as his inadequacy as a critic. She condemned his *Lives of the Poets* as 'that overwhelming tide of injustice and malignity', concluding that 'To me there appears no middle path to be adopted with any rationality, after having read … Lives of the Poets, but either we must perceive and despise the envy and injustice of their author, or believe that there is little or no English poetry worth reading.' In Seward's eyes he was illiberal, which was why he did not like modern poetry and did not fully appreciate Milton and Gray.

Here there were clear differences of taste – Johnson's preferences were for clear, vigorous, witty verse and for orderliness and design, while much of the poetry that Seward favoured was often marked by the affectation, archaisms and excessive ingenuity which Johnson disliked. But we should not exaggerate these differences. On occasions, Seward was a fierce advocate for Johnson. In a long letter to the Dewar Club, a London literary society, she explained:

> I have always maintained, that his powers, and style, in moral declamation, are far superior to Addison's, and indeed to every other essayist; – and that his compositions are luminous, impressive, and harmonious; – that to them may be fairly imputed the immense improvement in English prose-writing with the last half-century; that, by Latinizing our language, he has expanded its powers, and harmonized its sound.

She also shared Johnson's views on a number of issues, including the undesirability of religion as a subject of poetry. Her view of Johnson, summarized in her remark that he was 'a stupendous but imperfect Being', was more balanced than might at first appear.

What Seward really disliked was not the idol but 'the idolaters', the 'blind worshippers' of Johnson, like a female acquaintance who told her that 'he must be allowed a Colossus, bestriding what she supposes the narrow world of intellect and virtue'. It is here that we come to the heart of the matter. Is literature to become a special province belonging

223. *The Bard* by Phillippe
de Loutherbourg, 1784

to a certain sort of critic, a professional writer in London with unequalled opportunity to persuade, cajole and bully the public taste? Are such men to be the voice of literature and the arbiters of taste? Or is taste to be shaped differently, not in Grub Street, but by refined members of polite society whose sense of social propriety, fashioned in provincial drawing rooms, will ensure that their taste will be charitable and ecumenical?

The metaphors that Seward used about Johnson and his followers identified them as enemies of the Whig Enlightenment. She repeatedly described Johnson as tyrannical and despotic, his followers' enthusiasm as superstition. She worried about how the cult of Johnson narrowed the canon of British literature, and put it at the mercy of London's critics. She wanted a broadly based critical heritage in which poetry was a sign of higher sensibility and not a professional property. Almost all her work – her poetry, her criticism, her carefully doctored published correspondence and her exemplary 'warts and all' *Memoirs of the Life of Dr Darwin* – was intended to assert this view.

Seward was unreservedly hostile to the professional literary market-
place. She objected not only to Johnson's individual importance but to
professional critics in general. When Clara Reeve's *The Progress of
Romance*, the first history of the novel in English, was published in 1785,
Seward criticized it for being

> written chiefly to court the favour of our reviewers, whom it meanly
> invests with that justice and ability of decisions to which their
> general strictures have so little pretension. How should they be *able*,
> and how are they likely to be *just*, composed, as the general class
> of them are, of hireling authors, whose own works have not merit,
> or celebrity to afford them a maintenance? Hence are they naturally
> the foes of their superior and more fortunate rivals.

Her hostility to 'the stupidity of review-criticism, and the as stupid respect
paid to it by the general reader' was in part provoked by the increasing
frequency with which reviewers attacked her work. (Her verse novel
Louisa had been a popular success but panned by the critics; in her later
years the highly conservative *British Critic* was especially hostile.) But it was
also an effort to assert the importance of the provincial writer against the
metropolitan literary establishment, the amateur against the professional.

Seward's attacks read like a snobbish invocation of the superiority
of the writer of independent means, of liberal gentlefolk over Grub
Street, but her position was not that simple. Her attack on tyrannical
critics in general and on Johnson in particular stemmed less from aesthetic
disagreements – for she shared a number of their views – than from her
sense that Britain's literary heritage should be generously construed and
widely shared. Though she was eventually to turn strongly against the
French Revolution, publicly attacking her friend Helen Maria Williams
for her continued support for it ('Fly, dear Helen, that land of carnage!
from the pernicious influence of the equalizing system, which, instead
of diffusing universal love, content, and happiness, lifts every man's hand
against his brother'), she remained throughout her life a staunch Whig.
As she put it in a letter to George Hardinge, a distinguished lawyer and
amateur critic, 'There is a toryism in [poetical] science as well as in
government. I have not been accustomed to give my mind political hectics
(sic). Unable to serve my country, I have turned my contemplation upon
pleasanter themes; but the whig principles, on their broad and general
basis, that of claiming for all men what is granted to some, have invariably

been mine.' Seward was not a democrat, but she believed in a catholicity of taste. And she was adamant that people like her had every right to voice their opinions about poetry and letters.

Anna Seward's literary endeavours were supported by interconnected networks of friends, acquaintances and correspondents throughout Britain, but her life was centred on the town of Lichfield. The small and intimate literary circle there was far from insular and had connections throughout the Midlands. A steady flow of poets, scientists, musicians and literati moved between Lichfield, Birmingham and Derby, dining at one another's houses, attending plays and concerts, and participating in public debates, scientific lectures and experiments. The fame of some of these people – Anna Seward herself, Erasmus Darwin, Sir Brooke Boothby (1743–1824), a friend of Rousseau, a poet, botanist and political pamphleteer – also brought visitors from London and elsewhere in Britain, and their circles of acquaintance and conversation were re-inforced and extended by means of voluminous private correspondence. By writing many letters to close friends or to famous figures by whom she wished to be noticed, Seward expanded her influence and enhanced her reputation. She formed coteries of pen-friends, whom she rarely saw but who supported her in her polemical forays in the literary magazines. She also kept in contact with friends by visiting them, but did so sparingly; she depended more on her pen than on her person. She rarely travelled to London and only occasionally to Bath. More usually she visited the Derbyshire hill spa of Buxton, the sea-bathing resort of Hoylake, and Plas Newydd, the house in north Wales of the two literary 'ladies of Llangollen', Lady Eleanor Butler and Miss Sarah Ponsonby, whose life of rustic isolation, intellectual refinement and ardent female friendship fascinated fashionable society.

Lichfield was a typical English cathedral town, its genteel social life centred on the families of clerics and ecclesiasts who were neighbours of Anna Seward in the cathedral close. They fraternized with Lichfield's lawyers, doctors, traders and prosperous merchants, and with the squire-archy whose houses were not far from the city. In the early eighteenth century Lichfield was the social and cultural centre of the west Midlands; even as it was eclipsed by the growing industrial city of Birmingham, it remained a lively town, with a theatre (first opened in 1736), several

booksellers and printers, a cathedral lending library of 3,000 literary, philosophical, scientific and religious books, an annual musical festival on St Cecilia's Day, and a busy social calendar tied to the Lichfield races. In the winter there were private subscription balls and large public dinners. Seward described a typical season in a letter to a clerical friend in 1788: 'Lichfield had been very dissipated through the winter. Plays thrice in a week – balls and suppers at our inns, cards and feasting within our houses. No mode of amusement neglected, except that in which we are best calculated to excel – our concerts.'

The town's literary coterie was a small body of men and women united by their common interest in art, literature, music, science and education. In addition to Anna herself, they included her father, Thomas Seward (1708–90), the editor of Beaumont and Fletcher's *Works* and author of the verse 'Female Right to Literature'; her first patron, the poet, doctor, botanist and inventor Erasmus Darwin, who lived in Lichfield between 1756 and 1781; Sir Brooke Boothby; Thomas Day (1748–89), a Rousseauist, poet and author of the best-selling children's book *History of Sandford and Merton* (1783–9); and Richard Lovell Edgeworth (1744–1817), an educator, inventor and father of the novelist Maria Edgeworth. In addition to these luminaries, Lichfield literary society boasted a number of learned clerics and the well-educated musician John Saville, who became Anna's beloved 'Giovanni'. Joseph Wright (Wright of Derby) painted portraits of most of these men and women when he was in Lichfield in the 1770s, while at the end of the century the circle included the drawing master and artist John Glover, 'our Lichfield Claude', as Anna called him. The group was not exclusively male. As the unusually high number of women borrowers from the cathedral library shows, Anna was not the sole learned lady in Lichfield society, though she was the only one to acquire a national reputation.

The most important cultural figure of all these was Erasmus Darwin, the grandfather of the more famous Charles (fig. 224). Energetic, inventive, highly intelligent and inveterately curious, he was willing to explore every avenue of knowledge. He was passionately committed to the exchange of ideas with others, eager to share and to learn, though this appetite led to quarrels in his later years. His fame gave Lichfield a vicarious importance, his magnetic presence as the cynosure of its intellectual and cultural life drew outsiders into its orbit, and his connections with writers, scientists and manufacturers in Birmingham and Derby

224. *Erasmus Darwin* by
Heath, engraved by
Rawlinson

ERASMUS DARWIN, M.D., F.R.S.
AUTHOR OF THE LOVES OF THE PLANTS.

placed his town in a constellation of cultural societies in the Midlands. When Anna Seward wanted to publicize Lichfield's culture she shrewdly chose to write a biographical memoir of its most illustrious figure. She knew that she owed Darwin a great deal. His presence in Lichfield had enormously increased her circle of acquaintance and, when he left in 1781, she inherited his mantle as the most conspicuous of its writers.

Erasmus Darwin was a well-educated gentleman. A graduate of Cambridge University, a fellow of the Royal Society, the student of the famous anatomist William Hunter, trained in medicine at Edinburgh, he quickly established himself in Lichfield as a popular and skilled physician. But medicine could not satisfy his restless curiosity. Darwin was an ambitious polymath who devoted his life to experimental science, education and poetry. He leaped over whatever barriers separated disciplines, whatever chasms might exist between science, arts and humanities.

His means of educating the public in science and agriculture was to write an epic poem in rhyming couplets.

Darwin's numerous projects included the invention of a horizontal windmill (which the industrialist Josiah Wedgwood used in his pottery works), a coach with special reading shelves, a speaking machine which simulated the human voice and a writing copying machine. He designed automata, weighing machines, steam engines and canal locks. In his laboratory and on his patients he carried out experiments on deafness, the properties of the eye and the effects of heat on air. The *Transactions of the Royal Society* and other learned journals published his papers on meteorology, balloons, artesian wells, geology and agriculture. But his most famous work was the enormously successful verse epic *The Botanic Garden* (1789–91), which surveyed the botanic universe, explained the Linnaean system of classification in its 'The Loves of the Plants' and, in its first part, 'The Economy of Vegetation', celebrated the wonders of modern commerce and industry. Darwin's poem epitomized the union of science, commerce and the applied and fine arts that the literary and philosophical societies of the provinces saw as the key to modern progress.

Today this poem is largely forgotten, or remembered only because of the famous parody 'The Loves of the Triangles', which it provoked in the conservative *Anti-Jacobin* of 1798. But at the time it was enormously influential, going through five English, Irish and American editions in its first ten years as well as being translated into German, French, Italian and Portuguese. *The Botanic Garden* excited the admiration of such diverse figures as Horace Walpole and William Cowper and became the poem that Romantics such as Coleridge and Shelley loved to hate.

Darwin's success lay in his skilled popularization of scientific knowledge and his cultivation of a euphoric feeling of progress by using familiar poetic values, figures and forms. His poem is filled with sentiment. Sympathy appears, as Seward describes it, 'in a female form, bending over a rock to assist the shipwrecked mariners; she is shown afterwards as supporting feeble Age on her arm, and pouring balm into the wounds of Sorrow; snatching the dagger from Despair; lulling Envy to sleep, and while she reposes, stealing her envenomed arrows from her quiver'. Darwin used such figures to embrace rather than avoid modern life. Similarly the beautiful and the sublime are married to the wonders of modern technology. Beauty resides in the pottery of Darwin's close friend Josiah Wedgwood:

> Etruria! next beneath thy magic hands
> Glides the quick wheel, the plastic clay expands,
> Nerved with fine touch, thy fingers (as it turns)
> Mark the nice bounds of vases, ewers and urns;
> Round each fair form in lines of immortal trace
> Uncopies Beauty, and ideal Grace.

The awesome strength of the steam machine, developed by his friends Matthew Boulton and James Watt, is every bit as sublime as the wildest Highland mountain:

> The Giant-Power from earth's remotest caves
> Lifts with strong arm her dark reluctant waves,
> Each caverned rock and hidden den explores,
> Drags her dark coals, and digs her shining ores. –
> Next in close cells of ribbed oak confined,
> Gale after gale, he crowds the struggling wind;
> The imprisoned storms through brazen nostrils roar,
> Fan the white flame, and fuse the sparkling ore.
> Here high in air the rising steam he pours
> To clay-built cistern or to lead-lined towers;
> Fresh through a thousand pipes the wave distils,
> And thirsty cities drink the exuberant rills. –
> There the vast millstone with inebriate whirl
> On trembling floors their forceful fingers twirl,
> Whose flinty teeth the golden harvests grind,
> Feast without blood! and nourish human-kind.

Darwin's poem appealed to scientists and manufacturers, who wanted to raise the standing of the technical and manual processes which they promoted in applied arts and modern industry, and it enraptured persons of cultivated sensibility, who were delighted to learn about technology and botany in such an elevated literary form. Seward's verdict on the poem was shared by many other readers: 'Adapting the past and recent discoveries in natural and scientific philosophy to the purpose of heroic verse, the Botanic Garden forms a new class of poetry, and by so doing, gives the British Parnassus a wider extent than it possessed in Greece, or in ancient, or modern Rome.'

Darwin's verses suggested a progressive, commercial, Whig Britain

that celebrated its natural wonders as well as manufacturing achievements. Unlike many of his contemporaries, he did not see nature and improvement as antithetical, nor the country and the city as conflicting environments. They were both acclaimed as part of a universal history of progress whose culmination lay in the man-made and natural riches of the British Isles.

Less pleasing to Darwin's conservative critics were his enthusiastic liberal politics, which included support for the French Revolution, his un-Christian materialism, and an erotic botany that suggested that female forms were often polygamous in the natural world. But his progressivism was typical of the provincial scientific circles from which he came, and the *Anti-Jacobin*'s attack on him was a tribute to the popularity of his work.

Darwin connected what otherwise might have been a self-contained provincial circle with a larger intellectual world. Friends from Edinburgh and Cambridge came to visit him in order to discuss medicine and science; he sent papers to the Royal Society which published them in their *Transactions* and elected him a fellow in 1761; while his correspondence with the Society for the Promotion of Arts, Manufactures and Commerce brought him prominence as an inventor. These two London institutions, the one devoted to science, the other to the applied arts, served as central switchboards, connecting Darwin to other men of science and letters all over Britain and Europe.

Richard Lovell Edgeworth, an Irish gentleman, inventor, educator and poet, was invited to Lichfield by Darwin because of their mutual interest in designing carriages, but Edgeworth was quickly sucked into Lichfield society. He wrote later,

> We talked upon . . . mechanical subjects, and afterwards on various branches of knowledge, which necessarily produced allusions to classical literature; by these he [Darwin] discovered that I had received the education of a gentleman . . . The next day I was introduced to some literary persons, who then resided at Lichfield, and among them foremost to Miss Seward. The next evening the same society re-assembled at another house, and for several ensuing evenings I passed my time in different agreeable companies in Lichfield.

As Seward explains in her memoir of Darwin, over the next few years he attracted a number of other writers to Lichfield. Thomas Day,

225. *Thomas Day* by
Joseph Wright of
Derby, *c.* 1770

whom Edgeworth introduced to Darwin, moved to Lichfield in 1770
(fig. 225). The sportsman, poet and man of leisure Francis Mundy (1739–
1815) of Markeaton Hall was a frequent guest. Largely because of the
encouragement of Darwin and Seward, his poem *Needwood Forest* was
published in Lichfield in 1776. Brooke Boothby arrived in the 1770s and,
together with Darwin, he helped to set up the Lichfield Botanical Society.
During these years Darwin also befriended Joseph Wright, and when
Darwin moved to Derby in 1783 he continued to act as Wright's physician
and mentor.

Though their interests were disparate and their personalities singular,
the Lichfield circle had much in common. They were all strong Whigs.
Darwin, as we have seen, welcomed the French Revolution; Thomas
Day was an active member of the Society for Constitutional Information,
which advocated parliamentary reform; Brooke Boothby published
pamphlets on the French Revolution attacking Edmund Burke and
praising the reformer Tom Paine. This political enthusiasm was comple-
mented by unadulterated Rousseauism. All of the Lichfield circle were

interested in education – Darwin published a scheme of female education; Day wrote one of the most successful children's books of the eighteenth century; Boothby's final work was a book of fables much admired by Bewick; and Edgeworth wrote instructional works for young children. Their model of educational reform was Rousseau's *Émile*, which advocated practical instruction rather than book learning, play and encouragement rather than coercive punishment, and lots of fresh air and exercise, together with careful and considerate moral nurturing.

The circle's commitment to Rousseau was unequivocal. Only Seward herself expressed any doubts about his educational schemes. Darwin, as the artist diarist Joseph Farington noted, 'made it a rule never to contradict his children, but to leave them entirely their own master', an approach which he believed Joseph Wright adopted because of Darwin's influence. Edgeworth educated his son according to the principles of *Émile*, proudly displaying his boy for the philosopher's personal approval in 1771. Brooke Boothby first met Rousseau when Rousseau came to Staffordshire in 1766–7, and visited him in Paris in 1776, where he was rewarded with the manuscript of Rousseau's first dialogue, which Boothby published as *Rousseau Juge de Jean Jacques – Dialogues . . . Premier Dialogue d'Après le Manuscrit de M. Rousseau laisse entre les mains de M. Brooke Boothby in Lichfield in 1780*, and then presented the manuscript to the British Museum. In Wright's famous portrait of 1780–81 he grasps this volume in his left hand (plate 10).

Thomas Day was Rousseau's most enthusiastic Lichfield follower. In 1769 he wrote to Edgeworth:

> Were all the books in the world to be destroyed, except scientific books (which I except, not to affront you) the second book I should wish to save, after the Bible, would be Rousseau's Emelius. It is indeed a most extraordinary work – the more I read, the more I admire – Rousseau alone, with a perspicuity more than mortal, has been able at once to look through the human heart, and discover the secret sources and combinations of the passions. Every page is big with important truth.

Day sought to practise what he preached. Deeply disillusioned with contemporary education and even more dissatisfied by the sort of instruction that made women frivolous, superficial and the objects of 'shew' – 'he had learnt,' wrote Seward, 'to look back with resentment to the

allurements of the Graces' – he determined to train up a wife as an ideal
mother who would avoid the vices Rousseau had so vividly described in
Émile. She would, in Seward's words, 'have a taste for literature and
science, for moral and patriotic philosophy . . . she should be simple as
a mountain girl, in her dress, her diet, and her manners; fearless and
intrepid as Spartan wives and Roman heroines.'

The result of the credulous Day's experiment was not as he wished.
He took two foundlings, whom he named Lucretia and Sabrina, and set
about educating them. They fought back, resisting his blandishments and
quarrelling with one another. The intractable Lucretia was apprenticed to
a milliner, while the unfortunate thirteen-year-old Sabrina was brought
to Lichfield to continue Day's experiment. But, as Seward observed with
tart satisfaction, Day's efforts failed. He was forced to place the girl in
a boarding school, the sort of institution he had been determined to
avoid. Sabrina later married Day's attorney, was widowed, and became
the housekeeper of the musician Charles Burney. Day had to wait until
the publication of *Sandford and Merton* in 1783 before his educational
ideas achieved any success.

Day, the most literary of Darwin and Seward's friends in Lichfield,
became a member of the most important club in the west Midlands, a
group called the Lunar Society, through his association with Darwin.
This club, made up of scientists, businessmen and philosophers, met once
a month at full moon. 'The Lunatics', as they ironically called themselves,
had formal meetings, but corresponded and talked in smaller groups
much more frequently. Growing out of the friendship between Darwin
and Birmingham industrialist and inventor Matthew Boulton, the Lunar
Society, the most important group of scientists outside London, over-
lapped in membership with literary circles, which was typical of provin-
cial associations at the time. The talents of its members were recognized
by the Royal Society – ten of them, a majority, were fellows – but few
Lunatics had had a typical upper-class education. Only Darwin, Day and
Edgeworth had attended Oxford or Cambridge, though several of them
had gone to the medical school and scientific lectures at Edinburgh (the
society contained a disproportionate number of Scots). Matthew Boulton,
the inventor and watchmaker James Watt and the pottery entrepreneur
Josiah Wedgwood were largely self-taught. Most of the men were low
churchmen, or Nonconformists or disbelievers, like Darwin himself. So
in many ways they were outsiders.

The Lunar Society was primarily concerned with applied science and technology: the chemistry of dyes, the use of steam engines and windmills, the development of reproductive processes. It funded Joseph Priestley's laboratory and experimental work in Birmingham between 1781 and 1791. Individual members – Darwin, Withering and Stokes – contributed to the history of botany. And in the history of science and technology, the invention, development and marketing of Boulton and Watt's steam engine and the researches of Joseph Priestley remain its greatest achievements. But the society was also remarkable for the extensive network of intellectual cooperation it established in the heart of England, and for its commitment to the public propagation of scientific ideas. Members shared their schemes and speculations in letters or during frequent meetings in private households, just as they disseminated them more broadly in public lectures and didactic literature.

The corpulent figure of the polymath Erasmus Darwin embodied the Lunar Society's ideals and values. He was a gentleman, like Day and Edgeworth, but he had had a Scottish education. He was a specialist enough to be able to contribute solutions to scientific problems, but he was also a generalist. He enjoyed the company of practical men of industry like Boulton and Wedgwood as much as those of poets like Seward and painters like Wright of Derby. He linked science and letters. Above all, he was a publicist. His verses in both parts of *The Botanic Garden*, with their detailed and learned footnotes appended to mellifluous couplets, conveyed scientific achievement and botanical knowledge to a far larger audience than any papers submitted to the Royal Society.

Anna Seward does not mention the Lunar Society in her memoir of Darwin and, though she recalls individual friendships that Darwin enjoyed with other society members, she does not discuss its collective achievements, perhaps because she was excluded as a woman. But for her, Darwin was first and foremost the centre of Lichfield society (she says almost nothing about his later years in Derby) and a great modern poet. Her memoir of Darwin seems lopsided, its earliest pages paying as much attention to Darwin's friends as to the doctor himself, its later ones devoted to a detailed critical analysis of *The Botanic Garden*. But to criticize this bias is to miss the point. Anna Seward's aim was to establish herself as a luminary and critic, an official chronicler of Lichfield society, emphasizing its intellectual distinction and giving it a greater degree of unity than it probably had, insinuating herself into its centre. Her debts

to Darwin – his encouragement of her verse and his role in enlarging her circle of acquaintance – go largely unacknowledged. Instead she is at pains to make clear that she had been the inspiration for the verses that had led to *The Botanic Garden*, and in offering a full-length critical account of the poem – her longest and most sustained piece of criticism – she both associated herself with Darwin's epic and placed herself above it.

By the 1770s Anna Seward was a figure of some note in Midlands society, acquainted with a wide circle of men of letters. But beyond this world she was unknown. Only in the 1780s, with the critical approval of her *Elegy on Captain Cook* (1780), *The Monody on the Unfortunate Captain Andre* (1781) and *Poem to the Memory of Lady Miller* (1782), together with the popularity of her *Louisa, a Poetical Novel* (1784), did she gain a national reputation. Her visits to London became more frequent, though she still professed a preference for the quiet life of the provinces and used her father's increasing decrepitude to explain the brevity of her trips. Even more important was her involvement in the poetry competitions organized by Lady Miller at her villa at Batheaston, on the London road out of the genteel spa and resort of Bath. The Batheaston circle made Seward's name familiar to drawing-room society and to the many gentlefolk who enjoyed amateur versifying. As Sir Walter Scott put it in his preface to her poetical works,

> Miss Seward's poetical powers appear to have lain dormant, or to have been only sparingly exercised, until her acquaintance with Lady Miller, whose fanciful and romantic institution at Bath Easton was then the subject of public attention ... The applause of this selected circle gave Miss Seward courage to commit some of the essays to the press; and the public received with great favour the elegiac commemorations of Andre and of Cook.

The Batheaston world was an apt place for someone like Anna Seward to launch herself. Its ambience was that of the genteel amateur, for whom poetry was a sociable pastime, and though it was one of Bath's amusements, it was never entirely accepted by the aristocrats and London critics whom Seward disliked. The competitions were described in *The New Prose Bath Guide* of 1778:

on certain Days, a great Deal of Company meet, who possess poetical
Talents, and who admire them. In one of the Rooms of this Villa,
stands an antique Vase, into which the Ladies and Gentlemen put
Copies of Verses, written on certain given Subjects, which being
drawn out, and read by one of the Company, the Majority of them
determine which Piece has the most Merit, and then the Author is
called upon to avow it; this being done, the LADY of the VILLA
presents the Author with the Wreath of Myrtle; and preserves the
several Productions thrown into the vase, till they are bulky enough
to compose a little Volume, some of which have been published . . .
under the Title of 'Poetical Amusements at a Villa near Bath'.

In all, four volumes of *Poetical Amusements* appeared between 1775 and
Lady Miller's death in 1781. The proceeds from their sale were donated
to a local pauper charity whose president was none other than Sir John
Miller himself.

The Batheaston poems dropped into the famous urn were social and
sentimental. The topics Lady Miller chose were either about local society
– 'Bath: its beauties and amusements' – or seasonal sentiments – 'The
Month of May' – or an abstraction such as 'Harmony', 'Dreams' or
'Dissipation'. The poems invoked the literary heritage of Spenser, Shake-
speare and Thomas Gray, but were most frequently modelled on
Seward's favourites, Milton's 'L'Allegro' and 'Il Penseroso'. Satire was
actively discouraged and controversial subjects were banned. There was
much mutual flattery: praise for Sir John and Lady Miller for their
patronage, the celebration of the beauties who graced the assembly, and
applause for the versifiers. As Edward Jerningham, one of Seward's
friends, put it in the final stanza of his poem on 'Dissipation',

> But on the precincts of *this* classic ground,
> With her best gifts the Deity is found;
> She bids the pure of taste, the'enlighten'd Fair,
> With Learning's sons, to this blest dome repair.

Though the social tenor of Batheaston, which was visited by aristo-
crats while they were taking the waters, differed from that of the close
of Lichfield Cathedral, Seward found it agreeably familiar. The compe-
titions were less serious than the female salons and less intimidating than
London's literary societies. They combined conviviality, hospitality –
taking place 'amidst a profusion of jellies, sweetmeats, ice creams and

the like' – and literary endeavour, and they linked pleasure to utility by contributing the poems' profits to Sir John's charity. Most of the participants were provincial gentry and clergy, the sort of company Seward knew so well. At Batheaston she formed friendships with other literary figures who became her correspondents.

In short, Batheaston was a community to Seward's taste. The company determined what it thought was good and proper, a decision which everyone affirmed in the ceremony of the laurel wreath. When Lady Miller chose a verse to be published, the poems were offered to a larger world as having passed a test of polite taste and aesthetic decorum. The Batheaston assemblies exemplified the view that high-minded provincial gentlefolk were the proper judges of good verse.

Not surprisingly, the Batheaston Society excited sarcasm and derision in more fashionable circles and among London literati. Dr Johnson was contemptuous: according to Boswell, 'He held [their poems] very cheap' and said of one friend who competed there that 'He was a blockhead for his pains'. Frances Burney described Lady Miller as 'a round plump, coarse-looking dame of about forty, and while all her aim is to appear an elegant woman of fashion, all her success is to seem an ordinary woman in very common life, with fine clothes on. Her manners are bustling, her air is mock-important, and her manner very inelegant.' Burney laughed at the attentions paid her by Lady Miller's family, who were overawed by the presence of the author of *Evelina*, while numerous satirists mocked 'Proud Knights, silly Squires, and bald pated Sears' who 'beat their Brains once a Week, and weave with Penelope's Maids their Taffety Trappings'.

But for Seward the Batheaston gatherings were a link to a larger literary public. They gave her the confidence to move into print, and introduced her to wealthy amateur men of letters, such as the poet William Hayley and the cleric, traveller and friend of Sarah Siddons, Thomas Sedgwick Whalley, described in his later years as 'the true picture of a sensible, well-informed and educated, polished, old well-beneficed, nobleman's and gentleman's house-frequenting, literary and chess-playing divine'.

Most of the poets Seward met at Batheaston were, like her, genteel and provincial. They went to Bath and sometimes to London, but although they preferred to stay at home, like her, they were not isolated. Their private correspondence as well as their published letters, criticisms and

poems show their full participation in a national community of letters.

Seward's published correspondence gives us a remarkable insight into her world. It is, of course, a highly selective compilation, as we can see from comparing the originals with the printed texts; she rewrote many of the letters in a more elevated and less colloquial style when preparing them for publication, and she was not averse to altering dates and changing matters of substance. This artifice and contrivance, designed to suppress, conceal or alter her original words, is in fact revealing, for it represents the idealized version of a literary community she wishes posterity to imagine, a body of men and women united by their good taste, at the centre of which Seward herself is to be found. Her published letters include only those she herself wrote and none of the replies, so her single point of view, her interpretation of the values and sensibility of the group prevails; no one else is given a direct voice.

The correspondence is as interesting for what it omits as for what it includes. There are almost no letters to London recipients except for a few women like Hester Piozzi and Helen Maria Williams, almost none to professional writers, and when they do appear they are, like Herbert Croft, genteel folk forced to live by the pen because they have fallen on hard times. London's professional literary world is conspicuous by its absence.

Many of the letters were written to friends, many of them women, who spent time in Staffordshire or near Lichfield. Correspondents like Miss Weston of Ludlow, Miss Powys of Clifton, Miss Scott, Philip Homer, the schoolmaster at Rugby and translator of Metastasio, and Court Dewes, Esquire – 'a refined gentleman and excellent scholar' – were recipients of Lichfield gossip and Seward's extended discussions on the merits of poetry, criticism and fiction. Such protégés as the brilliantly precocious Henry Cary, later to become famous as a translator of Dante; Mundy, the hunting squire and author of 'Needwood Forest'; William Newton, the carpenter's son, known as the 'Peak Minstrel'; and James Woodhouse, 'the poetical shoemaker' of Stafford, received long letters of advice. But most of her letters were addressed to writers in other parts of Britain who had sent her verses, asked her opinion, or wanted to exchange ideas. Many of them were clerics or members of the professions with an interest in literature – West Country friends like the Reverend Richard Polewhele, poet, topographer and literary chronicler, and Dr Downham, a physician and imitator of Spenser, both of whom were founding members

of Exeter's literary society; Edward Jerningham, a Norfolk gentleman, prolific sentimental poet and imitator of Thomas Gray; William Crowe, a Wiltshire cleric, ultra-Whig, botanist and local poet whose 'Lewesdon Hill' of 1788 went through numerous editions.

In many letters Seward presents herself as mentor and adviser, a superior and wiser person than her correspondents or, at least, as someone whose counsel is eagerly sought. But in a few instances it is apparent that she is the supplicant. She eagerly cultivated the correspondence which William Hayley, whom Robert Southey described as 'the most fashionable of living poets', initiated when he sent her verses praising her *Elegy on Captain Cook*. Her enthusiasm for Hayley knew no bounds: 'How charming is your poetical gallantry! If all the testimonies of it bestowed upon my flattered self, were collected and given to the world, the garlands of Swift's Stella and Prior's Chloe would fade before mine. My pride, my heart exults in these distinctions, conferred by the transcendant English Bard of the present era.'

Seward hitched herself to Hayley's rising star. When his *The Triumphs of Temper*, an enormously popular and frequently reprinted poem intended to teach young women the virtues of good humour, appeared in 1781, she rapturously praised its 'magic' in her *Ode to Poetic Fancy*. The two exchanged poems and gifts. Then, in the winter of 1781, Hayley came to visit Seward for two weeks. Flattered by her praises, charmed by her person, if somewhat overwhelmed by the social round of Lichfield, Hayley became one of Seward's most ardent supporters. When he returned, exhausted, to his Sussex villa at Eartham (and to the pleasures of the company of John Marsh), she was so loath to lose him that she accompanied him for part of the way before returning home to complete her 'Epistle to William Hayley, Esquire', a few days later.

Hayley's visit confirmed Anna Seward's position as a new leader in Lichfield's literary society. She had been the sole reason for his coming to Lichfield, and his presence there during the busy holiday season was a personal coup for her. She was determined to keep him in her orbit, and when his letters to her later fell off, she felt slighted and rebuked him for his neglect.

Seward especially admired Hayley because he was the sort of poet she aspired to be. He was like many of Seward's poet friends, only much more successful. He had independent means, he preferred the provinces over London life, his politics were liberal and he was a patron of the

arts. A friend of George Romney, whose life he wrote, and of Joseph Wright of Derby, whom he helped with his literary subjects, he was also William Blake's employer and protector, and secured a pension for the ailing William Cowper.

Hayley was Seward's passion of the 1780s; the ladies of Llangollen were her passion during the following decade. Lady Eleanor Butler and Miss Sarah Ponsonby were two aristocratic Irish women whose passionate personal attachment had led them to flee their families and to settle in north Wales in a house at Plas Newydd, just outside the town of Llangollen. They never again ventured from these beautiful romantic surroundings, where they enjoyed what their contemporaries described as a 'romantic friendship' and shared a daily round of edifying self-improvement, fixing up their house and cultivating their small estate close by the ruined abbey of Valle Crucis and the hilltop remains of the castle of Dinas Bran. The two women enjoyed an income of £280 a year, so they could afford to amass a substantial library, create a well-stocked garden, and enjoy a comfortably furnished house. They read aloud to one another, they drew, sewed and gardened. They read Spenser and Milton, Sterne and Captain Cook's *Voyages*, botany books and works on the picturesque; they devoured Rousseau's *Nouvelle Héloïse*, reading it aloud in three-hour stints. Macpherson's *Ossian* was read aloud on the lawn, looking up at the ruin of Dinas Bran (fig. 227). They learned Italian so as to read Petrarch and Metastasio in the original. And, like all such literary people, they carefully kept journals in which they recorded their daily activities.

Plas Newydd and its inhabitants became a well-known secret. By the 1790s the ladies of Llangollen were entertaining a regular stream of admiring visitors. Anna Seward first met them at a special outdoor dinner held in the ruins of the Valle Crucis abbey, where 'Rosalind and Celia', as she called them, entertained their guests with a Welsh harpist. This first encounter quickly led to friendship, subsequent visits and a regular correspondence. As her poem *Llangollen Vale* reveals, no acquaintance or place provoked more hyperbole. Plas Newydd and its surroundings were the perfect inspiration for Anna Seward's literary imagination. Its history, ruins and scenery offered an ideal environment for tranquil reflection, and the love between the two women represented an ideal of romantic female friendship to which Anna Seward, with her memories of Honora Sneyd, had always been attached.

227. *Dinas Bran from Llangollen* by Richard Wilson, 1770–1

In her letters to Hayley and the ladies of Llangollen Seward drew
her correspondents into her circle, telling them at great length about her
interests and obsessions – the fight with Johnson, her contempt for hack
critics, the importance of Britain's native tradition and of Milton, and
the virtues of cultivated friendship – and tried to get them to endorse
her views. With Hayley it is poetry that dominates. But Eleanor Butler
and Sarah Ponsonby – though they shared poetic interests with her and
introduced her to Southey's epic poem *Joan of Arc* – gave her the chance
to reflect on the importance of friendship. Seward wrote of her attach-
ment to them as 'fervent, equal and unalterable', and confessed the story
of her youthful attachment to Honora Sneyd, whose departure from
Lichfield twenty years earlier had left her in a state of traumatized
bereavement. She sent the two ladies an engraving by J. R. Smith of
George Romney's painting of a scene from Hayley's *The Triumphs of
Temper*, Serena reading Burney's *Evelina*, for which Honora Sneyd was
the model (fig. 228). She was delighted when this token of romantic
friendship was hung in a prominent place at Plas Newydd.

Just as Seward's *Memoir of Darwin* shaped for posterity our view of Lichfield's intellectual life, so her published correspondence depicted the far-flung skeins of friendship and the deeply felt values that defined her circle. As you read her correspondence you become more and more conscious of how tirelessly she advocated her view of literature. Her vision of poetry and poetic life, tied to provincial values, to sociability and to female friendship, was radically at odds with the masculine individualism that was eventually to prevail.

As Seward well knew, the survival and success of her vision of poetry depended on London. As we have seen, her attitude to London reviewers, reviews and booksellers was one of unremitting hostility, and her antipathy was not ill-placed. Reviewers of poetry like John Langhorne and William Woodfall of the *Monthly Review* were at best begrudgingly admiring and more often condescending or hostile to women poets. In their review of Mary Scott's *Female Advocate* (1774) they complained, 'It is dreadful for a man of real knowledge and politeness to encounter one of these literary vixens ... The effects of real knowledge are gentleness and modesty, particularly in a sex where any thing approaching to assurance is intolerable.' Their bias was often accompanied by contempt for the sort of 'unlettered' or sentimental poets whom Seward admired. She complained that sometimes talented poets were so intimidated by these reviewers that they refused to publish their works.

Her response to what she saw as the critical blindness of London's critics was resolutely determined and self-promoting, and she made sure that her views were represented in the national press. Her favourite means of doing so was to write in the most successful monthly of the period, the *Gentleman's Magazine*. Founded in 1731, the *Gentleman's Magazine* was a remarkable compendium of information on politics and international affairs, science and literature, art and agriculture, prices and bankruptcies, as well as births, marriages and deaths. Both its famous editors – Edward Cave, who employed Samuel Johnson, and John Nichols, the source of most literary gossip in the second half of the century – relied on readers to contribute letters, comments, poetry and even full-length articles. And for much of the century the *Gentleman's Magazine* was one of Britain's most important publishing outlets for poetry, the quality of which varied, though many well-known poets contributed to its pages. It was especially important for provincial poets who had never before been published and as a monthly indicator of

228. *Serena* by George
Romney, engraved by
J. R. Smith, 1782

changing poetic tastes. Its columns offered a national platform for the
sort of poetry and poets that Seward admired and the reviewers disliked;
its correspondence section allowed readers to debate current questions
of literary taste. As we have seen, it offered a home for the first publi-
cations of many literary figures.

Anna Seward chose the *Gentleman's Magazine* because, unlike the
Monthly Review or the *Quarterly Review*, it was not produced entirely
by professional hacks and critics. It was less a periodical with a critical
point of view than a forum for different opinions solicited from readers.
Its prose polemics and short verses were understood to express rather
than shape current knowledge and taste. This eclecticism, which made
the *Gentleman's Magazine* remarkably accessible to a wide readership,
accorded with her Whig view that everyone should have a chance to
display their natural genius.

Seward was involved in four major controversies in the *Gentleman's Magazine*. Two concerned her old bugbear, Dr Johnson. In 1786, shortly after his death, she published there a series of letters under the pen name 'Benvolio', attacking his admirers' credulous and craven praise. Later, in the winter of 1793–4, she crossed swords with James Boswell, who had chosen to omit materials she had supplied him for his *Life of Johnson*, which appeared in 1791. A third controversy concerned pulpit oratory. But her most extensive polemic was in a quarrel over the relative merits of John Dryden and Alexander Pope, which ran in the magazine for the three years 1789–91.

The origins of this last controversy lay in a debate between Seward and Joseph Weston, an epicene organist from Solihull, outside Birmingham, who had translated into English a Latin poem, *Philotaxi Ardenae* ('the Woodmen of Arden,' 1788), written by a Birmingham lawyer and poet named John Morfitt. Weston's version of the poem was in rhyming couplets in the manner of Dryden, and he prefaced his work with an essay asserting the superiority of Dryden over Pope and calling for a purification of corrupt modern verse, with its 'Tinsel Phrases and tinkling Compound-Epithets'.

Seward had met Weston, admired his 'wit, intelligence, and poetic genius', and added him to her list of correspondents. But she found his condemnation of modern poetry unacceptable. She wrote to him privately urging him to change his mind. Then, in April 1789, the *Gentleman's Magazine* published the first instalment of Seward's 'Strictures on the Preface to the Woodmen of Arden'. Thanks to the magazine, what had begun as a private debate became a national one.

The Dryden–Pope controversy involved nineteen correspondents and ran to some 30,000 words. Participants included several members of Seward's circle in the Midlands as well as critics from Edinburgh, Norfolk and Wales. The tenor of the discussion differed little from that of Seward's letters published after her death. The community of conversation was amateur, predominantly provincial, and resolutely high-minded.

Seward used the debate to lay out her views on the general state of modern poetry and gave her list of the most distinguished practitioners – including Gray, Thomson, Collins, Akenside, Cowper, Burns and Chatterton. She insists that the key to good poetry lies in the expression of elevated sentiment:

A poem has little merit if it does not remain fine poetry after having been taken out of *all* measure. Where there is loftiness of thought, ingenuity of allusion, and strength of imagery, to stand *that* test, true lovers of the art allow an author to do almost what he pleases with the numbers, provided he does not insist upon their preference of the slovenly to the polished one, readily promising that such a work shall be dear to them in *any* dress.

By reworking passages from Dryden's translation of Virgil, she tried to show how a poet should tackle the *Aeneid* according to modern critical principles. (Thus Dryden's 'Cou'd angry Pallas, with revengeful spleen, The Grecian navy burn, and drown the men?' becomes, 'Shall injur'd Pallas, with avenging aim O'erwhelm the Greeks, and wrap their fleets in flame?') Weston responded to Seward's 'improvements' by commenting ironically: 'The chief Blemish in *modern* poetic Diction is Inflation. If that Blemish is undiscoverable in Miss Seward's Works, it is probably owing to the Grandeur and Sublimity of her Conceptions, which *justify* the uniform Majesty of her Style. *The Shortness* of her Poems is a Circumstance also much in her Favour.'

Seward was not deflected by such sarcasm. Her tone conveys her belief not only in the rightness of her own opinions but in the general value of the critical views of people like her. As a public controversialist she was concerned not only with individual taste but with ensuring that the refined genteel voice of the modern poet was given a full hearing. She was acutely and shrewdly conscious of how views about Britain's literary heritage affected opinions about current taste. And she knew that battles over the interpretation of poetry were often struggles about *who* should interpret literature. The care she devoted to the presentation of her literary work and opinions is sometimes dismissed as a sign of a minor poetess's misplaced egotism. But this is not the point. She was making a larger claim, representing a view of poetry as woven into the fabric of genteel social life, best sustained in provincial tranquillity and enhanced by friendship, especially friendship among women. Seward was popular because she spoke for many gentlefolk – including a great many women – who shared her view of poetasting.

Though this community of amateur and women poets survived into the next century, its importance dwindled. By the 1790s and in the aftermath of the French Revolution, proponents of sentiment and sensibility were under political attack for their egalitarian and reformist

sympathies. The democratic impulse behind the notion of natural genius gave way to a loftier view of genius as the agonized privilege of a naturally gifted few. Anthologies of British verse produced as patriotic and commercial enterprises by Robert Anderson (1792–5) and Alexander Chambers (1810) sided with the 'ancients' rather than the 'moderns' and included no living authors. The decision to exclude anonymous authors and women meant that many works were not enshrined for posterity but came to be forgotten. At the same time a new generation of critics attacked what they considered the insipid verse of their predecessors. The world of poetry was reconstructed in a way that denied the ecumenical and diverse sentiments of the women and provincial poets Seward championed.

VII

BRITAIN

CHAPTER SIXTEEN

Culture, Nature and Nation

CATHERINE MORLAND, the heroine of Jane Austen's *Northanger Abbey*, is confused. Walking in the countryside around Bath with her newfound friends Henry and Eleanor Tilney, she is baffled by their conversation about landscape: 'They were viewing the country with the eyes of persons accustomed to drawing, and decided on its capability of being formed into pictures, with all the eagerness of real taste. Here Catherine was quite lost. She knew nothing of drawing – nothing of taste – and she listened to them with an attention which brought her little profit, for they talked in phrases which conveyed scarcely any idea to her.' But all is not lost, for Catherine, though a partly formed heroine, is teachable:

> she confessed and lamented her want of knowledge; declared that she would give anything in the world to be able to draw; and a lecture on the picturesque immediately followed, in which [Henry Tilney's] . . . instructions were so clear that she soon began to see beauty in every thing admired by him, and her attention was so earnest, that he became perfectly satisfied of her having a great deal of natural taste. He talked of fore-grounds, distances, and second distances – side-screens and perspectives – lights and shades; – and Catherine was so hopeful a scholar, that when they gained the top of Beechen Cliff, she voluntarily rejected the whole city of Bath, as unworthy to make part of a landscape.

The chief target in Jane Austen's first novel was not an over-refined view of nature but, rather, the sensationalism of the gothic novel, but this did not stop her from occasionally swiping at other fashions like the cult of the picturesque. She was not alone in this. William Combe and Thomas Rowlandson combined witty text and satiric image in their

229. *Rev D'Ewes Coke, his wife Hannah and Daniel Parker Coke, MP*
by Joseph Wright of Derby, 1780–2. They compare the Derbyshire
landscape, probably the grounds of Brookhill Hall, the Rev. D'Ewes
Coke's new property, with a sketch from Hannah Coke's portfolio

extraordinary successful spoof of picturesque tourism, *The Tour of Dr
Syntax in search of the Picturesque* (1813) (fig. 230).

Satires like Austen's vignette of the swift transformation of Cath-
erine's ignorance into arrogant judgement depended for their effect on
the well-entrenched presumption that a natural, rural environment (note
that Catherine excludes the city of Bath as unworthy of the scene) was
an object of taste and a topic of refined conversation. Every cultured
person had to know how to talk about the country and about landscape,
using the fashionable jargon of the picturesque, the taste and feeling for
scenery which was varied, asymmetrical and 'rough', filled with interest-
ing detail. (The least plausible aspect of Austen's portrayal of Catherine, a
clergyman's daughter, is her comprehensive ignorance of the subject.)
The picturesque was a soft target for satire because the English had long
been in the business of making nature into culture.

The pleasures of the imagination were never, as we have seen,
confined to literature and the fine arts. French, German and English

commentators on taste all discussed the aesthetic pleasures of landscape and the natural world and this not only encouraged an admiration of the landscape itself, but the proliferation of images and representations of nature. The small *vedute* of the Roman Campagna, sold by the de Rossi family in Rome and brought back to England by grand tourists and hung in their parlours and print rooms, the landscapes exhibited at the annual Royal Academy shows, the poems of sentimental writers like Anna Seward and the woodcuts of Bewick all affected how landscape itself was seen. The growing criticism of the artifice of refined society and its recreations, the distancing of a growing number of town dwellers from rural life, together with provincial sentimentalism, made nature and the images it called forth seem all the more compelling towards the century's end. And though the cult of nature was a European phenomenon, it took on a strongly patriotic and even regional tone, as cosmopolitan men and women of letters cherished local roots and traditions which they feared were being lost. In England and then Britain it took the

230. *Dr Syntax Sketching the Lake* by Thomas Rowlandson, 1813

form of a revolt against the formalism of French and Dutch gardens, especially the geometrical parterres of Le Nôtre's Versailles, which smacked of a rigid absolutism, and in favour of gardens and landscapes which, though they certainly tamed an ordered nature, offered the viewer a more sinuous and 'natural' scene.

Aestheticizing nature and finding personal solace in rural life, whether lived or imagined, were of course never uniquely English pleasures nor confined to the eighteenth century. Their roots lay in classical and Christian traditions of Arcadia and Eden; the 'pastoral' tradition of literary celebration of rural life dated back to the Greeks in the third century before Christ; Virgil's *Eclogues* and *Georgics*, written some 200 years later, were the model for Renaissance pastoral verse before they inspired Pope and John Gay. Similarly, the British traditions of landscape painting drew on Dutch art and on the depictions of Italian scenery by Claude Lorraine, Gaspard Poussin and Salvator Rosa. The appreciation of the native landscape and of bucolic pleasures had a long, foreign pedigree.

Yet the association of Englishness, and then of Britain, with the landscape of the British Isles, though it was not first forged during the eighteenth century, became firmly riveted to the national imagination then. Its enduring strength explains why today many Londoners imagining Britain think of the hop fields of Kent rather than of the Old Kent Road, why a Liverpudlian (or, at least, this one) dreams not of Lime Street but the hills of north Wales, while a Glaswegian rejects Sochihall Street for Loch Lomond. Such yearnings mirror the sensibility of the poet, essayist and landscape gardener William Shenstone, who wrote in 1748 that 'no one will prefer the beauty of a street to the beauty of a lawn or grove; and indeed the poets would have found not very tempting an Elysium, had they made a *town* of it'; they also show how easy it has become to transform the identity of what we have seen was one of the most urbanized nations in Europe into a series of Edenic rural idylls. (I am not, of course, denying the presence of those who overlook or reject the values of the countryside or who speak of the 'idiocy of rural life': I am simply emphasizing the extent of the enthusiasm for rusticity and the ease with which this has become attached to national identity.)

During the eighteenth century the countryside and nature came to represent several different ways of life and to express a variety of values:

different versions of England and of Britishness, many in tension or conflict, though people often held them simultaneously. The countryside could be a place of arcadian rest, even indolence, the home of social harmony and virtuous self-sufficient work, a site of aesthetic pleasure, or a place in which to realize oneself through confronting 'nature'. Lumping these together, the modern admirer of the countryside is very like his or her eighteenth-century predecessor, who also espoused many ways of looking at nature and rural life.

This repertory has been shaped in the British imagination by means of art and literature. The modern tourist visits Brontë, Jane Austen, Hardy or Constable country, or Sir Walter Scott's Highlands and sees the landscape and its people through the words of the writer and the images of the artist. Similarly eighteenth-century observers relied on poems and paintings. When Horace Walpole visited Stanstead, the country estate of the Earl of Halifax, he saw it as a painting: 'the very extensive lawn at that seat . . . particularly when you stand in the portico of the temple and survey the landskip that wastes itself in rivers of broken sea, recall such exact pictures of Claude Lorrain that it is difficult to conceive that he did not paint them from this very spot.' Similarly, the heroine of Susanna Harvey Keir's novel *The History of Miss Greville* is described on a walk, reaching a 'height commanding one of the grandest prospects', where she pulls out her copy of James Thomson's poem *The Seasons*, and is happy to find 'a lively description of the whole surrounding scenery'.

Here lies a central paradox in the idea of country life and the cult of nature. Its appeal is often said to be found in its distance from the artificial, commercial or modern man-made world, yet rusticity and even nature itself is evidently a cultural artifact. Certainly in the eighteenth century the countryside and nature were considered malleable, to be adapted, created or realized through human agency. In *Northanger Abbey* the Tilneys discuss, in a phrase reminiscent of the famous landscape gardener Capability Brown, 'the capability of [the countryside] being formed into pictures'. Later in the conversation Henry describes to Catherine 'a piece of rocky fragment and the withered oak which *he* [my emphasis] had placed near its summit'. The Tilneys and Miss Morland act like William Combe's Dr Syntax on his picturesque tour:

> I'll do as other sketchers do –
> Put any thing into the view;
> And any object recollect,
> To add a grace, and give effect.
> Thus, though from truth I haply err,
> *The scene preserves its character.*

Nature and culture enjoyed a complex and often fraught affinity.

Throughout the century painters like Richard Wilson and Gains-borough, poets like Pope, James Thomson and John Dyer, landscape gardeners like William Kent, 'Capability' Brown and Humphry Repton, and the authors of guidebooks like William Gilpin fashioned the British landscape in their own image, using words, paint and the labourer's implements to reshape hills, divert rivers, expand lakes and make ruins more ruinous. The business of shaping nature was a major artistic occupation. A host of amateur versifiers, sketchers and gardeners, gentlefolk like the Tilneys and aristocrats like Horace Walpole ensured that this fad was not confined to a group of professionals. As Uvedale Price, author of *Essays on the Picturesque* (1794), explained: 'When I speak of a painter I do not mean merely a professor, but any man (artist or not) of a liberal mind, with a strong feeling for nature as well as art, who has been in the habit of comparing both together.'

The complex relations between nature and culture or nature and art are summed up in the term 'landscape'. Originally used in the seventeenth century to denote a pictorial representation of countryside, it quickly came to describe a chunk of nature, a piece of the countryside itself: the land – country, nature, the environment – was viewed as if it were a picture. Thus Addison wrote that 'a man might make a pretty Landskip of his own Possessions', while Pope, describing a view of the river Thames, recalls: 'You look thro' a sloping Arcade of Trees, and see the Sails on the river passing suddenly and vanishing, as thro' a Perspective Glass.' It is as if nature had become a thing of human artifice, even a commodity. What unites these two ideas of landscape – as piece of land and as a representation of it – is the idea of seeing it from a single point of view (in Catherine Morland's case from the top of Beechen Cliff), creating what Dr Johnson in his *Dictionary* referred to as a 'prospect' and what others, using a theatrical term as Henry Tilney did, called a 'scene'. What is surveyed from a particular spot is not just a landscape

but yet another example of *the* landscape, a generic term applied to the shape and form of the land. When the Tilneys and Catherine Morland look out from Beechen Cliff they compare what they see with other landscapes they have considered, whether imaginary, ideal or actual, bringing their taste to bear on the land before them.

Though ways of seeing and understanding landscape and nature are visual and literary, closely tied to the culture of the age, we can understand the particular forms they assumed in the eighteenth century only by moving beyond the landscapes, verses and gardens themselves, to trace the changing mental and material contexts in which they were made. For the transformations in eighteenth-century economic, social and cultural life enormously affected how people saw nature. The urbanization of Britain, the declining number of people working on the land, a new, more distanced and scientific view of the natural world, the development of agricultural 'improvements', the growth of domestic tourism among the polite classes, and the gradual incorporation of remote regions – the Highlands and north Wales, for instance – into Britain's national economy – all these developments, so eloquently analysed by the Scottish philosophers and political economists, irrevocably transformed the relationships among the British, nature and their landscape.

As we have seen urbanization proceeded at an unprecedented pace in eighteenth-century Britain. First London and then the other cities we associate with the Industrial Revolution created an urban hierarchy that still prevails today so that by the mid-eighteenth century most people did not work on the land. At the same time land ownership became concentrated more than ever in the hands of a powerful few. Though the timing and extent of this change have been a source of scholarly dispute, the larger trend is beyond question: the demise of the cottager and small farmer, and the growth of the large estate. In the early eighteenth century some 30 per cent of English land may have been in the hands of small landowners, but 100 years later the figure was more like 10 per cent. The overall effect was to distance more and more of the population from the business of cultivating the land and to remove people from direct, daily contact with nature.

This process of detachment changed people's ideas about the natural world. In the sixteenth and seventeenth centuries nature was defined by its relation to man: the Bible taught that animals and plants were given by God for human use. As the Book of Genesis puts it, 'Every moving

thing that liveth shall be meat for you'. Man was at the head of a God-given, hierarchical nature, below his Maker but, by virtue of his immortal Christian soul, above all other brute creation. Nature was man's servant, and it was also filled with symbolic and emblematic meaning. Lions meant strength, foxes cunning and goats lust; ladybirds, four-leaved clovers and black cats were lucky: pregnant women should avoid cyclamens which caused miscarriages; rowan and mistletoe protected their wearers from witchcraft. Classical learning and popular lore combined to represent the worlds of man and nature not as separate spheres but as full of correspondences, analogies and connections.

This view of the natural world entwined with that of man began, during the late seventeenth and eighteenth centuries, to be replaced by a 'scientific' view which separated nature from man, creating a distinct realm whose order and classification could be established through external observation. Natural philosophers stripped nature of its symbolic and emblematic meaning. As the naturalist John Ray put it in 1678, 'We have wholly omitted what we find in other authors concerning . . . hieroglyphics, emblems, morals, fables, presages or aught else appertaining to divinity, ethics, grammar or any sort of human learning; and present . . . only what properly relates to natural history.' Such associations, like popular beliefs about the efficacy of the natural world, were dismissed as forms of superstition and popular error.

Descriptions of the natural world also changed. The many regional words and dialect terms that had been used to identify flora and fauna were abandoned as being obscure, erroneous and ignorant by new classifiers of a universal and abstract nature in favour of a single, international language that could make sense of the multiplicity of terms derived from local popular knowledge. Plants were given Latin names – the London Society of Gardeners tried to develop a standard nomenclature in the *Catalogus Plantarum* of 1730 – and scientists used internal 'intrinsic' features of plants or animals to develop more rigorous taxonomies such as the Linnaean system celebrated in Erasmus Darwin's *The Botanic Garden*.

Uniformity, not oddity, became the important feature of nature. Whereas natural objects had earlier been collected for their singularity, curiosity and strangeness and included in cabinets of curiosities along with remarkable manmade things, they were now arranged in types or series, ordered to reveal patterns, or laws, of nature. Though there was

231. *Detail of an Anatomy of the Horse* by George Stubbs, 1766

much debate about the source of such order – was it God-given, from nature itself, or imposed by the human mind? – there came to be broad agreement that laws of nature existed and could be discovered and revealed. The project of ordering knowledge of man and his creations – of writing histories, dictionaries and great synthetic works like the *Encyclopédie* – was extended to the natural world, which ceased to be a cabinet of curiosities and became an ordered collection.

Nature was to be understood through direct observation. Its forms observable to the naked eye – its geometry and shape – were the first indicators of its order, but these could be penetrated by the telescope, the microscope and the scalpel, all of which enabled the scientific observer – the astronomer, the natural historian or the anatomist – to view clearly an order that he might not otherwise see (fig 231). Scientific discoveries challenged the view that the natural world was made for humankind. Knowledge of the universe, and the rejection of a geo-centric view of the solar system, the revelations of the microscope and the telescope exposed how little had once been known of the world and how much there was to be learned. 'What lies within our ken', Locke wrote, 'is but a small part of the universe.'

This new, more scientific attitude, like the proportionate decline of people engaged in agricultural work, had the effect of distancing man from the natural world. Man's relation to nature became increasingly *visual*; nature was something experienced from the outside. Of course, older attitudes which interpreted nature symbolically or analogically persisted and vestiges of them remain with us today. But the prevailing habit was to observe nature as detached from human contrivance. It became a surface on to which all sorts of values and views could be projected, notably the idea that it was untainted by man, opposed to human artifice.

In practice the boundary between the man-made and the 'natural' was exceedingly difficult to draw. So many of the contours of nature had been made or affected by human contrivance and the line between artifice and unsullied nature constantly shifted. A remarkably large part of England (rather less of Britain) had been under cultivation or put to agricultural use for centuries. Nature and culture had long been mingled. (The term 'culture' had been used to mean the tending of livestock or crops long before it was applied to human cultivation or to the arts.) Moreover the seventeenth and eighteenth centuries had seen an unprecedented taming, ordering and reshaping of Britain's natural landscape – a change in the way the countryside looked – effected as part of an aggressive and largely successful effort by landed proprietors to increase agricultural productivity and output. As the agriculturalist Arthur Young explained it, the aim was to bring 'the waste lands of the kingdom into culture'. To observe the natural world was, then, to look at a work of human artifice.

Between the sixteenth and eighteenth centuries (there is much debate about the precise timing of these changes) many new techniques and farming practices were adopted through much of the nation. New crops – notably clover, sainfoin, lucerne, trefoil and turnips – improved the fertility of the soil and the yields of cereal crops. Better drainage of lowlands and better fertilization of uplands increased output and brought new land – some two million more acres during the eighteenth century – into cultivation. Livestock were selectively bred to produce larger and healthier animals. The techniques to achieve these improvements were disseminated in periodical publications like the *Annals of Agriculture*, edited by the indefatigable improver Arthur Young, which spread its findings to more than sixty agricultural clubs and societies. In 1784 a

French visitor to Britain, François de la Rochefoucauld, commented on the efficiency of these networks of communication. British farmers, he remarked, 'gather all kinds of information from their neighbours and from those who have better results than themselves. The clubs where they often go provide the opportunity for instructive conversation.' The influence of these journals and organizations on agricultural practice was questioned at the time and remains questionable. But it is beyond doubt that they propagated a new attitude towards the land and its cultivation, a mentality powerfully committed to improvement. The same institutions – clubs, periodicals and magazines – that had shaped the literary world informed changes in farming practices.

The most famous and most controversial feature of improvement was enclosure: the consolidation of parcels of land which might previously have been held in common by a group of villagers and which were newly defined by law as owned by a single individual, physically marked off by hedgerows, walls or fences. Such enclosures were usually of three sorts: the conversion of open-field husbandry; the enclosure of land previously held as commons; and the appropriation of 'waste' land. Enclosure itself was not new – indeed it is estimated that as much as 70 per cent of cultivated land in England and Wales was already enclosed by 1700 – but rapidly increased in the eighteenth century: between 1750 and 1830 no fewer than 4,000 acts of parliament permitted the enclosure of 6.8 million acres or about 21 per cent of the land. A long-term process accelerated to its final climax.

Enclosures were the most conspicuous sign of agricultural improvement, because they changed the appearance of the landscape. In England, wrote one resident in 1783 after returning from years abroad, 'landed property is all lined out, and bounded and intersected with walls and hedges'. The unencumbered view across hills and vales associated with open-field agriculture and admired by Bewick was broken up into a series of planes and discrete spaces. Enclosures created a distinctive landscape, which painters and poets, sketchers and critics either applauded or condemned; they knew that enclosure and improvement raised aesthetic issues as well as moral ones. Improvers like Arthur Young and even the radical William Cobbett spoke of 'those very ugly things, commonfields' and turned with distaste from large unbroken tracts of land. They preferred the bounded, formal shapes created by enclosure. In the words of one improving poet,

> But, Industry, thy unremitting hand
> Has chang'd the formless aspect of the land . . .
> And hawthorn fences, stretch'd from side to side,
> Contiguous pastures, meadows, fields, divide.

Such a landscape was considered beautiful as well as productive, and it is essentially the cultivated British landscape we know today.

The changes wrought by enclosure did not occur without considerable public debate. The issues were rehearsed in newspapers, magazines and pamphlets, verses, novels and prints. In every medium the aesthetics of landscape and the morality of improvement were closely intertwined. Opposition to enclosure was not confined to sentimental poets (though they were vociferous in their hostility), nor was it the prerogative of a particular interest or party. A sizeable body of opinion, made up of agriculturalists, clergy and small landowners, argued against changes which they believed were corroding rural society. The case against enclosure had many elements – it was held, for instance, to encourage an undesirable conversion of arable land to pasture and to lead to rural depopulation – but above all it was believed to destroy the livelihood of independent cottagers and small farmers. As Oliver Goldsmith put it in *The Deserted Village*: 'But times are alter'd; trade's unfeeling train/Usurp the land and dispossess the swain.'

Ironically this became one of the main arguments in favour of enclosure. For its proponents argued that self-sufficient cottagers and smallholders contributed nothing to the market, were unruly and idle, and deprived the improving employer of much-needed labour. As the land agent John Clark wrote about Herefordshire, 'the farmers in this county are often at a loss for labourers: the inclosure of wastes would increase the number of hands for labour, by removing the *means* of subsisting in idleness.' For such commentators Goldsmith's virtuous 'swains' were 'brutes', 'trashy Weeds or Nettles growing usually upon Dunghills', or primitive peoples like the North American Indians. Both sides agreed that the effect of enclosure was to destroy a way of life – the independence of the smallholder: opponents of enclosure regretted the passing of a bold, self-sufficient peasantry, while advocates welcomed the transformation of an ill-disciplined, idle rabble into an industrious, productive labour force, employed by tenant farmers.

Improvement also provided the money, in the form of rents, that

enabled landowners to build new country houses or remodel their existing dwellings, to create parks or retain a landscape gardener to transform their grounds. As David Garrick put it in his play *The Clandestine Marriage* (1766), 'The chief pleasure of a country house is to make improvements.' There could be no better example of Hume's precept that improvement in the applied arts – in this case husbandry – led to improvements in taste. The country house, the landscaped park and home farm were the visible embodiment and celebration of 'improvement', further instances of the landed proprietor's reworking and transformation of nature, of his power to command the landscape. For like agricultural improvement, the creation of a pleasing landscape also often meant the reshaping of the surrounding topography and rearranging of rural life.

The English country house, with its grounds and gardens, was not, of course, an eighteenth-century innovation; what changed in this period was its status, importance and nature, and its relationship to its immediate surroundings. Contrary both to twentieth-century impressions and to the view of some contemporary commentators, the eighteenth century was not England's greatest period of new country-house building – that had occurred between Henry VIII's dissolution of the monasteries and other religious houses in the 1530s, which brought a great deal of land on to the market, and the disruptions of the civil wars in the mid-seventeenth century. Country houses certainly increased in number in the eighteenth century, but only slowly; remodelling, which was much less expensive than building a completely new house, was all that most owners could afford. But two circumstances help to explain this misconception: a boom in new construction occurred in the 1720s – John Summerson estimates that more than seventy new buildings were begun in that decade; and many spectacular and large houses built by men who had acquired fortunes in politics, money and commerce, several of whom were close to London, which conveyed the impression that the age of the sixteenth-century 'prodigy house' (so-called because of its prodigious size) was about to revive. Visitors gawped at the spoils of politics – the palaces of Whig grandees like the Duke of Devonshire's Chatsworth, completed in 1707, or Sir Robert Walpole's Palladian mansion at Houghton in Norfolk, designed by Colen Campbell and Thomas Ripley; they wondered at the riches of trade materialized in Sir Richard Child's vast pile at Wanstead in Essex, erected out of his East India Company fortune; and they marvelled that the spoils of battle could be transformed into

Marlborough's baroque pile at Blenheim and into Canons in Middlesex, the house of James Brydges, Duke of Chandos, whose wealth had come from astute and shady dealings as a wartime financier.

These highly visible new power houses concealed the less spectacular piecemeal changes that were transforming the English country house and its relation to the land. Houses became bigger, and the number of small houses precipitously declined. New spaces designed to display the taste of the owner were added to existing houses or included in new plans: libraries filled with rows of bound tracts from Grub Street and folios from such fine publishers as the Tonsons; music rooms to accommodate amateurs and professionals; private theatres (all the rage in the 1780s); picture and sculpture ·galleries to exhibit the best antiquities of Old Masters collected on the Grand Tour or bought in London auctions by the likes of Charles Towneley and the Cokes of Norfolk.

As temples to the arts, places of polite and refined sociability, country houses became ever more distant from the agricultural work on which they depended. Outbuildings – storehouses, stables, brew houses, laundries, forges, servants' quarters – were either removed from the main building or incorporated and concealed behind its façade. The home farm was placed at a distance, sometimes outside the park. The house itself, whether a new neo-Palladian design or one with a reworked façade like Roger North's house at Rougham Hall in Norfolk, became a single coherent statement about the taste of the owner.

The eighteenth-century country house also became a visual focal point: a place from which to look as well as to be seen. Earlier houses had nestled in hollows, close to shelter and running water, but now the site for the ideal house afforded a view, like Balls Park in Hertfordshire, praised by Henry Chauncy for 'towering upon an hill from whence is seen the most pleasant and delicious prospect'. The aim was to see a landscape that expressed harmony and order and was in consequence aesthetically pleasing. But this general expression of human concord with nature took the form of a particular person's power to shape and control the land. The landscape gardener Humphry Repton, who drew up plans for more than 200 parks and gardens, told his clients that houses should be sited with views that showed a 'command of property'; similarly Arthur Young praised houses on 'hills that command noble prospects'. The proprietor's view expressed his relation to his land: from the top, from the commanding social as well as geographical heights. What he,

his family and guests saw from the *piano nobile* of his country house was a landscape disposed and ordered at his pleasure. As Repton explained, landscaping was about 'appropriation . . . that charm which only belongs to ownership, the *exclusive right* of enjoyment, with the power of refusing that others should share our pleasure'.

In order to be able to see such an exemplary landscape the natural and social environment had to be controlled. Notoriously, country-house proprietors sited their dwellings away from towns and villages, in parks and landscaped grounds that, like enclosures, were often walled off and fenced in. During the course of the century these parks grew larger, and more and more of the view was directly shaped by the owner. Making a park and building walls were expensive undertakings. The wall around Blenheim Palace grounds built in 1722, for instance, cost a total of £10,000, or £1,200 a mile.

Landlords' desire to create idyllic views led them to add features to the landscape, to shift hills and rivers, to move or remove what did not conform to their taste. This might entail the demolition or relocation of entire communities. Vanbrugh dispensed with the village, castle and church at Henderskelfe when building Castle Howard, Lord Cobham removed or altered three villages when building Stowe's elaborate gardens in Buckinghamshire, while Lord Milton swept away the entire 120 dwellings of Milton Abbas and removed the freehold grammar school to Blandford six miles away. Sometimes, as at Stourhead, the seat of the banking dynasty of the Hoares, a village was accommodated into the picture, but where it did not fit into a prospect, as at Houghton, Nuneham Courtenay, Milton Abbas and Ickworth, it was removed from view.

This imperious approach to the landscape and the landed estate can be especially associated with 'Capability' Brown and his successor, Humphry Repton. For though their admirers regarded their sinuously landscaped grounds as more natural than earlier formal gardens of the Dutch or French type, with their rigid angles and neat squares, more in harmony with the 'capabilities' of the landscape than the emblematic gardens, built on geometric lines and filled with statuary, temples and expressing a complex iconography which had preceded them, they nevertheless involved an unprecedented appropriation and control of the land.

Increasingly, then, the relationship between the country house and its surroundings was aestheticized. The idea was less about having a

working landscape, land that the proprietor worked *in*, than of an ideal form which he contemplated from *outside*. This distance was amplified by physical absence, for landowners were much more often away from their country seats than their seventeenth- and nineteenth-century relatives. This was partly the consequence of the consolidation of landholding, with more landowners having more than one country seat, but it was chiefly attributable to the growing political, social and cultural attractions of London and, later in the century, of regional cultural centres like York and Norwich. Urban refinement drew proprietors away from the country house. Country houses were often occupied for only six months of the year; some landowners just used them as a rural retreat for the summer. When a tourist like John Byng, a younger son of an aristocratic family and former army officer, stopped to view the many country houses on his travels, he usually found their owners absent, the premises minded by small staffs under the direction of a housekeeper (fig. 232).

Yet we should not think of these houses as beautiful, empty shells. They were not. Whether the proprietor were present or not, estate administration, run by a steward, continued year-round, and year-round it not only expressed the proprietor's taste and refinement, but was the base, the visible symbol of his political power. In the snug spaces of the ground floor and the grand apartments on the *piano nobile* the proprietor entertained and wooed tenants, voters, parsons, gentlemen and grandees, cementing friendships, seeking political support and granting favours. If he wanted to be more than a mere owner of a mansion he had to cultivate local interests. The house and its grounds were considered above all the embodiment and celebration of the power of culture over nature, and of the proprietor over all he surveyed.

By late in the century England's country houses had become items on the itinerary of genteel tourists, one of the attractions, along with picturesque scenery, sublime natural wonders and the occasional factory, visited by ladies and gentlemen in pursuit of leisure and knowledge. Genteel travel was not new, of course. English gentlemen (and, less usually, gentlewomen) had for long travelled as soldiers, sailors, diplomats, traders, ambassadors, explorers, missionaries and colonizers and, as we have seen, not only young gentlemen but whole families enjoyed the European Grand Tour, culminating in a trip to see the treasures of Italy. Travel literature, whether describing St Peter's at the Vatican or Matthew Boulton's metalwares factory at Soho in Birmingham, was a

232. *The Honble. John Byng* by Ozias Humphry

well-established genre, closely connected, through its emphasis on first-hand experience, with a tradition of history writing that ran all the way back to Herodotus and Thucydides. Britain in the early modern era was, as many historians have emphasized, a society of movement, not stasis. Not only those at the top of society but many ordinary people changed residences and travelled as part of their work in the three centuries before the Industrial Revolution.

But travel for mere knowledge and pleasure had been uncommon before the eighteenth century. Since the Renaissance English gentlemen and scholars had travelled to the continent for refinement and pleasure, but this was a small minority. More parochially, British historical investigation by antiquaries depended on tours like the one taken by William Camden, author of the extraordinarily popular *Britannia*, and Robert Cotton in the north of England in 1599. But it was not until the late seventeenth century that educational travel became a regular feature of genteel life, and not until the end of the eighteenth that recreational travel

on the continent and throughout the British Isles, something equivalent to the modern holiday, was a fashionable activity of the polite classes.

Throughout the eighteenth century travel, like many other cultural pursuits, was justified by Horace's two twins *'utile et dulce'* – use and pleasure. But the educational value of travel was gradually accorded a lower and lower priority. Though never entirely overlooked, it became a supplementary reason for enjoying foreign and domestic travel. Originally the Grand Tour had been a means to extend instruction for privileged university-educated young gentlemen, and had become, as Reynolds and Wilson showed, essential for the aspiring artist. But until the French Revolutionary Wars (especially the French Terror of 1792–3) put an end to much continental travel (and thereby gave an enormous boost to domestic tourism), the Grand Tour had become an altogether different affair. It involved people of all ages, men as well as women and children – in short, families – and less socially elevated and less well-educated people than the aristocratic male heirs who had once frequented French and Italian academies. Tourists moved swiftly from city to city, taking in the sights, and never stayed long in one place. Travellers still kept journals, though they were neither so scholarly nor so extensive as those which Francis Bacon had urged young gentlemen to keep in his essay 'On Travel'. Often the improving manuscript diary was set aside to consult a published guidebook. The sorts of distinction we associate with modern tourism ('I am a traveller, he is a tourist') began to emerge: fashionable young men moved on from Italy to Greece and Asia Minor; they avoided the *pensione* and coffee houses where English-speaking guests were served by English-speaking proprietors.

Similar trends occurred in Britain. Earlier travel had been didactic and patriotic; antiquaries may have enjoyed their work, but they were engaged in research, and travel journals (most of them unpublished) emphasized similar purposes: Celia Fiennes, who travelled throughout England between 1685 and 1703, saw her journey as a saga of patriotic instruction: 'It would also form such an Idea of England, add much to its Glory and Esteem in our minds and cure the itch of over-valueing foreign parts.' Such sentiments were echoed in Robert Morden's *The New Description and State of England* (1701): 'The True Knowledge of our Native Country concerns us much more than to be acquainted with the travels into foreign parts ... Be not mistaken, England may Glory to be full of Natural Wonders, Rarities, and Excellencies as any Nation

under the Sun. It becomes the Inhabitants not to be ignorant of them.'
James Brome in his *Travels over England and Wales*, published a year
earlier, had similarly waxed lyrical about native wonders: 'There is not
anything worth our wonder Abroad, whereof Nature hath not written
a Copy in our own Island . . . As Italy had Virgil's Grotto, so England
had Ochy-Hole by Wells . . . the Pyramids at Stonehenge, Pearls of Asia
in Cornwall, and Diamonds of India at St Vincent's Rocks.' *England
Describ'd*, published in the second half of the century, offered an
Enlightenment gloss on this patriotic message: 'The love of our native
soil being so engrafted in the very nature of man, the necessity of being
acquainted with their situation and produce is as self-evident as any
proposition in Euclid.'

This kind of patriotic instruction gradually gave way to patriotic
pleasure. The 1787 edition of *A New Display of the Beauties of England*
spoke of 'a desire of being acquainted with whatever is most beautiful,
remarkable or curious in our own country', while Gray's *A Supplement
to the Tour of Great Britain*, which appeared in the same year, maintained,
'The present prevailing passion for viewing and examining the beautiful
scenes which abound in our native country, precludes every necessity for
the apology for the publication now offered to the world.' William Gilpin,
whose accounts of his travels on the Wye and in south Wales (1782), the
Lake District (1789) and the Highlands (1800) did a great deal to make
domestic tourism fashionable, preferred to emphasize pleasure over
instruction: 'we dare not promise . . . more from picturesque travel, than
a rational and agreeable amusement. Yet', he added rather feebly, 'even
this may be of some use in an age teeming with licentious pleasure; and
may . . . at least be considered as having a moral tendency.'

Gilpin wrote in the middle of a travel boom partially of his own
making. For domestic tourism was in large part a literary phenomenon
stimulated by travel books and guides, by personal accounts of travels
and by verses evoking the beauties of the British countryside. In *An Essay
to Direct and Extend the Inquiries of Patriotic Travellers* (1789) Leopold
Bertold referred his readers to forty-three different British travel books
published between 1700 and 1770. Many of these were typical Grub
Street products, inaccurate works of pastiche that shamelessly plagiarized
one another, cobbled together by aspiring writers who had yet to move
from penury to fame. Thus the *New Display of the Beauties of England*
of 1776 repeated verbatim information taken from a publication of the

1750s which, in turn, derived its road mileages from the popular and
frequently reprinted *Britannia Depicta*. *Britannia Depicta*, which took
much material from Ogilby's *Britannia* of 1675, had first appeared in
1720 and had reached a thirteenth edition as *England Illustrated* by 1764.
This sort of literary theft was not confined to information. The *New
Display of the Beauties of England* lifted many of its descriptions of the
north of England from Arthur Young's *A Six Month Tour Through the
North of England*, which had appeared six years earlier. When Combe's
satirical picturesque traveller, Dr Syntax, tries to get the journal of his
tour published he is scoffed at by a bookseller:

> We can get Tours – don't make wry faces,
> From those that never saw the places.
> I know a man who has the skill
> To make your Books of Tours at will;
> And from his garret at Moorfields
> Can see what ev'ry country yields.

We should not underestimate the importance of these Grub Street pro-
ductions. Eighteenth-century garret writers shaped tourist sensibilities by
taking material not only from other travel books but from contemporary
works on taste like Gilpin's own *Three Essays: on Picturesque Beauty; on
Picturesque Travel; and on Sketching Landscape* (1792). The guides, feeding
off one another, gained weight and gravity as a genre. From the 1770s
more tourist attractions are mentioned in the literature, and are discussed
in a new language of appreciation. 'Romantic', 'sublime' and 'picturesque'
scenery supplements the standard fare of earlier guides – fine buildings,
antiquities and country houses. Arthur Young's *Tours* seem to have been
a seminal influence on these works. Though he was concerned mainly
with agriculture and its improvement, his extremely popular accounts of
journeys through the agricultural regions of Britain were saturated with
the jargon of contemporary taste. Scenery and views are 'truly romantic
and sublime', wild nature 'tends to impress upon the mind an idea of
awe and terror'; 'an amphitheatre of wood and rock' is 'wild, romantic
and sublime'. Soon the hacks were following in his footsteps, scribbling
about 'lofty rocks' and 'unbounded prospects', describing the approaches
to towns as 'romantic' because they went 'through a deep hollow clothed
on either side with wood', and recording the 'horror at the prospect from

the summit of the cliff, into a dark and stupendous chasm, rendered still more stupendous by the roaring of its water over its distant bottom'.

Sources such as these were just as important as technical manuals and treatises on aesthetics in teaching the tourist, whether comfortably ensconced in an armchair, bouncing along a country road in a carriage, or marching with his stick, as Johnson did in Scotland, how to describe the view. The language of appreciation that Catherine Morland found at once so obscure and yet so easy to learn seeped into periodicals, private letters, journals and every sort of topographical description. Even scientists and agricultural reformers laced their supposedly dispassionate comments with an enthusiasm for the romantic, picturesque and sublime feelings provoked by the varied scenery of Britain.

This encouragement of a rather general set of sentiments about nature and the landscape was complemented by specialized works devoted to telling those with the proper attitude what they should look at and how they should see. The owners of the most popular country seats printed guides to their houses and gardens, pointing visitors to the best pictures and explaining the iconography and symbolism of their gardens. More than twenty such guides had appeared by the end of the century. Works like Thomas West's *Guide to the Lakes*, first published in 1778 and reissued seven times before 1800, told tourists what routes to take and even what places (called stations) to stop at and see the best view. As the numbers of tourists increased, so their itinerary and what they should do was more strictly determined. By the end of the century it was possible to buy a single guide, William Mavor's *The British Tourists* (1798–1800), which compressed the wisdom of many previous guides into six pocket-size volumes that the traveller could easily carry. Mavor included such famous tours as Dr Johnson's trip to the Western Isles of Scotland, the numerous journeys of the indefatigable Welsh naturalist William Pennant, and Arthur Young's tour of Ireland. His collection was compre-hensive, covering tours of England, Wales, Scotland and Ireland.

Then, as now, tourism produced knick-knacks – not only guides but sketchpads, pencils and watercolours, and finely printed books like *A Travelling Journal* with neat, narrow columns to record places and dates, larger spaces in which to write observations, as well as a special 'omissions' section in which to add later comments. The most important of these tourist knick-knacks was the so-called Claude glass. Sometimes a piece of coloured glass through which to look at the landscape, it was more

usually a convex mirror that miniaturized the view and, in its com-
pression of the landscape, made it look more general and uniform. It
was a tool for capturing and manipulating nature, for making a frameable
possession, and it required you to turn your back on what you wanted
to see. In 1769 the poet Thomas Gray described looking at Derwentwater
in the Lake District from the garden of Crosthwaite Vicarage using his
Claude glass: 'saw in my glass a picture, that if I could transmit it to
you, & fix it in all the softness of its living colours, would fairly sell for
a thousand pounds. this is the sweetest scene I can yet discover in point
of pastoral beauty. the rest are in a sublimer style.'

Gray made nature into a painting and then valued it as a commodity;
it was an exemplary tourist response, which would have pleased the
growing number of personal guides, innkeepers and hoteliers who thrived
on the tourist trade. The passion for touring filled the pockets of the
many (ostensibly blind) Welsh harpers (fig. 233), dressed picturesquely
and with flowing locks, who cashed in on Gray's famous poem of *The
Bard* by performing in Wales's main tourist towns; it filled the pleasure
boats that ran between Ross and Chepstow on the Wye, transporting the
tourist past a series of important picturesque views; and it encouraged the
first tourist entrepreneurs such as Peter Crosthwaite, a retired naval officer,
who opened a museum in the Lakeland town of Keswick, a curious place
filled with miscellaneous objects that also doubled as a shop. Crosthwaite
sold West's guide to the Lakes, Claude glasses and detailed local maps
which he himself produced. Despite the somewhat spurious air of his collec-
tion – it was more like an old-fashioned cabinet of curiosities and wonders
than a systematic museum – tourists rolled in. He claimed no fewer than
1,540 visitors 'of quality and fashion' during the season of 1793.

Tourism creates things unique to itself: places that no one would
choose to visit unless he were a tourist, objects that are solely souvenirs
or mementoes of a tour. Like the country house, sites visited by the
picturesque tourist were as much places to see from as places to be seen.
Typical was the summer house at one of the stations for viewing Lake
Windermere visited by the poet Southey. Downstairs was a lodge for
the caretaker, who also acted as guide; upstairs a large viewing room
boasted three windows framing the scene that corresponded to the views
in West's *Guide to the Lakes*: 'The room was hung with prints, rep-
resenting the finest similar landscapes in Great Britain and other coun-
tries, none of the presentations exceeding in beauty the real prospect

233. *John Smith, the Blind Harper of Conway* by Julius Caesar Ibbetson, 1793

before us. The windows were bordered with coloured glass, by which you might either throw a yellow sunshine over the scene, or frost it, or fantastically, tinge it with purple.' Here was an environment whose sole purpose was to create a tourist experience, one that was all about looking at nature.

Memories of the pleasures of tourism were kept alive in the journals and sketches that polite tourists were encouraged to make, and which they sometimes succeeded in publishing. Nature was elevated into a literary artifact and made part of culture. Writing and sketching became important genteel accomplishments, to be shared with friends or the public once one's tour was over.

Tourist memories were also sustained by trinkets and souvenirs. Tourists were constantly chipping pieces off ancient abbeys and Stonehenge. At Stratford-upon-Avon, which had become a major site of cultural pilgrimage after Garrick's much-publicized Shakespeare Jubilee in September 1769, tourists could buy trinkets – snuff boxes, toothpicks,

234. *Tintern Abbey by Moonlight* by John Warwick Smith, 1789. The ruined abbey was the highlight of any picturesque tour of the Wye valley

goblets and even items of furniture made from a mulberry tree supposedly planted by Shakespeare in his garden. When John Byng visited Stratford in 1785 he stole a piece of the pavement from Shakespeare's grave. Later, when he visited Shakespeare's birthplace on Henley Street, he purchased from Mrs Hart, a descendant of Shakespeare, 'a slice of [Shakespeare's] . . . chair equal to the size of a tobacco stopper', returning later to buy the chair's lower cross bar. The modern pilgrimage had acquired its relics.

It might appear from this account that by the late eighteenth century the full paraphernalia of modern tourism had arrived. Certainly the term 'tourist' was a coinage of the 1780s and 1790s which, within a few decades, acquired the pejorative associations it often has today. But eighteenth-century tourists differed from their twentieth-century counterparts. Touring was a minority, not a mass, recreation, an expensive hobby for those with ample leisure time and a purse to match. The two stages of the often-described boat tour down the Wye valley each cost one and a half guineas (fig. 234). Privately owned carriages and horses were expensive. Travel by coach, though swift by the standards of the day, was beyond the pocket of all but the prosperous: single fare from London to York

with a seat inside a mail coach (as opposed to hanging on for dear life up top) cost three guineas in the 1780s. Though coach prices fell temporarily during that decade, when many new operators set up rival services to the mail coaches (the cheapest London-to-York fare dropped to £1.15s.), such bargains did not last (fig. 235). The overall standard cost for coaches was 3d. a mile, while the chaises hired out by innkeepers averaged 7d. This meant that a coach trip from London to the edge of the Highlands cost about £5, one to Wales about £2.5s.) Touring was socially exclusive, and the most distant spots were the most exclusive of all. John Byng's incidental expenses on his two-month tour of the north of England between 26 May and 17 July 1792 amounted to £18.9s.5d., about half an artisan's annual wage.

Travel costs were by no means the only expense. Visitors to country houses, privately owned monuments or viewing stations on private land had to tip house- and gate-keepers and guides. Visitors had to appear genteel to secure access to houses, gardens and private lands where public admission was at the discretion of their owners or their servants. The

235. *Passengers for Bath Waiting at an Inn* by John Nixon, 1807

memoirs and accounts of tours that mention visits to country houses are almost all written by persons of rank or respectability. Mrs Lybbe Powys, herself a country-house owner, claimed on a visit to the Earl of Pembroke's seat at Wilton in 1776 that 2,324 visitors had preceded her that year. But this figure, for one of the most popular houses, is exceptional. Horace Walpole's gothic fantasy at Strawberry Hill, within easy distance of London, averaged between 250 and 300 visitors a year, an impressive sign of the interest of gentlefolk but hardly evidence of mass tourism.

The eighteenth-century fashion for touring was only possible because of improvements in communication. The earlier traveller could not rely on milestones, signposts or good route maps, and more often than not needed local guides. Coach and carriage services were slow, roads on the main routes were worn and rutted by the heavy volume of commercial traffic, while in remoter regions they were often in poor repair and difficult to follow. In these circumstances it was hard to think of travel as a pleasure.

It did, however, become easier to move about. More reliable information was available to the traveller, who no longer had to depend on the testimony of an often fallible human guide to know where he was. Milestones and signposts were erected; folding road books with elegantly engraved route maps, first developed by John Ogilvy in the late seventeenth century, gave travellers detailed information about the main roads. The roads themselves were better maintained, largely by turnpike trusts which could levy tolls in order to keep them in good repair. Between 1720 and 1760 England's main arteries were improved; in the second half of the century more and more local roads were turnpiked. (By 1770 there were 15,000 miles of turnpiked road in England and Wales.) Though this made travel more expensive, it made the long-distance travel of the polite tourist much easier. Regions that had previously been impenetrable to all but the most intrepid traveller became relatively accessible. It was easier to enjoy the beauties of the Lake District after a series of turnpike trusts in the Carlisle and Penrith region opened up better routes into Cumberland and Westmorland.

These improvements increased the volume of traffic and seemed to shrink the size of Britain. In one summer week of 1765 259 coaches, 491 wagons, 722 carts and 206 drays with 11,759 horses passed through Lawford's turnpike gate on the main road out of Bristol to the Midlands.

The density of this traffic – more than 1,500 horses a day – explains why picturesque tourists eager for escape took to more obscure and remote byways.

They could do so because travel times continued to fall, being most drastically reduced during the decades of the mid-century. An emphasis on speed began to appear in newspaper advertisements for coaches in the 1760s. By the 1780s operators were for the first time publishing reasonably exact timetables. Thus the Newcastle and London Post Coach was announced as setting 'out from Newcastle at 4 in the Morning, and arrives at York at 3 in the afternoon; dines and sets out at 4, and arrives in London at 7 the next Evening'. This greater precision was in part prompted by the proliferation of connected coach lines established by innkeepers to rival the post coaches: precise schedules were needed if passengers were to take one coach service in order to link up with another. The growth in services and their greater reliability was not matched by a fall in costs, but they succeeded in becoming swifter. The best coach service between London and Edinburgh in 1780 was twice as fast as the swiftest coach twenty years earlier.

As travel grew swifter so it became more comfortable. Vehicles were better sprung, reducing the jolts produced by rutted roads. With their soft, capacious beds and well-stocked kitchens and cellars, English inns were the envy of Europe, offering their patrons a variety of services, notably the hiring of horses and carriages. It was therefore possible to travel by public coach to a district inn, and then explore the countryside in a smaller vehicle or on horseback. When the thrifty German traveller Karl Moritz decided to undertake a walking tour of England in 1782, his English friends laughed at him as an old-fashioned eccentric and innkeepers looked on him with suspicion as they found it impossible to imagine a respectable gentleman tourist who was on foot.

The cumulative effect of these several sorts of improvement in agriculture and communications was to make nature at once more accessible and yet more distant. It could be tamed and controlled by technologies of taste which ranged from selective breeding and crop rotation to the Claude glass, and it could be read about and seen in books and engravings devoted to nature, landscape, travel and tourism; for those with resources it was easy to reach and to view in person. Yet nature was defined over

and against man and society, viewed from outside itself – like a picture or a stage set.

So if, on the one hand, improvement had transformed much of the countryside into something tame and beautiful, a sort of domesticated nature, wild nature itself became detached from culture and society and was considered as standing against them. Nature was defined as both a precursor and a residue: it existed prior to the cultivation that consumed it, and it was what was left over when modern society, culture and economy had gobbled up the rest. The rise of the arts and sciences had expelled raw nature to the margins. No longer an integral part of human society, it was now confined to those places – remote Pennine uplands, and spectacular mountains in Snowdonia and the Highlands, the lakes and hills of Cumberland and Westmorland – which had escaped human improvement.

The prevalence of the ideas of improvement derived from political economy meant that such uncultured and uncultivated areas and the people who lived in them were seen as barbarous and uncivilized. A Scottish minister writing of the Perthshire Lowlands earlier in the century recalled, 'At that time the state of the country was rude beyond conception. The most fertile tracts were waste, or indifferently cultivated, and the bulk of the inhabitants were uncivilized ... To emancipate the inhabitants of this country from such a state of barbarism and to rouse a spirit of industry was a bold and arduous enterprise.' Barbarism, which had long been equated with the absence of Christianity, was now defined by the absence of commercial society. It remained a primitive state, because untouched by the trader, the agricultural improver or the merchant rather than by the pious missionary. Thus Samuel Johnson blamed 'the total ignorance of the trades by which human wants are supplied' for the lamentable state of Scotland before its 1707 union with England, when 'their tables were coarse as the feasts of the Eskimeaux, and their houses filthy as the cottages of Hottentots'. Just as commerce was now considered as a civilizing process which encouraged politeness and refinement, so its absence produced a different social character. 'Savages, in all countries', commented Johnson when on the island of Skye, 'have patience proportionate to their unskilfulness, and are content to attain their end by very tedious methods.' This primitivism or lack of civilization could be regarded as virtuous and desirable, as encouraging ardour and fidelity, bravery and courage. But it was also often seen as a failing

that needed to be remedied. Yet, in both cases, the concern was with what was lacking or missing in the primitive, uncivilized or 'natural' state.

The British had not always noted such a marked contrast between nature and culture, nor always seen wilderness as natural. Timothy Nourse, writing at the beginning of the century, viewed cultivation as a 'Restauration of Nature'; nature was realized or revealed through cultivation. The wild was both frightening and unnatural. Writing much later about the Highlands, Dr Johnson remarked, 'An eye accustomed to flowery pastures and waving harvests is astonished and repelled by this wide extent of hopeless sterility. The appearance is that of matter incapable of form or usefulness, dismissed by nature from her care and disinherited of her favours.' Johnson believed that the order and fruitfulness which he equated with nature had passed Scotland by. This jaundiced picture of north Britain naturally excited the wrath of patriotic Scots, who put it down to Johnson's chauvinism, but it was also a rather old-fashioned view of nature by the time *The Journey to the Western Isles of Scotland* was published in 1775. More typical was Gilpin's assertion that the Highlands were 'entirely *in a state of nature*'. They were so because man had not – or at least appeared not – to have imposed himself on the land. Nature, in Raymond Williams's phrase, had ceased to be an improver and had become an original. And improvement, whether approved of or condemned, had become the destroyer of nature.

Urbanization, agricultural improvement, the cult of the country house and the growth of picturesque tourism all informed the taste and values attached to the eighteenth-century landscape. They were less the context within which aesthetic and literary views developed than a part of the development itself. This emerges clearly in the writings of someone like Arthur Young, for we cannot easily separate the poet from the improver, the landscaper from the landlord, the sketcher from the gentleman tourist.

In the second number of his journal the *Annals of Agriculture*, which appeared in 1784, Young published an essay on 'The Pleasures of Agriculture'. In the pages of a periodical devoted to the practical business of increasing agricultural output, the hardheaded improver set out to further his cause by expatiating on the joys of rural life. The prose comes as a surprise – rich and ornate, lyrical and rapturous, in marked contrast to the magazine's usually sober and practical manner. In spring, he says,

'the orchard's loaded branches bid streams nectareous warm the peasant's heart and the rifled sweets of *incense-breathing* flow from the labours of the industrious bee'. While in winter, *'sliding through the sky* pale suns unfelt at distance roll away ... [Then] the planter appropriating the right soil for the beauties of landskip, marks his barren spots, and the *prophetic eye of taste* sees refreshing shades thicken over the bleak hills while the sturdy woodman provides for the hearth.'

Young's purple prose expresses a number of familiar but not always complementary ideas about nature and country life. At times he writes as if nature is an Eden which spontaneously offers up its riches, its 'loaded branches' and its 'streams nectareous'. In this place of ease the bee, not the peasant, does the work. At other times he points to the activity of 'the planter' whose eye combines use and beauty in choosing a spot in which to improve 'barren' nature by well-placed and, no doubt, profitable trees. This is the improved nature of the energetic and tasteful proprietor. And finally, in the manner of Virgil's *Georgics*, he offers us an image of virtuous rural industry, 'the woodman' who is reassuringly 'sturdy' as he gathers wood for the family hearth. This is stable, orderly nature, where to subsist is to be happy and contented with your lot.

As the advocate of rural life, and more particularly of the lot of the gentleman farmer – which, he claims, offers 'freedom from anxiety, duration of pleasure, and views sufficiently interesting to command the attention of the cultivated mind' – Young condenses most of the eighteenth-century ways of representing cultivated nature and rural society. He holds together very different ideas of rural society by the rather crude process of juxtaposition and overlooks conflicts and differences. For rural society, after all, was supposed to be a place without conflict. But throughout the century both the aesthetics of landscape and the moral value of rural living were, as we have seen, sources of controversy. These disagreements arose not only because rural society changed so remarkably but because nature and the countryside were asked to represent too much. The chance for solitude in the countryside may have been one of its attractions but, as Young reveals, it was overpopulated with moral and aesthetic associations.

In the early eighteenth century English poets and painters depicted the countryside as arcadian, filled with nymphs and shepherds who enjoyed a leisured life in a fecund landscape, drawing on nature's bounty for their sustenance. This was an Edenic nature, the first of Young's

natures, in which people did not really work, led tranquil and harmonious lives, with time to enjoy themselves. Though a working landscape was more often represented in verse than in paint, it was only very rarely shown as a place of backbreaking toil. Rural labour was a pleasure; a rewarding task which brought labourers and masters together, a harmonious expression of rural cooperation. The fecundity of nature was matched by the fertility of man. Love was the leisure of the rural swain.

The virtues of a natural rural order were often opposed either to a politically corrupt court or to the unnatural luxury and dissipation of the town. Sometimes rural felicity was contrasted with both. Thus Ben Jonson apostrophized in *To Sir Robert Wroth*:

> How blest art thou, canst love the countrey, Wroth,
> Whether by choice, or fate, or both;
> And though so neere the citie, and the court,
> Art tane with neither's vice, nor sport.

Seventeenth-century royalists vanquished in the Civil War celebrated the virtues of enforced rural retirement, just as a century later Tories and disgruntled Whigs opposed to Sir Robert Walpole and his successors extolled the rural proprietor and the moral sanctity of country life. Making a virtue of necessity, each imagined how the world might conform to an ideal of rural life.

This tradition, celebrated in country-house verse from Ben Jonson to Alexander Pope, honoured the hierarchy, order and harmony of rustic life centred on the home of a virtuous landed proprietor. An idealized society mirrored the idealized bucolic landscape. Here everything was plain and natural and put to good use. Gentleman and labourer worked in harmony, accepting the inequalities of the social hierarchy because they understood their mutual obligations: for the landlord to be benevolent, charitable and just, and for the labourer to be obedient, industrious and grateful. The community is organic, bound together by threads of complaisance, deference, compliance and charity. Thomas Carew wrote of the royalist William Crofts, the proprietor of Saxham in Suffolk:

> Thou hast no Porter at the door,
> T'examine, or keep back the poor;
> Nor locks nor bolt; thy gates have been
> Made only to let strangers in.

Though there are marked social differences in this rural society, the community is seen as inclusive, with the landlord connected by bonds of mutual obligation to everyone else.

The tasks of rural life, the work needed to make the land give up its riches, do not feature prominently in this type of verse; in country-house poems of the seventeenth century Edenic nature yields its fruits easily. As Carew put it:

> The Pheasant, Partridge, and the lark
> Flew to my house, as to the Ark.
> The willing Oxe, of himselfe came
> Home to the slaughter, with the Lamb,
> And every beast did thither bring
> Himselfe to be an offering.

As the eighteenth-century progressed, readers were made more conscious of the work needed to secure nature's harvest. The figure of the industrious happy countryman was invoked repeatedly: he is a stalwart rustic, based on the sturdy husbandman of Horace's second epode and on the rural figures depicted in Virgil's *Georgics*, who achieves felicity through his industrious labour, which enables him not merely to subsist but to enjoy the comforts of his family. This is Young's third vision of nature as a place of felicitous labour, of complete satisfaction. In Pope's version of Horace:

> Happy the man whose wish and care
> A few paternal acres bound
> Content to breathe his native air
> In his own ground.
> Whose herds with milk, whose fields with bread,
> Whose flocks supply him with attire;
> Whose trees in summer yield him shade,
> In winter fire.

Here is self-sufficiency and, through the altering seasons, an enchanting, immutable stability. Happiness comes from bounded, circumscribed expectations, from wanting what is needed and not desiring an excess. Similar sentiments can be found in works like William Vernon's *The Cottage* of 1758:

Remote from cities, in a rural scene,
I lately saw the cottage of a swain;
So neat, so private, so serene a place,
The seat it seemed of innocence and peace . . .
No rich materials cou'd the building boast,
No curious produce of a foreign coast;
But woven hurdles, cover's o'er with sod . . .
A shelter only from the winter's cold,
As were the *Arcadian* Shepherds cots of old.

In Vernon's verses the 'innocence and peace' of country life are secured by the absence of the temptations of modern commerce. The distance of the cottager from cities, trade and titillating commercialism – precisely the conditions that had enabled literature and the arts to flourish – ensures calm, peace and tranquillity. The rustic swain inhabits a realm devoid of desire. Like the village preacher in *The Deserted Village*, the labourer 'Nor e'er had changed, nor wished to change, his place'.

Both the country-house tradition of felicitous retirement and the depiction of the uncorrupted labourer engaged in virtuous work contrasted worldly-urban-courtly unnaturalness, corruption and luxury with natural, rural virtue. The desires induced by the former – for power, wealth and frivolous or luxurious commodities – were artificial when compared with the necessary but limited wants of the rural husbandman. Court and city life made for giddy change, social flux and the pursuit of illicit desires, while the bucolic world was stable, orderly, bounded and fixed – in short, natural. Of course, it was only possible to make such a contrast when you knew about both, as a gentleman or proprietor, but not a rural labourer would, at least not as he was depicted in genteel verse. Even when the viewpoint appears to be in the depths of the country, the poet observes the rural scene from outside, from the perspective of the court and the city. His sentiments are symptomatic of a *general* anxiety about the pace of economic, social and cultural change and about the urbanism, luxury and over-refinement which were its results. Rural life offers a safe haven from such change, and embodies precious cultural values which should be protected from contamination. As William Cowper put it:

> The town has ting'd the country: and the stain
> Appears a spot upon a vestal's robe,
> The worse for what it soils.

Like its classical precursors, this view of rural life offered an alternative order to corrupt urbanism. But its emphasis on stability rather than change, paternalism rather than profit, self-sufficiency rather than the interdependence of the marketplace, was severely strained by the ideas and practices of improvement. For rural society in the eighteenth century was changing, no longer the home of the independent proprietor and the autonomous peasant but of commercially minded landlords and agricultural labourers. Improvements in agriculture reduced the number of sturdy and self-sufficient yeomen and cottagers and replaced self-sufficiency with commerce, threatening the countryside's 'natural' values. The distinction between town and country, so central to the idealization of rural life, seemed to be breaking down; the contrast between rural autonomy and urban markets could be sustained only by suppressing the realization that agriculture was Britain's greatest industry. Hume's 'rise of the arts and sciences', as the French physiocrats realized, depended first and foremost on a commercial, rural society. The home of refinement was in towns but its birthplace was in the country.

If this tension was in part between an elevated literary invention and the dynamic of rural progress, it was also built into the improvers' idea of nature itself. Writers of the literature of improvement were often unsure about how to reconcile their aim, shared by poets, painters and landscape gardeners, to reveal the universal, timeless ideals embodied in landscape and in the social order it nurtured, with their equally powerful sense that this ideal, unchanging order could be realized only when it was shaped by human eye and hand. The adoption of a particular point of view, the omission of certain landscape features, the imposition of a structure, through verbal or visual composition or by reordering the landscape itself – all these might be necessary to realize nature. Order and design were not so much revealed in nature as through its transformation. Was nature found or made?

Poets and critics made efforts to solve these problems. It was common to make the distinction – developed by Pope and frequently invoked later in the century – between artificial and natural improvements. Virtuous, natural improvements respected nature; artificial ones did not. Pope's

most famous expression of this distinction was in his *Epistle to Lord Burlington* (1731):

> To build, to plant, whatever you intend,
> To rear the Column, or the Arch to bend,
> To swell the Terra, or to sink the Grot;
> In all, let Nature never be forgot.
> But treat the Goddess like a modest fair,
> Nor over-dress, nor leve her wholly bare . . .
> Consult the Genius of the Place in all;
> That tells the Waters or to rise, or fall,
> Or helps th' Ambitious Hill the heav'n to scale,
> Or scoops in circling theatres the Vale,
> Calls in the Country, catches opening glades,
> Joins willing woods, and varies shades from shades.

These famous lines are often taken to exemplify the values of the landscaped English gardens of Bridgeman, Kent and Brown as opposed to their more obviously ordered continental predecessors. Yet one man's nature was another's artifice. Just as Brown's supporters thought that the earlier, explicitly moralized gardens were somewhat artificial, so his later critics, like Uvedale Price, thought his large, wholescale alterations of the landscape – flattening hills, building lakes and moving villages – were a tyrannical imposition on nature, a schematization that came close to violating its precepts. (Given that Brown is supposed to have worked on some 200 different garden projects between 1750 and 1770 such accusations are not altogether surprising.)

This criticism reflected aesthetic changes, shifts in taste and in the terms used to describe nature and landscape. Burke's extremely influential *Philosophical Inquiry into the Origin of our Ideas of the Sublime and Beautiful* (1757) had distinguished among different sorts of taste, contrasting the sensations produced by the Beautiful, which was soft, smooth, sensuous, gently or gradually varied and feminine, with the Sublime, which was masculine, obscure, vast and powerful. Between these two categories William Gilpin inserted the Picturesque, which was not smooth like beauty but 'rugged', 'rough' and destructive of symmetry, yet devoid of sublimity's power and obscurity. These three categories are roughly connected with three different versions of nature: as beauty in a carefully controlled, extensive vista, an improved Brownian landscape of the

country house and its intensively cultivated lands; as picturesque, varied, asymmetrical landscape, filled with interesting and surprising detail, associated with less grand country-house views, rural cottages and the topography of tourism; and finally, as sublime, terrifying nature found on the wild peripheries of Britain, the cliffs, peaks and stupendous views reached only by the more intrepid visitor.

But the art and literature devoted to nature were never concerned purely with formal or aesthetic questions; they hardly ever managed to escape the association between the countryside and the morally virtuous life. This is not to deny that an aesthetic tendency in the representation of nature was almost always present and, on occasion, overrode other considerations. Many of the paeans to Brown's work are as formalist and morally vacuous as some of his critics supposed his landscapes to be. And Gilpin's famous aestheticization of poverty has long remained a key passage in any indictment of the picturesque: 'In a moral view, the industrious mechanic is a more pleasing object than a loitering peasant. But in a picturesque light, it is otherwise. The arts of industry are rejected; and even idleness, if I may so speak, adds dignity to character.' The countryside and its inhabitants could easily become a matter of formal pleasure and pleasing aesthetic response, yet the moral issue, even when suppressed or forgotten, was never far away. Pope was one of the first in a long line of authors to argue that the improvements of modern agriculture and its genteel practitioners were morally justified so long as the profits were put to good use: 'Tis use alone that sanctifies expense.' The proprietor should employ his wealth for the benefit of his tenants and for the public; in this way his riches could be distinguished from mere luxury and be accommodated to a rural ideal. Later in the century, especially when enclosure was proceeding apace, many authors, including such influential writers on the picturesque as Price and Gilpin, argued that virtuous landowners should treat their tenants with Christian benevolence and create an organic community centred on their estates which aimed to alleviate the rigours of rural life. Such commentators were every bit as critical as Bewick of the improving landlord who not only made the landscape ugly but, in a ruthless pursuit of profit and in his failure to fulfil his Christian obligations, shaped a morally tainted society. Picturesque critics of improvement, advocating the return to a rural economy of small proprietors, had a moral as well as aesthetic preference for picturesque cottages with healthy loyal labourers rather than for

grand estates surrounded by high walls. They believed a natural order had been subverted by the ruthless pursuit of improvement.

It is often argued that this picturesque vision of rural society was sentimental and nostalgic, offering a critique of the values and aesthetics of improved nature but not a coherent alternative. Though this does not do justice to the clear differences of opinion among the landed classes about the proper form of a morally desirable rural society, it does draw attention to the failure to resolve the tension in a vision of rural society and nature that was simultaneously peaceful, harmonious and static, and changing and dynamic. One usual response to this tension was to idealize rural values of hierarchy, cooperation, peace and tranquillity while at the same time drawing attention to their decline or even their eclipse.

From the mid-century it became common to regret the inevitable passing of the rural order, which grew more luminous and whose values seemed more palpable as it receded into the past. Oliver Goldsmith's *The Deserted Village* (1770) makes clear that the world it describes is irrevocably lost: 'I see the rural virtues leave the land.' Gone are 'Contented toil and hospitable care ... kind connubial tenderness ... piety ... steady loyalty and faithful love'. The ruin of Auburn's mansion is all that remains of a once noble order:

> Thither no more the peasant shall repair
> To sweet oblivion of his daily care;
> No more the farmer's news, the barber's tale,
> No more the woodman's ballad shall prevail;
> No more the smith his dusky brow shall clear,
> Relax his ponderous strength and lean to hear;
> The host himself no longer can be found
> Careful to see the mantling bliss go round;
> Nor the coy maid, half willing to be pressed,
> Shall kiss the cup to pass it to the rest.

Goldsmith's reiteration of 'No more' presses home the sense of perpetual loss, the feeling that the community's cooperation and social cohesion can never be restored. Such a way of life, as Hazlitt shrewdly pointed out in an essay on 'The Love of the Country' (1814), is associated with the irrecoverable state of childhood. Goldsmith is engaged in the doomed task of trying to recover 'Dear lovely bowers of innocence and ease/ Seats of my youth, when every sport could please.' The advent of improvement

was like the Fall: it corrupted Eden, creating a point of no return. The question then became, Where could Eden now be found? Every picturesque tourist asked this question, and the usual answer was to displace nature, to push it away from the now luxurious realm of commercial agriculture into the less cultivated regions of Britain.

For the picturesque tourist nature was something that had to be hunted and pursued, searched out and found. In Gilpin's words, 'The first source of amusement to the picturesque traveller, is the *pursuit* of his object – the expectation of new scenes continually opening, and arising to his view.' Nature had to be trapped, collected, put in a specimen bottle and brought back into cultivated society, where it could be admired like a trophy. Nature became an exotic. Its strange forms and ways were revealed to the civilized eye not just through personal observation but in the growing number of published accounts of individual tours, in printed engravings of natural scenes, in individual sketchbooks that amateur artists displayed to their friends and relatives, and in private cabinets of shells, botanical specimens and wildlife. The enthusiasm for the picturesque was all about this translation of what at a distance seemed wild into something more orderly and civilized which could be appreciated in the comfort of one's own home. Yet the picturesque, too, was more often than not nostalgic because it saw this translation as a loss, for the authentic nature that it treasured was inevitably compromised by its contact with cultivated society.

Nature had to be seen as remote, far from the madding crowd. The virtues of the Lakes lay for Gilpin in their being far away from modern life: 'At a distance from the refinements of the age, they are at a distance also from its vices.' Nature was far away but also distant in time. It was unmodern and unimproved, belonging to the very earliest stages of human development. Thus John Byng complained of Cromford, the site of Arkwright's mill in the Derwent valley, that it had lost its tourist charm:

> I dare not, perhaps I shou'd not, repine at the increase of our trade, and (partial) population; yet speaking as a tourist, these vales have lost their beauties; the rural cot has given way to the lofty red mill ... the stream perverted from its course by sluices, and acquaducts

... the simple peasant (for to be simple he must be sequester'd) is changed into the impudent mechanic: – the woods find their way into the canals and the rocks are disfigured for limestone ... a fear strikes me that this (our over stretch'd) commerce may meet a shock; and then what becomes of your rabble of artisans!!

Byng, writing in 1790 just after the outbreak of the French Revolution, wanted to escape from radical labouring men and modern industry. The picturesque tourist wanted to experience what was old and timeless, not what was new and changing. Tourism was the modern form of the flight from modernity. The attraction of regions like the Highlands, north Wales and the Lakes was that they had apparently retained their uncultivated naturalness, and gave the visitor an authentic experience of nature (figs. 236, 237, 238). It was important to think of these places not only as undeveloped but also, as Gilpin explained, as 'unexplored'. This

236. *Lake District Scenery* by Sir George Beaumont. The painter was an accomplished amateur artist in the manner of Claude and Richard Wilson, the patron of Wordsworth and Coleridge, and a founding figure of the National Gallery

237. *Llanberis Lake* by Philippe de Loutherbourg, 1786

is why, when Colonel Thomas Thornton embarked on a Speyside expedition in 1784, he took all his food with him, living off his supplies and the animals he killed rather than drawing on the hospitality and produce of the prosperous local gentry, which would have undermined his sense of being in uncharted territory. Of course, the Highlands had long been 'explored' by its own lairds, tracksmen and peasants. They had no need to 'discover' what they already knew. But from the point of view of the tourist, whether a London writer or an Edinburgh professor, these natives were alien creatures, separated by their supposed primitive naturalness. They were part of the nature the tourist had come to see.

Like previous admirers of nature, the picturesque tourist was a spectator rather than a part of the natural world he observed. But he wanted to divest himself of his identity as a polite urban spectator, exchanging glances with other polite people in a complex shared world of appearances. When the picturesque tourist looked at peasants on the Welsh hillside or at Highlanders and their cattle he did not expect or want the natives to look back. They were supposed to be transparent, unaffected, unconscious of being observed. Like the sturdy husbandman of Georgic poetry, they were to be self-sufficient, self-contained, inhabiting a world that the tourist might admire, record, collect but never inhabit.

The perfect position for the picturesque tourist was therefore on the boundary between cultivated and wild nature, so that the variety and contrast between the beautiful and the sublime, between the beauties of Claude and the savagery of Salvator Rosa, could be appreciated as picturesque. Thus a picturesque tour of the Highlands began at Dunkeld and ended through Luss; included the three great aristocratic seats of Atholl, Breadalbane at Taymount and Argyll at Inverary; and its highlight was Loch Lomond (fig. 239). It did not include Scotland's wildest mountains and instead combined some of Scotland's improved estates with fine natural scenery. Similarly, when Sir George Lyttelton toured Wales in 1755 he preferred Montgomeryshire because there 'the soft and agreeable is mixed with the noble, the great and the sublime'. The Irish cleric Dr John Campbell, travelling through north Wales in 1775, exclaimed at Penmaenmawr, 'Nature hath painted with her boldest pencil; nor hath she neglected the graces in the lower grounds; there are great elegancies in the vally [sic] which dulcify the stupendous cragginess of the mountain.' (plate 12 and fig. 241.)

238. *Pont Aberglaslyn* by Francis Nicholson, *c.* 1805

Ironically, the arrival of tourists was the death-knell of what they wished to observe. The improvements that enabled travellers like Johnson and Gilpin to visit the Highlands – coaches and improved communications with Scotland; roads into the Highlands built by General Wade after the Jacobite Rebellion of 1715; the pacification after the rising of 1745 that ensured law and order and safe travel – were already intruding on the 'natural' primitiveness which travellers had come to observe. The conditions that made tourism possible meant that the tourist arrived at the moment when what he wanted to see was beginning to vanish. The advent of law and order in the Highlands stimulated the cattle trade, while the advent of the potato as a subsistence crop, replacing oats, the encouragement of sheep farming and extensive deforestation – all undertaken by Scottish improvers – changed the tone both of the landscape and of Highland society. Samuel Johnson recognized this:

> There was perhaps never any change of national manners so quick,
> so great, and so general, as that which has operated in the Highlands

239. *Viewing in Strathtay* by Paul Sandby. Strathtay, between Dunkeld and Blair, was the beginning of the true Highlands tour

by the last conquest and the subsequent laws. We came hither too
late to see what we expected – a people of peculiar appearance, and
a system of antiquated life ... Of what they had before the late
conquest of their country there remains only their language and
their poverty.

Similarly, the increased accessibility of north Wales spread commercial
farming practices, while by the 1790s tourists in the Lake District were
complaining of the commercialism for which they themselves were
largely responsible.

Picturesque tourism, especially as it reached remoter regions, was
inevitably tinged with nostalgia and a sense of loss. Tourists, complaining
about the authenticity of their experience, bemoaned the decline of dialect
in the Lake District, or, like John Byng, complained that the Welsh were
not Welsh enough. Pockets of authenticity became rarer and rarer and
had to be carefully spotted and identified, rather like obscure species of
butterfly. But the hunt was worth the quarry. 'This is truly the patriarchal
life: this is what we came to find,' exclaimed Johnson on the isle of
Raasay. Dorothy and William Wordsworth, accompanied by Coleridge,
had a similar response on their 1803 tour of Scotland: 'We called out
with one voice, "That's what we wanted!"' On the same tour Dorothy
Wordsworth, watching a herdsman and his dog in Glen Dochart,
described the scene as 'a beautiful picture in the quiet of a Sabbath
evening, exciting thoughts and images of almost patriarchal simplicity'.
This is one of many examples of the Highlands being represented as a
place which embodied the simple virtue of unconditional allegiance.
Similarly, Wales was a place of loyalty and stability. 'I found', wrote
John Shebbeare in 1756, 'more remains of ancient vassalage among the
common people, and a greater simplicity of manners, than is to be met
with in England ... The peasants, as free by law as those in England,
retain yet a great deal of obedience to their landlords, which was paid
to the Barons of old.' Edward Cooper praised Wales for its retention of
'those happy days of innocent simplicity, when the peaceful scenes of *still
life*, and domestic tenderness were unadulterated'.

Here again we confront the tension between nature as change and
nature as stillness. What makes Wales and the Highlands attractive is
that they belong, as it were, to an earlier moment in the history of Britain.
Their virtues stem from their contrast with the changed world with

which they are surrounded. Their values are not those of modern society; they seem to offer – or, at least, to enable visitors to recollect – a simpler way of life.

This nostalgia took various forms, many conservative and some radical. Before the 1790s much of Britain's travel literature and poetry was chiefly sentimental, mourning the loss of a way of life because of modern improvement but not placing this loss in an explicitly political context. But in the aftermath of the French Revolution this changed. A large body of conservative literature, which culminated in the novels of Walter Scott, depicted the Highlands as a place where antique values – feudal fealty rather than commercial contract, rude fierceness and unthinking courage rather than polite sensitivity, sacrifice rather than stratagem, straightforwardness rather than subtlety, and above all uncritical loyalty to one's leaders – had once resided before they had been destroyed by modern ideas of commerce and equality. While Scott provided a Tory literary myth for Scotland, Welsh poets, most notably the radical stonemason, Iolo Morganwg (Edward Williams), fabricated a radical Welsh past complete with a druidical natural religion and a democratic social order.

These different versions of a Celtic tradition were produced not by Highlanders and Welsh hill farmers but by the many Scots and Welsh who had been absorbed into a British culture that often seemed to them too metropolitan and English. Scots gentry in Edinburgh and London, polite Welsh folk in modern south Wales and London, artisans and merchants who had left their native country for the English capital or parts of the British empire, all led the quest for a native culture of which they were no longer a part. The cult of Ossian, the warrior and poet, whose ancient Gaelic epic *Fingal* James Macpherson claimed to have 'reconstructed' in the 1760s, was largely a product of the highly sophisticated club and university society of Edinburgh. The defence of Highland dress, which culminated in Walter Scott's orchestrated tartan pageant of 1822 for George IV's visit to Scotland, was promoted by London Scottish societies and by Lowlanders. The London Welsh societies – the Honourable Society of Cymrodorion and the Gwyneddigion – and such London merchants as Owen Jones (Owain Myfyr) were the chief promoters of the Welsh literary revival, publishing works in Welsh and supporting the *eisteddfodau*, the gatherings of Welsh bards to celebrate their literature. Neo-druidism was invented not in Wales but in London, where the first bardic-druidic moot was held on Primrose Hill in 1792.

241. *Bonnington Linn* by Paul Sandby, 1778. One of the spectacular falls on the Clyde near Lanark, usually visited at the end of a Highland tour

Because what these exiles and gentlefolk wanted was something they were sure was lost, they wanted to recover and revive what improvement and the United Kingdom had destroyed or suppressed. Yet such recovery was often invention. The kilt was not worn by ancient Caledonians but invented in the eighteenth century by an English Quaker manufacturer; Welsh costume dates from the 1730s. Macpherson's works of Ossian, though based on Gaelic fragments, were fakes, as were some of the best works 'found' by Iolo Morganwg. Many of the sites of picturesque tourism were also fabrications: Ossian's birthplace at Glencoe, his grave north of Crieff, the grotto at Dunkeld, Fingal's grave at Killin and his cave at Staffa. Traditions were invented and eventually became part of regional and national myth which the tourist, like the returning exile, could recover as history.

The regional and national cults of the late eighteenth and early nineteenth centuries should not therefore be seen as an attempt at cultural separation. They asserted the spirit of Wales or of the Highlands within a British framework rather than the desire (except among a very few) for a Welsh or Scottish state. The creed of improvement found in

economic treatises and in every sort of imaginative literature and art offered a general way of understanding all of Britain (indeed, of other societies, too). It was possible to look at any part of region of the British Isles, to admire its beautiful, picturesque and sublime scenery and to place it within a history of improvement, what today we would call economic development. It was possible to imagine the British nation both economically and aesthetically.

William Mavor makes this clear in his introduction to his six-volume *The British Tourists*, published between 1798 and 1800:

> The natives of the three kingdoms have linked more closely in the social tie, by the intercourse which has thus taken place; and the judicious and liberal sentiments, promulgated, through the medium of the press, by a PENNANT, a NEWTE, and a TOPHAM [three travel writers], have manifestly tended to lessen prejudices, to obviate error, and to extend knowledge.
>
> Improvements, also, in arts, agriculture, and domestic economy, have been freely imparted, by ingenious tourists, to such as, without such aids, might long have been ignorant of their existence. By the frequency of communication, an acquaintance with the practices of the most dextrous in business, with the modes of the most refined in manners, has been rapidly diffused over the great mass of the people; and the various tribes and classes of men, who are subject to the same government, however remotely situated, are now either animated by example, or taught by contrast.

And he goes on to conclude that his book collects 'into one focus, the scattered rays of information; or, rather it forms a galaxy of the blended lights, which distinguised modern tourists have thrown on the British Isles . . . it forms a whole of itself, and embraces a subject, of all others, the most delightful and instructive to a Briton.'

Although it may have become possible to imagine the nation, there was no one way of doing so. The Britain of the polite, picturesque traveller is recognizably that of Thomas Bewick, but lacks his reformist vision; Scott and Morganwg are both close and very far apart; those who attacked improvement and those who praised it (and they were sometimes one and the same person) shared an account of what had happened to Britain, but did not agree on its value.

William Cobbett, himself a keen agricultural improver, remembered

in his *Political Register* of 1816 'a book we used to look at a great deal entitled, A *Picture of England*. It contained views of *Country Seats* and of fine hills and valleys ... Alas! This was no picture of *England*, if by England we mean anything more than a certain portion of Houses, Trees and Herbage. If, by England, we mean the English *nation*; and if, by the nation we mean the *great body of the people*.' Cobbett was making a political point that had real cultural significance. The way we represent a nation in art and literature does not just offer a description but expresses a choice. The depiction of nation and nature is never innocent, though the desire for innocence may be one of its most powerful motives.

CONCLUSION

SAMUEL MADDEN, an Anglican priest, poet and playwright and
founding member of the Dublin Society of the Arts, published in 1733
a futuristic vision of Britain, *Memoirs of the Twentieth Century: being
original letters of state under George the Sixth*, in which he envisaged
Britain as the cultural capital of the world. 'We have made Great Britain,
the seat of these lovely Arts, and have drawn hither, the first Masters of
the World', he wrote, 'we have better new Pictures and Statues in Great
Britain, than in all Europe besides, and perhaps Italy her self, will not,
in a little time be able to excel the Palaces we have built here'. In 1733
Madden's vision was certainly utopian, but by the end of the century his
claim that British culture was on a par with the rest of the world no
longer seemed fantastic.

By the early nineteenth century most of the cast and set of props of
what we now regard as the nation's cultural heritage were in place.
There were well established worlds of theatre, music and art and a
flourishing professional literary scene, based in London but not confined
to it. Shakespeare had been enshrined as the great British poet, Handel
as the national composer, and Reynolds as the supreme British painter.
The provincial cities that were to dominate the British economy in the
nineteenth century had founded artistic institutions to channel the profits
of the Industrial Revolution into art galleries, museums, theatres and
concerts that were marks of civic pride. And the British countryside had
become irrevocably sanctified as the nation's greatest beauty.

Described in this way, the change in the arts in eighteenth-century
England may appear to have been smooth, gradual, inevitable, almost
'natural'. But, as I have been at pains to show, this transformation, though
radical and enduring – indeed, in many respects its results remain with
us today – was never easy or uncontroversial. Professional writers and
artists claimed respectability and a place as arbiters of public taste, but
amateurs remained powerful. Dealers successfully made a flourishing

business of art, but never escaped suspicion of being vulgar traders. Though they epitomised the values that shaped so much art and literature, ideas of politeness and sentiment – the former concerned with public appearances, the latter with private feeling – were never free from criticism. Much of this controversy stemmed from the success and novelty of the eighteenth-century arts: new forms of expression like the painted conversation piece, the periodical essay and the stipple print, new audiences for literature, painting and the performing arts, and new selling and promotional techniques to reach larger publics. The commercialism and modernity of the arts, the very aspects which made them more prominent, were also those which provoked most hostility. Critics like Pope looked back nostalgically to an earlier, better age, when the arts were patronised by men of taste and discernment, who broadly agreed about what constituted good art and what values it expressed.

This should not surprise us. Our contemporary debate about the state of literature and the arts, which we often incline to think of as thoroughly modern, includes much that would have been familiar to our eighteenth-century predecessors. Today critics debate the effect of mass media like television on 'good' taste, the role of sexuality and violence in art, the problems of aesthetic discrimination in a world of competing moral and social values and the corrupting effect of the marketplace. The technologies may be different but the broad issues – about culture and commercialism, about the arts and morality, about aesthetic hierarchies and cultural fragmentation – remain the same. Though today some artists and critics not only accept but actively embrace the links between art and money and between culture and the mass media (I am thinking of such contemporary British artists as Damien Hirst), others reject this view and look back nostalgically to a lost golden age of artistic integrity, education and cultural refinement, one that is usually associated with a well-informed elite. Indeed, it is not unusual for critics to cite the eighteenth century as such a time, when cultural hierarchies were respected and the rule of taste prevailed.

This was not, as I have tried to show, how most artists and critics or the majority of the public saw their situation at the time. They saw flux and change where we, less well placed to understand them, see stability, unity and order. Of course in the eighteenth century the audience for the arts was smaller and the variety of media was less. But the dynamism of those who produced, sold and enjoyed the arts ensured

that the boundaries – between fine art and popular forms of expression, between the discerning and refined spectator and the cheerful punter, between the rich patron and the less affluent audience – were every bit as hard to draw.

In visiting country houses, watching films of Georgian novels and admiring the works of an earlier age in museums, we often engage in a nostalgic reverie (one of the pleasures of our own imaginations), dwelling on what we believe we have lost as a result of our modern condition. This is perhaps an inevitable consequence of our sense that twentieth-century society and culture are radically different from their predecessors, which leads us to emphasise the order, stability and decorum of eighteenth-century England. But, as I have tried to show, contemporaries saw their culture as modern, not traditional, an indication that their society and way of life was changing. It was its dynamism, variety and exuberance – not its respectability or elegance – which intoxicated them.

BIBLIOGRAPHY

THE BIBLIOGRAPHICAL ESSAY that follows is not intended to be comprehensive, but to serve several related purposes. First and foremost it is a way of identifying many of the textual and graphic sources that I have used over the several years that I have worked on this book. Much of the graphic material which is reproduced and discussed in the text is from the major collections: the British Museum collection of personal and political satires; the rich London materials in the print room of the Guildhall Library in the City of London; the archives of the Royal Academy; the extraordinary collection of W. S. Lewis at Farmington Connecticut, now held by Yale University; the Yale Center for British Art in New Haven; the Harvard University Theatre collection in the Houghton Library; and the Huntington Library in San Marino, California. All of these graphic materials do not so much illustrate as help to create the central arguments of the book.

Most of the chapters of *The Pleasures of the Imagination* develop their general theme by using one or two biographical case studies which are often based on manuscript or published primary sources which I discuss briefly in what follows. I've also made extensive use of eighteenth-century newspaper materials, chiefly from the Burney collection in the British Museum, but also in the form of scrapbooks of cuttings such as those in British Library special collections (eg. B.L. 840 m.30 for cuttings on the London Pantheon), the London Guildhall (scrapbook on Vauxhall Gardens, C.27) and the Bodleian Library (Fillingham Collection on pleasure gardens). In addition, of course, I have relied on the extensive pamphlet literature, memoirs and letters of the period. For all the use of primary sources, I have depended for much of my discussion on the very large body of scholarship on eighteenth-century Britain written in the last twenty years. In what follows I hope that I manage to express my gratitude to the many scholars who have produced so much interesting work on the period and who have helped shape my argument. One of my aims in writing this book has been to bring much of this work to the attention of an audience that extends beyond specialists by presenting it in an accessible way. Inevitably I have had to rely on much research and many insights that are not my own, but which I have woven into my general account. It is an impossible task to cite all of this work and so, wherever possible, I have picked out studies that tell the reader about the present state of scholarship,

and have mentioned specific interpretive studies that have affected how I have presented the argument.

The way I have written this book has been strongly affected by recent writing on cultural theory and most notably by Pierre Bourdieu's studies *Distinction: A Social Critique of the Judgment of Taste*, trans. Richard Nice (Cambridge: Harvard University Press, 1984); Randal Johnson (ed.), *The Field of Cultural Production: Essays on Art and Literature* (Cambridge: Polity, 1993), Susan Emanuel (trans) *The Rules of Art: Genesis and Structure of the Literary Field* (Cambridge: Polity, 1996). I have also found especially stimulating John Guillory's *Cultural Capital: The Problem of Literary Canon Formation* (Chicago and London: University of Chicago, 1993).

Similarly, a number of general works on eighteenth-century England and Britain have helped shape the argument of this book. Paul Langford's work, in my view, provides the best scholarly overview of the period. His *A Polite and Commercial People: England 1727–1783* (Oxford: Clarendon, 1989), and his *Public Life and the Propertied Englishman, 1689–1798* (Oxford: Clarendon, 1989) offer the most balanced account of the modernity and traditionalism of English society and politics, as well as including many insights of importance to cultural historians. The work of Ronald Paulson, notably his reworked three volume biography of *Hogarth* (New Brunswick and London: Rutgers, 1991–3), and *Popular and Polite Art in the Age of Hogarth and Fielding* (Notre Dame and London: Notre Dame Press, 1979), Pat Rogers' *Literature and Popular Culture in Eighteenth-Century England* (Sussex: Harvester, 1985) and John Barrell's *English Literature in History 1730–80: An Equal, Wide Survey* (London: Hutchinson, 1983) are all models of how to connect literary and artistic work to culture and society. My debt to Jack Plumb, who has done so much to open up the debate about culture and society in eighteenth-century England, is obvious. His contributions to Neil McKendrick, John Brewer and J. H. Plumb, *The Birth of a Consumer Society: The Commercialization of Eighteenth-Century England* (London: Europa, 1982), and the exhibition he organized for the opening of the Yale Center for British Art at New Haven (J. H. Plumb, *The Pursuit of Happiness: A View of Life in Georgian England: An Exhibition Selected from the Paul Mellon Collection*, catalogue entries by Edward J. Nygren and Nancy L. Pressly [New Haven: Yale Center for British Art, 1977]) opened up the field and set the agenda for research for the next generation. Finally, *The Pleasures of the Imagination* owes an enormous debt to the scholars who contributed to the three volumes on consumption and culture in the seventeenth and eighteenth centuries that I jointly edited with Roy Porter, Susan Staves and Ann Bermingham and which were part of a three year research project at the Center for Seventeenth and Eighteenth-Century Studies and the Clark Library at the University of California in Los Angeles. *Consumption and the World of Goods* (London and New York: Routledge, 1993), *Early Modern Conceptions of*

Property (London and New York: Routledge, 1995), and *The Consumption of Culture 1600–1800. Image, Object* (London and New York: Routledge, 1995) together map much of the territory covered in this book.

INTRODUCTION

The most important work on the emergence of the idea of the fine arts remains a famous long essay by Paul Kristeller, 'The Modern System of the Arts,' in Paul Kristeller, Michael Mooney (eds.), *Renaissance Thought and its Sources*, (2 vols, New York: Columbia University Press, 1979), pp. 163–227. The best recent discussion of his themes is a collection edited by Paul Mattick entitled *Eighteenth-Century Aesthetics and the Reconstruction of Art* (Cambridge and New York: Cambridge University Press, 1993). For Enlightenment views on taste, progress and refinement I have used Peter Gay, *The Enlightenment: An Interpretation* (2 vols, London: Wildwood House, 1973), David Spadafora, *The Idea of Progress in Eighteenth-Century Britain* (New Haven: Yale University Press, 1990) and Istvan Hont and Michael Ignatieff, *Wealth and Virtue: The Shaping of Political Economy in the Scottish Enlightenment* (Cambridge: Cambridge University Press, 1993). The figures on European and British urban growth are taken from Jan De Vries, *European Urbanization 1500–1800* (London: Methuen, 1984) and E. Anthony Wrigley, 'Urban Growth and Agricultural Change: England and the Continent in the Early Modern Period' in Robert I. Rotberg and Theodore Rabb (eds.), *Population and History from the Traditional to the Modern World* (Cambridge and New York: Cambridge University Press, 1986). My analysis of the relations between polite and popular culture draws on Peter Burke's classic, *Popular Culture in Early Modern Europe* (London: T. Smith, 1978). D. E. C. Eversley, 'The Home Market and Economic Growth in England, 1750–1780', in E. L. Jones and G. E. Mingay (eds.), *Land, Labour and Population in the Industrial Revolution: Essays presented to J. D. Chambers* (London: Edward Arnold, 1967) offers an analysis of the structure of income in eighteenth-century England, while Lorna Mui & Hoh-cheung Mui, *Shops and Shopping in Eighteenth-Century England* (Montreal: McGill-Queens University Press, 1989) is the fullest discussion of the retailing patterns revealed by the 1759 excise survey of shops. For foreign views of Britain see Johann Wilhelm von Archenholz, *A Picture of England: Containing a Description of the Laws, Customs, and Manners of England*. Translated from the original German (London, 1977), Karl Phillip Moritz, *Journey of a German in England in 1782*, R. Nettle (trs. and ed.) (London: Jonathan Cape, 1965); Voltaire, *Lettres Philosophiques* (Oxford: Blackwell, 1979) and Karl Geiringer, *Haydn: a Creative Life in Music*, 2nd ed. (London: Allen and Unwin, 1964). The activities of the Remondini publishing and print business are traced in Carlo Alberto Zotti Minici,

Le Stampe Popolari dei Remondini (Vicenza: Neri Pozza, 1994). Laurence Fontaine's, *Histoire du Colportage en Europe XVe–XIXe siècle* (Paris: Albin Michel, 1993) is the best discussion of the networks of packmen and chapmen who operated throughout Europe, while David Bindman (ed.), *John Flaxman*, exhibition catalogue, Royal Academy of Arts (London: Thames and Hudson, 1979) discusses Goethe's views on Wedgwood and art.

PART I · CONTEXTS

I. CHANGING PLACES: THE COURT AND THE CITY

For sources on the seventeenth- and eighteenth-century court see John Evelyn, *The Diary of John Evelyn*, edited by William Bray (London: Everyman's Library, 1966); the indispensable Samuel Pepys, *The Diary of Samuel Pepys*, 11 vols., edited Robert Latham and William Mathews (London: G. Bell and Sons Ltd, 1977), where the reference to the incident at Oxford Kate's tavern is described in v.4, p. 209. This should be supplemented by the comments in Anthony Wood, *The Life and Times of Anthony Wood, antiquary, at Oxford 1632–1695, described by himself*, collected from his diaries and other papers by Andrew Clark, Oxford Historical Society, Publications, vols 19, 21, 26, 30, 40 (Oxford, 1891–95). Lybbe Powys, *Passages from the Diaries of Mrs Philip Lybbe Powys, of Herwick House, Oxon., A.D. 1756 to 1808*, edited by E. J. Climenson (London: Longmans and Co., 1899), contains her account of the palace at Windsor. Romney Sedgwick's edition, *Some materials towards memoirs of the reign of King George II, by John, Lord Hervey; printed from a copy of the original manuscript in the royal archives at Windsor Castle* 3 vols. (London: Eyre & Spottiswoode, 1931) gives a witty though jaundiced account of George II's court. Fanny Burney's less than exciting experiences of George III's court can be found in Joyce Hemlow (ed.), with Cyrtis D. Cecil and Althea Douglas, *The Journals and Letters of Frances Burney (Madame D'Arblay)* 12 vols. (Oxford: Clarendon Press, 1972–89).

My analysis of the seventeenth-century court is based on Stephen Orgel, *The Illusion of Power: Political Theater in the English Renaissance* (Berkeley: University of California Press, 1975), Roy Strong, *Britannia Triumphans: Inigo Jones, Rubens and Whitehall Palace* (London: Thames and Hudson, 1980) and Roy Sherwood, *The Court of Oliver Cromwell* (London: Croom Helm, 1977). Malcolm Smuts is particularly interesting on the limits of Stuart patronage in his essay, 'The Political Failure of Stuart Cultural Patronage', in Lytle Fitch and Stephen Orgel (eds.), *Patronage in the Renaissance* (Princeton: Princeton University Press, 1982), pp. 165–187. Jonathan Brown, *Kings and Connoisseurs: Collecting Art in Seventeenth-Century Europe* (Princeton: Princeton University Press, 1995) is excellent in contextualizing

Stuart collecting and art patronage. On the later Stuarts and the Hanoverians see John Miller, *Charles II* (London: Weidenfeld and Nicholson, 1991), Michael Foss, *The Age of Patronage: The Arts in Society, 1660–1750* (New York: Cornell University Press, 1971), James Winn, *John Dryden and his World* (New Haven: Yale University Press, 1987), R. O. Bucholz, *The Augustan Court: Queen Anne and the Decline of Court Culture* (Stanford: Stanford University Press, 1993), David Green, *Queen Anne* (London: Collins, 1970), John Beattie, *The English Court in the Reign of George I* (Cambridge: Cambridge University Press, 1967). Linda Colley's *Britons: Forging the Nation 1707–1837* (New Haven: Yale University Press, 1992) is full of insight into the status of the royal family. H. M. Colvin (ed.), *The History of the King's Works* (London: HMSO, 1963) is the essential work for any discussion of royal palace building in both the seventeenth and eighteenth centuries. Helmut von Erffa and Alan Staley, *The Paintings of Benjamin West* (New Haven: Yale University Press, 1986) is the best account of Benjamin West's decoration of the royal apartments at Windsor. On images of the royal family see Simon Schama, 'The Domestication of Majesty: Royal Family Portraiture, 1500–1850' in Robert J. Rotberg and Theodore K. Rabb (eds.), *Art and History. Images and their Meaning* (Cambridge: Cambridge University Press, 1988), pp. 155–183.

My account of the commemoration of the Peace of Aix la Chapelle in 1749 is taken from several contemporary newspapers and journals and from engravings described in *Catalogue of political and personal satires preserved in the Department of Prints and Drawings in the British Museum* [by] Frederick George Stephens and Dorothy George (Photolitho ed. London, published for the Trustees of the British Museum by British Museum Publications, 1978). Christopher Hogwood offers an accessible recent account of the events in his *Handel* (London: Thames and Hudson, 1984).

Boswell depicts his experiences in London in his journal: Frederick A. Pottle (ed.) *Boswell's London Journal, 1762–3* (Edinburgh: Edinburgh University Press, 1991), which should be supplemented by Ralph S. Walker (ed.), *The Correspondence of James Boswell and John Johnston of Grange* (London: Heinemann, 1966). I refer in Chapter 2 below to other important views on the city. James Boswell, *The life of Samuel Johnson, LL.D. Comprehending an account of his studies and numerous works, in chronological order; a series of his epistolary correspondence and conversations with many eminent persons, and various original pieces of his composition, never before published* ... (London: Charles Dilly, 1791) is, of course, essential reading.

My analysis of eighteenth-century views of London relies on Max Byrd, *London Transformed: Images of the City in the Eighteenth Century* (New Haven, Yale University Press, 1978), Roy Porter, *London: A Social History* (London: Hamish Hamilton, 1994) especially Chapter seven, Arthur J. Weitzman, 'Eighteenth-Century London: Urban Paradise or Fallen City?', *Journal of the History of Ideas* XXXVI (1975), pp. 469–80, and Pat Rogers, *Grub Street: Studies*

in a Subculture (London: Methuen, 1972), a remarkable study which reveals the city in all its variety. On alehouses, taverns and coffee houses see Peter Clark, *The English Alehouse: A Social History, 1200–1830* (London: Longman, 1983) and my discussion in Chapter eight of *Party Ideology and Popular Politics at the Accession of George III* (Cambridge: Cambridge University Press, 1976). Bryant Lillywhite, *London Coffee Houses: a Reference Book of Coffee Houses of the Seventeenth and Eighteenth and Nineteenth Centuries* (London: Allen and Unwin, 1963), is an astonishing guide to every coffee house in London. I've also greatly benefited from an unpublished paper by Lawrence Klein, *Coffee Clashes: The Politics of Conversation in Seventeenth and Eighteenth-Century England*, which the author kindly showed me. On clubs see Robert J. Allen, *The Clubs of Augustan London* (Cambridge, Mass: Harvard University Press, 1933). Catherine Howells, *The Kit-Cat Club: a Study of Patronage and Influence in Britain, 1696–1720* (PhD thesis, University of California, Los Angeles, 1982) is an excellent study of the Kit-Cat Club. David Solkin, *Painting for Money: The Visual Arts and the Public Sphere in Eighteenth-Century England* (New Haven and London: Yale University Press for the Paul Mellon Centre for Studies in British Art, 1993) has an outstanding discussion of the Kit-Cat portraits. Lawrence Lipking, *The Ordering of the Arts in Eighteenth-Century England* (Princeton: Princeton University Press, 1970) is still the best discussion of the contribution of the Johnson circle to the shaping of Britain's cultural heritage.

2. THE PLEASURES OF THE IMAGINATION

Anna Larpent's diary is in the Huntington Library, San Marino, California. It consists of seventeen volumes and is catalogued as Huntington Manuscripts 31201. Her family history is outlined in George Larpent, *Turkey: Its History and Progress from the Journals and Correspondence of Sir James Porter, Fifteen Years Ambassador at Constantinople; continued to the present time, with a Memoir of Sir James Porter, by his grandson*, 2 vols. (London, 1851). The Larpents' work as censors is discussed in L. W. Conolly, *The Censorship of English Drama 1737–1824* (San Marino, California: Huntington Library, 1976). On theatres see Edward A. Langhaus, 'The Theatres' in Robert D. Hume (ed.), *The London Theatre World 1660–1800* (Carbondale and Edwardsville: Southern Illinois Press, 1980), pp. 35–65. The best recent discussion of London concert life is Simon McVeigh, *Concert Life in London in the Age of Haydn and Mozart* (Cambridge: Cambridge University Press, 1993). John Harley, *Music in Purcell's London: The Social Background* (London: Denis Dobson, 1968) is valuable for the late seventeenth century. David Solkin, *Painting for Money: the Visual Arts and the Public Sphere in Eighteenth-Century England* (New Haven and London: Yale University Press for the Paul Mellon

Centre for Studies in British Art) and Richard Altick, *The Shows of London: a Panoramic History of Exhibitions* (Cambridge, Mass: Harvard University Press, 1978) discuss the exhibition of art in its various contexts. Warwick W. Roth, *The London Pleasure Gardens of the Eighteenth Century* (London: Macmillan, 1896) is an old work, but remains the best account of eighteenth-century pleasure gardens. I have supplemented it with Brian Allen's account in *Francis Hayman* (New Haven and London: Yale University Press, 1987).

Of many eighteenth-century responses to the city and its entertainments I have used *The Journal of Samuel Curwen, Loyalist*, ed. Andrew Oliver, 2 vols. (Cambridge, Mass.: Harvard University Press, 1972), John Marsh, 'A History of my Private Life', Huntington Library Mss HM 54457, *The Diary of the Visits of John Yeoman to London in the years 1774 and 1777*, ed. Macleod Yearsley (London: Watts & Co. 1934), Sophie von la Roche, *Sophie in London*, Clare Williams (trs.) (London: Jonathan Cape, 1933).

For the debate about corruption, luxury and their relation to the arts see William Law, *A Serious Call to a devout and holy life, adapted to the state and condition of all orders of Christians* (London, 1729), *The devil upon crutches in England; or, Night scenes in London. A satirical work ... By a gentleman of Oxford ...* (London: P. Hodges, 1755), and the most famous contemporary statement, John Brown, *An Estimate of the Manners and Principles of the Times, by the Author of the Essays on characteristics, etc.* (London: L. Davis and C. Reymers, 1757–8). Recent work on the debate about luxury, effeminacy and the morally corrupting potential of the arts includes John Sekora, *Luxury: the Concept in Western Thought, Eden to Smollett* (Baltimore: Johns Hopkins University Press, 1985), Christopher Berry, *The Idea of Luxury: a Conceptual and Historical Investigation* (Cambridge: Cambridge University Press, 1993) and Peter Stallybrass and Allon White, *The Politics and Poetics of Transgression* (Ithaca, New York: Cornell University Press, 1986). I have developed these themes in John Brewer 'The most polite age and the most vicious'. Attitudes towards Culture as a Commodity, 1660–1800' in Ann Bermingham and John Brewer (eds.), *The Consumption of Culture 1600–1800: Image, Object, Text*, pp. 341–61.

In the eighteenth-century literature on taste, I have found most useful Edmund Burke, *A Philosophical Enquiry into the Origin of our Ideas of the Sublime and Beautiful* (1756), J. T. Boulton (ed.) (London: Routledge, Kegan Paul, 1958), James Miller, *A Man of Taste: A comedy ...* (London: 1735); Archibald Alison, *Essays on the Nature and Principles of Taste* (London: J. J. G. and G. Robinson; Edinburgh: Bell and Brafute, 1790); Alexander Gerard, *An Essay on Taste ... With Three Dissertations on the Same Subject. By Mr de Voltaire, Mrs d'Alembert [and] Mr. de Montesquieu* (London: Millar, 1759); Francis Hutcheson, *An inquiry into the original of our ideas of beauty and virtue: in two treatises. I. Concerning beauty, order, harmony, design. II. Concerning moral good and evil* (3rd ed., corrected),

(London: Printed for J. and J. Knapton, etc., 1729). In recent writing about taste I have found Jerome Stolnitz, 'On the Origins of "Aesthetic Disinterestedness",' *Journal of Aesthetic and Art Criticism* 20 (1961–2), pp. 131–43, Howard Caygill's brilliant *Art of Judgement* (Oxford, 1989), and Paul Mattick (ed.), *Eighteenth-Century Aesthetics and the Reconstruction of Art* (Cambridge and New York: Cambridge University Press, 1993) most valuable. B. Sprague Allen, *Tides in English Taste (1619–1800), a Background for the Study of Literature* (Cambridge, Mass., 1937), 2 vols., contains much interesting historical material, like so many of the American studies of British culture of the 1920s and 1930s.

The key texts on politeness are *The Spectator*, edited with an introduction and notes by Donald F. Bond. 5 vols. (Oxford: Clarendon Press, 1965) and *The Tatler*, by Isaac Bickerstaff Esq. (London, 1709–11). In discussing politeness I have relied heavily on the writings of Lawrence Klein and especially on 'Property and Politeness in the Early Eighteenth-Century Whig Moralists. The case of *The Spectator*', in John Brewer and Susan Staves (eds.), *Early Modern Conceptions of Property*, pp. 221–233; 'Politeness for Plebes, Consumption and social identity in early eighteenth-century England', in Bermingham and Brewer, *The Consumption of Culture*, pp. 362–382, and *Shaftesbury and the Culture of Politeness: Moral Discourse and Cultural Politics in Early Eighteenth-Century England* (Cambridge: Cambridge University Press, 1994). The best single work on *The Spectator* is Michael Ketcham, *Transparent Designs: Reading, Performance and Form in The Spectator Papers* (Georgia: Athens, 1985). On polite accomplishments see Ann Bermingham, 'Elegant Females and Gentlemen Connoisseurs: the Commerce in Culture and Self-Image in Eighteenth-Century England', in Ann Bermingham and John Brewer (eds.), *The Consumption of Culture 1600–1800: Image, Object, Text*, pp. 489–513.

For sentiment and sensibility see, among innumerable contemporary texts, Laurence Sterne, *A sentimental journey through France and Italy. By Mr Yorick* (London: T. Beckett and P. A. De Hondt, 1768), *The Sentimental Magazine; or, General Assemblage of Science, Taste*, etc., vol. 1–3 (London, 1773–75), George Cheyne, *The English Malady: or, a Treatise of nervous diseases of all kinds. With the authors own case* ... (London: G. Strahan, 1733), Samuel Richardson, *Clarissa. Or, The history of a young lady: comprehending the most important concerns of private life. And particularly shewing, the distresses that may attend the misconduct both of parents and children, in relation to marriage*, published by the editor of *Pamela* (London: S. Richardson, 1747–48) and Thomas Day, *The History of Sandford and Merton, a work intended for the use of children* (London: J. Stockdale, 1783–89). Of all the large literature on sensibility I have found most useful G. J. Barker-Benfield, *The Culture of Sensibility: Sex and Society in Eighteenth-Century Britain* (Chicago: University of Chicago, 1992), John Mullan, *Sentiment and Sociability: The Language of Feeling in the Eighteenth Century* (Oxford: Clarendon, 1988) and

Janet Todd's synthesis, *Sensibility: An Introduction* (London: Methuen, 1986).

For the Nine Living Muses and the bluestockings in general see Sylvia Harcstark Myers, *The Blue Stocking Circle: Women, Friendship, and the Life of the Mind in Eighteenth-Century England* (Oxford: Clarendon, 1990). Gerald Newman, *The Rise of English Nationalism. A Cultural History, 1740–1830* (New York: St Martin's Press, 1987) analyses cultural nationalism in a rather flamboyant manner, and his account should be tempered with Linda Colley's more judicious analysis in *Britons*.

On ideas of the gentleman and the social hierarchy see John Barrell, *English Literature in History 1730–80: An Equal, Wide Survey* (London: Hutchinson, 1983) especially the Introduction: artificers and gentlemen, pp. 17–50 and Penelope Corfield, 'Class by Name and Number in Eighteenth-Century Britain,' *History* (1984), pp. 32–47. Peter Earle, *The Making of the English Middle Class: Business, Society and Family Life in London, 1660–1730* (London: Methuen, 1989) and Lorna Weatherill, *Consumer Behaviour and Material Culture, 1660–1790* (London: Routledge, 1988) discuss patterns of consumption, especially among the middle ranks of society. On ideas about the public see my essay, 'This, that and the other: Public, Social and Private in the Seventeenth and Eighteenth Centuries', in Dario Castiglione and Lesley Sharpe (eds.), *Shifting the Boundaries: Transformations of the Languages of Public and Private in the Eighteenth Century* (Exeter: University of Exeter Press, 1995), pp. 1–21.

PART II · PRINT

3. AUTHORS, PUBLISHERS AND THE MAKING OF LITERARY CULTURE

Every biographical account of Richardson must depend on two works, W. M. Sale, *Samuel Richardson: Master Printer* (Ithaca, New York: Cornell University Press, 1950) and T. C. Duncan Eaves & Ben D. Kimpel, *Samuel Richardson, A Biography* (Oxford: Clarendon Press, 1971). The best general account of British publishing in this period is John Feather, *A History of British Publishing* (London: Routledge, 1988), which I have supplemented with Marjorie Plant, *The English Book Trade* (London: Allen and Unwin, 1965). Michael Harris, 'The structure, ownership and control of the press, 1620–1780' in G. Boyce, J. Curran and P. Wingate (eds.), *Newspaper History from the Seventeenth Century to the Present Day* (London: Constable, 1978) is a fine overview of newspapers in the period. Cyprian Blagden, *The Stationers Company: A History, 1403–1959* (London: Allen and Unwin, 1960) is the standard history of the Stationers Company. Terry Belanger's 'Publishers and writers in eighteenth-century England' in Isabel Rivers, *Books and their Readers in Eighteenth-Century England* (Leicester: Leicester University

Press, 1982), pp. 5–25, is a model of compression and lucidity. The provincial book trade is covered by another of John Feather's excellent studies, *The Provincial Book Trade in Eighteenth-Century England* (Cambridge: Cambridge University Press, 1985). Two important works of reference on the book trade are Ian Maxted, *The London Book Trades, 1775–1800: A Preliminary Checklist of Members* (Folkestone: Dawson, 1977) and John Pendred, *The Earliest Directory of the Book Trade*, Graham Pollard (ed.) (London: Bibliographical Society, 1955). Terry Belanger has written about book auctions in his 'Bookseller's Trade Sales, 1718–1768' *Library* 5th series 30 (1975), pp. 281–302. On copyright see John Feather, 'The Publishers and the Pirates: British Copyright Law in Theory and Practice, 1710–1775' *Publishing History* 22 (1987), pp. 5–32 and the very important article by Mark Rose, 'The Author as Proprietor: Donaldson *v.* Becket and the Genealogy of Modern Authorship' *Representations* 23 (1988), pp. 51–85 and, more generally, David Saunders, *Authorship and Copyright* (London and New York: Routledge, 1992).

The standard bibliographical work of reference for eighteenth-century periodicals is George Watson, ed., *The New Cambridge Bibliography of English Literature, 1660–1800,* vol. 2 (Cambridge: Cambridge University Press, 1971). Roger Lonsdale uses many examples of women first using the periodical press in order to publish their work in his fascinating *Eighteenth-Century Women Poets: An Oxford Anthology* (Oxford and New York, 1990). James Basker's study, *Tobias Smollett Critic and Journalist* (Newark: University of Delaware Press, 1988) is an interesting account of one periodical journalist and his literary endeavours. On Grub Street and authorship see Alexander Pope, 'The Dunciad', edited by James Sutherland in *The Twickenham Edition of the Poems of Alexander Pope*, general editor: John Butt, 2nd ed., v.5 (London and New Haven: Methuen and Yale University Press, 1953), Henry Fielding, *The Author's Farce; and the Pleasures of the Town ... Written by Scriberius Secundus* (London: J. Roberts, 1730), Pat Rogers, *Grub Street: Studies in a Subculture* (London: Methuen, 1972), Richard Holmes, *Dr. Johnson & Mr. Savage* (London: Hodder and Stoughton, 1993), A. S. Collins, *Authorship in the Days of Johnson* (London: Routledge, 1927) and Alvin Kernan's wide-ranging study of Johnson and publishing, *Printing Technology, Letters and Samuel Johnson* (Princeton: Princeton University Press, 1987). John Nichols's *Literary Anecdotes and Illustrations of the Literary History of the Eighteenth Century* (Carbondale, Illinois: Southern Illinois University Press, 1967) has proved an invaluable source for everyone writing about Grub Street. Robert Dodsley, *The Correspondence of Robert Dodsley, 1733–1764*, edited by James E. Tiemey (Cambridge: Cambridge University Press, 1988) is embarrassingly revealing about the bruised egos and petty slights of the literary world, while Paul Korshin's essay 'Types of Eighteenth-Century Literary Patronage,' *Eighteenth-Century Studies* 7 (4), pp. 453–469 lays out the possibilities and prospects for an aspiring author. Investigating the practice

of book subscription has been transformed by the publication as a CD-ROM of the *Biography Database, 1680–1830* (Newcastle-upon-Tyne: Romulus Press, 1995), which includes more than a thousand subscription lists of the period.

4. READERS AND THE READING PUBLIC

I have used a number of eighteenth-century accounts of reading practices, including *Dr. Campbell's Diary of a Visit to England in 1775*, newly edited by James L. Clifford (Cambridge, 1947), John Marsh, 'A History of my Private Life', Huntington Library Mss HM 54457; 'Memoirs of the Birth, Education, Life and Death of Mr John Cannon, sometime officer of the Excise at Mere, Glastonbury and West Lidford in the County of Somerset,' Somerset Record Office DD/SAS C/ 1193 4; *The Diary of Thomas Turner 1754–1765*, David Vaisey (ed.) (Oxford: Oxford University Press, 1985), *Thomas Bewick: A Memoir*, ed. Iain Bain (Oxford: Oxford University Press, 1979). James Lackington's memoirs, which have been used in almost all studies of English reading, appeared in many editions. I have used James Lackington, *Memoirs of the First Forty-Five Years of the Life of James Lackington: the Present Bookseller in Chiswell Street, Moorfields, London, written by himself in a series of letters to a friend* (London, 1791).

On broad literacy trends see Roger Schofield, 'The Measurement of Literacy in Pre-Industrial England' in Jack Goody, ed., *Literacy in Traditional Societies* (Cambridge: Cambridge University Press, 1975), pp. 311–25; R. A. Houston, *Literacy in Early Modern Europe: Culture and Education 1500–1800* (London: Longman, 1988), esp. 116–154; David Cressy, 'Literacy in Context: Meaning and Measurement in Early Modern England,' in John Brewer and Roy Porter (eds.), *Consumption and the World of Goods*, pp. 305–319; Keith Thomas, 'The Meaning of Literacy in Early Modern England' in G. Baumann (ed.), *The Written Word: Literacy in Transition* (Oxford University Press, 1986), pp. 97–131. The standard discussion of 'intensive' and 'extensive' reading is in Rolf Engelsing, *Der Burger als Leser: Lesergeschichte in Deutchland, 1500–1800* (Stuttgart, 1971).

The figures on types of books published in English are taken from John Feather, 'British Publishing in the Eighteenth Century: a Preliminary Subject Analysis,' *The Library* 6th series, 8 (1986), pp. 32–46. For the earlier period see Maureen Bell and John Bernard, 'Provisional Count of Short Title Catalogue Titles, 1475–1640', *Publishing History* 31 (1992), pp. 48–64.

Margaret Spufford, *Small Books and Pleasant Histories: Popular Fiction and its Readership in Seventeenth-Century England* (London: Methuen, 1981); Victor Neuburg, *Chapbooks: A Guide to Reference Material* (London: Woburn Press, 1972); Laurence Fontaine, *Histoire du Colportage en Europe (XVe–XIXe siecle)* (Paris: Albin Michel, 1993), esp. 69–94 explain the part of pedlars and chapmen in

distributing small books and prints, and should be read in conjunction with
Feather's account of the provincial book distribution network in *The Provincial
Book Trade in Eighteenth-Century England.*

On reading practices see James Raven, Helen Small and Naomi Tadmor
(eds.), *The Practice and Representation of Reading in England* (Cambridge: Cam-
bridge University Press, 1996), including my essay, "Reconstructing the Reader:
Prescriptions, Texts and Strategies in Anna Larpent's Reading', pp. 226–245, and
Naomi Tadmor, '"In the even, my wife read to me": Women, Reading and
Household Life in the Eighteenth Century', pp. 165–170. Johnson's views on the
reading public are discussed in Leopold Damrosch, *The Uses of Johnson's Criticism*
(University of Virginia Press, Charlottesville, 1976).

The best works on circulating and subscription libraries are Hilda Hamlyn,
'Eighteenth-Century Circulating Libraries in England', *Library* 5th series 1 (1947),
pp. 197–218; Paul Kaufman, *Libraries and their Users: Collected Papers in Library
History* (London: Library Association, 1969); Devendra P. Varma, *The Evergreen
Tree of Diabolical Knowledge* (Washington, 1972); James Raven, 'From Promotion
to Proscription: Arrangements for Reading in Eighteenth-Century Libraries,' in
James Raven, Helen Small and Naomi Tadmor (eds.), *The Practice and Represen-
tation of Reading in England*, pp. 175–188, M. Kay Flavell, 'The Enlightened
Reader and the New Industrial Towns: A Study of the Liverpool Library, 1758–
1790', *British Journal for Eighteenth-Century Studies* 8 (1985) pp. 17–35. Peter de
Bolla's critically acute account of the debate on novel reading is in his *The
Discourse of the Sublime: History, Aesthetics & the Subject* (Oxford: Blackwell, 1989),
especially pp. 235–38. I have based my analysis of Bristol library borrowings on
Paul Kaufman, *Borrowings from the Bristol Library, 1773–1784: A Unique Record
of Reading Vogues* (Charlottesville: Bibliographical Society of the University
of Virginia, 1960). Kaufman also wrote the pioneering work on book clubs,
'English Book Clubs and their Role in Social History', in *Libri* XIV no 1 (1964),
pp. 1–31.

Private libraries are discussed in Mark Girouard, *Life in the English Country
House: A Social and Architectural History* (New Haven: Yale University Press,
1978); Raven, 'Arrangements for Reading', pp. 188–91; and Robin Myers and
Michael Harris (eds.), *Property of a Gentleman: the Formation, Organisation and
Dispersal of the Private Library, 1620–1920* (London: New Castle, Delaware: Oak
Knoll Press, 1996).

PART III · PAINT

5. THE MARKET AND THE ACADEMY

A number of general works are essential to a study of eighteenth-century painting. William T. Whitley, *Artists and their Friends in England 1700– 1799* (2 vols, London: 1928) is a wonderful collection of anecdotes and miscellaneous material, much of it culled from newspapers and ephemera. George Vertue, *Notebooks*, 6 vols, *The Walpole Society*, 18, 20, 22, 24, 26, 30 (1930–55) is a similar mixture of commentary, gossip and astute analysis, and remains the main source for artists' lives in the age of Hogarth. Ellis Waterhouse, *The Dictionary of British Eighteenth-Century Painters in Oils and Crayons* (London: Antique Collectors Club, 1981) is opinionated in a way that reference books are not supposed to be, but indispensable for all that. Iain Pears, *The Discovery of Painting: The Growth in the Interest in the Arts in England, 1680–1768* (New Haven and London: Yale University Press, 1988) offers the best overview of the first half of the century, and should be read in conjunction with Louise Lippincott, *Selling Art in Georgian London: The Rise of Arthur Pond* (New Haven and London: Yale University Press, 1983) and Sven H. A. Bruntgen, *John Boydell, 1719–1804: A Study of Art Patronage and Publishing in Georgian London* (London: Garland, 1985). David Solkin, *Painting for Money: The Visual Arts and the Public Sphere in Eighteenth-Century England* (New Haven and London: Yale University Press for the Paul Mellon Centre for Studies in British Art, 1993) is the most ambitious and complete recent interpretation of the period.

The recent catalogue of an exhibition at the Tate Gallery, *The Grand Tour: The Lure of Italy in the Eighteenth Century*, ed. Andrew Wilton and Ilaria Bignamini (London: Tate Gallery Publishing, 1996) is probably the best way to begin a study of the Grand Tour. An article by John Towner, 'The Grand Tour: A Key Phase in the History of Tourism', *Annals of Tourism Research* (1985), 12, 3, pp. 297– 333 is, to my knowledge, the only attempt at a systematic analysis of who went on the tour. Andrew W. Moore's *Norfolk and the Grand Tour: Eighteenth-Century Travellers Abroad and their Souvenirs* (Norwich: Norfolk Museums Service, 1985), is a model study of travel and collecting.

Ronald Paulson, *Hogarth*, 3 vols. (New Brunswick and London: Rutgers University Press, 1991–3) is essential to any study of Hogarth, as is his *Breaking and Remaking: Aesthetic Practice in England, 1700–1820* (New Brunswick: Rutgers University Press, 1989). William Hogarth, *The Analysis of Beauty, with the rejected passages from the manuscript drafts and autobiographical notes, edited with an introduction by Joseph Burke* (Oxford: Clarendon Press, 1955) is the standard edition of Hogarth's treatise on aesthetics. Jonathan Richardson, *An Essay on the Theory of Painting* (London, 1715) and his *Two Discourses, I An essay on the art of criticism, as it relates to painting ... II An argument in behalf of the science of a connoisseur ...* (London, 1719) are key works. Richardson is discussed in Lawrence Lipking,

The Ordering of the Arts in Eighteenth-Century England ch. 5 and by Richard Wendorf in his *Articulate Images: The Sister Arts from Hogarth to Tennyson* (Mineapolis: University of Minnesota Press, 1983), and, together with Reynolds, in his *The Elements of Life: Biography and Portrait-Painting in Stuart and Georgian England* (Oxford: Clarendon Press, 1990).

The display of paintings is discussed in Solkin, *Painting for Money: The Visual Arts and the Public Sphere in Eighteenth-Century England*; Francis Haskell, 'The British as Collectors', in *The Treasure Houses of Britain: Five Hundred Years of Private Patronage and Art Collecting* (New Haven and London: Yale University Press), pp. 50–59; Giles Waterfield (ed.), *Palaces of Art: Art Galleries in Britain 1790–1990* (London: Dulwich Picture Gallery, 1991) and, in the case of the pleasure gardens, in Brian Allen, *Francis Hayman* (New Haven and London: Yale University Press, 1987); *Rococo: Art and Design in Hogarth's England* (London: Victoria and Albert Museum, 1984), pp. 74–98 and T. J. Edelstein, *Vauxhall Gardens* (New Haven: Yale Center for British Art, 1983).

My account of the foundation of the Royal Academy and its struggle with the Incorporated Society relies heavily on the theses of Ilaria Bignamini and Brian Allen: Bignamini, *The Accompaniment to Patronage. A Study of the Origins, Rise and Development of an Institutional System for the Arts in Britain 1692–1768* (Ph.D, Courtauld Institute of Art, University of London, 1988) and Allen, *Francis Hayman and the English Rococo* (Courtauld Institute of Art, University of London, 1984) as well as on the Royal Academy Archives, which include the recently rediscovered receipt books for exhibitions, the Academy account books and papers concerning the Society of Artists, together with their accounts and minute books, and the Anderton and Jupp collections of materials on the Academy which interleave catalogues and miscellaneous materials from newspapers and pamphlets of the day. The London Library also has a bound volume of Academy Catalogues from 1769–1800 which includes a copy of Joseph Barretti's *A Guide through the Royal Academy by Joseph Baretti, Secretary for Foreign Correspondence of the Royal Academy*. I have also used the collection of newspaper cuttings relating to art exhibitions which has been assembled by the Paul Mellon Centre in London.

On the link between politics and the Academy see David Solkin, *Painting for Money: The Visual Arts and the Public Sphere in Eighteenth-Century England*, ch. 7, and his essay, 'The Battle of the Ciceros: Richard Wilson and the Politics of Landscape in the Age of Wilkes,' in *Reading Landscape: Country, City, Capital*, Simon Pugh (ed.) (Manchester: Manchester University Press, 1990), pp. 41–65.

6. CONNOISSEURS AND ARTISTS

Literature of the day commenting on seventeenth- and eighteenth-century *virtuosi* and connoisseurs includes Thomas Shadwell, *The Virtuoso* (1676), Marjorie Hope

Nicolson and David Stuart (eds.) (London: Edward Arnold, 1966), *The Connoisseur: or, Every Man in his Folly: A Comedy etc [By – Conoly]* (London: Richard Wellington, 1736) and Thomas Martyn, *The English Connoisseur* (1767) (Farnborough: Gregg, 1968). The recent revival of interest in early museums and collecting is best shown in the large volume of essays on early cabinets and collections in O. R. Impey and A. G. MacGregor, eds., *The Origins of Museums* (Oxford, Clarendon Press, 1985). The English virtuoso was the subject of a famous study by Walter E. Houghton, 'The English Virtuoso in the Seventeenth Century,' *Journal of the History of Ideas* 3 (1942), pp. 51–73, 190–219, but the really outstanding work in this field is Krzystof Pomian, *Collectors and Curiosities: Paris and Venice 1500–1800*, Elizabeth Wiles-Portier (trs.) (Cambridge: Polity Press, 1990).

For taste and the antique see James Stuart and Nicholas Revett, *The Antiquities of Athens* (4 vols, London: L. P., 1762–1814), Richard Payne Knight, *Select Specimens of Ancient Sculpture Preserved in the several Collections of Great Britain* (London: Society of Dilettanti, 1809), Richard Payne Knight, *An Inquiry into the Symbolic Language of Ancient Art and Mythology* (London: printed privately, 1818), Pierre François Hugues, Baron d'Hancarville, *Researches sur l'Origine, l'Esprit et les Progrés des Arts de la Grèce* (1785) (London and New York: Garland, 1986), Johann Joachim Winckelmann, *History of Ancient Art Among the Greeks* (1763–4), G. H. Lodge (trs.) (London, 1850). Payne Knight's notorious book is *An Account of the Remains of the Worship of Priapus . . .* (London: T. Spilsbury, 1786). Reactions to it and gossip about Payne Knight feature prominently in *The Diary of Joseph Farington*, ed. Kenneth Garlick and Angus Macintyre (16 vols, New Haven and London: Yale University Press, 1978–1984). Of recent writings on the subject Francis Haskell and Nicholas Penny, *Taste and the Antique: The Lure of Classical Sculpture 1500–1900* (New Haven and London: Yale University Press, 1981) remains the key text. Lionel Cust, *History of the Society of the Dilettanti* (London, 1898) is the official history of the society which should be complemented by studies of Hamilton, Payne Knight and their circle: Brian Fothergill, *Sir William Hamilton: Envoy Extraordinary* (London and Boston: Faber and Faber, 1979); Nicholas Penny and Michael Clarke (eds.), *The Arrogant Connoisseur: Richard Payne Knight* (Manchester: Manchester University Press, 1982); Francis Haskell, 'The Baron d'Hancarville: An Adventurer and Art Historian in Eighteenth-Century Europe' in his *Past and Present in Art and Taste: Selected Essays* (New Haven and London: Yale University Press, 1987), pp. 30–45. *Lady Hamilton in Relation to the art of her time* (London: Arts Council of Great Britain, 1972).

My analysis of the connoisseurs has been formed by John Barrell, 'The Dangerous Goddess: Masculinity, Prestige and the Aesthetic in Early Eighteenth-Century Britain,' in his *The Birth of Pandora and the Division of Knowledge* (London: Macmillan, 1992), pp. 63–87; John Berger, *Ways of Seeing* (London: British Broadcasting Corporation, Harmondsworth: Penguin, 1972), pp. 36–64;

Ronald Paulson, *Rowlandson: A New Interpretation* (New York: Oxford University Press, 1972), especially 'Youth and Age: the Romantic Triangle,' pp. 71–79, and most notably by Ann Beringham, 'Elegant Females and Gentlemen Connoisseurs' in Ann Bermingham and John Brewer (eds.), *The Consumption of Culture 1600–1800: Image, Object, Text*, pp. 489–513.

The saga of the Elgin Marbles is well told by William St Clair in his *Lord Elgin and the Marbles*, (Oxford and New York: Oxford University Press, 1983). My account of the committee itself is drawn from the *Report from the Select Committee of the House of Commons on the Earl of Elgin's Collection of Sculptures Marbles &c* (London: John Murray, 1816).

7. PAINTERS' PRACTICE, ARTISTS' LIVES

The best introduction to Reynolds's life and world is Nicholas Penny (ed.), *Reynolds* (London: Royal Academy of Arts and Weidenfeld and Nicholson, 1986). The key source is J. Northcote, *The Life of Sir Joshua Reynolds*, 2 vols (London, 1818). Apart from the sources mentioned above for Chapter 5, I have consulted John Romney, *Memoirs of the Life and Work of George Romney* (London, 1830), William Hayley, *The Life of George Romney* (Chichester, 1809) and James Northcote's autobiography which is in the British Library, Add. Mss 47790–1.

The papers of Ozias Humphry are in eight volumes in the Royal Academy Archives. They were used by George Charles Williamson for his study of Humphry published in 1918. The papers include several drafts of a mooted autobiography, much of his correspondence and a large body of papers relating to his legal disputes over payments in India. In the British Library there is a copy book of Humphry's from 1764 (Add. Mss 22947) and a series of accounts and memoranda (Add. Mss 22948–52). The Linley family are discussed by Giles Waterfield, *Nest of Nightingales: Thomas Gainsborough, the Linley Sisters* (London: Dulwich Picture Gallery, 1988).

Richard Wendorf, *The Elements of Life: Biography and Portrait Painting in Stuart and Georgian England* (Oxford: Clarendon Press, 1990), esp. pp. 227–60 analyses Reynolds's views on biography and portraiture, while his academic theory is the subject of John Barrell, *The Political Theory of Painting from Reynolds to Hazlitt* (New Haven and London: Yale University Press, 1986). The standard text of the *Discourses* is Robert W. Wark (ed.), *Sir Joshua Reynolds: Discourses on Art* (New Haven and London: Yale University Press, 1975).

On the circle of artists in Rome see Nancy L. Pressly, *The Fuseli Circle in Rome: Early Romantic Art of the 1770s* (New Haven: Yale Center for British Art, 1979), while for art in India the works of Mildred Archer are indispensable, especially her *India and British Portraiture, 1770–1825* (London: Sotheby, Parke Bernet, 1979).

PART IV · PERFORMANCE

8. THE GEORGIAN STAGE

In the debate about the eighteenth-century theatre I have found especially useful William Law, *The Absolute Unlawfulness of the Stage Entertainment fully demonstrated* (London, 1762), *An Essay on Acting . . . the Mimical Behaviour of a Certain Fashionable Faulty Actor [Mr G————K ie David Garrick]* (London, 1744); John Hill, *The Actor: a Treatise on the Art of Playing* (London, 1750), Colley Cibber, *Apology for the Life of Mr Colley Cibber . . . Written by Himself* (London: printed privately, 1740); Jeremy Collier, *A Short View of the Immorality and Profaneness of the English Stage* (1698) (Menston: Scolar, 1971); *A narrative of the life of Mrs Charlotte Charke, (youngest daughter of Colley Cibber, esq.) . . . Written by herself* (London, Printed for W. Reeve, 1755) and Thomas Gilliland, *A Dramatic Synopsis containing an Essay on the Political and Moral Use of the Theatre* (London, 1804).

Overall, there are two indispensable aids to the study of theatre history in this period. The first is the comprehensive account of every London performance from 1660 until 1800 – *The London Stage, 1660–1800*, Part 1, 1660–1700, ed. William Van Lennep, Emmett L. Avery, and Arthur H. Scouten (Southern Illinois University Press, 1965), Part 2, 1700–1729, ed. Emmett L. Avery (2 vols, 1960), Part 3, 1729–1747, ed. Arthur H. Scouten (2 vols, 1961), Part 4, 1747–1776, ed. George Winchester Stone, Jr. (3 vols, 1963), Part 5, 1776–1800, ed. Charles Beecher Hogan (3 vols, 1968). The second is a biographical dictionary that emanates from the same stable: Philip H. Highfill, Jr., Kalman A. Burnim and Edward A. Langhans, *A Biographical Dictionary of Actors, Actresses, Musicians, Dancers, Managers, and other Stage Personnel in London, 1660–1800* (3 vols, Southern Illinois Press, 1973–76). Equally useful is David Thomas (ed.), *Restoration and Georgian England, 1660–1788*, Theatre in Europe: a Documentary History Series (Cambridge: Cambridge University Press, 1989).

In addition, a number of general studies offer excellent surveys. They include Robert D. Hume (ed.), *The London Theatre World, 1660–1800* (Carbondale and Edwardsville, Illinois: Southern Illinois University Press, 1980), John Loftis, *The Politics of Drama in Augustan England* (Oxford: Clarendon, 1963), John Loftis, Richard Southern, Marion Jones and A. H. Scouten (eds.), *The Revels History of English Drama, vol. 5, 1660–1750* (London: Methuen, 1976). *The Revels History of English Drama, vol. 6, 1750–1880* (London: Methuen, 1976).

The best account of the significance of the Jubilee both on stage and at Stratford can be found in Michael Dobson, *The Making of the National Poet: Shakespeare, Adaptation and Authorship, 1660–1769* (Oxford: Clarendon Press, 1992). Gary Taylor, *Reinventing Shakespeare: A Cultural History from the Restoration to the Present* (New York and Oxford: Oxford University Press, 1989) is an outstanding example of a study that can be both scholarly and accessible and,

together with Jonathan Bates's, *Shakespearean Constitutions: Politics, Theatre, Criticism, 1730–1830* (Oxford: Clarendon Press, 1989), ensures that the importance of the Bard is not lost to eighteenth-century cultural history.

Thomas Davies, *Memoirs of the Life of David Garrick, Esq*, 2 vols (London, 1780) was the first biography of Garrick. The standard modern study, an exhaustive tome, is George Winchester Stone and George M. Kahrl, *David Garrick: A Critical Biography* (Carbondale, Illinois: Illinois University Press, 1979). David Garrick, *The Letters of David Garrick*, David Little and George Kahrl (eds.) (Oxford: Oxford University Press, 1963) is not only essential but pleasurable reading.

The long-standing hostility to the theatre is discussed in Jonas A. Barish, *The Antitheatrical Prejudice* (Berkeley: University of California Press, 1981). Shearer West, *The Image of the Actor: Verbal and Visual Representation in the Age of Garrick and Kemble* (London: Pinter, 1991) and Sandra Richards, *The Rise of the English Actress* (London: Macmillan, 1993) analyse the status and image of actors and actresses, while Donald A. Strauffer, *The Art of Biography in Eighteenth-Century England* (Princeton: Princeton University Press, 1941) discusses many theatrical biographies in the context of the genre as a whole. Charles Harold Gray, *Theatrical Criticism in London to 1795* (New York: Columbia University Press, 1931) is a work in the 1930s tradition of collection rather than analysis which includes a great deal of information about criticism throughout the century, while John A. Kelly, *German Visitors to London Theatres* (New York: Octagon Books, 1978) brings together the very many often astute comments by Germans on the London stage. W. E. Schultz, *Gay's Beggar's Opera* (New Haven: Yale University Press, 1923) is an indispensable work which traces almost every allusion to *The Beggar's Opera* during the eighteenth century. The classic study of the theatrical audience is Henry Pedicord, *The Theatrical Public in the time of Garrick* (New York, 1954), but see also Leo Hughes, *The Drama's Patrons: A Study of the Eighteenth-Century London Audience* (Austin: University of Texas Press, 1971) and James J. Lynch, *Box, Pit and Gallery: Stage and Society in Johnson's London* (Berkeley: University of California Press, 1953).

9. THE THEATRE, POWER AND COMMERCE

Robert Hume discusses late seventeenth-century theatre in his *The Development of English Drama in the late Seventeenth Century* (Oxford: Clarendon, 1976). H. Diack Johnstone and Roger Fiske (eds.), *The Blackwell History of Music in Britain, vol. 4: The Eighteenth Century* (Oxford: Blackwell, 1990), especially Chapters 3 and 6, offers the best introduction to theatre music whose development in the early eighteenth century is best analysed in Curtis Price, 'The Critical Decade

for English Music Drama, 1700–1710', *Harvard Library Bulletin* 26 (1978), pp. 38–76. The accounts of London concert life given in *The New Grove Dictionary of Music and Musicians*, ed. by Stanley Sadie (London: Macmillan, 1981) are also excellent. William Weber, *The Rise of the Musical Classics in Eighteenth-Century England: A Study in Canon, Ritual, and Ideology* (Oxford: Clarendon, 1992) traces the different strands of music that were woven into a national tradition, while Winton Dean's *Handel's Dramatic Oratorios and Masques* (London, 1959) is the classic study of Handel's contribution to the genre. Otto Eric Deutch, *Handel: a Documentary Biography* (London: 1955) is crammed full of original material, while Christopher Hogwood's *Handel* (London: Thames and Hudson, 1984) is both scholarly and accessible. Ronald Paulson discusses Hogarth's views on opera in *Hogarth*, vol. I, pp. 74–90. The fullest study of changes in drama in the 1720s and 1730s is Robert Hume, *The Rakish Stage: The London Theatre from the Beggar's Opera to the Licensing Act* (Carbondale, Illinois: Southern Illinois University Press, 1983). Vincent J. Liesenfeld, *The Licensing Act of 1737* (Madison: University of Wisconsin Press, 1984) is an oustanding study of the circumstances leading to the Act, and knocks on the head many old clichés about the legislation being a Whig government conspiracy.

10. PERFORMANCE FOR THE NATION

On the late eighteenth-century theatre see *Memoirs of Richard Cumberland Written by himself, containing an account of his life and writings, interspersed with anecdotes and characters of several of the most distinguished persons of his time* (London: Lackington, Allen, & Co., 1806). Gerald Kahan has written a study, *George Alexander Stevens and the Lecture on Heads* (Athens: University of Georgia Press, 1984). The lectures themselves were published as *A lecture on heads by the celebrated George Stevens, which has been exhibited upwards of three hundred successive nights to crowded audiences, and met with the most universal applause* (London: Printed for J. Pridden, at No. 100 in Fleet St., [n.d.]). Marc Baer, *Theatre and disorder in late Georgian London* (Oxford and New York: Clarendon Press, 1992) is an excellent study of the Old Price Riots of 1809 which is illuminating not only about the disturbances but about the state of the early nineteenth-century theatre in general. On Handel and 1784 see especially the final chapter of William Weber's *The Rise of the Musical Classics*. The changes in music in the theatre are well covered in Johnstone and Fiske, *The Blackwell History of Music in Britain*, especially Chapter 6. My account of Garrick draws on the materials cited in Chapter 9 and especially on Dobson, *The Making of the National Poet*, Stone and Kahrl, *David Garrick* and Taylor, *Reinventing Shakespeare*.

PART V · MAKING A NATIONAL HERITAGE

II. BORROWING, COPYING AND COLLECTING

I have used John Gay, *The Beggars Opera*, Edgar V. Roberts (ed.) (London: Edward Arnold, 1969) as the edition of Gay's wonderful work. W. E. Schultz, *Gay's Beggar's Opera* (New Haven: Yale University Press, 1923, is the most remarkable modern compendium of eighteenth-century material on *The Beggar's Opera*. A collection of essays edited by Harold Bloom, *John Gay's The Beggar's Opera* (New York: Chelsea House, 1988) offers the best critical account of the ballad opera. Lincoln B. Faller's *Turned to Account: the Forms and Functions of criminal biography in late-seventeenth and early eighteenth-century England* (Cambridge: Cambridge University Press, 1987) provides the literary context within which Gay worked, while Gerald Howson, *Thief-Taker General: The Rise and Fall of Jonathan Wild* (London: Hutchinson, 1970) discusses the criminal culture of the 1720s. Peter Linebaugh, 'The Ordinary of Newgate and his *Account*' in J. S. Cockburn (ed.), *Crime in England 1550–1800* (London: Methuen, 1977), pp. 246–69 is a study of criminal lives, while the first chapter of his *The London Hanged: Crime and Society in the Eighteenth Century* (London, Allen Lane, 1991) deals with the escapes of Jack Sheppard.

Richard T. Godfrey's *Printmaking in Britain: a General History from its Beginnings to the Present Day* (Oxford: Phaidon, 1978) is the best general introduction to the subject. David Alexander and Richard T. Godfrey, *The Reproductive Print from Hogarth to Wilkie* (New Haven: Yale Center for British Art, 1980) surveys the eighteenth-century reproduction of paintings. Marcia Poynton analyses Grainger and the practice of 'Graingerizing' in the second section of her *Hanging the Head: Portraiture and Social Formation in Eighteenth-Century England* (New Haven and London: Yale University Press, 1993), while David Alexander's *Affecting Moments: Prints of English Literature made in the Age of Romantic Sensibility, 1775–1800* (York: University of York, 1993) examines late eighteenth-century sentimental prints.

Apart from Reynolds's *Discourses* in the edition edited by Robert Wark, the key canonical works on British culture – which are best discussed in Lawrence Lipking, *The Ordering of the Arts in Eighteenth-Century England* – are Thomas Warton, *History of English Poetry* . . ., 3 vols (London: 1774–81); Horace Walpole, *Anecdotes of Painting in England* . . ., 4 vols (Strawberry Hill, 1762–71); Sir John Hawkins, *A General History of the Science and Practice of Music*, 5 vols (London, 1776); Charles Burney, *A General History of Music: from the Earliest Ages to the Present Period*, 4 vols (London: printed privately, 1776–89) and Samuel Johnson, *Lives of the English Poets*, 2 vols (Dutton: Dent, 1954). Sheridan's views can be found in Thomas Sheridan, *British Education: or the Source of the Disorders of Great Britain* . . . (London, 1756). There are a number of excellent recent studies

of the issue of bookselling and canons, notably Thomas Bonnell, 'Bookselling and Canon-Making: The Trade Rivalry over the English Poets, 1776–1783,' *Studies in 18th Century Culture*, vol. 19 (1989), pp. 53–69, Trevor Ross, 'Just *When* Did *British bards begin t'Immortalize?*' in *Studies in 18th-Century Culture,* vol. 19 (1989), pp. 383–93, and the oustanding Trevor Ross, 'Copyright and the Invention of Tradition,' *Eighteenth-Century Studies*, vol. 26 (1992), pp. 1–27.

PART VI · PROVINCE AND NATION

12. THE ENGLISH PROVINCES

There is no better general introduction to the literature on eighteenth-century towns and their culture than Peter Borsay, *The English Urban Renaissance: Culture and Society in the Provincial Town 1660–1770* (Oxford: Clarendon, 1989). Other extremely valuable works include P. J. Corfield, *The Impact of English Towns, 1700–1800* (Oxford: Oxford University Press, 1982); Peter Clark (ed.), *The Transformation of English Provincial Towns* (London: Hutchinson, 1985); Alan Everitt, 'The English Urban Inn' in Alan Everitt (ed.), *Perspectives in English Urban History* (London: Macmillan, 1973) and C. W. Chalkin, 'Capital Expenditure on Building for Cultural Purposes in Provincial England, 1730–1780,' *Business History*, 22 (1980), pp. 51–70.

13. THOMAS BEWICK: 'THE POET WHO LIVES ON THE BANKS OF THE TYNE'

The largest collection of Bewick materials is in the Newcastle-upon-Tyne central library, which holds the Pease, Charnley and Robinson and Vernon collections. These include correspondence and a vast quantity of graphic material produced by the Bewick workshop. The Huntington Library in California's Bewick manuscripts include lists of books owned by Jane, Elizabeth and Robert Bewick, as well as an inventory of their father's books, and some correspondence and memoranda. Bewick manuscripts in the National Art Library at the Victoria and Albert Museum include private accounts for 1812–17, correspondence with publishers and friends, and some weekly engraving account books. The bulk of Bewick's business records are deposited in the Tyne and Wear archives in Newcastle, and provide the fullest picture of any engraving business in the eighteenth and early nineteenth centuries. Iain Bain has done more than anyone else to inform us about Bewick's life. His *A Memoir of Thomas Bewick written by himself* (Oxford and New York: Oxford University Press, 1979) is the standard edition of Bewick's

memoir, his *The Watercolours and Drawings of Thomas Bewick and his Workshop Apprentices*, 2 vols (London: Gordon Fraser, 1981) is not only a book of great beauty but extremely informative, as is his catalogue *Thomas Bewick: An Illustrated Record of his Life and Work* (Newcastle-upon-Tyne, The Laing Gallery, 1979). Bain has also prepared a checklist of Bewick's correspondence and was one of the key figures in ensuring the restoration of Bewick's birthplace at Cherryburn which is now managed by the National Trust. The most interesting discussion of Newcastle politics and society in the period is Kathleen Wilson's *The Sense of the People: Politics, Culture and Imperialism in England, 1715–1785* (New York and Cambridge: Cambridge University Press, 1995). Also of interest is John Brewer and Stella Tillyard, 'The Moral Vision of Thomas Bewick' in Eckhard Hellmuth (ed.), *The Transformation of Political Culture, England and Germany in the late Eighteenth Century* (Oxford: Oxford University Press and the German Historical Institute, London, 1990), pp. 375–408.

14. 'THE HARMONY OF HEAVEN': JOHN MARSH AND PROVINCIAL MUSIC

There are two surviving versions of John Marsh's 'History of my Private Life'. One, in sixteen volumes, is in the Cambridge University Library (Add. Mss 7757), the other, a fuller version of thirty-seven volumes is in the Huntington Library in San Marino, California. The Cambridge version may well be a copy owned by Marsh's son, Edward Garrard, a fellow of Oriel College, Oxford, and an editor of the *British Review*. It consists chiefly of those extracts of the *Life* which are concerned with music and omits much personal detail and material on local social life. I suspect that it was the beginnings of a text prepared for publication, but which never went to press, probably because of its sheer bulk. I have written an essay about the history, 'John Marsh's History of my Private Life, 1752–1828,' in T. C. W. Blanning and David Cannadine (ed.), *History and Biography. Essays in Honour of Derek Beales* (Cambridge: Cambridge University Press, 1996), pp. 72–87. Marsh's other publications included *A Tour Through Some of the Southern Counties of England: By Peregrin Project and Timothy Type* (London: 1804) and *The Excursions of a Spirit; with a Survey of the Planetary World: A Vision with four illustrative Plates* (London: F. C. & J. Rivington, 1821), John Marsh, *The Astrarium Improved . . .* (London, 1807).

On Marsh's musical career see *The New Grove Dictionary of Music and Musicians*, ed. Stanley Sadie (London, 1981), vol. 11, 706–07; Stanley Sadie, 'Concert Life in Eighteenth-Century England,' *Proceedings of the Royal Musical Association*, lxxviii (1958–9), esp. p. 17; Brian Robins, 'John Marsh: a Georgian Gentleman Composer,' *Southern Early Music Forum*, no. 3 (1984), pp. 10–14; Ian Graham-Jones, 'An Introduction to the Symphonies of John Marsh,' *Southern Early Music Forum*, no. 3 (1984), pp. 15–18.

On music in the period in general see Richard Leppert, *Music and Image: Domesticity, Ideology and Socio-Cultural Formation in Eighteenth-Century England* (Cambridge: Cambridge University Press, 1988) which discusses the social significance attached to different forms of musical performance. The collection edited by Christopher Hogwood and Richard Luckett, *Music in Eighteenth-Century England: Essays in Memory of Charles Cudworth* (Cambridge: Cambridge University Press, 1983) contains an excellent series of studies which together provide a valuable overview. On musical life in the provinces see Trevor Fawsett, *Musical Life in Eighteenth-Century England* (Norwich, 1979). Nicholas Temperley, *The Music of the English Parish Church*, 2 vols (Cambridge: Cambridge University Press, 1979) is a masterly study of every aspect of church music. On music in Salisbury and the part played by James Harris see Clive T. Probyn, *The Sociable Humanist: the Life and Works of James Harris, 1709–1780: Provincial and Metropolitan Culture in Eighteenth-Century England* (Oxford: Clarendon Press, 1991). Also of importance are Cyril Ehrlich, *The Musical Profession in Britain since the Eighteenth Century: A Social History* (Oxford: Clarendon, 1985); William Weber, *The Rise of the Musical Classics*; H. Diack Johnstone and Roger Fiske (eds.), *The Blackwell History of Music in Britain, vol. 4: The Eighteenth Century*.

15. 'QUEEN MUSE OF BRITAIN': ANNA SEWARD OF LICHFIELD AND THE LITERARY PROVINCES

The key works of Anna Seward are *The Poetical Works of Anna Seward with extracts from her literary correspondence*, by Walter Scott (Edinburgh and London: Ballantyne and Co.; Longman, Hurst, Rees, and Orme, 1810); Anna Seward, *Letters of Anna Seward written between the years 1784 and 1807*, edited by A. Constable (Edinburgh, 1811), which should be read in conjunction with James L. Clifford, 'The Authenticity of Anna Seward's Published Correspondence,' *Modern Philology* XXXIX (1941), 113–122. Margaret Ashmun, *The Singing Swan: An account of Anna Seward and her acquaintance with Dr Johnson, Boswell, and others of their time, etc.* (New Haven: Yale University Press, 1931) is a standard biography. Gretchen M. Foster's *Pope versus Dryden: A Controversy in Letters to The Gentleman's Magazine* (Victoria, B.C.: English Literary Studies, 1989), analyses the most protracted of Seward's literary controversies. Ruth Avaline Hesselgrave, *Lady Miller and the Batheaston Literary Circle* (New Haven: Yale University Press, 1927) is the only study of the circle of amateur versifiers which Seward joined. Elizabeth Mavor, *Ladies of Llangollen: a Study in Romantic Friendship* (Harmondsworth: Penguin, 1973) examines the reputation and lives of Seward's two literary female friends. On the Midlands circles and the Lunar Society see John Money, *Experience and Identity: Birmingham and the West Midlands* (Montreal: McGill-

Queen's University Press, 1977) and Robert E. Schofield, *The Lunar Society of Birmingham. A Social History of Provincial Science and Industry in Eighteenth-Century England* (Oxford: Clarendon Press, 1963).

PART VII · BRITAIN

16. CULTURE, NATURE AND NATION

Among the many works of travel literature I have consulted are Celia Fiennes, *Illustrated Journey of Celia Fiennes, 1685–1712*, Christopher Morris (ed.) (Sutton, 1995); Robert Morden, *The New Description and State of England* ... (London, 1701); James Brome, *Travels over England and Wales* (London: Abel Roper, 1700); Leopold Bertold, *An Essay to Direct and Extend the Inquiries of Patriotic Travellers* (London, 1789); *Britannia Depicta* ... (London, 1720); John Ogilby, *Britannia* ... *or an Illustration of the Kingdom of England* (London, 1675); *England Illustrated* (London, 1764); Arthur Young, *A Sixth Month Tour through the North of England* (London: W. Strahan, 1770); *A New Display of the Beauties of England* (London, 1787); Thomas West, *A Guide to the Lakes* ... (London, 1778); William Mavor, *The British Tourists* ... (6 vols, London, 1798–1800) and Thomas Gray, *A Supplement to the Tour of Great Britain* (London, 1787). Of great importance for tourism and the picturesque are the works of William Gilpin: *Observations on the River Wye and several Parts of South Wales* (London, 1782) and the same author's *Observations relative chiefly to Picturesque Beauty* ... *particularly the Mountains and Lakes of Cumberland and Westmoreland* (London, 1786) and *Observations relative chiefly to Picturesque Beauty* ... *particularly the Highlands of Scotland* (London, 1789); *Three Essays: on Picturesque Beauty, on Picturesque Travel and on Sketching Landscape* (London: R. Blamire, 1792). Arthur Young, *Annals of Agriculture* (46 vols, London, 1784–1815) is the famous improving periodical of the period. John Byng, Viscount Torrington, *The Torrington Diaries: Containing the Tours through England and Wales of the Hon. John Byng* ... C. Bruyn Andrews (ed.) (London: Methuen, 1970) is probably the most famous account of domestic travel.

There is a great deal of excellent literature on landscape. Not only fine traditional scholarship of the sort exemplified in John Dixon Hunt, *The Figure in the Landscape: Poetry, Painting and Gardening during the Eighteenth Century* (Baltimore and London: Johns Hopkins University Press, 1989), but more recent critical analyses. I have found especially valuable the work of John Barrell, *The Idea of Landscape and the Sense of Place 1730–1840: an Approach to the Poetry of John Clare* (Cambridge: Cambridge University Press, 1972) and *The Dark Side of the Landscape: The Rural Poor in English Painting, 1730–1840* (Cambridge: Cambridge University Press, 1980), as well as Ann Bermingham's *Landscape and*

Ideology (Berkeley: University of California Press, 1986). Also of great help have been Denis Cosgrove and Stephen Daniels (eds.), *The Iconography of Landscape* (Cambridge, Cambridge University Press, 1988); Stephen Daniels, *Fields of Vision: Landscape Imagery and National Identity in England and the United States* (Cambridge: Polity, 1993); Stephen Copley and Peter Garside *(eds.), The Politics of the Picturesque: Literature, Landscape and Aesthetics since 1770* (Cambridge: Cambridge University Press, 1994). Nigel Everett, *The Tory View of the Landscape* (New Haven and London: Yale University Press, 1994) shows that left-wing historians don't have a monopoly of historical expertise and trenchant social criticism, and also rehabilitates a view of the landscape that was opposed to enclosure and improvement. As a general survey of the picturesque and its tours, Malcolm Andrews, *The Search for the Picturesque: Landscape Aesthetics and Tourism in Britain, 1760–1800* (Aldershot: Scolar, 1989) is outstanding. Ian Ousby's *The Englishman's England: Taste, Travel and the Rise of Tourism* (Cambridge and New York: Cambridge University Press, 1990) is an excellent and highly readable survey of the different sorts of eighteenth-century tourism. The country house has been served well for many years by Mark Girouard's *Life in the English Country House* (New Haven and London: Yale University Press, 1978). There is much of importance in the hagiographic *The Treasure Houses of Britain: Five Hundred Years of Private Patronage and Art Collecting*, ed. Gervase Jackson-Stopes (Washington, New Haven and London: National Gallery of Art and Yale University Press, 1985). On Wales, David Solkin's study of Richard Wilson, *Richard Wilson: The Landscape of Reaction* (London: Tate Gallery, 1982) is a stunning example of how a study of a single artist can combine traditional art historical skills with tough-minded social analysis and Gwynn Williams, *When was Wales? A History of the Welsh* (London, Black Raven, 1985) is full of insight about the Welsh and their relations to Britain. Peter Womack, *Improvement and Romance: Constructing the Myth of the Highlands* (London: Macmillan, 1989) is a brilliant and original dissection of the images and ideas about the eighteenth-century Highlands. Two other works by masters of their craft, Keith Thomas, *Man and the Natural World: Changing Attitudes in England, 1500–1800* (London: Allen Lane, 1983) and Raymond Williams, *The Country and the City* (London: Hogarth Press, 1985), have throughout informed my analysis. And finally, the collection of essays edited by Eric Hobsbawm and Terence Ranger, *The Invention of Tradition* (Cambridge: Cambridge University Press, 1994) is one of the most telling accounts of how we invent our past.

SOURCES OF ILLUSTRATIONS

Courtesy of The Lewis Walpole Library, Yale University:
plates 4 and 9, 3, 9, 10, 13, 14, 15, 17, 19, 24, 25, 36, 41, 42, 46, 56, 63, 80, 96, 108, 123, 128, 143, 152, 160, 163, 168, 176, 182, 183, 184, 185, 186, 187, 188, 189, 191, 192, 193, 213, 224, 230

Harvard Theatre Collection, the Houghton Library: 119, 121, 124, 127, 129, 131, 134, 135, 145, 148, 158, 162, 164, 170, 171, 172, 173, 174, 175

Courtesy of the Director, National Army Museum, London: 7

By Courtesy of the National Portrait Gallery: plate 1, iv, 26, 103, 126

Location unknown. Print provided by courtesy of the National Portrait Gallery, London: 49, 218

Victoria Art Gallery, Bath: Photo credit: Courtauld Institute of Art. 109

Copyright, British Museum: 20, 91, 95, 102, 105, 156, 161, 166, 177

Copyright British Museum, Photo Credit: Paul Mellon Centre for Studies in British Art, London: 126, 151

Copyright Tate Gallery, London: plates 10 and 12

City of Aberdeen Art Gallery and Museums Collections: 12

Norfolk Museums Service (Norwich Castle Museum): 88

Towneley Hall Art Gallery and Museum, Burnley. Photo credit: Bridgeman Art Library. London: plate 5

By permission of the British Library: 2, 97

National Gallery of Scotland: 61, 111, 239, 241

Reproduced by courtesy of the Trustees, the National Gallery, London: plate 7

National Museum and Galleries of Wales. Photo credit: Paul Mellon Centre for Studies in British Art, London, London: 220, 223

The Worshipful Company of Makers of Playing Cards. Photo Credit: Guildhall Library, Corporation of London: 169

Guildhall Library, Corporation of London: 11, 16, 22, 23, 27, 38, 52, 53, 67, 69, 81, 82, 87, 132, 136, 141, 142, 165, 167, 179, 188.

Warburg Institute, London. Photo Credit: RCHME: 137

Witt Library, Courtauld Institute of Art, 50, 85, 100, 115

Derby City Art Gallery and Museum. Photo credit: Paul Mellon Centre for Studies in British Art, London: 229

Yale Center for British Art, Paul Mellon Collection: 31, 44, 51, 57, 58, 65, 66, 75, 101, 116, 122, 139, 140, 155, 180, 219

Yale Center for British Art. Photo credit: Paul Mellon Centre for Studies in British Art, London: 133

Royal Academy Archives: plate 11, 18, 33, 55, 72, 83, 84, 104, 107, 124, 149, 150, 153, 154, 190, 232

Musée des Beaux-Arts, Strasbourg. Photo credit: Paul Mellon Centre for Studies in British Art, London, 237

Tyne and Wear Record Office, 195.

Newcastle-upon-Tyne City Libraries, 196–212.

The County Archivist, West Sussex Record Office. Photo credit: Beaver Photography: 214, 217

Sotheby's: 39, 43, 45, 71, 99, 112, 159, 225, 233, 235

Sotheby's. Photo credit: Mellon Centre for Studies in British Art, London: 110, 234, 238

Courtesy Lilly Library, Indiana University, Bloomington, Indiana: 32a, b.

INDEX